This is the first study of middle-class
collection practices in nineteenth-century
England. It examines the Victorian art world
from the perspective of the businessmen
whose successes during the Industrial
Revolution caused them to turn to art as
a means of carving out an identity of their
own that was distinct from the leisured
existence of the aristocracy and gentry.
Such patrons created a market for early-
Victorian narrative paintings which
nostalgically perpetuated the oral traditions
of village life, mid-Victorian scenes which
glorified the accomplishments and moral
probity of urban dwellers, and late-Victorian
eroto-religious subjects which promised
escapist pleasures to the world-weary buyer.
Macleod's analysis of class, motivations and
patterns of consumption among patrons is
supplemented by a biographical appendix
of 146 collectors.

Art and the Victorian middle class

Art and the Victorian middle class

Money and the making of cultural identity

Dianne Sachko Macleod
Art History Program
University of California, Davis

CAMBRIDGE
UNIVERSITY PRESS

Published by the Press Syndicate of the University of Cambridge
The Pitt Building, Trumpington Street, Cambridge CB2 1RP
40 West 20th Street, New York, NY 10011–4211, USA
10 Stamford Road, Oakleigh, Melbourne 3166, Australia

First published 1996
Reprinted 1998

Printed in Great Britain at the University Press, Cambridge
Designed in QuarkXPress and Monotype Columbus

A catalogue record for this book is available from the British Library

Library of Congress cataloguing in publication data

Macleod, Dianne Sachko.
 Art and the Victorian middle class: money and the making of
cultural identity / Dianne Sachko Macleod.
 p. c.
 Includes biographical appendix of 146 collectors.
 Includes bibliographical references and index.
 ISBN 0 521 55090 4 (hardback)
 1. Art and society – England – History – 19th century. 2. Art
patronage – England – History – 19th century. 3. Middle class –
England – Identification. I. Title.
N72.S6M23 1996
701'.03–dc20 95–24299 CIP

ISBN 0 521 550904 hardback

TAG

To Norman and Alexander

Contents

Color plates

Black-and-white plates

Acknowledgments

I did not set out to write a book about the ways that businessmen affected Victorian culture. I intended to explore the world of art criticism until I discovered the series that Frederick George Stephens wrote for the *Athenaeum* on the private collections of England which made me realize how little we knew about the people who bought Victorian paintings. The fact that Stephens conveniently grouped his reviews of collections of contemporary art geographically led me to Liverpool and Newcastle, where I encountered the riches of local history libraries and regional records offices. For aiding me in the early phase of my research, I am indebted to F. W. Manders, Local Studies Librarian, Newcastle Central Library; Robin Gard, Archivist, Northumberland Record Office; Hugh Dixon, Northumbria Regional Office, National Trust; and Janet Smith, Liverpool Record Office, Brown, Picton, and Hornby Libraries. The sources they directed me to made it possible to reconstruct the identities of individual collectors through obituaries, insurance inventories, post office directories, histories of their personal and business properties, newspaper accounts of their local activities, sales catalogues of their collections, and, in rarer instances, contact with their descendants. I found, in other words, that there was enough archival material to base a book on the interplay between art and commerce.

After I branched out from Liverpool and Newcastle, I checked the resources of the Royal Commission on Historical Manuscripts and the photographic library of the Royal Commission on Historical Monuments (England) against the list of major collectors that I had culled from artists' memoirs and art journals. I am grateful to the librarians at both those organizations for sharing their knowledge with me. Finding I still had many gaps to fill in, I continued to rely on the good graces of regional libraries and archivists. The staffs of the Birmingham Central Library, Manchester City Library, and Victoria and Albert Museum Library were very helpful. I would also like to thank I. G. Murray, Borough of Haringey Archives; D. A. Partridge, Havering Central Library; Eleanor Nannestad, Lincoln Reference Library; Glenise Matheson, John Rylands University Library; Ruth Schmidt, Lambeth Archives Department; R. M. Harvey, Guildhall Library; Lilian Gibbens, Westminster Heritage Researcher, Victoria Library; J. T. Smith, Essex Record Office; and Frank Strahan, University of Melbourne Archives. For undertaking time-consuming research on my behalf, I am

indebted to Brian Barber, Doncaster Record Office, for unearthing new information about Robert Vernon; Eric Hollerton, Old Central Library, North Shields, for investigating the civic activities of Alexander Stevenson and Jacob Burnett in Tynemouth; Murdo MacDonald, Argyll and Bute District Council, for searching for a key obituary on John Miller; Sandra L. Smith, Departmental Librarian, Leeds Central Library, for locating the source of Samuel Smiles's oft-quoted but undocumented remarks on art collecting in two separate passages in *Thrift: A Book of Domestic Counsel*; and Geoffrey Baggot for giving up a day of his own research to play detective for me by investigating the background of Daniel Roberts.

Given the nature of my subject, I relied on business archives to a large extent. It was by writing to Peter McKenzie at Vickers Defence Systems that I discovered the existence of letters written by Sir William Armstrong about his art collecting experiences. I am also grateful to Nicholas Faulkener, former historian for Ind Coope Ltd. (Allied Lyons), for answering my inquiries about brewer Charles Mathews; Bruce Pennay, Rivery Murray Institute of Higher Technology, Albury, NSW, Australia, for providing me with useful information about George McCulloch's mining ventures; and Kate Arnold-Forster, Museum Officer, Pharmaceutical Society of Great Britain, for patiently answering my many questions about Jacob Bell and Benjamin Godfrey Windus. I would also like to thank the librarians at British Steel Corporation, Northern Regional Records Centre, Middlesbrough, the Law Society; Gray's Inn, Inns of Court, Royal Institution, Wellcome Institute of Medicine, National Maritime Museum, and the Religious Society of Friends.

While it is difficult to locate descendants of the Victorians, those I managed to contact proved to be unstintingly generous. I would like to thank Lord Armstrong, Lady Bell, Peter Bicknell, the late W. A. C. Coltart, Roderick Enthoven, Richard Dumbreck, Dr. Gilbert L. Leathart, Christopher Newall, Hew Shannan Stevenson, Margaret Webster, Andrew Wells, as well as those who have chosen to remain anonymous.

Equally forthcoming were the scholars who shared their research with me. I am beholden to Malcolm Warner for providing me with a copy of his dissertation on John Everett Millais and for putting me in touch with the owners of several of that artist's pictures, Selby Whittingham and John Gage for information on Turner's patrons, Don McGuire for sending me the manuscript of his book on Charles Mitchell, Sheila Kirk for telling me about Philip Webb's clients, Oliver Garnett for producing typescripts of William

Graham's all but indecipherable handwritten letters, Lynn Matteson for sending me photocopies of George Watts's correspondence with Charles Rickards, Colin Hughes for telling me about his dissertation research on Thomas Combe, Leonard Roberts for information on John Hamilton Trist, Leonee Ormond for sharing an unpublished paper on F. G. Stephens, Stephen V. Sartin for his knowledge of Richard Newsham, Catherine Coan for providing me with a copy of her MA thesis on Birmingham patrons, collectors, and dealers, and Olive and Sidney Checkland for a stimulating discussion about the self-made man. I would also like to thank Jeremy Maas, who read my early chapters in draft and offered many sensible suggestions.

While much of the research for this project took me away from my usual art historical haunts, I still depended on curatorial expertise, particularly that of Julian Treuherz, first at the Manchester City Art Gallery, and more recently in his capacity as Keeper of Fine Art at the Walker Art Gallery, Liverpool, where Edward Morris also gave me valuable advice. I also benefited from the counsel of David Blayney Brown at Oxford, Richard Green at York, Rowland Elzea at Delaware, and Gary Corbett at Broken Hill. It was a joy to see my research efforts brought to life in the "Pre-Raphaelites: Painters and Patrons in the North East" exhibition at the Laing Art Gallery in Newcastle in 1989. Jane Vickers intelligently reconstructed a number of Northumbrian collections and added a local dimension of her own.

Not all of my discoveries into the lives of Victorian businessmen were made abroad. Closer to home, I was generously aided at the Provenance Index, Getty Art History Information Program, Santa Monica by my former student Julia Armstrong, who provided me with key copies of sales catalogues, as well as access to collectors' files and microfiches of Agnews's stockbooks. George Brandak, special Collections, Library of the University of British Columbia, Vancouver, was also unfailingly resourceful and cooperative in guiding me through the Leathart and Angeli-Dennis Papers. Art librarians Bonnie Holt and Jane Kimball kept me abreast of new holdings and electronic research opportunities at Davis, while Roberta Devine, Jerrie Wright, and Emma Katelba provided congenial staff support. I am grateful to the National Endowment for the Humanities, which afforded me the luxury of a summer's writing, and the Committee on Research at the University of California at Davis, which supported my endeavors. I am also indebted to the L&S Dean's Office and the Office of Research for providing a publication subvention grant. Finally, I wish to thank Oxford University Press for granting me permission to cite portions of my article, "The Dialectics of

Modernism and English Art," which appeared in the *British Journal of Aesthetics* 35 (Jan. 1995), 1–14.

While it is difficult for me to pinpoint the exact moment that I began to research this book, I distinctly remember searching for several photocopies only to discover that my five-year-old son had transformed them into paper airplanes. I am thankful for Alexander's good-natured ability to entertain himself while I promised to finish "just one more sentence," even though, as those sentences grew into chapters, he progressed from his aeronautical phase to surfing on the Internet. His father demonstrated other kinds of patience when he left a barrister's chambers early so that he could transcribe letters for me at the John Rylands University Library in Manchester, when he verified my usage of British terms and titles, and when he proofread my manuscript. For that and for his innumerable kindnesses I express my deepest gratitude.

Finally, I wish to acknowledge my mentors, colleagues, and students: the late L. D. Ettlinger, who introduced me to the complexities of the social and cultural viewpoint, the late Eugene Lunn, who encouraged my interdisciplinary bent, and the late Rosalie Mander, who always knew whom to contact. Fortunately, Dick Fredeman is still available for consultations, as are Susan Casteras, Julie Codell, Elizabeth Davis, Paula Gillett, Jeffrey Ruda, and Emmy Werner. My students are a continual source of inspiration. In addition to those who participated in my seminar on Victorian art collecting in 1986, I want to thank Annie Dean for sharing her research on Manchester patrons, Catherine Anderson for her enlightened assistance, and Allison Arieff, Leah Theis, and Kenney Mencher for keeping me current.

Abbreviations

Agnew Geoffrey Agnew, *Agnew's 1817–1967* (London: 1967).

Boase Frederic Boase, *Modern English Biography*, 6 vols. (Truro: 1892–1921).

"Constable Correspondence" "John Constable's Correspondence," ed. R. B. Beckett (vol. 18 ed. Leslie Parris and Ian Fleming-Williams) *Suffolk Records Society*, vols. 4, 6, 8, 10–12, and 18 (1962–75).

Darcy C. P. Darcy, "The Encouragement of the Fine Arts in Lancashire, 1760–1860," *Remains of the Chetham Society* 24 (1976).

DBB *Dictionary of Business Biography*, ed. David J. Jeremy, 5 vols. (London: 1984–86).

DNB *Dictionary of National Biography*.

ILN *Illustrated London News*.

Macleod (1986) Dianne Sachko Macleod, "Mid-Victorian Patronage of the Arts: F. G. Stephens's 'The Private Collections of England,'" *Burlington Magazine* 128 (August 1986), 597–607.

Macleod (1987) Dianne Sachko Macleod, "Art Collecting and Victorian Middle-Class Taste," *Art History* 10 (September 1987), 328–50.

Macleod (1989a) Dianne Sachko Macleod, "Private and Public Patronage in Victorian Newcastle," *Journal of the Warburg and Courtauld Institutes* 52 (1989), 188–208.

Macleod (1989b) Dianne Sachko Macleod, "Avant-Garde Patronage in the North East," in *Pre-Raphaelites: Painters and Patrons in the North East* (Newcastle: Laing Art Gallery, 1989), pp. 9–37 and 125–31.

Redford George Redford, *Art Sales: A History of Sales of Pictures and Other Works of Art*, 2 vols. (London: 1988).

Reitlinger Gerald Reitlinger, *The Economics of Taste* (New York: 1961).

Roberts William Roberts, *Memorials of Christie's: A Record of Art Sales from 1766 to 1896*, 2 vols. (London: 1897).

Waagen (1838) Gustav Waagen, *Works of Art and Artists in England*, 3 vols. (London: 1838).

Waagen (1854) Gustav Waagen, *Treasures of Art in Great Britain*, 3 vols. (London: 1854).

Waagen (1857) Gustav Waagen, *Galleries and Cabinets of Art in Great Britain* (London: 1857).

WWMP Michael Stenton, *Who's Who of British Members of Parliament*, 4 vols. (London: 1976–81).

Introduction

The simple truth is, that capital is the nurse and governess of the arts; not always a very wise or judicious nurse, but an exceedingly powerful one. And in the relation of money to art, the man who has money will rule the man who has art, unless the artist has money enough to enable him to resist the money of the buyer.

(P. G. Hamerton, *Thoughts about Art* [1871][1])

"The simple truth," as artist-critic Hamerton notes, is that Victorian art cannot be understood independently of its relationship to money. Capital empowered the emerging middle class and made patronage of contemporary art possible. Money, to the enterprising businessman, held the symbolic promise of a new cultural identity, while to the artist it represented freedom and security.

The link between art and money is inscribed in the unfolding saga of the cultural life of nineteenth-century England. Like a serialized Victorian novel, its plot spans several generations and shifts between provincial and metropolitan centers. While its unifying theme is the exchange of symbolic value for currency, it is the characters who provide the drama. They are the industrial and commercial magnates who struggled to define new roles for themselves in a society in which surplus capital was available to a wider spectrum of citizens than ever before. Tension erupts in this story, in the traditional relationship between artist and patron, but it resonates far beyond that duet when these new players in the cultural field challenge the very definition of art itself and its place in society.

My book examines these changes in Victorian culture from the perspective of the middle-class businessmen who felt it imperative to spend some of their wealth on the acquisition of art collections. Why was art so important to textile manufacturers, iron founders, and armament kings? Assumed by generations of scholars to have been motivated by a desire to emulate their betters, many of these men, I argue, had an even more ambitious agenda. My research reveals that art was a key element in the affirmation of a middle-class identity that was distinct from the leisured existence of the aristocracy. Rejecting high art and the time-consuming practice of connoisseurship, the new Maecenases supported representations by living

I

artists which embellished, morally reinforced, or sometimes even parodied the prevailing concept of daily life. Compositions crowded with telling narrative detail were prized by the early Victorians for their ability to entertain and to instruct, by the mid-Victorians for their talent for celebrating bourgeois virtues and social relations, and by the late Victorians for their skill at communicating to a dispirited public the illusion that all was still well. In other words, the motivations of middle-class art collectors lay at the very heart of the Victorian enterprise.

Although an audience for art existed among the middling ranks of society in the eighteenth century, it was not until the disruptive Napoleonic Wars had ended that their numbers and wealth were significant enough to alter the course of the art market. The expanding commercial élite in the early Victorian years made its presence felt throughout England in every sector of the cultural field: commercial galleries, art schools and academies, public exhibitions and museums, auction houses, art magazines, and artists' studios. Not content to imitate the aristocracy, these energetic businessmen recast the cultural system in their own image in an attempt to create a stable social category for their class. Yet virtually nothing is known about these Victorian counterparts to America's Mellons and Fricks, despite the fact that they were instrumental in shaping the cultural life of their era. Their obscurity arises from the scholarly neglect of Britain's middle class, in general, combined with the historic prejudice against businessmen, in particular. Only recently have social historians begun to divert their attention from the aristocracy and working class to the loosely formed segment of society that fell in between. Even so, researchers are still struggling to understand the most fundamental attitudes of the people who comprised the nineteenth century's most progressive class. According to Peter Gay, we have failed "to take the measure of their experience, their reception of the economic, political, intellectual, and social changes that so radically transformed their lives."[2] While Gay's four volumes have helped to remedy the situation by illuminating bourgeois social practices, the connection between culture and economics remains to be elaborated.

Such a rich and unexplored topic invites a host of questions. For the sake of coherence, I have restricted my discussion of the middle-class intervention in culture to six interlinking issues: the social backgrounds of art collectors and their motivations, their relations with artists and the effect of these relationships on patterns of consumption, and, finally, their conception of "taste" as it relates to the construction of culture at large.

Social background and motivations

Given the Victorians' propensity for categorical clichés, it is essential to reconstruct individual identities before drawing any conclusions about the middle class as a group. Class origins, wealth, education, occupation, travel, and geographic location are the raw materials from which character is forged. To gather this information I have consulted business and professional archives, ranging from the pharmaceutical to the armament industries, offices of records and deeds, parish records, local history societies, and schools and colleges, in addition to more traditional, but equally valuable, art historical sources, such as family papers and the holdings of libraries and art galleries. I have attempted to adopt a distanced and non-evaluative approach by compiling this data in an appendix of individual collectors to invite further interpretation of middle-class culture in the fine arts, humanities, and social sciences by scholars.

The tincture of trade associated with middle-class entrepreneurs has made them less appealing as subjects to the critics, curators, and dealers who launched the revival of interest in Victorian art. Frank Davis, former saleroom correspondent for *The Times*, included only two middle-class collectors of modern art among the twelve individuals he discussed in his seminal book, *Victorian Patrons of the Arts* (1963). Such prejudice, however, is not unique to writers on art. Historians and economists have also complained of their colleagues' long-standing lack of interest in the activities of the businessman, indicting with equanimity Marxists, neo-classical economists, and even the venerable *Dictionary of National Biography*. In an attempt to rectify this slight, the Economic and Social Research Council of Great Britain sponsored two major projects in London and Glasgow, resulting in the five-volume *Dictionary of Business Biography*, in 1984–86, and the two-volume *Dictionary of Scottish Business Biography* (1986–90). These publications, combined with current economic investigations into the distribution of individual wealth during the Victorian period have helped to bring into sharper focus the features of the Victorian businessman. When individual close-ups are substituted for the blurred contours of the standard group photograph, the portraits that emerge bear little resemblance to the hackneyed stereotype frequently employed to dismiss the Victorian capitalist as an insensitive, *nouveau-riche*, provincial entrepreneur.

My research into the backgrounds of 146 nineteenth-century collectors of modern art in England reveals a very different sort of individual who resembles the stereotype only in his gender. With little control over

their personal incomes before the latter part of the century, women did not conduct the financial transactions recorded in artists' or dealers' account books. Thus their names rarely occur in the archives of collecting prior to the time of the Aesthetic movement, when social strictures began to loosen. While I document the exceptions to this rule, such as Pre-Raphaelite patrons Martha Combe and Ellen Heaton, it is the men who dominate the field. The typical patron was a middle-aged male actively involved in business, but he was not a parvenu. Rather, his family had been comfortably off for at least three generations. He was educated at respectable, if unpretentious schools before entering the family business which frequently caused him to travel within the British Isles or abroad. While some patrons were the northern merchants or manufacturers of legend, the fact that the archetypal Victorian collector was just as likely to live in London or its suburbs and to earn his living in commerce or one of the professions disputes the popular provincial parody.

The blame for typecasting art collectors rests with the Victorians themselves. They were fascinated by the shift in patronage from patrician to pedestrian and made it a favorite topic of conversation in drawing rooms and artists' studios. The artist David Cox reports being questioned by an incredulous aristocrat (to whom he gave lessons), sometime between the years 1827 and 1835, about the fact that his "best patrons" were "the merchants and manufacturers of London, Liverpool, Manchester, and Birmingham."[3] Another early Victorian painter, Thomas Uwins, also verified that businessmen were replacing aristocrats in the art market. He claimed, "The old nobility and land proprietors are gone out. Their place is supplied by railroad speculators, iron mine men, and grinders from Sheffield, etc., Liverpool and Manchester merchants and traders."[4] The art periodicals were also guilty of stereotyping middle-class collectors. For instance, the *Art Union* observed in 1845 that "by far the greater number of recent productions of high value have their honoured places in the dwellings of our merchants and manufacturers" (p. 366).

Certainly the aristocracy and members of the landed gentry continued to buy art after the signing of the first Reform Bill in 1832; however, the number of their modern painting purchases fell in proportion to those of the middle class, despite the encouragement to living artists given by Queen Victoria and Prince Albert. As Jeremy Maas notes, although the monarch and her consort were good patrons of art, "Their interest in modern art came too late to induce the aristocracy to emulate them."[5] Less partial to

4

mid-Victorian Royal Academicians than their ancestors had been to Wilkie, Landseer, and Leslie, the names of the landed élite seldom figured in contemporary accounts of the art world. The *Art Journal* asserted in 1869: "The patrons of our day neither bear historic names nor are they famous …If we inquire by whom particularly our school has been supported in its advancement, we shall find its patrons among the wealthier sections of the middle class of society" (p. 279).

Because their family names were unfamiliar, the gentry preferred to think of all middle-class buyers of art as parvenus. Lady Eastlake, for one, so classified them when she attempted to analyze the transmission of purchasing power from landed to commercial aristocracy. Hers is the version most often cited by twentieth-century scholars, no doubt because of the position she held in the art world as wife of the man who was both director of the National Gallery and president of the Royal Academy, and because she was a respected author in her own right. In reference to the decade between 1830 and 1840, Lady Eastlake writes:

> A change which has proved of great importance to British art dates from these years. The patronage which had been almost exclusively the privilege of the nobility and higher gentry, was now shared (to be subsequently almost engrossed) by a wealthy and intelligent class, chiefly enriched by commerce and trade; the note-book of the painter, while it exhibited lowlier names, showing henceforth higher prices. To this gradual transfer of patronage another advantage very important to the painter was owing; namely, that collections, entirely of modern and sometimes only of living artists, began to be formed. For one sign of the good sense of the *nouveau riche* consisted in a consciousness of his ignorance upon matters of connoisseurship. This led him to seek an article fresh from the painter's loom, in preference to any hazardous attempts at the discrimination of older fabrics.[6]

The value of Lady Eastlake's remarks lies in their pithy summary of the main traits of the new patronage: the transference of leadership from the aristocracy to the middle class, the rise in price of modern art, and the emphasis on freshness that nullified the stringent demands necessary for the connoisseurship of Old Masters. But perhaps most important of all, in terms of our perception of these collectors, is her categorization of them as *nouveaux riches*. In adopting this term, Lady Eastlake addressed herself only to the more novel segment of the new patronage, the self-made entrepreneur, and discounted the vast majority of middle-class collectors with

inherited wealth. She goes on to name as examples Robert Vernon and John Sheepshanks as "founders of this class of collections"[7] when, although Vernon claimed to be from humble origins, Sheepshanks inherited a fortune from his father, a Leeds textile manufacturer who in turn was the son of a prosperous yeoman.[8]

By falling prey to the popular myth of the self-made man, Lady Eastlake was not unique among Victorians. Recent scholars have challenged the widespread nineteenth-century belief that most industrialists and manufacturers were the self-starters described in such hagiographic accounts of successful men as Samuel Smiles's *Self-Help* (1859) and James Hogg's *Fortunes Made in Business* (3 vols., 1884–86). Historian Harold Perkin describes the popular legend of the *homo novus* as "one of the most powerful instruments of propaganda ever developed by any class to justify itself and seduce others to its own ideal."[9] Moreover, the factual basis of the myth has been recently disputed by François Crouzet, who demonstrates that the majority of industrialists stemmed from the established mercantile middle class and the lower middle class of small landowners and merchants – not from the working class.[10] Similarly, Anthony Howe reports that only 20 percent of Lancashire textile manufacturers could claim to come from humble origins.[11] All these scholars agree that self-made tycoons were the exception rather than the rule in Victorian society.

To treat the patrons of modern art homogeneously as *arrivistes* is misleading because it ignores the gulf that existed between those who were surrounding themselves with luxury for the first time and those who had enjoyed the niceties of life for three or more generations. As Asa Briggs observes, "There were, indeed, at least as many differences of fortune and outlook within the middle classes (one-sixth of the population) as there were within the working classes."[12] Given the variety of attitudes and riches existing within the middle ranks of society, I use the term "middle class" in its broadest sense. My definition is both social and sociological. I consider an individual middle-class if his or her father was not born into the aristocracy or landed gentry and actively earned an income as opposed to living off the fruits of an inheritance. From a sociological perspective, my observations of the backgrounds, ambitions, and behavior of individual collectors has caused me to expand my field of vision and view them more broadly as middle-class "subjects," in the sense that they inevitably responded to broader social forces. I have tried to maintain a balance between individualism and collectivism by weighing the influence of biographical circumstances

6

against the pull of the tide of history. Jacob Bell, for instance, would have become an artist had not his fractious personality caused him to be expelled from art school. Instead he employed his feistiness more constructively when he became a dispensing chemist at a time when members of that field were eager to declare their independence from the medical profession and thus appreciated Bell's lobbying on their behalf. Consequently, while Bell's bourgeois occupation provided the wherewithal for his art collection, his early training in art coupled with his maverick personality influenced his decision to collect contemporary art. But for the vicissitudes of Bell's life, art works such as Frith's *Derby Day* would not be on view at the Tate Gallery today. The attitude of other collectors toward art was likewise altered by personal experiences such as the death of a child, a second marriage, or professional failures or successes. In taking these events into account, I am proposing a theory of middle-class culture that stresses the individualism of art collectors as a constitutive force in their interactions with society.

I am aware that my emphasis on individual biography is at odds with the theory of collective production favored by neo-Marxists and post-structuralists, particularly those whose antipathy to bourgeois individualism was initially inflamed by the high-profile entrepreneurs who form the core of my study. My reasons for focusing on the so-called culprits of capitalism are neither to celebrate nor to denigrate them. The fact that they were historically situated at the crossroads of modern culture is reason enough.

In interpreting these lives, however, I do not presume that each person is prepared to reject the influences of time and place. I do argue, nonetheless, that while circumstances such as family and education have a profoundly formative influence, their authority can be negotiated and reassessed in response to the constant stream of external stimuli and opportunity that confronts the individual. I agree with historian T. J. Jackson Lears who suggests that this vision of human agency recognizes the potential of individuals for "setting agendas on the basis of their own economic imperatives, tacit assumptions, unconscious prejudices and fantasies, moral commitments. Yet the vision also allows for all sorts of resistance to the meanings imposed by producers."[13] I am certain that Lears would concur that much of this process of evaluation and resistance takes place within the social group with which the individual has formed the strongest attachment.

There is a consensus, even among theorists as diverse as Ernst Gombrich and Pierre Bourdieu, that we are influenced in our likes and dislikes by our peers. While Gombrich sees such groups as arenas for the

"social testing" of what "to revere and what to abhor,"[14] Bourdieu, building on Erwin Panofsky's concept of habitus, expands the definition to include "the homogeneous conditions of existence" which produce "homogeneous systems of disposition capable of generating similar practices."[15] By designating social structures and systems as key elements in the decision-making process, Bourdieu makes room for a deeper level of dialectical exchange between the individual and the group which allows more opportunity for change.

Employing this model, it is possible to track the peregrinations of the Victorians through a succession of cultural identities. I discuss the emergence of the middle class as a cultural force in London in my first chapter. The early-Victorian art collectors who permanently altered the face of patronage consisted of a diverse group of financiers, members of the rising professional class, merchants, and manufacturers who at first shared little sense of group cohesion. Their history is one of idiosyncrasy and masquerade, from Robert Vernon's adoption of a Wellingtonian persona to John Sheepshanks's deliberately *déclassé* habits. Without the benefit of role models of their own or a clear cultural agenda, these early Victorian middle-class collectors fluctuated in their allegiance to aristocratic protocols and more plebeian sympathies. That this class had attained a more highly developed sense of self in the provinces becomes apparent in chapter 2, when I examine the Manchester cotton lords and Birmingham tin manufacturers whose collections shared wall space at the Manchester Art Treasures exhibition with some of the most august names in England. Unintimidated by the company, provincial magnates Henry McConnel and Thomas Miller were third-generations scions of Mancunian families that were well on their way to forming the dynasties that would continue to make their descendants impervious to the temptations of the leisured aristocratic lifestyle throughout the course of the nineteenth century.

By contrast, the social backgrounds of the first patrons of the modern movement in English art recalls the diversity of the early Victorians. With no established audience for avant-garde art, I suggest in my discussion of the Pre-Raphaelites in chapter 3 that it was necessary for these artists to appeal to individuals on a personal basis. I separate their collectors into two chronological groups: early backers, such as tobacco merchant John Miller and cotton spinner Francis McCracken, who, although not particularly affluent, were prone to taking risks in their businesses and thus more willing to gamble on new forms of art than the Pre-Raphaelites'

much richer second-wave clientele who did not venture forth until the group's reputation was established. Many of these collectors also supported the less controversial mainstream artists whom I discuss in chapter 4.

The most salient feature about these mid-Victorians was their ecumenism. Britain's growing wealth and world power created a demand for diversified capitalists that produced another shift in the identity of its middle class. Occupational and geographic distinctions were merged in a network of national and international investments. Nostalgic reverie over what was lost on a community level was stirred by the realization that the middle-class now possessed a tradition of its own that finally provided role models for imitation.

The carefully designated class lines of early Victorian England were redrawn once again as the century came to a close. In chapter 5, where I continue my analysis of the modern movement, I show that the middle class inverted the trickle-down theory of cultural development when it introduced a new standard into society based on the comprehensive design criteria of the Aesthetic movement. Artists smugly noted the return of aristocratic patrons to the fold who compliantly accepted their terms. Taking issue with those historians who insist that the Victorian commercial élite allowed itself to be seduced by the landed class, I argue in my epilogue that the relationship was a more amorphous one. While some members of the middle class succumbed to the charms of the aristocratic lifestyle, they were replaced by a dynamic group of new players from the lower ranks who were eager to claim their share of England's legendary wealth. These entrepreneurs invigorated the ranks of the middle class and fueled the economy of the art market.

Reasons for collecting are deeply embedded in the primitive instincts of the hunter and gatherer. Anthropologist James Clifford equates the accumulation of property with Western possessive individualism, noting that, "some sort of 'gathering' around the self and the group – the assemblage of a material 'world,' the marking-off of a subjective domain," is probably a universal phenomenon.[16] The impulse to create an ordered personal realm of objects was at first uncomplicated as the etymology of the phrase "to collect" indicates: the Latin *colligere* – to select and assemble – suggests a spectrum of ordinary activities. Social behavior only significantly altered when these preoccupations assumed a new urgency in the period of rapid industrial growth which dissolved the long-standing patterns that had previously provided group identification. With the advent of modernism's

crisis of authority, patrons' expectations of art became more complex. Often turning to it as a substitute for dislocated spiritual values, business-men hoped that art would provide an outlet for their unfulfilled longings and desires, as well as a means of escape from personal disillusionment, loneliness, or the pressures of daily life.

Just as I have tried to maintain a balance between individualism and collectivism in reconstructing the identity of the businessmen in my study, I have negotiated between the broad sweep of Marxist thought and the introspective perspective of Freudian analysis in theorizing their moti-vations for collecting art. My interpretation falls somewhere between the arguments presented in two recent books on this topic, *The Cultures of Collecting*, edited by John Elsner and Roger Cardinal, and Werner Muensterberger's *Collecting: An Unruly Passion*. Among the essays in the first volume, those by Jean Baudrillard and Mieke Bal view collections semioti-cally, as signs signifying social struggle or economic achievement.[17] While these tropes characterize the behavior of many of the collectors in my archive, I found that the absence of specific examples or historical observa-tions in these essays made it difficult to test the validity of their authors' observations. Muensterberger, in contrast, introduces a number of historic case studies ranging from Balzac to an anonymous contemporary collector. As a practicing psychoanalyst, Muensterberger treats collections as symp-toms of the needs of specific psychobiographies. I found this approach par-ticularly helpful in formulating my definition of the collection as an extension of the owner's identity which, in the case of the Victorians, extended beyond the personal to a sense of cohesion with their class.

Collecting, therefore, cannot be isolated from biography and his-tory, nor can its emotional value be understood apart from the blunt realities of money. As Robert Jensen contends in his study of French and German modernism, "The dialogue of money and art is manifest in the language, in the institutions, and in the actions of modernist artists and their audiences."[18] In England this symbiosis occurred much earlier due to the rationale provided by political economists.

Patterns of consumption and relations with artists

The theoretical framework justifying the ownership of expensive objects was erected in the seventeenth century. The discourse on luxury was an essential aspect of the emerging science of political economy: Adam Smith, in his *Wealth of Nations*, argued that acquisitiveness and the pursuit of

money was essential to the health of a mercantile country.[19] This theory was shared by Bernard Mandeville, who, in *The Fable of the Bees* (1714), insisted that extravagant consumption was economically desirable and that the buying and selling of pictures improved trade. Reinforced by the philosophers of the Scottish enlightenment, the concept of luxury came to be viewed as essential to national prosperity. David Hume, for instance, maintained that luxury contributed to the material progress of society.[20] With such a supportive rationale in place, there was virtually no reason for moneyed businessmen to hesitate over the propriety of owning art.

Current anthropological research into the phenomenon of consumption emphasizes the social nature of luxury items. Arjun Appadurai, for instance, argues: "I propose that we regard luxury goods not so much in contrast to necessities (a contrast filled with problems), but as goods whose principal use is *rhetorical* and *social*, goods that are simply *incarnated signs*."[21] Their signification ranges from the pleasure and meaning they lend to individual collectors to their extended social relationship with cultural systems, such as public exhibitions, art institutions, and class identity. As Appadurai insists, consumption is a means of both sending and receiving social messages.[22] In contrast with more linear theories of conspicuous consumption which view art solely as a search for status, this approach accounts for the clusters of collectors who formed networks of consumption in towns such as Newcastle-upon-Tyne, Birmingham, Manchester, and Liverpool in alliance with artists, educators, and agents. Their reasons for collecting art were more social then economic.

I find Bourdieu's designation of the individual's relation to art in terms of symbolic and cultural capital especially descriptive of the situation I have just described. Distinct from the work of art itself, he defines cultural capital as evidence of the knowledge necessary to appreciate and understand it, while symbolic capital invests art's possessor with a degree of prestige and celebrity.[23] Therefore an art collection signals its owner's cultural acuity and discrimination to others which mitigate against charges of mere conspicuous consumption. Victorian collectors who were burdened with the puritanical onus to seek more than pleasure in art were anxious to give the impression that their expenditures were intended to serve some higher purpose. This was not as difficult as it might sound, since the art press assumed that everyone shared the belief that, "the salutary influence of Art on the universal mind requires no argument."[24] Many collectors expressed faith in art's potential to improve the human condition, particularly those

who lived in areas threatened by social unrest, or, as the modern period progressed, those who were dissatisfied with the rewards promised by the cult of success. An important companion in this internalization of the aesthetic experience was the artist who was greeted by the grateful patron as part seer and part prophet.

Professional autonomy was not easily won by Victorian artists. At the beginning of the century, the paternal model of patronage was still the norm with its hallmarks of deference and subservience. As Iain Pears recently noted in regard to eighteenth-century England, "The patron–patronised relationship was one of the dominant and ideal models of social interaction."[25] Early Victorian upper-class collectors of modern art who continued to practice this model, such as Sir John Leicester and Sir George Beaumont, were gradually replaced by businessmen whose respect for artists as fellow professionals prevented them from intervening in the creative process. Nevertheless, not all tension was permanently removed from the mutually dependent artist–patron coalition.

As the middle class grew more sure of itself and gained expertise in the art world, many artists were surprised to find their patrons becoming more assertive. They discovered that businessmen who dictated the terms of contracts or who controlled production in their factories felt entitled to exercise the same rights in the artists's studio. While artists in the late eighteenth and early nineteenth centuries generally sprang from more modest backgrounds than their patrons, by the second half of the Victorian period they frequently outclassed them. The social fact of artists' backgrounds combined with their improved skill at the negotiating table, inevitably led to clashes, even in the climate of greater intimacy fostered by Pre-Raphaelite and Aesthetic movement artists.

Looking to art to satisfy psychological needs, Aesthetic patrons became more possessive, even neurotic about the art they invited into their inner sanctuaries. Artists, determined to win the upper hand, encouraged this emotional dependency by willingly playing the role of spiritual guides who operated in a superior social space. Even so, the constant attention demanded by patrons proved taxing to those artists who had not availed themselves of the broad spectrum of services offered by the art market. Stifled by a patron's demands, Dante Gabriel Rossetti fulminated, "I have often said that to be an artist is just the same thing as to be a whore, as far as dependence on the whims and fancies of individuals is concerned."[26] That financial independence was inseparable from professional freedom is illus-

trated over and over again in nineteenth-century artists' biographies. Analyses of why French artists capitulated to bourgeois market practices show that this was not entirely the result of the machinations of the dealer–critic nexus, but was also due to artists' expectations of attaining an income and lifestyle comparable to their middle-class patrons.[27]

In England the troubled history of private patronage is a story of artists struggling to carve out careers for themselves without the benefit of state or church support and of middle-class patrons, educated in the marketplace rather than in the galleries of the Uffizi and the Louvre like the connoisseurs of old, trying to respect artists' demands without having to compromise their business instincts. Both tried to reconstruct the artist–patron tandem but were defeated by their own claims to independence: artists discovered that they could thrive without patrons who in turn realized that they had accrued enough cultural capital so that they no longer needed artists to interpret their paintings for them. Both parties eventually tired of harboring secret resentments, so that by late-Victorian England the tie that had bound artists to their patrons was so hopelessly tattered that each reluctantly came to prefer the services of outsiders. Once that separation of interests occurred, the field was essentially dominated by profit-oriented purveyors of commodity culture.

John Berger traces the commodification of art to the Renaissance invention of transportable oil painting. He contends that, "a way of seeing the world, which was intimately determined by new attitudes to property and exchange, found its visual expression in the oil painting . . . Everything became exchangeable because everything became a commodity."[28] Berger's conclusions, however, are colored by the specter of the late twentieth-century art market. Few would disagree that art today is bought, sold, and traded for reasons often having little to do with aesthetic value. But in linking the relationship between art and money from the Renaissance to the present, Berger neglects the many earnest attempts to thwart the devaluation of the aesthetic. Economic determinism alone cannot fully explain why businessmen were attracted to art or why they tolerated temperamental artists when fleets of dealers were eager to intercede on their behalf. Theories of contemporary popular culture, particularly those put forth by the British Cultural Studies movement, are more applicable to the Victorian scene.

John Fiske, for instance, does not view commodification in a negative light. On the contrary, he believes that the act of consumption can empower consumers by granting them a measure of control over cultural

meaning systems. In opposition to Berger, he does not consider purchasers passive receptacles of use-value or exchange-value, but believes they have the capacity to blur the distinction between these categories or even to bury them entirely. Fiske reasons: "In the practices of consumption the commodity system is exposed to the power of the consumer, for the power of the system is not just top–down, or center–outward, but always two-way, always a flux of conflicting powers and resistances."[29] Although Fiske's analysis is addressed to the working class of today, an analogy can be made with members of the emerging middle class in the early-Victorian period who were attempting to carve out a portion of the social and cultural system for themselves. From this perspective, it is possible to view the gradual commodification of art in Victorian society as a vehicle through which the middle class sought first to claim access to culture and, after it succeeded, to reinscribe it in its own image. This explains the deeply conflicted relationships between artists and patrons as well as the development of a collector–dealer alliance in England.

Beginning with early Victorians Joseph Gillott and James Morrison, the congruence between art collectors and *marchands amateurs* continued unabated throughout the century. Scholars who focus on the dealer–critic nexus as the hallmark of capitalism's depersonalized art market have tended to overlook the equally important phenomenon of the patron-cum-dealer, perhaps because so little research has been done on individual collectors. I show that their active involvement in the art market was both a matter of profit seeking and, in the case of the early Victorians, a way of refusing delivery of the class-scented vellum envelope that enclosed the patrician model of patronage.

Even the most acquisitive art market manipulators were tolerated in a country where consumption was considered a national virtue. The discourse on luxury that evolved from the classical school of political economy's emphasis on spending encouraged ostentatious displays of material wealth. I explain, for instance, in my chapter on Aesthetic patrons, that even the clergy rationalized the obsession with beautiful environments as an earthly preparation for heavenly glories. Thus the relationship between art and money in England should not be construed simply as the adversarial struggle of dialectics, but as two parallel discourses that occasionally clashed but more frequently intersected harmoniously. Scholars have only recently begun to pay more attention to this interdependence. Regenia Gagnier, for instance, notes that, "intellectual historians of aestheticism

have failed to recognize the extent to which late-Victorian aestheticism was embedded in popular culture, everyday social life, and common experience. Social historians in turn have failed to emphasize the emerging service and consumerist economy that determined late-Victorian aestheticism."[30] In these chapters I demonstrate that the same holds true for early- and mid-Victorian forms of commodity culture.

"Taste" and the construction of culture

Because the commonalty of aesthetic experience was a central element of middle-class culture, the socially charged question of "taste" becomes an almost moot issue among Victorian collectors of modern art. I place the word "taste" in quotation marks to emphasize the fact that it lost its eighteenth-century élitist connotations after businessmen–patrons refused to indulge in the leisured contemplation of Old Master paintings specified by connoisseurs. Engaging the arguments of Bourdieu and others, I deconstruct the concept inherited by the Victorians and redefine it in relation to their social backgrounds and private aspirations. Contrary to eighteenth-century civic humanist theorists who assumed that only gentlemen were privy to the subtleties of taste, Victorian writers believed that anyone was capable of understanding art. Comprehensible images that evoked the mocking humor or righteous sermonizing of the folkloric narrative tradition not only excited first-time private patrons, but they were also among the most popular works in public exhibitions.

Whether the middle class manipulated the cultural field for its own ends, or whether it simply used it to legitimate itself, is open to debate. There is no question that the businessman–collector influenced artistic production, or that, as a class, he and his associates expected art to perform a host of non-aesthetic functions, ranging from the edification of the working class to the fomentation of patriotic pride. In this regard, England's burgeoning work force impelled its middle class to fill the vacuum left by the government's neglect of public patronage. Both factory owners and socially conscious city dwellers, recognizing the potential of visual imagery to educate and to inspire, supported art exhibitions for the lower classes. Were these philanthropic gestures intended to sanction the ideology of their organizers or to subdue and control the unruly masses?

The matter is further complicated by the middle class's genuine love of mimesis. The shrinking of the distance between pictorial delineation and optical reality was celebrated as another achievement of the progressive

ideal that inspired all phases of society, from the industrial to the aesthetic. It was essential to the Victorian conception of progress that no visible brushwork be allowed to mar the contours of the illusion or to fracture its planar surface. I argue that the reasons for this preference for highly finished canvases were deeply embedded in the identity which the middle class had constructed for itself. "Finish" as an aesthetic element signaled tangible evidence of painstaking labor, pride in the work ethic, and corroboration of money well spent. The appearance of Victorian painting, then, cannot be thoroughly understood apart from the topology of the members of its middle class.

Their history is tied to the history of the English School of Art. Like the middle class's protean attempts at self-definition, the English School constructed and reconstructed itself throughout the nineteenth century, from Wilkie's early-Victorian celebrations of village kinship systems, to Frith's mid-Victorian panoramas of urban stratification, and to late-Victorian artists' nostalgic evocations of "Olde England." William Vaughan contends that the English School assumed a nationalist cast from the moment of its inception under the reign of George III. While he identifies its primary traits as "a purposive mixture of naturalism, independence, and the Protestant tradition,"[31] I view the English School as a less calculated and more conflicted combination of middle-class hopes, fears, and self-deception. Nevertheless I agree with his ranking of independence and the Protestant tradition as formative features of the English national character. Without the bedrock provided by the work ethic and the desire to succeed, the Victorian ideal of progress would have foundered.

It is for these reasons that the art of replication also thrived, both in the standard form of mass-produced prints of original works of art and in now less acceptable hand-painted copies. Unlike the Victorians, contemporary collectors could never be induced to pay as much for a second or third version of a painting as for an original. After investigating this unusual practice, I conclude that as long as buyers believed that the painted image cohered with their view of reality, they lodged no objections against the practice of repetition. It was only after skeptics began to question the instrumentality of these shared suppositions that the copy was placed in jeopardy. That threat was compounded by the introduction into England of French avant-garde studio practices that defied the exacting process of replication.

England's resistance to formalist modernism sprang from the myth of wholeness which the middle class had constructed to lend credence

to its ambitions. That Courbet's and Manet's *facture* threatened more than normative standards was evident in the charges of anarchy and moral turpitude leveled at the French avant-garde in the years between the Whistler–Ruskin trial in 1878 and the exhibition of Degas's *Absinthe Drinker* at the Grafton Gallery in 1893. Because the middle class had so closely identified its values with those expressed in art over such a long period of time, it could not accept that the mirror of mimesis had finally shattered.

Notes

1 P. G. Hamerton, *Thoughts about Art* (London: 1871), p. 239.

2 Peter Gay, *The Bourgeois Experience: Victoria to Freud*, 4 vols. (Oxford: 1984–95), I, 9.

3 David Cox, quoted in N. Neal Solly, *Memoir of the Life of David Cox* (London: 1873), p. 76.

4 Letter from Thomas Uwins to John Townshend, 14 January 1850, in Sarah Uwins, *A Memoir of Thomas Uwins, RA*, 2 vols. (London: 1858), I, 125.

5 Jeremy Maas, *Gambart: Prince of the Victorian Art World* (London: 1975), p. 18.

6 Lady Eastlake in Sir Charles Lock Eastlake, *Contributions to the Literature of the Fine Arts with a Memoir Compiled by Lady Eastlake*, 2nd edn. (London: 1870), p. 147. Among modern scholars who cite this passage are John Steegman, *Consort of Taste 1830–1870* (London: 1950), p. 50, and Darcy, 123.

7 Lady Eastlake, *Memoir*, p. 147.

8 For Sheepshanks's family history, see Rev. R. W. Taylor, *Biographia Leodiensis* (Leeds: 1865), p. 514; *Dictionary of National Biography*; and R. G. Wilson, *Gentleman Merchants: The Merchant Community in Leeds, 1700–1830* (Manchester: 1971), pp. 25–27 and 247–48.

9 Harold Perkin, *Origins of Modern English Society* (London and Toronto: 1969; rpt. 1985), p. 225.

10 François Crouzet, *The First Industrialists: The Problem of Origins* (Cambridge: 1985), p. 127.

11 Anthony Howe, *The Cotton Masters, 1830–1860* (Oxford: 1984), p. 60.

12 Asa Briggs, *A Social History of England* (1983; rpt. Harmondsworth, Middlesex: 1985), p. 198. See also Briggs's essay, "The Language of 'Class' in Early Nineteenth-Century England," in *Essays in Social History*, ed. A. Briggs and J. Saville (London: 1967), pp. 43–73.

13 T. J. Jackson Lears, "Making Fun of Popular Culture," *American Historical Review* 97 (Dec. 1992), 1422.

14 E. H. Gombrich, "The Logic of Vanity Fair," in *Ideals and Idols: Essays on Values in History and in Art* (Oxford: 1979), p. 85.

15 Pierre Bourdieu, *Distinction: A Social Critique of the Judgement of Taste*, transl. Richard Nice (Cambridge, Mass.: 1984), p. 101.

16 James Clifford, *The Predicament of Culture: Twentieth-Century Ethnography, Literature, and Art* (Cambridge, Mass.: 1988), p. 218.

17 Jean Baudrillard, "The System of Collecting," in *The Cultures of Collecting*, ed. John Elsner and Roger Cardinal (Cambridge, Mass.: 1994), pp. 7–24, and Mieke Bal, "Telling Objects: A Narrative Perspective on Collecting," *ibid.*, pp. 97–115. Werner Muensterberger, *Collecting: An Unruly Passion* (Princeton: 1994).

18 Robert Jensen, *Marketing Modernism in Fin-de-Siècle Europe* (Princeton: 1994), p. 10.

19 See Adam Smith, *An Inquiry into the Nature and Causes of the Wealth of Nations* (London: 1752; rpt. 1776; Chicago: 1976) and Joyce Appleby, *Economic Thought and Ideology in Seventeenth-Century England* (Princeton: 1978).

20 David Hume, *Political Discourses* (1752). See also John Sekora, *Luxury, the Concept in Western Thought, Eden to Smollett* (Baltimore: 1977) and Jonathan Parry and Maurice Bloch, eds., *Money and the Morality of Exchange* (Cambridge: 1989).

21 Arjun Appadurai, "Commodities and the Politics of Value," in *The Social Life of*

Things: Commodities in Cultural Perspective
(Cambridge: 1986), p. 38.

22 *Ibid.*, p. 31. See also Mary Douglas and
Baron Isherwood, *The World of Goods*
(New York: 1979).

23 Bourdieu, *Distinction*, pp. 12–14.

24 *Art Union* (1847), 365.

25 Iain Pears, *The Discovery of Painting: The
Growth of Interest in the Arts in England,
1680–1768* (New Haven: 1988), p. 153.

26 Rossetti to Ford Madox Brown, 28 May
1873, *Letters of Dante Gabriel Rossetti*, ed.
Oswald Doughty and J. R. Wahl, 4 vols.
(Oxford: 1965–67), III, 1175. He was com-
plaining about patron Frederick Leyland,
despite the fact that Leyland was unfail-
ingly generous to the artist. As Francis
Fennell explains, Rossetti was genuinely
fond of Leyland, but "chafed under the
bondage" of the gratitude he was meant to
feel toward him. See Fennell, ed., *The
Rossetti–Leyland Letters* (Athens, Ohio:
1978), p. xviii. Rossetti was atypical in his
almost complete financial dependence on
patrons. He placed himself in this corner
because of his fear of attracting negative
publicity at public exhibitions.

27 See Robert Herbert, "Impressionism,
Originality, and Laissez-Faire," *Radical
History Review* 38 (1987), 7–15, and
Cynthia White and Harrison White,
*Canvases and Careers: Institutional Changes in
the French Painting World* (New York: 1965).

28 John Berger, *Ways of Seeing* (London: 1972),
p. 87.

29 John Fiske, *Reading the Popular* (Boston:
1989), p. 31. See also J. Williamson,
*Consuming Passions: The Dynamics of Popular
Culture* (London: 1986).

30 Regenia Gagnier, *Idylls of the Marketplace:
Oscar Wilde and the Victorian Public*
(Stanford: 1986), p. 5.

31 William Vaughan, "The Englishness of
British Art," *Oxford Art Journal* 13 (1990), 11.

1 *Nouveaux riches* or new order? Early-Victorian collectors in London

Middle-class patrons of culture were swept to the fore by the current of change in the 1830s and 1840s: political legislation which enfranchised male property owners, social reform which gave rise to the cult of self-improvement, and a demotic press which advocated wider class participation in the arts. Patiently waiting with purses lined by the Industrial Revolution and filled with profits earned during the twenty-two long years of war with France, the new patrons lost no time in exerting their influence.[1] While many members of the middling ranks had already been quietly collecting art for several years, their numbers swelled appreciably in those crucial decades of transition from aristocracy to middle class. Some were content with simply enjoying the cultural cachet that the ownership of art provided, but others were stimulated to take advantage of the opportunity it presented to alter the larger cultural field which was expanding as rapidly as the art market. "Art and culture," notes James Clifford, "emerged after 1800 as mutually reinforcing domains of human *value*, strategies for gathering, marking off, protecting the best and the most interesting creations of 'Man.'"[2] In the state of flux following the passage of the Reform Bill of 1832, members of the emerging early-Victorian middle class recognized that the time had finally come to claim their place in the cultural arena.

Preoccupied with weightier matters, the gentry at first offered little resistance. Novelist Wilkie Collins, in his account of his father William Collins's career as an artist, registered the disconcerting effect of the Reform Bill on aristocratic patrons. He wrote:

> The noble and wealthy, finding their lives endangered by a mysterious
> pestilence, and believing that their possessions were threatened by a
> popular revolution, which was to sink the rights of station and property
> in a general deluge of republican equality, had little time, while
> engrossed in watching the perilous events of the day, to attend to
> the remoter importance of the progress of national Art.[3]

As Collins indicates, art was a matter of low priority to the upper classes in the years immediately following the passage of the Reform Bill in 1832. Thus an opportunity was provided for ambitious members of the middle class to colonize art and culture as domains of their improved status. It was only at the end of the next decade when the élite belatedly realized that private middle-class patrons had accrued sufficient cultural capital to alter the standards and policies of public galleries and to affect the course of the English School of Art, that defensive action was taken. But given the strength and organization of the opposition, it was too late to prevent the redefinition of culture.

This transformation, however, unfolded in a somewhat haphazard manner due to the conflicting objectives of the new players in the cultural field. The alliances formed were often marriages of convenience between parties with contradictory dreams: some longed for acceptance by their social superiors, while others were intent on resisting the values that had been imposed on them. Nevertheless a contract was sealed that permanently altered the face of English culture when collectors, artists, critics, and social reformers realized the advantages of making common cause.

The catalysts in this change were the middle-class businessmen who form the thrust of my study. They have been the subject of an astonishing degree of speculation, yet the substance of their contribution to culture still remains undefined. A. Paul Oppé, in his seminal study written in 1934 for G. M. Young's classic handbook *Early Victorian England*, set the tone for much subsequent scholarship when he adopted Lady Eastlake's vocabulary and described the leading patrons of early-Victorian art collectively as newly enriched members of the mercantile class:

> From about 1840 it became a commonplace that the patrons of modern art had changed and that the buyers no longer belonged to the noble and landed classes but were the now prospering manufacturers . . . Such were Vernon, an ex-jobmaster and army contractor, and Sheepshanks, a clothier from Leeds, both of whom left their accumulations to the nation. Jacob Bell, who gave Frith's *Derby Day* and many other pictures, was a druggist who had once thought of becoming a painter. Wells of Redleaf, whose house was full of Landseers, had been a ship's captain, Bicknell and Windus, who were among Turner's chief purchasers, respectively an oil merchant and a carriage-maker.[4]

The six collectors whom Oppé picturesquely describes are indeed a representative sample of the new type of patron. They are not, however, a

homogeneous group in either background or ambition. Research into the history of shipping reveals that William Wells of Redleaf, for example, was much more than a common ship's captain: he was a millionaire shipbuilder whose family owned several London docks and traced the origins of its wealth as far back as the seventeenth century. Moreover, Wells was retired at the time he was actively involved in patronage and lived on a large estate in Kent, where his eccentric imitations of blustery sailors were tolerated by the neighboring gentry.[5] Nor was Benjamin Godfrey Windus a simple carriage maker. The records of the Pharmaceutical Society of Great Britain reveal that he was also a prosperous pill manufacturer (but not, as has been claimed, the proprietor of "Godfrey's Cordial," a deadly derivative of opium) who inherited substantial property from his father, which perhaps explains why he chose to identify himself on the 1851 Census Return as a "landed proprietor."[6] Concerning the other patrons Oppé mentions, Elhanan Bicknell, like Sheepshanks, was given a start in his whale oil manufacturing business by his father, a successful serge manufacturer.[7] But while Sheepshanks was content to spend time developing new species of flora, Bicknell was economic adviser to Disraeli and Gladstone. Jacob Bell also received the benefit of parental assistance when he entered his father's chemist shop from which he launched his campaign to gain recognition for his profession by founding the Pharmaceutical Society of Great Britain.[8] Finally, Robert Vernon, who donated his art collection to the nation, is frequently cited as the leading example of Oppé's stereotypical *nouveau-riche* merchant, particularly since he, himself, did nothing to dispute the legend that he had single-handedly earned a fortune. Yet documents which have recently come to light contradict the reputed modesty of his origins: his father ran a successful carriage-hire business in London and members of his family had lived in one of the more expensive properties in Doncaster since at least 1797.[9] Instead of fitting neatly into one social category, these six patrons of the early-Victorian period range from the established gentry to the professional class with ambitions that span an equally wide spectrum. Far from homogeneous, they support Homi Bhabha's contention that the stereotype is a "fixated form of representation" that denies difference.[10] By denying Victorian collectors the individual distinctions and mutations that have proved so compelling in histories of the aristocracy, writers have succeeded in diminishing their achievement by continuing to treat them as the awkward and uncultured by-product of England's economic growth.

The individualism of Victorian collectors counteracts their type-

casting in this or any other matter. To appreciate why Vernon exaggerated the poverty of his background, or why Wells liked to be thought of as a simple sailor, or why Sheepshanks preferred gardening to politics, one must first review the facts of their biographies and their habitus of choice before deciding to what extent they are the collective product of the broader social conditions of their time. This balanced reading of the past is akin to Lucien Febvre's concept of intellectual biography which Roger Chartier describes as a history of society which "locates its heroes simultaneously as witnesses and products of the collective conditioning that limits free and individual invention."[11] Accordingly, in this chapter I will weigh the distinctive character traits of middle-class collectors against the early-Victorian values that prompted them to partake in culture.

Since Oppé named only a portion of the collectors who were actively engaged in the art market in the 1830s and 1840s, I have extended my analysis to cover over two dozen individuals (see Appendix). I have been guided by the two major records of private collections of the early-Victorian period: Gustav Waagen's three-volume *Treasures of Art in Great Britain* (1854), followed by his supplementary *Galleries and Cabinets of Art in Great Britain* (1857),[12] and the series on private picture galleries that appeared in the *Art Union* (renamed the *Art Journal* in 1849) between 1839 and 1859.[13] Since many more middle-class collectors were active than the fourteen Londoners who appear in the pages of these two sources, I have added an almost equal number culled from artists' memoirs, biographies, museum archives, and auction sale catalogues in order to identify the leading collectors at this time.[14] I searched for individuals who deliberately collected the works of living English painters and who were recognized by their contemporaries for their efforts.[15] While I have undoubtedly omitted someone's favorite ancestor, the frequency with which I encountered the names of those I have singled out assured me that they can be construed as representative of the major collectors of the period. My criteria for selection are based on collectors who lived in London or its immediate suburbs and whose social habitus was middle class. Thus well-known "connoisseurs" and "amateurs" such as the Rev. Chauncey Hare Townshend, Sir George Beaumont, and Sir John Leicester appear in these pages only in a peripheral context as representatives of a more élite group.[16] Considering the standards I have just identified, William Wells should not properly be included in my study, since he was born into the landed gentry. Yet his name has been linked with those of other pioneering middle-class patrons of

modern art since the Victorian period, and for that reason I have included him, if only to set the record straight.[17]

Because research into social origins is problematic in the early-Victorian years, I have not managed to uncover the family origins of six collectors.[18] London newspapers did not print as many obituaries for the middle-class as did their provincial counterparts for an obvious reason: many of these men were small fish in the great metropolitan pond, unlike the mid- and late-Victorian tycoons who dominated both the worlds of art and of finance. While death certificates, wills, and census returns can be obtained in many cases, these sources do not list circumstances of birth. And unless individuals truly distinguished themselves through family lineage, marriage, career, or political life, they do not warrant inclusion in the *Dictionary of National Biography*.

None of the collectors whose roots I have traced came with certainty from a working-class background. Although Sir John Soane, an architect who willed his house and collection as a museum in 1833 and who was knighted in recognition of his talent, was described by Victorian sources as the son of a bricklayer, more recent research has determined his father was a small country builder.[19] Soane's lower-middle-class origins would still entitle him to be considered a self-made man according to Crouzet, who argues that "a self-made man was any individual who was the 'architect of his own fortunes,' who had built a fortune instead of inheriting it, and he did not necessarily have a working-class background."[20] Even if one were to expand the definition of "self-made" as Crouzet does, only three additional collectors would qualify. Considering who they were, however, one can understand the wide currency given to the myth of the self-starter.

The first is James Morrison, whose spectacular story must have gladdened many a humble heart – he was born the son of an innkeeper and died one of the richest commoners of the nineteenth century, leaving an estate valued at between 4 and 6 million pounds.[21] The second is John James Ruskin, the wine merchant whose fortune was modest compared to Morrison's (£157,000 plus considerable property holdings), but who holds an even greater claim to fame as the father of the most influential Victorian art critic, John Ruskin.[22] Last but not least, is Robert Vernon who, as I have already mentioned, exaggerated the meagerness of his ancestry. It may seem puzzling that someone who was as anxious as Vernon to be admired by patrician connoisseurs would diminish his background. Crouzet, however, discloses that this strategy was common in the nineteenth century among

those who wanted to be praised for the enormity of their success.[23] Besides, as students of English mannerisms are aware, even if one managed to imitate the appearance of a gentleman, speech patterns were difficult to disguise.[24]

Scholars who have tried to define the role of a gentleman in Victorian England have found it to be laden with ambiguity. Even the Victorians found the essence of a gentleman difficult to articulate. Thackeray's Clive Newcome admitted, "I can't tell you what it is, or how it is, only one can't help seeing the difference. It isn't rank and that; only somehow there are some men gentlemen and some not."[25] It was an elastic and expanding social category because the gentry were constantly infiltrated by families with new money. Marriage was the surest path to social acceptance, while a self-made man who bought a place in the country and established himself as a squire was not guaranteed acceptance by the local gentry.[26] Both Morrison and Vernon discovered the perseverance of this truth after they had acquired landed estates.

Morrison used part of his immense fortune to purchase William Beckford's 26-room Pavilion at Fonthill and the palatial Basildon Park in Berkshire, both in addition to Balham Hill (near Clapham) and a large residence on Upper Harley Street in London that allowed him easy access to his offices in Cheapside. Although he looked forward to the time he spent in the country, Morrison had no patience with the local gentry's fondness for wine or sport. They, on the other hand, were hindered by tradition from welcoming him into their closed circle. F. M. L. Thompson notes in *English Landed Society in the Nineteenth Century* that men with close connections with trade or business were excluded until after the middle of the century from becoming magistrates and lords lieutenant (p. 110). Although Morrison's business connections insured that his wife and daughters were presented at court, the conservative county set must have taken a dim view of Mrs. Morrison's habit of announcing how much the ornate ceiling in her bedroom had cost.[27]

Vernon also discovered that despite his purchase of Ardington House in Berkshire, his art collection, his annual subscription to the Old Berkshire hounds, and his donations to charity, judicial honors were withheld from him because of his connections with trade. While his nephew Vernon Heath claimed that his uncle was unconcerned with worldly recognition, artist John Horsley contradicted him when he stated that Vernon's "apparent interest in art was really used simply as a means of lifting him out of obscurity into some sort of *locus standi* in the world."[28] At first glance, this

opinion seems to be substantiated by Henry Pickersgill's portrait of Vernon (plate 1). His high, white, starched collar, embossed satin dressing gown with velvet trim, and the precious King Charles spaniel on his lap give him the self-conscious air of a leisured and pampered gentleman. Yet closer inspection reveals that Vernon had an additional role model in mind. His feathered hairstyle and erect bearing are imitations of the Duke of Wellington's. During the course of providing carriages to the upper classes, Vernon got to know many military officers but reserved his greatest admiration for the invincible Iron Duke. He avidly collected images of the commander and of his greatest moments of triumph: he owned Bailey's marble bust of Wellington and commissioned Landseer's celebrated *Dialogue at Waterloo* in 1848, as well as numerous battle scenes by the former army captain and Wellington look-alike, George Jones.[29] Vernon's fascination with the military prevented him from becoming a caricature of the country gentleman. In adopting this persona, he revealed that the streak of independence which had carried him from Berkeley Square to Berkshire had not abandoned him.

Searching for real-life examples to follow, some early-Victorian self-made men found it hard to resist the snobbish appeal of the upper classes. Soane attempted to improve his image by adding an *e* to his name and by decorating his home in the tasteful manner of his titled clients.[30] And although John James Ruskin was less concerned with the opinions of others than he was with instilling intellectual and religious values in his brilliant son, he was still impressed by the opportunities art collecting gave him to rub shoulders with what he referred to as "High people," and was particularly pleased when the young Queen Victoria started to purchase work by artists in his collection.[31] Despite this attraction, Ruskin senior's pragmatic Evangelicalism, along with his dedication to the work ethic, prevented him from allowing his life to be dictated by a desire to be socially acceptable.

Men like J. J. Ruskin found a more companionable model in a middle-class collector of the previous generation, Samuel Whitbread II (1758–1815), who ostensibly combined the best traits of the leisured and the working worlds.[32] Son of the self-made man who started Whitbread's Brewery, Samuel was educated at Eton. Although he went on the Grand Tour favored by connoisseurs, he preferred contemporary British artists to the Old Masters. And while he inherited landed estates and married the daughter of an earl, young Whitbread defiantly identified himself with the middle class when he went to work at the Brewery and when he refused to

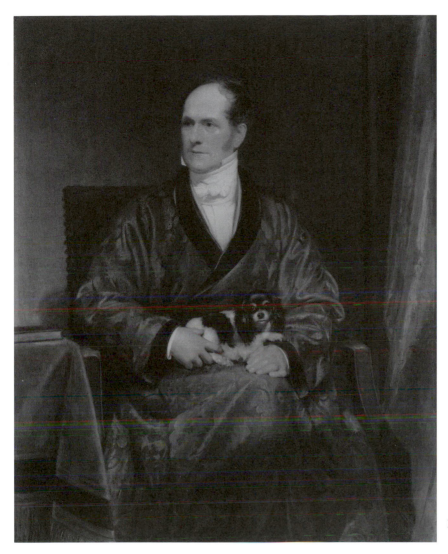

Plate 1. Henry Pickersgill, *Robert Vernon*, 1847, oil on canvas

sell his shares in it, even though such a move would have improved his chances of a cabinet appointment. Nevertheless, through his high-profile public life as a Member of Parliament, Whitbread helped to transmit the best of Regency values to the early Victorians. He emphasized the qualities he most admired in the epitaph he wrote for his father's tomb: religiosity, lack of ostentation, "the diffusion of Knowledge," and "honest Industry."[33] These are the attributes that would characterize the middle class at its prime.

27

Whitbread's patronage of English art also established an important precedent. J. J. Ruskin, for instance, was a chauvinist in his support of his countrymen, telling his wife, "I should worry myself to Death if I do not allot £40 to £50 a year & keep to that as an agreeable Charity to artists."[34] Canny businessmen like Ruskin senior, however, were motivated to collect modern English pictures in the 1820s and 1830s for another reason: the thriving market in Old Master fakes. Constant exposés by the *Art Union* persuaded cautious collectors that their money was better invested in paintings fresh off the easel. Wilkie Collins noted that these men "were not to be led by rules or frightened by precedents. They were not to be easily imposed upon, for the article they wanted was not to be easily counterfeited."[35] While Ruskin *père*'s financial commitment to English art was modest, the jingoist legacy he passed on to his son was to pay enormous dividends in the expanded mid-Victorian cultural field.

Most early-Victorian collectors benefited from similar financial, if not cultural, legacies. The majority of them, as I have indicated, were not first-generation Smilesian heroes, but the inheritors of some family money. Still the aura of success that surrounds individuals such as Morrison and Vernon has tended to rub off on collectors of lesser ambition who are mistakenly assumed to be equally as entrepreneurial. Poet Samuel Rogers, for instance, is sometimes placed in this category, despite the fact he retired from banking at age thirty after inheriting a fortune from his ambitious father.[36] Rogers's sister Sarah, on the other hand, is virtually ignored in the literature, although she can claim the distinction of being one of the few women whose home was visited by Dr. Gustav Waagen for his *Treasures of Art*.

Sarah Rogers is overshadowed by her famous brother Samuel and her younger brother Henry, from whom she inherited the nucleus of her collection of *virtu* and Old Masters in 1832. Since she continued to purchase paintings, she deserves to be recognized in her own right. While Waagen compared her taste in pictures and Greek vases to Samuel's, critic Anna Jameson paid special attention to Sarah's English canvases, complimenting her on owning "charming modern pictures by Reynolds, Stothard, Wilson, Gainsborough, Leslie, Bonnington [*sic*], Turner, and Wilkie."[37] Personally acquainted with many of these artists, Sarah Rogers had no need to employ an agent to intervene on her behalf, unlike the sole remaining early-Victorian woman collector, Mrs. George Haldiman.

The daughter of a London alderman and the wife of a financier, Haldiman is recorded as having commissioned one hundred watercolors "by

all the most celebrated Painters living in the year 1826," through the inter-
cession of artist George Fennel Robson.[38] Mrs. Haldiman presumably
required the services of a male agent because women were unaccustomed to
handling their own business affairs. It is well known that middle-class married
women were prohibited from signing contracts. Accordingly, Haldiman did
not become a patron until she was widowed. Thus both she and Rogers, who
was single, would have enjoyed more freedom than the average middle-class
woman in making their own financial transactions.[39] Mrs. Richard Ellison
was also widowed when she donated her husband's watercolor collection to
the South Kensington Museum in 1860. But her social position as the
doyenne of a large Lincolnshire estate that had been in her husband's family
for generations distinguishes her from the more bourgeois Mrs. Haldiman.[40]
Nevertheless she still relied on the counsel of a male friend, the Rev. Terrott,
to negotiate the terms of her husband's will with the museum.

It was not only social convention that prevented women from
being taken seriously as collectors. Aesthetic theorists maintained that the
female mind was incapable of comprehending ideas which did not relate to
the personal realm. Mary Wollstonecraft complained that writers denied
women "the power of generalizing ideas, of drawing comprehensive con-
clusions from individual observations."[41] This bias manifested itself in the
cultural field by an absence of women-oriented artists, dealers, and critics.
Even though Anna Jameson had to struggle for acceptance in the male-
dominated world of art criticism, she remained mute on the subject of Sarah
Rogers' gender in reviewing her collection.

Encouraged or not, there must have been many more female art
collectors like Mrs. Haldiman and Sarah Rogers among the middle class.
After all, women had ample free time, traditionally supervised the home,
and were expected to be skilled in embellishing it. Most middle- and upper-
class girls were encouraged to refine the feminine side of their nature by
taking drawing or watercolor lessons. Mrs. Haldiman's interest in watercol-
ors should be seen as an extension of this training. The fact that she intend-
ed her collection to be mounted in three separate albums securely links her
to a form of female visual culture that was considered a minor art form by
the male hierarchy.[42] Yet many women like Margaret Ruskin attended exhi-
bitions of high art with their husbands and must have been involved in the
decision-making process.[43] Nevertheless they were duty bound to leave the
bargaining and financial side of artistic consumption to their husbands and
thus their names do not appear in artists' diaries or dealers' account books.

According to existing records, the typical early-Victorian collector was the proverbial male breadwinner. He was forced to carve out a space for cultural pursuits in his demanding schedule as a financier, lawyer, merchant, manufacturer, or member of the growing professional class (dentists, pharmacists, architects, and engineers) that was rapidly developing to meet the needs of an expanding urban population. These men, however, were not run-of-the-mill professionals, but leaders in their field: Samuel Cartwright reportedly earned £10,000 per year in his dental practice, Jacob Bell founded the Pharmaceutical Society, and John Soane was the architect of the Bank of England, while civil engineer Isambard Kingdom Brunel numbered Paddington Station and the Clifton Suspension Bridge among his many projects. Although the merchants in the group did not achieve the same degree of fame, they still managed to acquire enough surplus capital to collect art. They attained this by specifically marketing products for sophisticated middle-class tastes – J. J. Ruskin and John Allnutt provided fine wines for pleasure, George Knott wholesaled groceries for entertaining, Elhanan Bicknell processed whale oil for candles, James Morrison located the finest silks for shirts and dresses, and Benjamin Godfrey Windus's pills soothed aches and pains, while William Joyce served these merchants themselves by transporting their goods along the Thames. He proved that even a waterman could earn enough to decorate a large house in Tulse Hill with paintings by some of the most sought-after artists of his day: Collins, Webster, and Goodall.[44] This was the common denominator in this diverse group: the realization that a life dedicated to money and worldly success was incomplete without the presence of art in the home.

The impetus behind this diverse group's involvement in art is probably no different from what first attracts people to culture today in countries that are only beginning to match early-Victorian England's degree of industrialization. Odina Leal's research in Brazil has led her to conclude that contemporary culture represents "a symbolic system, including an ethos of modernity, that is itself part of a larger symbolic universe that has as its principal focus of significance the city and industry. This system of meanings seeks to 'conquer' the urban power space."[45] The same can be said for first-time early-Victorian art collectors, who also wanted to master and rule their expanding and changing milieu and who viewed art as the symbolic representation of the social order they sought to harness. Art for this group was to become a means of making tangible the values they held most closely.

The middle class's imprint on culture grew in definition from faint to bold in a relatively short time due to the societal changes of the 1830s. While the signal event in the art world of the 1820s was the founding of the National Gallery, the 1830s witnessed the appearance of the government Schools of Design, developed to improve the skill of artisans in the manufacturing trades; and the Art Union of London, organized to make engravings available to the people according to the principle that art was a basic necessity in everyone's life.[46] This decade also saw the founding of the influential journal, the *Art Union*, created as the anvil on which the ideas of middle-class patronage of modern art were hammered out.[47] Simultaneously, in the social sphere, the catalysts for change were the Reform Act (1832), the Factory Act (1833), and the New Poor Law (1834) which collectively improved the quality of life for both the bourgeoisie and the working class. These accomplishments lent a higher visibility to the middling ranks. Instead of concealing their origins, men such as Lord Brougham who had risen up through the ranks were proud of them. "By the people," he announced, in 1831, "I mean the middle classes, the wealth and intelligence of the country, the glory of the British name."[48] Nurtured in this favorable climate, the middle class matured at an accelerated pace.

But before its representatives could proceed with the task of redefining culture, they first had to intervene in a practice that was almost exclusively aristocratic. The artist's first champions in England were the nobility and the gentry.[49] The intermittent history of royal patronage and the patrician support of living artists in England prior to the Victorian period are discussed by a number of writers and need not be repeated here.[50] Suffice it to say that before the Industrial Revolution, the landed élite provided the primary source of income for aspiring artists. What is more pertinent to this study is how the protocols of patronage changed when artists discovered an alternative market among nonaristocratic patrons.

The word "patron" is in itself charged with hereditary meaning. According to the *Oxford English Dictionary* (*OED*), a patron is "one who countenances, supports, or protects; one who stands to another or others in relations analogous to those of a father." In the seventeenth century, this support often extended to the housing, clothing, and feeding of artists over long periods of time. By the eighteenth century, although British artists sometimes followed this pattern by becoming drawing-masters-in-residence, an expanding art market provided more variations in the relationship. Louise Lippincott defines the typical patron of the Age of

Enlightenment as "one who made significant purchases over an extended time period … and compensated the artist with introductions, special favors, and personal advancement as well as with money."[51] The intimacy inherent in the definition of the eighteenth-century patron was sustained by the early-Victorian upper-class benefactor who characteristically involved himself in all phases of an artist's life and career. Although artists rarely lived in the great country houses anymore, they were closely watched over and given abundant advice. The paternal attitude implicit in the *OED*'s definition of a patron colored the relationship between the early-nineteenth-century artist and the connoisseur who, for the most part, expected his protégé to respond to his guidance with the deference that was his due.

While the members of the aristocracy were quick to acknowledge the talent of such rising young masters as David Wilkie, William Collins, and Edwin Landseer, they wanted them to conform artistically as well as socially to their standards: new paintings must harmonize with old or be banished from galleries and drawing rooms to less public parts of the house. The reality of élite patronage was not far removed from the fictional situation described by the artist Frank Softly in Wilkie Collins's novel, *A Rogue's Life*, when he muses:

> In my time, the encouragers of modern painting were limited in number to a few noblemen and gentlemen of ancient lineage … It was an article of their creed to believe that the dead painters were the great men, and that the more the living painters imitated the dead, the better was their chance of becoming at some future day, and in a minor degree, great also. At certain times and seasons these noblemen and gentlemen self-distrustfully strayed into the painting-room of a modern artist, self-distrustfully allowed themselves to be rather attracted by his pictures, and self-distrustfully bought one or two of them … but would never admit his picture, on terms of equality, into the society even of the second-rate Old Masters. His work was hung up in any out-of-the-way corner of the gallery that could be found; it had been bought under protest; it was admitted by sufferance; its freshness and brightness damaged it terribly by contrast with the dirtiness and dinginess of its elderly predecessors; and its only points selected for praise were those in which it most nearly resembled the peculiar mannerism of some Old Master, not those in which it resembled the characteristics of the old mistress – Nature.[52]

32

Collins could have been describing any one of a number of recalcitrant patricians who considered their modern art inferior to their Old Masters. David Wilkie complained that on his visits to great houses he never found the two mixed in the same room.[53] Sir Robert Peel, for instance, reserved his main picture gallery for his Netherlandish paintings and his dining room for his British pictures.[54] Modern artists fared better in Peel's arrangement than at Stafford House, however, where even Turner was consigned to "a steward's dark parlour."[55] Native talent, in other words, lacked the patina of acceptability. By contrast even those middle-class collectors who longed for the palatial splendor of the country house were more respectful toward English art once they had achieved their goal. James Morrison reversed the patrician pattern when he gave his English collection pride of place in the magnificent Octagon Room at Basildon and hung his Poussins and Murillos in ancillary rooms.[56]

Despite the élite's guarded response to modern art, not all artists wanted the situation to change. These reactionary painters fell into two groups: those who feared the transformations being wrought in the social order and those who were fortunate in their personal experiences with aristocrats. Thomas Uwins is representative of the first group, which was afraid that the liberties granted to the middle class by the Reform Bill would cause the main source of patronage to run dry. On the morning after its passage, Uwins dashed off a letter to a fellow artist, saying, "whether art will ever become fashionable again is rather doubtful."[57] These concerns, however, were quickly put to rest. William Collins's and William Henry Hunt's sale records, for instance, reveal that the titled patrons who were their primary purchasers between the years 1815 and 1830 were supplanted by a host of middle-class buyers. Some aristocratic names remain in Collins's and Hunt's ledger books, but they are outnumbered by untitled patrons.[58] Nevertheless a few artists preferred to rely on the old and familiar. Haydon spoke for those who were happy with the existing arrangement when he remarked that the titled paid him in advance for his work, in contrast to a patron from Hull who insisted on seeing the finished product first.[59] Additionally, as biased as the *Art Union* was against the aristocratic connoisseur, it admitted in its pages that Lords Lansdowne, Swinburne, and Northwick were exceptions among their class for their private patronage of British artists.[60] To this honor roll must be added Lord Egremont for his encouragement of Leslie and Turner, as well as Sir John Leicester, who was a pioneering advocate of home-grown art among his class.

William Carey, biographer of Leicester (later Baron de Tabley), tells us he decided to collect English art in lieu of the Old Masters after having made the obligatory Grand Tour in 1785–86, despite the fact that "patronage of his countrymen was derided as proof of bad taste."[61] Undaunted by the opinion of his peers, Leicester displayed his collection in a gallery attached to his London home (plate 2), which he opened to the public in 1818. Visitors to the baronet's Hill Street residence would have seen idyllic landscapes by Wilson, historic portraits by Northcote, and mythological subjects by Hilton spaciously arranged in a well-lit neo-classically patterned room.

Leicester's progressive attitude toward English art represented the bright side of the coin. Minted on the reverse are the more tenebrous images of his private relationships with artists. A good example of how Leicester tried to impose past standards on living artists occurred when he asked William Collins to paint a companion to a work he owned by Richard Wilson. Collins, who specialized in rustic landscapes peopled with humble folk, produced a finely detailed painting that reflected his close observation of nature. Instead of respecting the younger artist's invention, Sir John irately complained to Collins that his effort would not hold its own against the Wilson and recommended that he alter it to conform stylistically with "fewer parts, and more simplicity and breadth in the masses."[62] Enlightened though he may have been in his views about English art, Leicester showed little respect for artists' independence.

While Collins refused to compromise his integrity, the majority of artists generally yielded to the wishes of their sponsors. If artists wanted to sell their wares, little choice was left to them prior to the 1830s than to follow the guidance of their patrons. Even the outspoken Constable reflected upon the wisdom of giving in to a patron's demands: "Still it is a bad thing to refuse the 'Great.' They are always angered …they have no other idea of a refusal than that it is telling them to kiss your bottom."[63] This attitude is not surprising in a society that had been conditioned to bow to superior wealth and status, and to the possessor's hereditary right to state his wishes forcefully.

The autocratic behavior of patrons was not only justified by social convention, but by aesthetic axiom as well. Theorists such as Edmund Burke, Archibald Alison, and Richard Payne Knight maintained that artists were less qualified as arbiters of taste than were gentlemen. They reasoned that only individuals who possessed the leisure requisite for intellectual

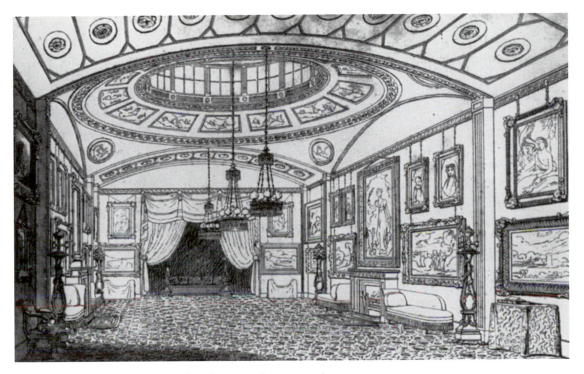

Plate 2. Sir John Leicester's Gallery, 24 Hill Street, London

contemplation were equipped to distinguish between good and bad art. Such theorizing, in the opinion of Andrew Hemingway, constitutes "forms of representation produced by social actors with interests and concerns largely defined outside the discourse of art theory."[64] The establishment of the British Institution in 1805 was an attempt on the part of connoisseurs to maintain their edge over the artist-controlled Royal Academy. To offset this intervention, the British Institution, which diarist Joseph Farington described as "the favourite lounge of the nobility and gentry," took it upon itself to remind artists that their duty was "to raise the standard of morality and patriotism; to attract the homage and respect of foreign nations, and to produce those intellectual and virtuous feelings, which are perpetually alive to the welfare and glory of the country."[65] This ideal of high culture, which was reinforced by the Institution's frequent exhibitions of Old Master paintings, was constructed by a group of self-appointed arbiters of taste to restore the hereditary equation between artist and patron. "No social outlook," writes David Roberts in *Paternalism in Early Victorian England* (1979), "had deeper roots and wider appeal than that which twentieth-century

historians call paternalism . . . It was even held, as habits of deference, by agricultural laborers, operatives, and the worthy poor" (p. 1).

Among "the worthy poor" must be counted the artist, who, for the first half of the century, ranked low on the social scale. "Painting is treated as a mechanical art," lamented the novelist and dramatist T. H. Lister in the *Edinburgh Review* in 1834, "and the man of rank would be considered to lose caste by following it."[66] Lister attributed this situation to the fact that although some eighteenth-century artists such as Reynolds, West, and Hoppner became the companions of royalty, most were of humble extraction: Gainsborough and Bird were clothiers' sons, Opie and Romney the children of carpenters, and Mortimer the son of a miller. Taking the disparity between ranks into account, artists expected to be treated in a patronizing manner by their social betters. William Bewick, the historical painter who studied with Haydon, registered his amazement at being introduced to Sir John and Lady Leicester when visiting their gallery with Leigh Hunt, Keats, Haydon, and the Landseer brothers; he remarked that it was "a very unusual thing on such occasions."[67] And the Victorian biographer of the painter David Cox, who was the son of a Birmingham blacksmith, observed that on visits to the great estates, Cox was "well-known to the stewards, gardeners, etc.," but made no mention of his reception by their employers.[68] William Thackeray cynically observed through the eyes of his character, the artist Clive Newcome:

> I have watched – Smee, Esq., R.A. flattering and fawning, and at the same time boasting and swaggering, poor fellow, in order to secure a sitter . . . I have seen poor Tomkins bowing a rich amateur through a private view, and noted the eager smile on Tomkins' face at the amateur's slightest joke, the sickly twinkle of hope in his eyes as Amateur stopped before his own picture.[69]

The transfer of power from patron to artist was to occur gradually as artists rose in the social scale. The early-Victorian period, because of its simultaneous dependency on the aristocratic model and the newer forms of patronage, is most appropriately viewed as a time of transition in the artist–patron relationship. One reason so many nuances were cast over the exchange of goods between artist and client was due to the fact that buyers of modern art now sprang from a wider class range: aristocrat to gentry, tycoon to merchant, and gentleman to parvenu. Artists responded to them accordingly, depending upon how accustomed they themselves were to

deal with the particular level of the social structure they were addressing. Constable, the son of a prosperous miller, was not easily intimidated. Nor was Edwin Landseer, who acted as if he were at home in the Palladian houses of his patrician clientele (despite the fact that his father was an engraver and thus not quite a gentleman), yet the job of keeping up with his betters was a great strain on him and led, as Richard Ormond concludes, to his nervous breakdown in 1840.[70] And while John Horsley's entrée into elegant drawing rooms was eased by his father, an Oxford-educated musician, he balked at the patronizing attitude of many of those he met there. Referring to the situation he encountered in the 1830s, he recalled: "In those days too the offensive word 'Patron' was commonly used, and people who bought a picture or two, arrogated to themselves the title of 'Patrons of Art.'"[71] It was only after artists realized that they no longer needed to be "patronized" by their patrons that the paternal–deferential equation became invalid. The social limitations which artists faced in the first few decades of the last century, however, were so overwhelming that the majority meekly adopted an attitude of servitude.

A case in point is David Wilkie. Although his father was a minister who came from the slightly higher class of yeomanry, the artist capitulated to the entrenched model of patronage in his dealings with the aristocratic Sir George Beaumont. The tenor of their relationship was established in 1806, when Sir George proffered the following advice to the 21-year-old painter:

> Pursue your studies without intermission; be not persuaded to deviate from the line nature and inclination have marked out for you; associate with older men than yourself; do not suffer poor-minded and interested persons to render you discontented; remember yours is a liberal profession; never suffer it to degenerate into a trade: the more you elevate your mind, the more you will be likely to succeed.[72]

Wilkie's reply to this parental missive was utterly decorous: "I have often had in my mind the advice you have often given me of improving myself as I go on. I am sensible still of having a great deal to learn."[73] Anxious lest he lose the interest of such a prestigious patron, Wilkie played into his hand.

It must have been a relief for Wilkie finally to encounter a patron who did not try to interfere in his life, middle-class banker Samuel Dobree, for whom he painted his celebrated comment on the artist–patron relationship,

The Letter of Introduction (plate 3) in 1813. The sitter is Dobree himself, who apparently extended a much warmer welcome to the young artist when he first arrived in London from Scotland than his dour countenance suggests. Wilkie's biographer claimed that Dobree, "of all the merchants of London knew better how to render courtesy to talent."[74] Thus *The Letter of Introduction* is more a reflection of the insecurities Wilkie felt as an artist newly arrived in the capital intent on cultivating a clientele than it is a comment on Dobree's reluctance to accept him. Wilkie's confidence was soon buttressed by other middle-class collectors such as George Young who treated him as their equals.[75]

The independence of artists was further expedited by the rapid expansion of the art market which ensured that their survival no longer depended upon the whims of a single individual. The sheer size of the art world in London contributed to the decline of ambassadorial patronage, in contrast to the provinces, where patrons remained in closer contact with one another and with artists. That is not to say traditional forms of patronage disappeared: many collectors still ordered paintings directly from artists and interested themselves in the creative process. Thus in early-Victorian England the categories of patron and collector meshed as those who wished to own art sometimes ordered it specially, but more often bought already finished canvases off the walls of studios and exhibitions. Paternal patrons who influenced what an artist read, where he lived, and what he painted, were gradually replaced by businessmen who typically favored a number of different artists instead of a select few. While the middle-class patron might entertain artists in his home, he rarely went out of his way to introduce them to his rich friends or to lend them money, as the eighteenth-century patron had sometimes done. This change did not meet with universal approval: the painter C. R. Leslie noted with some disappointment that Samuel Rogers "was too quiet to exercise the influence he should have maintained among the patrons of art."[76]

And although Robert Vernon succeeded in focusing public attention on the English School of Art, artists had mixed feelings about him. His private relations with them were conflicted due to his divided ambitions: his pragmatic business training vied with his longing to be recognized as a leisured country gentleman. Landseer grumbled about the stream of supercilious letters he received chastising him for his tardiness in completing a picture of Vernon's pet spaniels, while another painter compared the struggles and squabbles of the ducks in Vernon's pond at Ardington House with

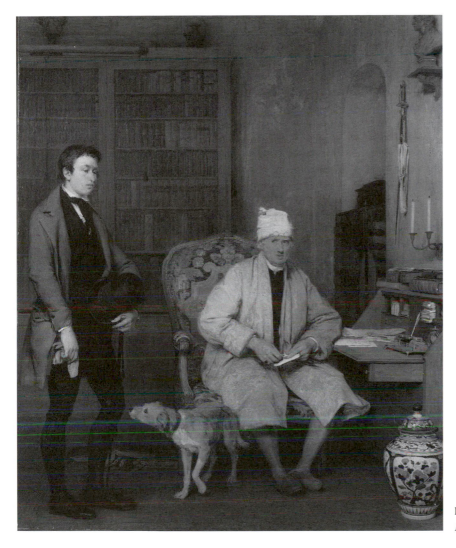

Plate 3. David Wilkie, *The Letter of Introduction,* 1813, oil on panel

the way artists felt about trying to get through the day as his houseguests.[77] He was also known to drive a hard bargain. Horsley insists that the patron asked him for a £5 discount on a picture after he decided not to take the frame, and that he tried to reduce the price of a painting by Thomas Webster by offering to pay in pounds instead of guineas. Horsley concludes, "a jobber he certainly was, by nature as well as by trade."[78] While Vernon's presumptuousness stems from his imitation of the landed class, his pettiness is indicative of the difficulty faced by the early-Victorian middle class in relinquishing its heritage of thrift, even after its fantasy life of riches began to materialize.

39

But the bargaining that frequently characterized the middle class's dealings with artists was more than a matter of old habits dying hard. Its members carefully husbanded the wealth that had placed them in the enviable position of being able to afford to buy art lest it drift away and carry with it the prestige it had brought. Vernon, accordingly, organized his artistic affairs in a cool and businesslike manner and kept a detailed inventory of his purchases. He also made certain that he owned the copyright of every picture he bought, which guaranteed that it could not be engraved without his permission, thus applying to his collection the methodical practices that made him a commercial success.[79]

Inexperienced as many of these first-time collectors were, they often sought the advice of professionals. Unlike many of their provincial counterparts, early-Victorian metropolitan collectors did not place their faith entirely in dealers, but took advantage of a variety of outlets. Many employed artists as their agents. Ever versatile, Vernon made purchases at the Royal Academy, British Institution, and at Christie's, in addition to sometimes using artists as go-betweens. His favorite was George Jones; in addition to sharing his enthusiasm for the military, Jones was Keeper of the Royal Academy and thus in a good position to negotiate with artists.[80] Mrs. Haldiman, as I have already stated, chose the watercolorist George Fennel Robson as her intermediary in commissioning pictures for her album and screen, just as Morrison consulted the painter Henry Pickersgill before he bought his Constable, and turned to architect John Papworth for advice in making several of his other modern art purchases.[81] Like him, the majority of early Victorians availed themselves of the ever-expanding market for art in the capital: soirées at artists' studios, private viewings at the Royal Academy, special showings staged by dealers or printsellers, and frequent sales at Christie, Manson, and Woods's auction house.

Morrison introduced an added dimension to collecting when he entered into a silent partnership with the dealer William Buchanan. Recognizing how rapidly his own investment in art had appreciated, Morrison advanced the dealer money to buy several private collections between the years 1838 and 1850. Although profitable, their association was complicated by Morrison's insistence on applying the strategies he practiced in the silk trade to the art trade. Hugh Brigstocke in his recent book on Buchanan observes that the collector had "a particularly disconcerting habit of demanding that unsold pictures should be deposited in his London home at Harley Street as security for unpaid debts."[82] Morrison was not an anomaly in the early-

Victorian era, which witnessed the advent of middle-class *marchands amateurs*. They irrevocably altered existing methods by introducing the finely honed instincts for trading they had perfected in the commercial arena. Men such as Morrison, Allnutt, Windus, and the Huth brothers [83] caused the breakdown of traditional forms of exchange when they assumed the mantle of the dealer.

Wine merchant John Allnutt turned professional when he opened a commercial gallery in Pall Mall in the 1820s.[84] His dealings with Haydon are perhaps responsible for the artist's dislike of businessmen–collectors. Allnutt upset the artist by behaving in a manner similar to Morrison when he allowed Haydon to stage an exhibition in his gallery in 1823, but confiscated one of his canvases when he defaulted on the rent.[85] To someone as convinced of his own genius as Haydon, it was unthinkable that one of his "creations" could be considered a mere commodity. Likewise the *marchand amateur* quickly learned that the artistic personality was far more difficult to deal with than his commercial suppliers. Episodes such as this one eventually convinced Allnutt to sell his gallery and to return to the less complicated realm of private patronage.

That Allnutt continued to collect art, however, is evidenced by the private picture gallery he hired architect John Papworth to add to his home in suburban Clapham, which artist David Cox captured in 1845 in a vigorous watercolor (plate 4) on the occasion of the wedding breakfast of Allnutt's daughter.[86] On the walls are many of the pictures described in the Christie's sale catalogue of Allnutt's collection in 1863 which included several Turners – *Newark Abbey on the Wey, The Pass of St. Godhard,* and *Bonneville, Savoy* – and Constable's *Landscape: Ploughing Scene in Suffolk,* which Allnutt commissioned from the artist. In contrast to Haydon, Constable was sympathetic toward Allnutt, whom he thought "much imposed upon by artists in general …who had encroached on his great liberality – he has often advanced money to artists … & never got any thing for it."[87]

Artists were less sanguine about Benjamin Godfrey Windus. He introduced the mercantile tactic of "cornering the market" to the art world when he bought up 650 drawings by Wilkie, which he held until just after the artist's death before he sold the choicest ones at a substantial profit. Applying the marketing skills he had developed in manufacturing popular pills, building carriages, and renting out property, Windus was an expert at when to buy, when to sell, and when to hold. He speculated on two of Turner's oils by successively submitting them for sale at Christie's and buying them back twice before they reached the prices he expected.[88]

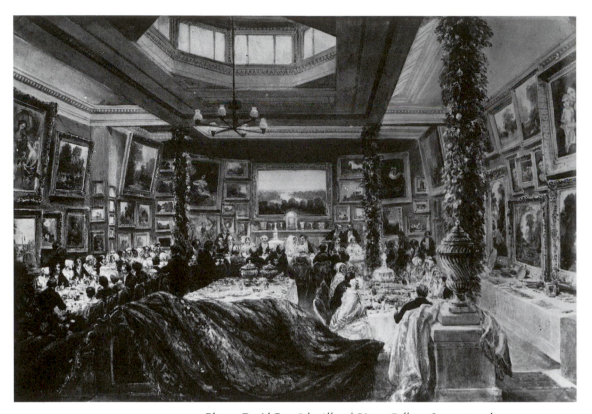

Plate 4. David Cox, *John Allnutt's Picture Gallery*, 1845, watercolor

It was manipulative maneuvers such as these that led the painter Ford Madox Brown to christen Windus "Godfrey's Cordial," because he felt the collector was as dangerous to artists as the dubious medicine of that name.[89] What exasperated artists about Windus was his disconcerting habit of buying their works and then sending them in to be sold at auction for a quick profit. Surely even the well-established Turner must have felt some qualms after Windus's sale of Wilkie's drawings, since the Tottenham collector also owned over 200 of his drawings.

Despite any fears Turner may have had, Windus never disposed of his works *en masse*. That they were the jewels of his collection is disclosed in a watercolor painted of Windus's library by John Scarlett Davis in 1835 (plate 5). After he inherited his house on Tottenham Green from his father, Windus had this room specially constructed without windows, presumably to protect Turner's delicate washes from the effects of natural light. As a further precaution, each of the framed watercolors was glazed. Those that

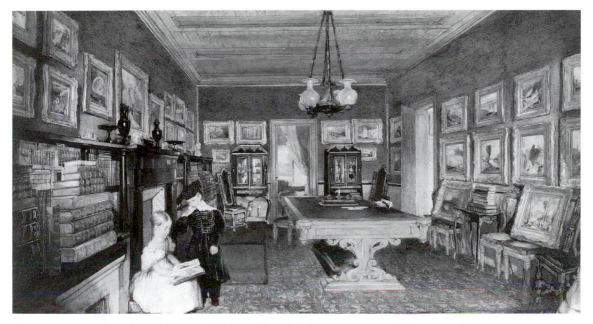

Panel 5. John Scarlett Davis, *Benjamin Godfrey Windus's Library*, 1835, watercolor

were unframed were kept in portfolios, such as the one on the table, while others were stored in the chinoiserie cabinets that stand at the back of the room, or mounted in albums like the one that is being examined by the two children in the foreground.[90] It was in this room that the young John Ruskin spent hours studying Turner in preparation for his first volume of *Modern Painters*, which he later claimed he never could have written without access to Windus's collection.[91]

Ruskin also studied the Turners in the collection of his Herne Hill neighbor Elhanan Bicknell, another businessman who dabbled in the investment side of art. A wealthy sperm whale-oil manufacturer, Bicknell bought several Turners and at least one Stanfield on speculation in collaboration with the dealer William Hogarth. He also financed prints for this dealer, including some of Turner's, whose hard bargaining was the cause of a celebrated row when Turner demanded fifty proofs in addition to a fee from Bicknell for permitting his *Fighting Téméraire* to be engraved.[92] Turner's behavior proves that artists aided and abetted the process of art's commodification. This was not the only altercation between the two – Bicknell found Turner to be almost as elusive as the Pacific sperm whales his business depended on: after the artist procrastinated in sending a painting he had

done for Bicknell to John Pye to engrave, the frustrated patron urged the engraver to "fasten your strongest hook into him before he fairly takes water again or he may get so far and so deep that even a harpoon will not reach him."[93] Turner ran afoul of the manufacturer on another occasion when he tried to cater to Bicknell's penchant for whaling subjects by offering him *The Whale Ship*; however, when Bicknell discovered passages of watercolor mixed in with oil on the canvas he quickly returned it to the artist. This incident, however, occurred after Bicknell had already bought nine oils from Turner for prices ranging up to 1,000 guineas each.[94]

That Bicknell had invested wisely in Turner and the other English artists he patronized was proved at the sale of his collection in 1863, which fetched almost £80,000, approximately three times what he had paid. The general public was amazed when it learned that a collection of this magnitude was formed by a middle-class businessman. Even a populist newspaper like the *Star* was stunned by the degree of cultural progress that had been attained by commoners. It reported:

> The collection of paintings thus sold has been gathered together by a private Englishman, a man of comparatively obscure position, a man engaged at one time in mere trade; a man not even pretending to resemble a Genoese or Florentine merchant–prince, but simply and absolutely a Londoner of the middle-class, actively occupied in business. This Englishman, now no more, had brought together a picture gallery which would have done no discredit to a Lorenzo the Magnificent, although his name is probably still hardly known to the general public of the very city in which he lived.[95]

These remarks reveal that the middle class had finally achieved social and cultural recognition. The value of the Bicknell collection was impressive enough to announce that money earned, not inherited, made it possible for a businessman "of comparatively obscure position," to infiltrate the élite realm of culture.

Art collecting therefore stabilized the category of culture for the middle class and lent luster to its emerging identity. This achievement is illustrative of Georg Simmel's contention that money can be an instrument of freedom in modern society.[96] Financially empowered, the middle class recognized the importance of using part of its wealth to signal its independence. From this perspective, the Marxist argument about the higher morality of use-value as opposed to exchange-value takes on a different cast. Rather than leading to fetishism for its own sake, or on behalf of the

luxury objects for which it was exchanged, money in the hands of the early-Victorian middle-class businessman instead facilitated a process of social deliverance.[97] While they changed the face of the art market with their negotiating and bargaining skills, not all of these early Victorians were solely interested in profit. As Mary Douglas and Baron Isherwood stress in *The World of Goods,* commodities have long been used to define and pre-serve social relations.[98] Art objects, to these collectors, represented a means through which they could clarify their place in the social order.

The motivation for art collecting cannot be separated from the social sphere, particularly in the early-Victorian period when the high premium placed on personal industry nullified self-gratification as an acceptable goal. While public acknowledgment of individual cultural worth was a factor, it mattered less at this time of identity seeking than the opportunity to rationalize one's place in the social habitus. "Consumption," according to Baudrillard, is a "bricolage in which the individual desperate-ly attempts to organize his privatized existence and invest it with mean-ing."[99] To determine the range of meanings the new patrons invested in art one must look at their daily milieu, as well as their political and cultural aspirations. London art collectors were not part of the homogeneous habi-tus that inspired businessmen in Birmingham and Manchester to patronize artists. Sources of income in the metropolis, although varied, generate a partial explanation of what Bourdieu terms the "systems of disposition" responsible for the cultivation of taste.[100]

While the careers that provided the money for art do not explain why, for instance, Isambard Kingdom Brunel was awakened to the poetry of painting when his fellow engineer George Stephenson was not, they can account for which qualities in art a collector deemed most important. Brunel was introduced to the inner circle of the London art world by his brother-in-law J. C. Horsley, who was a painter, and by the artist C. R. Leslie, who apprenticed his son to him. Thus it was Brunel's family and business connections, rather than the specifics of his occupation which were responsible for his initial involvement in collecting. Yet, once he made the decision to become a patron, he applied the critical standards of his exacting profession to the art that he commissioned. Horsley recalls that Brunel "had a remarkably accurate eye for proportion, as well as taste for form. This is evinced in every line to be found in his sketch books, and in all the architectural features of his various works."[101] Horsley's remarks are telling, not only in that Brunel's engineering background made him acutely

aware of how a composition should be structured, but also that his interest in art extended to the keeping of sketchbooks as well. One of Brunel's drawing books contains several schematic sketches for the arrangement of pictures in his celebrated Shakespeare Room that were executed in the economic manner befitting an engineer (plate 6).[102] Brunel's interest in drawing, combined with the sense of design and order which were his trademarks in the Clifton Suspension Bridge and the Thames Tunnel, made him appreciative of the mechanics of the fine arts. In another revelation, Horsley tells us that the engineer carried over his art appreciation into his commercial projects, especially in "the choice of colour in the original carriages of the Great Western Railway, and any decorative work called for on the line."[103] The acuity of a trained eye, then, can be counted as one of the motivations for collecting which blunted the harsher trajectory of art's profitability.

Anna Jameson attempted to summarize the meanings attached to art in her *Companion to the Most Celebrated Private Galleries of Art in London* (1844), when she noted: "Pictures are for use, for solace, for ornament, for parade; – as invested wealth, as an appendage of rank. Some people love pictures as they love friends; some, as they love music; some, as they love money. And the collectors of pictures take rank according" (p. 383). Jameson identifies the mixture of concealed and apparent motives harbored by art collectors. In suggesting that some are impelled by love, or by a need for solace, she enters the indistinct area of subliminal motivations that are often too well hidden, too indefinable, and too intangible to be reached by the awkward probing of the historian of the early-Victorian period. Even the more intimately pitched inquiry of psychoanalysis only results in conjecture if one cannot find confirmation in the collector's own statements. Since this kind of evidence is rarer in the earlier than it is in the later years of the century, I will reserve my analysis of the more impalpable motivations for owning art for my discussion of Pre-Raphaelite and Aesthetic movement collectors, who reveal more in their letters. The art historian is better equipped to deal with the social inducements for collecting in the first half of the nineteenth century – with the complex of socioeconomic, political, and cultural ideas that form its intellectual life.

On a national level, patriotism was the ostensible cause for the formation of many collections of English art during and after the war with France. Brunel's Shakespeare gallery was an obvious manifestation of this sentiment, as was the gallery of history paintings commissioned from

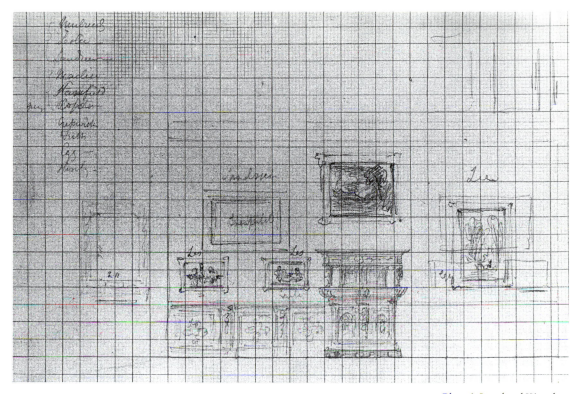

Plate 6. Isambard Kingdom Brunel's sketch for his Shakespeare room, 18 Duke Street, London, *c.* 1848

English artists by shadowy financier Arthur Davison (1750–1829) sometime around the year 1806.[104] In consultation with Valentine Green, Keeper of the British Institution, Davison invited eight artists to paint subjects of their choice from English history. His only stipulation was that each painter insert a self-portrait in his final work. At the height of his powers as clothing contractor to the army and the executor of Admiral Nelson's will, Davison's patronage abruptly ended two years later, when he was sentenced to Newgate for padding government contracts.[105] Despite his demise, the jingoism that had swayed Davison continued to stimulate the collecting of modern English art.

Robert Vernon could not have succeeded in giving the incipient middle-class cultural movement a national identity were it not for the candent climate of patriotism and social transformation in the years following the war with France. This redefinition of early-Victorian culture was orchestrated by an unlikely pair of players: a collector in search of fame and a journal publisher whose loyalties were divided between his social conscience and profitmaking.

Samuel Carter Hall founded the monthly *Art Union* in 1839 as a forum for his ideas about the socially ameliorating potential of English art. His commitment to the improvement of the working classes was to be directed from a more predicative base after 1878 when he initiated the weekly journal *Social Notes*, but until that time the *Art Union* remained the main outlet for his democratic notions. Hall argued that, "a collection of pictures powerfully helps to thin our poorhouses and prisons [and] men to whom public galleries are open will be seldom found in public-houses."[106] This suggestion that art induced civility, as I shall argue in the next chapter, was one of the primary motivations behind the staging of the Manchester Art Treasures exhibition in 1857.

Furthermore, Hall believed that native art was the most effective communicator. He set out to encourage the growth of the English school by convincing the newly endowed middle class that it was in its best interest to support living artists. Although the publisher exaggerated his contribution to the cultural field in his autobiography, his identification of the chief obstacles he faced at the time he launched his publication in 1839 rings true. Hall recollected:

> There was literally no "patronage" for British Art. Collectors – wealthy merchants and manufacturers – did indeed buy pictures as befitting household adornments, but they were "old masters" with familiar names; canvases that had never been seen by the artists to whom they were attributed; copies or imitations by "'prentice hands," that were made to seem *old* by processes which I persistently exposed ... I made manifest the policy of buying only such pictures as could be readily identified – certified by the artists who were living; urging the probability that they would increase and not decrease in value, while it was almost certain that so-called "old masters" would ultimately be worth little more than the value of the panels and frames ... I have lived to see such "old masters" valued according to their worthlessness, and a thorough transfer of patronage to modern Art.[107]

Hall, then, appealed to his middle-class readers in a language they readily understood: it behooved them economically to invest in authentic art by modern artists instead of running the combined risks of purchasing nefarious Old Masters and looking foolish. This alliance between art and money also infiltrated Hall's journalistic philosophy and prompted his search for a catalyst to expedite the transformation he anticipated in the cultural field.

In Robert Vernon, as Francis Haskell has pointed out, Hall found a middle-class hero to champion his patronage of living artists. To Hall, Vernon was "a true Patriot, and a powerful Instructor by the instrumentality of Art."[108] As admiring as Hall was of Vernon's pioneering support of English art, his relationship with the collector was based on an economic as well as a polemical foundation. It was only after Vernon temporarily relinquished his closely guarded copyrights and gave Hall permission to engrave his collection in 1849 that his precarious journal became a financial success.[109] It was a reward that Hall must have felt he justly deserved: he had unremittingly flattered Vernon in print for a decade. Beginning in his first year of publication, he held up the collector as a role model to his class. Hall dedicated the first in what was to become a 73-year series on private collections to Vernon, describing his "mansion" in Pall Mall and his collection in lavish terms, concluding that,

> We have told enough, however, to show how largely the arts of Great Britain are indebted to Mr. Vernon; and, we hope, to stimulate other wealthy gentlemen to follow so glorious an example. He is the best patriot – the largest benefactor of his country – who elevates its intellectual character, and contributes to advance that national distinction, which is the surest and most enduring. He whose pleasures are unselfish is the true philanthropist; he who is ever ready to recompense toil and to reward genius does more, in reality, to benefit and improve mankind, than the victor in a hundred fights. (March 1839, 19)

And so the praise continued, culminating, in 1847, when Vernon announced his intention to give his collection to the nation. Whether Hall was instrumental in this decision is unknown, but there is no question that its validation in the site of the National Gallery was the realization of his dreams for English art.

Before Robert Vernon's benefaction in 1847, few donations of modern English art were made to the nation. An exception was Sir George Beaumont, who gave his collection of old and modern paintings to the newly formed National Gallery in 1826.[110] And although Sir Robert Peel tried to persuade Sir John Soane to leave his collection to the British Museum, Soane chose in 1833 to endow it, along with his house, as a separate establishment supervised by trustees.[111] Like Sir Thomas Coram, who established a foundation across the way from Soane's Lincoln's Inn Fields residence under the guidance of Hogarth in 1793, Soane was impelled by private rather than public motives.

Artists were naturally more concerned about improving the status of English art, and they proved to be among its most bounteous donors in the early-Victorian period. The sculptor Sir Francis Chantrey willed the income from his estate in 1841 for the purpose of purchasing works of art by Royal Academicians for a national collection of fine art; however, these funds did not become available until the death of his wife in 1874.[112] Turner also displayed his generosity by bequeathing the finished paintings in his studio to the National Gallery in 1851.[113]

Collectors were not usually so magnanimous as artists; the National Gallery had to purchase its foundation collection of Old Masters from the merchant J. J. Angerstein.[114] While many middle-class tycoons were noted philanthropists, they were not in the habit of directing their acts of charity toward the art world. *Blackwood's Magazine* lamented in 1836:

> We daily hear of vast fortunes, two and three hundred thousand pounds, left to form colleges or endow hospitals, but never of one to bestow the durable blessing on his country of a great public gallery of pictures or statues ...[it] would stamp immortality on the munificent testator, and do more than all the insulated efforts of individuals to refine and purify the public taste.[115]

Inspired by such lofty rhetoric, with its promise of immortality, Vernon became the first private patron to donate a major collection of modern art to the nation.

Oddly enough, considering the publicity Vernon has garnered over the years as a pioneering patron of English art, no attention has been paid to the fact that he initially planned to include the Old Master paintings he had inherited in his gift. Some were by artists who had worked in England such as Sir Anthony Van Dyck and Sir Godfrey Kneller, which makes sense in the context of the historical scope of his collection, but others were by European Old Masters – he owned works by or attributed to Rubens, Watteau, Jordaens, and others. Even when most actively patronizing living artists, Vernon did not neglect his older paintings and regularly lent them to exhibitions.[116] The pictures we see today in the Tate and National Galleries represent only the more modern arm of the original Vernon collection.

Immortality was clearly among Vernon's goals: it was the reason he wanted his gift to be known as "The Vernon Gallery" and why he instructed the executors of his will to erect a monument to him near his

mausoleum at Ardington House. He uncompromisingly stated that he wanted his pictures to be "exhibited in a room or rooms set apart exclusively for them, to be called 'the Vernon Gallery.'"[117] While this condition was to prove problematic, Vernon was undoubtedly flattered by the attention he received in response to the announcement of his gift. Lord Monteagle, a member of the Trustee's selection committee, wrote to him, expressing his "deep sense of obligation" toward Vernon and urged him to include a portrait of himself as part of his gift so that it could be "handed down to posterity among the greatest benefactors to the Arts of England."[118] The regard of connoisseurs must also be counted as a primary motivation behind Vernon's gift. His strategy is the subtext of many British success stories: the smoldering desire to be sought after and treated as an equal by members of a higher class.

It was not simply Vernon's generosity that led the National Gallery to accept his gift, but the dawning realization that the public preferred modern art. The trustees had only to try squeezing through the crowded narrow corridor where the few modern pictures that came with the Angerstein purchase were hung to realize that these entertaining canvases outdrew the Old Masters. When the National Gallery moved to its new home on Trafalgar Square in 1838, Hogarth's *Marriage à la Mode* series and Wilkie's *Village Festival* were the pictures most favored by the public.[119]

The uphill battle fought by advocates of British art in the early decades of the century appeared to be over in the 1840s. While the private patron was successfully conscripted in the 1830s, it took the combined influence of the first two volumes of John Ruskin's *Modern Painters* (1843–46), the patriotic theme of the Houses of Parliament murals competitions (1842–47), and the threat of the formation of an independent national gallery of modern British art by the Society of Arts (1846), to convince the conservative National Gallery of the significance of the country's own artists.[120] Vernon shrewdly recognized that the time was ripe for a collection such as his to be welcomed by the nation.

Yet once he officially signed over his 162 works of art, in 1847, matters stalled. While the Trustees of the National Gallery placated the clamoring public by accepting the Vernon Gift, they were reluctant to disturb the harmony of the Old Masters which formed the core of their collection. Oppé lamented: "The taste of the nobles and their imitators was responsible for the continued purchase by the National Gallery of pictures by the dark masters long after they had ceased to interest."[121] By accepting

Vernon's collection without displaying it immediately, the old guard made it clear that it still controlled access to culture. It was reluctant to open the doors to newer patrons who did not subscribe fully to the values it had cherished for so long. After studying a parallel situation which developed in Boston later in the century, Paul DiMaggio concludes that dominant status groups preserve their social authority by making culture only partially available to those who are subordinate to them.[122] Clearly English art was still not considered worthy enough to be admitted into the canon of timeless masterpieces or to claim a place of honor in the national showcase.

When the Treasury still had not granted funds to erect an addition to the National Gallery a year later, Vernon agreed temporarily to open his house on Pall Mall to the public twice a week during the summer months while he was in Berkshire.[123] This was hardly a satisfactory situation since it limited access to the collection. Another provisional location was found for the Vernon Gallery in October 1848, in rooms in the basement of the National Gallery. A hue and cry was raised by the popular press over the indignity of this space – the *Illustrated London News* published an engraving of the new installation (plate 7) and remonstrated: "the provision is strange enough – in the basement of the west wing of the gallery, in a suite of small rooms built for servants' offices."[124] *Punch* also considered the location ludicrous, describing it as "the National Cupboard."[125]

Priorities had not significantly changed in the twenty years since Sir John Leicester's offer to sell his collection to the nation as the nucleus of a National Gallery of British Art was rejected. While the reason given at that time still held – Old Masters must be given priority in any national collection – there was now a more threatening dimension to the issue which rekindled the fears harbored by the élite at the time of the signing of the Reform Bill.[126] English art was becoming a rallying point for an increasingly outspoken middle class. Member of Parliament Thomas Wyse, recognizing the educative capability of imagery, agitated on behalf of the masses for broader accessibility to the arts and engraver John Pye, who shared these sentiments, published a scathing indictment of the patronage of British art.[127] These themes were reiterated by Hall, whose rechristened *Art Journal* claimed 15,000 subscribers by 1849.[128] He kept the issue in the forefront of his readers' minds with engravings of paintings that delighted, instructed, and cajoled them.

Middle-class subjects were not as apparent in the Vernon Gift as in John Sheepshanks's bequest ten years later, even though one-quarter of the

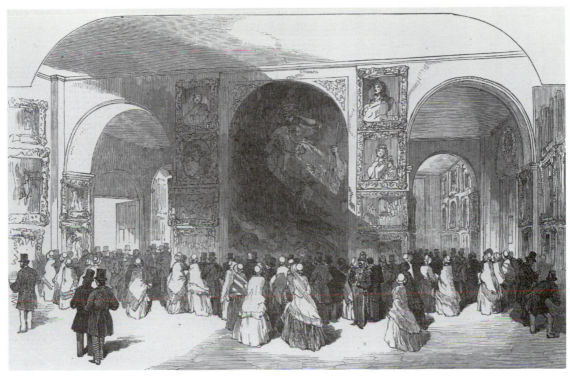

Plate 7. The Vernon Gallery's temporary home in the basement of the National Gallery

collection given to the National Gallery consisted of narrative scenes from everyday life or popular literature.[129] The bulk of Vernon's collection was comprised of pictures by English artists who expressed themselves in a more serious vein, such as Hilton, Wilson, Turner, Etty, and, perhaps most politic of all, Eastlake himself.[130] But because Vernon wanted to demonstrate his ownership of symbolic cultural capital by presenting a historic survey of the English School from the time of Reynolds, he could not exclude genre painting, despite the reservations harbored by many conservative critics. Narrative painting had accelerated in step with the middle class's preference for familiar themes in art. As the *Edinburgh Review* reasoned, in 1834, "The majority would rather see the likeness of something they have seen before, than stretch their faculties to understand a story told on canvas, or try to imagine whether a great event in history is adequately represented in the picture before them."[131] Anxious to turn over to the nation a finely crafted crucible of taste, Vernon compromised by selecting narrative works that were compatible with the low-toned palette and pensive mood of the remainder of his collection.

An example is Frederick Goodall's cabinet-sized *The Tired Soldier* (plate 8), an essay on human charity and compassion in a time of war which readily lends itself to the patriotic and moralizing interpretations of art favored by Hall; at the same time it is a reminder of the absorption with military life that contradicts the light-hearted anecdotes in Vernon's collection. Vernon was pulled between the top and the bottom of the social and aesthetic pyramids, between gentlefolk and jobbers and between high art and genre.

The philanthropists who followed Vernon's example by donating collections of modern art to the public were not mortgaged exclusively to any one aesthetic or social standard. Lacking his aristocratic ambitions, but having the advantage of his commitment to the English school to follow, it was easier for John Forster, the Rev. Alexander Dyce, John Sheepshanks, and Jacob Bell to develop their own models of patronage.[132] Trained as a barrister but choosing not to practice law, Forster was more influenced in shaping his art collection by his contacts in the literary world than by the world of aesthetics.[133] Also a writer and close friend of Forster, Dyce was induced by his cousin, artist William Dyce, to bequeath his art and book collection to the public.[134] Sheepshanks was secure enough in his middle-class status to follow his own drummer, even to the point of repudiating some of the values he had inherited. And although Bell was a paragon of bourgeois professional virtue, his training as an artist enabled him to balance his pragmatic reading of art with an appreciation of its aesthetic advantages.

Sheepshanks's social and aesthetic habitus differed significantly from Vernon's. He was a product of Leeds's well-established merchant class, which traditionally "spent their surplus earnings in buying parcels of land, government stocks and transport investments so that one day their families would be provided with an independent income that was not tied to the fluctuations of trade."[135] This conservative investment policy on the part of Leeds merchants such as John Marshall and Joseph Sheepshanks allowed their sons to retire early and to focus their attention on art collecting. William Marshall, for instance, divided his time between Eaton Square and the Lake District,[136] while John Sheepshanks was able to retire from the family business before the age of forty and devote his attention to art and gardening.[137]

The Sheepshanks's coffers had swelled as a result of the Napoleonic Wars. By that time his farming family had been in the business of manufacturing and selling cloth for two generations. Herbert Heaton, in

Plate 8. Frederick Goodall, *The Tired Soldier*, 1842, oil on canvas

his study of the Yorkshire woolen and worsted industry, describes the Sheepshanks' involvement in the war: "When the struggle with France began, Yorkshire was flooded with orders from every part of Europe for fabrics for the clothing of troops … and in 1797 Mr. Sheepshanks of Leeds was supplying scarlet and white cloth for the militia to the extent of £1,400 a year."[138] This prosperity made it possible for Sheepshanks's cousin to marry the daughter of the Earl of Harewood and for his brother to study astronomy at Trinity College, Cambridge, where he became a Fellow.

Instead of trying to become assimilated into the local gentry, John Sheepshanks opted to settle in London, where his new lifestyle was captured in a portrait by William Mulready in 1832–34 (plate 9). The artist represents the bachelor at home in New Bond Street informally leafing through a portfolio of prints. What makes Mulready's image unusual is the

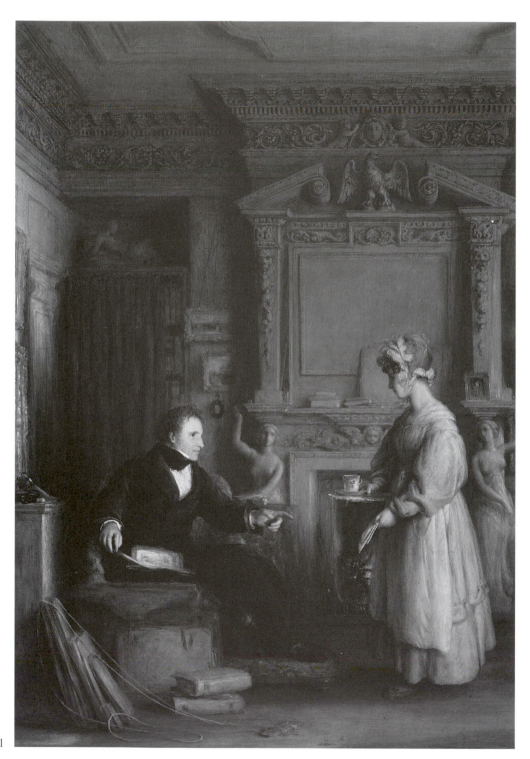

Plate 9. William
Mulready, *John
Sheepshanks at home at
172 New Bond Street,*
1832–34, oil on panel

dominant position he gives to Sheepshanks's housekeeper Elizabeth Suthors. Although she is shown performing the duties of serving tea and delivering mail, because her profile is depicted with the dignity of a classical relief against the looming marble of the mantelpiece, she is awarded an elevated status. This representation is consistent with Sheepshanks's egalitarian treatment of his servants: he was known to have been generous with his household retainers, giving them salmon, turkey, and goose, while Vernon, in contrast, insisted that his staff eat only boiled meat because he believed it resulted in less waste than when roasted.[139] The differences between the two men extended beyond the domestic sphere, to the conditions of their public patronage.

Sheepshanks placed the welfare of his countrymen above personal ambition, while Vernon, inspired by the possibility of fame, valued acceptance by the old guard above the needs of the community. Unlike Vernon, Sheepshanks did not use his collection as a pawn in bargaining for immortality; on the contrary, he specifically stated in his Deed of Gift, in 1857, that he did not want his collection to "bear my name as such."[140] He even approached Vernon with the suggestion that they merge their collections into a "National Gallery of British Art" – an idea flatly rejected by Vernon, who wanted to be permanently associated with his collection.[141] Furthermore, instead of seeking the approval of the connoisseurs at the National Gallery, Sheepshanks turned to the more socially-conscious staff at the new South Kensington Museum (now the Victoria and Albert), a move that was to be followed by Forster and Dyce.

Sheepshanks's peer group included former social-protest painter Richard Redgrave, who had become Inspector General of the Schools of Art, and his supervisor at the Department of Science and Art, Henry Cole. A Utilitarian, Cole firmly believed that museums were "antidotes to brutality and vice."[142] Anxious to have Sheepshanks's instructive collection of narrative paintings form the core of the new collection at South Kensington, the administration accommodated the donor's wish that "the public, and especially the working classes, shall have the advantage of seeing the collection on Sunday afternoons" (in contrast to Richard Ellison, who specified in his will that if the museum were to be open on Sundays, the frames of his paintings must be fitted with blinds "which could be securely drawn").[143] Siding with Sheepshanks, Cole introduced gas lighting into the painting galleries so that they could remain open until 10:00 p.m. three evenings a week to accommodate working people.[144]

As dissimilar as their goals were, Sheepshanks and Vernon were alike in their need to forge a public persona that hid aspects of their character. Sheepshanks's habit of deliberately dressing down was as deceptive as Vernon's officer-cum-gentleman image. After he moved to Blackheath in the 1830s to pursue his interest in horticulture, his guests often mistook the shabbily dressed Sheepshanks for a gardener. Nor did he change his attire when he traveled: he was once refused admittance to the first-class carriage on a train because of his appearance. His friend Richard Redgrave confirmed that Sheepshanks's dress was unusual for his station in life when he recalled, "as far as his attire goes no one would think his income a hundred a year."[145] Sheepshanks's wealth is disputed by the riches apparent in Mulready's portrait. The gilded frames that decorate the walls, combined with the casually stacked portfolios in the left foreground, inform us that this is much more than an ordinary middle-class residence. Sheepshanks, in fact, left a substantial estate of over £45,000. Why, then, did he feel compelled to misrepresent himself?

The need to dissemble is a form of masquerade. According to the concept developed by feminist theorists, masquerade is "the decorative layer which conceals a non-identity."[146] In Sheepshanks's case, this was more a matter of wanting to conceal a socially unacceptable orientation. Significantly excluded from his gift of 233 oils and 298 watercolors, drawings, and etchings was the large group of watercolors of little boys Sheepshanks had specially commissioned from William Henry Hunt. His desire to keep these images private suggests that he may have had homosexual tendencies which he wanted to disguise.[147] Whether his drinking bouts[148] were related to the strain of constantly dissembling, or to some other cause, Sheepshanks's unorthodox lifestyle, at the very least, disputes the bland bourgeois stereotype of the Victorian.

Sheepshanks prided himself in his marginality in other regards: he did not try to curb his contentious character, which Frith described as "irascible" and the blunter Horsley found "extremely irritable."[149] Nor was he unafraid of championing unpopular causes. Sheepshanks made no secret of his annoyance at the Royal Academy for its privileging of high-art oil and watercolor painters over engravers.[150] Sheepshanks had begun his collecting career by purchasing Dutch and Flemish etchings in Leeds and on the Continent and he continued to collect prints by contemporary artists, proving that unlike many patrons, who abandoned their interest in prints after they discovered oil painting, he refused to treat graphics as an inferior medium.

Sheepshanks's receptivity to less élitist art forms is one explanation for the enthusiasm he showed for narrative painting. Almost half of the oils in his gift are genre subjects, either scenes from daily life or anecdotes derived from popular literature. While titled collectors had provided a measure of support to genre painters such as Morland in the early years of the nineteenth century, the early-Victorian middle class quickly appropriated this branch of art and impressed it with its own indelible stamp by making it expressive of its hopes and fears.

Narrative painting appealed to some businessmen–collectors because of the way it reflected modern metropolitan values, while others discovered that its storytelling component filled the void left when urbanization disrupted the oral tradition of village life. Both Sheepshanks and Jacob Bell, for instance, derived enormous pleasure from sharing stories of their pictures with an audience. One way for a Londoner to compensate for the loss of the intimate kinship structure that had existed in agrarian communities and small towns was to construct a predictable and certain world of his or her own. Familiar, reassuring images in paintings which lined the walls of drawing rooms and bedrooms were one means of instilling a sense of order on the chaos of urban life. Novelist and art critic William Makepeace Thackeray also vigorously defended narrative painting, insisting that the best pictures celebrated the "sentiment of reality," by speaking to the heart.[151] Even Vernon, despite his grand ambitions, found solace in owning a few rustic evocations of a simpler time and place, such as Mulready's *Coming from the Fair*. The storytelling potential of these images permitted the preservation of elements of village life in a milieu where neighbors were often strangers and appearances could be misleading.

City viewers also soon discovered that it was possible to create new stories of their own based on the incidents that artists began to paint from the world of common experience. These scenes invited audience participation, unlike the intellectual metaphors of history painting, by capturing everyday events: going to school, reading a letter, or suffering the loss of a loved one. Self-recognition was virtually instantaneous in such commonplace themes as learning, prayer, romance, or bereavement. Because of the elemental appeal of these subjects, narrative painting quickly attracted a large following.

Sheepshanks was the proud owner of one of the most popular and repeatedly engraved images of the early-Victorian period, Landseer's *Old Shepherd's Chief Mourner* (plate. 10).[152] It struck a common chord through the

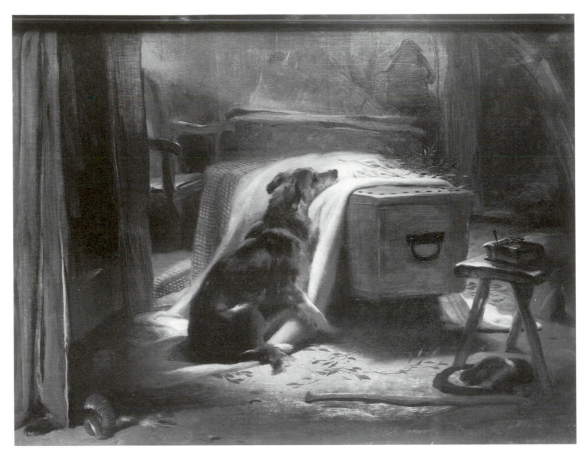

Plate 10. Edwin Landseer, *The Old Shepherd's Chief Mourner*, 1837, oil on panel

poignancy of the faithful dog's lonely vigil by his master's coffin. Redolent with the guileless bonds that characterize the deepest relationships, this raw emotional message overcame class boundaries and spoke directly to servants, merchants, and even sophisticated critics. Young John Ruskin revealed that he shared the common compulsion to weave an explanatory tale around the image when he wrote, in his first volume of *Modern Painters*, that:

> The close pressure of the dog's breast against the wood, the convulsive clinging of the paws, which has dragged the blanket off the trestle . . . the spectacles marking the place where the Bible was last closed, indicating how lonely has been the life, how unwatched the departure, of him who is now laid solitary in his sleep; – these are all thoughts – thoughts by which the picture is separated at once from hundreds of equal merit, as far as mere painting goes, by which it ranks as a work of high art, and stamps its author, not as the neat imitator of the texture of a skin, or the fold of a drapery, but as the Man of Mind.[153]

60

Ruskin, like Thackeray, believed that genre painting's communicative skills raised it to the highest category of art. It succeeded where history painting had failed in reaching all segments of society with its moral lessons, not because it appealed to the lowest common denominator, but simply because it invited reflection. As Kendall Walton observes in his recent exploration of the nature of mimesis, "it is the function, in any reasonable sense of the term, of ordinary representational works of art to serve as props in games of make-believe."[154] Genre painting thus succeeded where history painting had not in sparking a creative chain of thought in the mind of the viewer.

This achievement, however, did not sit well with the defenders of high art. Eastlake was concerned that the prevailing trend toward such small-sized and highly detailed canvases would stultify the soul of the artist.[155] Also registering its complaint, in 1852, *Fraser's Magazine* lamented that English art was becoming "commonplace" (p. 229). Underlying these remarks was the fear that art would lose its privileged position in society if the current trend continued. Taste would no longer be a dependable marker of class status if painting was demystified to the point that it became instantly accessible to the masses.

The working-class response was indeed overwhelming. So large were the crowds that pushed their way into the Sheepshanks Galleries at the South Kensington Museum that they threatened to endanger the works of art on display, despite the fact that Henry Cole had posted signs reminding visitors that they were "shareholders" in the collection and asking them to protect the art from mischief. Redgrave nevertheless reported that the coughing and sneezing throngs who crushed up against the pictures were causing saliva damage to the painted surfaces, which necessitated that they be covered with glass.[156] The problem was not simply one of overcrowding, but the eagerness of the have-nots for exposure to culture. Critic Anna Jameson recalled that when the Grosvenor Gallery and Bridgewater House were open to the public: "We can all remember the loiterers and loungers, the vulgar starers, the gaping idlers …[who] strutted about as if they had the right to be there, talking, flirting, peeping and prying."[157] As the daughter of court painter to Princess Charlotte, Jameson, presumably, had been well schooled in the necessity of displaying deference to noble patrons and was thus dismayed by those who did not. On the other hand, she recognized the strong popular attraction of subjects from everyday life.[158]

The enthusiasm demonstrated by the working class for narrative painting was considered a strike against the middle-class patrons whose money had stimulated its growth. Aesthetics, in other words, were in danger of being usurped by the wrong people. Bourdieu contends that the popular "aesthetic" is a rejection of the formalized codes of high art which necessitated education, travel, and extensive time spent in mulling over symbolic representations. Its alternative is an art based on common sense and palpable pleasure.[159] Once this pleasure was experienced in English art, there was no turning back.

Enjoyment, however, was only one aspect of genre painting's appeal. Another was the familiar and comforting refuge it offered to inhabitants of a city that was becoming increasingly crowded. A somewhat similar situation was to occur in Paris in the 1860s, when a program of urban renewal eliminated the old insular neighborhoods and transformed the city into a modern metropolis. Artists attempted to compensate for this upheaval, according to T. J. Clark, by painting representations of more predictable, ordered, and "knowable" worlds of experience that compensated for the disruption of familiar habitats.[160]

Forced to reckon with the dislocation of neighborhood and village life half a century earlier, British artists adopted a variety of responses. Some, like Mulready and Wilkie, turned their backs on progress and continued to paint as if the rhythm of country life were unchanged. Others, like William Witherington, dared to refer to the negative side effects of economically driven progress. Both Vernon and Sheepshanks owned versions of Witherington's *The Hop Garden* (plate 11), a painting that seems to encapsulate one of childhood's golden moments: three sun-drenched and smiling children play with hop blooms in an idyllic landscape.[161] They are not there to enjoy themselves, however, but to work: poor London children from the East End were transported to Kent in the summers to pick hops.[162] Sheepshanks's ownership can be explained by the pleasure he took in twigging the establishment, but Vernon's pattern of embracing establishment values would make his purchase seem like an act of self-criticism unless we allow genre painting the flexibility of narrative conventions in literature.

While a painting has a less complex structure than a novel, it is nevertheless a form of representation that also relies on communicable codes to express its meaning. Art historians have traditionally read these codes (iconography) as neutral markers, believing that if only they plumbed far enough, they would arrive at the "truth" (iconology). Gombrich, for

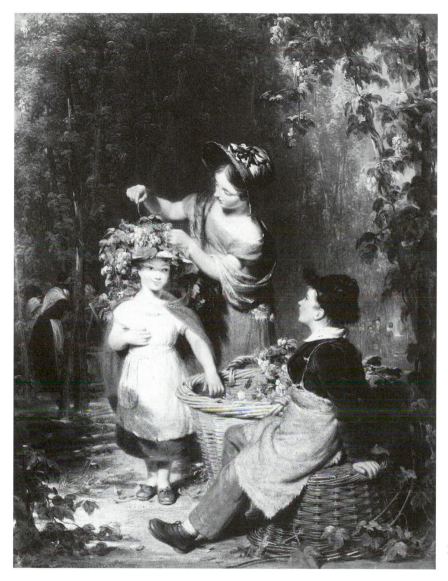

Plate 11. William Witherington,
The Hop Garden, 1834, oil on panel

instance, contends that "All art is 'image-making' and all image-making is rooted in the creation of substitutes."[163] Literary historians, however, have long recognized that mimesis can be inherently contradictory and that meaning is often multilayered. Novelists such as Dickens, Thackeray, and Trollope routinely maneuvered narrativity in ways that both endorsed and critiqued Victorian values. By the same token, Victorian painting should not be taken at face value, nor should it automatically be assumed to reflect

63

principles of domination and control. It must also be examined for indications of resistance to authority. In the case of *The Hop Garden*, since these codes are not present in the canvas itself, one must look outside of art to the history of child labor. Even at that, this representation is not a bitter invective of social practices, or a satirical exposé in the manner of Hogarth. Its mildness is typical of early-Victorian critiques which were content with drawing attention to social disorders or behavioral quirks without attacking actual sources of authority which were still considered to be ultimately benign in the years of optimism immediately following the passage of the Reform Bill.

That Sheepshanks viewed his art in this dialectical manner, is demonstrated by the language he chose to describe his pictures to the Prime Minister, Lord Palmerston, when he ushered him through his private gallery in 1856. Redgrave, who was present that day, recorded a conversation which wandered from the anecdotal to the parodic. Sheepshanks noted, for instance, that Mulready's *The Wolf and the Lamb* was a great favorite with George IV, who dripped candle wax on it, and that Lady Fanny Cowper had sat for Anne Page in Leslie's *Dinner at Page's House*, while Mulready himself was one of the models for Wilkie's *Duncan Gray*.[164] Determined to enthrall his distinguished visitor, Sheepshanks's tone became more boisterous as he progressed through his gallery. When the collector and the Prime Minister reached George Clint's *Portrait of Miss Glover as Ophelia*, Sheepshanks "told a story of George the Third, when partially insane, falling in love with Miss Glover; of a consultation of physicians on the subject; and that when Queen Charlotte offered herself as a substitute, dressed up as Miss Glover, the old King cried out, ''Tis Charlotte; take her away, take her away'" (p. 170). By the time the pair reached Francis Danby's *Disappointed Love*, the tone of their dialogue was even more raucous. After Palmerston commented on the ugliness of the model, Sheepshanks agreed, adding that her death by drowning would be no loss, and then went on to substantiate his opinion by reciting a callous story about a judge who had refused to remit a woman's sentence because she was ugly (pp. 170–71). Striking our ears today as crude, remarks such as these were not as uncommon in the middle of the nineteenth century: Charles Dickens immediately comes to mind as someone who also indulged in cruel humor and vulgar vignettes.

Sheepshanks's burlesque performance, then, can be viewed as a parody of the earnest Victorian desire to explicate and understand voiced by Ruskin and Thackeray. But because Sheepshanks's words were spoken

rather than written, he was allowed even greater license: he could draw on the lower stratum of oral culture that was historically conditioned to jeer at pretentiousness. Sheepshanks's declassé proclivities granted him more exposure than most other art collectors to non-élite subcultures which thrived on ridiculing snobbish standards and behavior. His determination to regale Lord Palmerston with droll stories was similar to the ironic impulse Bakhtin describes in relation to the underclass's participation in carnival: their laughter mocks the values and hypocrisy of officialdom.[165] From this perspective, Sheepshanks's anecdotes were slurs directed at the governing social and cultural order – the buffoon-king, the addlepated queen, and the defective lover. The fact that Lord Palmerston, as the representative of that order, joined in the sport indicates that there was an open season on paintings in the early-Victorian period that, like the oral tradition, permitted a variety of readings instead of a single ideological interpretation. Despite his political position and title, Palmerston adopted the subject position of the rowdy commoner when he joined Sheepshanks in his game of ridicule, proving Bakhtin's contention that language often is used to subvert the dominant discourse.[166] As a visual text, early-Victorian painting invited a spirited, open critique of prevailing practices and pretensions without the expectation of closure.

An urban Victorian equivalent of the carnival took place annually at the race track. Derby day was one of the most popular sporting events of the year, drawing crowds from all over England to Epsom Downs. That it was an occasion for working-class participation is recorded by artist Ben Marshall, who noted that everyone came, "from the Cockney behind his counter, down to the cellerman at Hatchett's."[167] An even wider spectrum of humanity was captured on a large canvas commissioned by pharmacist Jacob Bell from William Frith, in 1856–58, titled *Derby Day* (plate 12). Ragged beggars compete for attention with gypsy fortune tellers and gamblers of various persuasions, from thimble riggers to racing touts. Just as Goya's festival scenes focus on peasants whose irrational behavior mirrors and magnifies the most undesirable characteristics of their betters, so Frith's characters censure the upper classes. He directs the viewer's eye to the elegantly attired central group through a series of visual directives on the frontal plane: the foreshortened red lobster, the elongated arm of the top-hatted dandy, and the counterclockwise orientation of the rear wheel of the first carriage. The shimmering highlights on the intricate gowns and jackets of the wealthy racegoers entice the spectator's eye further into the canvas

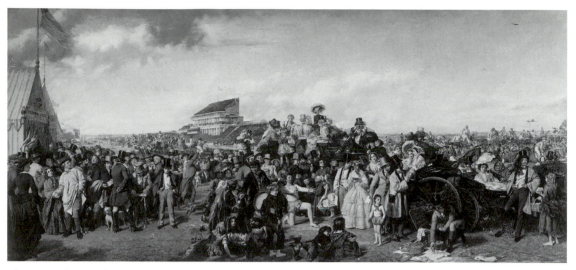

Plate 12. William Frith,
The Derby Day, 1856–58,
oil on canvas

along the angled plane of the carriages until it reaches the site of corruption at the center of the composition where the russet-haired gent standing in the second carriage pours a glass of champagne for a child who is precariously perched on stilts. Frith contrasts this vignette of upper-class debauchery with the stalwart values of the only two other figures he garbs in white in the central sector of the canvas: the acrobat and his young son. While the father has brought his child to Derby day to teach him how to earn an honest day's wage in exchange for his talents, the son is distracted by the discovery of luxuries which so surpass his meager level of existence that he cannot take his eye from them, despite his father's pleas. Frith thus turns the carnivalesque atmosphere of Derby day into an occasion for somber reflection on the comparative importance of riches and necessity, leisure and work, dissipation and integrity.

Frith expects these comparisons to be drawn by the middle-class subject who is conspicuously absent from his composition. Situated symbolically between the rowdy working-class crowd and the upper-class dissolutes, this viewer is left to complete the reading of the picture from a position of power located outside the canvas. It is this absent actor who possesses what Foucault terms the "sovereign gaze" that decodes and processes visual references.[168] Aesthetic perception, then, was invoked as a means of legitimating bourgeois social norms.

It was the spectacle, or what Frith preferred to call the "kaleidoscope aspect of the crowd," that made his painting one of the most popular

ever to be exhibited at the Royal Academy: a rail had to be erected to protect it, a precaution taken only once before in the history of the Academy for Wilkie's patriotic *Chelsea Pensioners* in 1822.[169] *Derby Day* owed its popularity not only to the way it empowered the middle-class viewer, but also to its irreverent carnivalesque inversion which invited multiple, even contradictory readings. The lower classes could vicariously relish the amusements offered for their delectation and chuckle over the misbehavior of the rich, while the sanctimonious could be satisfied that social impropriety had been exposed, and the lords of the land could either snicker or sneer at the outlandish antics of their kin. The painting's decentered narrative left it open to a series of oppositional interpretations.

Owner Jacob Bell, however, was quick to defend the painting against charges that it celebrated low-life characters. In a catalogue he wrote when he exhibited the cream of his collection at the Marylebone Literary and Scientific Institution in 1859, just months before his early death at the age of forty-nine, Bell insisted:

> Those especially, who at one time objected to what they considered to be the exhibition of vice in too attractive a form, were obliged to admit that the picture "points a moral" as well as "adorns a tale" . . . on reading the subject attentively there is much matter for serious thought and rather melancholy reflection.[170]

Consistent with the proselytizing role he played as president of the Pharmaceutical Society, Bell maintained that art had a pedagogical function: it must rise above anecdotal interest and be instructive. One detects the vestiges of his former Quakerism in these remarks which link Bell to the swelling moral current in Victorian art appreciation.

Ruskin, however, avoided a discussion of *Derby Day*'s moral implications, remarking instead that he found it "quite proper and desirable that this English carnival scene should be painted."[171] His concern was that Frith's "popular manner of painting" encouraged mere illustration rather than flights of the imagination. In daring to depict a subject from daily life on a large-scale canvas that had traditionally been the exclusive preserve of history painters, Frith confused his critics. That their reaction to his break with tradition was not more hostile was largely due to the widespread positive reaction to the narrative paintings in the Vernon and Sheepshanks collections.

Redgrave, as custodian of the Sheepshanks collection, appointed himself the daunting task of winning acceptance for genre painting as high

art. His 1857 introduction to the catalogue of the Sheepshanks Gift is an apologia for early-Victorian narrative art. Redgrave's strategy is to focus on the instructive content of genre painting and to insist that this feature ranks it in a category that approximates history painting. He argues: "The subjects of British artists ...if they are below what is usually classed as historic art, almost always appeal to the higher sentiments, and embody the deep feelings and affections of mankind."[172] Redgrave maintains that while this strain runs through all narrative painting, it is particularly evident in scenes taken from literary sources.

Literary genre was a major category in Sheepshanks's collection: his gift consisted of fifty-two subjects from novels, plays, and poems in contrast to Vernon's ten. It only stands to reason that Sheepshanks, given his pleasure in storytelling, would be attracted to pictures that illustrated familiar scenes from fiction. Richard Altick ties the vogue for literary subjects to middle-class reading habits and the advent of cheap editions of novels and plays. He notes that, "Paintings from literature reached the height of their popularity between 1830 and the 1850s, when as many as one hundred such paintings were hung each year in the London exhibitions alone."[173] Even so, in his attempt to prove the democratic appeal of genre painting, Redgrave argues that it was not necessary to be familiar with literary sources in order to appreciate this branch of art. He cites as an example a painting in the Sheepshanks collection by Leslie, *The Dinner at Page's House* from Shakespeare's *Merry Wives of Windsor*. He states that because Leslie, in this work, has entered "fully into the poet's mind ...The multitude are thoroughly able to enter into [it] and appreciate" it – even more so than if they had seen the play – claiming, "it has been found by experience that men apprehend more easily by the eye than by the ear, that pictures are to them greater realities than are words."[174] In an age lacking compulsory schooling, educators such as Redgrave counted on visual imagery to fulfill a useful social function.

The "use" value of early-Victorian painting was an important element in its consumption. Art, at this stage of middle-class cultural development, had not yet become a gratuitous aestheticized object. Narrative paintings in particular were viewed as inspirational and entertaining social texts that lent credibility to the spectator's own experiences.

Because accessibility or "utility" was rated higher on the scale of art appreciation than aesthetics, collectors had no objection to purchasing copies of popular paintings. The middle-class businessman who missed his

chance at the London exhibitions routinely ordered a full-scale oil replica from the artist. William Frith frankly disclosed, in 1842, that "all the best artists" repeated their "best pictures to a great extent, as it is not considered to injure the original at all."[175] As the artist suggests, collectors did not object to artists copying their own works, particularly since it was they who had created the demand.

Simmel's insight into the phenomenon of replication is instructive, since he formulated his observations at the turn of the century, at a time when aestheticism was in the ascendant. He noted:

> In those cases that offer realistic pleasure, our appreciation of the object is not specifically aesthetic, but practical … So long as objects are merely useful they are interchangeable and everything can be replaced by anything else that performs the same service. But when they are beautiful they have a unique individual existence and the value of one cannot be replaced by another.[176]

Although Simmel did not address his remarks to the practice of copymaking, the distinction he draws between the objective and subjective functions of art accounts for the replica's prominence throughout the nineteenth century.

Valuing meaning over artistry, the early Victorians became eager collectors of the copy. This widespread practice accounts for the appearance of identical paintings in the collections given to the nation by Vernon, Sheepshanks, and Bell.[177] Each contains a version of C. R. Leslie's *My Uncle Toby and the Widow Wadman* (plate 13, figs. 1–3), a painting based on the scene in Laurence Sterne's *Tristram Shandy* in which the widow Wadman coquettishly claims to have an irritant in her eye in order to entice Toby to come nearer to her. Additional versions were owned by London collectors George Knott and Mrs. George Haldiman.[178] These private collectors were not alone in their enthusiasm for this particular painting: it so fired the early-Victorian imagination that it was reproduced in countless engravings and on the lid of a hair ointment called Russian Bear's Grease, no doubt because of the luxuriant locks Leslie bestowed upon Uncle Toby.[179] The commodification of this image, however, did not deter collectors from wanting to possess their own fine-art version.

Conditioned by the premium placed on originality by the twentieth-century art market, it is difficult for us to comprehend why a Victorian collector would pay full price for a copy. People living at the beginning of the

69

Plate 13.

Fig. 1 Charles R. Leslie, *My Uncle Toby and the Widow Wadman,* 1831, oil on canvas, Vernon collection

Fig. 2 Charles R. Leslie, *My Uncle Toby and the Widow Wadman,* 1832, oil on canvas, Sheepshanks collection

Fig. 3 Charles R. Leslie, *My Uncle Toby and the Widow Wadman,* 1842, oil on canvas, Bell collection

nineteenth century, however, were not as bedeviled as we are today by the search for newness and change. Repetition, in the early phase of industrial development, carried a certain rhythmic satisfaction with it, recalling the oral tradition's telling and retelling of stories. The same pleasurable sense of continuity was derived from reading and rereading novels. Because reiteration is an instrumental feature of any narrative form, it follows that paintings based on literature would be particularly prone to duplication. But what of those replicas that were made of purely imaginative paintings, such as *The Hop Garden*, which appear in both Vernon's and Sheepshanks's collections? To understand why collectors who could afford to buy whatever they wished would settle for an imitation, we must probe even more deeply into the Victorian social structure.

After the strife with France and the intervention of industrialization in daily life, predictability was prized over disruption. Therefore representations that confirmed expectations and perceptions were valued as reassuring demonstrations of continuance and endurance. By the same rea-

soning, pictures which reiterated these values were not deemed redundant. As Svetlana Alpers argues in regard to seventeenth-century Dutch art, in which copies also proliferated, "it is the world, not the maker or viewer, which has priority."[180] In other words, artists, audiences, and owners were in one sense passive witnesses to the disclosure of "truths" extracted from a larger reality. Far removed from the modern concept of the transcendental artist–genius, the artist whom Alpers describes is a facilitator. Because this painter looks outward toward the world, intent on imitating phenomenological conditions, Alpers traces a relationship between mimesis and the practice of replication and repetition, observing that "multiples are the normal condition of Dutch pictures." Like Holland, England was also bourgeois, Protestant, and mercantile. In both countries the desire to record and map novelties in the social sphere was grounded in confidence in the unimpeded development of material and spiritual progress. The copy, then, was a sign that signified both of these values: worldly wealth and faith in the future.

Replication could only flourish in a climate which nourished this unwavering belief in the march of progress. The capitalist system of mechanization and standardization had not yet transformed the replica into what Barthes terms "secondary mimesis," which was to occur at the end of the century when faith in the correspondence between the image and the world was shattered.[181] Once that analogue ceased to exist as a system of signs that could be relied on, the iconic fidelity of images was called into question and originals as well as their replicas began to be mistrustfully perceived as copies in a dubious tradition of copies. But in the early-Victorian years, originals and their mirror images were still believed to be truthful representations of causal relationships in the continuum. Foucault argues that, in the premodern world, "it was resemblance that largely guided exegesis and the interpretation of texts; it was resemblance that organized the play of symbols, made possible knowledge of things visible and invisible, and controlled the art of representing them."[182] That resemblance was grounded in a belief in the great chain of Being that persisted, uninterrupted, well into the Victorian period. Elaborating on Foucault's argument, Baudrillard draws an analogy between representation and pictorial replication. He states: "In a world that is the reflection of an order (that of God, of Nature or, more simply, of discourse) in which all things are representation, endowed with meaning and transparent to the language that describes them . . . all copies … are justified as the multiplied reflection of an order whose original is in any case transcendent."[183]

English art practice verified this affirmative attitude. As disparate as their views were on other matters, both Reynolds and Blake condoned copying; Reynolds, because of his belief in the existence of idealized general forms and Blake, because of a more spiritual notion of "Eternal Forms."[184] Their endorsement, however, was primarily pedagogical: copying or imitating was an essential part of the artist's education. Walter Benjamin notes that, prior to the age of mechanical reproduction, "Replicas were made by pupils in practice of their craft, by masters for diffusing their works, and, finally, by third parties in the pursuit of gain."[185] All three categories were operative in the early-Victorian practice of replication. Art students frequently copied paintings in public collections in order to perfect their techniques, while established artists, as Frith attested, routinely replicated their own originals. The early Victorians were also responsible for introducing Benjamin's third category of profiteering when they initiated the lithographic and photographic reproduction processes which were to challenge

the "aura" of the original work of art. Not yet cognizant of the implications of their ingenuity, they guilessly fostered an industry of replication.

In drawing attention to the public preference for utility over artistry, I am not suggesting that the art audience was totally indifferent to the aesthetic merits of the copy. Leslie's versions of *Uncle Toby and the Widow Wadman* were closely scrutinized by critics such as Dr. Waagen and Tom Taylor. Waagen argued that Leslie's rendition of the figure of Mrs. Wadman was coarser in the Vernon original (fig. 1) than in Sheepshanks's "more refined" replica (fig. 2).[186] Taylor also preferred Sheepshanks's copy, which he claimed was "the most vigorous in colour and the most perfect in expression," despite the fact that "Uncle Toby's hands are too delicate for the rest of his figure."[187] The artist himself, however, considered Jacob Bell's version (fig. 3) his best effort. Painted in 1842, eleven years after Vernon's original, Leslie took advantage of the opportunity to correct any parts he felt needed improvement. While Leslie's alterations technically remove Bell's canvas from the category of the duplicate, his changes were not significant enough to make it a fresh work of art.[188] Instead of challenging the aura of the original, his copies were intended to share it. The fact that Bell himself was a trained artist may have impelled the painter to strive for a higher artistic standard. Among Jacob Bell's papers is a letter from Leslie written in 1849, asking the patron if he could copy his replica of *Uncle Toby*, yet again, explaining: "I wish it for the National Gallery in place of that given by Mr. Vernon."[189] There is no record of such a substitution having been made, but Leslie's assessment of his own work conveys the impression that aesthetics played a greater role in Bell's collection than in Vernon's or Sheepshanks's.

From deep within, the framework of Bell's philanthropy and pedagogy was indeed buttressed by the aesthetic appreciation of works of art he had cultivated while a student at Sass's Academy. He differs from Vernon and Sheepshanks because he was able to look at the paintings in his collection through two lenses: the instructive and the pictorial. For instance, simultaneous with his claim for a moral reading of *Derby Day*, Bell defended its overall visual effect – what he called, its "unity, harmony, breadth, and other conventionalities of the pictorial art" (p. 6). Bell repeats this pattern in his discussion of several other paintings in his 1859 exhibition catalogue, such as Landseer's *The Defeat of Comus*, in which he praises the artist's "usual vigour of execution" (p. 10). And in connection with another Landseer, *The Dead Warrior*, Bell takes the time to notice that the "expression and tone of colour are surprising." Jacob Bell's artistic background made him conscious

of the intricacies of formal properties such as brushwork, color, and composition. While the paintings in his collection came from the same general storehouse of pictorial wares as Sheepshanks's and Vernon's, his sensitivity to both word and image added another dimension to his appreciation of them.

Bell was not alone among early-Victorian collectors in possessing an aesthetic sensibility. Even though the average businessman waited for art to speak to him in a literal sense, a number of patrons had some training in the arts, either due to their vocations like Brunel and architect John Soane, or because of an avocational interest in sketching such as that demonstrated by John Hornby Maw, the surgical instrument manufacturer.[190] He received the ultimate accolade from artist Samuel Prout, who told him: "You can talk with drawings as with the artist, disentangling all the science & process, making the whole your own."[191] This affinity to art practice among collectors lessens as the century unfolds. As we shall see, there are a number of reasons for the separation of personal skills from collecting, most notably the escalating price of the art object.

At least that was the situation in London, where the sheer size of the city contributed to the depersonalization of the art market. The industrial towns in the North, however, were closer-knit communities and, as a result, economic practices, religious attitudes, and local customs impinged more directly on the middle class's relationship with art. In Birmingham and Manchester, for instance, civic pride was championed as an antidote to gentrification. While art appreciation was nevertheless prized by Birmingham's patrons, in Manchester it took second place to the local businessmen's sense of responsibility toward the public. Their crowning achievement was the Manchester Art Treasures exhibition of 1857 which, occurring the same year that Sheepshanks presented his collection to the nation, unequivocally announced the middle class's intervention in the cultural sphere.

Notes

1 The prosperity engendered by the Napoleonic Wars is discussed in H. M. Hyndman, *Commercial Crises of the Nineteenth Century* (London: 1892; rpt. New York: l967), pp. 18–26, and Phyllis Deane and W. A. Cole, *British Economic Growth 1688–1959* (Cambridge: 1962), p. 164.

2 James Clifford, *The Predicament of Culture: Twentieth-Century Ethnography, Literature, and Art* (Cambridge, Mass.: 1988), p. 234.

3 Wilkie Collins, *Memoirs of the Life of William Collins RA*, 2 vols. (London: 1848), I, 345. For an overview, see J. F. C. Harrison, *The Early Victorians, 1832–1851* (London: 1971).

4 A. Paul Oppé, "Art," in *Early Victorian England, 1830–1865*, ed. G. M. Young, 2 vols. (London: 1934), II, 115. Another modern scholar who treats early-Victorian collectors generically is Gerald Reitlinger, who, in his *Economics of Taste* (New York: 1961), describes Sheepshanks, Vernon, Bicknell, and Windus as "wholesale merchants" (p. 89).

5 When Wells retired to Redleaf in 1811, he was already well known in the area. He was raised at nearby Cainster House, Chislehurst, an estate which his father had inherited from cousins who had lived there since *c.* 1700. I am grateful to Andrew Wells for providing this information. Moreover Wells was married to Mary Hughes, a wealthy member of the local gentry. See John Burke, *A Genealogical and Heraldic History of the Commoners of Great Britain and Ireland*, 4 vols. (London: 1836), III, 87. Joseph Farington recorded that when he visited Wells in 1811, they were entertained on several neighboring estates by both gentry and aristocracy. See *The Farington Diary*, ed. James Grieg, 8 vols. (London: 1952), VII, 46. The daily routine that Farington describes at Redleaf (VII, 41) remarkably matches that of the typical landed aristocrat outlined by F. M. L. Thompson in *English Landed Society in the Nineteenth Century* (London and Toronto: 1963), p. 95. The Wells family's commercial development is described in Henry Green and Robert Wigram, *Chronicles of Blackwall Yard* (London: 1881), pp. 37–40 and 45–48, and in P. Banbury, *Shipbuilders of the Thames and Medway* (London: 1971), pp. 139–41.

6 A sample of Godfrey's pills manufactured by Windus is preserved in the Pharmaceutical Society of Great Britain. In reply to my inquiry about the purpose of these pills, Ms. Kate Arnold-Forster, Museum Officer, wrote on 23 January 1987: "I have not been able to find any evidence of Godfrey's pills being used for specific ailments and as its packaging makes no particular claims for the conditions it cures, I think it would be fair to say that it was used as a 'general fever remedy, purgative or pain-killer.'" Windus was nicknamed "Godfrey's Cordial" by Ford Madox Brown; see *The Diary of Ford Madox Brown*, ed. Virginia Surtees (New Haven and London: 1981), p. 125. For biographical information on Windus, see W. Robinson, *The History and Antiquities of Tottenham*, 2 vols. (London: 1840), I, 83; *Pigot's London Directory* (1827, 1834, and 1839); and the 1851 Census Return, London Public Record Office.

7 Bicknell's background is discussed in A. S. Bicknell, *Five Pedigrees* (London: 1912), the *DNB*, and in an article co-authored by his great-grandson Peter Bicknell and Helen

Guiterman, "The Turner Collector: Elhanan Bicknell," *Turner Studies* 7 (1987), 34–44. I wish to thank the authors for making their manuscript available to me prior to publication and for answering my questions.

8 For Jacob Bell see *DNB*; Leslie G. Matthews, "Statesman of Pharmacy, Jacob Bell 1810–1859," *The Chemist and Druggist* (6 June 1959), 610–16; G. E. Trease, "Jacob Bell (1810–1859)," *Pharmaceutical Practice* 1 (Nov./Dec. 1979), 26–28; and Juanita Burnby, "The Family History of Jacob Bell," *The Pharmaceutical Journal* 230 (21 May 1983), 582–84.

9 The *DNB* repeats Vernon's claim to a humble background. See "Account of Furniture Sold at Auction on the Premises of Mr. Vernon, Hall Gate, Doncaster on Monday, October 12, 1812 and the three following days," Jenkyns Papers (Box II), Balliol College, Oxford. I am indebted to Doncaster Archivist Dr. Brian Barber for consulting the parish records, water rate book and land tax records for me. Dr. Barber informed me in a letter of 16 September 1986, that "Hallgate was one of the principal streets of the town and still possesses a number of substantial Georgian town houses." For the Vernon family in London, see Robin Hamlyn, *Robert Vernon's Gift* (London: Tate Gallery, 1993).

10 Homi Bhabha, "The Other Question: The Stereotype and Colonial Discourse," *Screen* 24 (1983), 27.

11 See Roger Chartier's discussion of Febvre in "Intellectual History or Sociocultural History," in *Modern European Intellectual History: Reappraisals and New Perspectives*, ed. Dominick LaCapra and Steven L. Kaplan (Ithaca: 1982), p. 22.

12 Waagen, a Van Eyck scholar, was more interested in aristocratic collections of Old Masters than in middle-class galleries of modern art. In London, for instance, he ignored the important works of art owned by John Allnutt, Jacob Bell, Isambard Kingdom Brunel, Charles Huth, and William Joyce. Even his staunch supporter Lady Eastlake alluded to his sketchy treatment of collections of living artists when, in her review of his *Treasures of Art*, she noted: "The time will come when we shall hear where all the Mulreadys, Stanfields, and Landseers are dispersed" (*The Quarterly Review* 94 [1854], 508).

13 The early-Victorian collections described either by Waagen or the *Art Journal* belonged to Elhanan Bicknell, Charles F. Huth, William Joyce, J. H. Mann, William Marshall, James Morrison, Sarah Rogers, Samuel Rogers, John Soane, John Sheepshanks, Robert Vernon, William Wells, Benjamin Godfrey Windus, and George Young.

14 These thirteen additional collectors are John Allnutt, Jacob Bell, William Broderip, Isambard Kingdom Brunel, Samuel Cartwright, Samuel Dobree, Alexander Dyce, William Stone Ellis, John Forster, Mrs. George Haldiman, George Knott, John Hornby Maw, and J. J. Ruskin.

15 Among those familiar patrons I have excluded are William Beckford, who was a vastly rich member of the gentry, and Dr. Thomas Monro, who formed the greater part of his collection before the 1830s (see Andrew Wilton, "The 'Monro School' Question: Some Answers," *Turner Studies* 4 [1984], 8–23). On the other hand, I have used Waagen as my guide in including William Marshall of Leeds in my

group of London collectors, since he discloses that the gems of Marshall's collection were located in his home in Eaton Square.

16 Although Townshend (1798–1868) bequeathed one hundred nineteenth-century oils and 174 watercolors to the South Kensington Museum, he was "very much a dilettante in the eighteenth-century sense." See Ronald Parkinson, *Catalogue of British Oil Paintings 1820–1860* (London: Victoria and Albert Museum, 1990), p. xix. Parkinson also cites Bulwer-Lytton's encapsulation of Townshend's life as "elegant rest, travel, lots of money." See also *DNB* and Waagen (1857), pp. 176–81. For Beaumont (1753–1827), see *'Noble and Patriotic': The Beaumont Gift 1828* (London: National Gallery, 1988). Leicester (1762–1827) is discussed at length by Douglas Hall in "The Tabley House Papers," *The Walpole Society* 38 (1960–62), 59–122, and more recently by Selby Whittingham, "A Most Liberal Patron: Sir John Fleming Leicester, Bart., 1st Baron de Tabley, 1762–1827," *Turner Studies* 6 (1986), 24–36.

17 Wells's name was commonly grouped with those of Bicknell, Sheepshanks, and Vernon by Victorian commentators as one of the four major collectors of modern art. See the *Athenaeum* (7 December 1861); *Star* (28 April 1863); and Vernon Heath, *Recollections* (London: 1892), p. 3.

18 The social backgrounds of Samuel Dobree, William Ellis, William Joyce, George Knott, J. H. Mann, and George Young are unknown.

19 Dorothy Stroud, in *Sir John Soane, Architect* (London: 1984), identifies Soane's father's occupation (p. 17). Anna Jameson is one of

the Victorian scholars who claimed he was a bricklayer, in her *A Handbook to the Public Galleries of Art in and near London*, 2 vols. (London: 1842), II, 545.

20 François Crouzet, *The First Industrialists: The Problem of Origins* (Cambridge: 1985), p. 48.

21 See W. D. Rubinstein, "Wealth, Elites and the Class Structure of Modern Britain," *Past and Present* 76 (Aug. 1977), 106, and Richard Gatty, *Portrait of a Merchant Prince: James Morrison 1789–1857* (Northallerton, Yorkshire: 1977).

22 For the amount of J. J. Ruskin's estate see the entry for John Ruskin in *DNB*.

23 Crouzet, *First Industrialists*, p. 44.

24 See K. C. Phillipps, *Language and Class in Victorian England* (Oxford: 1984).

25 William Makepeace Thackeray, *The Newcomes*, 2 vols. (London: 1855), ch. 7, p. 66.

26 Robin Gilmour, *The Idea of a Gentleman in the Victorian Novel* (London: 1981), p. 5. See also R. J. Morris, *Class and Class Consciousness in the Industrial Revolution 1780–1850* (London: 1979) and Leonore Davidoff, *The Best Circles: Society Etiquette and the Season* (London: 1973).

27 See Gatty, *James Morrison*, pp. 112 and 147–50.

28 Heath, *Recollections*, pp. 24–25 and *passim*, and *Recollections of a Royal Academician by John Callcott Horsley, RA*, ed. Mrs. Edmund Helps (London and New York: 1903), p. 60.

29 For an overview of Jones's career see Joany Hichberger, "Captain Jones of the Royal Academy," *Turner Studies* 3 (1983), 14–20.

30 Stroud, *Soane*, p. 54.

31 J. J. Ruskin to Margaret Ruskin, 27 April 1839 and 2 May 1838, *The Ruskin Family Letters*, ed. Van Akin Bird, 2 vols. (Ithaca: 1973), II, 606 and 518.

32 See *DNB* and Stephen Deuchar, *Painting, Politics and Porter: Samuel Whitbread II (1764–1815) and British Art* (London: Whitbread and Museum of London, 1984).

33 Deuchar, "Introduction," *Whitbread*, note 34.

34 Bird, *Ruskin Family Letters*, II, 518.

35 Wilkie Collins, *A Rogue's Life* (first pub. in *Household Words* [1856], rpt. London: 1879), ch. 5, p. 51.

36 See *DNB* and Samuel Rogers, *Recollections* (London: 1859), pp. xi–xv.

37 Waagen (1854), II, 266, and Anna Jameson, *Private Picture Galleries* (London: 1844), p. 412.

38 *The Choice Cabinet of Water-Colour Drawings, Pictures, Engravings, Books, Enamels, etc., The Property of Mrs. Haldiman, Deceased*, Christie, Manson, and Woods, 2 June 1861, London, lot 80. For Thomas Uwins's part in this project, see Sarah Uwins, *A Memoir of Thomas Uwins, RA*, 2 vols. (London: 1858), I, 184, 192, and II, 48, 57, 101.

39 See Leonore Davidoff and Catherine Hall, "The Architecture of Public and Private Life," in *The Pursuit of Urban History*, ed. Derek Fraser and Anthony Sutcliffe (London: 1983), p. 328.

40 Lincoln Record Society, *Bibliography of Printed Items Relating to the City of Lincoln* (1990), 1012 and 1032. See also F. M. Redgrave, *Richard Redgrave: A Memoir Compiled from his Diary* (London: 1891), p. 231.

41 Mary Wollstonecraft, *A Vindication of the Rights of Women* (1792), ed. Carol Poston (New York: 1975), p. 54.

42 See Anne Higonnet, "Secluded Vision: Images of Feminine Experience in Nineteenth-Century Europe," *Radical History Review* 38 (1987), 16–36.

43 J. J. Ruskin describes to his wife the art exhibitions she has missed and the purchases he has made in her absence in Bird, *Ruskin Family Letters*, II, 464ff.

44 Joyce's occupation is listed as "lighterman" in the Census Reports of 1851, 1861, and 1871 and as "waterman" in the London *Post Office Directory* for 1855. The nature of this employment is described by Celia Davies in "Skilled Boatmen of the Thames, The Company of Watermen and Lightermen," *Country Life* (14 Nov. 1974), 1488–89. I am grateful to Mrs. Ruth Schmidt of the Lambeth Archives Department for bringing this material to my attention.

45 Odina Fachel Leal, "Popular Taste and Erudite Repertoire: The Place and Space of Television in Brazil," *Cultural Studies* 4 (1990), 25.

46 See Quentin Bell, *The Schools of Design* (London: 1964), and Lyndel Saunders King, *The Industrialization of Taste: Victorian England and the Art Union of London* (Ann Arbor, Mich.: 1985).

47 For the *Art Union* and *Art Journal*, see S. C. Hall, *Retrospect of a Long Life from 1815 to 1883* (New York: 1883), pp. 194–209; *The Art Journal: A Short History* (London: 1906); and Jeremy Maas, "S. C. Hall and the *Art Journal*," *Connoisseur* 191 (March 1976), 206–9.

48 Lord Brougham, cited in Harold Perkin, *Origins of Modern English Society* (London: 1969; rpt. 1985), p. 230.

49 Two scholars who emphasize the trend-setting role played by the aristocracy in the collecting of modern art are Francis Haskell in *The Treasure Houses of Britain: Five Hundred Years of Private Patronage and Art Collecting*, ed. Gervase Jackson-Stops

(New Haven and London: 1985), p. 54, and Edward Morris in "John Naylor and other Collectors of Modern Paintings in Nineteenth-Century Britain," *Annual Report and Bulletin*, Walker Art Gallery, Liverpool, 5 (1974–75), 74–75.

50 Summaries of the history of aristocratic patronage in England prior to the nineteenth century can be found in Horace Walpole, *Anecdotes of Painting in England*, 4 vols. (London: 1765–71); (T. H. Lister), "Review of Allan Cunningham, *Lives of the Most Eminent British Painters, Sculptors, and Architects*," *Edinburgh Review* 59 (April 1834), 53–64; John Pye, *Patronage of British Art, an Historical Sketch* (London: 1845); Ellis Waterhouse, *Painting in Britain 1530 to 1790* (Harmondsworth, Middlesex: 1953); and Michael Foss, *The Age of Patronage: The Arts in England, 1660–1750* (Ithaca: 1971).

51 Louise Lippincott, *Selling Art in Georgian London: The Rise of Arthur Pond* (New Haven: 1983), p. 56.

52 Collins, *A Rogue's Life*, ch. 5, pp. 48–49.

53 David Wilkie cited by Anna Jameson, *Companion to the Most Celebrated Private Galleries of Art in London* (London: 1844), p. xxxv.

54 See Waagen (1854), I, 413–14.

55 Letter from J. C. Horsley to W. Longsdon, 5 September 1872, published in the *Art Journal* (Oct. 1872), 265.

56 See Waagen (1854), pp. 301–4.

57 Uwins to Joshua Severn, 5 June 1832, in Uwins, *Uwins*, II, 261.

58 See Collins, *Collins*, II, 347–52 and Wolverhampton Art Gallery, *William Henry Hunt 1790–1864* (Wolverhampton: 1981), p. 17.

59 *The Diary of Benjamin Robert Haydon*, ed.

Willard Bissell Pope, 5 vols. (Cambridge, Mass.: 1963), IV, 632.

60 For Lord Lansdowne, see *Art Union* (Oct. 1846), 274 and (Oct. 1847), 36; Sir John Swinburne (May 1839), 59; and Lord Northwick (Sept. 1846), 251–56 and (Oct. 1846), 271–74.

61 William Carey, *Some Memoirs of the Patronage and Progress of the Fine Arts ... with Anecdotes of Lord de Tabley* (London: 1826), p. 107.

62 Sir John Leicester to William Collins, 6 Dec. 1818, in Wilkie Collins, *Collins*, I, 150.

63 John Constable to C. R. Leslie, "Constable Correspondence III," 8, p. 41.

64 Andrew Hemingway, "The Political Theory of Painting without the Politics" (review of J. Barrell, *Political Theory of Painting*), *Art History* 10 (Sept. 1987), 391. See also Hemingway, "The 'Sociology' of Taste in the Scottish Enlightenment," *Oxford Art Journal* 12 (1989), 3–35.

65 Joseph Farington, 2 May 1814, cited in Peter Fullerton, "Patronage and Pedagogy: The British Institution in the Early Nineteenth Century," *Art History* 5 (March 1982), 64, and *Catalogue of the Works of British Artists placed in the Gallery of the British Institution, Pall Mall* (London: 1811), p. 9, cited *ibid.*, p. 65.

66 *Edinburgh Review* (1834), 65. For the low standing of artists in society, see also Reitlinger, p. 96; King, *Art Union of London*, p. 6; and Marcia Pointon, *William Mulready 1786–1863* (London: 1986), p. 18.

67 *Life and Letters of William Bewick*, ed. Thomas Landseer, 2 vols. (London: 1871), II, 170.

68 N. Neal Solly, *Memoir of the Life of David Cox* (London: 1873), p. 85.

69 Thackeray, *Newcomes*, ch. 36, II, 322.

70 Richard Ormond, *Sir Edwin Landseer* (Philadelphia and London: 1981), pp. 9–10.

71 J. Horsley to W. Longsdon, *Art Journal* (Oct. 1872), 265.

72 Sir George Beaumont to David Wilkie, 15 June 1806, in Allan Cunningham, *The Life of Sir David Wilkie*, 3 vols. (London: 1843), I, 118.

73 Wilkie to Beaumont, 20 Aug. 1806, *ibid.*, I, 120.

74 Cunningham, *Wilkie*, II, 64. On this picture, see Leslie Errington, *Tribute to Wilkie* (Edinburgh: National Galleries of Scotland, 1986), pp. 40–42.

75 For George Young see appendix.

76 Tom Taylor, *Autobiographical Recollections by the Late Charles Robert Leslie, RA*, 2 vols. (London: 1860), I, 234.

77 Undated letter from Edwin Landseer to Jacob Bell, Jacob Bell Correspondence, Royal Institution, London. For the complicated saga of this commission, see Jenkyns Papers, Box II, Balliol College, Oxford, and Ormond, *Landseer*, pp. 196–97. *Recollections of Horsley*, ed. Helps, p. 58. Horsley is reporting Daniel Maclise's assessment of Vernon.

78 Horsley, *ibid.*, p. 60.

79 See *Art Union* (Sept. 1848), 287.

80 Vernon's use of intermediaries is disclosed in his "Inventory," Jenkyns Papers, Box II, Balliol College, Oxford. His unpublished correspondence also discloses that George Jones contacted the Chalon brothers and Shee on Vernon's behalf, recommended John Linnell to his attention, and negotiated with Wilkie on his behalf. See also Cunningham, *Wilkie*, III, 90–93. Jones also claimed he directed Vernon to Turner. See George Jones, "Recollections of J. M.

W. Turner," in *Collected Correspondence of J. M. W. Turner*, ed. John Gage (Oxford: 1980), p. 5.

81 For Mrs. Haldiman, see Uwins, *Uwins*, II, 48, and Michael Clarke, *The Tempting Prospect: A Social History of English Watercolours* (London: 1981), pp. 137–39. Morrison's use of Pickersgill is mentioned by Constable himself. See William Whitley, *Art in England, 1821–1837* (Cambridge: 1930), p. 143. The other early Victorians who relied on artists as agents were Thames transporter William Joyce, who put W. E. Bates, the landscape and marine painter, in charge of his selections (see *Art Journal* [1858], 13); John Allnutt both searched for art on his own and consulted Robson and Papworth in regard to Constable. See "Constable Correspondence II," 6, p. 375.

82 See Hugh Brigstocke, *William Buchanan and the Nineteenth-Century Art Trade* (London: 1982), p. 34.

83 The names of Charles and Louis Huth have recently been associated with the trafficking in works of art. See Evan Firestone and Derek and Timothy Clifford citations in appendix entry for Charles Huth.

84 Allnutt purchased his gallery sometime before 1823 and closed it in 1838. See "Constable Correspondence IV," 10, p. 85.

85 See *Diary of B. R. Haydon*, ed. Pope, II, 441. The painting in question was Haydon's *Macbeth,* which unfortunately belonged to Sir George Beaumont, who obtained an injunction preventing Allnutt from selling it.

86 For Allnutt's ancestry, see *Farington Diary*, ed. Grieg, VI, 95–96. On his private

gallery, see John W. Papworth and Wyatt Papworth, *Museums, Libraries, and Picture Galleries, Public and Private* (London: 1853), pp. 73–74.

87 J. Constable to Maria Constable, "Constable Correspondence II," VI, 400. Constable remained on good terms with Allnutt despite the fact that after buying his *Ploughing Scene*, Allnutt asked John Linnell to repaint the sky and then later requested Constable to make it look more like the sky in a Callcott he owned and also to match it in size. See Malcolm Cormack, *Constable* (Oxford: 1986), pp. 80–84 and plates 75–76.

88 Windus bought Turner's *Dawn of Christianity – the Flight into Egypt* and *Glaucus and Scylla* at the Royal Academy in 1841. He entered both in his sales of 1853 and 1859 at Christie's (see appendix) but did not finally relinquish them until 1862. See Con McCarthy, "Tottenham's Turners," *Ambience* 2 (Spring 1971), 6. Windus sold 159 Wilkie drawings at Christie's on 1–2 June 1842, only two years after William Robinson had declared while visiting his collection, "no money would tempt Mr. Windus to part with" his Wilkies. See William Robinson, *The History and Antiquities of the Parish of Tottenham, in the County of Middlesex*, 2 vols. (London: 1840), I, 85.

89 See *Diary of Ford Madox Brown*, ed. Surtees, p. 125.

90 They are presumably two of Windus's three grandchildren, Mary Windus de Putron, and either Edward William Windus or Godfrey Pierre de Putron, for whom he established trust funds in his will. See "Last Will and Testament of Benjamin Godfrey Windus," proved 31 August 1867, London Public Record Office.

91 John Ruskin, *Praeterita* (1889), *The Complete Works of John Ruskin*, ed. E. T. Cook and Alexander Wedderburn, 39 vols. (London: 1903–12), XXXV, 254.

92 See *Turner Correspondence*, ed. Gage, pp. 211 and 240. On Bicknell's dealings with Hogarth, see Martin Butlin and Evelyn Joll, *The Paintings of J. M. W. Turner*, 2 vols. (New Haven: 1984) I, 72 and 262.

93 Elhanan Bicknell to John Pye, 23 June 1845, MSS: Pye Correspondence, Victoria and Albert Museum Library, 86FF73.

94 On *The Whale Ship*, see Bicknell and Guiterman, "Turner Collector," p. 39. For the amount of money Bicknell spent on his Turners, see Butlin and Joll, *Turner* (1984), I, xx and Reitlinger, pp. 86–87.

95 *Star*, 28 April 1863, in George Redford, *Art Sales: A History of Sales of Pictures and Other Works of Art*, 2 vols. (London: 1888), I, 166.

96 Georg Simmel, *The Philosophy of Money* (1900), transl. T. Bottomore and D. Frisby (London: 1990), p. 307.

97 See Karl Marx, "Commodities: Use-Value and Exchange Value" (1872), *Karl Marx: Selected Writings*, ed. David McLellan (Oxford: 1977), p. 421.

98 Mary Douglas and Baron Isherwood, *The World of Goods* (New York: 1979), p. 60.

99 Charles Levin, "Introduction," in Jean Baudrillard, *For a Critique of the Political Economy of the Sign*, transl. Charles Levin (Telos: 1981), p. 5.

100 Pierre Bourdieu, *Distinction: A Social Critique of the Judgement of Taste*, transl. Richard Nice (Cambridge, Mass.: 1984), *passim*.

101 J. C. Horsley to Isambard Brunel (Junior), February 1870, in Isambard Brunel, *The*

Life of Isambard Kingdom Brunel, Civil Engineer (London: 1870), p. 507. Architect Sir John Soane was also in a profession that demanded an understanding of the principles of design and one which frequently required his involvement in decoration. Similarly, J. H. Mann was in an art-related career – he was an artist's colorman, and therefore presumably had an understanding of the materials he supplied to the artists he patronized.

102 This plate is one of three in Brunel's sketchbooks in the University of Bristol Library detailing his ideas for the display of paintings in his Shakespeare Room. The cryptic notations beside each picture refer to the names of artists he commissioned. In all, eight paintings were completed. They were identified by the *Art Journal* (p. 181), at the time of the sale of Brunel's collection in 1860, as Augustus Egg, *Launce Offering his Dog to Silvia*, Sir Augustus Callcott, *Launce and his Dog*, F. R. Lee, *Jacques and the Stag*, C. R. Leslie, *Henry VIII Discovering himself to Cardinal Wolsey at the Wall*, C. W. Cope, *The Death of King Lear*, Charles Stanfield, *Landscape Scene from Macbeth*, and Sir Edwin Landseer, *Titania*.

103 Horsley to Brunel (Junior), *Life of Brunel*, p. 507.

104 For Davison, see *DNB* and *A New Biographical Dictionary of Cotemporary Public Characters* (London: 1825). His gallery is described in the *Annals of the Fine Arts* I (1817), 242–54. The artists who participated included Wilkie, Northcote, Smirke, Copley, and West.

105 Davison's trial and imprisonment are reported in the *News* (7 Dec. 1808), in *British Biographical Archive*, ed. Paul Sieveking (Michrofiche, London and New York: 1984–).

106 *Art Union* (Nov. 1847), 365.

107 Hall, *Retrospect*, p. 197.

108 "Portrait of Robert Vernon," *Art Journal* (Jan. 1849), 1. Francis Haskell, *Rediscoveries in Art* (Ithaca: 1976), p. 52.

109 Hall, *Retrospect*, p. 205.

110 See Margaret Greaves, *Regency Patron: Sir George Beaumont* (London: 1966), pp. 147–150; David Robertson, *Sir Charles Eastlake and the Victorian Art World* (Princeton: 1978), p. 292; and Philip Hendy, *The National Gallery London* (London: 1960, revised 1971), pp. 15–16.

111 The details of the Soane Bequest are contained in the Soane Museum Act of Parliament (1833). See Stroud, *Soane*, pp. 7 and 111 and letter from John Constable to C. R. Leslie, 17 July 1832, "Constable Correspondence III," 8, p. 8.

112 For the Chantrey Bequest see George Jones, *Sir Francis Chantrey, RA Recollections of his Life, Practices and Opinions* (London: 1849); *Art Journal* (Jan. 1883), 15–16; D. S. MacColl, *The Administration of the Chantrey Bequest* (London: 1904); and *Turner Correspondence*, ed. Gage, pp. 244–45.

113 Turner's bequest is discussed in A. J. Finberg, *The Life of J. M. W. Turner, RA* (Oxford: 1938; 2nd ed., 1961), pp. 329–31 and 441–45 and Butlin and Joll, *Turner*, I, xxii–xxiv.

114 For Angerstein see Robertson, *Eastlake*, pp. 49–50 and 292; Hendy, *National Gallery*, pp. 16–21; Whitley, *Art in England*, pp. 65–73 and C. Fry, *John Angerstein and Woodlands Art Gallery* (Woodlands: 1976).

115 (Archibald Alison), "The British School of Painting," *Blackwood's Magazine* 40 (July 1836), 85.

116 Eastlake was empowered by the Trustees to decide whether or not Vernon's Old Masters and his Stothards should be accepted by the National Gallery. See Eastlake to Vernon, 10 August 1847, Jenkyns Papers, Box II, Balliol College, Oxford. Vernon lent several of his Old Masters to exhibitions at the British Institution in 1835, 1838, 1844, and 1846. See Algernon Graves, *A Century of Loan Exhibitions*, 3 vols. (London: 1913–15, rpt. 1970). Although he sold a few at Christie's in 1836, he kept the majority, which were auctioned by his heirs in 1877 (see appendix).

117 Letter from Vernon Heath (written at his uncle's request) to the Marquess of Lansdowne, Chairman of the Trustees of the National Gallery, 18 June 1847, in Heath, *Recollections*, p. 18. Eastlake replied, assuring him that the Board of Trustees was trying to meet his demands and was "strongly recommending the immediate addition of a portion of the National Gallery …respecting Mr. Vernon's munificent intentions." Charles Eastlake to Vernon Heath, 2 August 1847, Jenkyns Papers, Box II, Balliol College, Oxford.

118 Lord Monteagle to Vernon, 17 August 1847, Jenkyns Papers, Box II, Balliol College, Oxford. The result was Pickersgill's portrait of Vernon (plate 1).

119 Hendy, *National Gallery*, p. 26.

120 For the Houses of Parliament competitions see T. S. R. Boase, "The Decoration of the New Palace of Westminster 1841–1863," *Journal of the Warburg and Courtauld Institutes* (1954), 319–58. The Society of Arts' plans for a national gallery of British art are discussed in Kathryn Moore Heleniak,

"William Mulready, RA (1786–1863) and the Society of Arts (ii)," *Journal of the Royal Society of Arts* 124 (Aug. 1976), 558–62. See also *Art Journal* (April 1860), 111.

121 Oppé, "Art," II, 114, note 1.

122 Paul DiMaggio, "Cultural Entrepreneurship in Nineteenth-Century Boston, Part II: The Classification and Framing of American Art," *Media, Culture and Society* 4 (1982), 303.

123 "Copies of Correspondence between the Trustees of the National Gallery and the Lords of the Treasury respecting the Gift made by Mr. Vernon to the Public of his Collection of Modern Pictures and other Works of Art," 2 June 1848, p. 13, National Gallery Archives. See also Heath, *Recollections*, pp. 349–50.

124 *ILN*, 13 (4 Nov. 1848), 284.

125 *Punch*, 15 (1848), 221.

126 See Hall, "Tabley House Papers," 61 and 111.

127 For Wyse, see Pye, *Patronage*, p. 86.

128 See Oppé, "Art," 119.

129 In the Vernon Gift there are forty-six narrative scenes compared to thirty-eight landscapes and marines, twenty-eight poetic subjects, thirteen historic costume pieces, and fourteen history paintings. The balance consists of a scattering of still lifes, portraits, animal subjects, and sculpture.

130 Vernon hung Eastlake's *Christ Lamenting Jerusalem* over the mantelpiece in his drawing room in his house in Pall Mall. See *Art Union* (March 1839), 369.

131 Lister, *Edinburgh Review*, 63. For discussions of the development and range of narrative painting, see Richard Redgrave and Samuel Redgrave, *A Century of British Painters* (London: 1866, rpt. 1947),

pp. 288–307; Sacheverell Sitwell, *Narrative Pictures* (London: 1937); Graham Reynolds, *Painters of the Victorian Scene* (London: 1953); Richard Lister, *Victorian Narrative Painting* (London: 1966); Melvin Waldfogel, "Narrative Painting," in *The Mind and Art of Victorian England*, ed. Joseph Altholz (Minneapolis: 1976), 159–74; and Lionel Lambourne, *An Introduction to 'Victorian' Genre Painting* (London: 1982).

132 See appendix for details of these bequests. I have excluded professional dealers such as printseller William Smith (1808–76) who donated portions of his watercolor collection to the South Kensington Museum in 1871 and 1876. For Smith see *DNB* and *Athenaeum* (1876), 377.

133 See *DNB* and James Davies, *John Forster: A Literary Life* (London: 1983).

134 William Dyce had been employed by the Schools of Design and was therefore sympathetic to the South Kensington Museum. See South Kensington Museum, *The Dyce Collection* (London: 1975).

135 R. G. Wilson, *Gentlemen Merchants: The Merchant Community in Leeds, 1700–1830* (Manchester: 1971), p. 3.

136 See W. G. Rimmer, *Marshall's of Leeds, Flax Spinners 1788–1886* (Cambridge: 1960); Waagen (1857), pp. 183–85; and Rev. R. W. Taylor, *Biographia Leodiensis* (Leeds: 1865), pp. 364–66 and 411–14.

137 For Sheepshanks's family history, see Taylor, *Biographia*, p. 514; *DNB*; and Wilson, *Gentlemen Merchants*, pp. 25–27 and 247–48.

138 Herbert Heaton, *The Yorkshire Woollen and Worsted Industries* (Oxford: 1965), p. 280.

139 Vernon's parsimonious treatment of his servants is discussed in Vernon Heath's *Recollections*, p. 45, while Sheepshanks's generosity is described in F. M. Redgrave, *Memoir*, p. 215. He also remembered his servants in his will. See Probate Copy of the Last Will and Testament of John Sheepshanks, 2 December 1863, Somerset House.

140 John Sheepshanks, Deed of Gift, 6 February 1857, *Minute Book of the Department of Science and Art*, p. 3, Victoria and Albert Museum Library.

141 See *Journal of the Society of Arts* 6 (3 March 1858), 237, and Henry Cole's diary, 4 April 1852 (Victoria and Albert Museum), both cited in Heleniak, "Mulready and the Society of Arts," 558 and 561.

142 Henry Cole, cited in Elizabeth Bonython, *King Cole* (London: 1982), p. 9. For Cole's part in the formation of a working-class committee to attract visitors to the Great Exhibition, see Sir Henry Cole, *Fifty Years of Public Work*, 2 vols. (London: 1884), I, 188–93. See also A.S. Levine, "The Journalistic Career of Sir Henry Cole," *Victorian Periodicals Newsletter* 8 (June 1975), 61–65.

143 Sheepshanks, Deed of Gift, *Minute Book*, pp. 3–4. For Ellison, see *The King's England: Lincolnshire* (London: 1949), p. 370.

144 John Frederick Physick, *The Victoria and Albert Museum, the History of its Building* (Oxford: 1982), pp. 35–36, and *Survey of London: The Museums Area of South Kensington and Westminster*, ed. F. H. W. Sheppart, 42 vols. (London: 1900–), vol. 38 (1975), 101.

145 Redgrave, *Memoir*, p. 171. See also "John
 Sheepshanks, Esq." (obituary), *Art Journal*
 (December 1863), 241.

146 Mary Ann Doane, "Film and the
 Masquerade: Theorising the Female
 Spectator," *Screen* 23 (Sept.–Oct. 1982),
 81. See also Joan Riviere, "Womanliness as
 Masquerade," in *Psychoanalysis and Female
 Sexuality*, ed. Hendrik M. Ruttenbeck
 (New Haven: 1966).

147 For his gift, see "Schedule of the Original
 Pictures and Drawings, the Subject of the
 foregoing Deed of Gift from John
 Sheepshanks, Esq.," *Minute Book*, pp. 5–10,
 and Richard Redgrave, *Inventory of the
 Pictures, Drawings, Etchings, etc. in the British
 Fine Art Collections deposited in the New
 Gallery at Cromwell Gardens, South
 Kensington, being for the most part the Gift of
 John Sheepshanks Esq., with an introduction by
 Richard Redgrave* (London: 1857). The
 Hunt watercolors formed part of the estate
 inherited by his brother William of Leeds
 and his nephew Rev. Thomas
 Sheepshanks of Harrogate. A few were
 sold at Christie's on 5–7 March 1888 and
 others are still owned by the family. See
 Sir John Witt, *William Henry Hunt
 (1790–1864): Life and Work* (London:
 1982), p. 46.

148 See Charles Henry Cope, *Reminiscences
 of Charles West Cope* (London: 1891),
 p. 121.

149 W. P. Frith, *My Autobiography and
 Reminiscences*, 3 vols. (London: 1887–88),
 I, 203, and Horsley, *Recollections*, p. 53.

150 After listening to him express his views, in
 1836, Constable reported that
 Sheepshanks was "full of the ill usage &
 disgrace the engravers received at the

 hands of the Academy." Constable to
 Leslie, 8 December 1836, "Constable
 Correspondence III," 8, p. 139. For
 Sheepshanks's patronage of engraving,
 see "Autobiography of John Burnet," *Art
 Journal* (Sept. 1850), 276; letter from
 Sheepshanks to Constable (1833),
 "Constable: Further Documents and
 Correspondence," ed. Leslie Parris and Ian
 Fleming-Williams, *Suffolk Records Society* 18
 (1975), 133; and letter from Sheepshanks to
 Landseer, (1837), Victoria and Albert
 Museum Library (86.RR.Box 5).

151 Helene Roberts, "'The Sentiment of
 Reality': Thackeray's Art Criticism,"
 Studies in the Novel 13 (Spring–Summer
 1981), 36.

152 See Sheepshanks to Landseer, 6 August
 1842, Victoria and Albert Museum Library
 (86.RR.Box 5) and Ormond, *Landseer*, p. 111.

153 Ruskin, *Modern Painters*, vol. I, *Works*, III, 89.

154 Kendall Walton, *Mimesis as Make-Believe*
 (Cambridge, Mass.: 1990), p. 53.

155 Eastlake cited in Uwins, *Uwins*, II, 313.

156 Richard Redgrave, *Seventh Report of the
 Science and Art Department 1859*, 1860, p. 124,
 cited in Physick, *Victoria and Albert*, p. 39.
 See also *Art Journal* (August 1857), 239.

157 Jameson, *Private Galleries of Art*, p. xxxiv.

158 Ibid., pp. 343–44.

159 Bourdieu, *Distinction*, p. 32 and *passim*.

160 T. J. Clark, *The Painting of Modern Life: Paris
 in the Art of Manet and his Followers*
 (London: 1985), ch. 1.

161 Vernon's was titled *The Crown of Hops* and
 was painted in 1843, eleven years after
 Sheepshanks's.

162 Lambourne, *Genre Painting*, pp. 21–23.

163 E. H. Gombrich, *Meditations on a Hobby
 Horse* (Oxford: 1963), p. 9.

164 Redgrave, *Memoir*, pp. 169–70. Subsequent references to Lord Palmerston's visit will be given in the text.

165 Mikhail Bakhtin, *Rabelais and his World*, transl. Hélène Iswolsky (Bloomington, Ind.: 1984), pp. 5ff.

166 See Mikhail Bakhtin, *The Dialogic Imagination*, transl. Michael Holquist and C. Emerson (Austin, Tex.: 1981), pp. 269–315.

167 Ben Marshall, cited in E. D. H. Johnson, *Paintings of the British Social Scene* (New York: 1986), p. 198.

168 Michel Foucault, *The Order of Things: An Archaeology of the Human Sciences* (1966; rpt. New York: 1973), p. 5.

169 Frith, *Autobiography*, I, 272.

170 (Jacob Bell), *Descriptive Catalogue of Pictures, etc. Exhibited at Marylebone Literary and Scientific Institution* (London: 1859), pp. 6–7.

171 Ruskin, *Works*, XIV, 161–62.

172 Redgrave, *Inventory*, p. 4.

173 Richard Altick, *Paintings from Books: Art and Literature in Britain, 1760–1900* (Columbus, Ohio: 1985), p. 93. While we do not know what Sheepshanks read, we do know that he was acquainted with one of the leading dramatic actors of the day, Frederick Young and that he belonged to the Athenaeum Club, a favorite haunt of Thackeray, Dickens, and other literary men. In a letter to Landseer, dated 10 February 1840, Sheepshanks asks him to vote for Young's membership in the Athenaeum (Victoria and Albert Museum Library). See also Frank Richard Cowell, *The Athenaeum: Club and Social Life in London 1824–1974* (London: 1975).

174 Redgrave, *Inventory*, p. 7.

175 William Frith to Charles Hawker, 6 May 1842, cited in Parkinson, *Catalogue of British Oil Paintings*, p. 97.

176 Simmel, *Philosophy of Money*, pp. 74–75.

177 Bell bequeathed sixteen pictures to the National Gallery in 1859. See his undated inventory, Bell Papers, Royal Institution.

178 George Knott's purchase is mentioned by Leslie in a letter to Sheepshanks, 15 September 1840, MSS: Private Collection. Mrs. Haldiman's version was in watercolor; see Parkinson, *Catalogue of British Oil Paintings*, p. 97.

179 For the assimilation of this image into popular culture, see Lambourne, *Genre Painting*, p. 43, and Altick, *Paintings from Books*, p. 73. Leslie's model for Uncle Toby was theatrical idol Jack Bannister. See *Art Union* (Nov. 1847), 371.

180 Svetlana Alpers, "Art History and its Exclusions: The Example of Dutch Art," in *Feminism and Art History: Questioning the Litany*, ed. Norma Broude and M. Garrard (New York: 1982), p. 187.

181 Roland Barthes, *S/Z*, transl. Richard Miller (London: 1975), p. 55.

182 Foucault, *Order of Things*, p. 17.

183 Baudrillard, *Political Economy of the Sign*, p. 103.

184 See John Barrell, *The Political Theory of Painting from Reynolds to Hazlitt* (New Haven: 1986), pp. 125–30 and 225–27.

185 Walter Benjamin, "The Work of Art in the Age of Mechanical Reproduction," in *Illuminations*, ed. Hannah Arendt, transl. Harry Zohn (New York: 1969), p. 218.

186 Waagen (1854), II, 299.

187 Taylor, *Leslie*, I, lix.

188 The degree of originality in "strict copies" as opposed to "reconstructions," "imita-

tions," and "variants" is debated by James Elkins in "From Original to Copy and Back Again," *British Journal of Aesthetics* 33 (April 1993), 113–20.

189 Leslie to Bell, 14 May 1849, MSS: Pharmaceutical Society, London.

190 Amateur artists in the group in addition to Bell and Maw were W. Stone Ellis, J. J. Ruskin, and Sarah Rogers.

191 Prout to Maw, c. 1838, cited in *Turner Correspondence*, ed. Gage, p. 269. For William Henry Hunt's high opinion of Maw's artistic ability, see Wolverhampton Art Gallery, *William Henry Hunt*, no. 40, p. 22.

2 Culture and middle-class identity in Manchester and Birmingham

The provincial middle class was buffeted by the same winds of change that stirred Londoners in the years following the Napoleonic Wars. Patriotic fervor and a thriving economy coalesced after the passage of the Reform Bill to produce a chauvinistic appreciation for the native school of art. Like early Victorians in London, businessmen in the smaller towns to the north recognized that the aristocracy and gentry's leisured pastime of art collecting could easily be adapted into an effective cultural tool for middle-class ambitions. Yet the means to that end were even less distinct in the provinces than in the metropolis because of the diversity of opinions and opportunities. If there was any common denominator, it was the shared realization that the cultural field was ripe for plucking.

The appropriation of culture is a political act, whether one views culture in its generalized anthropological sense as a way of life or, from a more specifically sociological perspective, as a signifying system through which a social order is reproduced.[1] Either meaning rests on the assumption that culture is an active, continuous process comprised of thoughts, values, and beliefs which generate new matrices of meaning. Because this activity is personalized and localized, it often results in frictions between individuals and groups. "The shapes of the social pyramids which furnished grounds for aspirations and condensations," explains Peter Gay in regard to the middling ranks, "were partially obscured by subtle social distinctions and conflicting claims."[2] Some of these tensions became apparent in the first few decades of the nineteenth century in the clashes between north and south, traditional and modern, and personal and public.

According to popular Victorian stereotypes, the northerner was "independent, practical, rough, calculating, and enterprising," while the southerner was "genteel, graceful, romantic, idealistic, and benevolent."[3] The Manchester author Mrs. Gaskell perpetuated these regional personality types in *North and South* (1855), despite the fact that by the time the novel appeared, these contrasting qualities had been homogenized into an iden-

88

tifiable middle-class presence. "By the middle of the nineteenth century," according to Leonore Davidoff and Catherine Hall, "disparate elements had been welded together in a powerful unified culture."[4] What might have been true for the marginal men of 1815 was no longer applicable to the national and international capitalists who prospered in Britain's age of empire building.

Prior to its consolidation in the second half of the nineteenth century, however, the identity of the middle class was modified by the social and economic orientations of each of the new towns. Leeds, for instance, developed its own tradition of social consciousness: its history of working-class unrest was responsible for the sermonizing tone of much of the art commissioned by its patrons. Manchester, too, demonstrated that the character of its city permeated the walls of its private residences – there, civic pride combined with a sense of social obligation to impel many private patrons to buy paintings of somber subjects. On the other hand, Liverpool's early policy of art education created a citizenry that was receptive to a wider variety of art. Birmingham was even more unusual in that its flourishing amateur tradition resulted in patrons with a higher regard for technique than content.

Since Liverpool and Leeds figure so prominently in the careers of the Pre-Raphaelites, I will reserve my comments on the middle class's involvement in the culture of those centers for the following chapter. Here, I focus on Manchester and Birmingham, the two cities which have afforded such a fruitful basis of comparison for scholars from John Cobden and Alexis de Tocqueville to G. M. Young and Asa Briggs. Briggs's pithy summation of "free-trade Manchester and protectionist Birmingham" contains the seeds of the cultural contrast I wish to sketch.[5] By characterizing Manchester as open and venturesome and Birmingham as closed and self-contained, Briggs points toward a fundamental difference in outlook that contributed to the disparate character of middle-class identity in these cities. I will demonstrate that the idiosyncratic industrial and economic make-up of each city affected its definitions of culture.

Birmingham's small workshops depended for their livelihood on cycles of short-term economic exchange. Art collectors in the community likewise were swayed by the profit motive and so bought and sold frequently. This self-interested practice of acquisitiveness was not frowned upon in a community where the quick turnover of goods was essential to the local economy. The factors which help form the ethos of place in any city must be

taken into account in a definition of culture, since they essentially shape or mediate standards. For instance, Birmingham's mercantile attitude toward art was modified by its amateur tradition. Invigorated by the presence of David Cox, several local collectors became proficient sketchers and water-colorists. The result was a greater degree of aesthetic acuity among patrons in Birmingham than in Manchester, which lacked a resident artist with a national reputation and where many collectors allowed the art dealer Thos. Agnew and Sons to conduct their aesthetic negotiations for them.

Manchester's conception of culture was also colored by its indigenous industrial formation. The textile industry endured a more complex cycle of long-term exchange based on the importing and spinning of cotton which in turn made it in the best interest of its money men to promote a stable social and economic order. Their ensuing working-class consciousness led factory owners to consider art exhibitions as public-spirited occasions for rational recreation. Thus the public took precedence over the private in Manchester, where the Enlightenment concept of civic humanism was adapted to serve the needs of the community.

I shall address these issues in relation to the practices of fifteen Manchester and Birmingham collectors. All but three of them were singled out in the Victorian period as leading devotees of contemporary art by Gustav Waagen or by the *Art Journal*.[6] To these sources I have added iron-master John Gibbons of Birmingham, because he was hailed as an ideal patron by artists such as Thomas Danby and William Frith, and bleacher James Eden of Bolton who lent his paintings to the Manchester Art Treasures exhibition. Of even more importance historically was machine manufacturer Sir Thomas Fairbairn, chairman of the Art Treasures exhibition committee and patron of Pre-Raphaelite painter William Holman Hunt. In addition to examining Fairbairn's personal collection, I will use the massive exhibition which he worked so hard to mount as a point of connection between Manchester's and Birmingham's urban patriciate, since they displayed some of their choicest art holdings there.

A further distinction between Manchester and Birmingham rests in the relative merits each accorded to progressive modernism. Londoners regarded Manchester as the "Symbol of a New Age"[7] because of its feverish progress in the early days of the Industrial Revolution, its advanced school of economics, and its enlightened social programs. To Disraeli's Mr. Millbank Manchester was "the most wonderful city of modern times" and offered "a new world pregnant with new ideas, and suggestive of new trains

of thought and feeling."[8] Birmingham, in contrast, was content with continuing traditional methods and attitudes. Noting this difference, Eric Hobsbawm concludes: "It was not Birmingham, a city which produced a great deal more in 1850 than in 1750, but essentially in the old way, which made contemporaries speak of an industrial revolution, but Manchester, a city which produced more in a more obviously revolutionary manner."[9] This distinction between change and continuity naturally affected the formulation of each city's cultural identity.

That Lancashire was at the hub of the new fashion for the native school gradually became apparent to Londoners. "Galleries of modern Art," noted the *Art Journal* in 1858, "are numerous in the vicinities of Preston and Manchester; and it is to those patrons who, instead of purchasing copies of the works of the ancient masters, hang their galleries with undoubted productions of our own school, that British Art is indebted for its flourishing condition."[10] This contention was borne out by cotton spinner Henry McConnel, whom the *Art Journal* had first visited almost twenty years earlier. At that time, it lauded McConnel's early and earnest devotion to the English School, claiming that his "collection of modern art is unrivalled out of London" (1839, p. 5). During the boom years of the cotton trade, stimulated by the wars with France, McConnel distinguished himself as one of Manchester's foremost patrons of the incipient native school of art.

McConnel actively commissioned paintings from Etty, Eastlake, Callcott, and Collins at a time when their best patrons still came from the aristocracy. John Horsley, in a tribute to McConnel published in the *Art Journal* in 1872, registered the surprise of his uncle, the painter Augustus Callcott, when McConnel visited him in the 1830s and commissioned two pictures. Horsley states that until that time Callcott's patrons "almost invariably came from the leading representatives of the 'upper ten thousand,'" and "the fact of a gentleman from Manchester wanting pictures was an event to be legitimately wondered at!" (p. 265). That a London artist should hold such a snobbish opinion of Manchester men is not surprising considering the manner in which they were treated in the literature of the period.

The tired cliché of the boorish Manchester patron crops up again and again in Victorian fiction. In Thackeray's *The Newcomes* (1855), Frank Softly complained, "I have listened to a Manchester magnate talking about fine arts before one of J.J.'s pictures, assuming the airs of a painter, and laying down the most absurd laws respecting the art" (II, 322). Thackeray at

least gives his Manchester patron credit for knowing the vocabulary of art, even if he did not understand its meaning, in contrast to Geraldine Jewsbury, who, in her novel *Marian Withers* (1851), ridicules rich millowners who collected art. In the following passage, she exposes their motives before she unveils their malapropisms:

> At first, it was a species of Fetish worship: they began to buy pictures and engravings without anything higher than a vague idea that they were worth the money, and that there was a certain distinction in possessing what they persisted in calling "articles of bigotry" [for *bijouterie*] and "virtue" [for *vertu*]; and although many of the old race of spinners and mill-owners would still sit in the kitchen and smoke their pipes, leaving their drawing rooms full of beautiful things which they thought much too grand to live amongst, still a taste for art and a respect for cultivation of the intellect had begun to make itself felt.[11]

Although Jewsbury's book was published in the 1850s, she, like other authors of social novels, wrote about stereotypes that had been formed during the first flush of the Industrial Revolution, between 1760 and 1832. According to Ivan Melada's examination of this literary genre, a substantial amount of time passed between the emergence of the first-generation industrialist and his literary counterpart.[12] None of the Manchester patrons described by Waagen or the *Art Journal* in the 1850s can be accused of behaving awkwardly in the presence of art or stumbling over words associated with it. Jewsbury's fetishistic, pipe-smoking stereotype dates from the late eighteenth century, rather than her own day. By the time she penned her account, Manchester was a thriving art center with regular public exhibitions and a number of commercial art galleries. But in recognizing that "a respect for cultivation of the intellect had begun to make itself felt," Jewsbury brings her readers closer to the events of their generation where men like McConnel were going about the business of making art available to the general public.

Henry McConnel was anything but a gauche newcomer when he began to collect art: a third-generation scion of a dynastic Mancunian family, his father had been instrumental in the founding of the Royal Manchester Institution and had actively supported the Mechanics Institute. Thus a tradition of cultural and social awareness was already established in his family. He is typical of the Manchester patrons visited by Waagen and the *Art Journal*, most of whom could boast of well-founded pedigrees and inherited fortunes.[13]

McConnel's commissions to artists reveal that he was initiating rather than imitating existing patterns of patronage. A Nonconformist, he offered Mulready 1,000 guineas in 1822 to paint a picture of a street preacher titled *Church and Dissent*, which he thought would discomfit the clergy.[14] Attuned to the economic debates at issue in Manchester and Birmingham, he owned a pair of paintings by Landseer called *Free Trade* and *Protection*, the first personified by a sturdy farmer next to a horse of Flemish breed, and the other by a stately groom and an elegant steed.[15] McConnel was confident enough about his artistic and social standing to associate himself with the ungainly workhorse that represented the policy of free trade which had made it possible for him to patronize artists such as Landseer, Maclise, and Turner.

Instead of escaping through art from the smoke-filled milieus of his factories, McConnel commissioned Turner's *Keelmen Heaving in Coals by Moonlight* (plate 14) in 1835, one of the rare examples of the intrusion of industry in the artist's oeuvre. Because it was painted as a companion to another of McConnel's Turners of a Venetian scene, Turner scholars Martin Butlin and Evelyn Joll propose that the Manchester cotton spinner "may have suggested to Turner that he should paint a pair of pictures contrasting the sunlit indolence of Venice with the smoke and bustling activity, carried on even by night, of the industrial north of England."[16] This observation raises the problematic question of the patron's intention in commissioning this picture. In McConnel's mind, was the dirt and grime associated with labor transformed into a sublime and progressive image or did he view the picture as an opportunity to soften the public perception of the industrial region that provided his fortune? Because artistic and social practices are unusually closely related in Manchester, the ideological implications of the art collected there cannot be ignored.

When Manchester's business leaders were threatened by working-class riots and demonstrations in the 1830s and 1840s, caused by unemployment and a rise in the price of bread, they wisely chose to support economic and social reform rather than face civil unrest. The private collectors who were factory owners were drawn into the fray: the McConnels, Ashtons, Bashalls, and Millers responded by building workers' houses, schools, or chapels next to their factories and mills (see appendix). McConnel, in fact, had been publicly censured by Alexis de Tocqueville for the conditions he saw at McConnel's Ardwick factory in 1835:

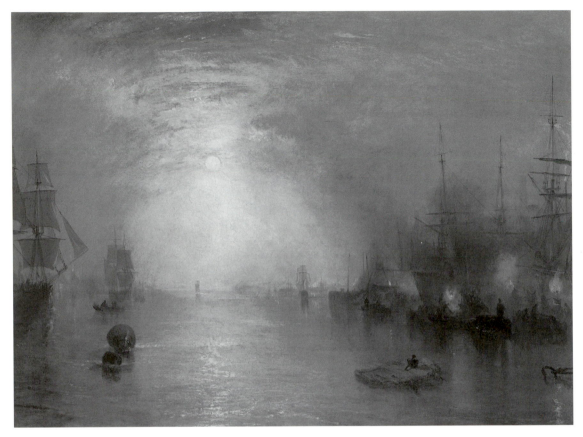

Plate 14. J. M. W. Turner,
*Keelmen Heaving in Coals by
Moonlight*, 1835, oil on canvas

Messrs. Connel's [*sic*] factory, one of the biggest Manchester spinners:
1,500 workers labouring sixty-nine hours a week . . . Three-quarters of
the workers in Messrs. Connel's factory are women or children: a system
fatal for education and dangerous for the women's morals, but one
which follows naturally from the fact that this work needs little physical
strength, so that the work of women and children is enough and costs
less than that of men.[17]

De Tocqueville was not embellishing the facts: cotton mills were responsible for employing unprecedented numbers of women and children. Women comprised approximately half of the work force and many had begun their careers in the mills as children. In Manchester and neighboring Salford, in 1852, 76 percent of all fourteen-year-old girls and 61 percent of boys the same age were employed in the mills.[18]

Conditions within the mills varied enormously. While McConnel cannot be exonerated for employing children, he, at least, built a school

next to his factory. Four years before de Tocqueville's visit, a factory inspector reported that the school promoted "good feeling and sympathy between the master and his workpeople."[19] Furthermore, in 1835, when McConnel constructed another large mill at Cressbrook in Derbyshire, he attempted to make the lives of his workers more pleasant by erecting a group of quaint Elizabethan and Swiss-style cottages for them "on the brow of a lofty hill covered with luxuriant plantations."[20] Do these concessions to his employees mark McConnel as one of the more benevolent employers of his time or as someone who enlisted aesthetics as a social placebo?

Janet Wolff believes that Manchester "provides a key location in which to test unquestioned clichés about the expression of 'bourgeois ideology' in Victorian art which have had currency, and not only within Marxism, for some time, and which are being revived, relatively uncritically, with the recent growth of interest in Victorian painting."[21] We have seen that the cliché of the boorish Manchester patron did not withstand the proof of documentary evidence. Before we can test the more general thesis that art in Manchester was an ideological reflection of social conditions, we must first examine the history of the middle class's involvement in the culture of that city.

After the death of Sir John Leicester in 1827, Manchester was essentially devoid of a resident landed class. "Gentle blood had begun to desert the town long before the 1820s," observes V. A. C. Gattrell, who explains that an exodus of gentry occurred as Manchester "grew larger, dirtier, and smellier."[22] The field was left wide open for the middle class to dominate the city's political and cultural life. Rather than attempting to disguise their industrial origins, Manchester's civic leaders were proud to be recognized as "Cotton Lords" or "Millocrats." In his analysis of the cotton industry, Anthony Howe maintains that wealth was the basis for a "pride of order, not for shame-faced concealment."[23]

Middle-class civic pride combined with the need for social recognition led to the founding of the Manchester Literary and Philosophical Society (1781), Natural History Society (1821), Royal Manchester Institution (1823–24), Botanical Society (1827), Statistical Society (1833), Medical Society (1834), and Geological Society (1838).[24] In their search for social legitimation, Manchester's rising middle class first felt more at ease with science as a mode of cultural self-expression because it was an area which had not already been dominated by the aristocracy. Therefore, Arnold Thackray posits that membership in organizations such as the

Literary and Philosophical Society gave socially marginalized men the opportunity to announce "their distance from the traditional value systems of English society, and offered a coherent explanatory scheme for the unprecedented, change-oriented society in which they found themselves unavoidably if willingly cast in leading roles."[25] Hence, the advantages in the rise of educative organizations were twofold: they allowed the middle class to assert itself in the community, while at the same time they improved the conditions of daily life. As this progression suggests, scientific organizations first dominated the cultural scene, but once local businessmen realized that the major landowners in the area had relinquished their claim to the fine arts, they quickly appropriated that part of the cultural field as well.

How the local aristocracy and gentry came to give up control of Manchester's art establishments is revealed in the saga of Sir John Leicester, the pioneering collector of English art, who maintained homes in London and near Manchester. Still believing that the civic humanist philosophy articulated by eighteenth-century theorists was viable, Leicester tried to discharge his duties as a citizen of the republic of taste by stimulating the public role of art. In his capacity as a Cheshire landowner, he concentrated on improving the state of the arts in Manchester, where he was a founding member of the Royal Manchester Institution (RMI). He assumed that the titled collectors he knew whose interests extended to contemporary art, such as the Duke of Bedford, Earl of Egremont, Marquises of Stafford and Lansdowne, and Sir Robert Peel, would also recognize their obligations. Leicester wrote to them asking their support for the new provincial institution, but was sadly disheartened when he was rebuffed by nearly all.[26] One of his bitterest disappointments was Sir Robert Peel's refusal to endorse the fledgling institution. Peel, after all, was the son and grandson of cotton spinners and one of the first private collectors to appreciate English cabinet pictures rendered in the Dutch mode.[27] Expecting Peel to be sympathetic to the need for art in the region that had supplied his fortune, Leicester hoped that, in addition to acquiring the king's patronage, Peel would make a generous personal contribution. The sense of betrayal felt by the founders of the RMI over the failure of Peel or his family to make a financial donation was expressed by their chairman, Dr. James Davenport Hulme, in a private communiqué to Leicester:

> Would you believe it? that tho' Mr. Peel purchases Paintings of the Old
> Masters at very high Prices and that his immense fortune, his Fathers

and his Uncles, were all acquired by cotton spinning at Manchester, and altho' they have had at least 40 guineas worth of *compliments* paid them by their Friends, upon this occasion, yet not one of them have had the good sense to support us.[28]

Leicester's cherished ideal had lost its appeal to a landed class who, according to John Barrell, allowed the civic humanist discourse to be redefined to accommodate self-interest.[29] Their sense of *noblesse oblige* did not extend into the arena of public patronage.

In this regard, the aristocracy and gentry had the full support of past convention. As I demonstrated in chapter 1 in my discussion of the Vernon Gift, the history of public patronage in England was riddled with indifference. As Janet Minihan points out in her analysis of government support of the arts in Great Britain, national practice held that patronage should be conducted on a private, not a public, level.[30] When the artist Benjamin Robert Haydon, conversing with Prime Minister Lord Melbourne in 1835, questioned this policy, he was told: "There is private patronage enough for all that is requisite."[31] Supported by Romantic theorists who argued that the appreciation of painting should be a fundamentally private exercise, the rich and powerful were relieved of their obligation to the public.[32] Given this attitude, Sir John Leicester's attempt to entice élite patrons into the public sphere seemed doomed from the start: they were comfortable in their time-honored roles of private connoisseurs, and saw no reason to extend themselves into other arenas.

Instead, it was left to the urban rather than the landed aristocracy to support the Royal Manchester Institution. In a recent article on the history of the RMI, Stuart Macdonald offers a further explanation for the upper-class apathy Leicester encountered: "Reform and revolution were in the air, and many aristocrats disapproved of attempts by liberal merchants to foster learning in industrial centres."[33] Had the nobility and gentry taken a greater interest, the Royal Manchester Institution might well have placed more emphasis on antiquarian and traditional aesthetics, and less on social programs. That the converse was destined to occur became evident in the RMI's prospectus of 1823, which strikes a chord that was replayed in Manchester many times in the Victorian period. In it, the founders expressed their hope that the new organization would "have the pleasing effect of removing prejudice, [and] of softening the asperity of party feeling." The prospectus continued, in a visionary tone, to extol the beneficial

effects of literature and the fine arts which, it stated, "tend, even more perhaps than the sciences themselves, to diffuse through the discordant elements of society a pervading emotion of friendly sympathy and mutual satisfaction."[34] Lacking a strong aristocratic presence and its accompanying traditions of amateur painting and connoisseurship, the needs of the industrialists to deploy art as a civilizing influence prevailed.

Class harmony was the leitmotif that continued to run through the exhibitions and lectures sponsored by the Institution. In 1844 the annual art show was kept open on several evenings so that the working classes could attend at the reduced admission fee of sixpence. This program was improved in 1847, the year the Ten Hour Factory Act granted laborers more leisure, by reduction of the evening entrance charge to twopence during the last two weeks of the exhibition, a policy which succeeded in attracting 11,000 people.[35]

Making art available to the working class satisfied everyone. It assuaged middle-class consciences by giving pictures a purpose other than decoration; it provided a rationale for the ownership of objects of luxury that might otherwise be associated with aristocratic habits of self-indulgence; and it lent contemporary art a special purpose: the edification and instruction of the less fortunate.

We can conclude, then, that 'bourgeois ideology' played an important part in the construction of culture in Manchester: the amelioration of social conditions presented a convenient and praiseworthy reason for collecting and displaying art in a way that was distinct from aristocratic praxis. Paul DiMaggio contends that cultural sponsorship is a strategic action, one that becomes a claim for the identity and status of the patron.[36] In Manchester, the fine arts helped to define the "bourgeois" part of the ideological equation and became an element in establishing the middle-class identity of its community leaders. But that was the public face presented by Manchester's earnest cultural mavens. In private, these men did not differ significantly from collectors elsewhere.

An interrogation of the motives of Manchester's individual collectors discloses a psychological bond with Londoners of the same timeframe. Like Robert Vernon, a dream of immortality impelled Richard Newsham, the only Manchester patron to make a public bequest of his art in the early-Victorian period. The catalogue of the collection he gave to the city of Preston credits him with possessing the sentiments Walter Savage Landor expressed in *Count Julian*: "Man's only relics are his benefits."[37]

Newsham earned his epitaph; he was generous not only to the arts, but to schools, churches, and poor-relief funds. While the desire to be remembered may have been one of his loftier motives for collecting art, a more immediate one was personal rivalry with his friend and neighbor at Preston, Thomas Miller. They frequently visited London exhibitions and studios together, and they patronized many of the same London artists. In this relationship Miller, the cotton manufacturer, was the leader and Newsham, the barrister, the follower. For instance, in 1859 Miller purchased J. C. Hook's *The Fisherman's Departure* at the Royal Academy, leaving Newsham to buy its pendant, *The Fisherman's Return*.[38] As strong as was the predilection for didactic art among Manchester's private patrons, it was far from their sole motivation for collecting art. Beyond socially relevant topics, Henry McConnel was moved by a "love of excellence" and by "intellectual enjoyment," while Thomas Fairbairn, who fathered two deaf and dumb children, and James Eden, who was a bachelor, both specialized in collecting scenes of untroubled children.[39] These patrons demonstrate that art collecting in Manchester was not an entirely situational practice, but ran the gamut of emotional and intellectual drives that impelled collectors elsewhere.

Smaller communities do not produce vernacular values, but they sometimes magnify impulses that are less apparent in larger locales. The moral motivation for collecting art, for instance, that leaps to the fore in Manchester does not stand out as prominently in the tumult of London. In surveying the fine arts in Victorian Lancashire, C. P. Darcy was struck by the number of didactic subjects in private collections. Among the many examples he gives are J. R. Herbert's *Sir Thomas More in Prison, Visited by his Daughter*, in the Thomas Miller collection, and F. W. Topham's explicitly titled companion pieces, *The Mother's Blessing* and *The Mother's Pride*, in Henry Cooke's collection of watercolors.[40] Despite their disparate private motives, once Mancunians decided to collect art, they displayed a preference for narrative subjects and inspirational landscapes.

One explanation for the relative uniformity of Manchester collections was the presence of the dealers Thos. Agnew and Sons. In addition to serving Eden, Fairbairn, Miller, and Newsham, the firm contributed to the collections of Samuel Ashton and his brother Thomas, Thomas Miller's son Thomas Horrocks Miller, and Henry McConnel, particularly in his later years.[41] Although William Bashall apparently formed his collection on a first-hand basis with artists, Agnew's immediately stepped in after his death

with an offer to buy eighty-five pictures from his estate.[42] And while Fairbairn, Miller, Eden, and Newsham gave direct commissions to artists, they never entirely abandoned the practice of shopping at Agnew's.[43] It would be no exaggeration to say that every Lancashire collection of note was served, in one way or another, by this influential firm of art dealers.

A print of the interior of Agnew's gallery on Exchange Street in Manchester gives some indication of the nature of their operation in the 1840s (plate 15). Paintings, engravings, sculptures, and *objets d'art* are attractively arranged in a large and elegantly appointed showroom that was one of Manchester's main cultural attractions. The gallery was a mecca for literary figures, such as Mrs. Gaskell and American diplomat and novelist, Nathaniel Hawthorne, as well as for collectors. Hawthorne, after visiting the Manchester showroom in 1856, wrote: "There are many handsome shops in Manchester; and we went into one establishment . . . devoted to pictures, engravings, and decorative art generally, which is much the most extensive and perfect that I have ever seen."[44]

In addition to serving as an arbiter of taste, William Agnew left his personal mark on artistic production. In a revealing passage in a letter to John Linnell, the dealer gives some indication of the visual and emotional effects he personally prized:

> Now I am going to commit an extravagance perhaps for myself. I am about to ask you to paint one of similar size for my "alter ego," anyhow for my private self and I leave its subject entirely to yourself only observing that I always like "loads" of distance, that I like to escape behind the canvas and I dislike to be shut in, and that a sunset is to me an impressive charm and solemn teaching.[45]

William Agnew apparently communicated his feelings about the spiritual power of sunsets to his customers: these scenes could be found in the collections of Thomas Miller and Richard Newsham, among others.

While Miller and Newsham only occasionally bought from Agnew's, Samuel Ashton left the delicate business of negotiating with artists entirely in the dealer's deft hands. He spent over £10,000 there between 1848 and 1856, buying the works of a wide spectrum of artists. In his history of the family company, Sir Geoffrey Agnew writes that by 1850, Thomas Sr. was "dealing in Constables, Turners and Ettys," as well as in works by "Pyne, Callcott, 'Mad' Martin, Danby, Creswick and Clarkson Stanfield," among other artists.[46] Until a definitive study is written about the aesthetic canons

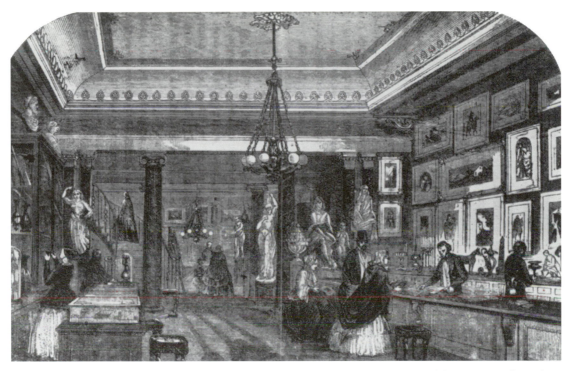

Plate 15. Agnew's, Exchange
Street, Manchester, *c.* 1840

created and promoted by Thomas Sr., William, and Thomas Agnew Jr., our understanding of the leverage they had with their clients must remain incomplete. There is no doubt, however, about the influential behind-the-scenes role that William Agnew played in the Manchester Art Treasures exhibition: he undertook a survey of collections in the neighborhood which he then submitted to the exhibition's chairman, his client Thomas Fairbairn.[47]

Fairbairn's faith in the redemptive potential of art deeply colored the organizational structure and choice of exhibits at the Manchester Art Treasures exhibition under his chairmanship. He was a third-generation Mancunian philanthropist of the class most concerned with the steward-ship of wealth and civic affairs. A Unitarian, Fairbairn worshiped at the Church Street Chapel administered by Mrs. Gaskell's husband William, a firm believer in art as a powerful moral force.[48] Fairbairn, accordingly, added a wide selection of modern moral subjects to his private collection. But it was the instrumentation of his beliefs in the public sphere that was to have a much greater impact.

Fairbairn set the ideological tone of the largest fine-arts exhibition ever held in England six months before its opening, on 15 August 1856. On this day Fairbairn, who had successfully drawn upon his experience as a commissioner of the Great Exhibition of 1851 to raise £60,000 for Manchester's endeavor, disclosed as he laid the foundation stone, that moral probity and social harmony were the goals of the exhibition he had worked so hard to bring about. *The Times* quoted Fairbairn as saying: "I trust that the throngs who will crowd these halls will retire from them with their thoughts elevated, their ideas refined, and with a more tolerant disposition in judging of the works and the motives of their fellow-creatures." The Art Treasures exhibition presented Fairbairn and the cotton lords who contributed to it with the opportunity to forge a communal consensus based on self-improvement and moral responsibility in the aftermath of the working-class demonstrations of the previous two decades. Their objective accorded with the civic humanist goal of protecting the state from discord by appealing to the higher nature of its subjects.[49]

To this end, Fairbairn placed in charge of the English section of the exhibition his friend Augustus Egg, an artist skilled at painting moral lessons that enlightened as well as entertained.[50] It was Egg's job to choose, from lists provided by artists and collectors, some 500 works to hang in the contemporary wing. Egg's choices naturally ran to the kind of figurative subjects he specialized in, despite the able assistance afforded him by the landscape painter Thomas Creswick. Even though Samuel Ashton lent Constable's *Salisbury Cathedral* and John Naylor and John Miller sent over their Turners from Liverpool, the *Athenaeum* found cause to lament the dearth of landscapes in the exhibition and quite correctly assumed this situation was due to "the choice depending upon one whose ambition lies in figures."[51]

An engraving of the Gallery of Modern Painters published in the *Illustrated London News* in 1857 (plate 16) shows that while landscapes and marine subjects were not entirely absent in Manchester, narrative pictures dominated. Among these were Lawrence's *Napoleon*, Haydon's *Judgment of Solomon*, and Etty's *Joan of Arc at the Stake*. The overall tone of the exhibition was decidedly somber if one takes into account that, in addition to these weighty pictorial essays, Jacob Bell lent Landseer's didactic *Alexander and Diogenes* and John Naylor parted with *Christ Weeping over Jerusalem*, his version of the Eastlake in the Vernon Gift. Further, Manchester's John Chapman and Richard Newsham, in lending *Lear Disinheriting Cordelia* and

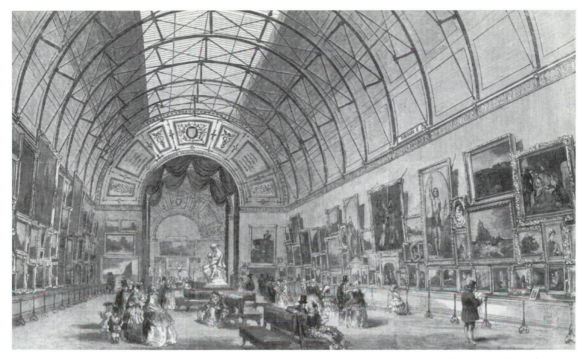

Plate 16. Gallery of Modern Painters, Manchester Art Treasures Exhibition, 1857

The Boy Daniel, both by J. R. Herbert, contributed to the soul-searching mood of the exhibition, as did Newsham's friend Thomas Miller when he lent Frith's *Trial of a Witch*.[52] As these titles suggest, themes of noble sacrifice, suffering, and the punishment of transgressors were well represented. Two of Chairman Fairbairn's personal loans were in these categories: Holman Hunt's *The Awakening Conscience* and Pickersgill's *Flight of the Pagan*, both seemingly selected to promote Fairbairn's goal of inculcating Christian values.

The paintings at the Art Treasures exhibition embodied two master narrative themes of modern society: the importance of self-denial, and obedience. Jean-François Lyotard identifies the *grand récits* of modern industrial society as those which appeal to "the dialectics of the Spirit, the hermeneutics of meaning, the emancipation of the rational or working subject, or the creation of wealth."[53] By holding up to the worker the appreciation and ownership of art as a positive benefit of the accumulation of wealth, Manchester's cultural élite implied that attention to art's coded messages would lead to his or her material and social advancement. The *Art Treasures Examiner*, a weekly journal published during the course of the exhibition, reinforced this notion of progress through conformity in an article titled, "Working Men and the Art-Treasures Exhibition." It stated:

> A taste for the fine arts has an immediate bearing on the moral
> elevation of the working class ... Let working men seek to be refined, –
> to be gentlemen in feelings and in manners; let them extend the range
> of their information, and acquire the habit of thinking and acting for
> themselves, and they will speedily take their proper rank in the great
> human family.[54]

As the *Examiner* unabashedly promised, art could produce two
miracles of transformation in working people. A simple awareness and
appreciation of the fine arts in general would grant them a certain gentility,
while on another, more spiritual, plane workers could reach new heights of
morality if they dutifully received and decoded art's narratives. Robert
Lamb, in his lengthy review of the Manchester exhibition published in
Fraser's Magazine, argued that moral messages need not be arcane, but could
be gleaned from a wide variety of pictorial art. He attested:

> And not simply may subjects strictly religious exert a moral influence;
> the painter who represents a virtuous and ennobling deed of any kind, is
> a benefactor of his species ... Is there not a lesson in the child praying on
> its mother's knee, in the hearty, rollicking face of the schoolboy, in the
> happy country scene, in the way-side flowers, in the running brook, in
> the golden sunset, in the cottager's home, in the old churchyard? There
> is not a sunny spot or a dark shadow on the face of nature which is not
> calculated to improve the heart, if the eye that looks on it be pure and
> simple. (Oct. 1857, p. 388)

In other words, abstract virtues were less appealing than the common and
familiar subjects which had become a central feature of middle-class
aesthetics by 1857. If critics such as Lamb felt a need to "domesticate" civic
humanism's abstruse high-art goals, clearly, the working people for whom
the exhibition was purportedly staged experienced an even greater necessity.

Employers from all over the North and the Midlands arranged
excursions for their workers to ensure that this golden opportunity for self-
improvement was available to as many as possible. It comes as no surprise to
learn that Henry McConnel's factory hands attended.[55] They were joined
by thousands of additional workers brought in on special excursion trains
from such places as Birmingham, Liverpool, Macclesfield, Bradford, and
Halifax.[56] The largest and most elaborately scheduled group of day-trippers
came from Saltaire; it consisted of 2,500 workpeople from Titus Salt and
Company, a textile factory designed by Fairbairn's father, engineer Sir

William Fairbairn, which the *Art Treasures Examiner* described as a "monster manufactory."[57] The *Examiner* delighted in chronicling the fanfare that accompanied the Salt workers:

> These visitors, all attired in their Sunday best, were brought to
> Manchester in three special trains, the first train consisting of 37 carriages.
> The fine brass band belonging to the establishment accompanied the
> first two trains, and the Saltaire drum-and-fife band the last. The work-
> people entered the Exhibition in an orderly manner, with the bands
> playing "The Fine Old English Gentleman." They were accompanied
> by their generous employer, Mr. Titus Salt, who paid all the expenses
> connected with the trip, and remained with his interesting charge
> during the time they were in the palace. The 2,500 partook of dinner
> in the large refreshment tent adjoining the second-class room. (p. 252)

The brass band and free food were necessary adjuncts to an exhi-
bition which made no concessions to the working class's ability to appreci-
ate art. No matter how hard the uneducated tried to learn from the pictures
at Manchester, they were given little assistance. Nathaniel Hawthorne, on
one of his several visits, was moved by "how earnestly" some of the working
class "sought to get instruction from what they beheld."[58] Yet there were no
labels on the paintings, or placards on nearby walls, nor was the modern
section arranged in chronological order, making it impossible for all but the
connoisseur to trace stylistic development. Worst of all, there were no lec-
turers to explain the iconography of the English or any other school.
Contrary to the pedagogical goals voiced by Thomas Fairbairn, the orga-
nizing committee vetoed educational aids for fear they would reduce the
number of catalogues sold.[59] Without any art historical preparation, *The
Times* caustically observed on 16 September, workers' visits to the Art
Treasures were "like feeding infants strong meat." Charles Dickens con-
curred. After visiting Manchester, he expressed the concern that the exhibi-
tion was too lifeless and dull for working people, saying: "But they want
more amusement, and particularly something in motion, though it were
only a twisting fountain. The thing is too still after their lives of machinery;
the art flows over their heads in consequence."[60]

The "stillness" to which Dickens referred was not unique to the Art
Treasures exhibition, but is endemic to art museums in general. Their archi-
tectural grandeur and august settings dictate the viewer's relationship to
their treasures even before the point of entry. Architecturally intimidated
by the scale of these enterprises, the visitor is swept along vast hallways

leading to shrinelike galleries where paintings are displayed in a hushed atmosphere of reverence. While the correct posture of quiet contemplation is familiar to the initiate, the first-time visitor is destined to become restless.

Employers such as Titus Salt realized that they must enliven the experience for their workers in order to transform it into a positive one; however, Salt's decision to transport his noisy band into the exhibition itself excited controversy. The *Art Treasures Examiner* reported:

> After dinner, the drum-and-fife band took up a commanding position in the Clock Gallery, and played several of their most popular pieces, to the evident gratification of many of the visitors, though some thought the music hardly a fit character for the place; but even these cheerfully acquiesced on the principle that some license should be conceded on such an extraordinary occasion. (p. 252)

The general consensus, however, was that such entertainments produced a happy result. Friedrich Engels did not seem at all perturbed by the carnival atmosphere when he wrote to Karl Marx: "Everyone up here is an art lover just now and the talk is all of the pictures at the exhibition . . . you and your wife ought to come up this summer and see the thing."[61] Clearly the Art Treasures exhibition presented an unusual occasion for both workers and intelligentsia to enjoy themselves. Nonetheless some critics felt that it had failed to fulfill its mission to produce a lasting change among the lower classes.

Robert Lamb asked the question that was on everyone's lips when he wrote: "But what will be the permanent effect of the Exhibition upon our people?" Before suggesting a reply, Lamb recalled, "in April and May we . . . were told how it would teach pictorially those who were unable to read alphabetically – how artisans would derive instruction in the respective departments of their employment – how the Manchester man was to soar above his cotton, and become a poet in imagination, and a connoisseur in matters of taste." Lamb concludes: "Sanguine expectations these!" (*Fraser's*, p. 394). John Bright was equally skeptical. He ruminated in a letter to Richard Cobden: "I am not sure that the Collection of Pictures may not be almost too great for enjoyment. I don't believe in the regeneration of a people, or the saving of a Country by pictures, or statues, or by any amount of Fiddling."[62] While the organizers of the Art Treasures exhibition obviously did believe that it was possible to consolidate a community of beholders, they thought it unnecessary to provide instruction in the ways of seeing, presuming that images alone were sufficient to convey messages of civility.

That Fairbairn trusted the power of art to communicate universal values was revealed in a remark he made three years later, while reporting on the success of the Art Treasures exhibition. He described "the useful lesson of humility which gradually steals upon every one's thoughts, when he stands uncovered at the shrine of genius."[63] According to him, transcendental values, which required no explication, were automatically communicated by the efforts of the artist–genius. Yet, in private, Fairbairn did not treat the artists from whom he commissioned works of art as infallible paragons: he asked Holman Hunt to alter *The Awakening Conscience* (plate 17), requesting that the woman's tormented expression be replaced with a more radiant one.[64] Had Fairbairn truly believed in the concept of the artist as inspired genius he would not have dared to intervene in the creative process.

This was only one of the discrepancies between Fairbairn's public and private personalities. It became evident that he had allowed a degree of hubris to penetrate his promises concerning the Art Treasures exhibition when, in 1860, he altered his rhetoric in appealing to businessmen to join him in establishing a permanent art gallery in Manchester. While Fairbairn still insisted that the 1857 exhibition had had a positive effect on the 600,000–700,000 working people whom he claimed had attended it,[65] he now bypassed the benefits that a permanent display would have for the public and, instead, emphasized what his fellow committee members stood to gain personally. He cajoled: "I believe that everyone in this room, let him be ever so instructed, will readily admit, at least as regards himself, the pleasure and instruction which he would derive from the means of frequent association with works of Art which are in themselves beautiful" (p. 5). Fairbairn confirmed that his motives were not entirely altruistic when he went on to remind his fellow financiers that "self-interest calls us to action; because whatever hurts the humblest workman amongst us indirectly hurts ourselves; and whatever benefits him in his home, his income, his occupation, his character, or his tastes, benefits us too" (p. 6). His frank admission of his vested interest in the constructive channeling of working-class energies, would seem to sully the purity of his intentions.

But before we rush to condemn Fairbairn for exploiting laborers for his own ends, we should stop and assess the contributions he made toward improving their lot. He unselfishly invested time and energy in the Art Treasures project which he could have more profitably spent reaping rewards from his business. Moreover his efforts made it possible for thousands to experience the fine arts for the first time. Even if that did not

Plate 17. William Holman Hunt,
The Awakening Conscience, 1853–54,
oil on canvas

change their lives, it created goodwill between workers and employers.
Fairbairn further demonstrated that he placed the welfare of his community
above his own when he refused a knighthood for his efforts in 1857.[66] Thus
his determination to introduce Manchester's workers to the benefits of art
was less a question of self-interest and more a matter of a utopian belief in
the power of his class to articulate a new basis for social integration.

The rhetoric associated with the art for the public movement in Manchester cannot be dismissed as wholly ideological. It was pronounced by a commercial élite which was in the process of elucidating its goals in counterpoint to those of the classes situated above and below it in the social pyramid. Manchester's middle class ambitiously attempted to redefine art's place in the aristocratic order, before stamping it with its own imprint, and presenting it to the lower classes as an ennobling experience. "The aesthetic," according to Terry Eagleton, "offers a generous utopian image of reconciliation between men and women at present divided from one another, it also blocks and mystifies the real political movement towards such historical community."[67] But while the aesthetic may block the political, it does not necessarily invalidate it.

Reflecting on the sometimes paradoxical relationship between art and ideology, Eugene Lunn observes that even Marx and Engels saw some of the most obvious and self-serving bourgeois examples of ideology as "a form of historically understandable self-deception" and not "in terms of a conscious and hypocritical manipulation of the public by a cynical bourgeois elite."[68] That observation applied to men like Fairbairn and John Pender, who was to win an international reputation in mid-Victorian England in the new field of submarine telegraphy and who strongly endorsed Fairbairn's scheme for a permanent gallery in 1860. Pender confessed, "I feel a deep interest in any movement that is likely to add to the importance, and promote the social, moral and intellectual progress of this great industrial community" (p. 14). While this utterance can be construed as self-serving, it can also be taken as a yearning for a sense of community at a time of inexorable growth.

Manchester's collective self-interest encompassed an entirely different constellation of values than the individual self-interest practiced by Birmingham's business class. This difference became a matter of public record in the Art Treasures exhibition. Joseph Gillott lent Etty's playful *Bivouac of Cupid*, Danby's hushed *Poet's Hour*, and two lyrical landscapes by Turner – a selection of paintings in which the didactic element was noticeably absent. Gillott's loans signaled that there was a higher level of aesthetic appreciation operative in Birmingham, and that its middle class did not experience the need to marshal didactic art as a form of social control or to prescribe it as an antidote to proletarian malaise.

In drawing this contrast I am not suggesting that Birmingham and Manchester were opposed; rather, I am attempting to show how complexly

polysemic the provincial middle class was in the early-Victorian period. It lacked consistency not only within individual towns where private needs vied with public ambition, but also across the general terrain of the North and the Midlands, where time-honored practices resisted more progressive forms of modernism before finally capitulating to them. If I could unravel only one thread from the tangled skein of middle-class culture in the provinces, it would be that which led from closely knit Manchester to Birmingham, where the concept of collective self-interest underwent a transformation in purpose: it randomly meandered through industrial quarters, private homes, artists' studios, and auction houses, serving individual needs without forming any coherent pattern.

The compartmentalism suggested by this sketch also describes Birmingham's industry. Its system of individually owned workshops relied on independent businessmen who competed to maintain their edge among the "jungle of small firms producing essentially consumer goods for the home market,"[69] goods such as buttons, candlesticks, pens, and jewelry which earned Birmingham the epithet, "toy shop of the world." Because the proprietors of workshops depended on their employees to meet cost-effective deadlines, expediency was in their best interest rather than the long-range goals of Manchester's factory owners, whose fixed cycle of investment operated at a slower pace.[70] More intimate than the factory floor, the workshop drew owners and laborers into closer proximity, which in turn facilitated better communication.

De Tocqueville observed that workers in Birmingham seemed healthier and better provided for than in Manchester.[71] Some of the perquisites available to them impressed Dr. Waagen, who was struck by the cultural opportunities afforded by Birmingham's Town Hall, its Monday concert series, and its other forms of civic philanthropy. He noted in his 1857 *Galleries and Cabinets of Art*:

> Every philanthropist must hail with pleasure an arrangement which thus renders a noble and intellectual enjoyment accessible to the working classes. At the same time the manufacturers have shown a truly humane and Christian feeling by the way in which, by means of churches, schools, reading-rooms, and medical institutions, they have provided for the wants, spiritual and bodily, of their workmen. (p. 402)

Waagen's opinion was echoed by other Victorian observers such as Richard Cobden, who remarked that in Birmingham, with its "small

manufacturers, employing a few men and boys each . . . There is a freer inter-course between all classes than in the Lancashire town, where a great and impassable gulf separates the workman from his employer."[72] From state-ments like these, current scholars conclude that absence of class friction resulted in more opportunities for economic and social advancement. Asa Briggs reiterates Cobden's argument when he stresses that "there was con-siderable social mobility in Birmingham, or at least considerable local opti-mism about the prospects of 'rising in society.'"[73] Other authors, however, argue that there was indeed a separation between the classes, citing as evi-dence the Chartist riots of 1839 at the Bull Ring.[74] Both factions however, agree that the first lasting schism did not occur until the 1860s, when declining industry resulted in bankruptcies and unemployment which sparked an oppositional working-class movement.[75]

It was at that point that the middle-class leaders on the City Council levied a penny rate to establish an art gallery in conjunction with a central reference library and museum which the city fathers dedicated with the epigraph, "By the gains of Industry we promote Art."[76] This motto can be interpreted in a number of ways: as a concession to workers, as an apolo-gy for not acting sooner, or as a summation of the close relationship that existed between art and industry in Birmingham. The first and second explanations cast Birmingham's efforts in Manchester's shadow as a belated attempt to harness art as a keeper of the peace. But that scenario was not expanded into a full-length feature until the later Victorian period when large-scale investors consolidated the workshop system into larger units of production and when civic leaders such as the Cadburys, Chamberlains, Kendricks, and Tangyes financially supported the art for the public move-ment.[77] In the early- to mid-Victorian years, however, it was the close alliance between art and industry which was responsible for raising the level of aesthetic awareness in the community. Staffordshire's workshops depended on skilled designers and meticulous craftsmen, just as the ceram-ics produced in the Potteries district relied on knowledge of artistic princi-ples. The art gallery's epigraph would have been more accurate had it read, "By the efforts of Art we promote Industry."

The higher instance of cultural capital in the Midlands can be traced to the members of the late eighteenth-century Birmingham Lunar Society, to Matthew Boulton, who taught drawing and modeling to the employees of his Soho Works, to Joseph Priestley, who found time, away from his scientific experiments, to reorganize the main library, and to

Joseph Wright of Derby, who defied the recognized canon of subjects by rendering those experiments in paint.[78] Art appreciation in Birmingham, in other words, existed because of industry, not despite it as in Manchester.

Nevertheless that fact alone is insufficient to explain why ironmaster John Gibbons or pen manufacturer Joseph Gillott were more interested in color, brushwork, and composition than in the narrative lessons of painting. Another reason that the middle class was converted to connoisseurship in Birmingham owed to the compliance of its local aristocracy and gentry. Unlike Lancashire's absentee landlords, many Staffordshire aristocrats were actively involved in urban affairs, particularly in cultural endeavors. For instance, nine of the first fifteen presidents of the Birmingham and Midland Institute were local aristocrats.[79] This group was responsible for housing the School of Design and endorsing the idea of a public art gallery.[80] A climate of cooperation dulled the edge of middle-class dissatisfaction felt elsewhere, and made it less imperative for Birmingham's marginal men to claim a new territory for their cultural self-expression.

The composition of Gillott's collection, for instance, was closer to that of Lord Northwick, an early supporter of modern art, whom the pen manufacturer visited at Cheltenham, where he carefully studied the nobleman's vast collection.[81] Whether or not Joseph Gillott consciously modeled his taste after Northwick's is not certain; however, a painting of the picture gallery at Thirlestaine House (plate 18) reveals that the aristocrat and the commoner favored many of the same artists: Francis Danby, whose painting *The Wood-Nymph's Hymn to the Rising Sun* appears at the left, below Titian's *Pope Paul III*, was well represented in Gillott's collection.[82] Daniel Maclise, whose *Robin Hood and his Merry Men* hangs on the right, next to a version of Reynolds's *Infant Hercules*, was also one of Gillott's favorite artists; moreover, he owned several pictures by Reynolds. Gillott must have been enormously pleased when Lord Northwick complimented him in a letter of 14 October 1846 on his "taste and discrimination and true feeling for works of Art of a superior order."[83]

Gillott's taste, however, also revealed the amateur's appreciation of delectable surface, soft and subtle lighting, and luminous composition, while at the same time it echoed the local middle class's preference for the traditional category of landscape. Because the amateur tradition did not have negative class-based associations in Staffordshire, it continued to thrive among businessmen. Charles Birch, John Gibbons, and pottery manufacturer Charles Meigh junior were all artists, while Edwin Bullock was a

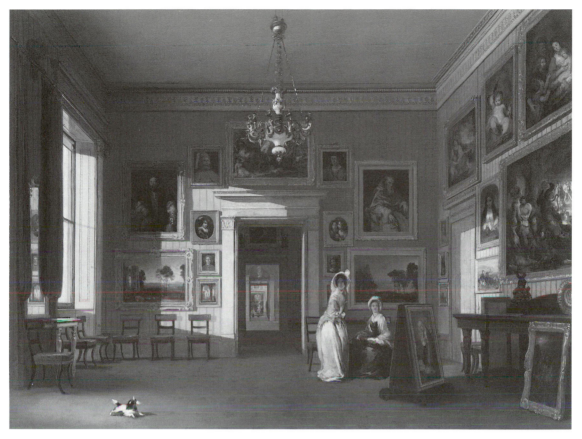

Plate 18. Robert Huskisson,
*Lord Northwick's Picture Gallery
at Thirlestaine House, c.* 1846

connoisseur of the works of Turner, Müller, Constable (he owned seven), and David Cox.[84] The high regard for landscape painting among local collectors was reinforced by the presence of David Cox. Much as Jacob Bell shepherded Landseer's affairs, Charles Birch supervised Cox's move to Birmingham by finding a house for him near his own and overseeing its repairs. Other Birmingham collectors gathered around Cox: Bullock and Roberts were in and out of his studio and even Gillott visited him at Betws-y-Coed.[85] This first-hand exposure and eager interest in the creative process partially accounts for the aesthetic awareness of Birmingham collections.

John Gibbons, on one occasion, practically begged William Frith to keep him informed about a painting he had commissioned, so that he could vicariously be present at its birth.[86] Enriched by his own attempts at depicting nature, Gibbons exhaustively scrutinized the work of professional artists. Frith records a letter in his *Autobiography* that characterizes Gibbons's astuteness:

> Your picture . . . looks well; but I still feel that there is something wrong
> about its general effect, that the eye is not fully satisfied. I hardly know
> why. The story is capitally told, the character is good, the local colour
> good, the keeping good; so that the defect, if there be any, is in the man-
> agement of the light and shade, the chiaroscuro. I believe myself that the
> whole of the background is in too light a key, and that thus the repose
> and harmony of the composition is disturbed. (III, 211)

Frith generally felt no hesitation about putting interfering collectors in
their place, yet he considered Gibbons "a most kind and generous patron,"
and therefore accepted his critique in a constructive rather than an offensive
light.[87]

Although Gibbons and Gillott are often spoken of in the same
breath in discussions of middle-class Birmingham collectors, they came
from opposite ends of the social scale. Gibbons, like William Wells, sprang
from a prosperous family which dated back to the seventeenth century.[88]
Classically educated and in delicate health, Gibbons was the antithesis of
the robust and self-taught Gillott. Therefore, because Gillott purchased
Gibbons's home, in 1845, when the ironmaster decided to retire to London,
it would seem logical to assume that the pen manufacturer was attempting
to model himself after the connoisseur. While I do not dispute this assess-
ment, I will demonstrate that Gibbons was only one in a long line of rep-
utable and disreputable individuals whom Gillott found convenient to his
purposes.

By 1845 Gillott could afford to leave his modest home on Newall
Street for a palatial dwelling in Edgbaston, the "Belgravia" of Birmingham,
a fashionable community that was home to the mercantile élite. The new
suburb was extolled in rhyming couplets by H. H. Horton in 1851 in a poem
which throws some light on Gillott's reasons for living there:

> See Edgbaston, the bed of prosperous trade
> Where they recline who have their fortunes made;
> Strong in their wealth, no matter how possessed,
> There fashion calls, and there at ease they rest.[89]

The move to Edgbaston suggests that Gillott was someone who cared about
status and the opinion of his neighbors. David Cannadine notes in his
detailed study of the development of this exclusive suburb that Gillott's
house, "even by contemporary Edgbaston standards . . . was lavish – six

bedrooms, a library, extensive wine cellars, two picture galleries, stables, an aviary, a greenhouse and a carpenter's shop."[90] Many of these features were improvements added by Gillott to the original house after he purchased it from Gibbons. By moving into Gibbons's home, Gillott symbolically laid claim to that intangible part of the older collector that classed him a gentleman.

Gillott's attitude toward his social and cultural superiors is crucial to an understanding of his motives and taste in art collecting. The force of the legend of Joseph Gillott the self-made man tends to negate any notion of him as a man of taste. Gillott was what the Victorians themselves described as "a character." Originally a cutler from Sheffield, he liked to dazzle his friends by pulling from his pockets precious stones wrapped in bits of paper. John Linnell, with whom Gillott conducted several complicated artistic deals, reported that whenever Gillott invited him to tea in his rooms at Furnival's Inn, where he stayed on his visits to London, "The queer little pen-manufacturer would empty out the pot, and make fresh tea for every cup they drank, saying that they could not drink it stale."[91]

Naive in the social graces, Gillott was worldly wise when it came to business. A portrait sketch by R. E. Tayler (plate 19), made during the last years of Gillott's life, supplements the description of his appearance and mannerisms published in the *Birmingham Daily Post* on 6 January 1872:

> His figure was short, sturdy, square; his hair and beard silvery and venerable; his forehead broad, well rounded, high; his eyes clear, humorous, and bright; his expression pleasant and assuring; his walk light, active, firm. His chief characteristics were remarkable quickness and accuracy of observation, wonderful shrewdness, common sense and frankness, boldness, and decision, and enterprise, rare mechanical skill and constructive powers, special talent for arrangement and organisation, and rapid and sound judgment on all matters which came before him.

Gillott's "wonderful shrewdness" and "common sense" were responsible for his fortune. He switched from buckle-making to the pen trade at a time when the spread of education and commerce created a great increase in the need for writing and record-keeping. The subsequent demand for writing materials, which increased after the introduction of penny postage, could not be met by the laboriously produced quill pen.[92] Quickly perfecting a way to mechanize the manufacture of pen nibs, Gillott was soon churning out over 5 tons of gold, silver, and steel pens per week.[93] He invested his

Plate 19. R. E. Tayler, *Joseph Gillott,* drawing, *c.* 1870

profits wisely. In 1851 Gillott purchased a further 500 acres in Edgbaston for £90,000 which, Cannadine maintains, he subsequently developed "in conscious imitation" of Lord Calthorpe, whose family had created the Edgbaston estate.[94] That explanation accounts for the way he presumably wished others to view him. Privately, Gillott emulated shrewder and less-distinguished men.

When Gillott first decided to become an art collector in the 1830s, he turned to ironmaster and coal mine proprietor Charles Birch for his role model.[95] Victorian historians offer several reasons why the clever but unpolished Gillott may have admired Charles Birch. Tom Presterne, in his history of Harborne, recalls that the sometime-dealer was "one of the handsomest figures I have ever seen. He was tall and aristocratic in his bearing. He had dark curly hair, and black penetrating eyes which would almost discover the innermost being of friend or enemy." [96] With his magnetic visage and knowledgeable discourse on art, the more sophisticated Birch must have irresistibly drawn the rough-hewn pen manufacturer to him. Members of the Birch family had been property owners in Staffordshire since the seventeenth century; however, because Charles Birch was not a civic leader or an exceptionally rich man, there were no obituaries published at the time of his death to explain whether his lineage was responsible for his elegant bearing, or whether he simply emulated his social betters.[97] One suspects that it was not Birch's genealogy that attracted Gillott to him, but the fact that he perceived Birch as someone worth studying because of his skill at manipulating the art market.

Birch staged a series of sales of his collection following a disastrous fire at his coal mine. Birch's mine was located near Dudley, in the Black Country of south Staffordshire, long famous for its coal fields. Coal veins in this region were rarely deep, making them easily accessible to small capitalists who could work them cheaply.[98] The risks were great, however, as Black Country "thick" coal was susceptible to spontaneous combustion, especially in the deeper pits. Presumably such a cataclysm occurred at Birch's mine, precipitating his fall from fortune.

During the thirty years he was active in the Birmingham area, Birch was recognized as an influential art authority.[99] One reason why Birch's peers accepted his judgments is that he always seemed to be in the right place at the right time, in the right company. Ever the dedicated connoisseur, he made himself indispensable. When Gillott was not at home to receive a call from Lord Northwick in 1846, Birch willingly gave the patrician patron a tour of the neighborhood in his carriage and a private view of his own collection at Metchley Abbey; when Rosa Bonheur visited Birmingham ten years later, Birch hosted a gala dinner in her honor to which he invited "literary men, artists, and patrons of art"; and when David Cox's friends decided to honor the painter by commissioning a portrait of him, the presentation collation took place in the private picture gallery of the chairman of the portrait committee – Charles Birch.[100] Birch was also admired for his close relationships with artists. Like London stockbroker William Stone Ellis, he often accompanied David Cox on sketching trips; however, unlike Ellis, who was in awe of artists, Birch tried to control Cox's career.[101]

One reason Cox moved from London to Birmingham in 1841 was to try to become more proficient in oil painting by studying the canvases in Birch's well-appointed gallery.[102] However, Birch tried to dissuade him from adopting the new medium, arguing that Cox should not jeopardize the reputation he had won as a watercolorist. Fortunately, another Birmingham patron, William Roberts, intervened and encouraged Cox to expand his repertoire.[103] Although Birch finally accepted Cox's decision, and even bought some of his canvases, the prices he paid him for oils remained in the watercolor range (£8–£25).[104] One wonders if this was force of habit on Birch's part or if he recognized a good investment when he saw one: in the sale of his collection David Cox's oils quadrupled in value.

But it was not the prices earned by the Coxes in Birch's various sales that were the talk of London – they were insignificant compared with

his Turners, Ettys, and Landseers, which set saleroom records and excited a controversy over English art's rapid escalation in value. After his coal mine burned in 1855, Birch staged six sales at Foster's in London over the following four years, beginning with a well-advertised auction on 15 February 1855. The *Art Journal* was full of sympathy for Birch's predicament when it announced the forthcoming event in its February issue, expressing the hope that it would prove modern art a safe investment (p. 65). The remarkable change in tone in the next month's issue reveals that its editor, Samuel Carter Hall, was taken aback by the spectacular prices afforded by Birch's collection, despite the fact that the publisher had touted the merits of the English School in the pages of his journal for over fifteen years. The *Art Journal* editorialized:

> Specimens of our best artists are still eagerly sought after, and large sums – we may say, in some instances, ridiculously large sums – are forthcoming for their acquisition. Without any desire to prejudice the exertions of our painters, or to damp the enthusiasm of collectors, it is yet our duty to offer an opinion that the time cannot be very far distant when the latter will find they have often "paid too much for their whistles." (p. 96)

The fact that Turner's *The Lock* (*Grand Junction Canal at Southall Mill*) brought 600 guineas caused the *Art Journal* to exclaim that it was "a most extravagant sum for a picture which, according to our judgment, never possessed any of the best qualities of Art." Equally overpriced in its opinion was Etty's *Fleur de Lys* at 700 guineas, "another outrageous price," in contrast to Constable's *Barge Passing a Lock,* which, although of a subject similar to Turner's, was considered "well worth" the 860 guineas it realized.

In making these remarks, the *Art Journal* was concerned that English art would price itself out of the marketplace. Jeremy Maas identifies the 1850s as the beginning of an intensive period of investment in contemporary English art that naturally followed "a period of daring speculative ventures, beginning with the railway mania in the forties" and lasting until the Franco-Prussian War of 1871.[105] Furthermore, in commenting on the increased value of the works of recently deceased artists such as Constable, Turner, and Etty, Gerald Reitlinger adds: "What happened in the 1850s was something quite new. The conviction that Turner had been underrated in his own lifetime became so strong that even his followers achieved old-master status."[106] Charles Birch, then, was one of the first to benefit from

investing in English masters of the previous generation. His good fortune did not occur without a great deal of forethought and planning: he piqued interest in the sale at Fosters' with advance publicity and a catalogue illustrated with fine wood engravings.

Birch repeated the practice with equal success for his next sale at Foster's in February 1856. The top price was brought by Maclise's enormous (12 × 6 feet) *Baron's Hall* at £1,050, which Birch had lent in 1855 to the Universal Exposition at Paris. The fact that Maclise and John Linnell, two of the artists whose works sold for high amounts, were still alive made it clear that rising values of English art were not restricted to its deceased practitioners. The *Art Journal* overcame its initial shock and now assured its subscribers: "One thing is evident from this sale; our painters need not at present begin to despond, nor fear to be driven out of the field by the progress of photography, or any other of the many *graphics* which our age has produced; the painter's star is yet in the ascendant" (April 1856, 115).

Surprisingly, the same could not be said about Birch's third sale, in 1857, even though it featured another illustrated catalogue, this time studded with reproductions of such well-known works as Constable's *Opening of Waterloo Bridge* and Maclise's two frescoes, the *Spirit of Justice* and the *Spirit of Chivalry* (plate 20). While the Constable brought a respectable £609, the Maclises only fetched £430 between them despite the fact that they were well-executed reduced copies of his commissions for the Houses of Parliament. Nor was the drop in prices a matter of a fluctuating art market. The *Art Journal* dismissed this possibility when it ruminated: "The average prices realised by these pictures …are certainly lower than we have been accustomed to record as given for works of similar character."[107] The problem was not with the merits of the English school, but with Birch's behind-the-scenes machinations.

The sudden drop in value of Birch's collection occurred when the dealers who attended the sale realized that they were being offered pictures reputedly sold in his previous sales in 1855 and 1856. Whereas the *Art Journal* reported in 1855 that Etty's *Fleur de Lys* sold for the "outrageous price" of 700 guineas (p. 96), this painting apparently never left Birch's possession; it was offered for sale again in 1857, when it brought £525.[108] Similarly, Etty's *Golden Age*, which reputedly brought £850 in the previous year's sale, was knocked down once again for the smaller amount of £630. This turn of events suggests that the remarkable prices earned at Birch's first two sales were deliberately inflated by insider bidding. The *Art Journal*, in

Plate 20. Daniel Maclise, *The Spirit of Chivalry*, c. 1845–49, wood engraving

fact, had noticed in 1856 that, "the dealers mustered numerously in the rooms of the auctioneers and bid so freely there was no chance of any mere amateur securing a bargain" (p. 115). Whether this scheme was Birch's idea, was suggested by Foster's, or was possibly even orchestrated in cooperation with Joseph Gillott (who had a consortium of dealers to call upon) will never be known, since Birch's correspondence disappeared some time

before 1873. Moreover Birch himself mysteriously dropped out of sight after his 1865 sale.[109]

The manipulation of art auction prices is unusual for the early-Victorian period. While some of the London art collectors who I described dabbled in the art market, the majority valued art for the messages they could extract from it. Art's value as a social text was even more highly cherished by Manchester's solicitous patrons. But in Birmingham, where the oral tradition had been less disrupted by industrial change, narrative painting did not gain a strong foothold. Because its indigenous economy, as I have explained, was centered on the frequent exchange of commodities, art became one more item in the long list of products destined for sale. The process was expedited by the local preference for the artistic over the anecdotal, proving Simmel's contention that aesthetic experience occurs when moral value is reduced to exchange value.[110] That rapid exchanges became the norm in the art world is verified by artist Thomas Uwins, who was taken aback when he visited Birmingham, in 1841, to discover just how widespread the practice had become. He reported: "My private business at Birmingham terminated oddly. I said to the new possessor of my picture of the *Saint Shop*, that I would give for it what I had received. He immediately took me at my word, and I am now again the proprietor of my own picture, the patron being a gainer by the transaction of thirty guineas."[111]

Uwins might have been describing any number of Birmingham businessman–collectors who interpreted the rules of political economy literally. Men such as Charles Birch and Joseph Gillott took to heart the principle which David Solkin recently described in his book, *Painting for Money: The Visual Arts and the Public Sphere in Eighteenth-Century England* (1993), as "the heretical proposal that the general good might best be served by a pattern of acquisitive behaviour driven entirely by personal desires" (p. 1). Whereas in Manchester, self-interested expenditures were rationalized by the positive contribution they made to the public good, in Birmingham they were viewed as extensions of the workshop mentality which supported the local economy. Birch and Gillott therefore took the lessons that they had learned in the mercantile market and applied them to art.

Gillott's numerous letterbooks and ledgers, preserved in the Getty Archives, reveal that he began to collect and to deal in art in earnest in the late 1850s, at the time of Birch's sales. George Gee, a dealer with whom Gillott sometimes did business, estimated that the rich penmaker had spent "upwards of £80,000 to £100,000" on art between the years 1849 and

1857.[112] Yet these were the fledgling years when Gillott was serving his apprenticeship, as an art collector and *marchand amateur*. After that time, his art expenditures defy computation, because, as Jeannie Chapel noted in her article on Gillott and Turner, Gillott's dealings were often Byzantine:

> Throughout Gillott's extensive business, particularly with dealers, there emerge complicated transactions often involving large numbers of paintings, either singly or in groups, being exchanged for cash, violins, wine, horses, jewels and pens, and this became common practice. On one occasion, early in Gillott's collecting career, he exchanged *The Elopement* by Van Schendel, landscapes by Schelfout, Ruysdael and one "with sheep" by Ommeganck, a portrait by Cuyp and *Fête Champêtre* by Henry Andrews with the dealer Louis Victor Flatow (1820-1867) for 14,020 gross-worth of steel pens.[113]

Gillott's practices straddle the old and the new modes of art consumption. When he bartered pens for paintings he was following a pre-industrial system of exchange. This characteristic also stamps his eclectic collection of rare trees and shrubs, gems, and violins, which resembled the cluttered assemblages of bric-a-brac imported into England by eighteenth-century traders.[114] But when Gillott speculated on art as an investment, he demonstrated his awareness of modern economic models. Gillott proudly told artist T. S. Cooper that he had bought eight Turners, kept the two best for himself, and immediately sold the remaining six for what he had originally paid for the lot.[115] In this regard, Gillott followed a nineteenth-century pattern of economic objectification which "reconstitutes the subject as an owner, consumer, or seller of commodities."[116] He was so active in each of these categories that he retained a retinue of local and London dealers, such as William Hall, Edwin Everett, Thomas Rought, Samuel Woodburn, and Ernest Gambart. Moreover, Gillott hired a former Birmingham art dealer, Charles Hawker, as his private secretary in the 1850s, when he began to trade most actively on the art market.[117]

The voluminous correspondence that Hawker penned for his employer indicates that rarely a week went by without a transaction of some kind with artists, dealers, or fellow collectors. Gillott must have felt empowered when he wrote out cheques to luminaries such as Lord Northwick and John Gibbons, or when he lent money to sophisticated but impoverished Charles Birch.[118] His dealings with Liverpool collector John Miller were less satisfactory, at least from Miller's point of view: he complained

of feeling "cruelly treated" and "upset" by the pen manufacturer's delays in submitting payment.[119] Moreover Gillott's letter books reveal that his arrangements with certain dealers were somewhat shady. For instance, he used the services of John du Jardin, a restorer who often touched up paintings for him as a "secret service" before Gillott resold them.[120] As Catherine Coan concludes, in regard to such practices, an "unflattering picture of Gillott emerges, as a man of fluctuating, if not fickle taste, who tomorrow for a new prize, would trade yesterday's trophy."[121] After almost forty years of buying, bartering, and selling, the 525 lots of oils and watercolors that brought almost £170,000 at Christie's in 1872, after Gillott's death, represented only a small portion of the pictures that passed through his hands.[122]

The art objects in Gillott's final sale reveal a degree of consistency. One would expect, considering his lack of education and unrefined habits, that he would have preferred simple narratives and humorous anecdotes. On the contrary, Gillott's collection is remarkable in the early-Victorian period for an almost total absence of genre painting. Instead, he preferred the idyllic landscapes and seascapes of Müller and Turner,[123] the poetic fantasies of Etty, the heroic figurative compositions of Maclise, and the hypnotically detailed still-lifes of William Henry Hunt. The historical scope and range of Gillott's collection was even more carefully balanced than Robert Vernon's. Both collections featured Old Master canvases,[124] and chronologically surveyed the progress of the English School from the time of Reynolds, Wilson, and Gainsborough to the moderns. But Gillott did not imitate Vernon in sacrificing one-third of his wall space to popular narrative subjects. Thus his was not a strictly cabinet-sized collection like Sheepshanks's, but neither did it contain as many large canvases as Vernon's.[125] Rather, in its recognition of the aesthetics of painting, Gillott's collection most closely approximated Jacob Bell's.

The degree of Gillott's visual acuity becomes apparent in his careful critiques of the paintings he bought. In sending out a picture by John Crome to be restored, the pen manufacturer cautioned: "I am anxious that the *round fat touches* should not be *flattened*."[126] Such a tangibly physical response to brushwork is indicative of the keen eye of a connoisseur. In his rivalry with Birch and his admiration for Gibbons, Gillott not only followed their preferences for figural and natural subjects over anecdotal painting, but also apparently learned from them to pay close attention to the components of art-making. On another occasion, his sense of proportion led Gillott to notice that Daniel Maclise's *Choice of Hercules* would be

improved by "a slight elongation of drapery."[127] Also, like Gibbons, he requested changes from Frith, specifying that a recent purchase, *The Lovers*, needed the "sky carrying out and just touching round the margin."[128] It is typical of Gillott to prize painterly over narrative values. Another instance is provided by one of the few anecdotal paintings he owned, Thomas Webster's *Roast Pig* (plate 21).[129] There is a formal deftness and balance in this work that grants it an appeal independent of its homely subject and which makes it seem less out of place in a Birmingham collection. It is an example of Webster's more expressive later style, in which narrative vies with his more developed sense of formal construction for attention. Andrew Greg maintains that *Roast Pig* reveals "the best of Webster's characteristically fluid use of figures," which he describes in terms of their "almost baroque rhythms."[130] Gillott was willing to pay handsomely for *Roast Pig*. He commissioned it for £700, as much as he spent on any of his Turners. His judgment was vindicated at his posthumous sale, in 1872, when Agnew's paid £3,727 for it.

But we must still recognize the likelihood that some aesthetic editorializing originated with Gillott's secretary, Charles Hawker. He and Cox's biographer, the dealer William Hall, have been credited by at least one Victorian source for influencing the formation of taste in early-Victorian Birmingham.[131] Yet John Linnell's biographer marveled at Gillott's personal incisiveness: "Although what is called a 'self-made man,' Mr. Gillott had very fine perceptions in art, and seldom made a wrong judgment" (II, 21). Few would dispute that Gillott was a quick learner or that, like other early-Victorian self-made men such as James Morrison, he was anxious to master the abstruse codes of painting. Behind their compulsion to assemble large and important art collections hovers the self-made man's hunger for knowledge. Yet it was not erudition for its own sake that drove these entrepreneurs to learn the language of the connoisseur. Theirs was not a disinterested appreciation of art, but a self-serving one that benefited them economically and socially. Thus while Gillott was absorbed with brushwork, proportion, and composition, he never completely lost himself in the distanced contemplation of the connoisseur.

The regard for money and its promised advantages links the emerging metropolitan and provincial middle classes in the early-Victorian period. Whether it facilitated personal gain and private experiences, as in Birmingham, or communal coherence and public well-being, as in Manchester (or a combination of the two in London), money was an agent of change,

Plate 21. Thomas Webster,
Roast Pig, 1862, oil on canvas

improvement, and progress. Although social attitudes toward capital varied widely in individual communities, patterns of acquisition were ideologically tied to the Protestant work ethic. Birmingham's self-interested investors and speculators had as high a regard for the social utility of labor as Manchester's civic humanists or London's commercial élite. It follows that these middle-class magnates would measure the art they bought against this standard.

Despite their varying aesthetic sensibilities, early-Victorian art collectors shared one common feature: an appreciation of paintings with a high degree of finish. They favored canvases which demonstrably proved that artists had labored long and hard over their subjects. Wilkie, for instance, was offered a financial bonus by a client, in 1821, if he agreed to redo a painting with more detail.[132] Frith encountered a comparable proposal from John Gibbons, in 1843, when the ironmaster informed him, "I *love finish*, even to the *minutest details*. I know the time it takes and that it must be paid for; but this I do not object to."[133] Gillott, despite his admiration for

creative brushwork, also expected the paintings he ordered from artists to exhibit visible evidence of time-consuming labor. In commissioning *Roast Pig* from Webster, the patron specified that it feature "the high finish you so much excel in."[134] Francis Danby, an artist who was noted for his fluid brush, quickly caught on to this growing preference: he reassured Gillott that the picture he was painting for him was "*light, bright* ...and highly finished."[135] Similarly, in Manchester, crisply detailed paintings by artists such as Webster, Egg, and Frith proliferated. Victorian painting styles became labor-intensive, whether the object was to render telling detail in a Hogarthian manner or to embellish a vista with the verisimilitude of nature.

Precisely when the shift from the vigorous impasto of the eighteenth century to the enameled surface of the Victorians occurred is imprecise. Dr. Waagen, in his first volume on English collections, published in 1838, complained of the "flimsiness and negligence" and "misty indistinctness" displayed by artists who followed Hogarth and Reynolds, a tendency which he felt was rectified by Wilkie's "careful and complete making-out of the details."[136] By the time of the Vernon Gift, the *Art Union* identified mindful technique as a salient feature of the English School. It traced this development in an article on Vernon's collection, in 1847, when it classified *Old Pier, Littlehampton*, an early work of 1812 by Callcott, as "painted in the free style of the infancy of our school," and contrasted it with the artist's later pictures, which marked a "change from a free touch to minute finish" (p. 366). The English School's mutation in style, however, was less a matter of artistic evolution than a response to the middle class's desire to leave its mark on contemporary culture.

Foucault has proposed that the formal elements of painting can be interpreted discursively, as ethical expressions of an implicit philosophy. He calls this method an "archaeological analysis" and maintains that its purpose is "to discover whether space, distance, depth, colour, light, proportions, volumes, and contours were not, at the period in question, considered, named, enunciated, and conceptualized in a discursive practice."[137] I have suggested that middle-class collectors, who wanted to be assured that the work ethic they lived by was honored in the art they bought, were responsible for fostering the trend toward proficiently executed paintings. Jonathan Crary rephrases this point of view when he discusses "the problem of mimesis," which he contends, "is not one of aesthetics but of social power, a power founded on the capacity to produce equivalences."[138] This line of thought also brings us to the conclusion that the highly finished and

detailed surface of Victorian art announced the middle class's moral equation between manual labor and the well-honed finished product.

Baudrillard offers a further explanation when he argues that varnished and lacquered surfaces, like mirrors, conform to the "formal logic" of the bourgeois environment. He maintains: "There is a triumph of conditioning, of envelopment by an all-powerful puritan morality, of ritual hygiene; the triumph of varnish, polish, veneer."[139] That sanitized and perfected view of the world is comparable to the mode of comprehension that I described in chapter 1 which countenanced the practice of replication. In other words, both the highly finished image and the replica are products of an attempt to produce equivalences between the conceptual and the real, to collapse the distinction between belief and mimesis, and to create conformity between moral order and aesthetic logic. It is no coincidence, then, that the copy flourished alongside the crisply realistic original in provincial collections as well as in London throughout early-Victorian England.[140]

Everyone knows that the Pre-Raphaelites made the finely wrought image even more pronounced in the late 1840s and 1850s. I will return to this issue in the following chapter, when I take up the question of why Pre-Raphaelitism's detailed and smooth surfaces controvert standard definitions of modernism. Preliminary to that discussion, I want to consider the resistance of Birmingham's patrons to this avant-garde movement, even though it abided by their preference for highly finished art.

Civilized and cultured though it may have been, Birmingham was more complacent about experimental art compared to Manchester. As Richard Ormond concluded in his study of art in Birmingham, the early-Victorian city "remained obstinately philistine" in its refusal to accept avant-garde art.[141] Content with their city's record of achievement, middle-class patrons preferred to accept the familiar over the adventurous. Birmingham's businessmen saw no reason to interrupt the comfortable recitations of the traditional credo. As we saw, the genesis of the middle class in this community was defined in relation to existing values rather than in opposition to them. Middle-class pride was a matter of making workshops and foundries more efficient, of cultivating relations with the local aristocracy and gentry, and of amassing individual fortunes. The art-collecting élite in Birmingham remained unresponsive to advanced art until after 1860, when the business community relinquished its attachment to the old ways and opened the door to the reorganization schemes of modern commerce.

Try as they might, the Pre-Raphaelites made little headway in Birmingham collections. Gibbons, for instance, bought one of Holman Hunt's paintings, but kept it hidden away in a closet, while Gillott disparagingly referred to Hunt's nocturnal image of Christ, *The Light of the World*, as "that man with his lantern."[142] Typically, Gillott put his reservations aside when he saw a chance to make money from investing in the engraving of the picture, but he still did not change his mind about hanging art of this kind in his home. Thus the Pre-Raphaelites' entrée into Birmingham collections was delayed until the latter part of the century.

For all their interest in social cohesion, Lancashire patrons were widely applauded for supporting new movements in art. Eager to be in the forefront of the most important cultural and social changes of their generation and to separate themselves from the habits of the aristocracy, the Manchester men who paid for some of the most adventurous warehouse designs of the period were sympathetic to the idea of a companion movement in painting. The dozen Pre-Raphaelite canvases on display at the Art Treasures exhibition announced that the avant-garde had won recognition in Lancashire.

The most popular picture in the exhibition was not Fairbairn's prized modern moral subject by Holman Hunt, *The Awakening Conscience*, but *Chatterton* (plate 22), painted by Pre-Raphaelite follower Henry Wallis, and lent by artist Augustus Egg.[143] Cotton manufacturer Henry Gibbs reported that this tragic image of a suicide was "the idol of the public" and that "the self-destroyed young poet, lying on a couch in his garret, and clothed in a silk suit, remained there for six months in his alluring ghastliness, attracting thousands of morbid eyes day after day." [144] John Ruskin contributed to *Chatterton*'s mystique when he proclaimed it "faultless and wonderful: a most noble example of the great school," and exhorted his readers to "examine it well inch by inch."[145] So pressing was the crowd around the picture that two policemen had to be assigned to its protection.[146] The memory of it at the Art Treasures obsessed Henry McConnel until 1875, when he was able to buy a smaller replica of it.[147] How ironic that the romantic image of an artist who was rejected by bourgeois society would have accrued so many accolades in middle-class Manchester.

One could argue that the tenor of this compelling little (23½ × 36 inches) picture was in keeping with the solemn strain that ran throughout the Art Treasures exhibition and that, despite its melodramatic presentation of the martyred artist, *Chatterton* contained the hallmarks of aesthetic

Plate 22. Henry Wallis, *Chatterton*, 1855–56, oil on canvas

reform: the gutted candle on the table, the torn scraps of discarded poems on the bare floorboards alongside the deadly vial of arsenic, and the morbid still-life arrangement of the body itself draw the viewer's attention to the frontal plane with a vivid intensity that tends to compress the pictorial space in a way that anticipates the liberties taken with the picture plane by twentieth-century artists. Conversely, this shallow space also suggests the naively rendered images of the early Renaissance artists who were the Pre-Raphaelites' namesakes. The implications of this mingling of visual codes is the subject of the next chapter.

Notes

1 The latter definition is Raymond Williams's. See *The Sociology of Culture* (New York: 1981), p. 13. For the anthropological and other definitions of culture, see the introduction to *Rethinking Popular Culture: Contemporary Perspectives in Cultural Studies*, ed. Chandra Mukerji and Michael Schudson (Berkeley: 1991).

2 Peter Gay, *The Bourgeois Experience: Victoria to Freud*, 4 vols. (Oxford: 1984–95), I, 17.

3 C. Dellheim, "Imagining England: Victorian Views of the North," *Northern History* 22 (1986), 217.

4 Leonore Davidoff and Catherine Hall, *Family Fortunes: Men and Women of the English Middle Class, 1780–1850* (Chicago: 1987), p. 23.

5 Asa Briggs, *Victorian Cities* (London: 1963), p. 243.

6 In Manchester, Waagen visited cotton spinner Samuel Ashton, railwayman John Chapman, and stockbroker Henry Cooke. The *Art Journal*, in addition to reviewing the Chapman and Cooke collections, described the art belonging to cotton spinners William Bashall, Henry McConnel, and Thomas Miller, and to barrister Richard Newsham. In Birmingham, Dr. Waagen was taken by the painter John Horsley to see the homes of ironmasters Edwin Bullock and Charles Birch, pen manufacturer Joseph Gillott, and lead and glass merchant William Sharp. Gillott and pottery manufacturer Charles Meigh of Shelton were the only local collectors who attracted the *Art Journal*'s attention.

7 Briggs, *Victorian Cities*, p. 83.

8 Benjamin Disraeli (Lord Beaverbrook), *Coningsby* (1844; rpt. London: 1959), book 4, ch. 1, pp. 130–31.

9 Eric Hobsbawm, *Industry and Empire* (Harmondsworth: 1985), p. 34.

10 "The Pictures of Richard Newsham, Esq., of Preston," *Art Journal* (Nov. 1858), 322. Additional statements about the importance of Lancashire collections appear in (Feb. 1857), 1 and (March 1870), 70.

11 Geraldine Jewsbury, *Marian Withers*, 3 vols. (London: 1851), III, 239–40, cited in Ivan Melada, *The Captain of Industry in English Fiction, 1821–1871* (Albuquerque: 1970), p. 47.

12 Melada, *ibid.*, pp. 13–14.

13 The social origins of each are given in the appendix. Those who were removed by at least three generations from lowly origins were Ashton, Fairbairn, McConnel, Miller, and Newsham. The biographical information that is available on Bashall and Chapman is more limited; however, it suggests that their forebears possessed fortunes for at least one, if not two, generations. Only Henry Cooke's and James Eden's social origins are unknown. Since Cooke was Honorary Secretary of the Royal Manchester Institution, it is unlikely that he was a self-starter.

14 Kathryn Moore Heleniak, *William Mulready* (New Haven: 1980), n. 130, p. 236. See also Marcia Pointon, *William Mulready* (London: Victoria and Albert Museum, 1986) p. 70. The commission was not completed. For McConnel's background and religious beliefs, see Julian Treuherz, "The Turner Collector: Henry McConnel, Cotton Spinner," *Turner Studies* 6 (Winter 1986), 37–42.

15 The paintings are described in the *Art Journal* (Sept. 1870), 286.

16 Martin Butlin and Evelyn Joll, *The*

Paintings of J. M. W. Turner, 2 vols. (New Haven: 1984), I, no. 360, pp. 210–11.

17 Alexis de Tocqueville, *Journeys to England and Ireland*, ed. J. P. Mayer (New Haven: 1958), p. 108.

18 See Louise A. Tilly and Joan W. Scott, *Women, Work, and Family* (New York: 1978), p. 83.

19 *Report of Factory Inspector Leonard Horner* (1831), cited in David Gadian, "Class Formation and Class Action in North-West Industrial Towns, 1830–1850," in *Class, Power and Social Structure in British Nineteenth-Century Towns*, ed. R. J. Morris (Leicester: 1986), p. 56.

20 Francis White & Co., *History, Gazetteer and Directory of the County of Derby* (Leeds: 1857), p. 642.

21 Janet Wolff, "The Problem of Ideology in the Sociology of Art: A Case Study of Manchester in the Nineteenth Century," *Media, Culture and Society* 4 (1982), 68.

22 V. A. C. Gattrell, "Incorporation and the Pursuit of Liberal Hegemony in Manchester 1790–1839," in *Municipal Reform and the Industrial City*, ed. Derek Fraser (Leicester: 1982), p. 22.

23 Anthony Howe, *The Cotton Masters, 1830–1860* (Oxford: 1984), p. 251.

24 For a discussion of these organizations, see Michael E. Rose, "Culture, Philanthropy and the Manchester Middle Classes," in *City, Class and Culture: Studies of Social Policy and Cultural Production in Victorian Manchester*, ed. Alan J. Kidd and K. W. Roberts (Manchester: 1985), pp. 103–17.

25 Arnold Thackray, "Natural Knowledge in Cultural Context: The Manchester Model," *American Historical Review* 79 (June 1974), 682. See also pp. 679–80

for additional reasons for the importance of science as a cultural pursuit.

26 Douglas Hall, "The Tabley House Papers," *The Walpole Society* 38 (1960–62), 60 and 112. See also Trevor Fawcett, *The Rise of English Provincial Art: Artists, Patrons, and Institutions outside London, 1800–1830* (Oxford: 1974), pp. 90–91. Fawcett notes that among the gentry only Sir Abraham Hume, Walter Fawkes, and George Hibbert made adequate responses.

27 Peel's collection of modern and Old Masters is described in the *Art Union* (May 1846), 120–22 and (November 1846), 303–5. His background is recounted in Norman Gash, *Mr. Secretary Peel: The Life of Sir Robert Peel to 1830* (Cambridge, Mass.: 1961).

28 Dr. J. D. Hulme to Sir John Leicester, 19 February 1825, in Hall, "Tabley House Papers," p. 112. Ironically, Peel professed to believe in the support of art museums by public subscription. See Janet Minihan, *The Nationalization of Culture* (London: 1977), p. 91.

29 John Barrell, *The Political Theory of Painting from Reynolds to Hazlitt* (New Haven: 1986), p. 9.

30 Minihan, *Nationalization of Culture*, p. 60.

31 Conversation with Lord Melbourne recorded by B. R. Haydon in his diary, 19 October 1835, in Frederic Wordsworth Haydon, *Benjamin Robert Haydon: Correspondence and Table-Talk*, 2 vols. (London: 1876), II, 389. For a confirmation of this attitude, see also (T. H. Lister), "Review of Allan Cunningham, *Lives of the Most Eminent British Painters, Sculptors, and Architects*," *Edinburgh Review* 59 (April 1834), p. 63; John Pye, *Patronage of British*

Art, an Historical Sketch (London: 1845);
and Waagen (1838), I, 38.

32 Barrell, *Political Theory of Painting*, p. 64.

33 Stuart Macdonald, "The Royal
Manchester Institution," in *Art and
Architecture in Victorian Manchester*, ed.
John H. G. Archer (Manchester: 1985),
p. 33. The history of the RMI is also traced
in S. D. Cleveland, *The Royal Manchester
Institution* (Manchester: 1931).

34 "Proposal of 1823," Archives of the Royal
Manchester Institution, cited in Thackray,
"Natural Knowledge," 702–3.

35 Darcy, 71–72.

36 Paul DiMaggio, "Cultural
Entrepreneurship in Nineteenth-Century
Boston, Part II: The Classification and
Framing of American Art," *Media, Culture
and Society* 4 (1982), 303–22.

37 *Catalogue of the Pictures and Drawings of the
Newsham Bequest to the Corporation of
Preston, Prepared by the Testator, Richard
Newsham, Esq.*, ed. James Hibbert (Preston:
1884), title page.

38 Stephen V. Sartin, "Richard Newsham's
Collection," *Antique Collector* (July 1985),
42–45. On another occasion, Miller did
not wait for his friend's opinion, but
bought Linnell's *L'Allegro* outright for him,
while at still another time, Newsham duti-
fully purchased E. M. Ward's *Royal Family*
after Miller told him to see it. See *Newsham
Bequest*, ed. Hibbert, nos. 50 and 18.

39 "The Collection of Henry McConnel,
Esq., Cressbrook, Derbyshire," *Art Journal*
(Sept. 1870), 286. Judith Bronkhurst,
"Fruits of a Connoisseur's Friendship: Sir
Thomas Fairbairn and William Holman
Hunt," *Burlington* 125 (Oct. 1983), 591. Along
with Sheepshanks and Vernon, Fairbairn
owned a version of Witherington's *The*

Hop Garden which he bought at William
Wells's nephew's sale in 1860. Among
Eden's many paintings of children were
Millais's *Autumn Leaves*, Hardy's *The Sweep*,
and four scenes by Webster on the theme
of the seasons.

40 Darcy, 158.

41 Agnew, pp. 16–18 and Treuherz,
"McConnel," pp. 41–42. For Eden and
Agnew's, see *Recollections of a Royal
Academician by John Callcott Horsley, RA*,
ed. Mrs. Edmund Helps (London: 1903),
pp. 228–29. The purchasing patterns of
John Chapman and Henry Cooke are not
known.

42 Agnew's purchase from the Bashall
executors is described in the *Art Journal*
(June 1871), 170. For Bashall's close rela-
tions with artists, see *Art Journal* (July 1857),
206.

43 For McConnel's relations with artists, see
John Horsley in *Art Journal* (Oct. 1872),
265. Fairbairn's relationship with Egg is
described in Hilarie Faberman, "Augustus
Leopold Egg, RA (1816–1863)," unpubl.
Ph.D. diss., 4 vols., Yale University, 1983,
I, 230, *passim*. For Miller and Frith, see
W. P. Frith, *My Autobiography and
Reminiscences*, 3 vols. (London: 1887–88),
I, 155 and 264.

44 Nathaniel Hawthorne, *The English
Notebooks*, ed. Randall Stewart (New
York: 1962), p. 352.

45 William Agnew to John Linnell, n.d.
(*c.* 1864), Linnell Papers, cited in Evan R.
Firestone, "John Linnell and the Picture
Merchants," *Connoisseur* 182 (Feb. 1973), 129.

46 Agnew, p. 9. For Ashton's purchases, see
p. 16.

47 27 June 1856, "Manchester Art Treasures,
Correspondence: Letters Dispatched, and

Register of Replies," Manchester Public Libraries, Ref. M6/2/8.

48 The Reverend Gaskell's opinion of the social role of art is recorded in the minutes of a meeting held at the Manchester Town Hall on 5 March 1860. See "Free Art Gallery and Museum for Manchester," Manchester Public Libraries, Ref. 708/273/M2. For the influence of Unitarianism on Manchester's intellectual life, see Alan J. Kidd, "Introduction: The Middle Class in Nineteenth-Century Manchester," in *City, Class and Culture: Studies of Social Policy and Cultural Production in Victorian Manchester*, ed. Alan J. Kidd and K. W. Roberts (Manchester: 1985), pp. 10–11.

49 Barrell, *Political Theory of Painting*, p. 9.

50 Faberman, "Egg," p. 285.

51 "Art-Treasures at Manchester," *Athenaeum* (2 May 1857), 566.

52 *Catalogue of the Art Treasures of the UK Collected at Manchester in 1857* (Manchester: 1857).

53 Jean-François Lyotard, *The Postmodern Condition: A Report on Knowledge,* transl. Geoff Bennington and Brian Massumi (Minneapolis: 1984), p. xxiii.

54 *Art Treasures Examiner* (1857), bound copy in Manchester City Library.

55 Howe, *Cotton Masters*, p. 299.

56 See *Art Treasures Examiner*, p. 144 *passim,* for weekly listings of visitors to the exhibition. In keeping with the philosophy of this publication, it gave special attention to groups of workers, orphans, and schoolchildren.

57 Titus Salt's mill, near Bradford, specialized in worsted cloth made from alpaca wool. Salt housed his workers in a model industrial village that contained a church, baths, schools, a music room, and a Mechanics' Institute. See *DBB,* V, 29–36.

58 Hawthorne, *English Notebooks*, p. 557.

59 See *Art Journal* (Dec. 1857), 362, and Ulrich Finke, "The Art-Treasures Exhibition," in *Art and Architecture in Victorian Manchester,* ed. John H. G. Archer (Manchester: 1985), p. 125.

60 Charles Dickens, 3 Aug. 1857, cited in Finke, "Art-Treasures Exhibition," p. 121.

61 Engels to Marx, 20 May 1857, in *Karl Marx and Frederick Engels, Collected Works,* 41 vols. (New York: 1975–85), XL, 131. Engels, however, went on to criticize the quality of the pictures in the exhibition as second rate and "English trash."

62 John Bright to Richard Cobden, 21 March 1857, cited in Howe, *Cotton Masters*, p. 299.

63 "Free Art Gallery and Museum for Manchester, p. 5.

64 Hunt consented to soften the expression, but felt that the change necessitated a revision in title, from "awakening" to "awakened" conscience. See Mary Bennett, *William Holman Hunt* (Liverpool: Walker Art Gallery, 1969), no. 27, p. 37.

65 "Free Art Gallery and Museum for Manchester," p. 8.

66 Fairbairn succeeded in 1874 to the baronetcy his father had been granted in 1869 for his innovations in structural engineering. See Bronkhurst, "Fairbairn," pp. 593–94.

67 Terry Eagleton, *The Ideology of the Aesthetic* (Oxford: 1990), p. 9.

68 Eugene Lunn, *Marxism and Modernism* (Berkeley: 1982), pp. 18–19.

69 Hobsbawm, *Industry and Empire*, p. 186.

70 On the implications of short-term and long-term exchanges, see *Money and the Morality of Exchange*, ed. Jonathan Parry and Maurice Bloch (Cambridge: 1989), p. 2.

71 De Tocqueville, cited in Dennis Smith, *Conflict and Compromise: Class Formation in English Society, 1830–1914* (London and Boston: 1982), p. 105.

72 J. Morley, *Life of Cobden*, 2 vols. (London: 1881), II, 199–200, cited in Harold Perkin, *Origins of Modern English Society* (London: 1969; rpt 1985), p. 180.

73 Briggs, *Victorian Cities*, p. 189.

74 See Clive Behagg, "Myths of Cohesion: Capital and Compromise in the Historiography of Nineteenth-Century Birmingham," *Social History* 11 (Oct. 1986), 382.

75 See Smith, *Conflict and Compromise*, p. xi, and Hobsbawm, *Industry and Empire*, pp. 186–87.

76 Briggs, *Victorian Cities*, p. 217. See also Smith, *Conflict and Compromise*, pp. 51ff. for the rational recreation movement in Birmingham, and Gay, *Bourgeois Experience*, I, 27, for the inscription on the memorial stone.

77 See A. C. Gardiner, *Life of George Cadbury* (London: 1923), and *DBB*, I, 547–54; J. L. Garven and J. Amery, *Life of Joseph Chamberlain*, 6 vols. (London: 1934–69); R. A. Church, *Kendricks in Hardware, 1791–1966* (Newton Abbott: 1968); and Richard Tangye, *'One for All': An Autobiography* (London: 1889).

78 See Robert E. Schofield, *The Lunar Society of Birmingham* (Oxford: 1963); Paul S. Cadbury, *The Lunar Society of Birmingham Bicentenary* (London: 1966); and Fawcett, *Provincial Art*, p. 177.

79 Smith, *Conflict and Compromise*, p. 28.

80 On the development of the fine arts in Birmingham, see J. A. Langford, *A Century of Birmingham Life* (Birmingham: 1868); R. K. Dent, *Old and New Birmingham, a History of the Town and its People*, 2 vols. (Birmingham: 1880); Fawcett, *Provincial Art*, pp. 177ff.; and Richard Ormond, "Victorian Paintings and Patronage in Birmingham," *Apollo* 87 (April 1968), 240–51.

81 See letters from Lord Northwick to Gillott, 16 September 1846, inviting him and his family to visit, and 14 October 1846, referring to the Gillotts' stay with him. In another letter of 15 October 1846, Lord Northwick reveals that the purpose of the visit was to interest Gillott in purchasing some of his pictures. See Gillott Papers, Getty Archive, Santa Monica, Calif.

82 My attributions are from J. H. Plumb, *The Pursuit of Happiness: A View of Life in Georgian England* (New Haven: Yale Center for British Art, 1977), no. 87, p. 49. Plumb notes that the Titian is a copy.

83 Northwick to Gillott, 14 October 1846, Getty Archive.

84 Edwin Bullock is unusual among Birmingham's major collectors in that, in addition to owning a large number of landscapes and ideal subjects, he also possessed a group of genre paintings by artists such as Leslie, Webster, Goodall, and Horsley (see appendix). Since his origins are unknown, it is difficult to speculate about his motivations. As for the other amateur artists, Birch studied with Cox, while Gibbons had been a member of a sketching club in Bristol. Meigh was a pupil of Müller.

85 On Birch and Cox, see N. Neal Solly, *Memoir of the Life of David Cox* (London: 1873), pp. 102–9, who also mentions Gillott's visit (p. 165).

86 Gibbons to Frith, 27 December 1843, Frith, *Autobiography*, III, 206–7.

87 *Ibid.*, p. 196. For other instances when Gibbons commented on Frith's paintings, see pp. 199–209.

88 For Gibbons, see Eric Adams, *Francis Danby: Varieties of Poetic Landscape* (New Haven: 1973), pp. 109ff., and Kathryn Moore Heleniak, "John Gibbons and William Mulready: The Relationship between a Patron and a Painter," *Burlington* 124 (March 1982), 136–41.

89 H. H. Horton, *Birmingham: A Poem in Two Parts* (Birmingham: 1911), cited in Leonore Davidoff and Catherine Hall, "The Architecture of Public and Private Life: English Middle-Class Society in a Provincial Town 1780–1850," in *The Pursuit of Urban History*, eds. Derek Fraser and Anthony Sutcliffe (London: 1983), 336.

90 David Cannadine, *Lords and Landlords: The Aristocracy and the Towns, 1774–1967* (Leicester: 1980), p. 206.

91 A. T. Story, *The Life of John Linnell*, 2 vols. (London: 1892), II, 21.

92 Conrad Gill, *History of Birmingham*, 3 vols. (London: 1952–74), I, 300.

93 Edward Edwards, *Personal Recollections of Birmingham and Birmingham Men* (Birmingham: 1877), p. 94.

94 Cannadine, *Lords and Landlords*, p. 90. For the size and price of the purchase quoted, see p. 206.

95 Redford, I, 187.

96 Tom Presterne, *Harborne "Once upon a Time"* (Birmingham: 1913), p. 104. He adds that Birch "was a great authority on pictures, and I think, in a way, a dealer in them too."

97 Patrick Baird of the Local Studies Department of the City of Birmingham Public Library kindly searched for Birch's obituaries. Mr. Baird informed me in a letter dated 20 May 1986 that, while Birch was listed in local directories between the years 1845 and 1856, he was not at home on the night the census taker visited his residence in 1851; therefore, his place and date of birth are unrecorded. Nor is Charles Birch mentioned in the detailed volumes of the *Victoria History of the County of Stafford* published to date (ed. William Page, 20 vols., Oxford: 1908–). Seventeenth-century references to the Birch family occur in XVII, 92, 105, 174, and 239. Catherine Coan does not sketch Birch's background; however, she states he led "an itinerant life." See "Birmingham Patrons, Collectors, and Dealers, 1830–1880," unpubl. MA thesis, University of Birmingham, 1980, p. 111. I am grateful to Ms. Coan for providing me with a copy of her thesis.

98 John Benson, *British Coalminers in the Nineteenth Century: A Social History* (Dublin: 1980), p. 20.

99 The local dealer William Hall considered Birch a man of refined taste, while Neal Solly, the biographer of both William Müller and David Cox, claimed Birch's "knowledge and correct taste in art-matters had a very marked influence on the judgement of other collectors in Birmingham and its neighbourhood." William Hall, *A Biography of David Cox* (London: 1881), p. 60, and N. Neal Solly, *Memoir of the Life of William James Müller* (London: 1875), p. 124.

100 See Lord Northwick to Gillott, 16 September 1846, Getty Archive and Solly, *Cox*, pp. 287–88 and 235–41.

101 The easy informality between patron and artist is revealed in an anecdote related by Solly, *ibid.*, pp. 156–57.

102 *Ibid.* Waagen mentions works by Leslie, Constable, Maclise, Etty, and another

"recalling Titian." See Waagen (1857), p. 403. Birch's sales prove that his collection was far more substantial than Waagen indicated. In addition to the English pictures which I mention in the text below, Birch owned many others, including Turner's *Burning of the Houses of Parliament*, Wilkie's *The First Earring*, Maclise's *Alfred in the Danish Camp*, and eleven copies by Etty of Venetian paintings which Birch bought at the artist's studio sale.

103 Solly, *Cox*, p. 105. William Roberts (fl. 1814–67) of Harborne Hall, Edgbaston, was a merchant in partnership in Wilmott and Roberts. He frequently went to Norwich on business, where he collected the works of John Crome, John Sell Cotman, and Peter De Wint. An amateur artist, Roberts occasionally exhibited at the Royal Academy. He carried on an extensive correspondence with Müller about pigments and media. See Solly, *Müller*, pp. 123–29, 174–76, 182–83, 202–4. On Roberts's life and dealings with other artists, see *Birmingham Post*, 30 March 1867; Solly, *Cox*, pp. 91, 105, 118, 124; Presterne, *Harborne*, p. 105; Gill, *Birmingham*, I, 401; Michael Pidgley, "Cotman and his Patrons," in *John Sell Cotman*, ed. Miklos Rajnai (London: 1982), p. 22; and Coan, "Birmingham Patrons," pp. 100, 105, 109–11.

104 Solly, *Cox*, p. 134.

105 Jeremy Maas, *Gambart: Prince of the Victorian Art World* (London: 1975), p. 17.

106 Reitlinger, p. 100.

107 *Art Journal* (April 1857), 129.

108 Dennis Farr, *William Etty* (London: 1956), no. 177, p. 169, where only the 1855 sale is listed. For the 1857 sale, see *The Metchley Abbey Pictures ... The Property of Charles Birch, Esq.*, London, Messrs. Foster, 27 Feb. 1857, lot 63.

109 Solly, *Cox*, p. 122. The last sale held in Birch's name at Foster's took place in 1865. His name abruptly disappears earlier, in 1852, from Gillott's ledgers in the Getty Archive, although someone by the name of William Birch appealed to Gillott for funds in 1857. Coan proposes that Charles Birch did not die until some time after 1872, since he is not referred to as "late" in the Gillott sale catalogue of that year ("Birmingham Patrons", p. 116).

110 See David Frisby, "Preface to the Second Edition," in Georg Simmel, *The Philosophy of Money*, transl. Tom Bottomore and David Frisby (London: 1990), p. xxxii.

111 Thomas Uwins to John Townshend, 28 June 1841, in Sarah Uwins, *A Memoir of Thomas Uwins, RA*, 2 vols. (London: 1858), I, 112.

112 George Gee to Joseph Gillott, 6 August 1857, Getty Archive.

113 Jeannie Chapel, "The Turner Collector: Joseph Gillott, 1799–1872," *Turner Studies* 6 (Winter 1986), 44.

114 James H. Bunn, "The Aesthetics of British Mercantilism," *New Literary History* 11 (1980), 304.

115 T. S. Cooper, *My Life*, 2 vols. (London: 1890), I, 316, reported in A. J. Finberg, *The Life of J. M. W. Turner, RA* (Oxford: 1938; 2nd ed. 1961), p. 409.

116 Kenneth John Myers, "On the Cultural Construction of Landscape Experience: Contact to 1830," in *American Iconology*, ed. David C. Miller (New Haven: 1993), p. 64.

117 On Hawker, see Chapel, "Gillott," p. 43 and no. 36, and Coan, "Birmingham Patrons," pp. 54–56.

118 For Northwick, see letter of 15 October 1846; for Gibbons, 20 August 1845; and for Birch, see "Sales and Bargains Memoranda," 2 June and 22 December 1852, Getty Archive.

119 John Miller wrote five letters to Gillott between 19 November and 16 December 1858, Getty Archive.

120 Charles Hawker uses the phrase in a letter to John du Jardin, 16 November (1859), Getty Archive.

121 Coan, "Birmingham Patrons," p. 77.

122 On the 1872 sale, see Redford, I, 185–89; Roberts, I, 213–22; Reitlinger, pp. 102–4; and Agnew, p. 26. Chapel speculates that the family allowed the collection to be sold because of lack of interest; however, she notes that two family members bought back items for their own collections in 1872. See "Gillott," 47.

123 Bernard Denvir, "Pens and Patronage, Some Unpublished Letters to Joseph Gillott," *Connoisseur Yearbook* (1958), 74, computes 343 landscapes and sea-pieces.

124 Waagen noted that Gillott's Old Masters were kept in his townhouse in Birmingham (1857, p. 404). Gillott, however, stopped collecting the ancient masters when he became interested in the moderns. In several letters in the Getty Archive he clearly states that he is no longer interested in buying Old Masters. See, for instance, 5 October 1859 and 27 September 1860.

125 The dimensions are given for approximately 300 oils in Gillott's 1872 sale catalogue. Of this number, 219 were under 3 feet in size, and 85 were over 3 feet.

126 Letter to J. du Jardin signed Charles Hawker for Joseph Gillott, 21 March 1859, Getty Archive.

127 Charles Hawker to William Wethered, 6 May 1859, Getty Archive.

128 Charles Hawker to Serjeant Thomas, 25 January 1859. Thomas was a barrister and art dealer whom Hawker asked to negotiate with Frith about the repainting of three of the artist's sketches owned by Gillott. On Thomas see Story, *Linnell*, II, 13, and Ralph Thomas, *Serjeant Thomas and Sir J. E. Millais* (London: 1901).

129 There were five Websters in Gillott's sale, in addition to six humorous anecdotes by Faed, Wilkie, Leslie, Nicol, Frère, and Poole. See also Denvir, "Pens and Patronage," 74.

130 Andrew Greg, *The Cranbrook Colony* (Newcastle-upon-Tyne: Laing Art Gallery, 1977), no. 72, n.p.

131 F. Condé Williams, *From Journalist to Judge: An Autobiography* (London: 1903), pp. 42–43. On Hawker, see also Chapel, "Gillott," p. 43 and no. 36, and Coan, "Birmingham Patrons," pp. 54–56.

132 See Wilkie's Journal, 6 January 1821, in Allan Cunningham, *The Life of Sir David Wilkie*, 3 vols. (London: 1843), II, 58. The offer was made by a Mr. Zachary in regard to the painting, *Unexpected Visitor*.

133 Frith, *Autobiography*, III, 201.

134 Gillott, quoted in a letter from Charles Hawker to T. Webster, 15 November 1858, Letter Book 1858–61, Getty Archive.

135 Danby to Gillott, 27 February 1855, Getty Archive.

136 Waagen (1838), I, 232 and 241.

137 Michel Foucault, *The Archaeology of Knowledge*, transl. A. M. Sheridan Smith (New York: 1972), pp. 193–94.

138 Jonathan Crary, *Techniques of the Observer: On Vision and Modernity in the Nineteenth Century* (Cambridge, Mass.: 1990), p. 12.

139 Jean Baudrillard, *For a Critique of the Political Economy of the Sign*, transl. Charles Levin (Telos: 1981), pp. 44–45.

140 In Manchester, I have identified replicas in the collections of Bashall, Chapman, Cooke, Fairbairn, McConnel, Miller, and Newsham. In Birmingham, even Gibbons endorsed the practice, despite his interest in the creative process. Frith records a letter in which Gibbons states, "where there is beauty, finish, and taste, I care little about 'originality'" (*Autobiography*, III, 202). Replicas also passed through the hands of Birch, Bullock, and Gillott.

141 Ormond, "Victorian Birmingham," p. 241.

142 See William Holman Hunt, *Pre-Raphaelitism and the Pre-Raphaelite Brotherhood*, 2 vols. (London: 1905–6), I, 177, and Maas, *Gambart*, p. 133, who also describes Gillott's investment in the engraving.

143 Wallis was a member of the Pre-Raphaelite-sponsored Hogarth Club. The standard reference for his biography is his obituary, see *Burlington* 30 (1917), 123–24.

144 H. S. Gibbs, *Autobiography of a Manchester Cotton Manufacturer* (London: 1877), p. 118. Critic Robert Lamb pronounced it "the most popular picture in the whole Exhibition" (*Fraser's* [1857], 390). The *Morning Star* (5 May 1858) called the painting "a sensation." For this and other critical responses, see Robin Hamyln, "Chatterton," in *The Pre-Raphaelites* (London: Tate Gallery, 1984), no. 75, p. 144.

145 John Ruskin, *Academy Notes* (1856), *The Complete Works of John Ruskin*, ed. E. T. Cook and Alexander Wedderburn, 39 vols. (London: 1903–12), XIV, 60.

146 Hamlyn, "Chatterton," 144.

147 Redford, I, 427. McConnel bought the replica at the Samuel Mendel sale.

3 Pre-Raphaelitism: progressive or regressive?

The Pre-Raphaelite presence at the Manchester Art Treasures exhibition bestowed an avant-garde aura on the city's Victorian patrons, one that has been buffed and polished by writers over the years.[1] While it is true that the Pre-Raphaelites found a home in prestigious collections such as those of Thomas Fairbairn, Henry McConnel, and Thomas Miller, no single Mancunian, with the exception of Fairbairn, bought more than two or three canvases from these artists in the initial phase of the Pre-Raphaelite movement, which lasted until 1859, when it was succeeded by the Aesthetic movement. Fairbairn was the only local man to lend to the progressive section of the Art Treasures exhibition; the remaining Pre-Raphaelite pictures on view belonged to artists or to other provincial patrons.[2] Nevertheless, considering the fanfare that greeted the Pre-Raphaelites in Manchester in 1857, Holman Hunt was surprised to discover a residual ambivalence toward the group in the minds of local collectors. He reported:

> The works of our school were received so favourably by the Manchester potentates that I assumed they had become converted to our views. Once when talking to my host [Fairbairn] about modern art I did not hesitate to refer to our school as Pre-Raphaelite in contradistinction to others. He stopped the conversation with a serious countenance and said: "Let me advise you, when talking to Manchester people about the works of your school, not to use that term; they are disposed to admire individual examples, but the *term* has to them become one of such confirmed ridicule that they cannot accept it calmly!"[3]

The name that so disturbed Fairbairn was, according to Holman Hunt, adopted by him and John Everett Millais from a *reductio ad absurda[sic]m* coined by their fellow students at the Royal Academy. After Hunt and Millais had publicly denigrated Raphael's painting, *The Transfiguration*, for its "decadence" and "grandiose disregard of the simplicity of truth," in contrast to the honesty and purity of the artists who had preceded him, their colleagues labeled them Pre-Raphaelite (I, 100–1). They were

139

joined in their admiration of early Italian art by Dante Gabriel Rossetti, also a student at the Royal Academy and an aspiring poet, Thomas Woolner, who was studying sculpture, Frederic George Stephens, a young painter who would soon turn to art criticism for a living, James Collinson, another student of painting, and William Michael Rossetti, who supported himself as a government clerk. It was the latter's brother, Dante Gabriel, who designated the Pre-Raphaelites a "Brotherhood."[4]

The idea of a brotherhood of artists caused no adverse comment in Manchester. Rather it was the associations conjured up by the group's name that was responsible for the skittishness Fairbairn diagnosed among his fellow collectors. Although Thomas Miller, for instance, eventually bought four of Millais's paintings, he nevertheless "deprecated what was termed the Pre-Raphaelite style."[5] That is to say that it was the group's choice of name, and not the content of its paintings, which was the cause of uneasiness in 1857. After all, Fairbairn had lent Hunt's modern moral subject, *The Awakening Conscience*, to the exhibition. Clearly it was the name "Pre-Raphaelitism" which carried connotations that are not apparent to us today.

Over the intervening years Pre-Raphaelitism has become synonymous with the avant-garde: it shines like a beacon in the industrial wasteland of Victorian bourgeois kitsch. Although students of the modern period often equate the avant-garde with modernism,[6] in England they were not identical phenomena. The avant-garde entailed an activist attitude toward institutions and events, whereas modernism had many different faces. Some scholars argue for the existence of multiple "modernisms" which embrace concepts as far-reaching as the doctrine of progress, cult of success, ideal of freedom, and aesthetic innovation.[7] Because of these divers definitions of reform, I will attempt to dismantle the public institution known as "Pre-Raphaelitism" in order to assess its place in the modern movement. To accomplish this I will first examine the clash of values that took place in Manchester between Pre-Raphaelite artists and collectors.

The backdrop for this conflict was the ambitious range of exhibits at the Art Treasures exhibition. Manchester collectors could not but feel implicated by the scathing criticism of their efforts published in the *Quarterly Review* in 1857. Written by Austen Henry Layard, a founder of the Arundel Society and a regular contributor to this distinguished journal, the article chastised patrons for the dismal state of British painting represented there, with the exception of Pre-Raphaelitism. Condemning Landseer, Mulready, Webster, Roberts, and Stanfield for falling into the "snare of continual repetition and

constant exaggeration," Layard scolded the purchasers of their art for supporting mediocrity (pp. 196–97). His remarks were undoubtedly embarrassing to Manchester patrons such as Miller and Fairbairn whose homes showcased many of the Royal Academy favorites he criticized alongside their Pre-Raphaelite canvases. When Layard went on in his review to single out the Pre-Raphaelites for "the casting away of that conventional treatment of things animate and inanimate taught by academies" (p. 200), he effectively condemned the major portion of Manchester collections at the expense of the minor. The businessman–collector would naturally prefer that no part of his possessions be devalued. While Mancunians bought new art, they saw it as a logical extension of their existing purchases, not as a critique.

That observation suggests another explanation for Manchester patrons' misgivings about the "Pre-Raphaelite" label: modernism in Manchester meant material and concrete invention and improvement. Fairbairn, an engineer and steam engine maker, and Miller, a cotton manufacturer, were committed to a forward-looking concept of progress that was at variance with the *pre*-industrial values that the Pre-Raphaelite name suggested. Obsessed as these businessmen were with new scientific and technological advances, they expected the same from artists who professed to be reformers. This explains the discomfort they felt toward the term "Pre-Raphaelite." The very words, with their early Renaissance associations, bespoke a regressive age that was in counterpoint to the advanced strides being taken in the industrial North.

These Manchester patrons were not alone in their expectations. Progress had become the catchword of Victorian England. Given tangible expression by the technological wizardry on display at the Great Exhibition of 1851, the nation marched to the triumphant tune of ingenuity. Geoffrey Best describes the spirit of well-being that was paramount in 1851 as the "sense of safety" after the storm of 1848.[8] Only one year later, in his 1849 *History of England*, an optimistic Lord Macaulay had signaled the end of the troubled 1840s by affirming his faith in his country's brilliant future.[9] Although a more cautious Thomas Carlyle decried the fetters of "Mammonism," he demonstrated his faith in Britain's progress when he rhetorically asked, "how can the 'Son of Time,' in any case, stand still?"[10] By conceding that the advent of the new was inevitable, Carlyle acknowledged that modernism in England was inextricably tied to the notion of progress.

Given this emphasis on newness and change, how could the Pre-Raphaelites be considered progressive if, as their name implies, they

looked back to the past? What their Manchester patrons did not understand was that these artists were following a well-established pattern when they took one step backward in order to move two steps forward. Visual artists have carried on a dialogue internal to their profession for eons. In the case of the Pre-Raphaelites, they turned to artists of the Trecento and Quattrocento for inspiration in order to correct what Holman Hunt termed "the stereotyped tricks" that had been practiced by artists since the Renaissance (I, 107). As a result, they defied Albertian perspective by disallowing recession in their backgrounds. Similarly, they often distorted the scale of figures in proportion to their settings as a deliberate repudiation of standard illusionism. In naming Fra Angelico among the artists they admired, they revealed that they subscribed to a canon of excellence. The "List of Immortals" drawn up by Rossetti and Holman Hunt (I, 159) is a clear indication that they placed themselves within, rather than in opposition to, a continuing history of art, proving E. H. Gombrich's contention that an artist's production is a conscious response to the work of previous artists. Gombrich insists that art is guided by a canon of masterpieces which "offers points of reference, standards of excellence which we cannot level down without losing direction."[11] Thus the members of the Pre-Raphaelite Brotherhood (PRB) mediated between past and present in order to cure the malaise of academic painting.

Does the fact that the core grammar of the PRB consisted of the language of art history brand them as regressive rather than as progressive modernists? Recent critics of the canon would undoubtedly dismiss any group of artists who relied on the tradition of past excellence as pawns of the master narrative of greatness. Yet Raymond Williams, remarkably, approaches the arch-conservative position of Gombrich when he allows that there are art forms which "are so embedded within the practice, as particular formal articulations, that they are at once social and formal, and can in one kind of analysis be treated as relatively autonomous."[12] The forms to which Williams refers are those which are transferred from one society to another and eventually become deeply imbricated in culture as a whole. Gombrich and Williams concur in granting the existence of a life of forms that is internal to creative practice. This consensus should not be misconstrued as an acknowledgment of Jungian archetypes, but is better understood as a recognition of an aspect of artistic practice which functions parallel to social change, operating as a tradition *within* a tradition. Painters, such as the Pre-Raphaelites, routinely have looked back and reexamined their

predecessors in order to bring their own projects into sharper definition. As self-evident as this practice is, it is too often neglected in the heated debates centering on the canon, especially by historical determinists who fear that any concession to aesthetics would fortify the canon's claim to autonomy.

Yet it would be misleading to claim that the Pre-Raphaelite project was simply a value-free formal enterprise. In turning back to artists such as Fra Angelico, they also embraced the spiritual qualities they perceived to be embedded in earlier art, qualities such as honesty and naiveté which they, in turn, attempted to instill in contemporary art. The example of pre-Renaissance artists was intended as a corrective to both the normative method of painting and its content. This, then, is the answer to the question I posed earlier, namely whether the Pre-Raphaelites were regressive or progressive in believing that a remedy to the plight of official art lay hidden within tradition: they were both. They were avant-garde in their defiance of orthodoxy and in their manipulations of the picture plane, but conventional in their oracular expectations of the canon.

However, because they dared to challenge the received opinion of the High Renaissance as the apogee of human endeavor, the Pre-Raphaelites were regarded with suspicion by those industrialists who still subscribed to the progressive principles of the Enlightenment. Their choice of name suggested they did not share the up-to-the-minute values that were making England the envy of other nations. Not only did the group sound foreign, they sounded old-fashioned as well.

Yet recent commentators like Martin Jay have identified the flattened visual field of mid-nineteenth-century painting as one of the salient features of modernism. He finds the "interrogation of the privileged scopic regime of Cartesian perspectivalism" which had been in place since the Renaissance to be the watershed which separated the authoritative eye of the old order from the independent eye of the new.[13] Although Jay is referring to the Impressionists and the avant-garde groups which followed in their wake, the aesthetic innovations he marks are applicable to the first Pre-Raphaelite paintings, which also rejected geometricized space and three-dimensionality in favor of flattened spaces and heightened attention to detail (p. 152).

Holman Hunt's *Rienzi Vowing to Obtain Justice for the Death of his Young Brother* (plate 23) and Millais's *Isabella* (plate 24), both of 1848–49, demonstrate a strikingly similar lack of recession and emphasis on surface details. Hunt locates the frontal plane as the center of interest through the

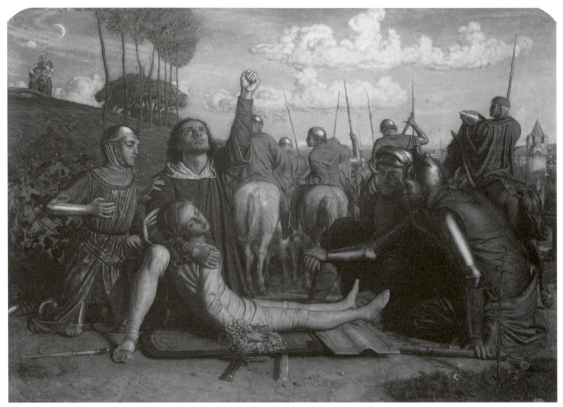

Plate 23. William Holman Hunt, *Rienzi Vowing to Obtain Justice for the Death of his Young Brother,* 1848–49, oil on canvas

dramatic gestures of his figures and the array of meticulously painted objects which surround them. In accordance with the emerging Pre-Raphaelite aesthetic, Hunt tells us that his painting was conceived with the purpose of "putting in practice the principle of rejection of conventional dogma" (I, 107). Already skilled in handling the human figure, Hunt deliberately distorts the scale of the mother and children in the background of his picture in order to draw attention to his repudiation of Renaissance illusionism. Instead, he adopts the more arbitrary ideographic canon of the art that preceded Raphael.

Millais, too, purposely archaizes his style to harmonize with Trecento and Quattrocento models. Having won a silver medal for drawing at the Royal Academy Schools when only nine years old, Millais renounces his training by organizing his composition along flat planes rather than receding orthogonals.[14] He shares Hunt's affinity for the particular by segmenting each area of activity within his canvas: the food on the table, the

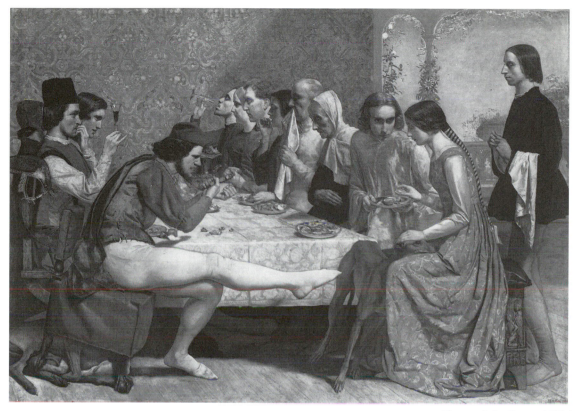

Plate 24. John Everett Millais,
Isabella, 1848–49, oil on canvas

background patterned wall, and the lavish costumes are so intricately rendered that they vitiate the viewer's attempt to gain a coherent optical summary of the scene. This attention to detail, combined with Millais's somberness of purpose, characterizes the professed goals of Pre-Raphaelitism, which William Michael Rossetti described as "serious and elevated invention of subject, along with earnest scrutiny of visible facts, and an earnest endeavour to present them veraciously and exactly."[15]

This intent is borne out in Dante Gabriel Rossetti's first painting, *The Girlhood of Mary Virgin* (plate 25), also of 1848–49. The artist scrupulously delineates the symbols of the Mariolatry that is his subject: the lily represents the Virgin's purity, the seven-leaved palm branch and seven-thorned briar foreshadow the sorrows she is yet to endure, just as the crimson cloak suggests Christ's blood. To insure that his viewer's attention is riveted on these objects, Rossetti blocks the eye's attempt to penetrate into the background with a curtain and the leafy branches of a tree.

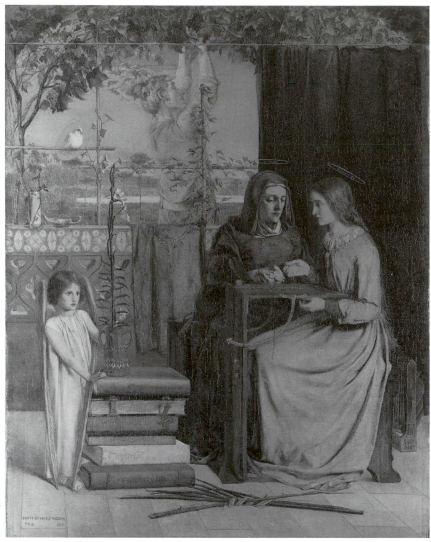

Plate 25. Dante Gabriel Rossetti, *The Girlhood of Mary Virgin,* 1848–49, oil on canvas

All three artists bearded Victorian conventions by spurning recession and illusionism and by highlighting surface detail – the very qualities which scholars single out as the distinctive features of French Impressionism which appeared twenty years later. Why, then, are the Pre-Raphaelites not recognized as harbingers of the international avant-garde? As I have argued elsewhere, modernism in England has not yet been reassessed on its own terms.[16] The fault lies, in part, with the long-standing scholarly and popular fascination with French modernity's shimmering pastel-hued palettes, elegant

iconography of leisure, and stunning auction prices – all of which have made the English contribution to the modern movement seem less dazzling by comparison. More importantly, use of the French yardstick in England has tended to slight the heterogeneous forces that were distinct to the British Isles. Ironically, it was in England that a mode of classification developed which James Ackerman claims was responsible for the ascendancy of French modernity as a critical standard. In analyzing the origins of the paradigm of the new, Ackerman contends, "it is not by chance that the avant-garde concept was formulated at the same time as Darwin's theory of evolution ...[it] was mistaken as a proof that innovative change is biologically desirable."[17] When the notion of the survival of the fittest began to inform artistic value judgments, it produced a narrow interpretation of the history of art as a rapid succession of radical movements which fed off of weaker and more hesitant species. Far from facing extinction, or even faltering, the English art of the modern period continued to evolve at its own pace, according to a selection process that was determined by an inherently different set of cultural values than those which constructed French modernity. As I have indicated, the course it followed was shaped by the interplay of indigenous attitudes toward progress with criteria internal to artistic practice. I shall further argue that modernism in England was adapted to accommodate nationalist views on work and leisure. The project of English modernity can only be recovered if it is investigated in relation to its own history, and not according to the value-laden standards of the French avant-garde.

Ironically English art was considered the more daring until the advent of Impressionism. When the Pre-Raphaelites were invited to exhibit in the English section of the Exposition Universelle in Paris in 1855, they became *causes célèbres*.[18] They were heralded by the French for their originality, which was deemed "as modern as Balzac."[19] Thomas Armstrong, who was an art student in Paris at the time, recorded his surprise at seeing a crowd of admiring French artists in front of Hunt's *Strayed Sheep* on opening day (plate 26).[20] Having painted his composition outdoors under the clear light of the sun, Hunt anticipates the Impressionists' attempts to capture the true hues of reflected light by tinging the wool of the sheep in the foreground with the myriad colors of the prism. That such virtuosity invited close examination was demonstrated by the throng of enthralled artists at the Exposition. Even the colorist Eugène Delacroix was stunned by the picture, saying, "I am really astounded at the sheep by Hunt."[21] The impact on

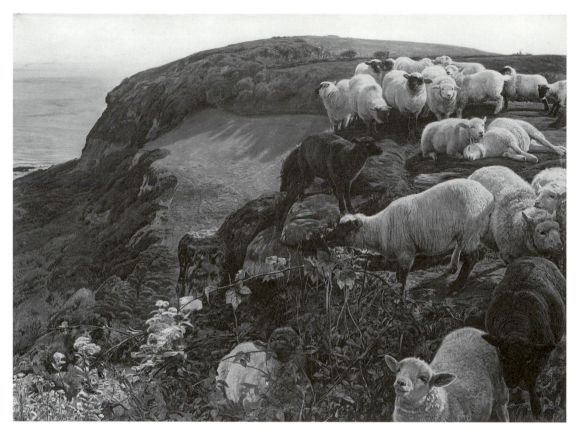

Plate 26. William Holman
Hunt, *Strayed Sheep,* 1852,
oil on canvas

Parisians of Hunt's colorful transcription of natural fact was reinforced by the presence of the other Pre-Raphaelite canvases, most notably Millais's chromatic rendering of weeds and wild flowers in *Ophelia.* The consensus of the critics of 1855 was that French art was at an impasse and that the Pre-Raphaelites possessed a freshness and a vitality that was lacking across the channel.[22] The reviewer for the *Journal l'Union,* on 25 May, proclaimed that at the English section of the Exposition, "Every eye is at once struck with its originality – originality of thought – originality of tint – originality of treatment." Not yet eclipsed by the more daring formal innovations of Manet and the Impressionists, English art briefly held center stage in 1855.

One might well ask why, after this critical juncture in European modernity, the British school lost its lead to the French. At least that is the view of the overwhelming number of scholars who claim that the race to modernity was won by the Impressionists in the next two decades. Even

Britain's own Roger Fry, who staged the first major exhibition of Impressionist and Post-Impressionist art in London in 1910, queried why Rossetti, who had progressed so far, did not take the next step into "complete freedom."[23] Yet to accuse the Pre-Raphaelites of faltering in their formalism by asking why they did not become more tactile and spontaneous is to judge them according to aesthetic criteria extraneous to their time and place. It is more instructive to investigate their reasons for remaining attached to smooth surfaces and meticulous detail.

A high degree of finish was a pertinacious preference in Victorian painting, from Wilkie's particularized village scenes to Frith's slickly rendered panoramas of urban customs. After the advent of Pre-Raphaelitism, it was even more highly prized due to the new heights reached by Hunt's obsessively truthful depiction of animal hair in *Strayed Sheep* and Millais's painstaking transcription of flora in *Ophelia*. John Linnell, who had made a comfortable living for himself by painting freely rendered landscapes, suddenly found himself in the position of being lectured to by dealers, one of whom urged him to tighten his brushwork, advising: "In these days of pre Raphaelitism in a picture the subject of which is the figures, it is quite necessary ... that they should have had at least as much form and finish as the accessories."[24] Underlying this trend toward a greater degree of completion in painting was the assumption that such effort offered more visible evidence of work. Thomas Carlyle, for instance, valued work as the component which made Victorian England prosper. In one of his many pronouncements on the nobility of labor, Carlyle declared, "true Work *is* Worship."[25] Accordingly evidence of dedicated labor was viewed as the measure of a successful painting. The Pre-Raphaelite method of execution is consistent with this philosophy: their tiny, indivisible strokes, in themselves, are a testimony to hard, steady labor.

It is the Protestantism of the work ethic that divisively separates English from French modernism. In implicitly contrasting English Protestantism with French Catholicism, I am not trying to sketch a picture of two cultures colliding, but of heterogeneous value-based systems glancing off one another at different angles. It was a difference that was apparent to contemporary observers of the Exposition of 1855. Gustave Planche, for instance, maintained: "Two things are missing [in British art] for the complete flowering of its faculties in the domains of statuary and painting: a poetic religion and the intervention of the State."[26] Lack of sensuality combined with the absence of grand historic themes were thus attributed to

Protestantism and private rather than public patronage. On the British side, William Holman Hunt was proud of these distinctions. Writing about the 1855 Exposition, he declared: "A Protestant country should give some evidence of its freedom – as much in Art as in other things."[27]

I have already noted that Evangelical Protestants viewed art as a moral teacher. The terms of the Sheepshanks bequest and the socially conscious intentions of the organizers of the Manchester Art Treasures exhibition were conceived with the benefit of the working classes in mind. The molecular code of Protestant Britain insisted that art be a form of rational recreation, and that both be tied to respectability. The iconography of leisure that was to be the hallmark of French Impressionism in the next decade had no place in the English lexicon until the 1880s and 1890s.[28] As Hunt went on to say in his letter of 1855, "Art" must be employed "to higher purpose than pleasing the eye."

The English, moreover, were less concerned with severing their ties with the past than the French. Having avoided a revolution in 1848, they did not equate progress with revolt. As Macaulay attested in 1849, "In consequence partly of our geographical and partly of our moral position, we have, during several generations, been exempt from evils which have elsewhere impeded the efforts and destroyed the fruits of industry."[29] To Macaulay, history had been generous to Great Britain, producing the impeccable traditions that had made it a world power. There was no need, then, to sever ties with the past, no need for what Robert Gooding-Williams describes in Nietszchean terms as endemic to continental modernism: "those breaks and ruptures that suppress the past and give birth to the new."[30] Consequently the Pre-Raphaelites did not perceive the past as an obstacle to be overcome, but as a resource to be mined for ideas. This respect for tradition and continuity, however, does not necessarily make the PRB any less avant-garde.

Even if one were to apply the French criteria of avant-gardism to England, the Pre-Raphaelites would meet many of the basic requirements of the term as currently defined by scholars who apply it to artistic movements which display a contempt for authority and are dedicated to improving both the standards of art and those of society.[31] It is no coincidence that the Pre-Raphaelite Brotherhood was formed in 1848, the year of revolutionary ferment across the channel. From its inception, the PRB was concerned with artistic and moral reform. Millais proclaimed that *our great object in painting*" is "turning the minds of men to good reflections and so

heightening the profession as one of unworldly usefulness to mankind."[32] Rossetti, along with Ford Madox Brown, who, although not one of the seven original members of the PRB, remained closely associated with the group, personally transformed their social ideals into practice by teaching at the Workingmen's College.[33]

While the subject matter of the first Pre-Raphaelite pictures was not ostensibly political, William Holman Hunt maintained that in painting *Rienzi* in 1848, he was "stirred by the spirit of freedom of the passing revolutionary time. The appeal to Heaven against the tyranny exercised over the poor and helpless seemed well fitted for pictorial treatment" (I, 114). Although Hunt's narrative is set in the past, his subject is one of oath-taking and undying commitment to a cause which analogically parallels the resolve of contemporary radicals. Millais made no such claim for his early efforts; however, subsequent scholars have identified covert references to contemporary social problems in his art. Alistair Grieve suggests that Millais's *Isabella* refers to the class struggle in Victorian England.[34] Based on John Keats's poem, "Isabella or the Pot of Basil," the painting depicts the tension caused by the disapproval of Isabella's family of her love for Lorenzo, a clerk in their employ.

The religious iconography of Rossetti's *The Girlhood* excludes it from the context of social criticism that has been suggested for Hunt and Millais's first PRB efforts. Despite the fact that Rossetti's political-exile father harbored victims of the Italian struggle, the artist's avant-gardism was more apparent in his attitude to authority than in his subject matter.[35] Of all the members of the PRB, he was the most committed in his anti-academic stance. While Brown and Hunt bitterly complained about the standards of the Royal Academy, they briefly exhibited there and even entertained the possibility of becoming members before they finally distanced themselves from its strictures. Millais, his youthful protestations notwithstanding, eventually capitulated so completely to the Academy's standards that he was elected its president in 1896. Rossetti, however, refused to compromise his principles and remained aloof from the London organization throughout his life.[36]

It was the Pre-Raphaelite's initial rebellious attitude toward official art and not their criticisms of society that made their Manchester patrons uncomfortable. Purchasers were not likely to be aware of the contemporary social implications of historical costume pieces such as *Isabella* or *Rienzi*, since the artists did not allude to any broader meaning when they

first exhibited these pictures. *Isabella* was bought by a consortium of dealers who eventually sold it to Benjamin Godfrey Windus, and although Holman Hunt was "stirred" by the political events of 1848 when he painted *Rienzi*, its first owner, John Gibbons, was not: he kept the painting in a closet.[37] According to the artist, Gibbons's purchase was merely "an act of generosity, for the gentleman never valued the work" (I, 183). While the subtle imagery of Pre-Raphaelite canvases could easily be ignored, statements in the press describing the group's disdain for academic art were not as lightly dismissed by conservative patrons who believed it was their solemn duty to move harmoniously forward.[38]

This paradoxical relationship between artist and patron was more symptomatic of the second phase of Pre-Raphaelite patronage than the first. Their earliest supporters were much more sympathetic to their cause. Men such as John Miller and Thomas Combe were magnetized by the aura of their originality, their youth, and their potential. Their constant praise and unequivocal support inflated the artists' notion of themselves, with the result that subsequent patrons found them high-handed and difficult to deal with.

John Miller set such a high standard of patronage in the early years of the Pre-Raphaelite movement that the artists spent the rest of their lives searching for his equal. His allegiance cannot be underestimated, for it convinced the fledgling Pre-Raphaelites of the legitimacy of their goals. This was achieved at no small price to Miller: his active involvement in their cause led to the dissolution of the Liverpool Academy in 1867. The Pre-Raphaelites, for their part, were duly appreciative of him. Madox Brown described the Scottish tobacco merchant in 1856 as "a jolly kind old man with streaming white hair, fine features & a beautiful keen eye like Mulready's ...A rich brogue, a pipe of cavendish & smart rejoinder with a pleasant word for every man, woman, or child he meets."[39] Despite his fondness for Miller, Brown puzzled, in the privacy of his diary, over his host's plebeian dining habits:

> Now on the subject of M[iller]'s dinners I may notice that his hospitality is somewhat peculiar in its kind. His dinner which is at 6 is of one joint & vegetable *without* pudding, bottled beer for drink. I never saw any wine. His wife dines at an other table with I suppose his daughters when at home. After dinner he instantly hurries you off to tea & then back again to smoke. He calls it a meat tea & boasts that few people who have ever dined with him come back again. (pp. 189–90)

Miller's use of the term "meat tea," instead of "dinner" would have immediately excluded him from the rank of gentleman in 1856.[40] Although his social origins have not been traced, Miller's habits indicate that he was likely from a modest background.

Miller managed to earn the money to collect art as a tobacco and wood merchant and later, as a shipowner. That he was just as highly regarded by businessmen as by artists is borne out in his obituary in *The Buteman*. He was apparently in such demand as an arbiter in commercial disputes that

> he was induced to give up business and lay himself out as a friendly referee. From the high reputation he had for probity and thorough knowledge of business, his services were largely resorted to, and so long as he was able to work, his time was fully occupied in hearing cases, and dealing out justice between man and man in this extra judicial way.
>
> (28 October 1876)

Even Miller's legendary negotiating skills could not avert the controversy sparked by the PRB in his native Liverpool. He and the Liverpudlian artist W. L. Windus, both members of the Academy's Council (known as "the 'Miller' and his men"), invited the Pre-Raphaelites to exhibit in their city in 1851, where they proceeded to win the Academy's annual £50 prize for the next seven years.[41] It was a painting lent by Miller in 1857, Millais's *The Blind Girl* (plate 27), which polarized the Academy's membership when it won the award. "This time it proved too much for a rival faction within the Academy," reports Mary Bennett.[42] An opposition Society of Arts was formed which successfully undermined the Academy, causing it to cease exhibitions after 1867.

The nature of the objections to Millais's painting may be gleaned from a local critic, who complained: "There is very little poetry about the girls, and much less melody in the defunct accordion. The younger child has a pair of very dirty stockings on."[43] Criticisms of candid realism in Millais's painting were hardly new; however, *The Blind Girl* is less susceptible to the charge than his earlier work. The overtly sentimental expressions on the children's faces combined with the looser brushwork in the foliage are indicators that Millais was moving in the direction his subsequent career would follow by appealing to more popular tastes. It was undoubtedly the Pre-Raphaelite hegemony over the Liverpool prize, as much as any specific features in Millais's painting, that irked more traditional local artists and caused them to secede from the Academy.

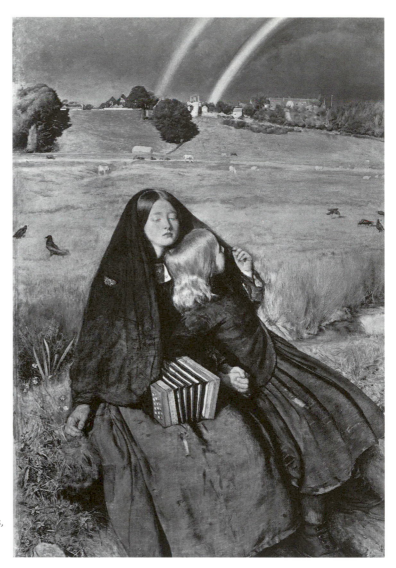

Plate 27. John Everett Millais,
The Blind Girl, 1854–56, oil
on canvas

Rather than withdraw his support because of the Liverpool deba-
cle, Miller continued to endorse the Pre-Raphaelites' avant-garde goals. In
1857 he encouraged them in their efforts to remain independent of the
Royal Academy by helping them stage an alternative exhibition in Russell
Place in London. He secured loans from collectors on their behalf, sent sev-
eral items from his own collection, and liberally proffered advice.
Counseling Madox Brown "to hang nothing whatever but what is first rate,"

Miller predicted that the exhibition "will be the reverse of the Royal Academy both in quantity and quality."[44] When the Pre-Raphaelites formed their own exhibition society, the Hogarth Club, in the following year, Miller was listed among its "non-artistic" members, again proving his active commitment to their cause.[45]

Miller demonstrated his passion for art through actions, not words. He encouraged his daughters to become artists and sanctioned the marriage of one of them to the architect Peter Marshall. Further, Miller instilled a love of collecting in his son Peter, who also patronized the Pre-Raphaelites.[46] Whether Miller's love of art was a surrogate for the artistic talent he lacked is a question that can only be posed, not resolved. Walter Benjamin suggests another explanation for Miller's motives when he attests that art collecting is a possessive gesture. He claims that the art lover harbors "spirits, or at least little genii, which have seen to it that for a collector . . . a collector as he ought to be – ownership is the most intimate relationship that one can have to objects."[47] Benjamin's speculation is pertinent to Miller, whose acquisitiveness caused the size of his collection to overspill the boundaries of his home into his office.[48] Yet the time he invested in furthering the careers of the Pre-Raphaelites indicates that he was more than a mere accumulator. Through his personal involvement Miller sought to extend the intimacy of ownership which Benjamin describes into his daily life.

To understand why Miller and other first-wave Pre-Raphaelite patrons felt the need to merge their identities with those of the young artists they admired invites a more psychoanalytical investigation. Oxford publisher Thomas Combe, for instance, was not simply content with owning the magical end products of creativity – he wanted to *become* a Pre-Raphaelite as well. His most revealing statement to this effect occurs in a letter to Hunt about the Royal Academy, where he states: "You remember how they treated Millais with his *Fireman* [*The Rescue*, 1855] last year; their behaviour proved how little his election was a mark of their repentance or of any change in them, beyond a conviction of the need of separating *us*, the active Pre-Raphaelites" (Hunt, II, 120; my italics). At one with the communal precepts of the Brotherhood, Combe wanted to accompany Hunt on his painting expedition to the Holy Land in 1854 (I, 344). The Oxford publisher was motivated to identify with the PRB because their mission satisfied his spiritual bent. Living at the center of the thickets of debate that defined the Oxford movement, married by the Anglo-Catholic Cardinal Newman, and fascinated by monasticism, Combe longed for the nineteenth-century

equivalent of a religious brotherhood.[49] Fondly called "the Early Christian" by Millais, who also likened him to patrons of the "Campo Santo time," Combe was motivated by a desire to recapture the essence of a more spiritual age in his daily life.[50]

Psychoanalyst Werner Muensterberger offers an explanation for why men as diverse as John Miller and Thomas Combe sought such close ties with artists. He maintains that, "Irrespective of individual idiosyncrasies of collectors, and no matter what or how they collect, one issue is paramount: the objects in their possession are all ultimate, often unconscious assurances against despair and loneliness ... They are magic remedies to ward off existential doubt."[51] In other words, by merging their identities with those of the Pre-Raphaelites, their early patrons hoped to quench a spiritual yearning.

Combe was the son of a Leicester bookseller and "a man of most cultivated tastes."[52] In charge of the Clarendon Press's monopoly on Bible printing, Combe and his wife Martha opened their home, first to the young Millais and later to the impressionable Hunt, who described the couple as "two of the most unpretending servants of goodness and nobility that their generation knew," adding that they were "'the salt of the earth' to a large circle" (I, 301). A portrait painted of Thomas Combe by Millais in 1850 (plate 28) reinforces Hunt's impression of amiable beneficence. Combe's tolerantly bemused expression, combined with his gentle fondling of the cat in his lap, creates an image of kindliness. By emphasizing the brilliant white of Combe's waistcoat and including a coat of arms in the background, Millais draws attention to his subject's social standing. This is in contrast to a later portrait drawing of Combe by Hunt (plate 29) in which his unruly hair and full, untrimmed beard give him the appearance of a religious divine. Just as Millais's ambitious personal values are evident in the earlier portrait, so is Hunt's own keenly religious view of the world superimposed onto his work, where he intensifies the publisher's piety.

Similarly, in an 1861 chalk drawing of Martha Edwards Howell Bennett Combe (plate 30), Hunt endows her with the serenity of a Madonna, through her stillness and downcast, introspective gaze. Martha Combe, however, cannot be considered a reflection of her husband's personality or a mere pendant to his patronage. She was instrumentally involved in the progress of the pictures they both commissioned, from the level of supplying artists with relevant texts and props, to determining the ultimate fate of their collection. It was she who decided, after her husband's death, to donate

Plate 28. John Everett Millais, *Thomas Combe*, 1850, oil on panel

Hunt's celebrated *The Light of the World* (1853) to Keble College and to construct a chapel to house it.[53] Yet virtually all credit for fostering Pre-Raphaelitism has gone to her husband. The cause of this neglect rests, in part, with the artists themselves. Despite their avowed commitment to social reform, the PRB viewed the everyday world through a binocular lens which separated the public male sphere from the private female domain. They saw only Martha Combe's domestic activities and ignored the fact that it was her family's money that sometimes paid for their paintings.[54] While Holman Hunt admired her, it was not for her visual acuity, but for her nurturing skills.

157

Plate 29. William Holman Hunt, *Thomas Combe*, 1860, red and black chalk

Omitting to mention that he relished her counsel, the artist explained that she "was the foster-mother of the whole parish; she knew the troubles of every house" (I, 312). Hunt's identification of Martha Combe as a "foster-mother" is ironically telling because it uncloaks her as a woman of action and influence. Ruth Perry and Martine Brownley attribute women like Martha Combe who have played unacknowledged roles in nourishing and sustaining the creativity of others with "mothering the mind."[55] The behind-the-scenes support that Martha Combe administered can be construed as a legitimate form of "matronage" – just as her husband fathered and protected the PRB, so did she mother and shield them.

158

Presented to the Taylor Buildings
Oxford by
W. Holman Hunt
1895

1861 Mrs Combe

Plate 30. William Holman Hunt,
*Martha Edwards Howell Bennett
Combe*, 1861, red and black chalk

The Pre-Raphaelites naturally reveled in their good fortune in having found such an appreciative couple. While Hunt was touched by Martha Combe's "solid sympathy" (I, 312), F. G. Stephens, who continued to plead the PRB's cause after he left the group to become an art writer, immortalized Thomas Combe as the ideal patron. In an early monograph on William Holman Hunt, Stephens compared the Oxford publisher to the most enlightened patrons of the early Renaissance, asserting: "The class of merchant princes, as in Florence of old, aided their own native art, and with characteristic common sense, inquired the sterling *meaning* of a picture before they bought one. The patronage and warmest friendship of Mr. Combe to

Hunt is an example of this kind."[56] In publicly acknowledging Combe, Stephens presumably hoped others would follow his example in offering a form of patronage that was intimate but not stultifying, paternal but not overbearing. Malcolm Warner effectively sums up Combe's role as a patron when he states: "He was essentially the material provider to a closed group of religious painters; his support of the Pre-Raphaelites was the same kind of slightly anachronistic expression of religious commitment as the building of St. Barnabas's Church in Oxford, which Combe financed in later life."[57] Patronage as practiced by Thomas and Martha Combe was a corrective to the deferential model of the eighteenth and early nineteenth centuries. While they invited intimacy, they also gave artists a great deal of latitude, and consequently earned their respect.

That description, however, does not suit Francis McCracken, who was Holman Hunt's and Rossetti's first client. He began buying their art even before he met them because he thought it seemed a good investment. Impressed by what he read about Hunt's *Valentine Rescuing Sylvia from Proteus* when it won the Liverpool prize in 1851, McCracken wrote to the artist and offered him a painting by Thomas Danby as down-payment on the £200 purchase price with a promise to pay the balance in monthly installments of £10 each (I, 282). Since, at this early point in his career, Hunt had managed to interest only family members and other artists in his work, he readily accepted McCracken's terms. Nor did Ford Madox Brown object to a similar arrangement when the Belfast patron offered to buy his *Wycliffe Reading his Translation of the Bible* after seeing it, in the same year, at an exhibition in Dublin.[58] Rossetti also benefited from McCracken's patronage in 1853 after Holman Hunt and Madox Brown recommended that the Belfast businessman add *Ecce Ancilla Domini* to his collection after the painting had sat on the artist's shelf for three years. Rossetti gleefully reported to Madox Brown: "I have got rid of my white picture to an Irish maniac."[59] As disparaging as Rossetti's terminology sounds, it registers his surprise that an outsider was finally interested in his work.

McCracken adds to the social diversity of those patrons who showed an interest in the PRB during the first four years of the group's existence. Frequently misidentified as owner of J. & R. McCracken, the prosperous packing and shipping firm that handled the Royal Academy's business, Francis McCracken was actually a financially troubled cotton spinner whose limited resources forced him to pay for his art purchases on installment.[60] He was accustomed to taking risks in his business, especially those which involved only a minimum outlay of capital. Although

McCracken's patronage provided a crucial psychological boost to the fledgling PRB, at a time when the artists had achieved little commercial recognition, it proved a mixed blessing. He frequently fell behind in his payments, adding an additional burden to the pecuniously strained lives of Madox Brown, Holman Hunt, and Rossetti.[61] Moreover, they thought him an odd character because of his incessant letter writing and expressions of Celtic effusiveness. Rossetti, for instance, marveled at his patron's "state of wild excitement about some subjects I have been mentioning to him."[62]

McCracken's idiosyncrasies prompted Rossetti to write a parody about him in 1853, based on Tennyson's sonnet *The Kraken*.[63] It reads:

> MACCRACKEN
> Getting his pictures, like his supper, cheap,
> Far far away in Belfast by the sea,
> His watchful one-eyed uninvaded sleep
> McCracken sleepeth. While the P.R.B.
> Must keep the shady side, he walks a swell
> Through spungings of perennial growth and height:
> And far away in Belfast out of sight,
> By many an open do and secret sell,
> Fresh daubers he makes shift to scarify,
> And fleece with pliant shears the slumbering "green."
> There he has lied, though aged, and will lie,
> Fattening on ill-got pictures in his sleep,
> Till some Praeraphael prove for him too deep.
> Then, once by Hunt and Ruskin to be seen,
> Insolvent he will turn, and in the Queen's Bench die.

When he published this sonnet almost a half-century later, William Michael Rossetti leapt to McCracken's defense, explaining that his brother would never have accused the Belfast patron of "spungings," telling a "lie," or of initiating a "secret sell," had he not been desperate to find rhymes to match Tennyson's. William Michael protested: "McCracken was my brother's mainstay in his most struggling years, and was well recognized and appreciated as such by my brother himself."[64] It is true that when the artist finally met his patron a year after writing the sonnet, he admitted: "I like Mac Crac pretty well enough, but he is quite different in appearance – of course – from my idea of him."[65] Nevertheless, the note of comic censure in Rossetti's sonnet is symptomatic of a new equality between artist and patron that is directly tied to the issue of social class.

While McCracken, whose father was a Belfast merchant, was not a proverbial self-made man, neither was he from a higher class than Rossetti, who stemmed from a family of intellectuals who lived in a middle-class section of Regent's Park.[66] Though John Everett Millais, the only Pre-Raphaelite painter to decline a commission from McCracken, was not as well-educated as Rossetti, he had the security of parents with independent means.[67] Brown's origins were even more distinguished: he was the grandson of a famous physician who had sat for a portrait by William Blake and the son of a British navy officer who served in the Napoleonic Wars.[68] William Holman Hunt, on the other hand, was a product of London's East End, where he was raised in rooms above the warehouse his father managed. Despite his modest station, Hunt senior earned enough excess capital to collect prints and art books (I, 4–5). Although none of the Pre-Raphaelites, with the exception of Millais, was financially independent, they did not perceive themselves as socially inferior.

Buttressed by their collective social and cultural capital, the members of the PRB balked at the idea of paying deference. Their disregard for the social taboos that plagued relations between earlier Victorian artists and their patrons, sometimes, however, bordered on indifference. Wanting to project an image of themselves as unworldly artists unconcerned with the plebeian details of daily life, they occasionally glossed over the identities of their patrons, leaving a trail of confusion. McCracken, for instance, is variously described as a "shipowner," "packing-agent," "merchant," or "ship-broker."[69] An even greater muddle surrounds the two patrons who shared the name Miller. Thomas Miller of Preston is credited by Millais's son as the second owner of his father's *Autumn Leaves*, when the painting was actually rescued by John Miller of Liverpool from a collector who was dissatisfied with it.[70] As casual as the Pre-Raphaelites may have been about their provincial patrons, they did not make the same mistake about their more sophisticated London clients.

Lewis Pocock entered the Pre-Raphaelite sphere in 1852, when he allowed Rossetti, Hunt, and Brown to participate in the Old Water-Colour Society's winter exhibition. Actively involved in the administration of a variety of art organizations, Pocock was treasurer of the Graphic Society, secretary of the Old Water-Colour Society, and honorary secretary of the Art Union of London, of which he was a co-founder. In her study of the Art Union, Lyndel Saunders King notes that Pocock "came from the background of the more traditional English art patron," and was considered the

"connoisseur" among its organizers.[71] Pocock's interest in the PRB, however, was more than professional: he bought oil sketches from Hunt and Brown, in addition to commissioning a canvas from Millais.[72] Although he owned only four Pre-Raphaelite works, Pocock played an important role in promoting the reputation of the group on the London art scene.

It was at the exhibition organized by Pocock in 1852 that John Ruskin first saw Rossetti's work.[73] Even though he had written about the PRB a year earlier, Ruskin at that time had not yet met any of its members. It was he, more than any other single figure, who pivoted Pre-Raphaelitism into national prominence, through his celebrated pamphlet of that name, and by his continued references to the PRB in his *Academy Notes* and successive volumes of *Modern Painters* throughout the 1850s.

Because Ruskin was so prolific an art writer, the tendency has been to consider him solely a tastemaker, rather than someone who was himself influenced by existing patterns of patronage. Schooled in the practice of collecting the works of living artists by his father, Ruskin was presented by his parent with three Turner watercolors as gifts when he was still in his early twenties. Ruskin senior also insured that his son's career as a gentleman amateur got off to a good start by paying for painting lessons from Charles Runciman, Copley Fielding, and J. D. Harding.[74] Oxford-educated, John Ruskin rose several notches above his self-made father on the social scale. Although only one generation separated him from the source of his family's wealth, Ruskin assimilated the speech, dress, and manners of a gentleman to the extent that Rossetti, when he first met him, considered him "an absolute Guy."[75] Moreover, in adopting philanthropic interests that were usually associated with at least the third generation of wealth, Ruskin assumed the appearance of the "old bourgeoisie" described by Pierre Bourdieu in that he demonstrated his cultural competence with an ease which seemed to be second nature.[76]

Before I go on to discuss the implications of Ruskin's intervention in the lives of the Pre-Raphaelites, I first want to consider his contribution to the social make-up of the group which gave them their earliest encouragement. He, Pocock, and the Combes bestowed a degree of gentility and knowledge that was less apparent in Miller and McCracken. They, on the other hand, proved to the young reformers that the business community in the provinces could be tapped as a source of support. First-wave Pre-Raphaelite patrons, then, represented a broad cross-section of society, in

terms of their social origins, gender, occupations, and degree of wealth. With no established audience for avant-garde art in England at this time, the PRB found it imperative to reach out to a wide assortment of individuals on a personal basis. They did not appeal exclusively to a single segment of the middle-class, but managed to speak to unsophisticated merchants such as McCracken and John Miller in the same voice they used to attract the worldly Ruskin, Pocock, and the Combes.

In the complex dealings of Ruskin we recognize the startling congruence of bourgeois liberalism and aristocratic paternalism. The irascible *éminence grise* of the Pre-Raphaelites, Ruskin was driven by a host of conflicting urges. Inventive in his theories of art appreciation, far-sighted in his ideas about philanthropy, he was considerably less of a trendsetter in his role as a private patron of the arts. Indoctrinated in his father's Evangelical faith and encouraged by him to become an amateur artist, Ruskin was the progeny of two conflicting traditions. One emphasized morality and social responsibility, while the other focused on pleasure and delectability. The tension between the two colored Ruskin's motivations as a patron and led him to rationalize the enthusiasm he felt for art in terms of its socially ameliorating benefit.

As I indicated in chapter 1, John James Ruskin's acquaintance with his neighbors Elhanan Bicknell and Benjamin Godfrey Windus gave his son access to their private collections of Turners. One might easily conclude that this proximity sparked Ruskin's appreciation of the Pre-Raphaelites, since Windus mingled their canvases with his Turners. On the contrary, neither patron was responsible for introducing Ruskin to the PRB. Rather than Bicknell swaying his young neighbor, Landseer was concerned that Ruskin might effect the reverse. The older artist expressed his anxiety in a letter he wrote to Bicknell in 1858, where he scornfully remarks: "Your friend and neighbour Ruskin will not recommend you to invest in any modern work unless it be 'pre-Raphaelite' – or the great Turner."[77] Landseer had good cause for worry. The Pre-Raphaelites were encroaching on his lucrative market; when Millais sold *Peace Concluded* to Thomas Miller of Preston in 1856 for £1,000, he was second only to Landseer in the high price stakes at the Royal Academy.[78] Landseer, however, need not have feared the loss of Bicknell's patronage to the Pre-Raphaelites: the collector remained faithful to the early-Victorian school. Windus did not. Still, he cannot be taken for Ruskin's guide to Pre-Raphaelitism either.[79] Credit for interesting Ruskin in Pre-Raphaelite painting must go to the artist William Dyce, who,

Ruskin confessed, "dragged me, literally, up to the Millais picture of *The Carpenter's Shop*, which I had passed disdainfully, and forced me to look for its merits."[80]

Exhibited at the Royal Academy in 1850 under the title *Christ in the House of His Parents* (plate 31), Millais's painting provoked a barrage of negative criticism. One of the most strident voices raised in protest against the picture's imagery belonged to Charles Dickens, who expressed his revulsion toward Millais's realistic and unidealized Holy Family. In an article in *Household Words*, Dickens complained that Christ looked like a "hideous, wry-necked, blubbering, red-headed boy in a bed-gown," while he asserted that Millais had represented Mary in the guise of "a Monster in the vilest cabaret in France, or in the lowest gin-shop in England."[81] Dickens echoed the outraged sentiments of conventional religious viewers who objected to the demeaning depiction of sacred mysteries through commonplace rather than divine symbols. Weaned on idealized and generalized representations of the human figure cast in a Renaissance mold, the public resented the PRB for taking art down from its pedestal and demystifying it.

In John Ruskin the PRB found a defender who was not intimidated by hostile criticism. Having called for the reform of English art in *Modern Painters*, Ruskin proved sympathetic when the poet Coventry Patmore approached him at Millais's urging and asked him to defend the Brotherhood in print.[82] Ruskin's motivation for supporting the PRB was closely tied to his aesthetic appreciation of Turner, whom he believed should be a role model for the young artists. In a letter to *The Times* of 30 May 1851, Ruskin intimated that he viewed the Pre-Raphaelites as mere beginners, mere youths who could be shaped and molded into Turner's image under his mentorship. That he saw their work as early efforts in a developmental stage that had yet to mature is evident in his optimistic prediction that they "may, as they gain experience, lay in our England the foundations of a school of art nobler than the world has seen for three hundred years" (*Works,* XII, 327). In other words, he believed that the PRB had the potential to soar above its literal approach to nature and become like Turner – if only the group would follow his advice.[83] Thus Ruskin concentrated his energies on shaping the course of the Pre-Raphaelite style.

Motivated by a desire to control and guide artistic production, Ruskin did not essentially differ from the aristocratic patron. He reverted to the patrician model of the protégé system when he placed Rossetti's fiancée Elizabeth Siddall on an annual stipend, conditional upon her giving him

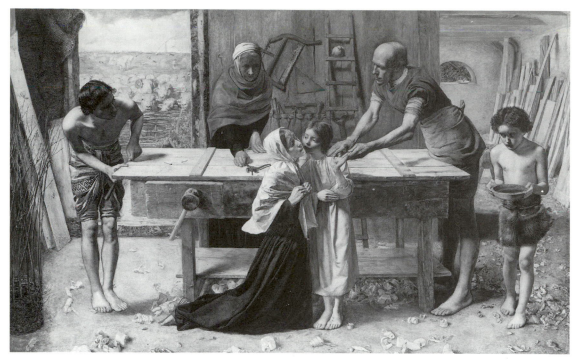

Plate 31. John Everett
Millais, *Christ in the House
of His Parents*, 1849–50,
oil on canvas

first refusal of her drawings and watercolors.[84] The critic won over Rossetti when he heaped praise on him in 1853 by claiming "the colour and grouping" of his Dante subjects were "superior to anything in modern art."[85] The artist was at first dubious, but after Ruskin offered to purchase everything that pleased him among Rossetti's productions, he rapidly acquiesced. Ruskin's interference in Millais's career was more extensive: he outlined a campaign of learning for the artist and supervised the painting of his own portrait *in situ* – an intimate arrangement which resulted in Effie Ruskin falling in love with the artist, whom she married after obtaining an annulment from her husband.[86]

Millais's portrait of Ruskin (plate 32) is a visual document of the patron's ideals. The revolutionary aspect of the picture is not in portraiture but in landscape painting, a subject to which Ruskin had devoted his attention since beginning *Modern Painters*.[87] Accordingly, the writer is depicted in the act of contemplating natural phenomena, not as a figure apart, but one who is at ease in the wild landscape. In order to ensure that Millais did not miss any of the botanical or geological detail Ruskin believed was implicit in Turner's summarized vision of nature, he stood over the artist's

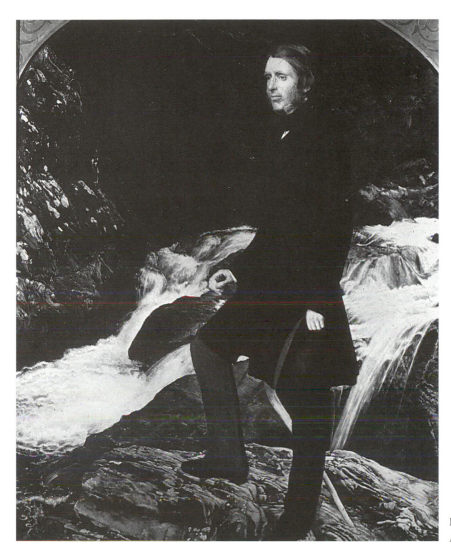

Plate 32. John Everett Millais, *John Ruskin*, 1853–54, oil on canvas

shoulder for ten weeks in Scotland, directing his attention to the microscopic particulars of the scene before them, predicting that the waterfall in the background would be as wonderful as Turner's *St. Gothard* (*Works,* XII, xxiv). Ruskin was frank about his intervention in Millais's work, telling a friend "I have stopped all this time … to keep him up to the Pre-Raphaelite degree of finish – which I have done with a vengeance, as he has taken three months to do half a background two feet over" (*ibid.*). His attempts to shape Millais's talent recall the stifling effects of earlier connoisseur–artist couplets such as Sir George Beaumont and Wilkie or Sir John Leicester and Collins.

Like these aristocratic patrons, Ruskin was a benevolent despot in his personal relations with artists.

Ruskin's private behavior militated against the magnanimity of his public pronouncements. In lecturing the cotton lords of Manchester on the occasion of the Art Treasures exhibition in 1857, he advised that "a rich man ought to be continually examining how he may spend his money for the advantage of others" (*Works,* XVI, 128). His ideas were to bear fruit two decades later, when one of his local admirers, T. C. Horsfall, established a museum in the slums of Manchester. An even more telling instance of the impact of Ruskin's humanitarian ideals is provided by Thomas Dixon, a simple corkcutter, who, after corresponding with the author of *Modern Painters,* led the movement to found the Sunderland Art Gallery in 1880.[88] As influential as Ruskin was with the public, he did not apply his altruistic principles to the more intimate realm of private patronage.

Perhaps the reason Ruskin found it difficult to grant freedom of expression to artists was because he harbored the "little genii" identified by Benjamin which made him feel possessive about their work. He confessed to Rossetti in 1854: "I forgot to say also that I really do covet your drawings as much as I covet Turner's; only it is useless self-indulgence to buy Turner's, and useful self-indulgence to buy yours."[89] The murmurings of his Evangelical conscience can be plainly heard: Turner was dead and no longer required money, while Rossetti was alive and needy. No matter how much he tried to justify his art collecting as necessary philanthropy, Ruskin, at heart, was a dedicated connoisseur who derived enormous enjoyment from his purchases. He admitted that his Turners gave him "exquisite pleasure" and that each new one achieved "a year added to my life, and a permanent extension of the sphere of life" (*Works,* XIII, xlviii). For someone whose religious scruples were at odds with his passion for art, the Pre-Raphaelites seemed an ideal compromise, since they, too, wanted to better society through the medium of art. Ruskin urged the PRB to participate in his reform by joining him in teaching at the Workingmen's College.[90] Additionally, he sympathized with their negative assessment of academic standards, criticizing, in his 1851 pamphlet on Pre-Raphaelitism, "the myriads of men" who "are making their bread by drawing dances of naked women from academy models, or idealities of chivalry fitted out with Wardour Street armour, or eternal scenes from *Gil Blas, Don Quixote,* and the *Vicar of Wakefield*" (*Works,* XII, 351). In theory, then, Ruskin endorsed the avant-garde intentions of the PRB, in both the social and the artistic realms,

to the degree that, like Thomas Combe, he even considered himself a Pre-Raphaelite.[91] In his personal practice, however, he favored a dogmatic and paternal ideal of aristocratic patronage that conflicted with the PRB's goal of individual liberty.

Ruskin demonstrated a similarly patriarchal attitude toward the women he mentored. After all, were not both artists and women as emotionally immature as children and thus in need of paternal guidance? Ruskin's lengthiest correspondence on the subject of private patronage was reserved for two women: Ellen Heaton and Lady Pauline Trevelyan. Admittedly, both initially sought his advice; however, he made it clear from the outset that his recommendations were not to be questioned. Holding to a Darwinian concept that the female of the species was destined by her gender to assume a subordinate position in society, he felt no qualms about dispensing advice to Heaton and Trevelyan, overriding their instructions to artists, or appropriating works for himself that they had commissioned. In Ruskin's dealings with women patrons, we recognize the shadowy presence of a puppet master who delights in controlling all of the characters on his stage.

Considering how much Heaton valued her independence, her reliance on Ruskin's judgment comes as a surprise. Freed by the legacy she received from the estate of her bookseller father in 1852, Heaton was determined to lead an unconventional life. Unmarried, she traveled about Great Britain, attending scientific meetings of the British Association, concerts, and art exhibitions. She also ventured abroad to Russia, Poland, and to Italy, where she was a member of the Browning circle. Having commissioned Thomas Richmond to paint her portrait in 1849, Ellen Heaton became fast friends with him, going on expeditions with the married artist, and making him a generous loan of £1,200, much to the exasperation of her more conventional brother, the physician John Deakin Heaton.[92]

Living in Leeds, Ellen Heaton had the example of Sheepshanks, as well as the active exhibition programs of the Northern Society for the Encouragement of the Fine Arts, the Mechanics' Institution, and the Literary and Philosophical Society to impel her toward patronage.[93] Additional cultural stimulus was provided by her father, who operated an informal salon in his bookshop, where, according to his son, "gentlemen of leisure in the town" gathered, "looking over books or chatting together on public and social affairs."[94] However, Heaton turned to Ruskin for guidance after reading the early volumes of *Modern Painters*. She began to correspond with him in 1855, first seeking his advice about the purchase of several

Turner drawings.[95] Ruskin then pointed her in the direction of the Pre-Raphaelites, encouraging Heaton to commission works from Rossetti.

Even though at thirty-nine years of age she was three years older than Ruskin in 1855, he condescendingly grouped Heaton with the stereotypical Victorian maiden when he advised her against accepting Rossetti's *Paolo and Francesca*. Ruskin contended that "prudish people might perhaps think it not quite a young lady's drawing," because it featured "the fatal kiss."[96] Instead of respecting Heaton's seniority and independence, Ruskin assumed a patriarchal posture in his dealings with her, believing, like a stern paterfamilias, that those in his care should accept his word as law. Thus he felt no compunction about purloining a watercolor Heaton had ordered from Rossetti. Ruskin made his position apparent in a letter he wrote to Rossetti justifying this transaction:

> Miss Heaton and other people, when they put themselves into my hands and say "What pictures shall I buy?" ought, I think, not to be treated as strangers, but as in a sort my clients and protégés. And although Miss Heaton never *heard* of the *Beatrice*, remember, it was begun for her, and, when I saw it was to be good, I took it for myself.[97]

In one fell swoop, Ruskin reminded the vulnerable Rossetti of his power to grant and take away patronage; at the same time he demeaned both the artist and Heaton by establishing his own claim as ultimate arbiter of artistic value. Having attracted few patrons by 1855, one can understand why Rossetti might tolerate Ruskin's behavior, but the fact that a woman as strong-willed as Ellen Heaton countenanced his interference only becomes comprehensible when viewed in the larger context of women's history of denial as interpreters of culture. So different in temperament from the compliant Martha Combe, Heaton would not have had any role models to inspire her to claim a more assertive place in the cultural field.[98]

Although richer and a member of a higher social class than Ellen Heaton, Lady Pauline Trevelyan was equally in awe of Ruskin's claim to cultural authority. She had easy access to the best circles through her marriage in 1835 to Walter Calverley Trevelyan, a notable botanist, geologist, and collector of Old Master paintings, who inherited a baronetcy in 1846, along with Wallington Hall in Northumberland and Nettlecombe Court in Somerset.[99] Pauline Jermyn Trevelyan, however, was not to the manor born. She was the intellectually precocious daughter of a cultured but impoverished Suffolk parson.[100] That is not to say that Pauline Jermyn was com-

pletely overwhelmed by her circumstances when she married her husband at the age of nineteen: she was already an accomplished botanist and linguist and was soon to become an established reviewer and art critic for *The Scotsman* (p. viii). Although she had not been educated in the aristocratic manner, she quickly rose to the occasion by developing definite views on what she conceived to be the duties of a patron. Nevertheless, Pauline Trevelyan's middle-class origins suggest that her acts of patronage were a means of legitimating her position as chatelaine of two imposing houses.

Lady Trevelyan's qualifications as a patron, however, extended beyond her money and social standing. As an avid amateur artist, she was anxious to adapt her abilities to the reforms suggested by Ruskin in his first two volumes of *Modern Painters*. It was for this reason that she called on him at Denmark Hill in 1847 (p. ix). Although Ruskin was three years her junior, Pauline Trevelyan deferred to his superior knowledge in matters of the visual arts.[101] Her admiration of him is apparent in the numerous letters she wrote to and about him between 1848 and her death in 1866. For instance, in 1853, she confided to her friend Louisa Stewart-Mackenzie (later Lady Ashburton), "I am so thankful to find that I can worship him so entirely as ever – and also that he is as kind and loving as ever – what a blessing *that* is, when one has been several years without seeing one's idol" (p. 41). As transparent as her hero-worship is, Pauline Trevelyan's reference to Ruskin's kindness indicates that her relationship with her mentor was more balanced than Heaton's. That is to say, the son of the wine merchant behaved with more civility to the wife of the baronet than to the spinster from Leeds. Snobbery must be taken into account in defining the attitudes of someone like Ruskin, who had risen so far on the social scale in a single generation.

For her part, while Pauline Trevelyan did not demur when Ruskin proffered his advice, neither did she consult him every step of the way. Her most ambitious project was the decoration of the main hall at Wallington which she created by roofing over the central courtyard in 1854. Like eighteenth-century connoisseurs returning from the Grand Tour with a battery of painters and craftsmen hired to enhance their country houses, Lady Trevelyan imported the Pre-Raphaelites to Northumberland, where she orchestrated their efforts. The scheme was well under way before she asked Ruskin's opinion of the art work she had commissioned. One senses that Pauline Trevelyan wanted to surprise and delight him with a grandly independent gesture; yet, when Ruskin expressed his dislike of the design on the spandrels, she had it changed.[102] Significantly, it was the design which

gave Ruskin pause and not the élitist concept underlying the Wallington project. That so much talent was essentially hidden from public view did not seem to worry Ruskin, who, as we have seen, applied a different set of values to private patronage.

These values, however, were becoming increasingly difficult for the Pre-Raphaelites to accept. Initially regarding him as a savant and savior, the artists came to resent his meddling. Ruskin so exasperated Millais over the painting of his portrait that he never worked with the same degree of detail again.[103] Rossetti was at first happy to fill Millais's position as protégé and extolled the virtues of Ruskin's paternalism, calling him, in the spring of 1855, "the best friend I have ever had *out of my own family*."[104] He was also remarkably complacent about Ruskin's criticisms, some of which were indeed harsh. An example is the patron's shrill peroration about Rossetti's watercolor, *The Nativity*:

> The drawing is in many respects likeable – but in many more *Wrong*. A human arm – on the one hand, is not this [sketches inserted by Ruskin] – as the academicians draw it – but neither is it this, – as *you* draw it [sketch by Ruskin]. Flesh is not Buff colour – as Mr. Neabert draws it – but neither is it pea-green, as you draw it. Half of the angels' noses are turned all on one side – the child's mouth is turned round into his right cheek: and the blue of the Virgin's dress is ridiculously bright to be in full shadow.[105]

Rossetti's response to this tirade was unusually benign: he calmly told his mother that, "R[uskin] disappointed me by not thinking [*The Nativity*] up to my usual mark. I shall do him another instead, and sell that to someone else."[106] Perhaps Rossetti optimistically hoped he would be included in the pantheon of modern artist–heroes Ruskin had begun to establish in *Modern Painters*. Impressed by his stature as a critic and awed by his attention, Rossetti did not become skeptical of his mentor's judgment until 1860, when he described Ruskin's *Unto this Last* as "bosh."[107] Once the artist had begun to doubt the critic's abilities, he became more assertive with his protégés. In 1861, for instance, Rossetti facetiously informed Heaton: "I am as pleased as anyone can be, my dear Miss Heaton, when my works have the good fortune to please such a judge and such a friend as Mr. Ruskin," firmly adding that he would not make the sale of any of his pictures contingent on Ruskin's judgment.[108] Nevertheless Rossetti remained in contact with him for another four years before definitely calling quits to the critic's interference.[109]

Heaton and Trevelyan are representative of second-wave Pre-Raphaelite collectors who granted mentors, such as Ruskin, or dealers the right to mediate for them. They were joined by the stockbroker Thomas Plint, who was descended from a well-known but not exceptionally affluent family of Leeds radicals, the distinguished barrister Joseph Arden, the Manchester magnates Thomas Fairbairn and Thomas Miller, and the intractable Benjamin Godfrey Windus, whose background has already been described in chapter 1. While many early- and mid-Victorian art lovers rounded off their collections by including an example or two of the Pre-Raphaelite style, the number of recurring names remained small: only these six stand out in the next phase of the movement.[110]

There are two reasons for the limited number of intimate Pre-Raphaelite patrons after 1853: the disbanding of the Brotherhood and the dulling of its avant-garde edge. Never a strong union, the PRB showed signs of what William Michael Rossetti termed "desuetude" as early as 1851, barely three years after they had first come together.[111] By the mid-1850s, the movement had lost its cohesion as Holman Hunt became more obsessive about painting religious subjects in the Holy Land, Millais joined the Royal Academy and veered away from the depiction of time-consuming minutiae, and Rossetti drifted further into his self-absorbed fantasies. The loss of united artistic goals was mirrored in the decline of those devoted patrons who wished to merge their identities with the Pre-Raphaelites.

At first operating tangentially to the Royal Academy, the Pre-Raphaelites were now torn between maintaining their marginality and sustaining the lifestyles they believed they deserved. The crisis of 1848 had bypassed England: instead of turmoil, the succeeding decade brought peace and plenty. Scholars of British history trace a sense of certainty to the years following the Great Exhibition of 1851. Geoffrey Best notes that the Bank of England's bullion reserves were enriched by new gold from California and Australia which permitted it to relax its credit policy, thus encouraging the formation of many more companies. Despite the economic fluctuations which occurred, this prosperous period produced, as Best comments, "a buoyant optimism and bold, confident enterprise."[112] Hence the avant-garde had less fodder for its project. Dissidents like the Pre-Raphaelites found fewer grievances to express until the cult of progress began to be assailed at the end of the decade.

The modern moral subjects which they introduced in the mid-1850s complemented rather than critiqued social values. Although the Pre-

Raphaelites had addressed the theoretical issue of modernity earlier in their short-lived journal, *The Germ*, they did not begin to transform their ideas into practice until 1854, when Hunt produced *The Awakening Conscience* (plate 17) as a companion to the religious allegories in Fairbairn's collection by more conservative artists.[113] Although his depiction of a kept woman and her lover was potentially controversial, his focus on her moment of salvation was not. Hunt attested that his intention was to demonstrate how "the appeal of the spirit of heavenly love calls a soul to abandon a lower life" (II, 429). Millais soon followed with *The Rescue* (plate 33), a subject that also conformed to existing protocols and thus, like Hunt's picture, was welcomed at the Royal Academy. Having stylistically abandoned their earlier ideographic canon, Hunt and Millais offered their public the well-rounded forms and depth of field that were sanctioned by academic practice.

Both pictures fall under the general rubric of Victorian narrative-cum-literary painting in that they are anecdotal and have literary provenances. Alastair Grieve draws a parallel between Hunt's magnification of telling detail and the imagery in Wilkie Collins's novel *Basil: A Story of Modern Life* (1852).[114] While the same cannot be said for Millais's more generalized treatment, the artist, however, consulted Collins and Dickens about his subject.[115] Even though Millais had actually witnessed firemen rescuing a child from a blazing house on Tottenham Court Road, he wanted to capitalize on the narrativity of the scene. His strategy proved successful when another writer, William Makepeace Thackeray, persuaded the wealthy barrister Joseph Arden to purchase the picture.[116]

The Rescue corresponds closely to the parameters that Thackeray had defined for Victorian painting: first, it features a subject from everyday life; and secondly, its poignantly sentimental tableau of a mother reunited with her child fulfills the critic's criterion for subjects which must touch the heart.[117] That *The Rescue* struck a responsive chord in its middle-class purchaser was demonstrated by Arden's refusal of an offer of £2,000 for it, even though that figure represented a substantial profit over the £580 he had originally paid Millais.[118] Its growth in value within four years is a marker of how far Millais had drifted into the mainstream market for art. That he was a willing traveler is evidenced by his willingness to compromise for the sake of a sale: after Thomas Miller of Preston became interested in *Peace Concluded* in 1856, Millais altered the painting's socially critical message by changing the central figure from an officer on unofficial leave from the Crimean War to the more patriotic representation of a wounded hero

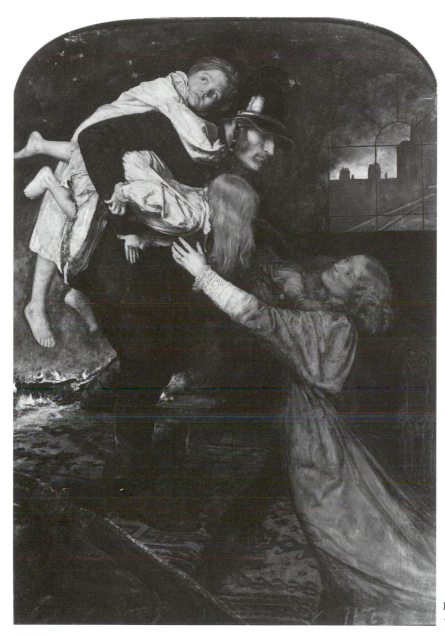

Plate 33. John Everett Millais,
The Rescue, 1855, oil on canvas

(p. 100). While Rossetti criticized the altered painting as "a stupid affair to suit the day," his own record was not unblemished.[119] In order to make *Ecce Ancilla Domini* more appealing to the Belfast Protestant Francis McCracken, Rossetti changed its title to *The Annunciation*, thus avoiding a Roman Catholic association.[120] In bowing to the conditions of the market, the Pre-

Raphaelites allowed themselves to be coopted by the middle-class values they had initially derided.

Despite their disdain for bourgeois businessmen, the Pre-Raphaelites articulated many of the same middle-class ambitions. Like their mercantile collectors, they kept a close watch on prices, were skilled negotiators, and carefully husbanded their profits. Harrison and Cynthia White report a similar phenomenon in their study of the French art market when they observe that the Impressionists were "middle-class men with middle-class aspirations."[121] The Whites go on to define that a middle-class standard to the Impressionists "meant steady support for one's family, dignified, reasonably furnished living quarters, and at least one servant" (pp. 129–30). The Pre-Raphaelites, too, demonstrated that they expected to live at a similar level of comfort. Millais's income spiraled upwards to the point where he was averaging £1,000 per year by 1853 from the sale of paintings and prints.[122] The degree of material amenity this brought him becomes readily apparent when one compares his income with that of a typical middle-class English family with one servant, which managed to exist on £250–300 a year.[123] Holman Hunt's income also significantly increased after he discovered the market for popular prints.[124] In comparison, Rossetti, whose obscure and undraughtsmanlike images were less adaptable to the engraver's burin, earned substantially less. Between the years 1849 and 1854 his income did not exceed £50, and while it had risen to £300 per annum by 1855 due to Ruskin's far-reaching influence, by the early 1860s he was still earning only £600 a year, far less than either Hunt or Millais.[125] In relying solely on private patronage during his Pre-Raphaelite phase, Rossetti was alone among his colleagues – even Brown reluctantly dealt with Windus's agent, D. T. White.[126] Rossetti's distance from dealers in the 1850s was less a question of principle than of opportunity. When he saw the fortunes amassed by his peers, he, too, cultivated a commercial relationship with both Gambart and Agnew in the next decade, and rapidly became skilled at setting patrons and dealers off against each other, as I shall describe in my chapter on the Aesthetic movement.

This pattern underlines one of the inherent contradictions of Pre-Raphaelitism as an avant-garde movement. Claiming to be outsiders, its artists took an active interest in the mainstream marketplace. Clement Greenberg comments on the paradoxical relationship between art and money when he observes:

No culture can develop without a social basis, without a source of stable income. And in the case of the avant-garde, this was provided by an elite among the ruling class of that society from which it assumed itself to be cut off, but to which it has always remained attached by an umbilical cord of gold.[127]

It was that "umbilical cord of gold" which produced a metallic tension between Pre-Raphaelite artists and patrons. While patrons could choose whether they wanted the tie to be taut, relaxed, or severed altogether, artists, although they might feel chaffed, were too often compelled by economics to leave the cord intact. The resulting strain sometimes erupted into emotional outbursts such as when Rossetti abused a Manchester collector by telling him he was "capricious and uncivil" for reneging on a commission.[128] Although William Michael Rossetti tried to play down his brother's aggressive temperament in his several monographs on the artist, he readily admitted that "of the least tinge of servility he was by his very nature – but this I need hardly say – incapable."[129] Millais's tone was equally disdainful in 1853, when he bragged, "It is quite a 'lark' now to see the amiable letters I have from Liverpool and Birmingham merchants, requesting me to paint them pictures, any size, subject, and amount I like – leaving it all to me. I am not likely to let them have anything, as they would probably hawk it about until they obtained their profit."[130] Millais and Rossetti's attitude signifies the atrophying of the early-nineteenth-century deferential model of patronage to which I referred when I compared the essentially bourgeois social character of both Pre-Raphaelite artists and their patrons.

Older and wiser, the Pre-Raphaelites developed a clearer idea of what constituted patronage. They became more businesslike in the management of their affairs and less likely to brook interference or to dismiss money matters for fear of dissension. Patrons were perceived as satisfactory when they appeared most fully to share the aspirations of the artists without question. They were perceived as unsatisfactory when they requested alterations in the finished product, consorted with dealers, or haggled about price.

The origin of the ambivalence Rossetti and Millais felt toward their purchasers is deeply rooted in the Pre-Raphaelites' romantic concept of the artist as creative genius. Nurtured by early indulgent patrons, such as Thomas Combe and John Miller, who subscribed to the stereotype of the artist as incapable dreamer, the PRB quickly adjusted to the role. Fanned

and fueled by Ruskin's ardor for their work, they expected to be recognized as special talents and treated with the respect they felt was their due. The paternal patronage of their first supporters was a mixed blessing: it offered the PRB a fund of confidence and security; however, by sheltering them from friction, these patrons created a level of expectation that was bound to lead to disappointment when it was not sustained by future buyers. Reckoning on sensitivity and understanding, the Pre-Raphaelites were upset when businessmen demanded changes in their work. Fractious relations were common with second-wave patrons who did not automatically assume that the Pre-Raphaelites' creative genius and crusading reforms placed them in a special category.

On the contrary, Fairbairn and Miller of Preston, as I already indicated, did not want to be reminded of Pre-Raphaelitism's "difference." Neither did Windus. He waited for five years until the critical furor caused by Millais's *Christ in the House of His Parents* had died down until buying it. By 1855, Millais could be considered a safe investment: he had been an associate member of the Royal Academy for two years and was receiving favorable reviews.[131] Despite their common interests in Turner and the PRB, Ruskin and Windus's motivations for collecting art represent the alpha and omega of Pre-Raphaelite patronage: artistic and social reform, on the one hand, and the forces of commerce, on the other. Windus began to traffic in Millais's work, buying only through dealers, and selling off quickly when the opportunity presented itself, such as in 1860, when he disposed of *A Huguenot* to Miller of Preston for £1,000, which was £750 more than the artist had been paid originally by Windus's dealer D. T. White.[132] Inevitably, the artist–patron relationship became fraught with tensions produced by the clash of social, economic, and artistic values.

It is these years of adjustment and change between the dissolution of the Brotherhood and the advent of the Aesthetic movement that are the subject of the remainder of this chapter. In that short time-span struggles were played out on a cultural field that had already had its boundaries stretched to accommodate the PRB. Bourdieu argues that the cultural field is a site of constantly shifting circumstances due to agents such as artists, critics, dealers, and patrons who have "entirely real interests in the different possibilities available to them as stakes and who deploy every sort of strategy to make one set or another prevail."[133] The entry of new players on the field was but one factor. Another was the continuing contest for control of artistic production in an increasingly commercialized art market.

Given the fragmented nature of later Pre-Raphaelite patronage, it was with some relish that the artists greeted two new customers in 1856 who displayed the enthusiasm of their original supporters toward the movement as a whole. Thomas Plint of Leeds and James Leathart of Newcastle were so eager to buy whatever was offered them that Rossetti called them "twin lambs at the altar of sacrifice."[134] Leathart's first purchases were the beginning of a long and intimate association with Pre-Raphaelite artists that peaked in the Aesthetic movement, and for this reason I will defer an analysis of his patronage until chapter 5. Not only does Plint's shorter and more intense period of activity fall within the range of second-wave Pre-Raphaelite patronage, but his character and actions are germane to both aesthetic and capitalist modernism – germane in the sense that Plint's life highlights the contradictions and tensions inherent in the myth of modernism's cult of progress. While arguments about the destruction spawned by modernism's reckless urban and industrial expansion have now become commonplace, it is less fashionable to focus on the individuals who are the casualties of these theories of collectivity. Yet those whose lives are situated at the crossroads of change, like Thomas Plint, can be a valuable "anthology of culture." The term is Peter Gay's and he uses it to argue that "since everyone belongs to a class with certain predictable styles of thought and conduct, and shares with all humans essential passions and defenses, the portraits that the psychoanalytically informed historian may draw of individuals can throw welcome new light on their class and their time."[135] Thomas Plint's life offers this kind of archival opportunity to discover and study modes of behavior that illuminate the crisis of faith in capitalist modernism's stratagem of success. In his short life as a patron we can chart the rise and fall of some of the most cherished Victorian values.

Rhapsodic in his missives to artists, well-informed about contemporary social and religious issues, and avant-garde in his politics, Plint seemed at first a patron nonpareil. Not only did he buy important pictures from the original members of the Brotherhood, but he took artistic risks by offering the unknown Edward Burne-Jones and William Morris their first commissions.[136] "He was kind and patient," recalled Georgiana Burne-Jones, "always ready to agree that an artist should choose his own subject and carry it out in his own way, and, as far as possible, at his own time" (I, 154). The Pre-Raphaelites and their young followers believed that in Plint they had found a man whose modern outlook and generosity of spirit matched the magnitude and magnanimity of their undertaking.

Yet there was a darker side to Plint's personality which adversely affected the PRB. It slowly revealed itself as his passion for collecting accelerated into an obsession, so much so that when he died at age thirty-eight in 1861, the only assets he left his wife and ten young children were his pictures.[137] Irresponsible in his enthusiasms, Plint contracted to purchase Holman Hunt's *Finding of the Saviour in the Temple* for a price in excess of £3,000 in the year of his death, even though he was already in serious financial trouble.[138] Walter Benjamin, who, as the son of a Berlin art dealer, had some opportunity to observe the behavior of collectors, recognized that excesses of the nature of Plint's were psychologically based. He observed: "The most profound enchantment for the collector is the locking of individual items within a magic circle in which they are fixed as the final thrill, the thrill of acquisition, passes over them."[139] Fixated on the idea of ownership, Plint lost sight of his day-to-day obligations, heedlessly demonstrating, in the words of a contemporary psychiatrist, that a collector who goes from conquest to conquest is compulsively using acquisition "as a vehicle to cope with inner uncertainty, a way of dealing with the dread of renewed anxiety, with confusing problems of need and anxiety."[140]

Although there are many previous instances in history of compulsive collectors (one need only think of Rudolph II and Napoleon), Plint's addiction more closely resembles that of the fictional Cousin Pons, who was created with authority and conviction by Honoré Balzac in 1847. The reason that Pons is such a believable character rests in Balzac's own collecting practices: his house in Paris was filled with bibelots, *objets d'art*, paintings, and sculpture – which led him to overextend his credit despite his success in the publishing world. Similar to many of the early-Victorian collectors I have described, Balzac was the son of a self-made man who became rich supplying goods to the French army; however, he lost most of his fortune before his death, leaving the young Balzac to be raised by a resentful and distant mother. Psychoanalyst Werner Muensterberger argues that the pathological side of Balzac's collecting was a way of compensating for the loneliness and sense of failure he experienced as a child.[141] Balzac transfers these qualities to the fictional collector whom he describes in *Cousin Pons* as someone for whom the "realities of life always fell short of the ideals which [he] created for himself."[142] Like Pons, Plint also perceived himself as a failure. Although we do not know the circumstances of his childhood, as an adult Plint displayed the pathological attachment to objects characteristic of those who have experienced early trauma. Georgiana Burne-Jones

reports that Plint, after he found himself in a precarious financial position due to his repeated overspending on art, "felt burdened and depressed by the debt when his health broke down" (I, 174). His self-induced angst is indicative of a dawning sense of loss and uncertainty experienced by the modern individual who begins to question the equation between success and happiness.

What makes Plint an even more characteristic example of the crisis-ridden modern man is his contradictory combination of manic drive and cool rationality, self-indulgence and guilty sense of *bourgeois oblige*. Like any businessman who is an art collector, Plint was not interested in aesthetics alone. Trained as a stockbroker, he gambled on his art investments, hoping they would increase in value, but he demonstrated a lack of self-control when he allowed his expenditures to exceed his income.[143] Yet, where he was impractical and irresponsible in his family obligations, Plint's social conscience was more fully developed. This paradox can be attributed to the emphasis placed on public service by his father. A Leeds woolen cloth manufacturer, he stemmed from the same social circle of gentlemen merchants as John Sheepshanks. More radical than Sheepshanks père, Thomas Plint senior was co-founder, with Samuel Smiles and J. G. Marshall, of the Leeds Parliamentary Reform Association which advocated household suffrage.[144] A Liberal like his father, Thomas was also actively involved in Evangelicalism: he was superintendent of the East Parade Chapel's Sunday School, a lay preacher, and the author of the posthumously published *Hymns and Sacred Poetry*.[145] Plint's social and religious interests coalesced in the commissioning of Madox Brown's *Work*, which the artist's grandson tells us the patron looked upon "as destined to effect an important moral, almost more than an artistic, revolution of thought."[146] Like the magnates who organized the Manchester Art Treasures exhibition, Plint believed that art could be an instrument of social reform.

Perhaps more than any other painting in Plint's collection of over 300 art objects, *Work* (plate 34), is a manifesto of his highest personal values. *Work* has been carefully analyzed by a number of scholars who concur about its status as a painted sermon.[147] Briefly stated, the picture represents a team of workers, or "navvies," as Brown called them, excavating a Hampstead street where they will lay a badly needed drainage line, surrounded by indigents, street hawkers, women of leisure, and gentlemen. Brown, in the catalogue for his 1865 exhibition, explicated the picture's iconography in a lengthy exegesis in which he contrasted the central navvy "as the outward

and visible type of *Work*," with "the ragged wretch who has never been *taught* to *work*," and "the brainworkers," who stand at the right. Although the latter group seems to be idle, Brown insists that they "are the cause of well-ordained work and happiness in others."[148] The picture, then, is a celebration of the Protestant work ethic in that it treats with equanimity and dignity the range of mental and physical activities required to make society flourish.

Plint was closely involved in the conception of the picture, writing to Brown only a week after they had struck their bargain to advise him on specific figures he wished to have included, asking, "Could you introduce *both* Carlyle and *Kingsley*, and change one of the four *fashionable* young ladies into a *quiet, earnest, holy*-looking one, with a book or two and *tracts?*"[149] The religious pamphleteer was duly included at the left, where she is shown in the act of delivering one of her tracts to a navvy. Brown, however, only acceded to part of Plint's other request when he rendered Carlyle as one of the "brainworkers," on the right, but substituted, in place of Charles Kingsley, Frederick Maurice, whom the artist knew from teaching art classes at the Workingmen's College which Maurice had founded. Albert Boime, in his article on *Work*, contends that in Brown's writing and in his art, he participated in Plint's evangelical and social sentiments, claiming the artist "preaches the Gospel of Labor and Self-Help, praises the achievements of Commerce and Industry, [and] greater respect for the working classes."[150] Because both artist and patron supported the tenets of Christian Socialism, and Maurice and Kingsley were proponents of the same philosophy, there were no grounds for disagreement.

Such a complete meeting of minds is rare in the history of Victorian patronage. Few artists were fortunate enough to encounter a sponsor who encouraged their loftiest intellectual and moral ambitions. On the surface, then, Plint's commissioning of *Work* would seem to have been a perfect arrangement; however, documentation proves that the ideal of work represented in the painting was not applied to the artist–patron relationship.

The £420 which Plint agreed to pay in monthly installments was insufficient for Brown to live on and still devote all of his time to the picture between the time it was commissioned in 1856 and the patron's death in 1861. Although Plint added to the artist's coffers when he bought *Christ Washing Peter's Feet* at the Manchester Art Treasures exhibition, he asked Brown to alter it, thereby distracting him from his *magnum opus* (Hueffer, *Brown*, p. 153). As he continued to labor over his big picture, Brown

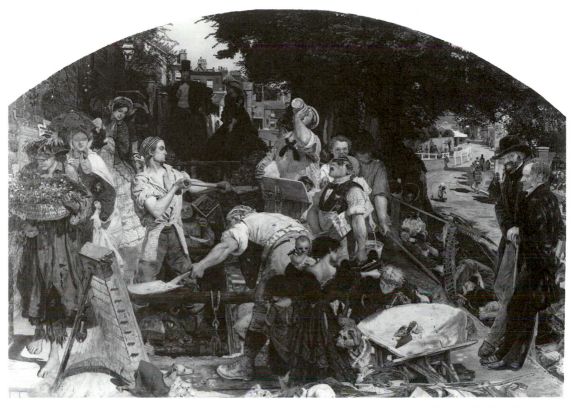

Plate 34. Ford Madox Brown,
Work, 1852–63, oil on canvas

was infuriated when he heard about the high prices Plint was paying other artists, such as the 350 guineas he offered the young Burne-Jones for the diptych which was the artist's first commission. Even more galling to Brown was the rumored £3,000–4,000 that Plint gave the dealer Ernest Gambart for Holman Hunt's *Finding of the Saviour in the Temple*. When Brown complained to his patron, Plint retaliated with "a somewhat tart letter upon the subject of the dilatoriness of artists," a reference to the five years *Work* had been in progress (p. 174). This exchange raises a number of questions about the work ethic: was the artist in the same category as the day laborer? Or did he more appropriately belong with the "brainworkers?" Should the conception of an idea be reimbursable or only the finished product? Who is entitled to control the terms of production, artist or patron? The posing of these questions points to the existence of a double standard among patrons such as Plint who claimed to respect the creative process but who quantified it according to the quotidian practices of the business world.

In maintaining that it was the patron's privilege to set prices, determine the method of payment, and decide whether or not a picture was finished, Plint had the backing of Ruskin. In the lectures he gave at the Manchester Art Treasures exhibition that led to the publication of *The Political Economy of Art*, Ruskin "consistently treats art works as goods from production to consumption, all stages of which patrons control and determine."[151] In keeping with his paternal philosophy of patronage, Ruskin maintained that businessmen were better managers than artists. That this notion was anathema to the Pre-Raphaelites is conveyed in the impertinent tone of Brown's reply to Plint. He and the members of the PRB were adamant about the necessity of protecting their rights to artistic production and determined not to abide by the golden rule which maintained that the customer was always right.

Rossetti was equally offhand with Plint when the patron visited his studio and suggested some changes in one of his versions of *The Annunciation*. The artist Val Prinsep, who was there, reports:

> Plint sat down before the picture. He was a Yorkshireman and talked with a strong accent. "Nobbut, Mr. Rossetti," he said, "that's a fine thing." Then, after a pause, he added: "Couldn't you put a soonset floosh over the whole thing?" Rossetti was very angry, and wouldn't let the repentant Plint purchase his *Annunciation*, and he trampled on him in a way that filled me with astonishment. For Plint was contrite and apologetic and in no wise offended.[152]

Seldom does a social tableau present itself so vividly. Knowing that he was not Plint's social or intellectual inferior, Rossetti had no reservations about putting him in his place. While Rossetti quickly laid to rest the matter of his patron's artistic interference, the financial burden placed on Brown was not as easily lifted. It was the monetary side of the artist–patron relationship that was to become increasingly problematic, both with Plint and with subsequent collectors.

Plint, in the last year of his life, became frenetic in his purchases. In addition to contracting with Gambart to buy Hunt's picture, Plint offered the same dealer £1,150 for Millais's *The Black Brunswicker*.[153] This was money the stockbroker did not have. Realizing that his denouement was at hand, Plint tried to escape his problems by surrounding himself with beautiful objects which would insulate him from his troubles. Muensterberger contends that, "objects in the collector's experience, real or imagined, allow

for a magical escape into a remote and private world" (p. 15). His art may have brought comfort to the beleaguered stockbroker, but it could not permanently insulate him from the real world. In an investigative article about the circumstances precipitating Plint's sale in 1862, the *Art Journal* reported: "It appears that Mr. Plint, about sixteen months since, being largely engaged in monetary speculations, met with reverses so heavy that he was obliged to suspend payment" (p. 105). Plint's loss of self-control and voracious appetite for goods would seem to make him a votary of modernist materialism. Yet his belief in the redemptive power of paintings such as *Work* indicates that he was also like those early Victorians who appreciated art's use-value over its status as a luxury object.

Moreover Plint intended to donate Hunt's *Finding of the Saviour* to the nation, "or to some great provincial gallery, probably at Leeds."[154] Even though he left his family no ready cash, in his will he specified that Rossetti's *Mary Magdalen* not be sold, but reserved for the future benefit of his children.[155] Perhaps he hoped that this image of a penitent sinner would prompt their forgiveness of his excesses. Plint presumably thought that he could spare these two pictures, expecting that the £25,000 he had spent amassing his collection would double or triple for his family when his art holdings were liquidated.[156] Given the irrational distribution of Plint's spending, his estimate of the value of his collection was unrealistic.

Plint's sale in 1862 fetched only £18,000 for his heirs. The prices brought for some of his Pre-Raphaelite canvases put the artists in a state of panic: Burne-Jones's *The Blessed Damozel*, which represented a sketch for half of the diptych commissioned at 350 guineas, earned only 16 guineas; Brown's *Christ Washing Peter's Feet* dropped from £220 to £94; and Rossetti's *The Wedding of St. George and Princess Sabra* fell from 55 to 40 guineas.[157] Although Rossetti complained about the modest prices his watercolors earned in the sale, he was saved a greater embarrassment by the fact that he had not yet completed £700 in commissions for Plint's estate.[158] Did this mean the Pre-Raphaelite barometer was falling?

The decline in value of the pictures in Plint's collection was due to a number of causes. One was the general economic slump of the five years preceding the sale, precipitated by overspeculation and overproduction of goods.[159] Because the ensuing recession resulted in bankruptcy for many art dealers, the bidding at the auction of Plint's collections was less spirited than it might have been.[160] Thus it was not only Pre-Raphaelite prices which decreased in value at the sale, but those of other artists as well, such as

the Belgian painter Baron Leys, whose *Capestro, the Carpenter of Antwerp, Preaching in his Workyard* fetched only £850, less than one-fifth of the £5,000 originally paid by Plint.

The precarious state of the economy, however, cannot be taken as the final explanation for these reduced prices. A closer analysis reveals that some artists fared better than others in the sale. Tom Taylor, reviewing the event for *The Times*, noted that David Cox, Peter De Wint, and Copley Fielding "still command, as they ought, a decided superiority in the market."[161] Nor did all of the Pre-Raphaelites suffer a dramatic decline in price: Millais's six watercolor illustrations of *Framley Parsonage*, for which Gambart had paid the artist 90 guineas in 1861, before reselling them to Plint, brought 163 guineas. By the same token, Agnew's bid 527 guineas for five Eastern watercolor scenes by Holman Hunt and Madox Brown's *Last of England* rose almost £100 above the £341 Plint paid the dealer White. Taylor offered an explanation for the discrepancy in Pre-Raphaelite market value when he contrasted Rossetti and Burne-Jones as "thoroughgoing mediaevalists who would transport the art back into the fourteenth century," with Millais, whose "later and less eccentric works obtained far better prices than his earlier productions" (pp. 165–66). Confirming the opinion of Manchester collectors who objected to the *retardataire* elements of Pre-Raphaelitism, Taylor concluded that arcane subjects were less marketable. Modern clients, in other words, were willing to pay more for modern-looking subjects.

The display of the Plint collection in the sale rooms of Christie's afforded the public a rare opportunity to analyze the direction the Pre-Raphaelite movement was following. Astute critics such as Taylor could readily recognize how diversified its members had become and see that some manifestations of the style had greater appeal on the London market than others. It was also evident that those Pre-Raphaelites who had worked most closely with the dealer Ernest Gambart commanded the best prices. Unsurprisingly, given this fact, the dealer's influence became increasingly dominant in the history of the movement.

Gambart was without question the major dealer of the Pre-Raphaelite period. His influence went unchallenged until 1860 when Agnew's finally opened a London showroom and began to contact the former members of the PRB. Gambart's involvement with the Pre-Raphaelites began in 1853 when the painter John Linnell advised him to visit Holman Hunt's studio to see the picture he was painting for Thomas Combe, *The Light of the World* (plate 35).[162] It was a fortuitous introduction for the dealer,

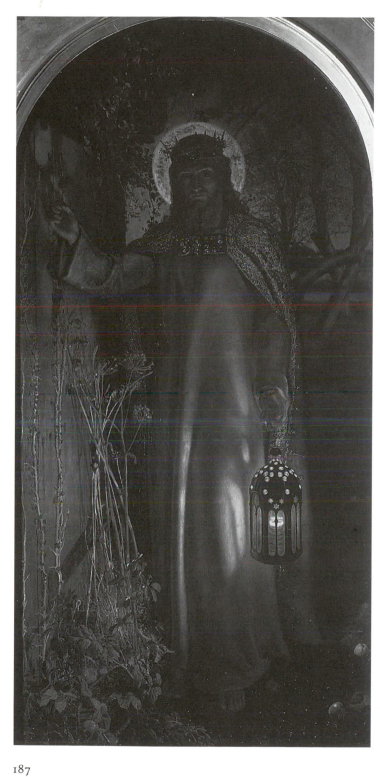

Plate 35. William Holman Hunt,
The Light of the World, 1851–53,
oil on canvas over panel

who instantly recognized that Hunt's work lent itself to the profitable medium of engraving. Gambart had already made a reputation for himself as a purveyor of fine paintings, but having begun his career as a printseller, he never lost sight of the enormous profits which could be made quickly through reproductions. In his venture with Hunt, after paying the artist £200 for the copyright of his picture, Gambart covered the engraving expenses by enlisting the financial support of Joseph Gillott. Though uninterested in the paintings of the Pre-Raphaelites, Gillott, as I mentioned in chapter 2, allowed his instinct for profitmaking to take precedence over his aesthetic preferences and became a willing joint partner in the publication of a painting he irreverently termed, "that man with his lantern" (Maas, *Gambart*, pp. 133–34). It was a wise move on Gillott's part: the sale of engravings were to provide him and Gambart with a lucrative income for many years to come (*ibid.*, pp. 150–51 and 161).

Gambart insured a wide reception for the initial publication of the print (plate 36) by negotiating with Combe for *The Light of the World*'s exhibition rights and paying him a paltry £180 for the privilege of using it to advertise the forthcoming engraving. Jeremy Maas, in his monograph on the picture, underlines how crucial this plan was to the future economic success of the print:

> Gambart's triumphant nineteen-month exhibition tour sharply exceeded its expected effect. The fame of the picture was spread far and wide; the sales of the engraving took it into virtually every home in the United Kingdom, and the print began to sell in Europe, America and the British Empire. In the words of Combe, "these proofs were published at fifteen guineas each", and the exhibition of his picture had enabled Gambart "to sell a greater number of impressions than have ever been sold of any print yet published."[163]

There is no question that the mass marketing of Hunt's engraving pushed *The Light of the World* into the category of the commodity: it was readily available, affordable, and designed to be mass-produced for a consumer market. Reduced to black-and-white contours, the aesthetic nuancing of color in the original was sacrificed for the sake of a clearly reproducible image. Unlike the artists' replicas I discussed in chapter 1 which faithfully imitated the intricacies of the original, an engraving does not pretend to be a true duplicate. Therefore, while I argued that replication was a process that impinged on the aura of the original, I view prints in a separate category. They do not presume to partake of the aesthetic exclusivity of

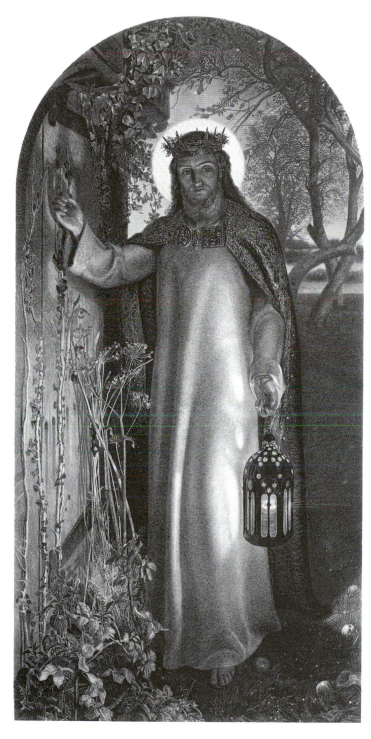

Plate 36. William Holman Hunt, *The Light of the World*, 1860, engraving by W. H. Simmons

the original work of art. Admittedly, mine is a postmodern perspective that does not venerate modernist notions of uniqueness and aesthetic autonomy, recognizing instead the potential benefits that can be gained from the circulation of art. Because prints can reach such a wide audience, they belong to the order of goods described by Mary Douglas and Baron Isherwood which help make visible and stable the categories of culture.[164] They have the potential to leap class barriers and target a much larger segment of the public than the organizers of the Manchester Art Treasures exhibition could ever hope to reach. Prints, according to Chandra Mukerji, create "a common cultural web" which draws both rich and poor together.[165]

While the dissemination of the print crossed class boundaries and introduced a less élitist audience to Pre-Raphaelite art, it would be incorrect to cite this as an instance of the unselfish fulfillment of the PRB's avant-gardist program. Undoubtedly gratified by his image's universal appeal, Hunt's interests were not unsullied: he closely monitored Combe's handling of the monetary affair with Gambart, whom he suspected of "business dodges."[166]

Hunt further proved his business acumen when he enlisted the support of no less distinguished a person than Charles Dickens to advise him on the tactic he should take for the sale and engraving of a second picture, *The Finding of the Saviour in the Temple*, in 1861. Resentful of publishers himself, and having shed the animosity he expressed toward early Pre-Raphaelite realism eleven years before, Dickens urged Hunt to hold fast to the 5,500 guineas he wanted for his picture, as well as its exhibition fee and copyright. Although Plint, to whom Gambart expected to sell the picture, had recently died, a bargain was nevertheless struck between artist and dealer, giving Hunt the distinction of earning the highest price ever paid to a living artist in Great Britain.[167]

Millais also had no reservations about producing a steady stream of new work to satisfy the demand for prints. Warner notes that after the artist was elected an associate member of the Royal Academy in 1853, he addressed his artistic production to "public taste and not to a single patron, and distributed not directly but through dealers, printsellers and publishers of books and magazines."[168] Millais consulted Jacob Bell on the matter of copyright, and after being informed about his rights, produced pictures, such as *The Ransom* (1862), which he painted to a "formula tried and successful on the print market" (p. 127).

Considering the enormity of the profits to be made from prints, the selling of the original image to a private collector became an almost

incidental ingredient in the bargain. Hunt, however, did not ignore that aspect of his profession. He also profited from the market for artists' replicas. Hunt revealed the extent to which he had allowed his vision to become commodified when he applied a commercial metaphor to describe his expedition to the Holy Land in 1855, saying: "I have a notion that painters should go out, two by two, like merchants of nature, and bring home precious merchandise."[169] The Biblical gloss that Hunt gives his statement does not disguise his identification of the painter with the merchant and his perception of the art object as merchandise. It follows that, if painting is construed as a product designed to compete on the open market, it must abide by the laws of supply and demand. Accordingly, Hunt and the other Pre-Raphaelites produced paintings, not only "two by two," but in even greater multiples, once they realized that copies, versions, and replicas were as saleable as originals. Hunt later attempted to exonerate his role in the industry of replication. He protested in his autobiography that he had succumbed to the practice after he returned to England from his painting expedition to the Holy Land because dealers had pressured him to paint "pot-boilers." Hunt explained: "At that time picture-dealers told me there was a great demand for replicas of works of mine exhibited years ago . . . I therefore took up the original studies of these, and elaborated them into finished pictures" (II, 95). What Hunt does not mention is that he began the practice before he even went to the Holy Land when he replicated *The Light of the World* for Thomas Combe.[170] Wanting his public to believe that he had only temporarily fallen prey to the demands of dealers, Hunt also did not disclose that he continued to produce copies of pictures such as *The Scapegoat* and *The Hireling Shepherd*, or multiple versions of *The Lady of Shallott*.

Madox Brown, despite his socialist leanings, also succumbed to the temptations of the marketplace when he produced a reduced version of *Work*.[171] Since Brown had invested so much time on the original (spending thirteen years on its tiny, indivisible strokes), he presumably thought it only fair that he should profit from his investment by replicating it. Nevertheless the artist attempted to justify his decision in terms of his politics by arguing that, "To do away with duplicates, were it possible, would only prevent many people from owning small works they have an affection for & prejudice the painters in pocket."[172] Theoretician Michel Pêcheux would not be convinced by Brown's defense. He views replication as a negative by-product of modernism's system of capitalist reproduction which he defines as "the necessities of the organisation of labour, of mechanisation and of

standardisation."[173] Even artists' replicas fall in the ideological category of repetitive labor undertaken for profit – usually under the supervision of an exploitative middleman. Some art historians concur, insisting that the long-standing practice of copymaking became objectionable only with the advent of speculative buying.[174] This is the scenario that Holman Hunt would have us believe: innocent artists were persuaded by manipulative dealers to repeat their work.

This claim would substantiate the oft-repeated conclusion that a depersonalized art market is a salient feature of the modern period.[175] Proffered by scholars in reference to conditions in France and Germany, this interpretation holds true for England as well, with one important caveat. While it is undeniable that English collectors through the very act of purchasing art from dealers contributed to the fraying of the bond between artist and patron, it is also true that their market calculations were often mediated by their sensitivity to the creative process. This achievement was made possible by the degree of understanding that frequently occurred between businessmen–patrons and Pre-Raphaelite artists. Unlike Millais, who eventually scorned the intricacies of private patronage, Hunt relished his ties with Fairbairn, just as Brown briefly reached a pinnacle of communication with Plint, and Rossetti was to seek and find comfort in his relations with a small but devoted number of patrons in the 1860s and 1870s. The careers of these artists must be charted on both the private and the public terrain of the art world.

Just as artists adapted to the intervention of the dealer in Pre-Raphaelite sales in a variety of ways, so did private patrons. Some, like Windus and Plint, felt more at ease negotiating with fellow professionals than with artists; in fact, Plint told Brown he preferred working with dealers.[176] Others, such as Gillott, simply recognized a good investment opportunity and plunged in. The preferred purchasing pattern of the majority of Pre-Raphaelite patrons, however, was balanced by contact with both artists and commercial vendors. Ellen Heaton, for instance, bought her Turners from dealers and her Pre-Raphaelites by commission.[177] Both John Miller of Liverpool and Thomas Miller of Preston could be seen as frequently in Agnew's provincial showrooms as in artists' studios, except when they were bartering with other collectors.[178] Only Thomas Combe remained independent of the dealer's wiles; however, even he could not resist the allure of Christie's sale room.[179] Nor was Ruskin above consorting with dealers when it came to acquiring the Turner of his choice, even while the artist was

still alive. After Turner's death in 1851, Ruskin demonstrated that his passion for the artist's work did not blind him to its value when he contrived a plan to buy a group of Turner's pictures *en masse*, at a cheaper rate.[180]

Yet in the lectures he delivered in Manchester in connection with the Art Treasures exhibition of 1857, Ruskin warned against the inflationary trend in the art market, saying, "as matters at present stand, it is wholly impossible for any man in the ordinary circumstances of English life to possess himself of a piece of great art" (*Works*, XVI, 60). Again, the private Ruskin contradicted the public figure when he advised Rossetti to "consider market value in all things."[181] Nor was Ruskin opposed in principle to dealers; on the contrary, he was surprisingly receptive to Gambart.

Shrewdly, early on in their relationship, Gambart won over Ruskin by appealing to the egalitarian side of his public persona: he invited him to attend a performance at the Canterbury Arms Music Hall in Lambeth, the center of working-class London.[182] Thus when Gambart asked the renowned critic to write an introduction to his print publication of Turner's *The Harbours of England* in 1856, Ruskin complied. He also consented to review Gambart's painting exhibitions at his successful French Gallery in *Academy Notes* between 1857 and 1859. Did Ruskin realize that he was working against his principles by promoting artists whose works would increase in value because of his attention, making them accessible only to the rich? As inchoate as Ruskin's motivations are, it is not easy to determine whether he was aware of the implications of his complicity. A more likely rationale is that he found it difficult to integrate his roles as social sage, art critic, and friend.

Like Ruskin, the influential *Art Journal* was not opposed to dealers in general. While it continued its campaign of exposing unscrupulous vendors, it distinguished between reputable and disreputable dealers. In a lengthy article on this subject, in its May 1860 issue, it made its position clear: "We shall not be suspected of unduly estimating the value of 'the dealer,' but in proportion to the evil done to Art by ignorant or dishonest traders" (p. 149). Having defined the type of commercial practice that was a cause for alarm, the *Art Journal* went on cautiously to name the beneficial effects of art dealing. It stated:

> The great patrons of British Art are the merchants and manufacturers, many of whom live in provincial cities, are seldom enabled to spend more than a day at a time in the Metropolis, and have no leisure, even

if they had knowledge (which cannot be gained in "six lessons"), to select pictures for themselves ... We are sure that nine out of ten of the pictures thus collected have been obtained from "dealers," and that, but for the mediumship of dealers, such pictures would not have found their way into the homes they adorn and dignify, *giving to their possessors a well-earned and well-merited renown.*

The dramatic increase in the number of art collectors referred to by the *Art Journal* is the subject of the next chapter; however, the phenomenon itself concerns us here because of the proliferation of dealers such as Ernest Gambart and William Agnew, who made their fortunes by catering to the type of client described above. Gambart and Agnew, however, were exempted from the numerous exposés published in the *Art Journal,* which instead frequently praised them for their professionalism.[183]

Twentieth-century critics, as well, have recently begun to reassess the positive value of art dealing in an attempt to redress the negative account of the dealer–critic alliance presented by historians of the modern movement. Albert Boime, for instance, maintains that "Dealers have expanded the art market, raised the value of individual artists and works, and most important of all, they have made the greatest progress in introducing aspirants or unknowns."[184] Moreover, not all dealers were impersonal entrepreneurs, but as Boime adds, many were art lovers who treasured their personal collections. This description fits both Gambart and Agnew, who functioned simultaneously as businessmen and as collectors by reserving favorite works from their galleries for their homes.[185]

In defending an artist's right to seek alternative forms of patronage, Robert Herbert challenges the scholarly bias against dealers when he writes, "Freedom, quite logically for the artists, was required both for the sake of producing their works (art historians recognize this) and for marketing them (art historians avoid this)."[186] Although Herbert is talking about the Impressionists, his observations also characterize the Pre-Raphaelites, particularly when he implicates artists in the practice of price escalation. Rossetti, for instance, was responsible for starting Burne-Jones out near the top of the price scale. Burne-Jones confessed: "I am afraid [Plint] will stare at the price Rossetti says I must ask – I'm quite frightened to ask it."[187] Similarly, Millais contrived to make the young Charles Collins's work more valuable in the opinion of Thomas Combe.[188] Clearly dealers alone were not the culpable architects of the Pre-Raphaelite price spiral. Sharing the middle-class traits of their class, both artists and dealers

prized business skills and did not hesitate to apply them in the sacrosanct realm of art. Millais nevertheless held patrons responsible for his capitulation to commerce. He noted with some rancor in 1859:

> I have striven hard in the hope that in time people would understand me and estimate my best productions at their true worth, but they (the public and private patrons) go like a flock of sheep after any silly bell-wether who clinks before them. I have, up to now, generally painted in the hope of converting them to something better, but I see they won't be taught, and as I *must* live, they shall have what they want, instead of what I know would be best for them. A physician sugars his pill, and I must do the same. (Hunt, II, 179)

Disappointed that his best efforts had failed to find a sympathetic audience which would provide him with a reliable source of income, the artist turned to the popular market. In the last days of Pre-Raphaelitism, Millais abandoned any pretense to marginality by painting subjects ripe for the engraver's tool: appealing children and lovers which found homes in the comfortable middle-class suburbs of London and the great provincial cities alongside prints of Hunt's inspirational Biblical themes.

But before we admonish these artists for losing their avant-garde faith, we must examine the implications of the choices made by Millais and Hunt. The forces with which they were contending were unprecedented in the history of British art. Never before had there been so many middle-class buyers eager to spend such vast amounts of money on the work of living artists in an art market expanded by what Harold Perkin terms "the mollifying effect of inflation."[189] The comfortable plateau of prosperity that existed during the mid-Victorian years allowed literally hundreds of new collectors to become involved in the buying of art, creating what Geoffrey Best calls the "crystallising of a cultural apparatus" during these years of free trade, relaxed credit, and complacency.[190] The issue raised by this more vigorous form of patronage is the subject of the next chapter.

Notes

1 This misrepresentation has largely arisen because of the extensive Pre-Raphaelite collection in the Manchester City Art Gallery which, in fact, was essentially formed after 1900. For the Gallery's delayed purchase of Pre-Raphaelite works, see Elizabeth Conran, "Art Collections," in *Art and Architecture in Victorian Manchester*, ed. John H. G. Archer (Manchester: 1985), p. 79.

2 John Miller of Liverpool lent John Everett Millais's *Autumn Leaves* and William Windus's *Burd Helen*; Thomas Combe of Oxford sent in Charles Collins's *Convent Thoughts*; and Fairbairn lent William Holman Hunt's *Awakening Conscience* and *Valentine Rescuing Sylvia from Proteus*. In addition, the cousins C. T. Maude and Walter Broderip respectively submitted Hunt's *Strayed Sheep* and *The Hireling Shepherd*. Among the artists who transmitted works were Ford Madox Brown, who sent in his *Christ Washing Peter's Feet*, and Augustus Egg, who loaned Henry Wallis's *Death of Chatterton* and Hunt's *Claudio and Isabella*, while the young William Morris sent in Brown's *The Hayfield* and Arthur Hughes's *April Love*. See *Catalogue of the Art Treasures of the UK Collected at Manchester in 1857* (Manchester: 1857).

3 William Holman Hunt, *Pre-Raphaelitism and the Pre-Raphaelite Brotherhood*, 2 vols. (London: 1905–6), II, 162. Hereafter references to this source will be inserted in the text.

4 See William Michael Rossetti, *Dante Gabriel Rossetti: His Family Letters, with a Memoir*, 2 vols. (London: 1895), I, 127. For Millais's role in the founding of the PRB, see John Guille Millais, *The Life and Letters of Sir John Everett Millais*, 2 vols. (London: 1899), I, 49–55. Modern studies of the movement include William E. Fredeman, *Pre-Raphaelitism: A Bibliocritical Study* (Cambridge, Mass.: 1965); John Nicoll, *The Pre-Raphaelites* (London: 1970); Timothy Hilton, *The Pre-Raphaelites* (London: 1970); Allen Staley, *The Pre-Raphaelite Landscape* (Oxford: 1973); and Tate Gallery, *The Pre-Raphaelites* (London: 1984).

5 Millais, *Millais*, I, 169.

6 Renato Poggiolo, for instance, sees both as cultures of negation. See *The Theory of the Avant-Garde*, transl. Gerald Fitzgerald (Cambridge, Mass.: 1968), pp. 61ff. See also T. J. Clark, "More on the Differences between Comrade Greenberg and Ourselves," in *Modernism and Modernity: The Vancouver Conference Papers*, ed. Benjamin H. D. Buchloh, S. Guibaut, and D. Solkin (Halifax, Nova Scotia: 1983), p. 177, where he argues that modernism was born in reaction to bourgeois indifference. Matei Calinescu, on the other hand, makes a qualified distinction between the two terms when he asserts that although the avant-garde is prefigured in the broader scope of modernity, it is more radical and less flexible. See *Five Faces of Modernity: Modernism, Avant-Garde, Decadence, Kitsch, Postmodernism* (Durham, N.C.: 1987), p. 96.

7 See, for instance, Calinescu, *Five Faces of Modernity*, and Liah Greenfeld, *Nationalism: Five Roads to Modernity* (Cambridge, Mass.: 1992).

8 Geoffrey Best, *Mid-Victorian Britain, 1851–1875* (London: 1971), p. 229. See also François Bedarida, *A Social History of England, 1851–1975*, transl. A. S. Forster (London: 1979), p. 8.

9 Thomas Babington Macaulay, *The History*

of England from the Accession of James II,
5 vols. (1849; rpt. New York [n.d.,
c. 1879]), I, 3 and *passim*.

10 Thomas Carlyle, *Sartor Resartus* (1838; rpt.
London: 1900), ch. 7, p. 189.

11 E. H. Gombrich, "Art History and the
Social Sciences," in his *Ideals and Idols:
Essays on Values in History and in Art*
(Oxford: 1979), p. 163.

12 Raymond Williams, *The Sociology of
Culture* (New York: 1981), p. 148.

13 Martin Jay, *Downcast Eyes: The Denigration
of Vision in Twentieth-Century French Thought*
(Berkeley: 1993). While Jay focuses on the
scientific and technological reasons for
viewing the world in a new way, Jonathan
Crary bases his interpretations of the
modernist vision on physiological causes
which introduced a heightened subjectiv-
ity. See Jonathan Crary, *Techniques of the
Observer: On Vision and Modernity in the
Nineteenth Century* (Cambridge, Mass.:
1990), and "Unbinding Vision," *October*
68 (Spring 1994), 21–44.

14 For Millais's early successes, see Millais,
Millais, I, 13–19.

15 W. M. Rossetti, *Memoir*, I, 127.

16 See Dianne Sachko Macleod, "The
Dialectics of Modernism and English
Art," *British Journal of Aesthetics*, 35
(Jan. 1995), 1–14.

17 James Ackerman, "On Judging Art without
Absolutes," *Critical Inquiry* 5 (Spring
1979), 446.

18 The paintings they displayed included
Hunt's *Light of the World* and *Strayed Sheep*;
Millais's *Ophelia*, *Order of Release*, and
Return of the Dove to the Ark; and Brown's
Chaucer at the Court of Edward III.

19 For the French assessment of British origi-
nality, see *Art Journal* (Aug. 1855), 229;

Marcia Pointon, "'Voisins et Alliés': The
French Critics' View of the English
Contribution to the Beaux-Arts Section
of the Exposition Universelle in 1855,"
in *Saloni, gallerie, musei e loro influenza sullo
sviluppo dell'arte dei secoli XIX e XX*, ed.
Francis Haskell (Bologna: 1979), pp. 118–
20; and Howard D. Rodée, "France and
England: Some Mid-Victorian Views of
One Another's Painting," *Gazette des
Beaux-Arts* 91 (Jan. 1978), 45. For the com-
parison with Balzac, see *Le Moniteur*, cited
and translated in *Art Journal*, ibid., p. 231.

20 L. M. Lamont, ed., *Thomas Armstrong, C.B.:
A Memoir* (London: 1912), p. 6. *Strayed
Sheep* was commissioned in 1852 by early-
Victorian collector Charles Maude as a
less expensive version of his cousin's *The
Hireling Shepherd* (see appendix entry for
Charles Broderip).

21 *The Journal of Eugène Delacroix*, 30 June
1855, transl. Walter Pach (1937; rpt. New
York: 1972), p. 476.

22 See summaries of French criticism in
Art Journal (Aug. 1855), 231–32; Jacques
Lethève, "La Connaissance des peintres
Préraphaélites anglais en France
(1855–1900)," *Gazette des Beaux-Arts*, 53
(1959), 315–16; Patricia Mainardi, *Art and
Politics of the Second Empire: The Universal
Expositions of 1855 and 1867* (New Haven:
1987), p. 105; and Rodée, "France and
England," p. 45, who notes that English
artists won a higher ratio of awards and
medals than their French counterparts
in 1855.

23 Roger Fry, "Rossetti's Water Colours of
1857," *Burlington Magazine* 29 (June 1916),
109.

24 Charles Wass to John Linnell, 17 December
1853, cited in Evan R. Firestone, "John

Linnell and the Picture Merchants," *Connoisseur* 182 (Feb. 1973), 125.

25 Thomas Carlyle, *Past and Present* (1843), in *Works*, 30 vols. (London: 1897; rpt. New York: 1969), X, 205.

26 Gustave Planche, "Exposition des beaux-arts," *Revue des Deux-Mondes* 1 (Aug. 1855), 471, cited in Mainardi, *Art and Politics*, p. 106.

27 Holman Hunt to Thomas Combe, 31 March 1855, MSS: John Rylands University Library of Manchester.

28 For a discussion of the place of leisure in British society, see Stanley Parker, *The Future of Work and Leisure* (London: 1971), pp. 33ff., and Chris Waters, "Socialism and the Politics of Popular Culture in Britain, 1884–1914," unpubl. Ph.D. diss., Harvard University, 1985, pp. 24–30.

29 Macaulay, *History of England*, V, 258.

30 Robert Gooding-Williams, "Nietzsche's Pursuit of Modernism," *New German Critique* 41 (Spring-Summer 1987), 99.

31 This definition is a distillation of the complex arguments of several scholars. See Poggioli, *Theory of the Avant-Garde*, pp. 4–12; Clark, "Differences," p. 177; Thomas Crow, "Modernism and Mass Culture in the Visual Arts," in *Modernism and Modernity: The Vancouver Conference Papers,* ed. Benjamin H. D. Buchloh, S. Guibaut, and D. Solkin (Halifax, Nova Scotia: 1983), p. 216; and Peter Bürger, *Theory of the Avant-Garde*, transl. Michael Shaw (Minneapolis: 1984), pp. li-lii. For the etymology of the term, see Calinescu, *Five Faces of Modernity*, pp. 96ff.

32 Millais to Mrs. Combe, 1851, in Millais, *Millais*, I, 103.

33 Ford M. Hueffer, *Ford Madox Brown: A Record of his Life and Work* (London: 1896), pp. 159 and 425–31.

34 Alistair Grieve, *The Art of Dante Gabriel Rossetti: 1. Found 2: The Pre-Raphaelite Modern-Life Subject* (Norwich: 1976), p. 21. The author also suggests that the children in Millais's *The Woodman's Daughter* (1851) refer to attempts to heal the rift between classes (p. 24). On the iconography of *Isabella*, see Mary Bennett, *PRB, Millais, PRA* (Liverpool: Walker Art Gallery, 1967), p. 25.

35 After being forced to leave Italy, Rossetti's father remained sympathetic to the Italian cause. In England he was appointed professor of Italian at King's College. See W. M. Rossetti, *Memoir*, I, 5–9 and 46–55.

36 For Brown, Rossetti, and Hunt's attitude toward the Royal Academy, see Hunt, *Pre-Raphaelitism,* II, 86–7 and 138–40. Millais's election as president in 1896 is discussed in Millais, *Millais*, II, 326.

37 Hunt, *Pre-Raphaelitism,* I, 177. *Isabella* was sold for £150, see Bennett, *Millais*, p. 26.

38 Calinescu, *Five Faces of Modernity*, pp. 8–10.

39 *The Diary of Ford Madox Brown*, ed. Virginia Surtees (New Haven and London: 1981), 25 September 1856, p. 189.

40 See K. C. Phillipps, *Language and Class in Victorian England* (Oxford: 1984), p. 27.

41 See Frank Elias, *John Lea, Citizen and Art Lover* (Liverpool: 1928), p. 15, and Mary Bennett, "The Pre-Raphaelites and the Liverpool Prize," *Apollo* 76 (Dec. 1962), 748.

42 Mary Bennett, "A Check List of Pre-Raphaelite Pictures Exhibited at Liverpool, 1846–67, and Some of their Northern Collectors," *Burlington* 105 (Nov. 1963), 489.

43 Cited in Mary Bennett, "Liverpool Prize," p. 750.

44 J. Miller to Brown, Hueffer, *Brown*, p. 144. The correspondent is incorrectly identified as Peter Miller.

45 See Deborah Cherry, "The Hogarth Club: 1858–1861," *Burlington* 122 (April 1980), 238.

46 Rossetti discusses the artistic activities of Miller's daughters in a letter to him of 9 October 1865, MSS: Fitzwilliam. One of Miller's daughters married Donald Currie (1825–1909), who, although from a modest background, eventually founded the Castle Steamship Company and was knighted. See *DNB*. On Peter Miller's collecting activities, see Hunt, *Pre-Raphaelitism*, II, 95, Hueffer, *Brown*, p. 144, and Virginia Surtees, *The Paintings and Drawings of Dante Gabriel Rossetti (1828–1882): A Catalogue Raisonné*, 2 vols. (Oxford: 1971), I, nos. 123 and 153.

47 Walter Benjamin, "Unpacking my Library, A Talk about Book Collecting," in his *Illuminations*, ed. Hannah Arendt, transl. Harry Zohn (New York: 1969), p. 67.

48 Frank Elias, an historian of Miller's native Liverpool, described John Miller as "a merchant with an ingrained love of paintings, with which even his business office was plentifully furnished." See *John Lea*, p. 15.

49 See Malcolm John Warner, "The Professional Career of John Everett Millais to 1863, with a Catalogue of Works to the Same Date," unpubl. Ph.D. diss., University of London, Courtauld Institute of Art, 1985, p. 58. I am grateful to Dr. Warner for providing me with a copy of his thesis. See also Alistair Grieve, "The Pre-Raphaelite Brotherhood and the Anglican High Church," *Burlington* 111 (May 1969), 294–95; and Michael Thomas Morris, "Cowled Creatures: The Image of the Monk in Georgian and Victorian England," unpubl. Ph.D. diss. University of California, Berkeley, 1985, ch. 4.

50 Millais, *Millais*, I, 88 and Mary Lutyens, "Selling the Missionary," *Apollo* 86 (Nov. 1967), 385.

51 Werner Muensterberger, *Collecting: An Unruly Passion* (Princeton: 1994), p. 48.

52 Millais, *Millais*, I, 87. See also *DNB*.

53 See Hunt, *Pre-Raphaelitism*, II, 378 and Mary Bennett, *William Holman Hunt* (Liverpool: Walker Art Gallery, 1969), p. 34. On Martha Combe's support of artists, see also Millais, *Millais*, I, 89 and 99.

54 Thomas Combe's income from his salary and share dividends at the Press was £800 per year, enough to live comfortably, but hardly enough, for instance, to spend a quarter of it (200 guineas), on a single canvas by Millais in 1850. I am indebted to Colin Hughes, who is researching a Ph.D. dissertation on Thomas Combe, for providing me with this information. Martha Howell Bennett's uncle, William Bennett, paid Holman Hunt 160 guineas for *A Converted British Family Sheltering a Christian Priest* as a gift for the Combes in 1850 (see Hunt, *Pre-Raphaelitism*, I, 234).

55 Ruth Perry and Martine Brownley, eds., *Mothering the Mind: Twelve Studies of Writers and their Silent Partners* (New York: 1984), cited in Whitney Chadwick and Isabelle de Courtivron, eds., *Significant Others, Creativity and Intimate Partnership* (London: 1993), p. 8.

56 Frederic George Stephens, *William Holman Hunt and his Works* (London: 1860), p. 36. On Stephens's career, see Dianne Sachko Macleod, "F. G. Stephens, Pre-Raphaelite Critic and Art Historian," *Burlington* 128 (June 1986), 398–406.

57 Warner, "Millais," p. 62.

58 Hueffer, *Brown*, p. 84. McCracken paid

£10.10s. for the sketch for the picture and £63 plus a work by Dighton for the picture itself. See also Bennett, "A Check List of Pre-Raphaelite Pictures," p. 486.

59 *Letters of Dante Gabriel Rossetti*, ed. Oswald Doughty and J. R. Wahl, 4 vols. (Oxford: 1965–67), I, 122. See also W. M. Rossetti, *Memoir*, I, 160, who reports that the selling price was £50.

60 For his association with J. & R. McCracken, see, for instance, *The Works of John Ruskin*, eds. E. T. Cook and Alexander Wedderburn, 39 vols. (London: 1902–12), IV, 38, note 5. My research at the Guildhall Library showed no connection between Francis McCracken and this firm. I am grateful to Richard Harvey of the Guildhall Library for verifying this information (letter to the author, 7 Sept. 1987). The Belfast section of *Slater's Directory of Ireland* (1846), however, lists Francis McCracken as a cotton spinner in York Lane, with a house at 98 Donegal Street. In the 1863–64 *Directory* he had moved to a house called "Richmond" on the Antrim Road, Belfast. He is unlisted in subsequent directories. I am indebted to Pauline Torrens at the Public Records Office of Northern Ireland for providing me with this information and for locating an entry in the Will Calendars, presumably for McCracken's father, who was also named Francis, and who, at the time of his death in 1837, was listed as a Belfast merchant. Regarding the younger McCracken's financial situation, Hunt states, "he was not a rich man" (*Pre-Raphaelitism*, I, 282), while Rossetti, in 1854, observed: "he seems hard up." See *Rossetti Letters*, ed. Doughty and Wahl, I, 203.

61 Hunt, *Pre-Raphaelitism*, I, 282; *Brown Diary*,

ed. Surtees, p. 74; and *Rossetti Letters*, ed. Doughty and Wahl, I, 128.

62 *Rossetti Letters,* ed. Doughty and Wahl, I, 148.

63 Both sonnets were enclosed in a letter from Rossetti to his sister Christina (8 Nov. 1853), *ibid.*, 164–65.

64 W. M. Rossetti, *Memoir*, I, 119.

65 *Letters of Dante Gabriel Rossetti to William Allingham, 1854–1870*, ed. George Birkbeck Hill (London: 1897), 26 June 1854, p. 21.

66 Albany Street, where Rossetti lived with his parents at no. 45, is designated as middle-class on the map illustrating Charles Booth's *Labour and Life of the People of London* (1889). Their neighbors were Edward Lear at no. 61, the naturalist Francis Trevelyan Buckland at no. 37, Henry Mayhew at no. 55, and Sir Edward Jenner at nos. 8 and 12. See Ann Saunders, *Regent's Park* (London: 1969), p. 116.

67 Warner, "Millais," pp. 24–25 and Millais, *Millais*, I, 1–2.

68 Hueffer, *Brown*, pp. 1–10.

69 W. M. Rossetti, *Memoir*, I, 160; *Dante Gabriel Rossetti as Designer and Writer* (London: 1889), p. 14; and *Praeraphaelite Diaries and Letters* (London: 1900), p. 5.

70 Millais, *Millais*, I, 291. The collector was James Eden of Bolton (see ch. 2 and appendix). For the correct identification of John Miller, see Malcolm Warner, "John Everett Millais's 'Autumn Leaves': 'a picture full of beauty and without subject,'" in *Pre-Raphaelite Papers*, ed. Leslie Parris (London: 1984), p. 126. These misnomers have been carried over into current scholarship: for instance, an undated letter from the painter William Frith to "Mr. Miller," is catalogued in the Fitzwilliam Museum

Library (MS3–1966) under John Miller's
name, although the text of the letter refers
to *The Nosegay*, a painting by Frith in
Thomas Miller's collection. See *Catalogue
of the Exhibition of Works by the Old Masters,
and by Deceased Masters of the British School*
(London: Royal Academy, 1899).
Similarly, in *The Diary of Ford Madox
Brown*, ed. Surtees, John Miller is misiden-
tified as the owner of Millais's *Peace
Concluded*, which was actually owned by
Thomas Miller (p. 163, note 23). Moreover
Mary Bennett, in her 1967 Millais exhibi-
tion catalogue, refers to Thomas Miller by
the name of his descendant, Thomas Pitt
Miller (*Millais*, p. 10).

71 Lyndel Saunders King, *The
Industrialization of Taste: Victorian England
and the Art Union of London* (Ann Arbor,
Mich.: 1985), p. 38. Although his origins
are untraced, the funds which paid for
Pocock's French education suggest a
moneyed background. See *DNB*.

72 For Pocock's involvement in the Old
Water-Colour Society, see Jeremy Maas,
Gambart: Prince of the Victorian Art World
(London: 1975), pp. 58–59. I have recon-
structed Pocock's Pre-Raphaelite purchases
from the catalogue of the sale of his col-
lection at Foster's on 18 March 1857 (see
appendix).

73 Maas, *ibid.*, p. 59.

74 See John Ruskin, *Praeterita* (1885–89), in
Works, XXXV, 76, 214–15, 254–55,
and 308.

75 Rossetti to Ford Madox Brown (14 April
1854), *Rossetti Letters*, ed. Doughty and
Wahl, I, 185.

76 Pierre Bourdieu, "The Production of
Belief: Contribution to an Economy of
Symbolic Goods," *Media, Culture and
Society*, 2 (1980), 288ff. See also Nicholas
Garnham and Raymond Williams, "Pierre
Bourdieu and the Sociology of Culture:
An Introduction," *Media, Culture and
Society* 2 (1980), 217–18.

77 Landseer to Bicknell, 16 May 1858, MSS:
Fitzwilliam, 114–1949.

78 Warner, "Millais," pp. 140–41, notes that
Landseer set the Royal Academy record
in 1856 by selling his *Saved* for £1,653.

79 Although the Pre-Raphaelite artist-
colleague George Price Boyce visited
Windus's Tottenham collection in 1851,
the same year that Ruskin published his
pamphlet on Pre-Raphaelitism, and
Millais followed suit in 1852, Windus did
not make room among his Turners for the
PRB's efforts until 1855. See *The Diaries
of George Price Boyce*, ed. Virginia Surtees
(Norwich: 1980), 8 July 1851, p. 2, and
Millais, *Millais*, I, 161.

80 Ruskin to Ernest Chesneau, 28 December
1882, *Works*, XXXVII, 427–28. He is
describing an incident which occurred at
the 1850 Royal Academy. For William
Dyce, see Marcia Pointon, *William Dyce:
A Critical Biography* (Oxford: 1979).

81 Charles Dickens, "Old Lamps for New
Ones," *Household Words* 1 (15 June 1850),
265–66. The painting is discussed by
Lutyens, "Selling the Missionary,"
pp. 380–87; Edward Morris, "The Subject
of Millais's *Christ in the House of His
Parents*," *Journal of the Warburg and
Courtauld Institutes* 33 (1970), 343–45;
and Albert Boime, "Sources for Sir John
Everett Millais's 'Christ in the House of
His Parents,'" *Gazette des Beaux-Arts* 86
(1975), 71–84.

82 For Patmore's involvement in Pre-
Raphaelitism, see Mary Lutyens, *Millais*

and the Ruskins (London: 1967), p. 36, who notes that Millais took the subject of his *Woodman's Daughter* from a poem of Patmore's.

83 A similar point of view is expressed by Robert Herbert when he states that Ruskin believed "a new school must rise from the Pre-Raphaelites' endeavors." See *The Art Criticism of John Ruskin*, ed. Robert Herbert (New York: 1964), p. xviii. Hunt later confirmed that Pre-Raphaelitism was an experimental phase in his artistic career, admitting that "in agreeing to use the utmost elaboration in painting our first pictures, we never meant more than to insist that the practice was essential for training the eye and hand of the young artist" (*Pre-Raphaelitism*, I, 150).

84 W. M. Rossetti, *Memoir*, I, 184, who gives the amount as £150, explaining that Ruskin agreed to take "in exchange her various works up to that value, and retaining them, or (if preferred) selling some of them, and handing over to her any extra proceeds." For Siddall, see Jan Marsh, *Pre-Raphaelite Sisterhood* (London: 1985), and Griselda Pollock and Deborah Cherry, "Woman as Sign in Pre-Raphaelite Literature: the Representation of Elizabeth Siddall," in Griselda Pollock, *Vision and Difference: Feminity, Feminism and the Histories of Art* (London and New York: 1988), pp. 91–114 and 214–19.

85 Ruskin's remarks were made in a letter to McCracken in 1853, who, in turn, forwarded them on to Rossetti. For Rossetti's summary of the comments, see *Rossetti Letters*, ed. Doughty and Wahl, I, 133. Rossetti's arrangement with Ruskin is described in W. M. Rossetti, *Memoir*, I, 181–82.

86 See Lutyens, *Millais and the Ruskins, passim*;

Millais, *Millais*, I, 116–19 and 195ff; and Warner, "Millais," pp. 79–80.

87 Staley, *Pre-Raphaelite Landscape*, p. 50. See also Tate Gallery, *Pre-Raphaelites*, no. 56, pp. 115–17.

88 For Horsfall (1841–1932), see Michael Harrison, "Art and Philanthropy: T. C. Horsfall and the Manchester Art Museum," in *City, Class and Culture: Studies of Social Policy and Cultural Production in Victorian Manchester*, ed. Alan J. Kidd and K. W. Roberts (Manchester: 1985), 120–47. For Ruskin's correspondence with Dixon, see *Works*, XVII, 309ff. Dixon's role in the founding of the Sunderland Art Gallery is described in *Newcastle Daily Chronicle*, 28 February 1893.

89 Ruskin to Rossetti, October 1854, W. M. Rossetti, *Memoir*, I, 182.

90 See Timothy Hilton, *John Ruskin: The Early Years, 1819–1859* (New Haven and London: 1985), pp. 203–5.

91 See *ibid.*, p. 246. Hilton refers to the summer of 1857 during which Ruskin was involved with Pre-Raphaelite sculptors at the Oxford Museum at the same time that the Pre-Raphaelite painters were decorating the Oxford Union. Hilton states: "Ruskin was callng himself a 'PRB' as though he were a member of the defunct Brotherhood, and addressing Jane Simon, the wife of John Simon, as a 'PRS,' a sister in art."

92 See *Sublime and Instructive: Letters from John Ruskin to Louisa, Marchioness of Waterford, Anna Blunden and Ellen Heaton*, ed. Virginia Surtees (London: 1972), pp. 143ff. and plate 15 for Heaton's portrait.

93 See Trevor Fawcett, *The Rise of English Provincial Art: Artists, Patrons, and Institutions outside London, 1800–1830*

(Oxford: 1974), p. 168 *passim,* and
R. J. Morris, "Middle-Class Culture,
1700–1914," *A History of Modern Leeds,*
ed. Derek Fraser (Manchester: 1980),
pp. 208–11.

94 John Deakin Heaton's diary, cited in
Morris, "Middle-Class Culture," p. 206.
See also T. Wemyss Reid, *A Memoir of John
Deakin Heaton, MD* (London: 1883).

95 *Sublime and Instructive*, ed. Surtees, pp.
146–47. Heaton also financially support-
ed Winnington Hall School, one of
Ruskin's pet projects. For Ruskin and the
Winnington Hall School, see John D.
Rosenberg, *The Darkening Glass: A Portrait
of Ruskin's Genius* (New York: 1986),
pp. 161ff.

96 Ruskin to Heaton, 8 November (1855),
cited in Surtees, *Rossetti Catalogue Raisonné,*
no. 75, p. 37.

97 Ruskin to Rossetti (?1855), W. M. Rossetti,
Ruskin: Rossetti: Preraphaelitism (London:
1899), pp. 59–60.

98 On the limitations faced by women in the
art world see Deborah Cherry, *Painting
Women: Victorian Women Artists* (London:
1993) and Pamela Gerrish Nunn, *Victorian
Women Artists* (London: 1987).

99 On Sir Walter's interests and background,
see *Wallington, Northumberland* (London:
National Trust, 1979), pp. 5–7, and
Raleigh Trevelyan, *A Pre-Raphaelite Circle*
(London: 1978), pp. 16–20.

100 Raleigh Trevelyan, a present-day family
descendant, remarks that "the match was a
fortunate one from the Jermyns' point of
view. For Calverley was not only wealthy
but heir to a baronetcy and considerable
estates." See "Foreword," in *Reflections of a
Friendship: John Ruskin's Letters to Pauline
Trevelyan, 1848–1866*, ed. Virginia Surtees

(London: 1979), p. viii.

101 Ruskin to Pauline Trevelyan, 19 January
(1848), *Reflections of a Friendship*, ed.
Surtees, p. 1.

102 *Ibid.,* p. 128. See also Trevelyan, *Pre-
Raphaelite Circle*, p. 122. For the decorative
scheme of the central hall, see National
Trust, *Wallington*, pp. 17–19, and Robin
Ironside, "Preraphaelite Paintings at
Wallington: Note on William Bell Scott
and Ruskin," *Architectural Review* 92
(Dec. 1942), 147–49.

103 Staley, *Pre-Raphaelite Landscape*, p. 52.

104 Rossetti to Charlotte Polidori (3 May
1855), *Rossetti Letters*, ed. Doughty and
Wahl, I, 250.

105 Ruskin to Rossetti (?June 1855), Surtees,
Rossetti Catalogue Raisonné, no. 71, p. 34.

106 *Rossetti Letters*, ed. Doughty and Wahl, I,
260. Ruskin apparently kept the work.
He advised Rossetti (in a letter the artist's
brother dates as possibly belonging to
January 1856): "*Nativity* is much mended;
many thanks." See W. M. Rossetti, *Ruskin:
Rossetti: Preraphaelitism*, p. 113. The present
location of the work is unknown.

107 Rossetti to W. Allingham, 31 July 1860,
Rossetti Letters, ed. Doughty and Wahl, I, 371.

108 Rossetti to Heaton, 26 December 1861,
Surtees, *Rossetti Catalogue Raisonné*, no. 151,
p. 87.

109 Their final argument occurred over Ruskin's
criticism of Rossetti's *Venus Verticordia*. See
Works, XXXVI, 490–91.

110 Those collectors already mentioned in
chapters 1 and 2 who mingled Pre-
Raphaelite art with their Victorian paint-
ings include Walter Broderip, James Eden,
J. H. Mann, William Marshall, Henry
McConnel, Richard Newsham, and John
Gibbons. The six second-wave patrons are

Fairbairn, Heaton, Thomas Miller, Plint, Lady Trevelyan, and Windus.

111 W. M. Rossetti, *Memoir*, I, 137. In 1853 Christina Rossetti wrote a sonnet, "The PRB," about the group's demise (*ibid.*, p. 138).

112 Best, *Mid-Victorian Britain*, p. 4. See also R. Church, *The Great Victorian Boom, 1851–1873* (London: 1975).

113 For Pre-Raphaelite discussions of modernism, see John Tupper, "The Subject in Art," *The Germ* (March 1850; rpt. Ashmolean Library, Oxford: 1979), 118–25 and Laura Savage (F. G. Stephens), "Modern Giants," *ibid.*, pp. 169–73. On the Pre-Raphaelite modern life subject, see Grieve, *Found*, pp. 21ff. Among the more traditional allegories in Fairbairn's collection was Richard Pickersgill's *Flight of the Pagan Deities on the Dawn of Christianity*, which Judith Bronkhurst suggests would have appealed to the collector as "an allegorical treatment of a serious religious theme, a valid alternative to Hunt's realistic treatment of a modern moral issue." See "Fruits of a Connoisseur's Friendship: Sir Thomas Fairbairn and William Holman Hunt," *Burlington* 125 (Oct. 1983), 591.

114 Grieve, *Found*, p. 35. See also Kate Flint, "Reading *The Awakening Conscience* Rightly," in *Pre-Raphaelites Re-Viewed*, ed. Marcia Pointon (Manchester: 1989), pp. 345–65.

115 Warner, "Millais," p. 93.

116 Thackeray had introduced Millais to Arden some years earlier, when the art collector bought *The Proscribed Royalist* and several drawings from the artist. See Warner, *ibid.*

117 See Helene Roberts, "'The Sentiment of Reality': Thackeray's Art Criticism,"

Studies in the Novel, 13 (Spring-Summer 1981), 29–30.

118 Warner, "Millais," p. 95.

119 Rossetti to William Allingham (April 1856), *Rossetti Letters*, ed. Doughty and Wahl, I, 300.

120 W. M. Rossetti, *Memoir*, I, 161.

121 Cynthia White and Harrison White, *Canvases and Careers: Institutional Change in the French Painting World* (New York: 1965), p. 112.

122 See Warner, "Millais," p. 141.

123 See King, *Industrialization of Taste*, p. 43. Middle-class incomes are also discussed by Patricia Branca, *Silent Sisterhood: Middle Class Women in the Victorian Home* (London: 1975), pp. 40ff., and Best, *Mid-Victorian Britain*, pp. 81–84.

124 See Hunt, *Pre-Raphaelitism*, II, 183 and 194–95.

125 See Warner, "Millais," p. 141; W. M. Rossetti, *Rossetti as Designer and Writer*, pp. 25 and 46; and Hunt, *Pre-Raphaelitism*, II, 194–95.

126 Hueffer, *Brown*, p. 106.

127 Clement Greenberg, "Avant-Garde and Kitsch," *Partisan Review* 6 (Fall 1939), 349.

128 Rossetti to John Heugh, 14 September 1865, W. M. Rossetti, *Rossetti Papers, 1862–1870* (London: 1903), p. 149. Heugh was a Manchester merchant and collector of Old Master and contemporary art (see appendix).

129 W. M. Rossetti, *Memoir*, I, 250.

130 Millais to Combe, October 1852, Millais, *Millais*, I, 172.

131 See, for instance, the positive critical response to *A Huguenot* (1852) and *The Order of Release* (1853) in Bennett, *Millais*, pp. 33–35.

132 Bennett, *ibid.*, p. 34.; Millais, *Millais*, I, 215–17 and 357; and Warner, "Millais," p. 71.

133 Pierre Bourdieu, *The Field of Cultural Production* (New York: 1993), p. 34.

134 Rossetti to Brown (?summer 1859), *Rossetti Letters*, ed. Doughty and Wahl, I, 355.

135 Peter Gay, *The Bourgeois Experience: Victoria to Freud*, 4 vols. (Oxford: 1984–95), II, 4.

136 See Georgiana Burne-Jones, *Memorials of Edward Burne-Jones*, 2 vols. (London: 1904), I, 152–54. For Plint's commission to Morris, see *ibid.*, p. 175, and Hueffer, *Brown*, p. 154.

137 See Brian Lewis, "Thomas E. Plint – a Patron of Pre-Raphaelite Painters," *The Pre-Raphaelite Review* 3 (May 1980), 90.

138 See W. M. Rossetti, *Ruskin: Rossetti: Preraphaelitism*, p. 281, and *Art Journal* (April 1862), 105.

139 Benjamin, *Illuminations*, p. 60, cited in Hiram W. Woodward, Jr., "Acquisition," *Critical Inquiry* 6 (Winter 1979), 294, where Benjamin's background is also discussed.

140 Muensterberger, *Collecting*, p. 11. See also Frederick Baekeland, MD, "The Art Collector: Clues to a Character Profile," *New York Times*, 16 September 1984.

141 On the parallels between Balzac's life and that of his character Cousin Pons, see Muensterberger, *Collecting*, ch. 7.

142 Honoré de Balzac, *Cousin Pons* (London: 1910), p. 8.

143 Lewis, "Plint," p. 84, who cites as evidence *Building News* (1862) and an unpublished letter from Plint to Brown.

144 See Alexander Tyrrell, "Class Consciousness in Early-Victorian Britain: Samuel Smiles, Leeds Politics, and the Self-Help Creed," *Journal of British Studies* 9 (May 1970), 108–10, and R. J. Morris, "The Middle Class and British Towns and Cities of the Industrial Revolution,

1780–1870," in *The Pursuit of Urban History*, ed. Derek Fraser and Anthony Sutcliffe (London: 1983), pp. 292–93.

145 Lewis, "Plint," p. 77.

146 Hueffer, *Brown*, p. 112.

147 See Mary Bennett, *Ford Madox Brown* (Liverpool: Walker Art Gallery, 1964), no. 25, pp. 18–20; Leopold D. Ettlinger, "Ford Madox Brown and the Ethics of Work," in *Kunst als Bedeutungsträger: Gedenkschrift für Günter Bandmann* (Berlin: 1978), pp. 459–77; and Albert Boime, "Ford Madox Brown, Thomas Carlyle, and Karl Marx: Meaning and Mystification of Work in the Nineteenth Century," *Arts Magazine* 56 (Sept. 1981), 116–25.

148 F. M. Brown in Hueffer, *Brown*, pp. 189–90.

149 Plint to Brown, 24 November 1856, Hueffer, *Brown*, p. 112.

150 Boime, "Work," p. 118.

151 Julie F. Codell, "The Artist's Labor: Respectable or Degenerate? Artists' Memoirs for the Middle Class," paper delivered at the Annual Meeting of Nineteenth-Century Interdisciplinary Studies, Yale Center for British Art, New Haven, 1991, p. 4.

152 Val Prinsep, "A Chapter from a Painter's Reminiscences. Part II. Dante Gabriel Rossetti," *Magazine of Art* (1904), 283.

153 Millais, *Millais*, I, 365.

154 *Athenaeum* (20 July 1861), 89.

155 Surtees, *Rossetti Catalogue Raisonné*, no. 109, p. 62.

156 For the valuation of Plint's collection and the prices earned by individual items in his sale, see *Art Journal* (April 1862), 105. The £25,000 figure did not include the commissions owed his estate (listed *ibid.*, p. 106). The dealer Ernest Gambart, as

agent for the executors, sold some of these works individually, others were placed in a sale at Christie's on 17 June 1865. The estate took five years to settle because Mrs. Plint died six months after her husband without leaving a power of attorney. See Maas, *Gambart*, pp. 143ff.

157 See Maas, *Gambart*, p. 106; *Art Journal* (1862), 105; Martin Harrison and Bill Waters, *Burne-Jones* (London: 1973), notes to pl. 45; John Christian, *Burne-Jones* (London: Arts Council, 1975), no. 23, p. 25; *Rossetti Letters*, ed. Doughty and Wahl, I, 325; Surtees, *Rossetti Catalogue Raisonné*, no. 97, p. 55; and Hueffer, *Brown*, p. 146.

158 Rossetti's outstanding commissions and the poor prices they fetched at the Plint estate's 1865 sale are discussed in W. M. Rossetti, *Memoir*, I, 213–14, and *Rossetti Papers*, p. 139.

159 See H. M. Hyndman, *Commercial Crises of the Nineteenth Century* (London: 1892; rpt. New York, 1967), p. 74. Further evidence is provided by Joseph Gillott's secretary, who advised a correspondent: "The business done here during the last 12 months offers but little encouragement …I hardly know anyone in the town, except my Governor who is buying pictures just now," 13 Oct 1858, Gillott Letterbook, 1858–61, f. 65, Getty Archives, Santa Monica, Calif.

160 For the impact of the economy on art dealers, see Maas, *Gambart*, pp. 97 and 108.

161 Tom Taylor, *The Times*, 5 March 1862, in Redford, I, 165.

162 Maas, *Gambart*, p. 60.

163 J. Maas, *Holman Hunt and the Light of the World* (London and Berkeley: 1984), pp. 73–74. See also, George Landow, *William Holman Hunt and Typological*

Symbolism (New Haven: 1979), pp. 34–36.

164 Mary Douglas and Baron Isherwood, *The World of Goods* (New York: 1979), pp. 59–60.

165 Chandra Mukerji, *From Graven Images: Patterns of Modern Materialism* (New York: 1983), p. 18.

166 Maas, *Light of the World*, p. 67. Moreover Deborah Cherry and Griselda Pollock argue that Hunt deliberately contrived to keep up the value of his early paintings by publishing a series of articles in the *Contemporary Review* in 1886–87. See "Patriarchal Power and the Pre-Raphaelites," *Art History* 7 (Dec. 1984), 485–86.

167 See Maas, *Light of the World,* and Bennett, *Hunt*, p. 10. After Plint's untimely death, Gambart kept the picture for several years before selling it to the London brewer Charles Matthews (Bennett, *ibid.*, no. 32, p. 41).

168 Warner, "Millais," p. 84.

169 Hunt to W. M. Rossetti, 12 August 1855, cited in Judith Bronkhurst, "'An interesting series of adventures to look back upon': William Holman Hunt's visit to the Dead Sea in November 1854," *Pre-Raphaelite Papers*, ed. Parris, p. 123.

170 See Bennett, *William Holman Hunt*, nos. 24 and 25.

171 For Brown's politics, see Boime, "Work." The replica was sold to James Leathart.

172 Madox Brown to James Leathart, 9 May 1864, MSS: Leathart Papers, Special Collections, University of British Columbia.

173 Michel Pêcheux, *Language, Semantics and Ideology: Stating the Obvious*, transl. Harbans Nagpal (London: 1982), p. 10.

174 See, for instance, Paul Oppé, "Art," in *Early-Victorian England, 1839–1865*, ed. G. M. Young, 2 vols. (London: 1934), II, 127.

175 Writers who reach this conclusion frequently refer to Marx's assertion that the commercial marketing of art led to the alienation of the artist. See, for instance, Eugene Lunn, *Marxism and Modernism* (Berkeley: 1982), p. 15; Janet Wolff, *The Social Production of Art* (1981; rpt. New York: 1984), p. 11; and Crow, "Modernism," pp. 229–30.

176 Hueffer, *Brown*, p. 174.

177 For Heaton, see *Sublime and Instructive*, ed. Surtees, p. 147. The source for Lady Trevelyan's Turners is unknown.

178 Agnew, pp. 18–19. Both Thomas Miller and his son Thomas Horrocks Miller were clients of Agnew's. For John Miller's exchange with James Eden for Millais's *Autumn Leaves*, see Warner, "Autumn Leaves," p. 126. Miller also sold Daniel Maclise's *The Installation of Captain Rock* (1834) to Joseph Gillott in 1858 (Getty Archives). Thomas Miller purchased Millais's *L'Enfant du Régiment (The Ransom)* and *A Huguenot* from B. G. Windus. See Millais, *Millais*, I, 357, Warner, "Millais," p. 101, and Bennett, *Millais*, no. 35, p. 34.

179 Combe purchased Rossetti's *First Anniversary of the Death of Beatrice* at McCracken's 1855 sale, where he used a dealer as an intermediary. See Surtees, *Rossetti Catalogue Raisonné*, no. 58, p. 22.

180 See Luke Herrmann, *Ruskin and Turner* (New York: 1969), p. 23. Herrmann, in reproducing a list kept by Ruskin of the estimated market value of the group of Turner drawings he gave to Oxford in 1861, concludes that this accounting reveals "Ruskin's somewhat mercenary attitude toward his collecting activities – an attitude which was no doubt the result of his father's influence" (p. 34).

181 Ruskin to Rossetti (?1855), W. M. Rossetti, *Ruskin: Rossetti: Preraphaelitism*, p. 60.

182 Maas, *Gambart*, p. 69. On the importance of the Canterbury Arms in working-class culture, see Chris Waters, "Manchester Morality and London Capital: The Battle over the Palace of Varieties," in *Music Hall: The Business of Pleasure*, ed. Peter Bailey (Milton Keynes: 1986), pp. 141–61.

183 For Agnew's see, for instance, *Art Journal* (Oct. 1861), 319 and (April 1872), 124. An example of Gambart's favorable press occurs in the May issue in 1860, p. 125.

184 Albert Boime, "Entrepreneurial Patronage in Nineteenth-Century France," in *Enterprise and Entrepreneurs in Nineteenth- and Twentieth-Century France*, ed. Edward C. Carter, R. Forster, and J. N. Moody (Baltimore: 1976), p. 165. Cynthia White and Harrison White also argue that "the apparent alienation of the artist from society is really the appearance of a new social framework to provide for him." See *Canvases and Careers*, p. 95.

185 Gambart's private collection is described in *Art Journal* (Aug. 1876), 276–79. For Thomas and William Agnew's gifts to the Salford Art Gallery, see *Presents from the Past: Gifts to Greater Manchester Galleries from Local Art Collectors* (Manchester: 1978), p. 33 and *passim*. See also Agnew, p. 32.

186 Robert Herbert, "Impressionism, Originality and Laissez-Faire," *Radical History Review* 38 (1987), 11. Herbert contends: "The role of private dealers greatly expanded in their era, and some of the painters, particularly Monet and Degas,

were very clever in manipulating them. They played one dealer off another, learned various maneuvers to keep their prices up, and bypassed commercial galleries when they could reach clients directly" (p. 12).

187 Burne-Jones, *Burne-Jones*, I, 174.

188 Millais persuasively argued: "Early works are also generally the standard specimens of artists, as great success blunts enthusiasm ... such patrons will be respected afterwards as wise and useful men among knavish fools" (Millais to Combe, 10 May 1851, Millias, *Millais*, I, 102).

189 Harold Perkin, *Origins of Modern English Society* (London: 1969; rpt. 1985), p. 413.

190 Best, *Mid-Victorian Britain*, p. 199.

4 Money and mainstream
mid-Victorian values

Spending reached new heights in the mid-Victorian art world, where hundreds of thousands of pounds per annum passed through the hands of collectors, artists, dealers, and auction houses. Critic Francis Palgrave marveled, in 1868, that "More money is probably spent on pictures in a year than was spent during the whole reign of George II."[1] England's rapid recovery from the recession of the late 1850s produced an even larger pool of businessmen eager to participate in the ritual of accumulation and display which by now was a standard feature of the moneyed middle class. Art collecting had become so prevalent by 1881 that the *Magazine of Art* could claim "There are probably very few houses – certainly none whose owners have the slightest pretensions to culture, and are not hampered by want of means – which do not possess some specimens of modern pictorial art" (p. 266). While the less prosperous contented themselves with popular engravings, their employers, reaping the rewards of England's preeminent position in mid-nineteenth-century world economy, bought directly from living artists and from dealers.

England, according to Victorian economist Michael Mulhall, had become the richest country in the world.[2] Nor did the affluent hide their assets. Foreign visitors were struck by the visible signs of prosperity they saw: Hippolyte Taine reported opulence everywhere, while the American Ralph Waldo Emerson claimed that no other country in the world paid such homage to wealth, remarking that the most abusive insult was to call someone "a beggar."[3] The philosophy of the classical school of political economy which advocated spending as a means to national prosperity, continued to win converts. Even Ruskin echoed Adam Smith and John Stuart Mill when he tendentiously alleged "The wealth of a nation is only to be estimated by what it consumes."[4] Although Ruskin still saw money as a moralizing agent and believed that it would eventually filter down to the poor, others interpreted this credo as license to indulge themselves. The new hotels,

homes, and shops which Taine and Emerson saw on their visits to England were monuments to the power and wealth of the private individual.[5]

England, by the middle of the nineteenth century, had become a middle-class nation.[6] The Reform Act of 1867 completed the process of liberation begun by the Act of 1832. As Walter Bagehot noted in *The English Constitution* in 1872:

> The middle class element has gained greatly by the second change, and the aristocratic element has lost greatly … The Spirit of our present House of Commons is plutocratic, not aristocratic; its most prominent statesmen are not men of ancient descent or of great hereditary estate; they are men mostly of substantial means, but they are mostly, too, connected more or less closely with the new trading wealth.[7]

This wealth signaled England's arrival at industrial maturity. The incessant preaching of the early Victorians about the rewards of hard work and the beneficence of material progress were realized in the bourgeoisie's ascendance to wealth and power. No longer fragmented and inchoate as in the early-Victorian years, the middle class was now a common body with a common goal and the means to attain it. Buoyant and optimistic, its aims were to consolidate its position in society and to celebrate its accomplishments by redefining culture in its image.

In arguing that consumption is always driven by the need to ascertain social status, Thorstein Veblen could have been describing the mid-Victorians who competed on the art market for ownership of the cultural markers of their age.[8] When financiers and art connoisseurs learned that the recently ennobled Baron Albert Grant had reputedly paid £10,000 for Landseer's *Otter Hunt* and that the newly knighted Sir John Pender owned a Turner worth an identical sum, they realized that art had entered the high commodity stakes and was a mercantile force to be reckoned with in the general economy.[9] The £10,000 figure was a multiple signifier: it was impressive because of its enormity (approximately $2 million in today's currency);[10] it was startling because it was paid by men who were not hereditary landowners; and it was provocative because it suggested that the desire for art knew no bounds.

Certainly the aristocracy and members of the landed gentry did not stop buying art after the signing of the Reform Bill; however, as I argued in chapter 1, the number of their purchases of contemporary art were modest in proportion to those of the middle class. Less partial to mid-Victorian Royal Academicians than their ancestors had been to Wilkie,

Landseer, and Leslie, the names of the landed élite were eclipsed by commoners in memoranda of sales. Critic F. G. Stephens amplified the *Art Journal*'s assessment when he pronounced:

> The so-called middle-class of England has been that which has done the most for English art. While its social superiors "*praised*" Pietro Perugino, neglected Turner, let Wilson starve, and gave as much for a Gaspar Poussin as for a Raphael; the merchant princes bought of Turner, William Hunt, Holman Hunt, and Rossetti.[11]

The early-Victorian dialectic between aristocratic hegemony and middle-class independence in cultural matters was resolved at mid-century by the weight of example. Admirable models were available in the public men of the period: Prime Ministers William Gladstone and Benjamin Disraeli were both art collectors.[12] Increasingly confident in its powers, the middle class no longer felt as compelled to look outside its own ranks for cultural paragons. Enfranchised and recognized, the mid-Victorian middle class now placed more store in the judgments of its own kind. At the time of the sale of the art collection of Manchester cotton and shipping merchant Samuel Mendel in 1875, it was reported: "He found himself a rich man, and he saw that other rich men in business, successful like himself, were displaying their wealth by buying pictures at high prices and making their dwelling-houses as magnificent with works of modern art."[13] Mendel, in fact, was more concerned about the opinion of his peers than of his betters. While on a visit to the Art Treasures exhibition, Earl Russell and a group of noblemen asked Mendel if they might visit his private collection and were refused permission, even though the merchant was a member of the exhibition's organizing committee.[14] Mendel apparently felt that he had nothing to gain from entertaining these visitors. Whereas Gillott had turned to Lord Northwick to acquire pedigreed works, Mendel turned to early-Victorian middle-class collectors, to Isambard Kingdom Brunel, from whom he bought two paintings, and to Samuel Dobree, at whose sale he purchased Wilkie's *Letter of Introduction* (plate 3).[15] When Mendel's own collection was sold in 1875, it was described as "the great event of this year at Christie's": it occupied twenty-one days and netted £98,000, even though Agnew's had privately purchased one hundred of his choicest paintings beforehand in a separate financial arrangement.[16]

These prices confirmed, even to the most cynical observer, that the visual arts had attained a towering place in society. Sanctioned as an

exemplar for the disadvantaged at the Art Treasures exhibition and as a chronicler of daily life at the time of the Sheepshanks bequest, art came to claim an even more influential role in the following decades because of its exchange-value. The financial resources of the mid-Victorian period produced a set of opposing cultural axes in which an intangible yearning of the spirit resulted in hefty price tags for aesthetic objects. Such paradoxical situations occur, explains Susan Stewart, because "the collected object represents quite simply the ultimate self-referentiality and seriality of money at the same time that it declares its independence from 'mere' money."[17] Protesting that it was symbolic rather than economic value that was more important to them, businessmen held up their art collections as proof of their detachment from materialism.

Samuel Smiles was converted to this argument in 1875, when he expanded his definition of self-help to include art collecting. An appreciation of art, he now reasoned, was an essential ingredient in the make-up of the successful man:

> To our eyes, a room always looks unfurnished, no matter how costly and numerous the tables, chairs, and ottomans, unless there be pictures upon the walls ... Any picture, print, or engraving, that represents a noble thought, that depicts a heroic act, or that brings a bit of nature from the fields or the streets into our room, is a teacher, a means of education, and a help to self-culture. It serves to make the home pleasant and attractive. It sweetens domestic life, and sheds a grace and beauty about it. It draws the gazer away from mere considerations of self, and increases his store of delightful associations with the world without, as well as with the world within.[18]

Quoted in the biography of Newcastle shipowner and art collector James Hall twenty years later, Smiles's contention that art possessed the means to elevate the mind and to raise material man above his mundane pursuits had become fully integrated into middle-class mythology.[19] Assuaging the Protestant conscience with the assurance that art collecting was not a senseless luxury, this argument presented a moral rationale for the classical school of political economy's emphasis on spending.

Such sophistry made it possible for mid-Victorians to turn to art as proof that they cared about more in life than amassing a fortune. Revealing a degree of defensiveness about his mercantile success, John Pender avowed: "Do not let it be said that Manchester men have no higher pursuit than making money."[20] Also desiring to correct the impression that its successful

citizens were materialists, the *Liverpool Daily Post* stressed in its obituary of shipowner George Holt that his art-filled home was "another conspicuous example of the fact that the pursuit of commerce is naturally compatible with the pursuit of refinement and intellectual interests."[21] Reading this, other aspiring businessmen were motivated to become art collectors if for no other reason than to avoid being charged with Philistinism. The "ear-marking" of money for art became a standard practice of the successful mid-Victorian businessman.[22]

While it may seem contradictory to esteem art for both its intangible and tangible worth, the mid-Victorians believed it was possible. The ambivalent space where money and motivations intersect is the subject of this chapter. Victorian economist Alfred Marshall pragmatically asserted: "In the world in which we live, money, as representing general purchasing power, is so much the best measure of motives that no other can compete with it."[23] Although Marshall's reasoning is consistent with nineteenth-century economic theory (and explains the monocular behavior of several of the art collectors I will discuss), it discounts the complexities inherent in the individual's relationship with money. So does the current branch of postmodern economic analysis that is based in semiotics. Baudrillard, for instance, insists that the commodification of goods has caused the difference between exchange-value and use-value to disappear. Writing about art auctions, he claims that, "In consumption generally, economic exchange value (money) is converted into sign exchange value (prestige, etc.); but this operation is still sustained by the alibi of use value."[24] While I agree that the purported use-value of art was often exaggerated or misrepresented as an "alibi" in order to justify spending, I find the reasons for this as intriguing as the occurrence itself. Whereas the semiotic treatment of systems of exchange as texts discounts the mediating effect of historical circumstances, social networks, and individual motivation, those are the social and psychological issues that I intend to explore in this chapter. I will draw on the research of recent anthropologists and sociologists, some of whom I have already referred to in these pages, who consider money a social and cultural agent which can signal a wide variety of positive as well as negative messages. For instance, I find Viviana Zelizer's presentation of the way people incorporate money into personalized social webs a useful tool for explaining why industrialists and entrepreneurs liked to buy each other's paintings.[25] The interactive aspect of art is further illuminated by Arjun Appadurai, who interprets consumption as "eminently social, relational,

and active rather than private, atomic, or passive" – as a way of both sending and receiving social messages.[26] This perspective is borne out by the motivations of the mid-Victorians who are the subject of this chapter. Not only did they want to be considered part of the cultural habitus of their time, but they mentally connected with the early Victorians as well as with each other.

Mid-Victorian motivations embrace the roster of reasons for spending money on art that was displayed by their middle-class predecessors: patriotism, self-education, investment, a need for social communication, and a desire for status, even for immortality. However, they also added reasons of their own: no longer embryonic, but in the full vigor of their social might, the mid-Victorians augmented their inheritance of cultural capital by confidently promoting a school of visual representation which extolled their virtues and played down their vices. More advanced forms of mechanical reproduction insured that their self-centered ideology was circulated to a larger audience than ever before. In this chapter I will describe some of the negotiations that occurred as the prosperous bourgeoisie attempted to balance their sense of moral restraint with their need for self-gratification, their longing for well-being with their denial of social ills, and their pride in accomplishment with their fear of failure. Because these contests were played out on the national cultural field, they shifted the hierarchical position of the agents already in place: collectors rapidly outnumbered patrons, preferring freedom of movement to a team effort, causing artists to move closer to dealers, who in turn strengthened their alliances with critics.

The reorganization of the cultural field was one of the by-products of modern capitalism's efforts to bring regional entrepreneurial systems into alignment as it expanded its national and international interests. Middle-class tycoons prided themselves in possessing those qualities that assured England's place at the forefront of the world market in engineering, shipping, discount financing, and international trade. Among art collectors, Albert Grant, for instance, was responsible for introducing the practice of high-risk stock flotations into the City of London, while John Pender was equally unafraid to face hazards when it came to laying submarine telegraph cables in remote parts of the world, just as Samuel Mendel braved the dangerous waters off the Cape of Good Hope when he sent his merchant ships off to India and China. Yet these were only three among the crowd of businessmen who felt compelled to take time away from their international enterprises to follow cultural pursuits in the mid-nineteenth century.

Rather than try to take the full roll call of mid-Victorian art collec-
tors, I have relied on the choices made by the *Art Journal*, *Athenaeum*, and
Magazine of Art when these periodicals described the leading private collec-
tions of contemporary art that had been formed in the middle decades of
the century. Although collectors of Aesthetic movement art were also rec-
ognized by the press in these years, I will reserve my discussion of them for
the following chapter, since their more concentrated vision is in counter-
point to the heterogeneity of the proponents of England's "age of
equipoise."[27] To the thirty-seven establishment art owners identified by the
art press, I have added four names from artists' memoirs and six from the
rolls of donors to the British Museum, National Gallery, and South
Kensington Museum (although none matched the Vernon or Sheepshanks
bequests).[28] This group of forty-seven collectors provides an unparalleled
insight into the cultural aspirations of the mid-Victorian middle class.

No women are mentioned by the art press as owners of leading
private collections. One has to look very hard to find the equals of Martha
Combe, Ellen Heaton, and Lady Pauline Trevelyan among the sponsors of
mainstream artists. Emma Pender and Mary Newall, wives of men who con-
tributed to the emerging field of submarine telegraphy, were eclipsed by the
shadow of their husbands' international achievements. Yet it appears that
Emma Dennison, the daughter of a Nottingham conveyancer who became
Pender's second wife in 1851, was involved in the selection of their art col-
lection. The same was true of Mary Newall, who first drew her husband's
attention to A. W. Hunt, an artist they subsequently patronized for many
years.[29] Creative in her own right, Emma Pender commissioned Keeley
Halswelle to illustrate her book *Norman and English History*.[30] As a friend of
John Everett Millais, Emma Pender was the likely instigator of the portrait
he painted of her daughters Anne and Marion in 1864.[31] Titled *Leisure
Hours*, it dominated the far end of the Penders' London dining room (plate
37), where it commanded the attention of visitors by its size and solemnity.
Mesmerized by the rhythmic movement of goldfish in a glass bowl, the
Pender daughters display none of the precociousness that characterizes
Millais's pictures of children in the 1860s. While every mid-Victorian col-
lection of any note featured a work by Millais, it is conceivable that Emma
Pender's friendship with the artist inspired him to rise above the tempta-
tions of popular portraiture.[32]

With so little information available to document the involvement
of female patrons, we are left with an incomplete image of the mid-Victorian

Plate 37. Dining Room, 18
Arlington Street, residence of
Sir John Pender, 1894, photo-
graph by Bedford Lemere

woman. Her more frequent appearance as subject in the private collections
of the period reinforces the pervasive nineteenth-century image of woman
as keeper of the hearth. Cotton spinner William Cottrill, for instance, owned
George Hicks's triptych, *Woman's Mission* (1863), a series that articulates the
notion of the sexes' separate spheres.[33] In three canvases successively depict-
ing woman's responsibilities – *Guide of Childhood*, *Companion of Manhood*,
and *Comfort of Old Age* – Hicks demonstrates the limited range of accepted
activities for the mid-Victorian woman. In the central episode, *Companion of
Manhood* (plate 38), a devoted wife is represented comforting her husband,
who has just been informed, by the black-rimmed letter he holds, of the
death of a loved one. Performing the duty expected of her by society, Hicks's
heroine conforms to the standard of domesticity enunciated in such popular
works as Coventry Patmore's descriptively titled poem, "The Angel in the
House" (1854). Hicks revealed his accord with this construction of gender

when he prejudicially pronounced: "I presume no woman will make up her mind to remain single, it is contrary to nature."[34]

It is appropriate that Hicks's painted definition of mid-Victorian womanhood should have found a home with Cottrill in Higher Broughton, the verdant retreat of Manchester's richer industrialists.[35] It was in the newer Victorian suburbs that the definitive separation of private and public spheres occurred as men distanced themselves from their work and turned to their homes as domestic havens presided over by obliging women.[36] Davidoff and Hall have discovered that many middle-class women willingly set their ambitions aside until financial security was assured for their families.[37] Yet, even after mid-Victorian families like the Cottrills had acquired sufficient surplus capital, the division of duties had become so entrenched that men continued to dominate the sphere of art collecting.

The leading art collectors of the middle decades were men who were actively involved in a wide spectrum of endeavors as merchants, manufacturers, insurance underwriters, financiers, or as trained professionals in the law, accounting, and engineering.[38] Geographic and occupational diversity, rather than conformity, was the norm. Only coal mine owner J. Grant Morris can be considered self-made, in contrast to the dominant third of the group who had possessed wealth for at least two generations and the remaining dozen whose families had enjoyed easy circumstances for three generations or more.[39] Sixteen mid-Victorian art collectors can be classified as provincial industrialists due to their ties to manufacturing, shipping, and iron and coal production; however, these occupational and geographic distinctions were becoming increasingly blurred due to their national and international investments. Liverpool industrialists are a case in point: George Holt, T. H. Ismay, and Robert Rankin were diversified capitalists who served on the boards of insurance companies, banks, railways, and shipping lines in which they had a financial interest. As Harold Perkin notes, the mid-Victorian years witnessed the rise of large-scale capitalists: "It was not the entrepreneurial class as a whole which was beginning to rise above itself, but a class of new and bigger business men, mostly corporate capitalists in the new large-scale joint-stock companies."[40] To persist in viewing the mid-Victorian businessman from the perspective of his domicile is to miss the point of Britain's economic transformation.

Pender's career typifies the mid-Victorian businessman's transition from regional to international status. Of Scottish Lowland and middle-class ancestry, he earned a high-school education before entering the bookkeep-

Plate 38. George Hicks, *Woman's Mission: Companion of Manhood,* 1863, oil on canvas

ing department of a textile factory in Glasgow, where he was made general manager at the age of twenty-one.[41] Transferred to Manchester, Pender was active on the cotton exchange in the 1850s and 1860s, along with Samuel Mendel. Unlike Mendel, who faced bankruptcy because he did not anticipate the effect that the opening of the Suez Canal would have on his markets in India and China, Pender kept an eye on international affairs.[42] In 1856 he made his first investment in submarine telegraphy, and by 1866 he and his associates had succeeded in laying a transatlantic cable. Less than ten years later, Pender's Eastern & Associated Telegraph Company owned a

third of the cables strung around the world, reaching points as distant as India and China.[43] Diversification protected Pender's fortune, both from the ill effects of the Lancashire cotton famine in the 1860s and from the national economic slump of 1873.[44]

Unashamed of the sources of their money, mid-Victorian magnates often celebrated their ties with industry in art. Pender commissioned the artist R. Dudley in 1870 to depict him in the telegraph hut at Porthcurnow in the act of writing the first telegram carried over the British–India line.[45] This picture is not the only instance of the mediating influence of a patron's occupation on artistic production. Other collectors, such as William Armstrong and Isaac Lowthian Bell, commissioned artists to add their factories and coal mines to the standard formula for landscape painting.[46] Vocations influenced art-making in other ways as well. Newall carried his scientific interests into his art patronage when he invited artist Henry Holiday to record selenographs through a telescope he had constructed.[47] Just as occupational boundaries were falling because of ventures into national and global schemes, so were those that separated the traditional artistic genres.

At the time Pender commissioned the painting of his historic act, he had moved his base of operations from Manchester to London. According to W. D. Rubinstein, London's middle class was distinguished from its industrial northern counterpart by its greater wealth earned from commerce.[48] Yet, as the mid-Victorian period progressed, provincial magnates, such as Pender, maintained London *pieds-à-terre*, or retired to the south, bringing their capital with them. Priding themselves in their individuality, sophisticated in their grasp of market opportunities, mid-Victorian entrepreneurs and financiers alike made the age-old regional distinctions redundant.

It is claimed that between 2,500 and 3,000 Victorian businessmen of the Victorian period left fortunes of at least £100,000.[49] The opulent lifestyles of many of these men would seem to support the contention that the middle class fell victim to the "aristocratic embrace" which has been described as "The salami technique of the upper class, nibbling away at those other elites by taking them into the charmed circle."[50] One would expect to find ample evidence for this contention among the mid-Victorians in this chapter, because of art collecting's origins in aristocratic practice. Yet their biographies prove that, while they enjoyed many of the traditional perquisites of wealth, they asserted their independence from the aristocratic model in other regards.

John Pender, for instance, imitated the upper-class way of life after his move to London when he bought a house with a historic pedigree located at 18 Arlington Street. Originally a present from Charles II to Nell Gwyn, it was later the home of Horace Walpole.[51] The ornate molded ceiling and carved fireplace in the room where he displayed Millais's *Leisure Hours* (plate 37) testify to the elegance of the house. Moreover, Pender followed in the footsteps of the landed élite when he purchased a palatial country estate, Footscray Place, near Sidcup in Kent. A photograph of the exterior of the mansion (plate 39) illustrates some of the tangible features of social position described by Perkin: servants, a liveried equipage, and a house of imposing size.[52] Pender, then, gave every appearance of desiring membership in the gentry, particularly after he accepted the title, in 1892, which raised him to the peerage as a baronet.[53] His lavish homes, art collection, and honorific appellation fortify the contention that the middle class's aspiration to become gentry resulted in its absorption into the dominant élite. Pender, however, veered off course when he refused to sacrifice his zeal for work to the pursuit of leisure. When interrogated about his outside interests in 1894, Pender replied: "I do not hunt, I do not shoot, I do a little bit of yachting, but ... I have made submarine telegraphy to a great extent my hobby."[54] By admitting that he did not participate in typical country pursuits and by confessing to his obsession with work, Pender pointedly marks his separation from the leisured landed élite.

Shipowner Thomas Henry Ismay was another middle-class tycoon who withstood the magnetic attraction of high-class power when he refused the baronetcy he was offered in 1898 for his achievements in founding the profitable White Star Line.[55] Others, like Pender, remained active in their businesses long after they could afford to retire, and even instilled the same reverence for work in their sons. Charles Morrison, the eldest son of the richest commoner in England, early-Victorian collector James Morrison, could have relaxed in luxury, but he chose to continue in the banking arm of the family business, where he increased his inheritance tenfold to £10 million by following a highly disciplined regime. Describing his standards for the man of business in 1854, the younger Morrison wrote:

> [he is] a man sparing of words – close in disposition – often intuitively seeing what is best to be done without being fluent in explaining to others his reasons for doing it – wary in his choice in men – cautious and balanced in his opinions – careful never to promise as much as he expected to perform – innovating in a gradual, practical, and tentative

Plate 39. Footscray Place, Kent, country estate of Sir John Pender, 1900, photograph by Bedford Lemere

manner – averse to tumult and verbal contention – willing to work in obscurity for a result only to be realised after years of patience – instinctively distrustful of everything showy and popular – and punctiliously correct in the minutest pecuniary detail.[56]

Clearly the early-Victorian ideal of social praxis was still in effect if the son of one of the richest men in England could advocate quotidian restraint and devotion to work as a formula for success.

This attitude was not confined to London-based financiers such as Pender and Morrison. Worcester glove manufacturer John Derby Allcroft, whose art collection was recently sold at Sotheby's, built a 100-room mansion with the profits he earned from selling his products in France and

the United States.[57] While he imitated the lifestyle of the country gentle-man when he served as a Justice of the Peace and High Sheriff of Shropshire, he maintained his allegiance to the middle class by remaining active in his business and by choosing to construct modern Stokesay Court rather than live in Stokesay Castle, which had come with the 8,500-acre estate he purchased. Likewise, both Sir Isaac Lowthian Bell and Sir William Armstrong, who were raised to the peerage for their entrepreneurial achievements, remained active in their businesses.[58] While Armstrong's life became more gentrified after he delegated responsibility at his engineering and armaments company and concentrated on the building of Cragside, his baronial retreat in Northumberland, he still monitored his executives and persisted in his electrical and scientific research.[59] Bell also remained involved in his iron foundry at Port Clarence which produced one-third of the nation's pig iron by 1875, as did his son Sir Hugh Bell.[60] The leisured life did not appeal to everyone, nor did all industrialists want to join the landed class. Iron founder William Crawshay professed: "I have but one pride, to be head of the iron trade and land won't do that."[61] To this pithy confession should be added the parting words of ironmaster Henry Bolckow, whose foundry in Middlesbrough claimed profits of over £1.5 million in the seven years between 1868 and 1875. As he lay dying in the baronial splendor of Marton Hall, surrounded by his large collection of contemporary pictures, Bolckow regretfully reflected: "Isn't it a pity to be dying when pig iron is nine pound a ton?"[62] Work and pride in accomplishment had become so deeply ingrained in the middle-class psyche that it took precedence over virtually everything else.

Although some northern industrialists lived on landed estates, they slipped through the arms of the "aristocratic embrace" in other instances. Instead of buying pedigreed houses, Armstrong and Bell, like Allcroft, chose to build modern mansions that reflected their individualism, much in the manner of Bolckow's Marton Hall.[63] Furthermore, as I have demonstrated elsewhere, rather than adjusting to the aristocracy's defini-tion of Newcastle's cultural life, they, along with other members of the town's middle class, controlled it: Bell was mayor of Newcastle, while Armstrong was president of several of its art associations.[64] Such instances illustrate that cultural dominance was a key identity symbol in the emer-gence of middle-class social power.

On the other side of the coin, several collectors were willing par-ticipants in what has been vividly described as "a veritable mid-Victorian

stampede" to gentility.[65] Henry Bicknell, son of early-Victorian collector Elhanan Bicknell, after inheriting his father's sperm whale oil manufacturing fortune, bought prestigious Cavendish House, the former residence of the nephew of the Duke of Devonshire.[66] John Henderson falls into the same category: he read for the bar but had no pecuniary reason to practice law, since he was so comfortably provided for by his parent that he was able to devote himself to the acquisition and study of Greek and Egyptian antiquities and modern painting which he bequeathed to various museums and galleries.[67] While Edward Hermon of Manchester did not inherit great wealth, he nevertheless activated the aristocratic model of paternal patronage when he brought in artists to decorate his country estate near Henley-on-Thames. Hermon's fortune was derived from the cotton-spinning firm of Thomas Miller, who placed Hermon in charge after his own sons demonstrated no interest in the business. Unfortunately, Hermon's lavish personal expenditures and distracted style of management caused the company to founder.[68] Misuse of money ranked high on mid-Victorian lists of social transgressions. While, as Walter Houghton attests, "The *summum bonum* for everyone not born into the aristocracy was success,"[69] the pietist tradition prescribed that good fortune be husbanded carefully.

Although Protestant sects encouraged the pursuit of wealth, and even held up their richest members as inspirations to their congregations, money carried a moral obligation. Quakers, for instance, praised the successful and expelled the bankrupt.[70] While Evangelicals did not resort to such drastic measures, they believed implicitly in the stewardship of wealth and expected the members of their congregations to spend judiciously. Philanthropy was expected of the successful parishioner – even the self-serving Joseph Gillott abided by this rule when he established a benevolent society for his workers.[71] Ruskin, who was reared in the Evangelical tradition, viewed wealth as "a personal *reward* for toil" and condemned "wanton expenditure," although he exempted art collecting from this category since it benefited artists and the general economy.[72] Money, then, was not a neutral means of exchange, but a carrier of social values: it was the prize awarded to the industrious, who were obligated to shepherd it discreetly and distribute it wisely lest they face the twin punishments of financial loss and social expulsion.

This sanctimonious attitude toward capital explains the censure that awaited Albert Grant after he fell from grace. Born Abraham Gottheimer in Dublin, the son of a German peddler who later prospered in

the London fancy goods trade, Grant, as he called himself after 1863, learned the rudiments of financial speculation in London and Paris.[73] He made his fortune by pioneering modern company promoting, attracting investors with higher interest rates than those offered by private banks.[74] Obtaining his clients from lists of clergy and widows, Grant managed to swell his pool of investors until 1868, when shareholders staged an inquiry into his Crédit Foncier. Undaunted, he sold off his penultimate art collection and retreated to Italy, where he was made a baron by King Emmanuele in return for constructing an elaborate arcade named after the monarch.[75] Returning to London two years later after having pleasantly spent his season in purgatory, Grant launched even more ambitious schemes for enterprises as diverse as the Imperial Bank of China, the Lisbon Steam Tramways Company, and the Emma Silver Mine in Nevada. He is said to have raised £24 million for his joint-stock companies as word spread about the profits he promised.

Without regard for his investors, Grant used their money to pave his way on the well-trodden path to gentility. He set out to dazzle society with his wealth: Grant spent £50,000 constructing an Italianate mansion near Kensington Palace on the former grounds of a lunatic asylum which he had torn down to make way for his vast new home. Kensington House (plate 40), completed in 1876, was the largest private residence in London. Faced with pink granite columns, its interior featured two marble staircases and counted a 106-foot picture gallery among its one hundred rooms. The grounds matched the extravagance of the house, containing an American-style bowling alley, an ice-skating rink, and a full-scale man-made lake.[76] Although Grant reputedly spent £150,000 on art for his gallery, he never had the satisfaction of seeing his collection displayed there; Kensington House was demolished in 1882, after his financial empire crashed and he could find no buyer for the mansion one of his contemporaries described as possessing a "hideous magnificence."[77] Inflamed by rumors about his shaky financial solvency, Grant's investors flooded the market with shares, causing his ruin.

Larger than life, Grant's Olympian fall both titillated and alarmed mid-Victorian pundits. Although many had envied his initial success, they viewed his failure as an occasion to moralize about the abuse of capital. H. Osborne O'Hagan, a City financier who knew Grant, was one of several commentators who drew a parallel between his demise and the corrosive effects of greed and overspending:

Plate 40. Kensington House, constructed for Baron Albert Grant, *c.* 1878

There was a time when all persons speculatively inclined came to believe that Grant held the Philosopher's Stone, that everything he touched turned to gold, but the gold eventually turned out to be nothing but dross. He had a very great following of people who wanted to get rich quickly. In consequence, he had the command of very large sums of money, and thinking his riches had come to stay, he committed great extravagances.[78]

Grant's crime was not in illicitly amassing wealth, but in abusing it. By disclosing how unstable the system of speculative investment actually was, he threatened the moral apologia for modern capitalism and provided fodder for critics of the system. Writing in the mid-Victorian period, Karl Marx cynically considered political economy a synecdoche for the "religion of everyday life."[79] In the hands of financial lenders and investors, money was divested of its ethical obligation and bared as an object of greed. Because Grant dealt in undisguised capital – stocks, shares, bonds, cash – and not in hardware products, fine textiles, imported wines, or any other useful product, he offered no socially redeeming rationale for his actions.

Nor did he attempt to disguise the perception that money was soulless and heartless when he defrauded widows and old people of their savings. Therefore it was imperative that he and his kind be singled out for their antisocial behavior.

Although he is not named as the model, William Frith's five-canvas *The Race for Wealth* (1880) and Anthony Trollope's serialized novel *The Way We Live Now* (1874–75) describe the meteoric careers of men who were Grant's mirror images.[80] Linked by a Hogarthian impulse to expose society's shifting values, both painter and novelist were provoked by the affront to the revered gospels of honest labor and self-control represented by such men.

Having the benefit of August Melmotte, Trollope's well-developed central character, as a resource, Frith had little difficulty in picturing his protagonist, whom he metaphorically named "the spider." In the first canvas of the series, *The Spider and the Flies* (plate 41), Frith begins his pictorial narration in the company promoter's office, where he is shown surrounded by gullible investors and merchants who wait to service him, including, on the left, a picture dealer. Frith draws attention to his main character by situating him squarely in the center of the composition and by rendering his waistcoat in the lightest tones, leading the viewer to focus on the spider's arrogant thumbs-in-sleeves stance as he condescendingly appraises a prospective female client. Having established the personality of his villain, Frith then turns the tables on him.

In the next episode, the painter departs from Trollope's text when he shows the fraudulent financier at home, meaninglessly pontificating about a work of art in his collection (plate 42). Always willing to aid viewers in the explication of his narratives, Frith elaborated on his intent in his *Autobiography*, where he wrote:

> The second picture represents the spider at home. He is here discovered in a handsome drawing-room, receiving guests who have been invited to an entertainment. He stands – in evening dress – extolling the merits of a large picture to a group of his guests, one of whom, a pretty girl, shows by her smothered laugh that she appreciates the vulgar innocence of the connoisseur, whose art terms are evidently ludicrously misapplied. (II, 141–42)

The popular Victorian conception of the *nouveau-riche* art collector offered Frith more amusing material than did the facts of Grant's

Plate 41. William Frith, *The Race for Wealth: 1. The Spider and the Flies,* 1880, oil on canvas

connoisseurship: *The Times* credited the financier in 1877 with having "really good taste in the Fine Arts."[81] A truer reflection of Grant's life occurs in the cluster of guests to the right and in the background, whom the artist tells us are aristocratic members "of 'the upper ten,' whose admiration of success, combined with the hope of sharing in it, so often betrays them into strange company" (II, 142). Frith's tone echoes the censorious note of Trollope, who observes that Melmotte "was admitted into society, because of some enormous power which was supposed to lie in his hands; but even by those who thus admitted him he was regarded as a thief and a scoundrel."[82] Both artist and writer thus satirize the aristocracy for allowing their greed to overcome their judgment. It is not they, however, who are penalized, but the Colossus who fell from his ill-earned pedestal. It was he who violated bourgeois social codes by striving to imitate the wrong models, by mistreating the

Plate 42. William Frith, *The Race for Wealth: 2. The Spider at Home,* 1880, oil on canvas

money entrusted to him, and by exposing the ruthless side of the economic system.

Frith and Trollope knew their audiences well; therefore, they deviated from the actual scenario of Grant's life by meting out severer punishment than actually befell the financier. Whereas Grant managed to keep a small office in the City after he had declared bankruptcy and retired to Bognor, the spider was banished to Millbank Prison, and Melmotte committed suicide.[83] That the public approved of Frith's moralizing turn is evidenced by the 15,000 photogravures of *The Race for Wealth* purchased by those who believed that honesty was a higher form of honor than ill-earned wealth or the fleeting comforts of the "aristocratic embrace."[84]

Despite Grant's need for social acceptance, it would be incorrect to accredit the lure of the upper ten thousand as the sole motivation behind

his art collecting. As I have already indicated, upwardly mobile business-men had role models closer to hand. Grant was apparently aware of the Crédit Mobilier in Paris, since, for a time, he added that appendage to the name of one of his companies.[85] Whether he met its owners when he lived in France, the brothers Emile and Isaac Péreire, who were engaged in simi-lar but more reputable transactions, is not known. Had he visited their lav-ish home on the Faubourg Saint-Honoré and viewed their extensive art collection, he would have been presented with a more socially accessible bourgeois model for his ambitions.[86] Closer to home, at the much-dis-cussed auction of Mendel's pictures at Christie's in 1875, Grant bid for sev-eral paintings in competition with a host of other collectors of his class.[87]

A reputable provenance added to the desirability of ownership and even altered the reception of a work of art: knowing that a painting had been displayed by an established middle-class collector was socially and finan-cially reassuring and thus deepened its appreciation. Elhanan Bicknell's renowned sale of pictures at Christie's in 1863, for instance, attracted Pender and accountant William Quilter, along with Manchester magnates Miller and Newsham.[88] Liverpool collector John Naylor also made a practice of buy-ing from established collections, such as that of Charles Birch.[89] Appadurai's distinction between the cultural biography of objects and their social history is pertinent to the mid-Victorian custom of moving paintings in and out of a limited circle of influence. He maintains that, while social history is con-cerned with large patterns, "cultural biography," on the other hand, "is appropriate to *specific* things, as they move through different hands, contexts, and uses, thus accumulating a specific biography, or set of biographies."[90] The paintings which passed from one middle-class collection to another fulfill this definition: their provenances were augmented by each sale and brought to successive owners the pleasure in knowing that these objects were not only accredited, but had also formed an intimate part of the daily existence of someone like them. When money was used in this way to define particu-lar categories of social relations, it helped to formalize middle-class customs.

For instance, when Albert Grant's enormous collection was placed on the block in 1877, *Times* art critic George Redford emphasized that it was only one in a recent succession of middle-class sales:

> The Gillott collection had been sold five years before, and the Mendel
> or Manley Hall Collection so recently as two years preceding – the first
> representing the success of Birmingham trade, the last-named of
> Manchester commerce, and together the most remarkable investments,

to say nothing of the Art question, ever made; and this third ...taking a place in the same rank as to money value and Art interest, since some of the finest pictures in it had come from the Gillott and Mendel sales.[91]

Factored into the price that new buyers paid for the individual paintings in Grant's sale was the enriched cultural value that each work of art had accrued over time. In this way, the consumption of English art became a pattern in the overall social history of the middle class.

Considering the amount of money that was at stake, it would be naive, however, to insist that cultural capital was the only object of this process – longer pedigrees only made art more saleable. Grant's collection (like Gillott's and Mendel's) generated close to £100,000. While these impressive figures stirred feelings of pride that members of the middle class had managed to put together such important collections, it was also a matter of great interest that these collections had significantly increased in value over time. Under these circumstances, speculation was inevitable. The art-as-investment construction is an old one, but it developed a higher profile in the mid-Victorian years of record-breaking sale prices.

Speculation was not initially frowned on by the art press. The *Art Journal*, which continued to proselytize on behalf of the English school, observed, in 1869, that if "we regard picture-collecting as a speculation, and not a taste, there are in the present day very few investments more certainly profitable, if judiciously made" (p. 279). Writing in the new journal *Belgravia* in 1867, R. Folkestone Williams also noted, but did not censure the construction of art as an investment:

> The trade [in art] expanded; and with a more general diffusion of wealth, consequent on commercial prosperity, arose two potent inclinations – the one to display the evidence of great riches by an accumulation of expensive articles of luxury; the other, to find an investment for surplus capital which should afford the largest amount of pleasure and the greatest prospect of profit.[92]

Under the benign eye of the periodical press, speculation in art accelerated in pace with England's expanding economy. Already structured on the *laissez-faire* model, the art market easily accommodated the needs of every type of investor, from the venal to the compulsive to the emotionally unfulfilled.

The dynamic between desire and demand was ritualistically enacted in the arena of the auction house. Crowds gathered in Christie's on

the morning of important sales, where they greeted their favorite pictures with rounds of applause. For instance, at the sale of Henry Bolckow's collection in 1888, it was reported that "The throng stretched to the ante-room and down the broad staircase into King street," and when Millais's *North-West Passage* reached a price of 4,000 guineas, "there was a huge cheer, and a few seconds later the sound of another cheer could be heard from King street beyond."[93] This was a theater where the auctioneer, wearing the mantle of purveyor of taste, excited the possessive and competitive instincts of his moneyed audience. Chemical manufacturer Andrew Kurtz complained of "the tremendous prices some of my pictures have cost me and which over and over again have been bought with little reflection and under the influence of picture *mania*."[94] Reality was momentarily suspended in the heat of bidding – all that mattered was the confrontation between the magical object and the urge to possess it. Rémy Saisselin, in *The Bourgeois and the Bibelot*, links "the mania for collecting" to "the nervous sensibility of the modern world and its boredom" (p. 69). We recognized this impulse in the obsessive buying practices of Thomas Plint, which precipitated his financial difficulties. The heavily publicized auctions of the mid- to late-Victorian period catered to the affective needs of such individuals whose resolve dissolved in the excitement of the chase. Desire, as Simmel maintains, is intensified by resistance, thus the rivalry inherent in the bidding process only increases its appeal.[95]

Even men as coolly rational as William Armstrong lost their objectivity in the frenzy of bidding. When he set out to make purchases at the Mendel sale in 1875, he behaved as if on a secret mission. He sequestered himself at the Athenaeum Club, sent Agnew to bid for him, and asked his wife to burn his letters. Only to her did Armstrong confess how eager he was, when he wrote, "I fear there will be a severe competition for Millais's *Jepthah* which is exciting great admiration. It is so very fine that I must have it."[96] While personal need compelled normally restrained men such as Armstrong and Kurtz to become emotionally involved in the act of possession, it did not prevent them from remembering their social obligations. Both viewed art as a communicator and, as such, insured that it was made available to all classes in their communities. Just as Armstrong was involved in art activities in Newcastle, so was Kurtz a supporter of the arts in Liverpool.[97]

It did not take long, however, for entrepreneurs to realize that the subjective character of the bidding which took place at sales made auctions

a ready target for exploitation. One of the most skilled practitioners of the clandestine strategies introduced by collectors such as Charles Birch and Benjamin Godfrey Windus in the early-Victorian period was accountant William Quilter. Learning the exigencies of profitmaking through the bankruptcy cases he specialized in handling after the collapse of the railroad mania in 1847, Quilter applied his expertise to the art market. At first, it seemed that he was simply an astute collector of watercolors, an art form that was enjoying increasing popularity as paintings became more expensive and walls more crowded. Invigorated by the advent of Pre-Raphaelitism, watercolorists claimed a growing clientele.[98] Ruskin, in noting that this medium suited "the second order of the middle classes, more accurately expressed by the term *bourgeoisie*," could have been describing Quilter, who prided himself in his yeoman origins and delighted in acting the part of the unpretentious farmer in City circles, despite the fact that, in private, he encouraged his son to become an art critic.[99]

Quilter seemed genuinely dedicated to the pursuit of watercolors, even to the extent that he had design changes made in his house in Lower Norwood to display them.[100] There was no cause for suspicion, therefore, when he staged a sale of his collection in 1875 for the ostensible reason of moving to another house. What did surprise the public, however, was the selling price of David Cox's *The Hayfield*, which fetched £2,950 in a spirited bidding contest between watercolor collector Samuel Addington and dealer William Agnew.[101] A further record was set by Copley Fielding's *The Mull of Galloway* at £1,732, paid after Quilter's son-in-law, carriage maker Charles Eley, had forced the bidding up for Agnew. These prices were said to have boosted Quilter's profits to 260 percent over his original expenditures, earning him a total of £80,000.[102] Even so, this amount was not considered unusual in this decade of high-priced sales.

Quilter's credibility went unquestioned until 1889, a year after his death, when a posthumous sale of his collection revealed that he had held on to some of the watercolors which he had supposedly sold fourteen years earlier. Taken aback, *The Times* reported on 20 May that the "tremendous prices [of 1875], which were at the time thought to be the outcome of genuine competition from the wealthy lovers of our native English art, are now shown to have been simply a matter of clever 'cornering.'" Expressing its disapproval, the newspaper tersely remonstrated:

> We were completely deceived by pretended buyers of repute and ample means, who were put forth as bidders against the real buyers, and in

whose names the various high-priced lots were knocked down and duly recorded as sold. In this way a cheap sort of glorification was achieved in contravention of all the amenities and the unwritten law of fair auction.

Quilter's prominence made the practices of "buying-in" and "price-hiking" seem particularly unsavory. Founding president of the Institute of Accountants, Quilter endeavored, as had Jacob Bell, to obtain recognition for his profession in the form of a Royal Charter. Although he did not succeed, Quilter was nevertheless considered a leader in his field. He owed his fortune, however, not to his ledger-keeping, but to his shrewd dealings on the stock market: he invested in the railway accounts he audited. Although this conflict of interest would be construed as unethical today, it was apparently normal business practice for Victorian accountants.[103] What was unacceptable, as *The Times* imputed, were the deceptive methods he resorted to in bidding up the value of his art.

Only when speculation continued to occur with greater frequency did observers begin to draw an analogy between the art market and the stock market. It was not until 1885 that *Fraser's* realized that "the excitement of the stock exchange has been 'imported' into the pure and formerly unsullied realm of art" (p. 66). The parallel was repeatedly made through the end of the century, when even a dealer protested that "pictures are the subject of bulling and bearing as though they were securities on the Stock Exchange."[104] *Blackwood's* finally warned its readers off auctions altogether, cautioning:

> Let not the philanthropist, let not the man who has formed and would retain a good opinion of his fellow-man cross the threshold of the sale-room. Verily they are the shabbiest, sordidest, seediest specimens of the *genus homo* who gather as vultures round a carcase on such occasions.[105]

Like Albert Grant's misuse of capital, these manipulations of the art market were too bold and too transparently avaricious to be acceptable. Speculators showed no inclination to enter into a dialogue with the members of their class or to share their cultural knowledge with the less fortunate. Current theorists use the term "spectacular society"[106] to describe the phase of commodification in which money-making activities are separated from social life, such as at the mid-nineteenth-century auction where speculators elevated art's sumptuary value over its use-value. Nevertheless, in keeping with the *laissez-faire* philosophy, art auctions remained unregulated by the government.

Because of the circuslike atmosphere of auctions, many collectors preferred to work with dealers. While only three of the forty-seven collectors I surveyed for this chapter relied exclusively on dealers, nearly everyone employed their services to some extent.[107] Armstrong, for instance, drew up a handwritten list describing the source and price of the eighty-seven pictures he owned by 1876.[108] It reveals that the Newcastle inventor purchased over half of his collection at Christie's through the agency of dealers. He acquired the remainder at artists' studios, commercial galleries, exhibitions, and from other collectors.

Observing that northern collectors traveled to London to visit artists' studios or to attend the Royal Academy's annual exhibitions, Agnew's branched out from the provinces to the metropolis in 1860, opening a showroom on Waterloo Place, later expanding to larger premises on Old Bond Street in 1875. More sophisticated than the interior of its Exchange Street rooms in Manchester (plate 15), the Bond Street gallery (plate 43) abolished shoplike counters and substituted more intimate drawing-room style settees and elegantly carved tables. With fewer objects on display, the London showroom more closely resembled the interior of a comfortable private home, a feature that allowed regular customers such as Pender, Armstrong, and Grant more ease in imagining the transition of art objects from showroom to home. The elegant decor also projected the illusion that the Agnews were not merchants but gentlemen.

With the retirement of Thomas Agnew in 1861, his eldest son William for the next thirty years dominated the "firm, the auction room and the national and international art market," particularly after Gambart's retirement to Nice in 1871.[109] A force to be reckoned with, William Agnew demonstrated his business acumen in his dealings with Samuel Mendel: he persuaded the Manchester merchant to name him beneficiary of a life insurance policy as security for money owed for art purchases.[110] Even after opening the London branch, he continued to shape the holdings of Charles Langton, George Holt, David Jardine, and John Naylor, among others in the provinces.[111] Seeing that some of his clients brought foreign art back with them from their travels, Agnew began to represent contemporary Dutch, Belgian, French, and German artists, as did Gambart. They competed for the patronage of clients such as sherry merchant Frederick Cosens, who, as a partner in the Oporto house of Silva, often traveled to Spain, where he became interested in contemporary art.[112] Similarly, George Fox's supervision of his American employer's far-flung import–export interests

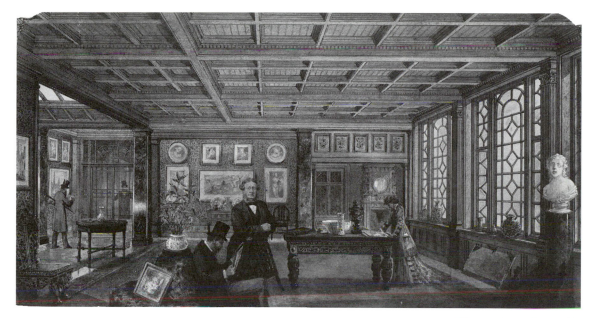

Plate 43. Agnew's, 39 Old Bond Street, London, 1877, architectural rendering by E. Salomons

enabled him to make purchases at the Paris Salon, the Brussels Royal Academy, and at international exhibitions in Munich and Vienna.[113] Once the privileged preserve of aristocrats on the Grand Tour, foreign travel was becoming more commonplace among the middle class. Reflecting on this change, the *Bedfordshire Mercury* noted in 1867: "It is, indeed, rather amusing to us now, that so lately it could have been thought worthy of record that a gentleman had made the Tour of the Continent. There are scores of business men who now cross the Atlantic four or five times in the year."[114] The international travel of mid-Victorian collectors induced dealers to overcome England's national boundaries and nativist bias.

While Agnew and Gambart managed to maintain their hegemony over the art market, they were given a good run for their money by a number of competitors. The *Art Journal* estimated that for the fifteen years preceding 1868, "It would not be beyond the mark to say the dealers in modern pictures have shared a million of money between them" (p. 163). Entry into this lucrative field was therefore well worth the effort. On the provincial front, John Clowes Grundy managed to operate at a profit in Manchester until his death in 1867.[115] In Liverpool, where Agnew's also had a showroom, major purchasers such as George Holt divided their favors among a selection of local dealers who included W. G. Herbert and T. Hardman.[116]

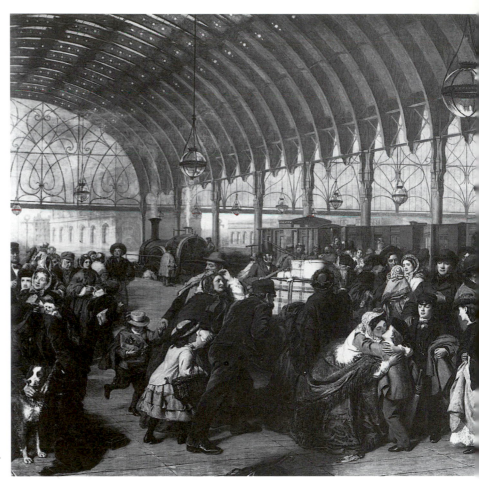

Plate 44. William Frith, *The Railway Station*, 1862, oil on canvas

In London, next to Agnew and Gambart, the name which most frequently rises to the top of the one hundred dealers listed in the Post Office directory in 1865 is that of Louis Victor Flatow.[117] Described as one of the most persistent salesmen who ever lived, Flatow operated as a chiropodist before trying his hand at the Old Master market and, finally, the moderns.[118] After cultivating a clientele, he gave commissions to William Frith, T. S. Cooper, Thomas Faed, David Roberts, and John Phillip, all painters who, the *Art Journal* insisted in its 1864 review of an exhibition at Flatow's gallery, were "'leaders' of our school; the men who are now famous; whose happy destiny it is to live at a time when 'patrons' are so many and so rich."[119] To satisfy these patrons, Flatow instructed his artists to produce cabinet-sized pictures which, as the *Art Journal* pronounced in

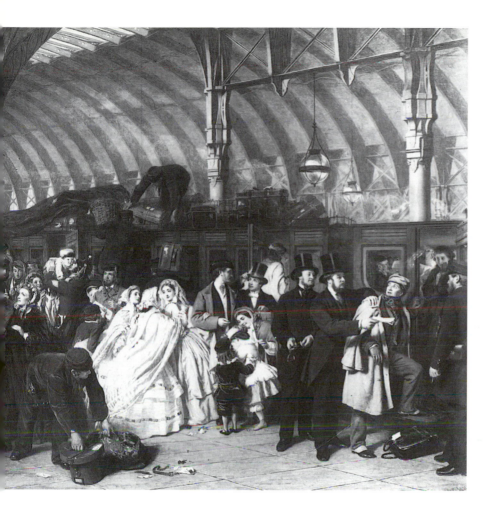

1861, represented "the taste of the time" (p. 365). Realizing that not every-one was an Albert Grant with a hundred-foot picture gallery, Flatow and his fellow dealers dictated the terms of production by urging artists to make their works smaller and thus more saleable, thereby reinforcing the foreign impression of England as the home of modest, rather than heroic art.[120]

Flatow made an exception, however, when he commissioned Frith's *Railway Station* (plate 44), which measures 46 × 101 inches. Since it was over twice as large as the pictures he normally handled, Flatow did not intend to let it immediately disappear into a private collection, but planned to feature it in traveling exhibitions and through engravings. For these privi-leges, and for the pleasure of being represented in the picture in conversa-tion with the engine driver, the dealer paid Frith £4,500, an investment on

which he was said to have earned £30,000.[121] Agnew topped the amount Flatow paid Frith when he gave Holman Hunt £11,000 for the right to exhibit and to engrave *The Shadow of the Cross* in 1874.[122] In entering the dynamic phase of entrepreneurial mass culture, artists and dealers realized enormous profits from the reproduction of images that reinforced Victorian values.

Engravings became cultural messengers that circulated to the remotest colonial outposts.[123] Since none of the public bequests of the 1860s and 1870s was of the stature of the Sheepshanks collection,[124] nor any exhibitions as ambitious as the Manchester Art Treasures, engravings achieved what cultural organizations could not: the communication of middle-class values to an expanded domestic and international audience. As I indicated in regard to Holman Hunt's *Light of the World*, prints succeeded in homogenizing the category of culture by transcending class boundaries. The *Art Journal*, for instance, in reviewing the engravings collected by a modest country parson which included such popular favorites as Wilkie's *Rent Day*, Webster's *Punch and Judy*, Landseer's *Otter Hunt*, and Faed's *When the Day is Done*, noted that: "These had been collected and placed here because he knew they would be appreciated by the humblest of his parishioners."[125] In London, those who could not afford to pay three shillings for a print or the one-guinea annual membership fee charged by the Art Union, which included an engraved work, could still vicariously enjoy the latest publications by window shopping.[126] William Macduff captured two bootblacks admiring a group of engravings in the shop window of printseller Henry Graves on Pall Mall in 1862 (plate 45). The elder poignantly points to a portrait of Lord Shaftesbury, who agitated for the reform of child labor laws. His portrait is flanked by Millais's *Order of Release*, on the left, below which is Thomas Faed's *Mitherless Bairn*, while Landseer's sentimental canine scene, *Saved*, appears on the right.[127] Printsellers such as Graves prospered because they understood the appeal of inspirational subjects such as these. Graves realized that prints must please the public. He insisted: "they will not buy them, if you do not give them a subject which they value."[128] In summarizing the profits made by culturally democratic printsellers, Maas notes: "It is impossible to over-estimate the importance of this trade in the Victorian art world ... It was they who carried an artist's reputation into every home in the country and to all four corners of the globe; it was they who brought prosperity to the artists and, of course, to themselves."[129]

While generous copyright fees significantly contributed to the price spiral of art, so did the growing sophistication of the dealer–critic

system. Although not yet as finely honed as it would become in the late Victorian period, this mutually beneficial partnership was already on its way to becoming a profitable proposition, as I suggested in the previous chapter in my discussion of the advantages of Ruskin's goodwill to Gambart. Another instance occurred when the dealer commissioned F. G. Stephens, in 1860, a year before the critic joined the staff of the *Athenaeum*, to write a laudatory monograph about Holman Hunt.[130] This alliance is important for a number of reasons that benefited artist, dealer, and critic. First, the end product contributed to the cult of personality which enhanced Hunt's career and eventually gained him entry into the £10,000 club. Next, Gambart's active encouragement of art historical literature increased the value of his investment in Hunt. Finally, the writing assignment contributed to Stephens's precarious earnings as a professional critic.

Because Stephens was paid only a modest salary by the *Athenaeum*, he hoped that the series he wrote on private collections would result in commissions to write catalogues of the holdings he reviewed.[131] He succeeded in winning an order from Londoner David Price, who asked him to document the 300 pictures he owned by artists such as Millais, Linnell, and Frith.[132] Thus Stephens's motives in singling out the noteworthy private collections of England were not entirely impartial.

Nor was the *Art Journal*'s criterion for selecting the most important owners of contemporary English art totally objective. Just as it had realized a profit from its publication of engravings from Robert Vernon's collection in the early-Victorian period, so it continued to rely on private owners as a source for its popular images in the mid-Victorian years. The *Art Journal* frankly admitted its debt to individual collectors in its review of conveyancer Thomas Williams's collection, in 1869, when it acknowledged:

> No fewer than four of the pictures of Mr. Williams will be engraved for the *Art-Journal*. Similar services have been rendered us, and favours conferred upon us, as our readers know, by many other collectors: without such aids, indeed, it would be impossible for us to issue this publication with the claims we assume it to have on public patronage and support, or to give it the high position it undoubtedly occupies in periodical literature. (p. 280)

Because the reproduction of engravings kept his journal solvent, publisher S. C. Hall was not above thanking compliant patrons in kind: he presented collector George Fox with a painting by George Hicks after the

Plate 45. William Macduff,
Shaftesbury, or Lost and Found,
1862, oil on canvas

Manchester magnate gave the *Art Journal* copyright clearance to engrave a work in his collection.[133] While the value of Fox's painting was enhanced by its publication in a distinguished periodical, Hall reaped the rewards of reduced overhead. Much like the benefits earned from the dealer–critic affiliation, the journal–patron reciprocity paid dividends to both parties.

Artists who accepted the terms of the marketplace were happy beneficiaries of the system. Rosamond Allwood notes that George Hicks "earned almost as much as a typical country squire living on a landed income of £5,000."[134] Even a relatively minor painter such as G. B. O'Neill

240

could claim income as high as £1,000 a year in the 1870s, while the earnings of a major artist such as Millais crept up to £30,000 per annum.[135] Artists, like businessmen, discovered that it was more profitable to diversify. The most successful did not limit themselves to a single patron, dealer, or exhibition society, but took advantage of the mid-Victorian art market's many lucrative outlets.

Only four mid-Victorian patrons are known to have bought their art solely from artists.[136] While many occasionally mixed direct patronage with other more commercial modes of collecting, this declining ratio signifies the fraying of the tie that bound artist to patron at the beginning of the century. With so many new experiences beckoning for their attention, art lovers were less inclined to invest in the time-consuming process of commissioning a series of works from a single artist. Although the aristocratic protégé system had provided a viable model for several early-Victorian patrons, it was becoming a rarity in the middle decades of the century – few but Pre-Raphaelite artists experienced the luxury of a close relationship with their patrons.

Disturbed by the corrosion of the "umbilical cord of gold" that linked artist to patron, mid-Victorians let accusations fly in all directions. Some collectors, such as Andrew Kurtz, blamed artists. After experiencing unhappy encounters with painters Vicat Cole, G. D. Leslie, and Frederic Leighton, Kurtz professed: "I am sick of commissions and dealing with artists at any rate – if in buying from dealers you pay through the nose – you get what you want and what you have seen."[137] Artists in turn complained of the unrealistic demands placed upon them. Ever the pragmatist, Millais gave his reasons for capitulating to commerce:

> I am inclined to think we are chiefly indebted to the much abused
> dealer for the great advance in the prices paid for modern art. It is he
> who has awakened the Spirit of Competition. Where the Artist knows
> of only one purchaser, the dealer knows many, and he has no scruples
> of delicacy in accommodating what is choice and admirable …he has
> on the whole been the Artist's best friend and scores of times has bought
> on the easel what the connoisseur has from timidity refused.[138]

One encounters the names of dealers time and time again in the autobiographies of mid- and late-Victorian artists who believed that professional middlemen protected them from the harsh realities of the marketplace.[139] Reflecting on the reasons that prompted artists to rely on agents so

extensively during the course of the nineteenth century, *The Times,* on 3 November 1909, in its obituary of William Frith, observed:

> The almost invariable rule [of patrons] was to buy direct from the artist, a method which sounds simple and unobjectionable. But every memoir of every artist of those days shows that the plan worked badly; that personal idiosyncrasies came to play too large a part; that buyers were exacting, patronising, changeable; that after a time the artist would feel humiliated, would lose his temper, and, as a consequence, his client.

Rossetti found mainstream businessmen particularly meddlesome. After learning that brewer Charles Matthews was in the process of rounding out his collection of Royal Academy art with a few Pre-Raphaelite works, Rossetti was at first exuberant. He reported to Ford Madox Brown:

> I have some good news for myself to tell you. I have been designing the Perseus and Medusa subject; and yesterday Mr. Matthews the Brewer came to see the design, and commissioned the picture for 1,500 guineas … Mr. Matthews is a queer character, – seems to buy all sorts. Frith's big daub in the RA belongs to him, also Hunt's *Afterglow* (do you remember what he gave for it?), Solomon's *Amphitheatre,* Millais's *Ransom,* lots of Pooles, and many other things. He thinks of building a Gallery, and may, I dare say, turn out permanently useful.[140]

Rossetti's hopes were dashed, however, when he discovered that Matthews had very definite ideas about picturemaking and refused to be cajoled into changing his mind. The incisive qualities that led the brewer to be appointed founding director of Ind, Coope & Co. were the same character traits Rossetti found most objectionable. Problems immediately arose over interpretation, price, and size of the proposed commission, *Aspecta Medusa.*[141] Although Matthews's correspondence with the artist reveals that he was fully cognizant of the details of the classical myth, he recoiled from the prospect of bringing a treatment as morbid as the one that Rossetti proposed into his home.[142] Drawing on his knowledge of the classics, Matthews dispelled the stereotype of the jolly brewer when he eruditely suggested alterations that were consistent with the Perseus legend.

Rossetti, as I indicated in the previous chapter, did not respond favorably to patronly interference; predictably, he refused to incorporate Matthews's suggestions.[143] Relations between artist and patron further deteriorated when Rossetti insisted on raising the price of a second subject in which the brewer was interested, *Dante's Dream,* from 1,500 to 2,000

guineas. Even though Matthews was to pay Gambart 2,500 guineas the following year for Holman Hunt's *Finding of the Saviour in the Temple*, he was presumably reluctant to advance such a sizable sum to an artist whose works had never been engraved and who refused to exhibit publicly.[144] Rossetti attempted to rectify the situation by introducing bourgeois business practices into the negotiations, but after he reminded Matthews of his verbal contract, the brewer tartly responded: "The tone of your correspondence is so unsatisfactory to me from the disposition which it shows to tie me down hand and foot to a certain outlay, that it makes me feel half disposed to withdraw my commission altogether. I will not do this, but I am determined that I will in no way be fettered."[145]

Rossetti proceeded to tie his own Gordian knot when he impulsively sent off a cancellation of the agreement, much to his later regret.[146] The issues that surface in the Rossetti–Matthews exchange are central to the historically shifting relations between artist and middle-class patron. Better educated and with more free time to devote to cultural pursuits, entrepreneurs were no longer satisfied with playing passive observer to the creative process. Confident that the imagination and ingenuity which served them so well in their mercantile endeavors could be applied to their commissions from artists, businessmen such as Matthews enthusiastically entered into the spirit of artistic production. Artists, on the other hand, were anxious to protect their independence and to insure that there was no backward slippage into the earlier Victorian paternal–deferential mold. Still new at applying the strategies of the business world to their art negotiations, artists ruefully learned, as did Rossetti, that patrons were much more adept at that particular art.

Always attuned to subtle shifts within the art world, the *Art Journal* worried that artists were placing their hard-won social advancement in jeopardy by becoming too much like merchants. It addressed this question in 1872 in its review of the collection of George Fox when it argued that artists, in order to maintain their place in society, must dissociate themselves from the taint of trade. The *Art Journal* reasoned that, by relying less on dealers,

> Artists grow to acquaintance with their "patrons"; Art is removed from the atmosphere of trade; a beneficial influence affects both; the artist becomes a more thoughtful member of society (which he too frequently ignores), and the patron learns to know and to estimate the power of mind and skill of hand to which he is indebted for his enjoyment; no

longer regarding production of Art as things that cost so much, and are
of so much worth. Hence it is matter of earnest desire on the part of
painters to contribute to this collection, and to other collections where,
in like manner, they are estimated as gentlemen as well as artists. (p. 117)

Underlying this argument, we recognize the eighteenth-century
construction of a pure and ideal art produced independently of the market-
place, but the ideal has been modernized to the extent that producers as
well as consumers must now be gentlemen. Choosing in this instance to
ignore its previous pronouncements encouraging the monetization of art,
the *Art Journal* inconsistently advocated a reversal of a trend it had helped to
initiate. In this utopian scenario, middle-class respectability took prece-
dence over economic gain.

Nevertheless, concern for the socialization of the artist lends even
more importance to the soirées hosted by Pender, Price, and the Burnand
brothers at which artists were invited to mingle with the rich and famous.
Just as Thomas Combe included Hunt and Millais in his circle of Oxford
literati, these London patrons recognized that artists had something to con-
tribute to the fabric of intellectual life. Insurance underwriters and uncles of
Punch editor Francis Burnand, Arthur and Theophilus Burnand moved in
literary, theatrical, and musical circles and often entertained a wide cross-
section of cultured guests at their respective residences.[147] Pender's invita-
tion list was an even broader mixture of figures from the worlds of public
achievement and creativity. Renowned for the luncheon parties he gave on
the day of the opening of the Royal Academy's annual exhibition, Pender
attracted luminaries from politics, commerce, and society, as well as from
the art world. Artist Frederick Goodall named Robert Browning, the
American ambassador, a distinguished scientist, and a roster of lords and
ladies among those he encountered at this annual fête.[148] Wool merchant
David Price, like Pender, bought a historic London house where, next door
to the mansion of the Duke of Buckingham and surrounded by the splendor
of two private picture galleries, he gave Monday "at homes" open to "men
from the public offices, from the City, from St. Stephens's, from the muse-
ums and galleries, men of letters and of law . . . [and] from the studios –
painters." At Price's salon, among the topics discussed were "art, and labour,
and the changing mart, and all the framework of the land."[149] Such social
occasions gave these businessmen an opportunity to assert their social and
cultural accomplishments, of which patronage of art was an essential ele-
ment. At the same time, their salons provided an entrée for artists into the

higher reaches of middle-class society and thus permitted them to win respect for their profession.

If one is to believe the art press and artists' memoirs, this nurturing mid-Victorian cultural environment was achieved without the benefit of women. Price relegated his female guests to a separate sphere at his Monday "at homes," where the *Art Journal* recorded that men convened in the evening, but "the afternoon had been set apart with the same kindly intent for ladies."[150] And, while artists did not forget to respond with gratitude in their memoirs to Pender for including them on his celebrated guest list, only one acknowledged Emma Pender's part in these annual luncheons; significantly, that author was a woman, the painter Henrietta Ward.[151] Resembling George Hicks's representation of woman in the Cottrill collection, the female hostess was expected to play a supporting role on social occasions.

That the age of equipoise cherished its illusions is verified by the proliferation of idealized genre subjects produced for the mainstream market. Painted for a beholder whose gaze was socially constructed to accept generalizations and stereotypes, the mid-Victorian genre painter presented "reality" as a series of tame conventions: devoted wife, innocent child, and happy worker. An instance of the latter category is Eyre Crowe's 1874 glorification of Lancashire factory life in *Dinner Hour, Wigan* (plate 46). Painted at Victoria Mills, a cotton manufactory owned by art collector Thomas Taylor, the artist's close attention to detail imbues the scene with an almost documentary quality. Factory women congregate in the forecourt of the looming mill at the junction of Pottery Road and Wallgate, an area circumscribed by the parameters of the New Star Inn, at the right, and warehouses along Wigan pier, further back at the left.[152] Such fidelity to site persuasively suggests that Crowe's depiction of healthy-looking, relaxed factory hands is also accurate. Yet, as I indicated in chapter 2, working conditions for women within factories were frequently deplorable.[153] When Harriet Martineau toured a glass factory in Birmingham in 1852, she was requested "not to notice the circumstances of women being employed instead of men" in one particular process. Today we would naturally conclude that this request was made to disguise the fact of women's menial employment, but Martineau explained that the factory owner was more concerned that Londoners would think women did not perform as well as men.[154] Crowe has avoided this dilemma by moving his female workers outside the red brick walls of the factory where there is no need for them to perform tasks the artist preferred to ignore.

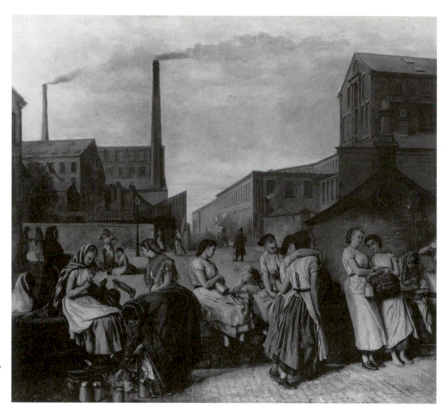

Plate 46. Eyre Crowe, *The Dinner Hour, Wigan*, 1874, oil on canvas

Elder brother of art historian Joseph Archer Crowe and cousin to Aesthetic movement patrons the Prinseps, the artist was party to the same kind of middle-class mythmaking that inspired George Hicks to paint his many idealized versions of London's private and public spheres. While Hicks was dependent on the income from his art, Crowe, as the "scion of Anglo-Indian sahibs," was not.[155] Therefore one cannot claim that all artists were forced by necessity to succumb to the pressure to paint rosy representations of mid-Victorian life. Rather, Raymond Williams argues for the recurrence of general types in the constitution of culture. He defines these elements as

> effective general forms (often using persistent modes and either modifying or interacting with persistent kinds) [that] are typical of a particular social order, which in its characteristic relations and distributions of interests continually reproduces them, and of course reproduces them as normal, as "self-evident" definitions of what various arts should be.[156]

246

In wishing to see their social order reproduced in the best possible light, middle-class patrons and artists alike drew on the related discourses of class identification, which I examined in my discussion of patrons' motivations, and class stability – the illusory but reassuring theme of Crowe's painting. The repertoire of familiar forms and images that were continually reproduced from the early-Victorian period in engravings and artists' replicas became "self-evident," because they satisfied needs of middle-class producers and consumers. Nevertheless, as Williams cautions, this "does not mean that everything, including the most specifically artistic and most specifically aesthetic processes, has to be dissolved into some indiscriminate general social or cultural practice" (p. 129). Patrons did not insist only on an art that normalized their social protocol: lack of conformity is readily discerned in a number of private collections. Newcastle banker Peter Stuart, progeny of a family who had long resided in Italy, displayed memorabilia associated with Garibaldi's fight for independence alongside his Royal Academy purchases. Less conventional than the average mid-Victorian, he was a believer in homeopathy and phrenology. The latter hobby led him to collect casts of the heads of famous people.[157] While Stuart's interests were scientific, others were attracted to images of eminent personages as a form of hero worship. Albert Grant formed a Hall of Worthies containing sculptured portraits of celebrated contemporary figures, among them the poet laureate, Alfred Lord Tennyson.[158] In a similar vein, paper manufacturer Charles Rickards, whose complex relationship with Aesthetic movement artist George Watts forms part of the following chapter, bought portraits which the artist conceived as entries for a Hall of Fame.[159] These representations are the visual counterpart of Thomas Carlyle's writings on the subject of hero worship and Samuel Smiles's adulatory accounts of industrial prowess.[160] Icons to genius and accomplishment, such images fueled the cult of individualism.

Aesthetic appreciation, however, was now practiced at a further remove than it had been at the beginning of the century. While one-third of the early-Victorian collectors I identified were draughtsmen or watercolor painters, only four of the forty-seven collectors named in this chapter are known to have participated in artmaking of any kind.[161] The declining ratio of mainstream collectors who were amateur artists provides an explanation for the hegemony of figural subjects in the collections of this period. The four mid-Victorian amateurs who pursued watercolor painting formed too small a group to initiate a trend or to awaken interest in landscape subjects.

Although the watercolor tradition was experiencing a revival of interest among collectors such as Quilter, its concern with natural motifs was not, overall, as appealing to the businessman–collector as narrative subjects.

Poet and critic Francis Palgrave, in his Royal Academy reviews, noted that figure painting had surpassed landscape. He first commented on this reversal in direction in his review of the 1863 Royal Academy exhibition, when he observed that there were no landscapists on the hanging committee and that no expressions of this genre had been placed at eye level, but "dismissed to floor and ceiling."[162] The following year, Palgrave attempted to account for the bias against landscape painting by attributing it to continuing academic resistance to the Pre-Raphaelite style. He wrote: "Our modern elaborately finished school of landscape does not in general appear to find more favor now with the Arranging Committee than it did in the days when we heard so much about Pre-Raphaelitism" (p. 79). By 1865, Palgrave's lament over the "comparative weakness of our Landscape School" was echoed by the *Art Journal*, which summarily pronounced: "We have lost in landscape, but gained in figure-painting."[163] While Palgrave and the *Art Journal* bemoaned the eclipse of the natural motif, many critics specifically encouraged the emphasis on human activity in art.

The narrative trend was legitimated by critics who, for the most part, were trained in literature rather than the fine arts and therefore emphasized the literary at the expense of the painterly.[164] The *National Review* claimed that somewhere between 70 and 90 percent of all art critics came from literary rather than artistic backgrounds.[165] Royal Academy-trained pundits such as F. G. Stephens were the exception rather than the rule, as were connoisseurs such as Ruskin and Palgrave, who obtained their early art educations at home in the leisurely study of family collections.[166] While the *Art Journal* also attempted to promote aesthetic awareness in its readers, it regretted that other publications continued to hire critics with no training in the fine arts:

> Art critics have been, up to a comparatively recent period, the mystery-men of modern civilization; nor is that race absolutely extinct ... In this country, and wanting the wholesome check of public opinion, those who would not be tolerated in any other walk of thought, have been esteemed good enough for noticing or writing about exhibitions; although their knowledge of Art was infinitely less than of politics, social economy, or the state of the money market.[167]

As the *Art Journal* indicates, art was subjected to the reviews of critics *manqués* who were ill-prepared to discuss aesthetic matters. The dominance of the human subject in mid-Victorian art thus owes to a variety of causes: the decline of the tradition of the amateur artist, the ascendancy of the literary critic, and, last but not least, the middle class's humanistic delight in scenes from daily life. Reinforced in their literal point of view by the vast majority of critics, businessmen–collectors believed that their narrative choices had been vindicated.

With the arrival of the mid-Victorian period, patterns of accumulation and display became an integral part of the middle class's identity. Having reached that plateau, collectors could now relax and enjoy what they had achieved. Bourdieu maintains that rapport with art objects has always been an assumed goal of the pursuit of culture. He holds that pleasure "is felt as the simple pleasure of play, of playing the cultural game well."[168] The criterion of delight entered many facets of gamesmanship from the moment the businessman assumed the posture of the art collector. Subjective in its very nature, the enjoyment of familiar subjects was a key aspect of mid-Victorian collecting.

Nonetheless the repetitious nature of the paintings that were entering mid-Victorian collections was a cause for concern. Palgrave's ruminations over the future of English painting in the *Saturday Review* reveal that he believed that artists needed to correct the "easy vices of the English school, – the pinafore and sentimental styles in figure-painting, with the cow-in-the-meadow and purling-brook species of landscape."[169] He urged artists to expand their repertoires by setting new challenges for themselves. To this end, in 1863, he reflected:

> Our national liking for pictures of children and lovers, household jests and drawing-room tragedies, has its good side; yet the art which lends itself decidedly to subjects of this range, although popular for the moment, is apt before long to lose its hold on the purchasing class, and, by iteration within a somewhat narrow and facile field, to relax the energies of the artist. (p. 10)

Redundancy of imagery had become more apparent than it was in the early-Victorian years because of the proliferation of engravings, lithographs, photogravures, and artists' replicas. The Commission on Fine Arts reported, in 1863, that the number of repetitions which were "bred from" a successful oil painting had become a scandal.[170] Whereas in the early-

Victorian period replication was prompted by a desire to testify to the continuity of human endeavor, in the mid-Victorian years copymaking functioned as a form of advertising that trumpeted the middle class's ascendancy to power. For instance, even though engravings of Frith's *The Railway Station* (plate 44) flooded the market, collectors still vied for the privilege of owning replicas made by the artist. Three mid-Victorian mandarins each purchased versions of it: Middlesbrough iron magnate Sir Isaac Lowthian Bell, sherry importer Frederick Cosens, who was also a frequent contributor to the *Athenaeum* and *Notes and Queries*, and wool merchant David Price, who boasted possession of the original canvas from which the engraving was made.[171]

One can understand the interest of a foundryman like Bell in the wrought-iron flying buttresses and cast-iron columns which Frith featured in his painting. Choreographed in Paddington Station, *The Railway Station* pays homage to the engineering feats of another patron, engineer Isambard Kingdom Brunel, who constructed a futuristic monument to England's railway might. Thus, on one level, Frith catered to his middle-class viewer's pride in industrial and scientific accomplishment symbolized by the sweeping arches of Brunel's temple to progress, which would have impressed merchants such as Cosens and Price whose economic well-being depended on this ideal. On a more general level, Frith offered the average middle-class spectator a narcissistic delight in self-recognition in his panoply of mid-Victorian types: mothers with children, businessmen, soldiers, and even a bridal group. In the opinion of the *Illustrated London News* in 1862, "A more characteristic illustration of the age could not have been selected" (p. 457). Beyond its powers of illustration, *The Railway Station* also functioned as a representation of how the middle class wished to see and be seen.

Many Victorians believed, as the reviewer for the *Illustrated London News* indicated, that one of the highest functions of art was to chronicle the achievements of its time. Palgrave supported this view of art's role as a cultural document when he wrote about the Royal Academy of 1865: "The lesser world of the Academy, as it ought in a civilized age, represents pretty accurately the course of the larger world about it."[172] Astutely, the critic went on to acknowledge that the patrons of Royal Academicians influenced what they painted: "the public exercises consequently a very wholesome influence, – profiting itself in turn by the lessons in good art which the painters, encouraged and upheld by national taste, give it." Cultural power,

in short, circulated from painters, who valorized middle-class values on canvas, to spectators, who benefited from seeing their conception of society clarified and reinforced, to art collectors, who encouraged the repetitious production of these representations through their purchases of them. Thus the three businessmen who bought versions of *The Railway Station* gave Frith's highly selective construction of images a vote of confidence, fueling the demand for paintings that represented an idealized notion of modern life, and thereby shaping the discourse on which they drew.

While the public was attracted to Frith's view of art as a reflection of daily life, his encyclopedic veracity introduced a new problematic when he refused to exclude truths that society wished to ignore. We have seen how Frith exposed social differences in *Derby Day* and avariciousness in *The Race for Wealth*. Again in *The Railway Station*, he referred to the dark side of urban development when he acknowledged that crime had become a threat to security. In the vignette on the far right, the artist shows two of the famous detectives of the day in the act of arresting a criminal, thus drawing attention to the oppressive aspect of metropolitan life that has more recently been described by Gareth Stedman Jones in *Outcast London*.[173] The episode of the criminals in *The Railway Station* punctures the illusion of social harmony perpetuated by mid-Victorian mandarins. Yet Frith's eye is candid, not critical. His inclusion of the felonious claims a small portion of his vast panorama of daily life, just as his tableau of the hungry child in *Derby Day* was finally overwhelmed by the artist's celebration of middle-class virtues.

Even though Frith presented some of the more disturbing aspects of contemporary society in his art, he ultimately assured his viewers that they were protected from menace. He skillfully homogenized the antisocial element by enveloping it in the uniformly untrammeled surfaces of his canvases, unlike his French contemporaries Courbet and Manet, who defied social standards when they disrupted the smooth veneer of academic painting with their crusty *facture*. French critics equated this aesthetic development with social anarchy, arguing that it presaged the fall of tradition and the institutional infrastructure of culture.[174] To the English moneyed class, then, the collective appeal of Frith's painting lay in its reassurance that social and artistic disruption were being successfully kept at bay.

Although Britain's orderly modern society set an example for the rest of the world, there was growing concern, as Geoffrey Best and others have pointed out, that its system of internal checks and controls might not

be working.[175] That doubt remained absent from popular mid-Victorian paintings and engravings. Only a few disaffected artists such as Frederick Walker and Frank Holl addressed issues of poverty and homelessness more directly in the 1860s and 1870s before turning to more saleable subjects.[176] That the middle-class public preferred representations which privileged them as beholders by celebrating their belief in a democratic and harmonious ideal of society is evinced by the redundancy which disturbed so many critics.

While Palgrave had no objection to artists catering to a popular audience, other critics held collectors accountable for not playing the culture game according to the rules of high art. J. Beavington Atkinson, writing with the authority invested in him by *Blackwood's Edinburgh Magazine*, one of the most intellectual of British journals, viewed the popularization of art as a thundercloud on the horizon of Europe which augured the end of good taste and good society. He pronounced, in 1862:

> Art, in common with other products of genius, has had to descend
> from her high pedestal, and become popular in sympathy and secular
> in spirit. Thus the people, both for evil and for good, have, throughout
> Europe, grown into a power, and pictures, accordingly, are made to
> pander to the wants of a dominant democracy. Painters paint down
> to the level of the multitude, a mass which in all countries is essentially
> one in its rude elements of humanity.[177]

Regarding art as a transcendental domain which should remain unsullied by democracy, Atkinson regretted the loss of the aristocratic ideal. His class-based system of evaluation became even more apparent three years later, when he bemoaned that "in these days there is too little of ideal beauty, too little of scholarly culture, too little of gentlemanly refinement."[178] Abhorring the introduction of common experience into art, critics such as Atkinson tried to preserve an eighteenth-century concept of culture which separated the aesthetic from the civic, the social, and the moral.

Artist Edward Poynter, who was to be recognized as President of the Royal Academy and Director of the National Gallery, revealed his sympathy at an early stage of his career with the conservative tropes laid down in the previous century by Sir Joshua Reynolds in his *Discourses*. Poynter maintained that popular anecdotal subjects demeaned the ideal nature of art, declaring, in 1869, "the artist whose only desire is to make a popular success, does his best to amuse the public with what they can appreciate, and repre-

sents his subject without regard to the more important and nobler truths of Nature, which he knows would be thrown away upon the ignorant."[179] In other words, Poynter positioned himself as a custodian of the republic of taste whose job it was to keep art from being sullied by the masses.

Even moderates maintained that the middle-class profile had become too pronounced. Prominent playwright and art critic Tom Taylor complained that a "private and *bourgeois* art" had replaced "history, largely conceived."[180] Taylor hoped to sway the balance away from the anecdotal incidents that dominated mid-Victorian collections by reviving an interest in the past. Palgrave's solution, much like Poynter's and Taylor's, was to foster a school of history painters. These critics differed, however, in their concept of this branch of art. Less concerned with grand passion than were the future president of the Royal Academy and the playwright, Palgrave drew a distinction between "the older manner, in which theatrical and melodramatic sentiment is apt to be predominant" and "the rising school of figure-painters whom one might call 'semi-historical.'"[181] Among the productions of younger artists such as Henry Stacy Marks and Philip Morris, Palgrave recognized the invention of "a new series of incident-subjects . . . being more poetical, and of wider scope" than "common life" subjects (p. 64). In essence, the critic for the *Saturday Review* proffered a compromise solution to the stalemate between popular and high art, since the artists he named specialized in subjects from the daily life of the past. Historical settings were held up as a corrective to the half century of repetitious narrative subjects.

Historical costume pieces found their way into nearly every major middle-class collection of the period. Dignified by an aura of time gone by, the incidents they represented were more easily deciphered than the classical allegories of traditional history painting. In analyzing "the triumph of history" in the mid-Victorian years, Roy Strong concludes: "History served as a collective genealogy of the new literate middle class."[182] The instant pedigree offered by paintings brushed with the patina of past ages found a ready welcome in the homes of collectors who were in the process of establishing social provenances for themselves. It was one more way to attest to the authenticity of the evolutionary process, one more element in the meritocracy of wealth's "culture-building" program,[183] and one more strategy for glossing over the contradictions of modern life. Sweeping ties with the past proclaimed an illusion of solidarity.

This miracle of class cohesion was supposed to be achieved by money. The agent of civility, it would make an expanded range of cultural

opportunities available to the working classes; it would give them visual texts to model themselves after; and it would inspire them to imitate the bourgeois virtues of self-help, self-discipline, and self-satisfaction. But as I contend in the following chapter, the embourgeoisement of social life was challenged from within by members of a counterculture who questioned the fundamental tenets of progressive modernism.

Notes

1 Francis Palgrave, "How to Form a Good Taste in Art," *Cornhill* 18 (1869), 171.

2 Michael Mulhall, *Balance-Sheet of the World for Ten Years, 1870–1880* (London: 1881), pp. 2–3. See also Asa Briggs, *A Social History of England* (1983; rpt. Harmondsworth: 1985), p. 229.

3 Hyppolyte Taine, *Taine's Notes on England* (1870), transl. Edward Hyams (London: 1957), pp. 290–91, and Ralph Waldo Emerson, *English Traits* (1856; rpt. Cambridge, Mass.: 1956), p. 99.

4 Ruskin, *Unto this Last* (1860), in *The Complete Works of John Ruskin,* ed. E. T. Cook and Alexander Wedderburn, 39 vols. (London: 1903–12), XVII, 101, cited in James Clark Sherburne, *John Ruskin or the Ambiguities of Abundance: A Study in Social and Economic Criticism* (Cambridge, Mass.: 1972), p. 145. Sherburne argues that this statement summarizes the main thrust of Ruskin's economic theory.

5 See Donald Olsen, *The Growth of Victorian London* (Harmondsworth: 1976), pp. 61–62.

6 J. F. C. Harrison, *The Early Victorians, 1832–1851* (London: 1971), p. 50.

7 Walter Bagehot, Introduction to the Second Edition, *The English Constitution* (London: 1872; rpt. 1964), p. 279.

8 See T. J. Jackson Lears, "Beyond Veblen: Rethinking Consumer Culture in America," *Consuming Visions: Accumulation and Display of Goods in America, 1880–1920,* ed. Simon J. Bronner (New York: 1989), p. 15.

9 For the amount Grant paid for his Landseer, see Redford, I, 255. The valuation of Turner's *Mercury and Herse* was given by the *Art Journal* (Jan. 1872), 9.

10 My computation is based on the fact that the English pound was consistently valued at approximately $5.00 in the Victorian period. I have multiplied this amount by the inflation factor of forty suggested by Julia Prewitt Brown in *A Reader's Guide to the Nineteenth-Century English Novel* (New York: 1985), 8. Her source is *Essays in Economic History,* ed. E. M. Carus-Wilson, 3 vols. (New York: 1954–66), II, 168–97.

11 Frederic George Stephens, "William Holman Hunt," *Portfolio* 2 (March 1871), 38. Ruskin, also, noted the shift from aristocratic to middle-class patronage. In testifying before the 1863 Parliamentary inquiry into the Royal Academy, he observed, "Our upper classes supply a very small amount of patronage to artists at present." "Report of the Commissioners Appointed to Inquire into the Present Position of the Royal Academy in Relation to the Fine Arts," *Parliamentary Papers* (1863), XXVII, 578.

12 For Gladstone, see Marcia Pointon, "W. E. Gladstone as an Art Patron and Collector," *Victorian Studies* 19 (Sept. 1975), 73–98, and for Disraeli, A. C. R. Carter, *Let Me Tell You* (London: 1940), pp. 292–95.

13 Redford, I, 200.

14 William Graham to Rossetti, 28 March 1873, Angeli-Dennis Papers, University of British Columbia.

15 *Art Journal* (May 1870), 154. Mendel also owned two paintings from Brunel's collection. See *Catalogue of the Magnificent Contents of Manley Hall, the Property of Sam Mendel, Esq.,* Christie, Manson, and Woods, London, 15 March 1875.

16 Redford, I, 200–1.

17 Susan Stewart, *On Longing: Narratives of the Miniature, the Gigantic, the Souvenir, the Collection* (1984; rpt. Durham, N.C.: 1993), p. 159.

18 Samuel Smiles, *Thrift: A Book of Domestic Counsel* (London: 1875; rpt. 1929), pp. 305–7.

19 William Hayward, *James Hall of Tynemouth, a Beneficent Life of a Busy Man of Business*, 2 vols. (London: 1896), I, 145.

20 "Free Art Gallery and Museum for Manchester," (1860), p. 15, Manchester Public Libraries.

21 *Liverpool Daily Post*, 4 April 1896.

22 The term is Viviana Zelizer's. See *The Social Meaning of Money* (New York: 1994), p. 18.

23 Alfred Marshall, "The Present Position of Economics" (1885), in *Memorials of Alfred Marshall*, ed. A. C. Pigou (London: 1925; rpt. New York: 1956), p. 158, cited in Zelizer, *Social Meaning of Money*, p. 9.

24 Jean Baudrillard, *For a Critique of the Political Economy of the Sign*, transl. Charles Levin (Telos: 1981), p. 112. For a critque of Baudrillard, see William Pietz, "Fetishism and Materialism: The Limits of Theory in Marx," in *Fetishism as Cultural Discourse*, ed. Emily Apter and W. Pietz (Ithaca: 1993), pp. 119–51.

25 Zelizer, *Social Meaning of Money*, p. 18 and *passim*.

26 Arjun Appadurai, *The Social Life of Things: Commodities in Cultural Perspective*, ed. Arjun Appadurai (Cambridge: 1986), p. 31.

27 W. L. Burn, *The Age of Equipoise: A Study of the Mid-Victorian Generation* (London: 1964).

28 See appendix listings for William Armstrong, John Wheeldon Barnes, Joseph Beausire, Isaac Lowthian Bell, Henry Bicknell, Henry Bolckow, Arthur C. Burnand, Theophilus Burnand, Frederick Cosens, William Cottrill, Thomas E. Crawhall, George Fox, Holbrook Gaskell, James Hall, John Heugh, George Holt, Thomas H. Ismay, David Jardine, Andrew G. Kurtz, Charles Kurtz, Charles Langton, Charles Peter Matthews, Samuel Mendel, John G. Morris, Robert S. Newall, William W. Pattinson, John Pender, David Price, Edward Quaile, William Quilter, Robert Rankin, Daniel Roberts, George Schlotel, Peter Stuart, Thomas Taylor, Henry J. Turner, and Thomas Williams. The donors are Henry Ashbee, Joshua Dixon, Wynn Ellis, John Henderson, John Jones, and Henry Vaughan. Artists' memoirs provided the names of John Derby Allcroft, Albert Grant, Edward Hermon, and John Naylor. For an analysis of the *Athenaeum* series, including Aesthetic movement collectors, see Macleod (1986), 597–607.

29 For Emma Dennison Pender, See *DBB*, IV, 609–14. For Mary Newall, see *The Newall Collection*, Christie's, London, 13 and 14 December 1979, no. 178. For Mary Pattinson's marriage to Robert Stirling Newall, see *DBB*, IV, 434. See also Macleod (1989a), p. 196 and pl. 40a. I am grateful to Christopher Newall for providing me with information about his family history.

30 The book was published after the artist's death in 1891. It is mentioned in *Pictures, Drawings and Sculpture Forming the Collection of Sir John Pender* (London: 1894), p. 27, where a brief biography of Halswelle is given. See also *Art Journal* (Feb. 1879), 49–53.

31 For Emma Pender's friendship with Millais, see *DBB*, IV, 612. The portrait is documented in M. Bennett, *PRB, Millais, PRA* (Liverpool: Walker Art Gallery, 1967), no. 66, p. 47 and Tate Gallery,

The Pre-Raphaelites (London: 1984), no. 126, pp. 202–3.

32 "The Millais of the year," observed critic Francis Palgrave in his Royal Academy review of 1865, "so soon becomes everybody's talk, that, a month after the Exhibition has opened, there is no need to describe it." Palgrave, *Essays on Art* (New York: 1867), p. 114.

33 There is some confusion about whether Cottrill owned the three oil sketches, the final version, or both. His sale catalogue lists three pictures under the title of *Woman's Mission*, each 10 × 8 inches. See *Catalogue of the Highly Important Collection of Modern Pictures and Water-Colour Drawings of William Cottrill, Esq.*, Christie, Manson and Woods, London, 25 April 1873, lot 150. Rosamond Allwood, on the other hand, names Cottrill as the owner, in 1870, of the central picture in the set, measuring 76 × 64 inches. See Allwood, *George Elgar Hicks: Painter of Victorian Life* (Inner London Education Authority: 1982), no. 26, p. 32. The problem is complicated by the fact that James Gilbert, the Sheffield dealer with whom Gillott often collaborated, was said to have sold forged copies of the set. See Allwood, *Hicks,* p. 33. For the notion of separate spheres in painting, see Deborah Cherry, *Painting Women: Victorian Women Artists* (London: 1993), pp. 120ff.

34 Copy of letter dated 23 June 1900, Hicks notebook, cited in Allwood, *Hicks,* p. 33.

35 See John Garrard, *Leadership and Power in Victorian Industrial Towns, 1830–80* (Manchester: 1983), p. 215.

36 Leonore Davidoff and Catherine Hall, "The Architecture of Public and Private Life: English Middle-Class Society in a Provincial Town 1780–1850," in *The Pursuit of Urban History*, ed. Derek Fraser and Anthony Sutcliffe (London: 1983), pp. 327–45. See also Janet Wolff, "The Culture of Separate Spheres: the Role of Culture in Nineteenth-Century Public and Private Life," in *The Culture of Capital: Art, Power, and the Nineteenth-Century Middle Class*, ed. Janet Wolff and J. Seed (Manchester and New York: 1988), pp. 117–34.

37 Leonore Davidoff and Catherine Hall, *Family Fortunes: Men and Women of the English Middle Class, 1780–1850* (Chicago: 1987), p. 13 and *passim*.

38 The occupations of Edward Quaile and Daniel Roberts are unknown.

39 Morris's claim to humble origins is mentioned in his obituary, *Liverpool Courier*, 24 June 1897. The social origins of the following nine collectors are unknown: C. Kurtz, Jardine, Matthews, Price, Roberts, Quaile, Schlotel, Turner, and Williams.

40 Harold Perkin, *Origins of Modern English Society* (London: 1969; rpt. 1985), p. 427. See also Simon Gunn, "The 'Failure' of the Victorian Middle Class: A Critique," in Wolff and Seed, *The Culture of Capital: Art, Power, and the Nineteenth-Century Middle Class,* ed. Janet Wolff and J. Seed (Manchester and New York: 1988), p. 23.

41 *DBB*, IV, 609. For Pender's biography, see also *Manchester Guardian*, 8 July 1896.

42 Mendel's preferred trade route around the Cape of Good Hope proved too costly compared to the shorter passage through the Suez Canal. See Manchester City Libraries Press Clippings. Mendel's biography is summarized in *Manchester Guardian*, 18 September 1884; *Manchester*

City News, 15 November 1913; and Elizabeth Conran, "Art Collections," in *Art and Architecture in Victorian Manchester*, ed. John H. G. Archer (Manchester: 1985), pp. 73–75. For Mendel's financial difficulties, see letters from Charles Howell to D. G. Rossetti, *The Owl and the Rossettis*, ed. C. L. Cline (University Park, Penn.: 1978), no. 295.

43 *DBB*, IV, 610–11.

44 See W. O. Henderson, *The Lancashire Cotton Famine, 1861–65* (Manchester: 1934; rpt. 1969), and Geoffrey Best, *Mid-Victorian Britain, 1851–1875* (London: 1971), pp. 1–4 for the 1873 depression.

45 See Pender's privately printed catalogue, *Pictures, Drawings, and Sculpture forming the Collection of Sir John Pender* (1894), no. 217, p. 97.

46 The industrial subjects commissioned by Armstrong and Bell are discussed in Macleod (1989a), p. 192. For Bell's commissions, see F. G. Stephens, "Washington Hall, Durham," *Athenaeum* (18 Oct. 1873), 501, and for Armstrong's, see National Trust, *Cragside* (London: 1992), p. 9.

47 Henry Holiday, *Reminiscences of My Life* (London: 1914), pp. 168–72.

48 W. D. Rubinstein, "Wealth, Elites and the Class Structure of Modern Britain," *Past and Present* 76 (Aug. 1977), 99. For a critique of Rubenstein's methodology, see Gunn, "Victorian Middle Class," pp. 20–24.

49 F. M. L. Thompson, *The Rise of Respectable Society: A Social History of Victorian Britain* (Cambridge, Mass.: 1988), p. 163.

50 F. M. L. Thompson, "Britain," in *European Landed Elites in the Nineteenth Century*, ed. David Spring (Baltimore: 1977), p. 37.

Martin Wiener concurs with this thesis, insisting that "the rentier aristocracy succeeded to a large extent in maintaining a cultural hegemony," by capturing the industrial bourgeoisie in its reflection. See *English Culture and the Decline of the Industrial Spirit, 1850–1980* (Cambridge: 1981), p. 8.

51 Commenting on the significance of the lineage of this property, the *Art Journal* observed in 1872: "It is probably the only freehold of the line of houses which flanks the Green Park on the east, in consequence of having been a free gift from the king" (p. 8).

52 Perkin, *Modern English Society*, p. 25.

53 *DBB*, IV, 612.

54 Cable & Wireless Archives Report, 25 January 1894, cited in *DBB*, IV, 612.

55 *DBB*, III, 459. On Ismay, see also W. J. Oldham, *The Ismay Line* (Liverpool: 1961) and Roy Anderson, *White Star* (Prescot: 1964).

56 Charles Morrison, *Essay on Labour and Capital* (London: 1854), p. 126, cited in *DBB*, IV, 343. For his inheritance and final worth, see pp. 342 and 345. Athough Morrison added to the art collection he inherited from his father, his art activites were not described in any of the leading journals.

57 See *Sotheby's Preview* (Oct. 1994), 3–5, for the sale which occurred at Stokesay Court on 28 September – 1 October 1994.

58 Armstrong was knighted in 1859 and made a baron in 1887 (*DBB*, I, 69 and 72). Bell was made a baronet in 1885 (*DBB*, I, 259).

59 Peter McKenzie, *W. G. Armstrong* (Newcastle: 1983), p. 104.

60 *DNB*. For Sir Hugh Bell, see the account

written by his wife Florence Bell, *At the Works: A Study of a Manufacturing Town* (London: 1907; rpt. 1985).

61 Perkin, *Modern English Society*, p. 86. Additionally, as S. G. Checkland argues, the middle-class élite often regarded their country estates merely as surplus assets. S. G. Checkland, *The Rise of Industrial Society in England, 1815–1885* (Oxford: 1964), p. 289.

62 Henry Bolckow, cited in Carter, *Let Me Tell You*, p. 43; see also *DBB*, I, 358.

63 For Marton Hall, see Ron Gott, *Henry Bolckow, Founder of Teeside* (Middlesbrough: 1968), and William Lillie, *The History of Middlesbrough* (Middlesbrough: 1968). For Armstrong and Cragside, see Andrew Saint, "The Building of Cragside," in National Trust, *Cragside* (London 1992), pp. 15–24; Mark Girouard, *The Victorian Country House* (New Haven: 1979), pp. 304–17; and Andrew Saint, *Richard Norman Shaw* (New Haven: 1976), pp. 67–75. Bell's Rounton Grange is described in Rosemary J. Curry and Sheila Kirk, *Philip Webb in the North* (Middlesbrough: 1984), pp. 21–26 The proliferation of modern mansions constructed by Manchester magnates is discussed in the *Art Journal* (April 1872), 117. For Liverpool, see Nikolaus Pevsner, *The Buildings of England: South Lancashire* (Harmondsworth: 1969), p. 35ff.

64 Macleod (1989a), pp. 196ff. and (1989b), pp. 9–37.

65 Thompson, "Britain," p. 32.

66 *Art Journal* (March 1872), 90.

67 For Henderson, see *DNB*.

68 *DBB*, III, 178–81; *Fortunes Made in Business*, ed. James Hogg, 3 vols. (London: 1884), I, 178; *Preston Guardian*, 7 May 1881; and *Manchester Guardian*, 7 May 1881.

69 Walter E. Houghton, *The Victorian Frame of Mind, 1830–1870* (New Haven: 1957), p. 191.

70 Anthony Howe, *The Cotton Masters, 1830–1860* (Oxford: 1984), p. 66, and Elizabeth Isichei, *Victorian Quakers* (London: 1970), pp. 183–84.

71 *DNB*.

72 Ruskin, *The Political Economy of Art* (1857), in *Works*, XVI, 127.

73 See *DBB*, II, 623–29.

74 *DNB*. See also W. T. C. King, *History of the London Discount Market* (London: 1936), pp. 223–24.

75 *DBB*, II, 625. Grant's collection was sold at Christie's on 20 June 1868.

76 Kensington House is described in the *Builder* 34 (8 July 1876), 653–54; W. J. Loftie, *Kensington Picturesque and Historical* (London: 1888), pp. 120–25; Priscilla Metcalf, *James Knowles: Victorian Editor and Architect* (Oxford: 1980), pp. 246–51; and *Survey of London: Southern Kensington*, ed. H. Hobhouse, 42 (1986), 62–67.

77 Loftie, *Kensington*, p. 124.

78 H. Osborne O'Hagan, *Leaves from My Life*, 2 vols. (London: 1929), I, 32.

79 Karl Marx, *Capital: A Critique of Political Economy* (1867–94), 3 vols., transl. David Fernbach (New York: 1981), III, 969.

80 Frith, in his *Autobiography*, admitted that he had known Trollope for a long time, but claimed he had not read his books, "till a few years ago" (*My Autobiography and Reminiscences,* 3 vols. [London: 1888], II, 335). Both were members of the Garrick Club, where they were pictured together in a painting by H. N. O'Neil in 1869. See Derek Hudson, "Billiards at the Garrick in 1869," *Connoisseur* (Dec. 1969), 274. There is some question about whether Trollope's

character Melmotte was based on Grant, since he was conceived three years before Grant's problems became common knowledge in 1876. Yet a parallel exists in contemporary literature in Tom Wolfe's *Bonfire of the Vanities* (New York: 1987). When the author was asked if he was surprised when the financial machinations of his main character were later mirrored in actual events, he replied: "We live in an age in which the imagination of the novelist is helpless before what he knows he will read in tomorrow's newspaper." See *Time* (13 Feb. 1989), 91.

81 See Redford, I, 253. In preferring the image of a philistine, Frith may also have been motivated by the personal animosity he felt toward several patrons. See *Autobiography*, I, 221–26.

82 Anthony Trollope, *The Way We Live Now* (1874–75), ed. Robert Tracy (Indianapolis: 1974), ch. 32, p. 256.

83 On Grant's later activities, see O'Hagan, *Leaves from My Life*, I, 34–35.

84 The series was commissioned by the dealer Louis Flatow. See Reitlinger, p. 150. The first known owner was Isaac Marsden who sold the set at Christie's on 15 June 1889. See Algernon Graves, *Art Sales*, 3 vols. (London: 1918), I, 301.

85 *DBB*, II, 624.

86 See H. Castille, *Les Frères Péreire* (Paris: 1861), and Albert Boime, "Entrepreneurial Patronage in Nineteenth-Century France," in *Enterprise and Entrepreneurs in Nineteenth- and Twentieth-Century France*, ed. Edward C. Carter, R. Forster, and J. N. Moody (Baltimore: 1976), pp. 142–43. In a similar vein, cotton merchant George Fox took for his artistic mentor his employer, American multimillionaire Alexander

Turney Stewart. An Irish immigrant, Stewart pivoted an inheritance of $5,000 into an average annual income of $2 million during the Civil War years, when his wholesale and retail stores serviced Army and Navy contracts. See *Dictionary of American Biography*, ed. Dumas Malone, 21 vols. (New York: *c.* 1928–58), XVIII, 3–4. After meeting the department store magnate in New York in 1842, Fox was put in charge of the Manchester branch of Stewart's import-export business. *Lichfield Mercury*, 8 June 1894.

87 Grant was represented by Agnew's at the sale. See Jeannie Chapel, *Victorian Taste: The Complete Catalogue of Paintings at the Royal Holloway College* (London: 1982), nos. 13, 19, and 71. Armstrong's purchases are recorded in his inventory of his collection, National Trust Archive.

88 See marked copy of *Catalogue of the Renowned English Pictures and Sculpture of that Distinguished Patron of Art, Elhanan Bicknell, Esq.*, Christie, Manson, & Woods, London, 25 April 1863, Getty Center for the History of Art, Santa Monica, Calif.

89 See Edward Morris, "John Naylor and Other Collectors of Modern Paintings in Nineteenth-Century Britain," *Annual Report and Bulletin*, Walker Art Gallery, Liverpool, 5 (1974–75), 79.

90 Appadurai, *Social Life of Things*, p. 34.

91 Redford, I, 253.

92 R. Folkestone Williams, "English Pictures and Picture-Dealers," *Belgravia* 2 (May 1867), 290.

93 Carter, *Let Me Tell You*, p. 41. See also Redford, I, 452 and 277–78 for the excitement generated by the Novar sale.

94 Andrew Kurtz to F. G. Stephens, 27 August 1885, Stephens Papers, Bodleian

Library, Oxford, c. 78, d. 116, ff. 249–50.

95 Georg Simmel, *The Philosophy of Money*, transl. Tom Bottomore and David Frisby (London: 1990), p. 66.

96 William Armstrong to Margaret Renshaw Armstrong, 23 April 1875, Armstrong Family Papers.

97 Kurtz gave Dicksee's *Ideal Portrait of Lady Macbeth* and Leighton's *Elijah* to the Walker Art Gallery in 1878–79. He also opened the private gallery in his home to the public. See *Athenaeum* (4 Oct. 1890), 455.

98 On the collectability of watercolors, see Jane H. Bayard, "From Drawing to Painting: The Exhibition Watercolor," unpubl. Ph.D. diss., Yale University, 1982; Michael Clarke, *The Tempting Prospect: A Social History of English Watercolours* (London: 1981); and Christopher Newall, *Victorian Watercolors* (Oxford: 1987), pp. 59ff.

99 Ruskin, *Notes by Mr. Ruskin on Samuel Prout and William Hunt* (1880), in *Works*, XIV, 373. For Quilter, see *DBB*, IV, 791–95, and the *Accountant* 14 (17 Nov. 1888), 754. I am grateful to my student Diane Evans for her preliminary research into Quilter's life and art collection. His son Harry Quilter (1851–1907) became an art critic, while his eldest son Sir William Cuthbert Quilter (1841–1911) was a stockbroker and art collector.

100 *Art Journal* (April 1871), 110 and 112 and Redford, I, 207.

101 Agnew was the victor; see Redford, I, 204. Addington was a London wool draper whose collection was sold in 1886. See *Art Journal* (Oct. 1886), 307 and Redford, I, 436–37.

102 On Quilter's estimated profits, see Redford, I, 206. His relationship to Eley is given in *DBB*, IV, 794.

103 *DBB*, IV, 793. See also Edgar Jones, *Accountancy and the British Economy, 1840–1980* (London: 1981), p. 67.

104 C. E. Hallé, *Notes from a Painter's Life, Including the Founding of Two Galleries* (London: 1909), p. 177.

105 (C. H. Goodruff), "The Collector on the Prowl," *Blackwood's* 147 (1890), 679.

106 See, for instance, Guy Debord, *The Society of the Spectacle* (Detroit: 1977), and T. J. Clark, *The Painting of Modern Life: Paris in the Art of Manet and his Followers* (London: 1985), p. 9.

107 The three collectors who relied entirely on Agnew's judgment were Jardine, Langton, and Rankin. Although Albert Grant frequently acquiesced to dealers' choices, he is known to have commissioned works directly from Thomas Woolner and Peter Graham. See Chapel, *Victorian Taste*, no. 25, p. 94, and Priscilla Metcalf, *James Knowles: Victorian Editor and Architect* (Oxford: 1980), pp. 250–51. The purchasing patterns of Henderson, Crawhall, Schlotel, and Turner are unknown.

108 Armstrong Inventory, National Trust. The list is undated but includes purchases Armstrong made up to and including the year 1876. That he continued to buy art is apparent in the posthumous sale of his collection at Christie's, held on 20 and 24 June 1910, which included ninety-nine modern pictures. See Macleod, "Armstrong the Collector," in National Trust, *Cragside*, 35–42.

109 Agnew, p. 23. William's brother Thomas junior was also active in the business, but Geoffrey Agnew maintains that "William was always the more enterprising brother" (p. 19).

110 The courts, however, thought Agnew had gone too far and after Mendel's death in 1884 reinstated his wife as heir. See Agnew, 22.

111 The names of these collectors frequently occur in Agnew's ledgers. See Thomas Agnew & Sons Ltd., "Indexed Picture Stock Books, 1853–1881," Getty Provenance Index microfiche, Santa Monica, Calif.

112 Significantly, Cosens did not begin his art collection until 1860, the year that the tariff was lowered on wine imports. See Asa Briggs, *Wine for Sale: Victoria Wine and the Liquor Trade, 1860–1984* (London: 1985), pp. 66–67.

113 Fox purchased canvases by Goubie and Lambinet at the Paris Salon in 1872, Rhomberg, Fichel, and Nieuwenhuys at the International Exhibition in Munich in 1869, Bellecour at the Vienna International Exhibition, and Bossuet at the Brussels Royal Academy in 1869. See *Catalogue of the Choice and Valuable Collection of Modern Pictures, the Property of George Fox, Esq.*, Christie, Manson, and Woods, London, 11 May 1877.

114 Obituary for William Henry Whitbread, *Bedfordshire Mercury*, 6 July 1867.

115 For Grundy, see *DNB* and Jeremy Maas, *Gambart: Prince of the Victorian Art World* (London: 1975), p. 29.

116 Mary Bennett, "Sudley," in *The Emma Holt Bequest, Sudley* (Liverpool: 1971), p. 4.

117 See Maas, *Gambart*, p. 176 and *passim,* for the major dealers of the period. Among the leaders were Joseph Morby and William Vokins. On Morby, see *Art Journal* (Nov. 1861), 349, (March 1864), 80, and (Feb. 1872), 60–61. For Vokins, see Jeremy Maas, *The Victorian Art World in Photo-*

graphs (New York: 1984), p. 201. Henry Wallis also captured a portion of the market until his financial difficulties of 1858–61, after which he worked as manager of Gambart's French Gallery until he was able to buy the lease in 1867. See *Art Journal* (May 1860), 149, and Maas, *Gambart*, pp. 98, 129–30, 151 and 200.

118 For Flatow's background, see T. Sidney Cooper, *My Life*, 2 vols. (London: 1890), II, 290; Maas, *Gambart*, pp. 45–47; and Allwood, *Hicks*, pp. 12–13.

119 *Art Journal* (Jan. 1864), 30. For Flatow's roster of artists, see *ibid.* (May 1861), 149, and (Dec. 1861), 365.

120 Samuel Redgrave and Richard Redgrave, *A Century of British Painters* (London: 1866; rpt. 1947), p. 288.

121 Maas, *Gambart*, p. 202.

122 *Ibid.*, p. 148.

123 See Jeremy Maas, *Holman Hunt and the Light of the World* (London and Berkeley: 1984).

124 Most of the collections of mid-Victorian benefactors, such as Henry Ashbee, Joshua Dixon, John Jones, and Henry Vaughan, were not officially donated until the last decades of the century. Of the remainder, Wynn Ellis bequeathed only the pre-nineteenth-century portion of his collection in 1875. However, John Henderson's bequests to the British Museum and National Gallery in 1878 included English watercolors.

125 *Art Journal* (Jan. 1882), 21–22.

126 See Lyndel Saunders King, *The Industrialization of Taste: Victorian England and the Art Union of London* (Ann Arbor, Mich.: 1985).

127 I owe these attributions to Anthony Dyson's *Pictures to Print: The Nineteenth-Century Engraving Trade* (London: 1984), p. xv.

128 Henry Graves, cited *ibid.*, p. 3.

129 Maas, *Gambart*, p. 28. See also, Reitlinger, p. 149.

130 Frederic George Stephens, *William Holman Hunt and his Works: A Memoir of the Artist's Life with Descriptions of his Pictures* (London: 1860). For Gambart's role, see Maas, *Light of the World*, p. 50.

131 See Macleod (1986), p. 598.

132 Frederic George Stephens, *Catalogue of the David Price Collection* (London: 1885).

133 Hicks recorded in his notebook for 1871 that his painting *Mother and Baby* was "purchased by Mr. S. C. Hall for Mr. Fox of Manchester." The sum paid was £130. See Allwood, *Hicks*, p. 57. The engraved work was H. S. Marks's *My Lady's Page in Disgrace,* which appeared in the March 1870 issue of the *Art Journal*.

134 Allwood, *ibid.*, p. 14.

135 For O'Neil's income, see the entry for him in Andrew Greg, *The Cranbrook Colony* (Newcastle: Laing Art Gallery, 1977), n.p. Millais's income is contrasted with Hicks's by Allwood, *ibid.*

136 The four patrons are Lowthian Bell, Arthur Burnand, Theophilus Burnand, and Thomas Taylor.

137 A. G. Kurtz to F. G. Stephens, 27 August 1865, Bodleian.

138 Letter from Millais addressed "To the Art Student," 29 May 1875, Pierpont Morgan Library, cited in Malcolm John Warner, "The Professional Career of John Everett Millais to 1863, with a Catalogue of Works to the Same Date," unpubl. Ph.D. diss., University of London, Courtauld Institute of Art 1985, p. 146.

139 See, for instance, Cooper, *My Life*, II, 185–86 and 292; Mary McKerrow, *The Faeds* (Edinburgh: 1982), pp. 106–7 and 146–48; Victoria and Albert Museum, *Arthur Boyd Houghton* (London: 1975), p. 10; Greg, *Cranbrook Colony, passim*; and Allwood, *Hicks*, p. 12.

140 Rossetti to Brown, 25 July 1867, in W. M. Rossetti, *Rossetti Papers, 1862–1870* (London: 1903), pp. 268–69. W. M. Rossetti identifies Frith's "big daub" as *King Charles the Second's Last Sunday*. The Simeon Solomon may have been *Habet* (1864), a painting inspired by White Melville's novel *The Gladiators*, which Matthews is recorded as having purchased. See Simon Reynolds, *The Vision of Simeon Solomon* (Stroud, Glos.: 1984), p. 10. Bennett does not indicate how much Matthews paid for Hunt's *The Afterglow*; however, she notes that it sold for £472.10 in the sale of his collection in 1891. See Mary Bennett, *William Holman Hunt* (Liverpool: Walker Art Gallery, 1969), no. 29, p. 38. Rossetti and Matthews were introduced in 1867 by Michael Halliday, a parliamentary clerk and semi-professional painter. See W. M. Rossetti, *Dante Gabriel Rossetti as Designer and Writer* (London: 1889), p. 58.

141 See Virginia Surtees, *The Paintings and Drawings of Dante Gabriel Rossetti (1828–1882), A Catalogue Raisonné*, 2 vols. (Oxford 1971), I, no. 182 and II, pl. 270. The incident is taken from a poem Rossetti wrote in 1865. See *Gabriel Charles Dante Rossetti: The Works*, ed. W. M. Rossetti (London: 1911), p. 209.

142 He advised the artist: "I cannot all get over the horror and repugnance with which I have always regarded that which according to your original design, is to be one of the chief features in it – I mean of course the *severed* head of Medusa. And I

cannot help thinking that the repulsive portion of your design would admit of some modification." Charles Matthews to Rossetti, 9 November 1867, Angeli-Dennis Papers, University of British Columbia.

143 See Rossetti to Matthews, 3 January 1868, *Letters of Dante Gabriel Rossetti*, ed. Oswald Doughty and J. R. Wahl, 4 vols. (Oxford: 1965–67), II, pp. 647–49. For Matthews's side of the correspondence, see Angeli-Dennis Papers.

144 On *Dante's Dream at the Time of the Death of Beatrice*, which Rossetti conceived in 1848, see Surtees, *Rossetti Catalogue Raisonné*, I, no. 81, pp. 41–48. See also Maas, *Gambart*, p. 219, where Gambart refers to the sale as having taken place in April 1869 with the amount "payable over 12 months." Rossetti rarely allowed his works to be exhibited after receiving negative reviews in 1850. See W. M. Rossetti, *Dante Gabriel Rossetti: His Family Letters, with a Memoir*, 2 vols. (London: 1895), II, 182.

145 Matthews to Rossetti, 8 January 1868, Angeli-Dennis papers. For Rossetti's letter to Matthews of 7 January 1868, see *Rossetti Letters*, ed. Doughty and Wahl, II, 649–51.

146 See Rossetti to Matthews, 9 January 1868, *Rossetti Letters*, ed. Doughty and Wahl, II, 651. This letter was followed by a more conciliatory note in which Rossetti tried to reopen the negotiations (see p. 652). Although Halliday brought about a reconciliation, Matthews bought nothing from Rossetti. See W. M. Rossetti, *Rossetti as Designer and Writer*, pp. 61–62.

147 For the Burnands' entertainments, see Sir Francis Burnand, *Records and Reminiscences Personal and General*, 2 vols. (London: 1904), I, 52–53 and 176–77, and Frederick

Goodall, *Reminiscences* (London: 1902), p. 158. Goodall confirms Frith's opinion of the Burnands when he states that they "were not merely buyers but true lovers of my art" (p. 176).

148 Goodall, *Reminiscences*, p. 157. Thomas Sydney Cooper also reported: "I meet at his house many most distinguished men of high standing, both in their professions and socially" (*My Life*, II, 215).

149 *Art Journal* (Nov. 1891), 322.

150 *Ibid.*

151 Mrs. E. M. Ward, *Memories of Ninety Years* (New York: 1924), p. 279.

152 I owe my information about the specific site of Eyre Crowe's painting to Mr. N. Webb of the Wigan Record Office, who kindly provided me with a map of the location. I am also thankful for the research he undertook on my behalf into the life of Thomas Taylor.

153 See, for instance, James Kay-Shuttleworth, *The Physical and Moral Condition of the Working Classes Employed in the Cotton Manufacture in Manchester* (Manchester: 1932), and Emerson, *English Traits*, p. 108. See also Louise A. Tilly and Joan W. Scott, *Women, Work, and Family* (New York: 1978), pp. 63ff.

154 Martineau Papers, 10 February 1852, University of Birmingham, cited in Clive Behagg, "Myths of Cohesion: Capital and Compromise in the Historiography of Nineteenth-Century Birmingham," *Social History* 11 (Oct. 1986), 380.

155 On Hicks's idealized urban scenes, see F. M. L. Thompson, "Painter of Victorian Life," *History Today* 33 (Jan. 1983), 42–44. For Crowe's background, see *DNB* and Graham Reynolds, *Victorian Painting* (London: 1966), p. 112.

156 Raymond Williams, *The Sociology of Culture* (New York: 1981), p. 196.

157 For Stuart's interests in homeopathy and phrenology and his collection of casts of eminent personages, see *Liverpool Daily Post*, 26 Sept. 1888.

158 For Grant's proposed Hall of Worthies, see Metcalf, *James Knowles*, pp. 250–51.

159 On Watts's Hall of Fame, see Hugh Macmillan, *The Life-Work of George Frederick Watts* (London: 1903), pp. 74–75.

160 See Thomas Carlyle, *Heroes and Hero-Worship* (London: 1841). Representative of Smiles's many works on this topic is *Industrial Biography: Iron Workers and Tool Makers* (London: 1863). See also Houghton's chapter, "Hero Worship," in his *Victorian Frame of Mind*, pp. 305–40.

161 The amateur artists were John Barnes, Thomas Crawhall, John Henderson, and John Naylor.

162 Palgrave, *Essays*, p. 19.

163 Palgrave, *ibid.*, p. 118 and *Art Journal* (Feb. 1865), 44. Artist William Bell Scott also informed collector James Leathart, in a letter dated 6 May 1865: "The landscapes in the RA seem getting annually fewer and worse" (Leathart Papers, University of British Columbia).

164 Helene Roberts concludes her study of Victorian art criticism with the observation that "Most writers on art in Victorian periodicals had a literary background …This orientation, as the periodicals themselves noted, produced reviewers who emphasized the subject matter over technical qualities and who gave prominence to those paintings with more interesting subjects." See "Exhibition and Review: The Periodical Press and the Victorian Art Exhibition System," in *The Victorian Periodical Press*, ed. Joanne Shattock and Michael Wolff (Leicester: 1982), p. 83.

165 *National Review*, 9 (1887), 515, cited in Roberts, "Exhibition and Review," p. 83.

166 For Palgrave's background, see *DNB*. His maternal grandfather was Dawson Turner (1775–1858), a notable antiquarian, collector, and amateur artist. See *Collected Correspondence of J. M. W. Turner*, ed. John Gage (Oxford: 1980), pp. 291–92, and Clarke, *Tempting Prospect*, p. 135.

167 *Art Journal* (June 1861), 161. For a similar assessment of the unqualified backgrounds of the majority of art critics, see *London Review* (22 Feb. 1862), 183.

168 Pierre Bourdieu, *Distinction: A Social Critique of the Judgement of Taste*, transl. Richard Nice (Cambridge, Mass.: 1984), p. 498.

169 Palgrave, *Essays*, p. 50.

170 1863 Commission, cited in Paul Oppé, "Art," in *Early Victorian England, 1839–1865,* ed. G. M. Young, 2 vols. (London: 1934), II, 127.

171 See Chapel, *Victorian Taste*, no. 23, p. 88, who lists David Price as the owner of version 1 and F. W. Cosens as the buyer of a replica painted by Marcus Stone, presumably at Frith's request. On the confused history of versions of this painting, see also Jeremy Maas, appendix, Chapel, *Victorian Taste,* pp. 141–42. Lady Bell, in a conversation with the author on 20 August 1985, recalled seeing a large version of *The Railway Station* on the staircase at Rounton Grange. It was perhaps the untraced prepatory oil sketch mentioned by Maas, p. 142.

172 Palgrave, *Essays*, p. 95.

173 Gareth Stedman Jones, *Outcast London: A Study in the Relationship between Classes in Victorian Society* (1971; rpt. New York:

1984). On this painting, see Chapel, *Victorian Taste*, p. 89, and Arts Council of Great Britain, *Great Victorian Pictures: Their Paths to Fame* (London: 1978), p. 37.

174 See *Impressionists in England: The Critical Reception*, ed. Kate Flint (London: 1984), pp. 14–15.

175 Best, *Mid-Victorian Britain*, p. 229. See also Stedman Jones, *Outcast London*.

176 Julian Treuherz, *Hard Times: Social Realism in Victorian Art* (Manchester: 1987), p. 11, who notes that Fildes, Holl, and Herkomer later turned to portraiture. As Treuherz also observes, only a small number of collectors, such as Taylor of Wigan and Edward Hermon of Preston, interspersed one or two social realist canvases among their more conventional paintings.

177 J. B. Atkinson, "Pictures British and Foreign: International Exhibition," *Blackwood's Edinburgh Magazine* 92 (1862), 360. Concerning this critic's rearguard orientation, George Landow maintains: "For almost three decades one can observe Atkinson of *Blackwood's*, who is typical of many conservative critics, express his dismay at the effect of democracy upon the arts." See "There Began to be a Great Talking about the Fine Arts," in *The Mind and Art of Victorian England*, ed. Josef Altholz (Minneapolis: 1976), p. 128. On *Blackwood's* position among Victorian periodicals, see Roberts, "Exhibition and Review," p. 79.

178 J. B. Atkinson, "The London Art-Season," *Blackwood's*, 98 (Aug. 1865), 236.

179 Edward Poynter, lecture of 1869, in his *Ten Lectures on Art* (London: 1880), pp. 43–44. For Poynter, see *DNB* and A. Margaux, *The Art of Edward John Poynter* (London: 1905).

180 Tom Taylor, "English Painting in 1862," *Fine Arts Quarterly Review* (May 1863), 18.

181 Palgrave, *Essays*, pp. 103 and 108.

182 Roy Strong, *And When Did You Last See Your Father? The Victorian Painter and British History* (London: 1978), p. 33.

183 See the discussion of class identity in Sweden by Jonas Frykman and Orvar Löfgren, *Culture Builders: A Historical Anthropology of Middle-Class Life* (Rutgers: 1987).

[1]
David Wilkie
The Letter of Introduction, 1813
oil on panel

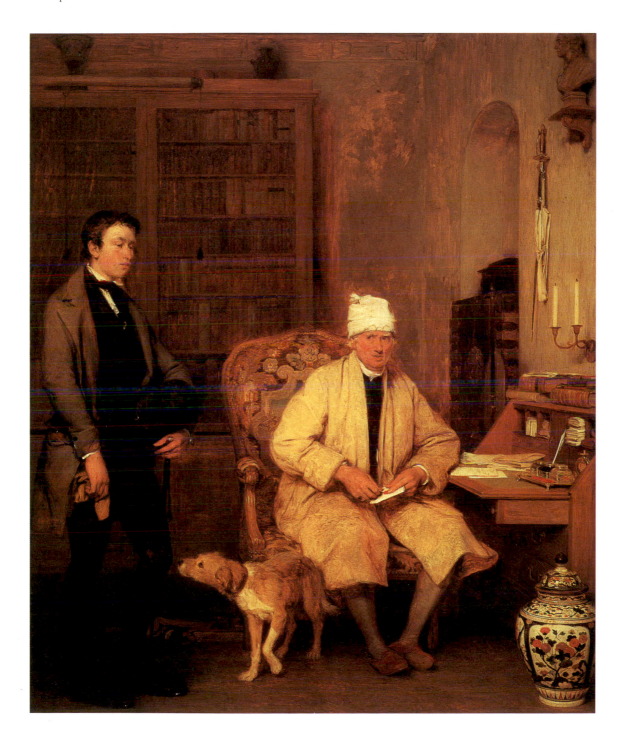

John Scarlett Davis
Benjamin Godfrey Windus's Library, 1835
watercolor

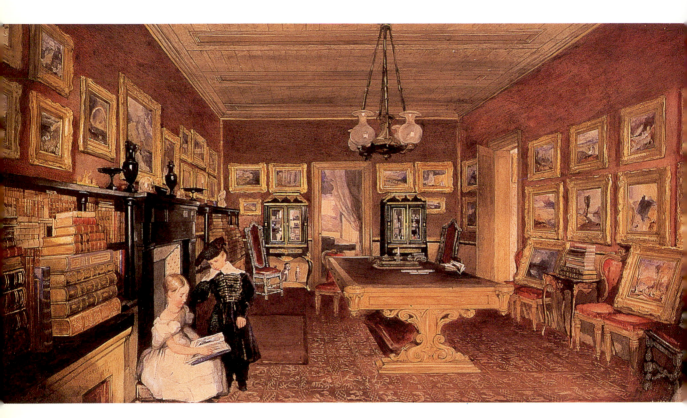

[4]
Thomas Webster
Roast Pig, 1862
oil on canvas

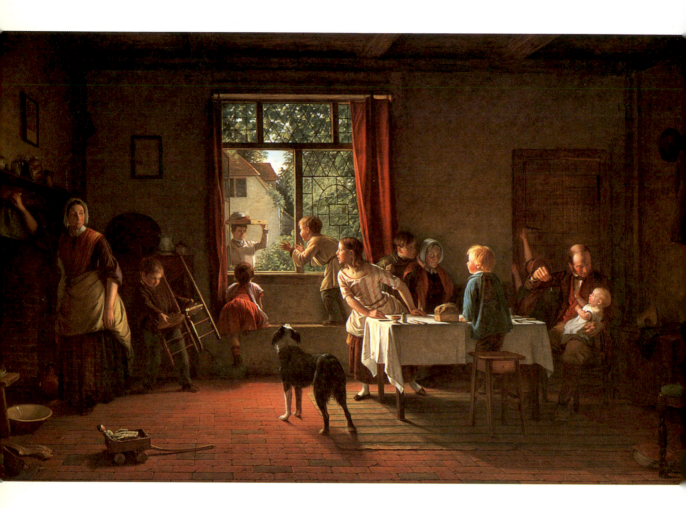

[5]
William Holman Hunt
The Light of the World, 1851–53
oil on canvas over panel

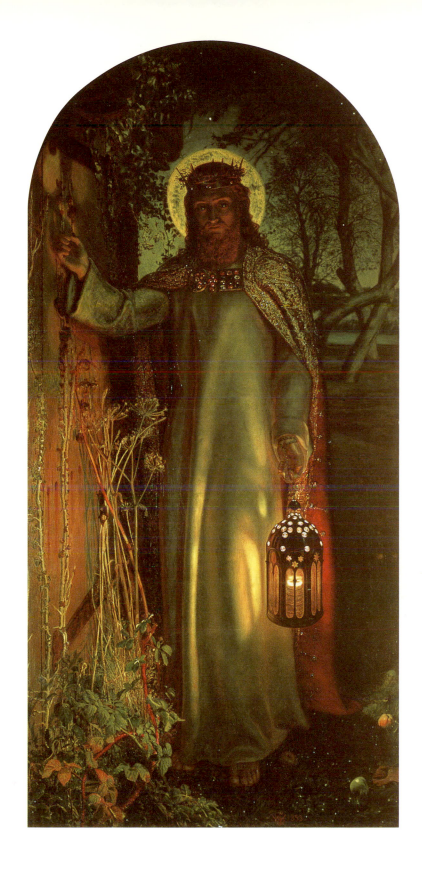

[6]
Ford Madox Brown
James Leathart, 1863–64
oil on canvas

[7] FACING PAGE
J. A. M. Whistler,
*The Gold Scab: Eruption in FRilthy
Lucre (The Creditor)*, 1879,
oil on canvas

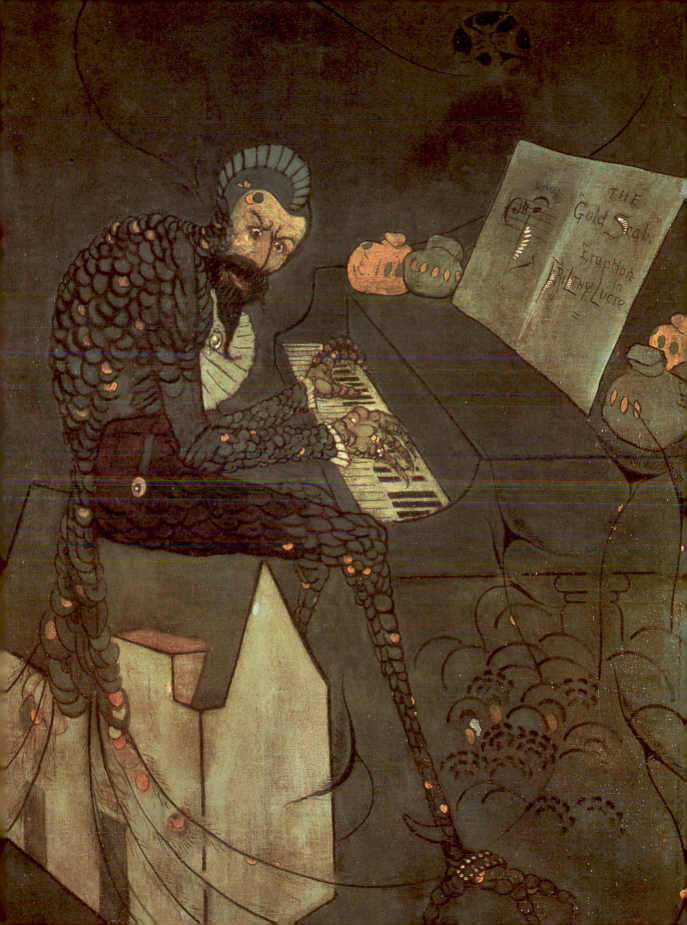

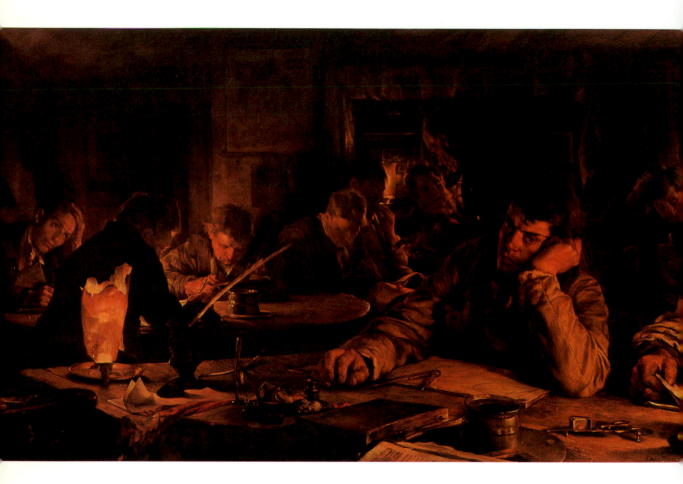

5 The Aesthetic movement: *l'art et l'argent*

The old order of society is breaking up and vanishing. New ideas, new relations,
new organizations, new principles of action, new beliefs, are constituting them-
selves. (James Baldwin, Young Men and Maidens [1871], p. 9)

Dissatisfaction with the ubiquitous mid-Victorian anecdotal sub-
ject was symptomatic of a wider climate of discontent. As author James
Baldwin attests, the fabric of belief was challenged by a run of new ideas,
principles, and relationships that threatened to rupture the foundations of
the Victorian citadel. Just when the middle class had finally achieved a sense
of identity and had successfully staked out claims to a cultural system of its
own, its accomplishments seemed to be impugned on all fronts. Baldwin's
recognition of the transformations occurring in society was, however, typi-
cally tardy due to the time lag characteristic of the novelist's craft.[1] The atti-
tudes to which he alludes had actually been introduced over a decade earlier.

Accuracy is important in locating the moment of this particular
shift in values, since it accounts for the speed with which the aesthetic dis-
position was embraced. It was less a matter of a gentle transition than an
epistemological break with the middle class's self-congratulatory ideology.
Therefore while Baldwin's reflective chronicle of change is correct, he sac-
rifices the urgency of the moment for the sake of the kind of synthesis that
Michel Foucault cautions against. Arguing that more can be learned by
preserving the integrity of disruptive past events than by integrating them
into cohesive stages, Foucault maintains that the task of the historian is
"to discover the limits of a process, the point of inflexion of a curve, the
inversion of a regulatory movement, the boundaries of an oscillation, the
threshold of a function, the instant at which a circular causality breaks
down."[2] When this strategy is applied to mid-Victorian culture, it reveals
that the middle class's questioning of its own orthodoxy was anything but
random.

Accepted systems of knowledge were challenged by a rash of revi-
sionist publications in the year 1859. Howard Mumford Jones signals the
appearance of John Stuart Mill's *On Liberty* as a "gateway into crisis."[3] If
Mill's political exegesis marked the gateway, Charles Darwin's *The Origin of*

267

Species opened the floodgates, not only to agnosticism and atheism, but also to a relativist critical model that was in antithesis to the earlier Victorian punctilious norm. Two further texts of 1859, Edward Fitzgerald's *Rubáiyát of Omar Khayyám* and Alfred Lord Tennyson's first four *Idylls of the King*, each, in different ways, legitimated sensuality and thus recognized the appeal of disengaged over instrumental reason. This tendency was counterbalanced by Matthew Arnold's *England and the Italian Question* and John Ruskin's *The Two Paths,* which tried to contain the artistic function by bringing it into alignment with the political and social changes that were afoot.[4] Nevertheless in the process of exposing society's ills, they revealed their affinity to the other publications of 1859. Viewed as a group, these texts were beacons of an incoming tide of dissatisfaction that was to erode the carefully constructed defenses of those mid-Victorian mandarins who insisted that theirs was an age of equipoise. The ramifications for visual culture were no less pressing.

Contemporary observers of the arts were quick to realize that the English School was at a watershed. In 1859, when J. Beavington Atkinson lamented in *Blackwood's Magazine* that art had reached "a turning-point …never was there a time when English art was so distracted," he confirmed the concern expressed by the *Art Journal* a year earlier, when it apprehensively announced: "we are living in an Art-crisis."[5] Even a cursory survey indicates that a number of artists were questioning their most fundamental precepts. Millais's son characterizes the dilemma faced by his father as "the struggle of 1859," calling it "the turning-point in the life of the painter."[6] Millais's solution, as we have seen, was to satisfy the demand for representations of adorable children and star-crossed lovers, leaving Holman Hunt to serve the religious end of the popular market. Rossetti also capitulated to commerce, but in a more subtle way. Because his recondite images did not lend themselves to the engraver's burin, he developed a more intimate strategy for marketing his art in his studio, which he transformed into an aesthetic boutique. But that resolution, as I shall demonstrate, was only reached after Rossetti recognized the need of his world-weary patrons for a place of retreat. First the artist had to come to terms with the quandary he faced in his own artmaking.

Significantly, it was in the year 1859 that Rossetti made a self-conscious and deliberate attempt to alter his artistic practice. This effort is evidenced by the painting he produced that year, *Bocca Baciata* (plate 47), which, as a visual text, must be numbered among the social and cultural

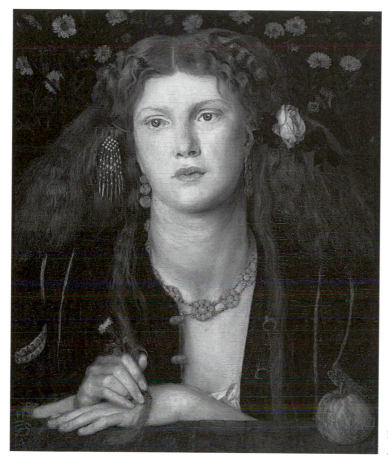

Plate 47. Dante Gabriel Rossetti,
Bocca Baciata, 1859, oil on panel

critiques of 1859. Distinct from Rossetti's earlier archaic imagery, this painting features a bejeweled strawberry-haired woman whose sensuous lips and *décolletage* radiate sexuality. Her alluring gaze draws the eye toward her, only to frustrate its entry into her space by the protective parapet on which she leans. Paradoxically, *Bocca Baciata* is inviting, but guarded. Staring beyond the viewer with unfocused eyes, she is both tantalizingly sensual and ethereally remote. This picture's artful strategies demand a more complex interplay between spectator and image than was required by Victorian narrative painting. *Bocca Baciata*'s conflicting set of codes introduced a level of ambiguity into English picturemaking that signals a Foucauldian "threshold" for art. It deviates from the received norm with its sensuous repertoire of forms that invite pleasurable contemplation unimpeded by narrative markers.

While Rossetti's alterations to the system of representation can be attributed to the avant-garde intellectual critiques of the same year, he was equally dependent on tradition: for the second time in his career he resolved his artistic dilemma by activating art's internal dialogue with the past. In modeling *Bocca Baciata*'s proportions after the beguiling courtesans of Pordenone and Palma Vecchio, two sixteenth-century Venetian painters whose sumptuousness excluded them from the "List of Immortals" he had concocted with Holman Hunt in their Pre-Raphaelite days, Rossetti demonstrated that his intention was not to sever all ties with the past, but to rephrase and reinvent – to look backward in order to move forward.[7] That he succeeded in invigorating the visual conventions governing painting is borne out by the response of his fellow professionals. Critic F. G. Stephens reflected, many years later, that Rossetti's picture was "one of the subtlest and most difficult pictures of our age."[8] Not having the advantage of historic distance, the artists and critics who first saw *Bocca Baciata* on Rossetti's easel in 1859 reacted in a more visceral way.

The colleagues that Rossetti invited to view the picture in his studio instantly remarked on its sexuality, even if they did not fully comprehend the extent to which he was testing the parameters of accepted norms. Poet Algernon Charles Swinburne deemed it "more stunning than can be decently expressed," an opinion that was seconded by painter Arthur Hughes when he described *Bocca Baciata* as "such a superb thing, so awfully lovely."[9] In a play on the English translation of its title, *A Mouth that has been Kissed*, which Rossetti had taken from Boccaccio's *Decameron*, Hughes went on to say that he was afraid its owner, painter George Price Boyce, would "kiss the dear thing's lips away."[10] Although William Holman Hunt did not share in this enthusiasm, he grudgingly admitted that others considered Rossetti's picture "a triumph of our School."[11] He may have been referring to James McNeill Whistler, who was so taken with the picture that he tried to arrange for its exhibition in Paris.[12] The painting's reception reveals that despite its modest 10 × 14 inch format, *Bocca Baciata* was recognized by Rossetti's fellow artists as a groundbreaking work.

Its impact on the Victorian public was to be far greater, however, because of its controversial challenge to the sacred axiom which held that it was the role of painting to edify. In her study of Victorian sexuality, Lynda Nead identifies "rigorous attention to morality and propriety" as traits which the English School of art proudly chose to be recognized by abroad.[13] Rossetti, in other words, thrust his dagger at the heart of nationalist rectitude

when he neglected to add a moral caveat to his picture. By placing Victorian love of instructive detail at the service of the viewer's visual luxuriation, Rossetti advocated an aesthetic disposition that bypassed English art's didactic function and shifted its focus from painting as dogmatic icon to viewer as sensual celebrant.

Holman Hunt was one of the first to comment negatively on this unorthodox aspect of the picture. Viewing it as a threat to common decency, the artist expressed his dismay to patron Thomas Combe. He wrote:

> It impresses me as very remarkable in power of execution – but still more remarkable for gross sensuality of a revolting kind, peculiar to foreign prints, that would scarcely pass our English Custom house from France even after the establishment of the most liberal condition of Free Trade. I would not speak so unreservedly of it were it not that I see Rossetti is advocating as a principle mere gratification of the eye and if any passion at all – the animal passion to be the aim of Art – for my part I disavow any sort of sympathy with such notion if Art could not do better service than dress up the worst vices in the garb only deserved by innocence and virtue.[14]

Hunt's tirade revolves around his contention that Rossetti's visual essay openly defied the received moralizing function of art, unlike his own exhibition piece of 1859, *The Finding of the Saviour in the Temple.* From his self-appointed position as guardian of morality for the English School, Hunt correctly perceived the long-range implications of Rossetti's new approach. The painting became the prototype for the Aesthetic movement's evocative images, introducing what Griselda Pollock describes as "a new regime of representation of woman on the axis of bourgeois realism and erotic fantasy."[15] Holman Hunt's concern about the imminence of an art form dedicated to "mere gratification of the eye," proved to be prophetic as Whistler, Burne-Jones, Albert Moore, and even George Watts and Frederic Leighton began to work in a more provocative mode. Analogous to the revisionist critiques enunciated in the texts of 1859, *Bocca Baciata* expressed intentions which would challenge art's subservience to ideology.

Whistler, whose timely arrival in London in 1859 acted as a catalyst in this process, summarized the purpose of his art as "having no desire to teach – seeking and finding the beautiful in all conditions and in all times."[16] In privileging the aesthetic over the cognitive function, he endorsed Rossetti's rejection of normative standards. Swinburne concurred when he insisted that art was not the "handmaid of religion, exponent of

duty, servant of fact, pioneer of morality."[17] Implicit in the poet's oft-quoted maxim is the wish to free the pictorial arts from the constraints of social ritual. Swinburne recognized a parallel intent in the paintings of Rossetti, Whistler, Albert Moore, Watts, and Leighton, which he codified as representing the "worship of beauty," in contrast to mainstream art's utilitarian purpose.[18] Philosopher Monroe Beardsley finds that this attitude is the essence of the aesthetic experience which he defines as "a feeling of freedom from concerns about matters outside the object."[19] While the mid-Victorians prized art, they still looked to it to explicate their position in society. Its "use-value" remained an important aspect of its appreciation, in contrast to the aesthetic point of view which reveled in the object itself.

It was Walter Pater who developed Aestheticism into a reception theory based on individual gratification. He attested that a true aesthetic critic should regard "all works of art, and the fairer forms of nature and human life, as powers or forces producing pleasurable sensations."[20] By naming pleasure as a central component in the appreciation of art, Pater established an alternative theoretical foundation to hegemonic moralizing. It is the acceptance of the pleasure principle that distinguishes patrons of the Aesthetic movement from their mid-Victorian counterparts. While both groups granted art an equally exalted place in daily life, one looked to it to confirm the grand narratives of Victorian society, while the other specifically avoided the dogma-riddled norm.

That is not to say that every Aesthetic patron expected only sybaritic satisfaction from art. For the majority, pleasure was interpreted in its broadest sense: a painting was thus categorized if it induced reflection, evoked poetic feeling, or was visually appealing. While some art collectors abandoned themselves to sensual gratification, most rationalized their enjoyment by insisting that pleasure was only one of the two primary goals of art, the other being what critic Francis Palgrave termed, the "higher education of the soul."[21] In emphasizing the spirituality of art, these collectors resembled those members of the middle class described by Peter Bailey who "sought a rationale which would relieve them of the need to apologise for their pleasures, yet still keep them within the bounds of moral fitness."[22] To them a pleasurable response was acceptable as long as it encompassed the intellectual and the spiritual, as well as the sensory. To that end, artists also produced paintings devoid of overt sexuality. Burne-Jones's brooding knights and George Watts's melancholic fantasies provided a different type of solace which invited the pleasure of sadness shared.

The attitude of critical self-evaluation expressed in the texts of 1859 had substantial reverberations on the individual level. Many successful businessmen began to realize that progress was an unsatisfactory *spiritus rector*. Peter Gay notes that "in the midst of material progress and political successes, the middle classes were apprehensive over social status, moral imperatives, religious traditions, familial conflicts, and, summing them all up, cultural change."[23] In attempting to fill the void left by their displaced values, more and more bourgeois businessmen turned inward, to the contemplation of well-crafted images in the privacy of their homes. Instead of mirroring the world in the manner of William Frith or George Hicks, Aesthetic artists offered their clients a means of escaping it. "The pure aesthetic," according to Bourdieu, "may take the form of moral agnosticism" or "of an aestheticism which presents the aesthetic disposition as a universally valid principle and takes the bourgeois denial of the social world to its limit."[24] While the merchants and industrialists who sought out the art of the Aesthetic movement cannot be credited with partaking of the extremist Kantian "pure aesthetic" which Bourdieu names, they, however, moved in that direction when they conceived of their art collections as contemplative retreats from the world of Mammon. Prompted by personal or professional disillusionment, these men chose to internalize their angst rather than to defy those in power. Their struggle to balance the weight of their cultural conditioning against their individual needs marks them as early examples of the anxiety-ridden modern businessman.

To foster the art which I have described was to admit that life was problematic, that the pull between economics and the spirit left one in a perennial state of tension, and that it was a relief to lose oneself in aesthetic contemplation, even if it did not permanently resolve the dilemma. This tug-of-war between action and contemplation, morality and self-indulgence, and public and private characterized the fractured subjectivities of Aesthetic patrons. No longer as resolute or as committed to the Victorian virtues as were their fathers or grandfathers, they sought an alternative lifestyle.

To achieve this, Aesthetic patrons conceived of their collections as places of retreat and reverie. Commenting on this pattern of behavior, Walter Benjamin maintains that collectors fantasize that they are in a better world.[25] Benjamin's musings accurately describe the havens created by James Leathart, William Graham, Frederick Leyland, George Rae, and a host of other Aesthetic patrons. As successful as these businessmen were in

the eyes of the world, each seemed to be troubled in some respect, whether by personal disappointment, financial reverses, or by a more general malaise that was to become increasingly common in the modern industrial age.

William Graham, by all accounts, had reaped life's riches: wealth, political power, and a devoted family. Yet Rossetti was perplexed by the dissatisfaction he detected in Graham's character, observing: "His state of health is melancholy, and curious in a man surrounded by an exceptionally loving and gracious family: *Taedium vitae* appears to be the main evil."[26] No longer content with what life had to offer, men like Graham looked to art to fill the void.

Another instance is provided by James Leathart, who embarked on his career as a patron of Aesthetic artists right on cue, in the year 1859. There are few clues in the portrait Ford Madox Brown painted of the Newcastle lead manufacturer in 1863–64 (plate 48) to indicate what led him to spearhead the taste for Aesthetic movement art in his community. He appears to be the stereotypical Victorian businessman: somber, observant, and dispassionate. Visually, his commitment to these stalwart traits is reinforced by the scenes which flank his image in Brown's portrait. Through the window on the left are the leadworks he managed at St. Anthony's-on-Tyne and, on the right, is a painting extempore, a framed fragment of Brown's *Work*.[27] The picture-within-the-picture's importance as a repository of values is reinforced by its position in the portrait – it balances the window view onto Leathart's actual place of work. Together, the two images function like the wings of a triptych in elaborating the sitter's character. These visual directives would have us conclude that Leathart was dedicated to the Victorian principles of hard work and technological progress. While that assessment may be true, it does not explain why he designed his home as a retreat from those very values or why so many Novocastrian businessmen followed his lead.

That there was another side to Leathart's character is disclosed by a studio photograph taken at approximately the same time as Brown painted his portrait (plate 49).[28] It reveals a more vulnerable individual, one whose gaze is less assertive, whose thinning hairline is more apparent, and whose clenched right fist exposes an inner tension. The cause of Leathart's worries can be unraveled from the facts of his biography: he had suffered a series of setbacks in his professional life and was grieving over the death of a child.[29] It was disappointment and loss, then, which caused him to insulate himself from the disturbing realities of everyday life by turning his

Plate 48. Ford Madox Brown, *James Leathart*, 1863–64, oil on canvas

Plate 49. *James Leathart*, *c.* 1860, studio photograph

home into a place where he could retrench and recoup his energy. The Newcastle lead manufacturer paid close attention to Madox Brown, who advised him that in order to achieve happiness "much depends upon getting a house and adorning of a beautiful house."[30] Leathart accordingly created an art-filled panacea at Bracken Dene, "North of the smoky capital on the Tyne."[31] His dimly lit drawing room (plate 50) showcased the blue and white Japanese porcelain and inlaid furniture favored by Aesthetic movement followers as well as paintings by Brown, Rossetti, and Burne-Jones rendered in their most somber mode. Leathart's well-appointed inner sanctum was both a denial and an acceptance of his station in life: its elegance repudiated the grim factory where he spent his working days, at the same time it revealed his affiliation with the intellectual debates of his generation which encouraged retrenchment and introspection.

Leathart's life is particularly illuminating because of his attempts to be all things to all people in both the public and the private spheres: bene-volent employer, civic patron of the arts, paterfamilias, and connoisseur of

Plate 50. Drawing Room, Bracken Dene, Gateshead, residence of
James Leathart, photograph

beauty. I have elsewhere described his efforts in bringing contemporary art
to Newcastle and his success in converting local businessmen such as
Alexander Stevenson, Sir William Armstrong, Jacob Burnett, Charles
Mitchell, and Sir Isaac Lowthian Bell to its cause.[32] Lest I create the impres-
sion that Aestheticism was borne out of middle-class malaise and served the
needs of only those who were disenchanted with their lot, I want to distin-
guish between its leaders and its followers. The reasons that impelled
patrons like Leathart to create contemplative interiors were not necessarily
embraced by the members of the commercial élite who emulated them.

276

Aesthetic collectors, as opposed to patrons, typically were not privy to the thoughts of the artists and architects who established the movement. To these imitators, the Aesthetic interior was another route to establishing their middle-class identity and, by extension in rapidly growing cities like Newcastle, the hegemonic right of their class to control cultural life. Nineteenth-century culture, as we have seen, was significantly changed by the fluid middle-class ethic. It behooved community leaders to stay abreast of the latest trends in the arts. Consequently, while many collectors of Royal Academy art added two or three representatives of Aestheticism to the walls of their homes, they were often more interested in attaining status than enlightenment.

Progress, in England, since the outset of the Victorian period, had been tantamount to material abundance, which in turn depended on visible consumption and display. Thus Aestheticism's well-crafted and expensive-looking objects served as easily identifiable markers for the socially mobile. "Goods," as Simon Bronner contends, contain the potential to act as "mediators and conveyers of cultural values, human emotions, and social priorities."[33] While he is referring to the situation in late-nineteenth-century America, England's head start in industrialization allowed it to experience this phenomenon much earlier.

The palatial taste associated with the Aesthetic movement was sanctioned, even encouraged, by the eighteenth-century discourse on luxury. Growing in sophistication with each passing generation, theories of consumption were articulated to suit every need. In its mid-Victorian manifestation, the justification of luxury increasingly focused on private rather than public well-being. Writing a chapter on individuality in 1859, John Stuart Mill argued that luxury was an agent of egalitarianism which allowed each person the opportunity to shape his or her own character.[34] While Mill assumed that more highly developed individuals would produce a stronger citizenry, his argument was easily coopted by advocates of self-gratification. Spending and the display of costly goods were interpreted by many as ends in themselves, resulting in a "commodity aesthetic" which held out the promise of personal satisfaction.[35] Luxury items were construed as magical entities which empowered their owners. Fitz-James Stephen reported in 1860 that this transformation was becoming increasingly widespread, noting: "Probably no nation was ever so rich, and it would be hard to mention one in which riches have had more power to confer everything which human nature desires, or in which that power has been more thoroughly recognized, or more devoutly worshiped."[36] Stephen cautioned, however,

that riches should not be abused. His was not a repetition of earlier warnings sounded by David Hume and William Thackeray, who condemned aristocratic excesses.[37] Stephen's remarks were addressed to the middle-class élite, whom he advised to balance its love of comfort with the pursuit of knowledge (p. 353). The ownership of luxury goods, that is to say, was not a self-indulgence as long as one's intellectual development was maintained. According to this line of reasoning, patrons of the Aesthetic movement were encouraged to display their wealth in personalized shrines to beauty as tangible evidence of transcendent elevation of thought.

Support for this point of view was offered by representatives of traditional religion. The Reverend William Loftie, an Anglican chaplain, introduced a moral imperative into the discourse on luxury in his *A Plea for Art in the House*. Acknowledging that "there seems to be something paradoxical in talking of the cultivation of taste as a moral duty," Loftie defensively reasoned that, "if we look on the home here as the prototype for the home hereafter, we may see reasons for making it a sacred thing, beautiful and pleasant, as, indeed, we have no hesitation about making our churches."[38] Ever supple, Protestant pietism was adapted to exonerate rich businessmen from guilt.

Endorsed by the persuasive forces of religious, economic, and philosophical argument, Aestheticism rapidly spread. It was founded by middle-class architects, designers, painters, and critics who were secure in the knowledge that their social group was no longer emerging, but had finally arrived. Just as mid-Victorian magnates demonstrated the growing confidence of their class in the wider political and economic arenas, participants in the Aesthetic movement likewise displayed a keen sense of their social identity. Backed by the weight of its own tradition, the middle class had gained more expertise in aesthetic matters. The English bourgeoisie, as Peter Gay concludes, "could now claim old luxuries as necessities to which their place in society entitled them: some hours of leisure and relaxation, occasional travel, and above all the blessings of domestic comfort."[39] Collectively, its members now possessed a cultural capital that boasted the patina of age.

Many of the thirty-odd individuals whose names occur most frequently in the archives of Aestheticism were descended from middle-class families that had been well-off for more than three generations.[40] Prior to emigrating to England in 1815, the Ionides clan had owned property in Greece. Other family fortunes originated throughout England: Thomas

Eustace Smith, who benefited from the efforts of previous generations of Smiths in shipbuilding, was the Newcastle counterpart of men such as Londoner William Alexander and Liverpudlian John Bibby, whose money also arose from the maritime world. Two self-made men succeeded in becoming Aesthetic trendsetters: Newcastle's James Leathart and Liverpool's Frederick Leyland. The influence they had on the arts in their respective communities is no doubt responsible for perpetuating the myth of modernism's philistine base of support. Just as Leathart interested a group of local businessmen in Aestheticism, so did Leyland's art-filled office and homes convert a number of his associates, including his partner John Bibby, his lawyer Sir John Gray Hill, and his shipbuilding colleague William Imrie.

This occupational listing indicates that the sources of wealth of Aesthetic patrons and collectors were similar to those of the mid-Victorians (manufacturing, merchandising, commerce, and the professions); however, there were fewer diversified capitalists who operated on an international scale among this group. Without corporate distractions, these patrons enjoyed the luxury of spending more time in the pursuit of art. What is also unusual among this group is the number of men who became collectors because of their professional associations with artists: publisher F. S. Ellis, photographer Clarence Fry, notary Henry Virtue Tebbs, and lawyers James Anderson Rose and Leonard Rowe Valpy were all drawn into the fold of Aestheticism by their artist clients.

Another distinctive feature of Aesthetic collectors is the high number who were amateur artists themselves or whose close family members were skilled at some form of the arts and crafts, such as embroidery or bookbinding.[41] This information should not be surprising since the creation of an aesthetically pleasing environment was in itself a work of art, one that called the creative talents into play. Constance Rothschild, wife of amateur photographer Cyril Flower, reminisced that, "wherever we chose to live he added and built, to accommodate furniture, statuary, pictures and books, of which we had a goodly collection."[42] Because the principles of the Aesthetic movement allowed the viewer to play an instrumental role, it attracted a more artistic audience.

The promise of active participation quickly led Aestheticism across class lines. The reappearance of the aristocratic patron at the moment when art began to emphasize its internal values once again would seem to suggest that this class was instrumental in freeing English painting from the

fetters of anecdote. After all, the pairing of connoisseurship with courtly contemplation has historically signaled the presence of a circle of leisured experts. Moreover there is a mystique of creativity surrounding art forms which emphasize their own hermeticism and exclusivity.[43] We have already witnessed an instance of this among Birmingham's early-Victorian patrons whose proximity to aristocratic collections sparked a sensitivity to variable brushwork and nuances of color. Undeniably, the Aesthetic movement's indulgences made it more appealing than didactic art to those trained in genteel modes of appreciation, but instead of allowing their social superiors to appropriate Aestheticism for themselves, its practitioners drew their high-born clients into their cultural web. The return of the prodigal aristocratic son to the fold of English art should be viewed as a "middle-class" embrace rather than the reverse.

Both George Howard, who was to become the ninth Earl of Carlisle, and the Earl of Wharncliffe altered the practice of artist-in-residence to suit the painters and craftsmen who executed decorative schemes for their palatial homes. Howard, who was an amateur artist, sought out Burne-Jones and William Morris as his mentors, while Wharncliffe turned to Millais, Edward Poynter, and Walter Crane for advice.[44] Burne-Jones and Morris were frequent house guests at Castle Howard and Naworth Castle, where they were treated with every courtesy. Fortified by their public-school educations and exposure to the high and mighty at Oxford University, neither artist recorded any feelings of insecurity on these occasions. Rather it was Rosalind Howard who worried that Morris, due to his leftist leanings, might find their lifestyle too patrician.[45] Similarly, when Walter Crane went to stay at Wortley Hall to make sketches for the billiard room, Lord Wharncliffe did not relegate him to the servants' quarters, but included him in shooting parties, picnics, and card playing.[46] Even though Crane, like Morris, was on his way to becoming a dedicated socialist, he found nothing to fault in his aristocratic host. Artists had progressed far enough along the social and professional scales to insure their independence from aristocratic servitude.

The same can be said for middle-class patrons, even those who appeared to have crossed over the upper-class line. William Graham, for instance, followed the élite social calendar when he wintered in London, summered on the Continent, and spent his autumns in Scotland. Educated in private schools and at Glasgow University, Graham spent more time pursuing an ideal of civic virtue after he was elected to Parliament, in 1866, than at his family's third-generation merchant house.[47] His appointment as

trustee of the National Gallery in recognition of the knowledge signaled by his collection of Old Masters would seem to confirm his capitulation to the "aristocratic embrace." Graham, however, remained staunchly middle class in his refusal to recognize the superiority of the dispassionate eye of the cognoscenti. "He was profoundly suspicious of the connoisseur," observes Oliver Garnett, who also notes that Graham complained about one such expert, finding him "more learned than sympathetic."[48] Kantian aesthetic distance was not Graham's goal. Quite the reverse: he confided that he expected his art collection to fulfill him, "at a time when most things pall and weary me."[49] Graham looked to art to diminish the conflicts and disappointments he experienced in his life.

Considered a rising star when he was first elected to Parliament in 1866, Graham's maiden speech was enthusiastically reported in the *Daily Telegraph*. His second address, on the subject of education, was not nearly as well received. The Glaswegian journal *The Bailie* asserted, on 15 January 1873, that "the House does not like being preached at, hates being lectured by instructors of doubtful competency." It went on to note Graham's controversial position within his own constituency, where his financial involvement with Indian cotton and Portuguese sherry caused him to be perceived as "a capitalist" and as "the *bête noir* of the working man." While Graham was attempting to rally from this attack, he faced another more grievous setback when his favorite son died from typhoid.[50] Resigning from Parliament, he turned to a combination of art and religion to help him deal with his public and personal losses.

Graham confided in Rossetti that "it always has seemed to me as if art were chiefly precious as it shadows out to us and echoes in our hearts the music of that fair and sweet and stainless world unseen."[51] Although Graham's statement seems to be a rationalization of art's delights in terms that assuaged his Protestant conscience, he contradicted himself on other occasions, in keeping with the rapidity of changing mores at this time. His undisguised delight in more sensorial art was apparent on the occasion when he smuggled a painting of a nude woman into his home and, hoping to avoid his wife's discerning gaze, disingenuously renamed it *John the Baptist* for her benefit.[52] A friend of Rossetti's charged him with a "letch for tantalisation," an opinion confirmed by Burne-Jones when he recollected: "When I first knew him I used to hide some pictures from him – pictures where people were naked – but I soon found he liked them best of all."[53] As contradictory as Graham's fusion of Eros and Thanatos appears to be, it was

a common occurrence among Aesthetic patrons who expected art to satisfy their most compelling needs.

Ensconced in their artful sanctuaries away from the prying eyes of society, businessmen–collectors were free to unleash their most intimate fantasies. Graham, for one, was apparently so stirred by a painting by Burne-Jones that he went up to it and kissed it.[54] Men like Graham who experienced a void or a "lack" in their lives, transformed the art they commissioned for their private interiors into fetish objects when they invested it with magical properties. Muensterberger observes that one solution for dealing with anxiety and loss is to allow objects to "become animatized like amulets and fetishes of preliterate humankind or the holy relics of the religionist."[55] Among Aesthetic patrons, this led to an eroto-religious worship of art centered around the display of sensuous paintings in sanctuarylike rooms. Photographer Clarence Fry advised Rossetti that he intended to hang the artist's voluptuous *Astarte Syriaca* in his "sanctum," while banker George Rae enshrined the twenty-one Rossettis he owned in a richly decorated room, segregated from the more traditional landscapes in his collection.[56] Rossetti, for his part, satisfied his clients' need for emotional stimulation by continuing the exploration of sensuality he had begun in *Bocca Baciata*.

Both Rae and his young second wife Julia greeted the newest arrival to their collection in 1866, Rossetti's *The Beloved* (plate 51), with the intensely personal response that is characteristic of those Aesthetic collectors who viewed their possessions as fetishistic provocations to desire. A depiction of the Bride of the Canticles from the Song of Solomon attended by two bridesmaids and an exotic black page, the painting combines a religiously impeccable source with a compelling emphasis on physical beauty. The Raes responded to the picture with the mixture of reverence and erotic excitement that was shared by Rossetti's most dedicated patrons. Rae enthusiastically reported that, for him, "The same sort of electric shock of beauty with which the picture strikes one at first sight is revived fresh and fresh everytime."[57] He then described his wife's involvement with the painting, observing that: "It is my belief that she spends half the day before the picture as certain devout Catholic ladies had used to do before their favourite shrines in the days of old." One would have to search diligently to find a plainer enactment of the fetishistic worship of art in the mid-nineteenth century than the spectacle of Julia Rae as the nubile acolyte tending the shrine of eroticism for the benefit of her older rich husband. Although

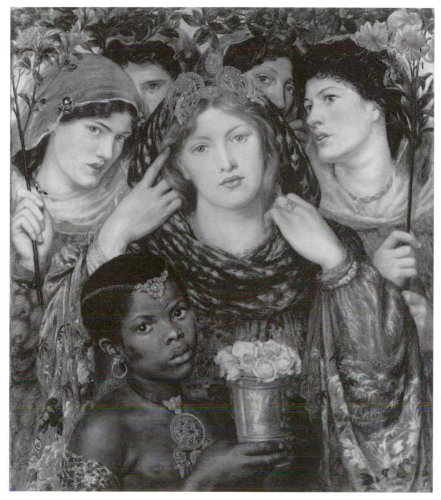

Plate 51. Dante Gabriel Rossetti,
The Beloved, 1865–66, oil on canvas

the physical *frisson* that the Raes experienced from Rossetti's art would be surpassed by *fin-de-siècle* decadents such as the fictional Dorian Gray and the Count des Esseintes, the psychopathology was set into motion during the Aesthetic movement in the 1860s.

Later French critics were startled to discover that these qualities had surfaced at such an early date in England. Théodore Duret, who crossed the channel to view Rossetti's retrospective exhibition in 1883, commended him for achieving "a degree of langor and mysticism which is called 'aesthetic' and is in absolute contrast with English utilitarian and puritanical tendencies," while Gabriel Mourey described his paintings as "spiritual perfumes that enthrall the soul."[58] English critics, in looking back at the

paintings of the Aesthetic movement, avoided commenting on their sexuality, but viewed them instead as receptacles for dislocated spiritual values. Frederick Myers, a close friend of patron Cyril Flower, employed the language of the French Symbolists when he credited Rossetti with producing "the sacred pictures of a new religion."[59] Roger Fry confirmed this interpretation from an early-twentieth-century vantage point when he described the later productions of the Pre-Raphaelites as representing a highly Protestant form of religion.[60] The theories these critics articulated were as much an expression of their own beliefs as they were chronicles of the trend that was initiated in the inner sanctums of such devotees as George and Julia Rae and ministered to by Aesthetic artists.

The Raes, however, were not an isolated case in England. Although Frederick Leyland made no self-revelatory remarks to compare with theirs, his actions indicate that he was a participant in the fetishistic approach to art. Leyland transformed his London residence at 49 Prince's Gate into a temple of Aestheticism, from its grand staircase and hall inset with lacquered panels painted by Whistler in the Japanese manner, to its suites of rooms dedicated to the paintings of Burne-Jones, Albert Moore, and Rossetti.

Leyland did not try to disguise the fact that he venerated art when he metamorphosed his home into a secular shrine. Like the speaker in Tennyson's "Palace of Art," he constructed a sumptuous "pleasure-house" with rooms specifically designed as mood chambers to induce meditation. The first floor featured Whistler's controversial Peacock Room, while the entire second floor was composed of three richly embellished interconnecting rooms separated by screens which, when removed, formed a single 94 foot long salon. The central section was dominated by seven works by Burne-Jones: *The Four Seasons*, *Day and Night*, and *Venus's Mirror*. The intended effect was not lost on American critic Theodore Child when he described these pictures as "poetic conceptions which seem to float in an atmosphere of beauty that fills the spectator with a sort of religious awe, and carries him away from coarse materialism into a region of tenderly ecstatic revery."[61] This aura of transcendence lay at the heart of Aestheticism's aims: art's role was to transport the weary businessman above and beyond his daily strife into a more pleasurably satisfying world. Child's blending of the sacred and the profane with the passionate and the spiritual confirms that Leyland had achieved an ambience in his home similar to that of William Graham and George Rae.

Plate 52. Drawing room, 49 Prince's Gate, London, residence of Frederick Richards Leyland, 1892, photograph by Bedford Lemere

The sanctification of art is even more apparent in the arrangement of Leyland's drawing room (plate 52). Nestled next to the Burne-Jones salon, this glass-roofed extension overlooking Exhibition Road was devoted primarily to the art of Rossetti. The placement and design of the paintings produced a sanctuarial atmosphere: the stillness of the single female figures featured on each canvas creates an iconic intensity, while the arched frame and predella of Rossetti's *Blessed Damozel*, which hangs in the center of the left wall, resemble Renaissance altarpieces. Yet that association is mitigated by its erotically charged central figure, who yearns for her earthly lover. In this painting we recognize another of Rossetti's attempts to seduce the senses. Theodore Child, once again, perceived that the scene was set for the worship of art when he described the room as "the shrine of some of the

most completely beautiful productions of modern English art" (p. 84). The decor of 49 Prince's Gate was intended to fulfill Leyland's affective needs and because money was no object, his efforts to escape the tyranny of loneliness, frustration, and despair knew no bounds.

Leyland's is an authentic rags-to-riches story, unlike that of those Victorian magnates who exaggerated their cleverness by denying their early advantages. While portions of the Leyland story may be apocryphal, such as the claim that his mother was forced to sell pies on the streets of Liverpool after his father abandoned her, it is true that Leyland received a tuition-free education as a student at the Liverpool Institute, which was that city's equivalent to the Mechanics' Institutes.[62] It can also be verified that his father worked as a bookkeeper for shipowners Bibby & Sons, the company which eventually took on the young Leyland as an apprentice. From that point on, his rise was meteoric: he was made manager of the concern in the 1860s and less than ten years later bought out his employers in a manner that today would be classified as a hostile takeover.[63] Boasting to Rossetti, whom he considered his closest friend, Leyland detailed his successful bid for power in 1872. He crowed:

> I have been most anxious and worried these last few months in disputes with my partners as to what is to be done on the approaching termination of our partnership on the 31st December. However, I have at last carried my point and got quietly rid of them and they leave me in full possession on the 1st January when I shall hoist my own flag and carry on the business in my own name . . . I have succeeded in dictating my own terms.[64]

While Leyland was obviously pleased about attaining his goal, his ruthless tactics earned him a good deal of enmity. Charles Augustus Howell, Ruskin's former secretary who later represented Rossetti as a freelance art agent, described the animosity that was felt toward Leyland in Liverpool. He reported: "Leyland's Liverpool enemies are so numerous and loud that he seems to hurry through the streets, and stands there almost hated . . . It seems that over night some one posted up the office with placards – 'Skunks, and robbers kick over / the ladder up which they climb.'"[65]

A good deal of the tension Leyland endured is evident in the portrait Whistler painted of him during the year of his partnership struggles which the artist appropriately titled *Arrangement in Black* (plate 53). Isolated against a dark ground without benefit of distracting accouterments, the shipowner's rigid stance and taut facial muscles are indicators of emotional

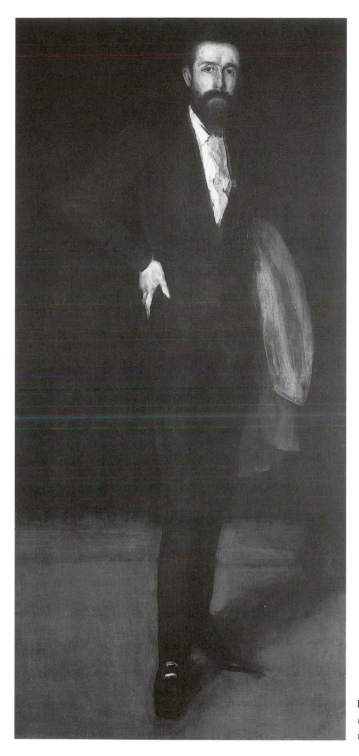

Plate 53. J. A. M. Whistler, *Arrangement in Black: Portrait of Frederick Leyland,* 1870–73, oil on canvas

stress. The authority of his elegant pose is belied by the clawlike position of his hand and by his troubled gaze. Each sign points to Leyland's struggle to ward off the negative forces in his life that, like the painting's dark background, threatened to engulf him.

I have tried to show how the main themes of this book – social mobility, the shifting nature of middle-class identity, the constantly changing values ascribed to art – have coalesced in the lives of certain individuals in a way that allows us to test the validity of abstract theorizing. By replaying the action in slow motion and "freeze-framing" the parts played by these characters in the script that was written for them, we can imagine ourselves in their position and decide whether or not the plot is believable. Frederick Leyland is another of those well-situated individuals whose lives are like dramalogues played out on a public stage. In analyzing his emotional and intellectual make-up, I am attempting to achieve what Chartier claims can be done by observing "how an 'ordinary' man appropriates for himself and in his own way" the beliefs and ideas of any given time.[66] Viewed from the standpoint of the Victorian progressive ideal, Leyland was an ordinary man who transformed himself into a Smilesian hero: millionaire shipowner, founding chairman of the National Telephone Company, and a director of one of England's largest electrical firms. Knowing only these facts about his life, it would be easy to assume that he collected art to advertise his wealth and cultural acuity. On an emotional level, however, Leyland's equilibrium was disturbed by memories of his hard-scrabble background, unhappy marriage and divorce, and the sudden death of an adored child.[67] Leyland's biography, in other words, modifies any deterministic assumptions we might make about his relationship to art.

Leyland's motivations for worshiping art are easier to fathom than those of most Victorians because he made no pretense about being a churchgoer: his only recorded involvement in the life of the spirit was his attendance at séances in the company of Rossetti, Whistler, and a few others who were disenchanted with traditional religion.[68] Joseph Kestner has noted the high incidence of agnosticism among Aesthetic painters, naming Leighton, Alma-Tadema, and G. F. Watts.[69] Leyland shared this spirit of disillusionment: he confessed, at one stage, that to him, "everything in life seemed so dull and hopeless."[70] Even though these words were written when he was at the pinnacle of worldly success, he lacked peace of mind.

Patrons such as Leyland who hoped to find permanent psychic release in Aestheticism's promise of sensual and spiritual satisfaction were

destined to be disappointed. As Muensterberger reasons, "the objects' grip on their owner can be described and understood only in terms of an emotional experience that appears to demand a more or less perpetual supply. The objects thus represent but a modicum of fulfillment" (p. 136). No matter how much magic collectors imbued their possessions with, they were ultimately turned back on themselves and their ability to sustain the illusion. It is not the interior of the private gallery that generates release, but, as Susan Stewart argues, it is the interior of the self.[71] Aestheticism, however, was driven by the belief that objects provided solace. This conviction goes a long way in explaining why industrious men such as Leathart, Graham, and Leyland invested so much time in designing the "perfect" interior.

Because Aesthetic patrons perceived their private living spaces as extensions of themselves, men increasingly intervened in the female domestic sphere. Ironically the traditional roles of man as collector and woman as interior designer were conflated at the moment when women finally achieved recognition as patrons in their own right. Increased prosperity led to a rise in the number of servants after mid-century, which, in turn, endowed homemakers with even more free time.[72] Since women were barred from taking an active role in public life, an acceptable way for them to spend this time was in beautifying the home. I want to take this line of thought one step further by suggesting that increased leisure gave them more time to decipher the complex cultural codes of the Aesthetic movement. Once the burden of aiding their families to attain financial security had been lifted, these wives were free to concentrate on more aesthetic matters. While men, with few exceptions, carried on negotiations with artists and dealers in the early-Victorian period, after mid-century women's expertise finally found an appropriate outlet in the decorative emphasis of the Aesthetic movement. It was a small leap from the discourse of domesticity to the cult of beauty which also centered on the home as an ideal haven.

It stands to reason that once women became creatively involved in the decorative aspects of the Aesthetic movement, they went on to make recommendations regarding the pictures which entered their private spheres. Women, though, should not be perceived as shadowy background figures, working behind the scenes as a way of filling their spare time. Possessing the requisite expertise, within a single generation they sprang forth as active rather than passive participants in culture. Burne-Jones, for instance, frequently adapted his designs to suit the embroidery needles of women such as Aglaia Coronio and Mrs. William Turner, who enthusiastically

applied these traditional skills toward the beautification of their personal environments. But in addition to demonstrating their home-based talents, women were increasingly crossing the threshold of the private sphere and venturing into the public marketplace.

Eleanor Tong Coltart was the primary collector in her household. Widowed by Jonathan Tong, she married William Coltart, who set out to please her by buying back her favorite pictures from the estate of her first husband. We do not know whether she was responsible for selecting these objects in the first place. Former Guildhall director A. G. Temple implies in his memoir that Eleanor Coltart was an habituée of artists' studios from an early age. He recollects that she was "in and out of the studios of the notable pre-Raphaelite painters in her young days, she was one of them, and absorbed in their beautiful and poetic interpretations in art."[73] This tantalizing description raises the possibility that she was an artist's model. Since the only surviving photograph of Eleanor Coltart (plate 54) was taken in middle age, it is difficult to relate this petite woman to the winsome figures in Pre-Raphaelite compositions. Nor do the few documents in the possession of Eleanor Coltart's descendants reveal her maiden name.[74] However the catalogue of the posthumous sale of her collection confirms that she was on close terms with several artists: Val Prinsep inscribed his portrait of her with the dedication, "To My Friend," while she, in turn, described artist Thomas Armstrong as her "intimate friend."[75] In addition to these close ties with artists, Eleanor Coltart matches the profile of the typical patron of the Aesthetic movement in the time and energy she expended on the beautification of her home, which was adorned with Old Nankin blue and white porcelain and decorative wall schemes by Thomas Armstrong.[76] Beyond that domestic accomplishment, it was she who initiated her second husband in the protocols of art collecting, leading him to add purchases from Madox Brown and Albert Moore to her existing collection of paintings by Burne-Jones, Rossetti, and Simeon Solomon. Having waited twenty-five years to marry her, William Coltart denied her nothing.

It is an intriguing psychological fact that male patrons who embarked on second marriages or May–December unions seemed more willing to accommodate their wives' opinions than the average collector. William Graham considered the second wife of mid-Victorian patron Samuel Mendel "more prononcée in her views about art than her husband, [she] has a very decided opinion of her own and influences him very much."[77] The scenario is repeated in Rossetti's correspondence with George Rae, who

communicated his young wife's reservations about the appropriateness of certain accessories in paintings they had commissioned.[78] Anxious to keep on the good side of his patron, Rossetti obligingly removed the offending details. Newcastle chemical broker Alexander Stevenson was also keen to please his much younger wife, the widowed amateur artist Alice Knothe Kewney. Even though they had only one child, Stevenson employed eight servants, including a lady's maid for his wife.[79] Alice Stevenson was thus guaranteed the leisure to produce paintings for local exhibitions and to oversee the decoration of their Aesthetically correct homes in Northumbria and Scotland.

While the desire to please a new or younger spouse contributed to the belated welcome women received in the world of collecting, one must also consider the part played by economics in the dynamics of these relationships. As widows, Eleanor Coltart and Alice Stevenson brought their own capital into their marriages and therefore felt entitled to have a say in how it was spent. Nor is it a coincidence that the two most confident Aesthetic women patrons, Aglaia Coronio and Eustacia Smith, had inherited fortunes of their own. Both were also advantaged in coming from families that believed in financial independence for women. Aglaia Ionides Coronio was the granddaughter of patron Constantine Alexander Ionides, who maintained that only women should inherit money, arguing that "dead men's money" was a curse because it discouraged initiative in males.[80] Financially secure, Aglaia Coronio commissioned pictures from Rossetti, Whistler, and Fantin-Latour and was a confidant of William Morris. Whistler admired her as "one of the most intelligent and witty women of the period"; nevertheless, he negated much of his praise when he accused her of having a "sharp tongue."[81] Aglaia Coronio's forthrightness conflicted with the standard Victorian notion of her gender. No matter how intelligent, independent, or creative women were, those who did not conform to the submissive ideal were censured.

Mary Dalrymple Smith was to suffer even more opprobrium. She was the eldest daughter of Captain W. H. C. Dalrymple of North Berwick, who made her co-heir to his fortune, thereby giving her an unusual measure of independence.[82] According to her critics, Eustacia, as she liked to be called by her friends, did not use this freedom wisely after her marriage to

Plate 54. Eleanor Tong Coltart, photograph

Newcastle shipping magnate Thomas Eustace Smith. Determined to make her mark on London society, she orchestrated the decoration of the family's London home on elegant Prince's Gate, near Leyland's, in the apotheosis of Aesthetic style. The walls of the drawing room were adorned with gilded friezes dramatically offset by a black dado, while the dining room boasted an inlaid ivory, ebony, and mother of pearl dado topped by a decorative border commissioned from Frederic Leighton. Eustacia Smith's inner sanctum was her boudoir, where she chose dull-red walls surmounted by a shimmering frieze of cockatoos with lemon and orange crests on a gold ground painted by artist Walter Crane.[83] In addition to commissioning decorative work, she also made the rounds of artists' studios, where she selected a series of images of women to adorn the rooms of her house: a drawing of *Pandora* from Rossetti, *The Wife of Pygmalion* from George Watts, two full-length figural studies from Thomas Armstrong, and another from Leighton.[84] The dazzling ambience of her efforts impressed Julian Hawthorne, son of the American novelist, who described an evening he spent with the Smiths in the company of Leighton, fellow American Henry James, and politician Sir Charles Dilke. "The hall," he recalled, "was marble, gilded, and spacious; in front of us a wide staircase ascended, on the first floor landing a portrait of Eustacia …The furniture was upholstered in batik cloth from Java – an innovation at that time: costly, but unobtrusive."[85] Eustacia Smith, in other words, had succeeded in achieving her own distinctive version of the Aesthetic ideal.

While Hawthorne's account tallies with other contemporary descriptions of the house on Prince's Gate, his recollection of Eustacia Smith's appearance does not conform with the image captured on canvas by Leighton (plate 55). Said to be a gift from the artist, the portrait reveals a proud, fresh-faced woman, with a resolute profile, fully at ease in the heavy beads and embroidered gown that proclaimed her allegiance to the Aesthetic dress code. Hawthorne, however, painted a much more voluptuous word portrait of Eustacia Smith when he wrote: "She was dressed this evening in dark blue silk, open in front, but caught together at the throat by an insolent diamond: one thought, Were that clasp to come undone, what an expanse of white loveliness would be revealed! but it held" (p. 135). The disparity between Leighton's modest portrait of Eustacia Smith and Hawthorne's provocative sketch can be attributed to the threat posed by independent women who dared to express themselves in the male realm. To insure the superiority of the masculine as a privileged position, men such as

Whistler and Hawthorne felt compelled to discredit forceful and unconventional women like Aglaia Coronio and Eustacia Smith.[86] Moreover the wife of the Newcastle magnate committed a further transgression when she appropriated the sumptuous and sensual style of interior design favored by Aestheticism's few select male patrons.

That Hawthorne found his hostess's sensuality disturbing is evident not only in his description of her appearance, but also in the conversation he claimed took place that evening. He related that while Eustacia admitted to posing for Leighton's nude *Venus Disrobing*, which was displayed in the drawing room, to the left of the fireplace, she insisted that she had modeled only for the bare feet. Hawthorne managed, however, to imbue even this aspect of the painting with fetishistic overtones when he described the figure as "soft, subtle, and naked, slipping off a sandal with the other foot, ready, that done, to step forward into your arms, apparently, but really, no doubt, into her perfumed bath" (p. 136). While this voyeuristic reading is consistent with arguments concerning the prurience of the male gaze, how do we account for Eustacia Smith's complicity in modeling for and displaying a representation of a nude female in her home?

Far less attention has been paid to the female gaze. In examining the phenomenon known as scopophilia, Laura Mulvey notes that it involves both the process of perceiving another as an erotic object and identifying the self with that object.[87] To do so in the mid-Victorian period was to indulge in a notion of sexual identity that was outside the norm of acceptable femininity. That Eustacia Smith dared to stretch the boundaries of the norm is evident in her contribution to the production of Leighton's nude figure. She took an even greater risk, however, when she defiantly decided to claim the Aesthetic movement's pleasure principle for her own.

It was no secret that Sir Charles Dilke, who accompanied her on her visits to artists' studios, was her lover.[88] In embracing both the artistic and sexual principles of Bohemia, Eustacia renegotiated the socially constructed definition of her gendered role in society. For this she was punished. She confirmed society's worst fears about Aestheticism: its acceptance of the sensual body would topple the citadel of instrumentalist thought on which everything else depended.[89] It was not her affair with Dilke, however, that caused Eustacia Smith to be ostracized by society, but the public knowledge that Dilke went on to become her married daughter's lover. The publicity that ensued after Virginia Smith Crawford's husband named Dilke as the other man in his divorce suit ended Eustacia Smith's

Plate 55. Frederick Leighton, *Mary "Eustacia" Dalrymple Smith,* oil on canvas

glittering career as a London hostess: her husband sold Prince's Gate and its art collection and took her to live in Algeria. Twice condemned, once for her own adultery and once for her moral laxity as a mother, Smith's penance was far greater than Dilke's, who remained in London. "Broadly speaking," notes Lynda Nead, "for a man unchastity was defined as the indulgence of natural urges and sexual lapses were regarded as regrettable but unavoidable;

294

for a woman, however, it was the betrayal of her father, her husband, her home and her family" (p. 49). While the Aesthetic movement was the locus of alternative values that conflicted with the dominant ideology, the condoning of adultery by women was not one of them.

Leyland summarily divorced his wife Frances Dawson Leyland after suspecting her of being intimate with Whistler.[90] And although Rossetti enjoyed a clandestine affair with Jane Morris, he felt no mercy for Frances Leyland, whom he accused of taking advantage of her husband.[91] Clearly a double standard was still in force, even in Bohemia. Refusing to accept that the discourses on domesticity and sexuality were fixed categories, "the weaker sex" determinedly pushed for reforms in all walks of life. Active involvement in art patronage should be construed as more than a dilettantish wish on the part of women: it represented a desire to exert control in the home and to integrate the private with the public sphere. The struggle of women to expand the domestic role assigned them by society was symptomatic of the same unsettling forces that prompted the crisis of 1859.

Distrustful and suspicious of where greater social freedom would lead their wives, most Aesthetic patrons were reluctant to let them associate too freely with artists or dealers, despite their qualifications and experience in decorative matters. This decision necessitated a redefinition of the middle-class concept of masculinity for those businessmen who ventured out of their muscular billiard and smoking rooms and into the home's public reception areas. A compromise had to be reached that allowed them to express greater sensitivity to light, color, and design and still maintain their manliness. None could be found in America, where men became alarmed by the European-style feminization of culture promoted by artists who had been trained abroad.[92] There, male art patrons preferred to relinquish their control over the decoration of the home to their wives, rather than run the risk of being branded effete aesthetes. Consequently American women, by default, assumed a more public role in cultural life earlier than their English counterparts.[93] One reason that the redefinition of the male ideal was not as problematic in England was because the languid connoisseur was a familiar figure, unlike in America, where resistance to aristocratic mannerisms was deeply entrenched in the national psyche. Another explanation rests in the emotional dependency on objects promoted by practitioners of the Aesthetic movement. This pressing psychological need, as we have seen, led otherwise pragmatic businessmen to spend an inordinate amount of time creating idealized refuges for themselves.

These men did not have to depend on their wives to coordinate their efforts for them when the makers of the charmed objects that went into Aesthetic interiors were so willing to oblige. Artists catered to their patrons' emotional and material needs in the intimacy of luxuriously furnished studios designed to embellish the mystique of their creativity. Graham's piquant letters to Burne-Jones and Rossetti, written after visits to their studios, brim with an emotion that refutes the mid-Victorian stereotype of the cold and calculating bourgeois businessman who is obsessed only with money and power. Co-acolytes in the worship of art, male artists and patrons were drawn together by the conviction that an artistic environment possessed restorative powers. Fatigued businessmen, arriving on artists' doorsteps craving stimulation that they could no longer find in the mechanized industrial world, were often at their most vulnerable. Recognizing that they possessed the power to influence their clientele, artists transformed their studios into places of aesthetic indoctrination where even the least imaginative collector could envision the transfer of an occult aura to his home. Anxious that their art maintain its mystique once it left their studios, artists freely offered advice about appropriate wall coverings, lighting, and furnishings and steered their clients to friends and associates who specialized in providing luxurious goods, or to shops like Liberty's which catered to more exotic tastes, or, best of all, they supplied designs of their own making for Aesthetic objects.

Burne-Jones's studio (plate 56), for instance, featured the heavily carved furniture, stained glass, embroidered draperies, and woven tapestries that he had a vested interest in providing through Morris, Marshall, Falkener & Co. The demand for objects stamped with his imprimatur became so great that he hired a studio assistant to aid him in readying his designs for production.[94] Thus the artist profited from selling both paintings and furnishings to collectors who did not have to puzzle over how they could match the ambience of his studio; they could simply ask him to orchestrate delivery of similar items to their homes.

The artist's studio was an "aesthetic boutique" designed to stimulate the acquisitive instincts of patrons. Sarah Burns, who, in her study of American artists' studios of the gilded era, uses this term to emphasize the commercial intent of their decor, contends that artists contrived to "create desire among potential clientele by seducing their senses."[95] On the surface, artists' homes appeared to be shrines to beauty, but they were actually artfully crafted salesrooms where prospective buyers were induced to lower

Plate 56. T. M. Rooke, *Interior of the Grange, Studio-Home of Edward Burne-Jones,* 1898, watercolor

their guard and become lost in the contemplation of ethereal objects. Their attention was drawn to the most expensive things in the studio – the artist's paintings – which were dramatically displayed on easels, as in the painting room of Leyland's son-in-law, Valentine Prinsep (plate 57). Photographed for F. G. Stephens's pictorial essay, *Artists at Home,* in 1884, Prinsep accentuated two of his recent paintings in this manner. At the right, *The Bookworm* is spotlighted by the skylight above, while in the center of the room, the artist

297

poses at another easel on which rests an unfinished portrait of a woman. It seems as if we have interrupted him at that magic moment of creativity wherein his special powers as an imagemaker and as a dispenser of beauty lay. It was this association with the intangible, this gift of transforming mystery into matter, that drew weary businessmen to studios like Prinsep's and Burne-Jones's. Prinsep revealed that he understood that his father-in-law ached for more than canvas and paint on his frequent visits to Rossetti's studio when he described the older artist as "the one real friendship in his life."[96] Yet like Prinsep's studio, Rossetti's was designed to entice prospective buyers with its iconic arrangement of paintings on easels displayed against a backdrop of casually arranged Oriental rugs, wall hangings, and japanned screens – items which required an artist's deft touch in selecting and arranging.

Paradoxically, the artist's studio professed to provide a refuge from materialism and commercialism, yet it was structured to induce spending. Tête-à-têtes notwithstanding, it was understood by artist and client that their mutual satisfaction hinged on the consumption of expensive aesthetic commodities. While the mercantile function of the studio came to supersede its regenerative role in subsequent decades, during the Aesthetic period artists still labored under the impression that they could offer their patrons emotional release and that their paintings were effective buffers against the onslaught of the workaday world. This was not false advertising – artists genuinely hoped that their renewed and reinvigorated clients would reciprocate in kind.

The Aesthetic artist–patron couplet was based on a symbiosis in which each fed off the other's needs. A degree of intimacy was fostered between artists and Aesthetic patrons that had not existed in art circles since the early days of Pre-Raphaelitism as both male and female patrons supplied moral support. Aglaia Coronio assumed the mothering role of Martha Combe when she spent hours searching for suitable fabrics and dresses for Burne-Jones to copy.[97] She provided a more intangible form of sustenance to William Morris by becoming his sympathetic correspondent in the 1870s, during the painful period of Jane Morris's affair with Rossetti.[98] Succor was also provided by men: Glasgow commodity broker William Connal nursed Albert Moore back to health after the artist suffered a severe illness. Proving that he was indeed an "intimate personal friend," Connal went on to guarantee Moore a steady income by commissioning dozens of his drawings and oils.[99] Cyril Flower likewise assured Frederick Sandys a

Plate 57. Studio of Valentine
Prinsep, photograph

regular income when he guaranteed the artist weekly advances against
future commissions, just as Colonel Gillum had briefly supported Rossetti
with a quarterly retainer in the early 1860s.[100] Nor was Rossetti unapprecia-
tive of Leyland's ministrations, saying, "he has shown affection towards me
at times, and I would not like to do anything abrupt if his *feelings* are hurt in
any degree by supposed neglect."[101] Few patrons merited this degree of

299

consideration from Rossetti, but Leyland had proved himself worthy by not haggling over the artist's escalating prices, by advancing him money when needed, and by endowing him with a stream of gifts.[102] Co-dependents, artists and patrons both believed they profited from their relationships.

Aesthetic patrons disregarded the advice of self-appointed equerries to taste, such as the Reverend Loftie, who admonished his readers:

> Do not confine yourself to the work of one artist; and, unless your taste runs very decidedly in one direction, do not confine yourself to a single school. It is said that the buyers of works by Mr. Burne Jones and Mr. Rossetti and other pictures of the so-called "pre-Raphaelite" class cannot take any pleasure in ordinary painting ...they must leaven their "advanced" works with a few of the kind people usually prefer.[103]

Although disapproving, Loftie seemed to realize that once viewers became party to the intense communication and contemplation Aesthetic artists required of their work, other art paled by comparison. Since he was not an initiate, however, he could not appreciate that a close relationship with the creators of Aesthetic images was of equal importance to their patrons.

As supportive as Aesthetic patrons were, the negative effect of their generosity was that it encouraged the kind of dependency associated with paternalism. George Frederic Watts spent fifteen years as protégé of Henry Thoby Prinsep and his wife Sara Monckton Pattle, parents of painter Valentine Prinsep, who married Leyland's daughter. Thoby Prinsep ventured out to India after completing his education at a series of private schools. There he made a name for himself as a jurist and was rewarded with an appointment to the prestigious Council of India after his return to England.[104] Steeped in the ways of colonial paternalism, Prinsep practiced a more stultifying form of patronage than most men of his social class. In this regard, he was encouraged by his upper-class wife, the granddaughter of the Chevalier de l'Etang, page to Queen Marie Antoinette.[105] In his study of the persistent manifestations of traditional models of political and social patronage in the nineteenth century, J. M. Bourne characterizes the relationship between Watts and the Prinseps as an instance of the detrimental effects of misplaced magnanimity. He argues: "Watts became a virtual fixture in the Prinseps' home, abandoning his habitual ascetic dedication to work only to organize their lives. He was known as 'Signor,' less formal than a surname, but less intimate than a Christian name and fully reflecting his inferior status and dominant, inescapable presence."[106]

Watts's reasons for enduring the confining aspects of paternal patronage are explained by his longing to be accepted in the genteel world to which he was first exposed when Lord Holland adopted him as his protégé in Italy in the 1840s.[107] The son of a piano manufacturer, Watts frankly admitted: "I confess I should like to have a fine name and a great ancestry; it would have been delightful to me to feel as though a long line of worthies were looking down upon me and urging me to sustain their dignity" (p. 2). Thus the artist behaved in the deferential manner expected of him in exchange for the opportunity to live among his superiors – but only until a better opportunity presented itself.

When a stream of commissions began to emanate from Manchester papermaker Charles Hilditch Rickards, Watts went out of his way to flatter him, saying, "I believe that you belong to the class that has made England great, and would make any nation great, earnest, sincere, and courageous, sympathising with all that is good in action and great in aspiration, free from meanness, and impatient only of wrong-doing."[108] The effusiveness of Watts's comments, however, carries a taint of the deference that had supposedly been put to rest by the Pre-Raphaelites at the beginning of the mid-Victorian period. I do not mean to imply that Rickards was undeserving of commendation. In addition to his devotion to Watts, he was a pillar of his community. The hard-working chairman of the Manchester Board of Guardians for seven years, the enthusiastic organizer of a relief program during the cotton famine, and the founder of a scholarship fund for the Manchester Grammar School, Rickards, as Watts indicates, was a socially conscious middle-class paragon.[109] Yet none of the Manchester papermaker's actions was quite as extraordinary as the artist's eulogy suggests. The enthusiastic tone of Watts's letter to Rickards does not stem so much from sycophantism as from relief. Having experienced two closely monitored paternal relationships in which he was the social inferior, the artist was delighted with the equality Rickards offered him. An appreciative Watts pronounced in 1873: "From Manchester and commerce I had received encouragement to carry out those abstract views which ...I had failed to receive from those whose inherited position, whose education, wealth, and leisure constituted the natural fosterers of the noblest aspirations in Art."[110] Having experienced both gentrified and middle-class patronage, Watts found the latter to be more supportive of his highest aspirations.

Rickards endeared himself to Watts by buying portraits and the mystical allegories for which the artist could not find buyers at the

exhibitions of the Royal Academy.[111] Willingly adapting to the role of supplicant, Rickards struggled to understand Watts's visionary works. After contemplating a replica he had ordered of *The Court of Death* (plate 58), Rickards apologetically wrote: "The subject was more than usually veiled and my art vision was not at the time strong enough to appreciate the full intent and meaning of the subject."[112] When the Mancunian timidly suggested that the introduction of a cross would clarify the meaning of the painting, Watts angrily responded that this was an example of "what the modern – I will not say unthinking – mind requires in art."[113] Rickards's provincial roots had nothing to do with Watt's high-handed tone: the artist responded in an equally irate manner to the more urbane Alexander Ionides when the patron reasonably requested that he see a sketch before commissioning a painting that the artist had described in particularly symbolic terms.[114] Watts's strategy, in other words, was to intimidate his patrons by reminding them of the sanctity of his artistic mission.

Clashes between Aesthetic painters and patrons occurred more often due to the feckless behavior of artists rather than clients. The most notorious instance of an artist's disregard for his patron is Whistler's treatment of Leyland. The details of the Peacock Room are too well known to repeat except insofar as they illustrate that the intimacy which was an essential ingredient in the ideal artist–patron relationship could, if abused, become a destructive weapon. Prior to the time when Whistler overpainted the embossed leather walls of the dining room at 49 Prince's Gate in a pattern of peacock feathers, he and Leyland had enjoyed a mutually satisfying personal and artistic communication. Not only had Leyland invited the artist to stay at Speke Hall in Liverpool, but he fully entered into the spirit of Whistler's artistic expression, even suggesting the moodily appropriate designation "nocturne" for his dark landscapes.[115] Whether the break between artist and patron was due to Whistler's rumored dalliance with Frances Dawson Leyland, or to his unlicensed decoration of the Peacock Room, it originated with the artist.

Both chose to vent their anger over the public matter of the artistic project instead, since it was a more acceptable vehicle than the private affair. The quarrel touched the very core of the artist–patron doublet as each fought for the right to protect his place in the process of artistic production. Whistler insisted that his was a spontaneous act that merited only admiration, while Leyland defended his right to choose the creative efforts that entered his "sanctuary." Whistler's demand for payment for work that had

Plate 58. George Frederic
Watts, *The Court of Death*,
1868–81, oil on canvas

not been authorized was to some extent a diversionary skirmish that disguised the artist's more totalitarian claim to supremacy in aesthetic matters.

In refusing to compromise, the artists of the Aesthetic movement vigorously perpetuated the Romantic image of the artist as genius. Posturing as divine creators who ministered to the pressing emotional and spiritual needs of their beleaguered parishioners, Aesthetic artists perceived themselves as members of a separate class that soared above both the aristocracy and the bourgeoisie. Just as Watts chastised Rickards for his interference and Whistler abused Leyland, Rossetti unleashed a philippic at mid-Victorian patron John Heugh after he canceled a commission, telling the Manchester merchant that he was not "your social inferior in any way except so far as your money can make [me] so (which it cannot, either socially or mentally)."[116] In defending the superiority of his mental or creative powers, Rossetti revealed that he shared the Aesthetic artist's perception of himself as belonging to a class apart from ordinary mortals.

The superior social space which Aesthetic artists claimed for themselves was a form of Bohemia. The variety that was imported into England by Whistler, Armstrong, and Prinsep, who had all studied in France, was less garret-oriented and more messianic in keeping with the aspirations of the Aesthetic movement. Christopher Kent observes that, in England: "On the one hand Bohemia evoked the romantic ideal of a community of artists dedicated to their callings to the exclusion of material concerns, and stressed asceticism and aestheticism. On the other, it evoked the idea of a counterculture, a sphere whose values defied middle-class philistinism."[117] Patrons demonstrated that they were attracted to both the aesthetic and the social aspects of Bohemia when they formed close friendships with the artists whose esoteric paintings decorated their homes. They prided themselves on their ability to penetrate the recondite meanings of Aesthetic painting which set them apart from the philistine flock. Some visibly demonstrated a rebellious streak of their own when they imitated Watts's eccentric berets or Rossetti's flowing capes, such as insurance underwriter Philip Rathbone, who was notorious for his strange dress. This habit, combined with his commitment to creativity, led the *Liverpool Courier* to describe Rathbone in his obituary as "a true Bohemian," explaining that, "he was bound up hand and soul" in art and literature.[118] Despite Rathbone's sensitivity, and his collection of Aesthetic art, he refused to worship blindly at the altar of artistic genius. He complained about artists:

whose works have become more and more morbid and unreal because they have shrunk from producing them in the broad light of day and have preferred the hot house admiration of a small circle of mutually appreciative friends to the slow and gradual growth of a healthy public opinion.[119]

Rathbone no doubt considered fellow Liverpudlians Leyland and Rae members of that small circle of insular, overprotective patrons who were responsible for sheltering Aesthetic artists from the harsh light of the public exhibition. Graham also demonstrated his complicity when he dissuaded Rossetti from marketing his art publicly, urging him instead to weigh the merits of working for his own interests against a predictable "small circle of loving appreciation and *for all time.*"[120] While Graham was convinced that he was indispensable to the idle dreamers whose canvases brought him so much satisfaction, Rathbone and others questioned the virtues of shielding artists from reality.

Charles Dickens, in an address he delivered to the Artist's General Benevolent Institute in 1862, ridiculed the concept of the defenseless artist:

> There have been, and perhaps are, those of certain conventional ideas who present art as a mere child, a poor moon-stricken creature unable to take care of itself, waiting, as it were, to be safely conducted over the great crossings of life by some professional sweepers as a miserable slovenly slattern down-at-heel and out-at-elbows, with no appreciation of a home, no knowledge whatever of the values of money and so on, but with these popular and still lingering hallucinations I have nothing whatever to do.[121]

All too familiar himself with the marriage between art and money, Dickens was not fooled by the pretense of helplessness. Nor was politician A. J. Beresford Hope, who railed against artists who assumed the mantle of superior beings. Speaking before a group of artists and patrons, Hope complained that too much had been written "about the Bohemian artist, the man who revelled in the idea of his own genius and imagination."[122] The machinations of Aesthetic artists were largely responsible for this assessment.

That Watts was not the detached spirit he pretended to be is apparent in the attention he paid to monetary transactions with patrons. There was a noticeable cooling of his tone toward Rickards after the Mancunian ventured to suggest a lower price for a picture.[123] Wilfrid Blunt concludes that Watts was "very far from being the guileless innocent that he

pretended . . . he was a past master in extracting the last penny from a client" (p. 167). Despite his ethereal ambitions, Watts proved to be as commercially astute as his clients.

Whistler's high-minded public persona also disguised a venal preoccupation with hard cash. Although Leyland finally relented and agreed to pay him half of his 2,000-guinea asking price for the Peacock Room, the artist was incensed when the patron remitted the sum in pounds rather than guineas. He wreaked his revenge by painting a second portrait of Leyland which he titled, in a play on his former patron's initials, *The Gold Scab: Eruption in FRilthy Lucre* (plate 59), caricaturizing him as a scabrous peacock surrounded by bags of money. While Whistler, as the West Point-educated son of an international engineer, did not flaunt his social superiority at Leyland before their rupture, he now made a point of ridiculing the self-made shipping magnate's déclassé predilection for frilled shirts. Whistler elaborated their differences on another occasion when he summarized the episode of the Peacock Room as "the apotheosis of *l'art et l'argent*," misleadingly suggesting that while artistic creation was foremost in his mind, cupidity was Leyland's major preoccupation.[124]

The Gold Scab is a grim reminder of the punishment awaiting patrons who dared to strike a dissonant note in their duets with artists: harmony quickly turned into discord. A displeased Rossetti developed alliterative names as his revenge against clients who refused to do his bidding, such as the "demon Dunlop," the "fool Fry," and the "Vampire" Valpy.[125] Such caricatures and rude nicknames are measures of the frustration felt by artists who had managed to convince themselves but not everyone else that their genius was unassailable.

It is likely that Whistler felt it necessary to trivialize Leyland in order to fortify the myth of his own genius. Part of that myth concerned the so-called spontaneous act that resulted in the decoration of the Peacock Room. David Curry disputes the credibility of Whistler's unrehearsed moment of creativity by pointing to the evidence of a full-scale cartoon stenciled for transfer that was found in his studio after his death, concluding that "the formal elements of what was later construed as an iconographic confrontation between artist and patron were clearly there from the start."[126] The design had, in fact, already been rejected by another of Whistler's clients, banker William Alexander.[127] Viewed in this light, it is apparent that Whistler's celebrated burst of inspiration was more calculated than instantaneous.

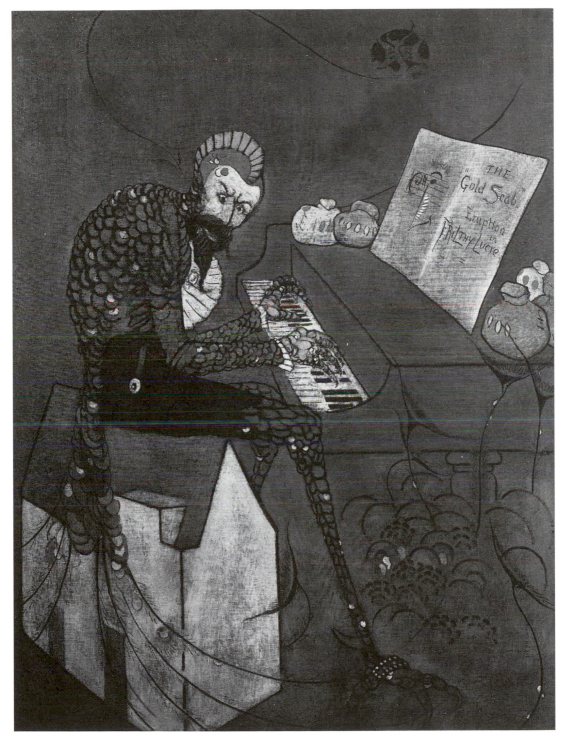

Plate 59. J. A. M. Whistler, *The Gold Scab: Eruption in FRilthy Lucre* (*The Creditor*), 1879, oil on canvas

Whistler's transgression was to violate the code of intimacy that defined the Aesthetic artist–patron relationship. Instead of persuasively convincing Leyland over the course of several visits to his studio that the Peacock design was in part the millionaire's idea, Whistler skipped an important step in the process that artists such as Burne-Jones and Rossetti patiently indulged in with their patrons. Whistler, however, did not show Leyland sketches or give him the opportunity to envision the gilded design transported from drawing board to dining room; rather, he appropriated Leyland's home as an extension of his studio in conceiving of it as a frame for his picture, *Princess of the Land of Porcelain*. Whistler thus inverted the acceptable order of things when he refused to sustain the illusion of collaboration that took place between Aesthetic artist and patron in the intimacy of the studio.

Whistler had disclosed that he was anxious to extend the boundaries of his studio earlier, in 1874, when he redesigned a commercial gallery as a domestic space to enhance the oils, prints, and drawings in the one-man exhibition he staged. He rented rooms at 48 Pall Mall on a one-year lease in order to make a definitive statement to his clients about how his art should be showcased.[128] To this end he imported couches and chairs covered in light maroon, blue pots filled with flowers, and designed free-standing screens to add an informal luster to the exhibition space. This effort was a preamble to the comprehensive renovation he undertook three years later on Tite Street in Chelsea, the site of his new atelier, commonly known as the White House but which he ceremoniously titled *Harmony in Yellow and Green* to convey that the entire effect should be viewed as a work of art rather than only the paintings which hung on the walls. By the same reasoning, we can conclude that he considered the studio–home ensemble not as a private space but as a commodity which was available for imitation to paying customers. Whistler, in fact, hoped to cash in on the lucrative interior design business enjoyed by Morris and Burne-Jones.

The mid-Victorian avant-garde was skilled at marketing maneuvers. Although both artist and patron publicly denounced dealers in order to perpetuate the mystique of shared creativity that was inferential in their close bond, each took advantage of commercial outlets. Mammonism was a recurring factor in the patron's complex attitude toward the ownership of art. Graham, with a sigh of relief, ostensibly turned his back on the commercial world when he confided in Rossetti: "I cannot tell you what a refreshment it is to get into the atmosphere of your studio after the jaded

sense of dissatisfaction which exhibitions and picture dealers' galleries give me."[129] The patron was particularly critical of some of Agnew's measures, such as when the Bond Street dealer dedicated an entire exhibition to a single work of art, Holman Hunt's *The Shadow of Death*, in 1873. Graham was aghast at what he termed, "the low vulgar (Agnewism) of its theatrical exhibition," which he described as "'lying in state' in a silent room draped in black with slippered attendants and reflected gas light and gaping spectators."[130] As prone as Graham himself was to fetishizing objects in his home, he recoiled from the bizarre appearance this tendency assumed when it was carried over into commercial space. One suspects that he recognized that the exaggerated effect was a parody of his private sensibilities. Yet the Glasgow merchant did not hesitate to avail himself of the services of Agnew's when it suited him, or to advise Burne-Jones to do the same.[131] Agnew's could also count several more Aesthetic patrons and collectors among their clients, including Leyland, Turner, Craven, Wood, and Rickards. Anxious to gain a foothold in the Aesthetic camp, Agnew's representatives regularly made the rounds of artists' studios and bid competitively for their work at auction.

It went against the grain of the businessman–patron to ignore the blue-chip shares he possessed in the contemporary English School. At first Rossetti believed that he had encountered an exception in Clarence Fry, telling him that "you belong to the class alone whom I wish to possess my work – that is, those who enter into its feeling and buy not only as an investment."[132] Having recently paid the artist 2,000 guineas for his painting *Astarte Syriaca*, which was the highest amount Rossetti was ever to receive for a single canvas, Fry could do no wrong as far as the artist was concerned. Others, who had had more extensive dealings with the commercial photographer, were more suspect of his motives. Edward Edwards, who was an amateur dealer himself, accused Fry of speculating in the art market by selling pictures for twice what he had paid.[133]

The resale market in Aesthetic canvases remained strong. Many collectors, such as Joseph Ruston, enriched their holdings by bidding on previously owned Aesthetic canvases. A photograph of his drawing room at Monk's Manor in Lincoln (plate 60) reveals that the manufacturer of agricultural machinery transformed his home into a repository for Aesthetic relics by Rossetti, Watts, and Burne-Jones which he had purchased at the posthumous sales of Graham's and Leyland's collections.[134] Others circumvented the auction house by consummating private deals of their own, such

as John Miller, who sold paintings off his own walls to Walter Dunlop, Cyril Flower, who disposed of several Whistlers to Charles Freer, the American magnate who was to transport Leyland's Peacock Room across the Atlantic, and John Hamilton Trist, who allowed James Leathart to purchase Albert Moore's important early work, *Elijah's Sacrifice*.[135] Like the mid-Victorian middle-class magnates who looked to their own kind to enhance the provenance of their paintings, Aesthetic collectors gained reassurance from pictures which had already successfully passed the test of taste. Still there were fewer buying opportunities for Aesthetic collectors, since their range of interest was much more limited.

While patrons could sometimes be recognized at Christie's or in the larger dealers' showrooms, they preferred the anonymity offered by amateur agents. In keeping with the Aesthetic movement's emphasis on personal relationships, patrons felt more comfortable with vendors who operated on an individual basis. Artists had no quarrel with this arrangement since, in most cases, they had steered their clients to these sources in the first place.

Artists realized that they could not shun merchandising and still hope to attract a steady stream of new buyers. Acknowledging the need for middlemen, the most acceptable mediators were other artists. Rossetti looked to Frederick Shields in Manchester and William Bell Scott in Newcastle to interest local collectors in his art.[136] Burne-Jones's art was also to benefit from increased exposure in Birmingham due to the ambassadorship of his studio assistant Charles Fairfax Murray.[137] Patrons, too, preferred the expertise and informality of working with artists as agents over dealers. Constantine Ionides depended upon the advice of Alphonse Legros while the French emigré was director of the Slade School in London, just as James Leathart consulted with Bell Scott during his term as Head of the Newcastle School of Design.[138] In a group where taste was narrowly defined, both artists and collectors were less desirous of relying on the ecumenical dealer.

Next in popularity to the artist–agent was the *marchand manqué* who offered the advantage of working behind the scenes. These purveyors of taste were scaled-down versions of the dealer. Since they did not operate from a commercial gallery as a base, they offered a more intimate and customized form of service than the denizens of Pall Mall or Bond Street. Because the Aesthetic milieu was defined by more than paintings, these merchants dealt in *objets d'art*, fabrics, and furniture as well. Moreover it was

Plate 60. Drawing room, Monk's Manor, Lincoln, residence of Joseph Ruston, photograph

assumed that men such as Charles Augustus Howell and John Aldam Heaton would be more sensitive to the needs of the artists and collectors they served, because they were from similar backgrounds.

Reputedly the son of a Portuguese wine merchant, Howell carried letters of introduction to the Aesthetic circle from Ruskin, for whom he had worked as private secretary for five years, as well as from John Miller of Liverpool, with whose sons he shared lodgings in London.[139] By 1870, Howell was negotiating sales of pictures by Rossetti, Burne-Jones, Whistler, Watts, and Sandys. Rossetti found his services particularly useful during the time he spent at Kelmscott in Oxfordshire, a location that made it difficult for patrons to view works in progress. Howell willingly agreed to steer potential customers to Rossetti's London studio, where, even if the master was not in residence, his personality was stamped on his hand-carved

furnishings, rows of Japanese porcelain, and paintings casually distributed on easels. Rossetti further explained to his brother that Howell offered the additional advantage of eliminating "the awkwardness of writing to purchasers much myself, which might otherwise be so nauseous as seriously to stand in the way of business."[140] Paradoxically, while Aesthetic artists had won the right to be treated as equals by their patrons, their victory behooved them to behave like gentlemen and thus not place undue emphasis on money matters.

Howell obligingly inserted himself into the financial equation, enthusiastically consummating deals with Fry and Valpy, and providing furnishings as well as fine art to Leyland and Graham. Additionally, he demonstrated his usefulness to artists in other ways: it was he who urged Whistler to make prints of his etchings and who aided him at the press.[141] Howell's advantages, however, were soon outweighed by the disadvantages caused by his meddling. Georgiana Burne-Jones accused him of inciting her husband's affair with Maria Zambaco; while Whistler questioned Howell's unauthorized sale of a cabinet from his house in Lindsey Row.[142] After perceiving the agent in a more dubious light, Whistler described him as "the superb liar, the Gil-Blas, Robinson Crusoe hero out of his proper time."[143] Rossetti also became suspicious of Howell's ethics and finally broke with him after accusing him of trafficking in fakes.[144] Given Howell's duplicitous character, it is a wonder that he managed to ingratiate himself with artists and patrons in the first place. Whistler provided a clue to Howell's success when he mused, "He had the gift of intimacy – he was at once a friend, on closest terms of confidence."[145] Not only did Howell satisfy the Aesthetic movement's craving for intimacy, but he preyed on the group's cliquishness. In a milieu where only fellow travelers were admitted, Howell shrewdly took advantage of the prevailing xenophobia.

Howell was also responsible for introducing John Aldam Heaton to the rarefied ranks of Aesthetic taste, though the Yorkshireman's tenure as an amateur dealer was even shorter lived than his own. Related by marriage to Pre-Raphaelite patron Ellen Heaton, he gave up a career as a textile merchant when he founded the Works of Arts Company in Bradford in partnership with Howell and W. Hutton Brayshaw.[146] After successfully placing stained-glass commissions in the Bradford home of John Mitchell, Heaton tried to interest a group of local businessmen in Aesthetic oil paintings. He was initially optimistic about merchant Walter Dunlop's potential as a client because he had already commissioned thirteen stained-glass windows with

designs by various Aesthetic artists from Morris & Co. Heaton succeeded in persuading Dunlop to order a large oil from Rossetti, but when no payment followed the verbal agreement, the artist demanded he rectify the situation.[147] Heaton's failure to resolve the issue resulted in the collapse of the artist–agent relationship. He wisely redirected his energies toward architectural decoration, a field in which he had more success in collaboration with Richard Norman Shaw. As much as artists preferred the well-spoken and low-keyed amateur agent to the aggressive dealer, they eventually came to value assertiveness over reticence, at least where money was involved.

The dealer of choice for Aesthetic artists was Murray Marks who combined the personalized attention of the amateur agent with the professionalism of the marketplace. He was preferable to Agnew and Gambart, due to his skill at creating Aesthetic environments. Marks's shop on Oxford Street was a repository for the porcelains, tapestries, and antiquities which Aesthetic artists themselves collected and which they believed enhanced the appearance of their paintings in private homes. Realizing that the paintings of Rossetti, Burne-Jones, Whistler, George Watts, Simeon Solomon, and Frederick Sandys naturally complemented the rooms he envisioned for his clients, Marks toyed with the idea of starting an interior design firm in collaboration with William Morris. He successfully obtained the backing of patron Alexander Ionides, but the plan is said to have been undermined by Howell, who feared losing his corner of the market.[148] Undeterred, Marks went on to sell and commission works from Aesthetic artists and to advise collectors on their decorative ensembles, an area in which he excelled.

Marks's most important client was Leyland, who entrusted a large part of the decoration of Prince's Gate to him. Part of Marks's talent was his insight into his clients' psychology. He astutely realized that Leyland would not be flattered by a series of cozy Arts-and-Crafts-style rooms; rather, Marks played up to Leyland's sense of self-importance by reproducing for him the luxurious ambience of what he described as the home of "a Venetian merchant" (p. 95). Leyland's dining room was to have been Marks's crowning achievement, since he recommended architects Shaw and Jeckyll with the understanding that their designs would showcase the blue and white porcelain he had sold Leyland. Thus when Whistler overpainted the costly Spanish embossed leather wallcovering which Marks had hand-picked for the room, his anger knew no bounds: he blamed the artist for Leyland's sudden death on the London underground at the age of sixty-one and for Jeckyll's subsequent descent into madness (pp. 93–96). As

excessive as these charges may be, they are testimony to the degree of personal involvement that participants in the Aesthetic movement invested in their projects.

Murray Marks suffered further disappointment when he was called in to advise the owners of the new Grosvenor Gallery in 1877. Sir Coutts Lindsay disregarded the dealer's advice when he covered the walls of the gallery with a nerve-tingling combination of crimson silk and green velvet. This display of disparate textures and colors was crowned with even more dissonant patterns and tones after Lindsay commissioned Whistler to paint the phases of the moon on a blue ground in the upper registers of the Grosvenor's main exhibition room. Visible in a contemporary engraving (plate 61), Whistler's celestial scheme is almost dwarfed by the barrel vault and central skylight. The overall effect is undeniably imposing, yet, as Marks lamented, it was "too strong for the pictures that were exhibited" (p. 99). Frederic George Stephens concurred, complaining that "this unwonted magnificence is disastrous to some of the finest paintings which it was designed to honour."[149] Whereas Marks's custom-tailored creations represented the union of art and idealism that marked the Aesthetic movement at its apogee, the Grosvenor's gratuitous opulence ushered in an exaggerated phase that signaled its decline.

While the Grosvenor may have duplicated the luxurious appearance of private shrines to art, its entrepreneurial organization necessarily excluded the close relationship between patrons and their artist–mentors that had first stimulated the sanctification of art almost two decades earlier. Often claimed as an icon of Aesthetic taste by observers who were not privy to the genesis of the movement, the gallery's glaring appointments and bold public relations were a mockery of the Aesthetic craving for intimacy. The hyperbolic scale and decor of the Grosvenor contorted the notion of the Aesthetic shrine to art.

The Grosvenor became a showcase for the late Italianate art of Burne-Jones, who was favored by both Lindsay and his gallery director, Comyns Carr. Carr favorably compared the Aesthetic painter to Michelangelo, claiming that in both artists he found "an intensity of expression" and a "mystery which comes with intense brooding upon any particular phase of passion."[150] This mannered direction in Burne-Jones's art augured the demise of Aestheticism, which had moved from the sensuality of Venice to the pomposity of Rome, from the cult of beauty to the adulation of excess, and from the private sanctuary to the public cathedral.

Plate 61. The Grosvenor Gallery, 1877

A testimony to the victory of those political economists who advocated luxury as a necessary adjunct to progress, the Grosvenor Gallery exposes the fallacies of that reasoning. If material accumulation and ostentatious display are good for society, their attainment should be beneficial to all concerned. Yet the Grosvenor never achieved that reward: its efforts were parodied in the press and on the stage and it was forced to close its doors for financial reasons in 1890.[151] Rather than a Darwinian improvement on the

315

Aesthetic model, it should be viewed as a Hegelian instance of cyclical decay. The kernel of Aestheticism that was nurtured by the filtered light of private interiors burst into aberrant bloom when it was exposed to the unnatural glare of the commercial gallery. It was an easy target for satirists, such as Gilbert and Sullivan, whose character Reginald Bunthorne ironically played on the metaphor of growth and decay when he described himself as a "greenery-yallery Grosvenor Gallery / Foot-in-the-grave young man."[152] Judged by the initial standards of the Aesthetic movement, the Grosvenor was a lavish masquerade, offering a glamorous semblance of ideals that had painfully evolved through a long night of self-examination and uncertainty. None of this equivocation penetrated its ultra-chic environment.

The Grosvenor's Sunday *vernissages* also became a parody of the Aesthetic patron's worshipful attitude toward art. By making Sunday its most social day, Lindsay provided a fashionably alternative milieu to conventional religious services when he displayed the icons of Aestheticism under his vaulted ceiling to the accompaniment of music.[153] Prominent on his guest list were the names of members of the fast set whom the biographer of sculptor Alfred Gilbert describes as denizens of "the dangerous world where artists mingled with society."[154] Concerned with seeing and being seen, the Grosvenor crowd directed its gaze outward, feasting on the panoply of animate and inanimate ornamentation offered for its delectation, in contrast to the inward resolution sought by the contemplative Aesthetic patron.

This displacement of values must be counted as one of the issues of the Whistler–Ruskin trial. When Ruskin saw Whistler's *Nocturne in Black and Gold: The Falling Rocket* (plate 62) on display at the Grosvenor Gallery in 1877 and described it as a "pot of paint flung in the public's face," he was reacting as much to the decline of the Protestant ethic as he was to the way the picture was painted.[155] He perceived the painting's impetuously corrugated surface, disregard for detail, and unmodulated color, combined with its obvious lack of narrative as a churlish challenge not only to the sacred precepts of the English School of Art, but to society as well. Ruskin's vituperative assault and Whistler's celebrated legal rejoinder made it clear that what was at stake was not simply a question of style, but the value-encrusted middle-class standards that English art had come to represent as respect for labor was pitted against freedom of expression, moral rectitude against pleasure, and regard for tradition against contemporaneity.[156] Because the trial took place in the transitional years between mid-Victorian equipoise

and late-Victorian retrenchment, a somewhat ill-defined concept of art emerged.

Summoned to testify on Ruskin's behalf, aging moralist William Frith indicted Whistler on the grounds that he advocated "pretty color that pleases the eye, but nothing more."[157] As we saw in *Derby Day* and *The Railway Station*, Frith's form of representation depended on weaving a tale around the middle class's virtues and accomplishments. While he paid lip service to society's inequities, his jingoist sentiments made it impossible for him to concede that the values to which he subscribed were steadily losing their credibility. Searching for a source to blame, Frith eventually settled on the French system of art education to which he attributed Whistler's self-indulgence.[158]

Narrative was less an issue with Burne-Jones than the discourse on labor. Despite his ties to the Grosvenor Gallery, he was incited to speak out on Ruskin's behalf by the lack of visible effort in Whistler's art. He argued from the witness stand that "complete finish ought to be the object of all artists."[159] Unlike Frith who discursively emphasized the importance of detail for communication, Burne-Jones calculated finish in monetary terms. He indignantly complained to George Howard that *The Falling Rocket* was overpriced at 200 guineas, protesting that:

> My average pay for a day's work is from £5 to £7 and I was justified in saying £200 [*sic*] was too much – prices like that will go near to discrediting the value of the work of every one of us ... I ought to know good work by now – Whistler's work looked more abdominable than I had thought – and I said all the good of it I could think of.[160]

Burne-Jones's candid remarks expose the tenacity of the equation between artistic effort and money. Originally touted by mandarins dedicated to competitive capitalism, the discourse on labor became firmly entrenched in the art world, where it was used as a measuring stick for success. Testifying at the trial, Burne-Jones seemed genuinely puzzled about how a picture that was admittedly painted in two days could be valued by the artist at such a high sum, "seeing how much careful work men do for so much less."[161] Burne-Jones's remarks underline the degree to which the systems of production and labor management employed in the workplace had infiltrated the creative world. Whistler's transgression struck at the core of the economic equation between time and labor. There was no place in this formula for nonmeasurable modes of expression. Collectors who were anx-

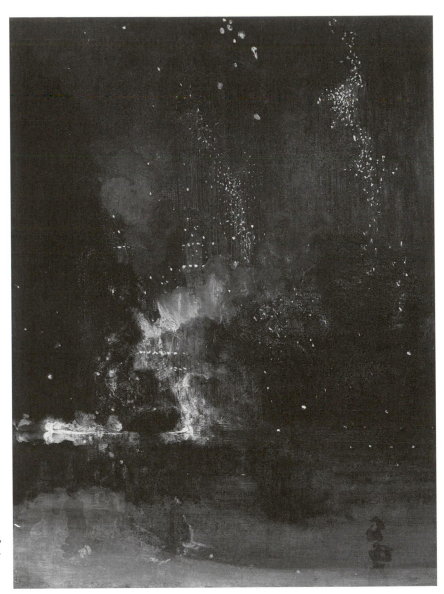

Plate 62. J. A. M. Whistler,
Nocturne in Black and Gold:
The Falling Rocket, c. 1874,
oil on panel

ious to protect the money they had invested in English paintings demon-
strated that they felt the same way as Burne-Jones when they contributed to
the costs of Ruskin's defense.[162]

The prosecution, however, refused to concede that the elemental
issues in this trial were time, money, and tangible evidence of labor. William
Michael Rossetti insisted, in support of Whistler, that he did not think it

318

was necessary for a painting "to show labor and finish," while Albert Moore, who was guilty of these traits himself, proved his loyalty to the French-trained artist when he presented the argument that "people abroad charge us with finishing our pictures too much."[163] He could have cited the example of Fantin-Latour, who frequently complained of his frustration with English clients who demanded a higher degree of finish in his floral still-lifes.[164] Regarding an obsession with detail as the trademark of academic rigidity, the French avant-garde analogized *facture* and textured surfaces with artistic liberty.

While the English avant-garde had modified its position regarding moral and narrative imperatives, it was still reluctant to relinquish the rewards of the labored surface. This is the same discourse that I identified in regard to the Pre-Raphaelites when I compared English and French modernism and attributed the diverse development of the avant-gardes in each country to the relative importance placed on aesthetic experimentation in relation to indigenous nationalist values. That situation had not changed.

This regard for the highly finished final product goes a long way in explaining why replication continued to thrive, even in the studios of Aesthetic artists. We have seen that the painted copy of the original work of art was a staple of the early- and mid-Victorian art markets, where its viability went unquestioned. As long as art was thought to be the transmitter of spiritual or educative values, the issue of one-of-a-kind originality was irrelevant; but as the new climate of doubt called previous beliefs into question, how could artists continue to insist that a replica was as power-laden as an original?

The credibility of the copy depended on the perception of the image as the reflection of a certifiable reality. Jean Baudrillard argues: "All of Western faith and good faith was engaged in this wager on representation; that a sign could refer to the depth of meaning, that a sign could *exchange* for meaning, and that something could guarantee this exchange – God."[165] When this relationship began to be doubted, it put into play a successive process wherein the image was initially construed to mask disbelief in a basic reality until, finally, the realization dawned that the image no longer bore any relation to reality at all. We have seen this course of action evolve from the early-Victorian faith in mimesis, to the mid-Victorian construction of representations that glossed over societal flaws, until it devolved into Whistler's abandonment of exacting middle-class glorifications in favor of idiosyncratic reveries rendered with the inimitable markings that defied repetition.

Yet as long as dealers and collectors continued to order copies, artists were reluctant to discontinue the practice. Operating on the principle of supply and demand, Aesthetic artists saw no reason to pass up the opportunity for a quick profit in the bullish market for copies. Despite Rossetti's personal agnosticism and cultural skepticism, he was one of the most persistent practitioners of the art of copying. Throughout the 1860s and 1870s, he systematically churned out duplicates, triplicates, and septets. An instance of the latter is *Proserpine* (plate 63) which underwent eight incarnations between 1874 and 1882. As far as Rossetti was concerned, it was an 800-guinea picture and, remarkably, that is what his clients paid for the original and its subsequent copies.[166] The interest of dealers can be easily understood, but the readiness of collectors to pay top price for an unoriginal work of art is less comprehensible.

Most Aesthetic patrons tried to respect the prerogative of artists to supplement their incomes with repetitions, rationalizing that the practice had existed for centuries. The sympathetic Graham actually encouraged Burne-Jones to produce pot-boilers for Agnew's so that the artist might be free to concentrate his best energy on his series *The Briar Rose*.[167] Admittedly, there was a significant difference between the painstaking artist's copy and the smaller pot-boiler in watercolor that was dashed off for ready cash. Graham, nevertheless, was also partisan to the production of full-scale replicas in oil on canvas. He assured Rossetti:

> I have never conceived the possibility of perfect identity of reproduction – that were a *miracle* – they say advisedly no two leaves or flowers or human faces of all the countless millions of the ages were ever exactly alike, and with such works as these I should be well satisfied to anticipate that "*one star should differ from another in glory.*"[168]

Graciously giving the artist every benefit of the doubt, Graham turned a blind eye to Rossetti's most reliable but least creative source of income.

Less poetic and more utilitarian, Charles Rickards suspiciously viewed any type of copymaking as a lucrative cottage industry. He compromised in his patronage of Watts by limiting the artist to making only one replica of any painting in his collection. With his typical aplomb, Watts frequently disregarded this restriction, much to Rickards's chagrin.[169] The patron, of course, had the option of withdrawing his support from artists who refused to heed his wishes. But in the febrile atmosphere of Aesthetic

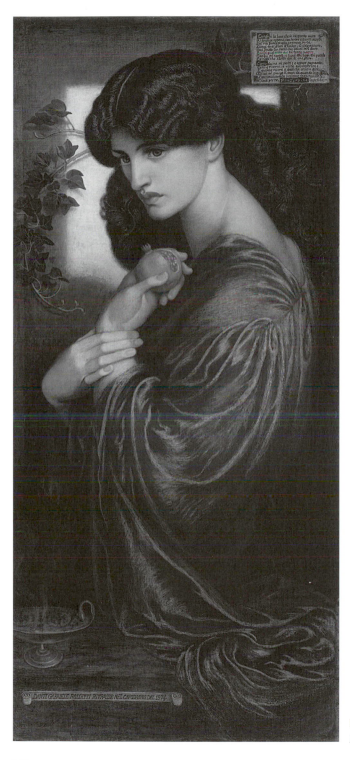

Plate 63. Dante Gabriel Rossetti,
Proserpine, 1874, oil on canvas

relationships, this was easier said than done. While each of the major Aesthetic patrons initially supported the habit to some extent, some eventually began to balk at the idea of the copy.

The reasons for this demurral stem from a complex intertwining of economic, psychological, and aesthetic impulses. Aesthetic patrons were among the most progressive and competitive businessmen of their generation, traits which finally made some of them reluctant to accept expensive imitations. Leyland, in particular, became concerned about the extent to which Rossetti's propensity for copying would undermine the economic worth of his collection. Rossetti disappointedly reported that he had refused him permission to copy *Sea-Spell* in 1878 because "it would considerably injure the value."[170] On another occasion, after the Liverpool magnate discovered that Rossetti had made a replica of *The Salutation of Beatrice* in his collection, he bought it in order to remove it from the market.[171] Leyland astutely realized that rarity had become an integral feature of commodity capitalism. American collectors of the next generation placed an even higher premium on uniqueness. Cornelius Vanderbilt, for instance, forbade artists to replicate the originals in his collection, recognizing that the rarefied object had become a marker of exclusivity.[172]

Artists' copies maintained their validity only as long as the Victorians believed that genius could be transferred with equanimity from the original to its mirror image. That possibility depended on an unquestioning faith in the origin of all creation. But once doubt began to blur the picture of reality, the copy ceased to be a logical part of the continuum. Foucault maintains that the notion of the original is conditioned by the spectator's knowledge and experience. He observes that, "This thin surface of the original, which accompanies our entire existence . . . is populated entirely by those complex mediations formed and laid down as a sediment in their own history."[173] As aesthetic and economic relationships were reassessed, patrons became more and more obsessed with possessing the solitary original. The psychology of ownership, in turn, made replicas less desirable as totems.

Possessiveness aided in dismantling the hegemony of the copy. The intimate bond between Aesthetic painter and patron often led the commissioners of works of art to feel as if they had participated in its creation. Believing that they had invested a part of themselves in a painting, such patrons experienced, to a greater degree than any ordinary collector, the intimacy of possession. That frame of mind evoked all of the protective instincts that come into play when a loved one is involved: jealousy, fear,

and anger. Take the case of pioneering Aesthetic patron James Leathart: he eagerly supervised the unfolding of the works of art he commissioned and freely offered his comments at all stages of execution. While he at first tolerated duplicates, as he became more and more involved in the art that entered his home, he rebelled. Thus when Leathart learned that Rossetti was planning to reproduce a subject in his collection, he cautioned the artist, saying, "In the state in which it was shown to me I should feel no jealousy of it whoever had it: but this would not be the case if it only differed from mine in size & price."[174] As his proprietorial instincts increased, Leathart became adamant that the artists whom he had nurtured abstain from making direct replicas of his prized possessions: he refused to allow Holman Hunt to copy *The Hireling Shepherd* and forbade Burne-Jones to replicate or even to photograph *The Merciful Knight*.[175]

The crude photographs that were available in the 1860s and 1870s would hardly seem to pose a threat to the sanctity of the original work of art. Critic William Michael Rossetti acknowledged that photography, by 1861, was taking over the role of transcription from engraving, yet he saw no cause for alarm as far as painting was concerned, insisting that "what photography cannot do is to colour and to invent."[176] Despite the disparity between the black-and-white print and the full-scale colored canvas, Leathart firmly refused to submit his originals to the scrutiny of the lens. He perhaps feared that the camera's ability to multiply meaning would nullify the authority of his originals. As Benjamin argues, "The presence of the original is the prerequisite to the concept of authenticity . . . that which withers in the age of mechanical reproduction is the aura of the work of art."[177] Midwife to his artists' creativity, Leathart was acutely sensitive to the distinctive features of each of his progeny. Not wanting his precious objects to be demeaned by overexposure, he implacably refused even the most eloquent pleas on behalf of reproduction.

The swing of the pendulum away from the replica created a sense of panic among collectors who owned well-known copies. George Rae, who had invested a good deal of money in Rossetti's replicas, was alarmed by the decision of the Liverpool Corporation in 1883 to banish copies from its municipal gallery. The banker defensively announced, "I would rather a wall hung with fine copies of the great men of old, than miles in length adorned with third and fourth rate mediocrities without a touch of genius in a square acre of them."[178] Was it Rae's genuinely Romantic regard for the "touch of genius," apparent to him even through the filtered gaze of the

copy, which gave replication its meaning? Was it satisfaction enough to own a piece of that genius, one flicker from the wizard's brush? Or, like the collectors who subscribed to Ruskin's defense fund, was Rae in his outburst attempting to protect his investment?

The timing of Rae's rationalization cannot be viewed apart from the Liverpool Corporation's firm stand in regard to the ubiquitous Victorian copy. It was clear by the year 1883 that the copy would never again be regarded in the same confident light. A further sign of its demise was the Royal Academy's belated realization that the replica did not constitute a separate work of art. The year 1883 also marked the extensive two-part Rossetti retrospective exhibition at Burlington House and the Burlington Fine Arts Club following the artist's death the preceding year. Since Rossetti had consistently balked at displaying his work during his lifetime, Royal Academy President Sir Frederic Leighton made every effort to allow the public finally to see the full range of his oeuvre. In the process of contacting Rossetti's major patrons, Leighton was astounded to encounter so many identical canvases, even in the finest collections. He expressed his concern to the artist's brother, saying, "the question of duplicates is my great practical stumbling block because all Gabriel's duplicates or many are a little varied and to admit one makes it even more difficult than it is to refuse others."[179] Despite his misgivings, Leighton found it impossible to avoid the problem. Perhaps because he was reluctant to offend patrons as distinguished as Graham, the Royal Academician reluctantly capitulated to the copy on this occasion.

The effect did not go unnoticed. After viewing the Rossetti retrospective, artist William Bell Scott lost no time in reporting the extent of the artist's indiscriminate copymaking to James Leathart. He critically remarked: "Rossetti never had any scruple in making replicas, triplicas, quadruplicas, in fact he only attained to the command of a subject by repeating it, so in these two exhibitions one sees the same subject over and over again."[180] Bell Scott's disenchantment with Rossetti's production runs at a deeper level than mere replication. His criticism points to the repetitiousness of the artist's entire oeuvre as a larger form of replication.

Rossetti's recurring images of sensuous women join Albert Moore's redundantly passive females and Burne-Jones's repetitiously somnambulant figures to produce a body of Aesthetic works that is remarkable for its similarity. In contrast to French modernism's rupture with the past and its pursuit of the new, the English avant-garde was content to rework its

images in gentle harmony with tradition. The artists of the Aesthetic movement fulfilled Nietzsche's prediction that, "modernity cannot assert itself without being swallowed up and reintegrated into a regressive historical process."[181] In England, however, the past was not viewed as a foe, but as a dependable source of solace in a time of need.

Notes

1 See chapter 2 and Ivan Melada, *The Captain of Industry in English Fiction, 1821–1871* (Albuquerque: 1970).

2 Michel Foucault, *The Archaeology of Knowledge*, transl. A. M. Sheridan Smith (New York: 1972), p. 9. Roger Chartier likewise advocates the study of "the passage of one system of representation to another" as a "drastic break (in branches of knowledge but also in the very structures of thought)." Chartier, "Intellectual History or Sociocultural History? The French Trajectories," in *Modern European Intellectual History, Reappraisals and New Perspectives*, ed. Dominick LaCapra and Steven L. Kaplan (Ithaca: 1982), p. 31.

3 Howard Mumford Jones, "1859 and the Idea of Crisis," in *1859: Entering an Age of Crisis*, ed. Philip Appelman, W. A. Madden, and M. Wolff (Bloomington: 1959), p. 13. For the crisis sparked in 1859, see also Asa Briggs, *A Social History of England* (1983; rpt. Harmondsworth: 1985), p. 229.

4 See William Madden, "The Burden of the Artist," in *1859: Entering an Age of Crisis*, ed. Philip Appelman, W. A. Madden, and M. Wolff (Bloomington: 1959), p. 258.

5 J. Beavington Atkinson, "London Exhibitions – Conflict of the Schools," *Blackwood's* 86 (Aug. 1859), 127–28, and *Art Journal* (1858), 161.

6 John Guille Millais, *The Life and Letters of Sir John Everett Millais*, 2 vols. (London: 1899), I, 335.

7 For Rossetti's interest in Venetian painting, see Dianne Sachko Macleod, "Dante Gabriel Rossetti and Titian," *Apollo* 121 (Jan. 1985), 36–39. He described *Bocca Baciata*'s "Venetian aspect," in a letter to the painting's owner, artist George Price Boyce, on 5 Sept. 1859. See Virginia Surtees, *The Paintings and Drawings of Dante Gabriel Rossetti, (1828–1882): A Catalogue Raisonné*, 2 vols. (Oxford: 1971), I, 69.

8 Frederic George Stephens, *Dante Gabriel Rossetti* (London: 1894; rpt. 1908), p. 128.

9 Algernon Charles Swinburne to William Bell Scott, 16 Dec. 1859, *The Swinburne Letters*, ed. Cecil Y. Lang, 6 vols. (New Haven: 1959), I, 27; Arthur Hughes to William Allingham (Feb. 1860), *Letters to William Allingham*, ed. Helen Allingham and E. B. Williams (London: 1911), p. 67.

10 Hughes, *Letters to Allingham*, ed. Allingham and Williams, p. 67. See Giovanni Boccaccio, *The Decameron: The First Five Days*, transl. Richard Aldington, 2 vols. (Westminster: 1954), I, 146. Rossetti inherited several volumes by Boccaccio from his father. See William Michael Rossetti, "Books Belonging to Dante G. Rossetti," Special Collections, University of British Columbia.

11 William Holman Hunt to Thomas Combe, 12 February 1860, in Surtees, *Rossetti Catalogue Raisonné*, I, 69.

12 Rossetti to George Price Boyce, 2 October 1862, University College, London.

13 Lynda Nead, *Myths of Sexuality: Representations of Women in Victorian Britain* (Oxford: 1988), p. 57.

14 Holman Hunt to Combe, 12 February 1860, in Surtees, *Rossetti Catalogue Raisonné*, p. 69.

15 Griselda Pollock, "Woman as Sign: Psychoanalytic Readings," in her *Vision and Difference: Feminity, Feminism and the Histories of Art* (London and New York: 1988), p. 124.

16 Whistler, "Ten O'Clock Lecture" (1882), in *The Gentle Art of Making Enemies* (New York: 1967), p. 136.

17 Swinburne, "William Blake," in *Works*, ed. Sir Edmond Gosse and T. Wise, 20 vols. (London: 1925–27), XVI, 137. William Michael Rossetti likewise maintained that an artist's purpose was simply to create "delight in a thing or in object of sight." See *Saturday Review* (15 May 1858), 300.

18 Swinburne, *Notes on the Royal Academy Exhibition* (London: 1868), p. 51.

19 Monroe Beardsley, *Aesthetics: Problems in the Philosophy of Criticism* (New York: 1958; rpt. 1981), p. lxii. See also pp. 561–64.

20 Pater, preface to *The Renaissance* (London: 1924), p. xi.

21 Francis Palgrave, *Handbook to the International Exhibition* (London: 1862), p. 9.

22 Peter Bailey, *Leisure and Class in Victorian England* (London: 1978), pp. 65–66.

23 Peter Gay, *The Bourgeois Experience: Victoria to Freud*, 4 vols. (Oxford: 1984–95), I, 459.

24 Pierre Bourdieu, *Distinction: A Social Critique of the Judgement of Taste*, transl. Richard Nice (Cambridge, Mass.: 1984), p. 5.

25 Walter Benjamin, *Reflections: Essays, Aphorisms, Autobiographical Writings*, transl. Edmund Jephcott (New York: 1978), p. 155.

26 Rossetti to Mrs. Gabriele Rossetti, 23 December 1880, *Letters of Dante Gabriel Rossetti*, ed. Oswald Doughty and J. R. Wahl, 4 vols. (Oxford: 1965–67), IV, 1828.

27 Leathart, however, did not purchase *Work* from the ill-fated Thomas Plint's estate, but ordered a reduced replica of his own from the artist.

28 I am grateful to Dr. Gilbert L. Leathart for providing me with a print of this photograph and a copy of his grandfather's correspondence.

29 For the death of his child, see Laing Art Gallery, *Paintings from the Leathart Collection* (Newcastle-upon-Tyne: 1968), p. 3. Leathart's professional difficulties are described in *DBB*, ed. David J. Jeremy, 5 vols. (1984–86), III, 698–700, and D. J. Rowe, *Lead Manufacturing in Britain* (London: 1983), pp. 128–32.

30 Ford Madox Brown to James Leathart, 6 January 1864, Leathart Papers, Special Collections, University of British Columbia.

31 F. G. Stephens, *Athenaeum* (13 Sept. 1873), 342.

32 Macleod (1989a), pp. 188–208, and (1989b), pp. 9–37.

33 Simon J. Bronner, "Reading Consumer Culture," in *Consuming Visions: Accumulation and Display of Goods in America, 1880–1920*, ed. Simon J. Bronner (New York: 1989), p. 14.

34 John Stuart Mill, *On Liberty* (London: 1859, rpt. Boston: 1864), p. 141.

35 For this term see Jean-Christophe Agnew, "A House of Fiction: Domestic Interiors and the Commodity Aesthetic," in *Consuming Visions: Accumulation and Display of Goods in America, 1880–1920*, ed. S. Bronner (New York: 1989), pp. 133–55

36 (Fitz-James Stephen), "Luxury," *Cornhill* 2 (Sept. 1860), 347.

37 For Hume, see Andrew Hemingway, "The 'Sociology' of Taste in the Scottish Enlightenment," *Oxford Art Journal* 12 (1989), 12–13. Thackeray's ideas are expressed throughout *The Four Georges* (London: 1856). See also Barbara Hardy, *The Exposure of Luxury: Radical Themes in Thackeray* (London: 1972).

38 W. J. Loftie, *A Plea for Art in the House* (London: 1876; rpt. New York: 1978),

p. 89. For Loftie see *Who was Who 1897–1916*, p. 436.

39 Gay, *Bourgeois Experience*, I, 439.

40 These scions were William Alexander, Aglaia Coronio, Alexander and Constantine Ionides, F. S. Ellis, Cyril Flower, Col. William Gillum, Sir John Gray Hill, T. H. McConnel, George Rae, Philip Rathbone, James Anderson Rose, Thomas Eustace Smith, J. H. Trist, and Leonard Valpy. With the exception of the self-made Leathart and Leyland, who are discussed below, the remaining collectors of Aesthetic art were second-generation inheritors of wealth. They include John Bibby, William Connal, Frederick Craven, William Graham, Charles Mitchell, Charles Rickards, Joseph Ruston, Alexander Stevenson, William Turner, and Albert Wood. I have been unable to trace the social origins of John Burnett, William Coltart, Walter Dunlop, Clarence Fry, John Mitchell, and Henry Virtue Tebbs.

41 The amateur painters were Coltart, Gillum, Trist, and Wood, while Flower practiced photography on an amateur level. Mrs. William Turner was an embroiderer, as was Aglaia Coronio, who did bookbinding as well. Alice Stevenson was an exhibiting watercolorist and Caroline Hardy Hill was a muralist. Leyland's daughter married artist Valentine Prinsep, while Philip Rathbone counted an architect and ceramist among his sons. Finally, H. V. Tebbs was married to the sister of architect John Seddon.

42 Constance Battersea, *Reminiscences* (London: 1923), p. 173.

43 See Eugene Lunn, *Marxism and Modernism* (Berkeley: 1982), pp. 34–35.

44 Since neither Howard nor Wharncliffe were members of the middle-class, I have not included them in my appendix. For Howard, see Carlisle Art Gallery, *George Howard and his Circle* (Carlisle: 1968) and Virginia Surtees, *The Artist and the Autocrat* (London: 1988). Wharncliffe is listed in Boase and discussed in Alison Inglis, "Sir Edward Poynter and the Earl of Wharncliffe's Billiard Room," *Apollo* 126 (Oct. 1987), 249–55.

45 Surtees, *Artist and Autocrat*, p. 87.

46 Walter Crane, *An Artist's Reminiscences* (London: 1907), pp. 172–73.

47 For Graham's background, see Boase, *WWMP*, and Frances Graham Horner, *Time Remembered* (London: 1933).

48 Graham to Burne-Jones, 1884, cited in Oliver Garnett, "William Graham: Pre-Raphael Collector and Pre-Raphaelite Patron," paper delivered at Paul Mellon Centre for Studies in British Art, London, 21 March 1985, p. 4. I am grateful to the author for providing me with a typescript of his talk.

49 Graham to Rossetti, 21 September 1875, Angeli-Dennis Papers, Special Collections, University of British Columbia.

50 *Glasgow Herald*, 16 July 1885.

51 Graham to Rossetti, 21 September 1875, University of British Columbia.

52 This incident is reported by Graham's daughter, Frances Horner, in *Time Remembered*, p. 6.

53 Burne-Jones cited in *ibid.*, p. 7, and Charles Augustus Howell to Rossetti, 7 July 1873, in *The Owl and the Rossettis*, ed. C. L. Cline (University Park, Penn.: 1978), no. 261.

54 Georgiana Burne-Jones, *Memorials of Edward Burne-Jones*, 2 vols. (London: 1904), I, 296.

55 Werner Muensterberger, *Collecting: An Unruly Passion* (Princeton: 1994), p. 9.

56 Fry to Rossetti, 10 March 1877, *Rossetti Letters*, ed. Doughty and Wahl, IV, 1481. For a description of Redcourt, George Rae's home, see A. G. Temple, *Guildhall Memories* (London: 1918), p. 105.

57 Rae to Rossetti, 5 March 1866, University of British Columbia.

58 Théodore Duret, "Les Expositions de Londres, D.G. Rossetti," *Gazette des Beaux-Arts* (July 1883), 52, and Gabriel Mourey, *Passé le détroit* (1895), transl. Georgina Latimer (London: 1896), pp. 93–94.

59 Frederick Myers, "Rossetti and the Religion of Beauty," *Cornhill Magazine* 47 (1883), 213.

60 Julia Margaret Cameron, *Victorian Photographs of Famous Men and Fair Women*, with an introduction by Virginia Woolf and Roger Fry (London: 1926; rpt. 1970), p. 10.

61 Theodore Child, "A Pre-Raphaelite Mansion," *Harper's* 82 (Dec. 1890), 91.

62 See Mabel Tylecote, *The Mechanics' Institutes of Lancashire and Yorkshire before 1851* (Manchester: 1957). Leyland's background is detailed in his obituary, *Liverpool Daily Post*, 6 January 1892, and in J. A. Picton, *Memorials of Liverpool*, 2 vols. (Liverpool: 1907), I, 394 and II, 259. A more recent account appears in M. Susan Duval, "F. R. Leyland: A Maecenas from Liverpool," *Apollo* 124 (Aug. 1986), 110–16.

63 On Bibby & Sons, see *The Rossetti–Leyland Letters*, ed. Francis Fennell Jr. (Athens, Ohio: 1978), pp. xii–xiii.

64 Leyland to Rossetti, 11 November 1872, *ibid.*, p. 35.

65 Charles Augustus Howell to Rossetti, 15 November 1872, *Owl and Rossettis*, ed. Cline, no. 163.

66 Chartier, "Intellectual History," p. 32.

67 Fanny Leyland died in childbirth at age twenty in 1880. On this and Leyland's divorce, see Duval, "F. R. Leyland," p. 115.

68 No memorial service was performed after his death, only an internment. See *Liverpool Mercury*, 9 January 1892. For the séances, see *Diary of William Michael Rossetti, 1870–1873*, ed. Odette Bornand (Oxford: 1977), p. 20.

69 Joseph Kestner, *Mythology and Misogyny* (Madison: 1989), pp. 18–19.

70 Leyland to Rossetti, 14 March 1880, *Rossetti–Leyland Letters*, ed. Fennell, p. 85.

71 Susan Stewart, *On Longing: Narratives of the Miniature, the Gigantic, the Souvenir, the Collection* (1984; rpt. Durham, N.C.: 1993), p. 158.

72 See Leonore Davidoff and Catherine Hall, "The Architecture of Public and Private Life: English Middle-Class Society in a Provincial Town 1780–1850," in *The Pursuit of Urban History*, ed. Derek Fraser and Anthony Sutcliffe (London: 1983), p. 333.

73 Temple, *Guildhall Memories*, p. 211.

74 I am grateful to W. A. C. Coltart of Hastings, New Zealand for generously giving me prints of family photographs, an annotated copy of the 1917 sale catalogue of Eleanor Coltart's possessions, and a list of paintings which the family still owns. I have been unable to locate descendants of Jonathan Tong.

75 *Catalogue of the Valuable Household Appointments at Woodleigh, 50 Park Road, Claughton, Birkenhead*, Brown & Brown, 30 October – 5 November 1917; and Eleanor Tong to L. M. Lamont in *Thomas Armstrong, CB: A Memoir*, ed. L. M. Lamont (London: 1912), p. 11.

76 Lamont, *Armstrong*, ed. Lamont, p. 33 and Brown and Brown, *Catalogue*, lots 231–376.

77 Graham to Rossetti, 26 March 1873, University of British Columbia.

78 Rossetti to Julia Rae, 15 March 1866 and to George Rae, 11 December 1873, *ibid.*

79 1881 Census Report. I am indebted to Hew Shannon Stevenson for giving me a synopsis of his research into his family's history.

80 Alexander C. Ionides, *Ion: A Grandfather's Tale*, 2 vols. (Dublin: 1927), I, 46.

81 Whistler made these remarks to Punch cartoonist George Du Maurier, see Leonée Ormond, *George Du Maurier* (London: 1969), p. 100.

82 I must extend my thanks to Lord Roskill for directing me to his cousin, Roderick Enthoven, who supplied me with details of the Smith family's history, including the fact that Mary Dalrymple Smith was co-heir of her father's estate. I also wish to thank another descendant, Mrs. Edward Douglas-Home, for her help in tracing Leighton's portrait of Eustacia Smith to Sotheby's.

83 Crane, *Reminiscences*, pp. 164–67; *Builder* (6 May 1876), 425; and Helen Smith, *Decorative Painting in the Domestic Interior in England and Wales, c. 1850–1890* (New York: 1984), no. 3.

84 Surtees, *Rossetti Catalogue Raisonné*, I, no. 224A; for the Watts, see Trustees of the Faringdon Collection, *The Faringdon Collection* (1975), no. 90 (the Smiths also owned Watts's *Choosing*; see Wilfrid Blunt, *"England's Michelangelo": A Biography of George Frederic Watts* [London: 1975], p. 11); Lamont, *Armstrong*, pp. 15–16; and Richard and Leonée Ormond, *Lord Leighton* (London: 1975), p. 72.

85 Julian Hawthorne, *Shapes That Pass: Memories of Old Days* (Boston: 1928), pp. 134–37.

86 See, for instance, *The Nice Woman and her Sisters: Feminism and the Theatre*, ed. Vivien Gardner and Susan Rutherford (Ann Arbor: 1991).

87 Laura Mulvey, "Visual Pleasure and Narrative Cinema," in *Feminism and Film Theory*, ed. Constance Penley (New York: 1988), p. 61. See also Rosemary Betterton, "How do Women Look? The Female Nude in the Work of Suzanne Valadon," in *Looking On: Images of Femininity in the Visual Arts and Media*, ed. Rosemary Betterton (New York: 1987), pp. 217–34; and Patricia Mathews, "Returning the Gaze: Diverse Representations of the Nude in the Art of Suzanne Valadon," *Art Bulletin* 123 (Sept. 1991), 415–30.

88 *The Diaries of George Price Boyce*, ed. Virginia Surtees (London: 1980), pp. 62 and 117. On Dilke's affairs, see Stephen Gywnn and Gertrude M. Tuckwell, *The Life of the Rt. Hon. Sir Charles W. Dilke*, 2 vols. (London: 1917); Betty Askwith, *Lady Dilke* (London: 1969); and Roy Jenkins, *Sir Charles Dilke: A Victorian Tragedy* (London: 1965).

89 For a version of this argument, see Terry Eagleton, *The Ideology of the Aesthetic* (Oxford: 1990), pp. 8–9.

90 Frances Dawson Leyland (1834–1910) was the daughter of a master mariner from Liverpool. The matter of her affair with Whistler is alluded to in Luke Ionides, "Memories," *Transatlantic Review* 1 (Jan. 1924), 47. After learning that Whistler had been seen at Lords' Cricket Ground with his wife, Leyland threatened to horsewhip the artist. See Hilary Taylor, *Whistler* (New York: 1978), p. 89.

91 Rossetti complained in a letter to his mother that Frances Leyland was unfairly "getting £2,000 a year out of him besides £3,500 down for house and equipage" (17 December 1879, *Rossetti Letters*, ed. Doughty and Wahl, IV, 1662). For Rossetti's affair with Jane Morris, see *Dante Gabriel Rossetti and Jane Morris: Their Correspondence*, ed. John Bryson and J. C. Troxell (London: 1976), especially letters nos. 15, 17, 70, and 122.

92 See Sarah Burns, "The Price of Beauty: Art, Commerce, and the Late Nineteenth-Century American Studio Interior," in *American Iconology*, ed. David C. Miller (New Haven: 1993), pp. 209–38, and Albert Boime, "Sargent in Paris and London: A Portrait of the Artist as Dorian Gray," in *John Singer Sargent*, ed. Patricia Hills (New York: Whitney Museum of American Art, 1986), 75–109.

93 See Kathleen D. McCarthy, *Women's Culture: American Philanthropy and Art, 1830–1930* (Chicago: 1991).

94 Martin Harrison and Bill Waters, *Burne-Jones* (London: 1973), p. 117, and Penelope Fitzgerald, *Edward Burne-Jones* (London: 1975), pp. 76ff.

95 Burns, "Price of Beauty," p. 209.

96 Val Prinsep, "The Private Collections of London: The Late Mr. Frederick Leyland's in Prince's Gate," *Art Journal* (May 1892), 134.

97 Julia Atkins, "The Ionides Family," *Antique Collector* (June 1987), 92, and Burne-Jones, *Burne-Jones*, II, 196.

98 Philip Henderson, *William Morris: His Life, Work and Friends* (New York: 1967), pp. 112ff.

99 See Robert Walker, "Private Picture Collections in Glasgow and West of Scotland: Mr. William Connal's Collection of Works by Albert Moore," *Magazine of Art* 17 (1894), 367 and 335.

100 For Sandys and Flower, see D. E. Shoenhen, "Frederick Sandys's *Amor Mundi*," *Apollo* 127 (May 1988), 318; Gillum's support of Rossetti is mentioned by the artist during the years 1860–64 in *Rossetti Letters*, ed. Doughty and Wahl, I, 375 and II, 499.

101 Rossetti to Howell, *Owl and Rossettis*, ed. Cline, no. 313.

102 See *Rossetti-Leyland Letters*, ed. Fennell, p. xvii.

103 Loftie, *Art in the House*, p. 54.

104 Thoby Prinsep was the son of a military cadet who had served in India, where he remained to earn a fortune in the indigo industry and by introducing cotton printing into Bengal. See *DNB.*

105 For the Pattle family, see Blunt, *Watts*, p. 70. Among Sara Pattle's six sisters were Julia Margaret Cameron and Virginia, Countess Somers.

106 J. M. Bourne, *Patronage and Society in Nineteenth-Century England* (London: 1986), p. 120.

107 See Blunt, *Watts*, pp. 28ff.

108 G. F. Watts to C. H. Rickards, excerpted in M. S. Watts, *George Frederic Watts: The Annals of an Artist's Life*, 3 vols. (London: 1912), I, 247.

109 For Rickards, see *Manchester Courier*, 30 December 1876; *Manchester Guardian*, 9 July 1886; and Elizabeth Conran, "Art Collections," in *Art and Architecture in Victorian Manchester*, ed. John H. G. Archer (Manchester: 1985), p. 75.

110 Watts to Rickards, 28 March 1873, in Watts, *Watts*, I, 276.

111 Blunt, *Watts*, p. 142.

112 Rickards to Watts, 8 July 1874, Beinecke Library, Yale University. I am grateful to Professor Lynn Matteson for sharing his research on Watts's unpublished letters with me. For *The Court of Death*, see Whitechapel Art Gallery, *G. F. Watts, 1817–1904* (London: 1974), no. 34. Rickards refers to the painting by its initial title, *The Angel of Death*. See Watts, *Watts*, I, 307.

113 Watts to Rickards, undated, in Watts, *Watts*, I, 308.

114 Blunt, *Watts*, p. 46.

115 E. R. Pennell and J. Pennell, *The Life of James McNeill Whistler*, 2 vols. (London: 1908), I, 166.

116 Rossetti to John Heugh, 14 September 1865, *Rossetti Letters*, ed. Doughty and Wahl, II, 571.

117 Christopher Kent, "'Short of Tin' in a Golden Age: Assisting the Unsuccessful Artist in Victorian England," *Victorian Studies* 32 (Summer 1989), 505.

118 *Liverpool Courier*, 23 November 1895.

119 P. H. Rathbone, *Realism, Idealism and the Grotesque in Art: Their Limits and Functions* (Liverpool: 1877), cited in Edward Morris, "Philip Henry Rathbone and the Purchase of Contemporary Foreign Paintings for the Walker Art Gallery, Liverpool, 1871–1914," *Annual Report and Bulletin*, Walker Art Gallery, Liverpool, 6 (1975–76), 65.

120 Graham to Rossetti, 1 September 1873, University of British Columbia.

121 Dickens, cited in Kent, "'Short of Tin,'" *Victorian Studies*, p. 491.

122 Hope, cited *ibid.*, p. 504.

123 Rickards later apologized to Watts in a letter dated 5 July 1877, saying, "[I] feel ashamed that I should have even thought of asking you to take a lower price for the Dray Horses." Beinecke Library, Yale.

124 Pennell and Pennell, *Whistler*, I, 208.

125 *Rossetti Letters*, ed. Doughty and Wahl, II, 516 and IV, 1482 and *Owl and Rossettis*, ed. Cline, no. 66.

126 David Park Curry, *James McNeill Whistler at the Freer Gallery of Art* (Washington, D.C.: 1984), p. 55.

127 Pennell and Pennell, *Whistler*, I, 204.

128 Robin Spencer, "Whistler's First One-Man Exhibition Reconstructed," *The Documented Image: Visions in Art History*, ed. Gabriel P. Weisberg, L. S. Dixon, and A. B. Lemke (Syracuse: 1987), pp. 28–29.

129 Graham to Rossetti, 1868, University of British Columbia.

130 Graham to Rossetti, 18 December 1873, *ibid.*

131 Agnew, pp. 26 and 33–34.

132 Rossetti to Fry, 18 August 1875, *Rossetti Letters*, ed. Doughty and Wahl, III, 1344.

133 Edward Edwards to Henri Fantin-Latour, May 1870, Douglas Druick and Michel Hoog, *Fantin-Latour* (Ottawa: National Gallery of Canada, 1983), p. 118.

134 At the far left is Rossetti's *Dante's Dream at the Time of the Death of Beatrice* (ex-Graham) which hangs next to Watts's *Bianca* (ex-Rickards) on the lower register and, separated by John Linnell's *Arcadian Shepherds*, is Burne-Jones's *Mirror of Venus* (ex-Leyland). Ruston also owned Burne-Jones's *Chant d'Amour* (ex-Graham) and Rossetti's *Veronica Veronese* (ex-Leyland) and *La Ghirlandata* (ex-Graham). See Claude Phillips, "The Ruston Collection," *Magazine of Art* 18 (1894), 37–44 and 97–101.

135 Miller sold a watercolor version of Rossetti's *Annunciation* to Dunlop. See

Surtees, *Rossetti Catalogue Raisonné*, I, no. 131. For Flower's sales to Freer, see Curry, *Whistler*, pp. 25–26. In a letter dated 9 March 1868, Trist offered Leathart £150 for his Moore, Leathart Papers, University of British Columbia.

136 For Rossetti and Shields, see *Life and Letters of Frederic Shields*, ed. Ernestine Mills (London: 1912), *passim*. His relationship with Scott is disclosed in William E. Fredeman, "The Letters of Pictor Ignotus: William Bell Scott's Correspondence with Alice Boyd, 1859–1884," *Bulletin of the John Rylands University Library* (Autumn 1975), 82, and in the Leathart Papers, University of British Columbia.

137 For Charles Fairfax Murray, see Richard Ormond, "Victorian Paintings and Patronage in Birmingham," *Apollo* 87 (April 1968), 246–48, and Fitzgerald, *Burne-Jones*, pp. 100ff.

138 Legros's advice to Ionides is discussed in Alexander Seltzer, "Alphonse Legros: The Development of an Archaic Visual Vocabulary in Nineteenth-Century Art," unpublished Ph.D. diss., Graduate School of the State University of New York at Binghamton, 1980, pp. 176–78. For Scott's advice to Leathart, see Macleod (1989b), pp. 19–20.

139 On Howell and Ruskin, see Helen Rossetti Angeli, *Pre-Raphaelite Twilight: The Story of Charles Augustus Howell* (London: 1954), and *Owl and Rossettis*, ed. Cline, pp. 4–8, where the Miller connection is also described in letter no. 48.

140 Rossetti to William Michael Rossetti, 10 July 1873, *Rossetti Letters*, ed. Doughty and Wahl, III, 1188.

141 G. C. Williamson, *Murray Marks and his Friends* (London: 1919), p. 119.

142 Howell's intervention in the affair is described in Fitzgerald, *Burne-Jones*, pp. 112ff. For an overview, see Eileen Cassavetti, "The Fatal Meeting and the Fruitful Passion," *Antique Collector* 60 (March 1989), 34–45. Regarding Whistler's cabinet, see Williamson, *Murray Marks*, pp. 128–32.

143 *Owl and Rossettis*, ed. Cline, p. 11.

144 *Ibid.*, pp. 23–24, and Angeli, *Pre-Raphaelite Twilight*, pp. 241–44.

145 Whistler, cited in Pennell and Pennell, *Whistler*, I, 113.

146 John Aldam Heaton's sister married Ellen Heaton's brother, Dr. John Deakin Heaton. On J. A. Heaton, see *Owl and Rossettis*, ed. Cline, p. 8, and Malcolm Hardman, *Ruskin and Bradford* (Manchester: 1986), pp. 47–49 and 198–210.

147 The proposed painting, *Ship of Love*, was intended as a companion to the five pictures by Rossetti which Dunlop had previously bought from dealers and other collectors. The artist explained to Madox Brown that, "under the auspices of Heaton, who dictates letters for the purpose, I am stirring up the demon Dunlop, who shows a new horn, hoof, tusk, or tail, at every new step of the correspondence. H[eaton] advises me to go to law with him, but I don't think I shall." *Rossetti Letters*, ed. Doughty and Wahl, II, 565.

148 Williamson, *Murray Marks*, pp. 98–99.

149 Stephens, "The Grosvenor Gallery Exhibition," *Athenaeum* (5 May 1877), 583.

150 J. Comyns Carr, "Painters of the Day – Mr. E. Burne-Jones," *The Globe* (19 May 1873), cited in Barrie Bullen, "The Palace of Art: Sir Coutts Lindsay and the Grosvenor Gallery," *Apollo* 102

(November 1975), 356. See also J. Comyns
Carr, *Some Eminent Victorians* (London:
1908).

151 Bullen, "Palace of Art," p. 353.

152 W. S. Gilbert and A. S. Sullivan, *Patience*
(London: 1881).

153 For the question of music, see C. E. Hallé,
*Notes from a Painter's Life, Including the
Founding of Two Galleries* (London: 1909),
p. 150.

154 Richard Dorment, *Alfred Gilbert* (London
and New Haven: 1985), p. 91.

155 Ruskin, "Letter 79: Life Guards of New
Life," *Fors Clavigera*, 7 (2 July 1877), in *The
Complete Works of John Ruskin*, ed. E. T.
Cook and Alexander Wedderburn, 39
vols. (London: 1903–12), XXIX, 160.

156 For an expansion of this argument, see my
"The Dialectics of Modernism and
English Art," *British Journal of Aesthetics* 35
(Jan. 1995), 1–14.

157 Frith, cited in Linda Merrill, *A Pot of Paint:
Aesthetics on Trial in Whistler v. Ruskin*
(Washington, D.C.: 1992), p. 177.

158 Shearer West, "Tom Taylor, William
Powell Frith, and the British School of
Art," *Victorian Studies* 33 (Winter 1990), 322.

159 Burne-Jones, cited in Merrill, *Pot of Paint*,
p. 172.

160 Burne-Jones to George Howard, *c.*
November 1878, in Mary M. Lago, ed.,
*Burne-Jones Talking, his Conversations,
1895–98* (London: 1982), p. 70.

161 Burne-Jones in Merrill, *Pot of Paint*, p. 174.
For Whistler's remark, see *ibid.*, p. 148.

162 See James H. Maroney, "Whistler's
*Nocturne in Black and Gold: The Falling
Rocket*," *Auction* (Feb. 1970), 33.

163 For the testimonies of William Michael
Rossetti and Albert Moore, see Merrill, *Pot
of Paint*, pp. 154–59.

164 Druick and Hoog, *Fantin-Latour*, p. 117.

165 Jean Baudrillard, "The Precession of
Simulacra," in *Art After Modernism:
Rethinking Representation*, ed. Brian Wallis
(New York: 1984), p. 256.

166 *Proserpine*'s complex history is outlined in
Surtees, *Rossetti Catalogue Raisonné*, I, no.
233, pp. 131–34. Leyland was the first to
commission the work, but after it was
damaged in transit, Rossetti sold the
repaired original to William Turner and
painted a copy for Leyland which is now
in the Tate Gallery.

167 See Graham to Burne-Jones, May 1885, in
Oliver Garnett, "William Graham and the
Patrons of Burne-Jones," in *Burne-Jones:
Dal Preraffaelismo al Simbolismo*, ed. M.
Benedetti and G. Piantoni (Rome: Galleria
Nazionale d'Arte Moderna, 1986), p. 12.

168 Graham to Rossetti, 7 November 1871,
University of British Columbia.

169 Rickards to Watts, 15 February 1876,
Beinecke Library, Yale.

170 Leyland, cited by Rossetti in a letter to
Leonard Valpy, 6 November 1878,
University of British Columbia.

171 *Rossetti-Leyland Letters*, ed. Fennell, p. 107,
n. 2 to letter 134.

172 See Albert Boime, "America's Purchasing
Power and the Evolution of European
Art in the Late Nineteenth Century," in
*Saloni, gallerie, musei e loro influenza sullo
sviluppo dell'arte dei secoli XIX e XX*, ed.
Francis Haskell (Bologna: 1979),
p. 127.

173 Michel Foucault, *The Order of Things: An
Archaeology of the Human Sciences* (1966;
rpt. New York: 1973), pp. 330–31.

174 Leathart to Rossetti, 15 September 1862,
University of British Columbia. The work
in question was *Paolo and Francesca da*

Rimini. Ironically Leathart's watercolor was itself a replica of a work Rossetti had painted for Ruskin. See Surtees, *Rossetti Catalogue Raisonné*, no. 75 and R. 1, pp. 36–39.

175 Leathart to Holman Hunt, 23 June 1886 and letter to Burne-Jones, n.d., Leathart Papers, University of British Columbia.

176 William Michael Rossetti, "Limitations of Art by Photography," *Fraser's* 64 (Nov. 1861), 591.

177 Walter Benjamin, *Illuminations*, ed.

Hannah Arendt, transl. Harry Zohn (New York: 1969), pp. 220–21.

178 Rae to F. G. Stephens, 9 April 1885, Bodleian Library, Oxford.

179 Leighton to W. M. Rossetti, 19 November 1882, University of British Columbia.

180 W. B. Scott to Leathart, 18 January 1883, University of British Columbia.

181 Nietzsche, cited in Robert Gooding-Williams, "Nietzsche's Pursuit of Modernism," *New German Critique* 41 (Spring-Summer 1987), 102.

Epilogue: mimesis versus modernism

Having achieved a level of prosperity unimaginable at the opening of the nineteenth century, the late-Victorian middle class was desperate to keep it. But the harsh realities of economic competition from America, an agricultural depression, and urban decay, combined with the vexing question of Irish Home Rule, were alarming indicators that the magic formula for success contained a hidden toxic ingredient for which there was no proven antidote. "Outwardly stable and triumphant and in complete moral and ideological control of their society," the members of the middle class, as Harold Perkin observes, were also "inwardly divided and confused and crumbling in their conviction of moral superiority and their faith in their class ideal."[1] Faced with a social and cultural crisis in identity, the middle class sacrificed its cohesion in a rush to locate a remedy for its ills.

To some, the sensible solution seemed to be a return to the simpler lifestyle that existed before the Industrial Revolution. Nostalgia for the uncomplicated social structure of pre-industrial England induced them to relinquish the hard-won independence of their class and seek comfort either in a fantasy of rural life or in the more sophisticated arms of the "aristocratic embrace." Others, refusing to accept that industrial growth was harmful, vigorously pursued the entrepreneurial ideal. The result was a middle class in disarray: defections from its upper registers left idle dreamers and social climbers at the mercy of fiercely ambitious moneymen.

Yet each group believed that its behavior was consistent with the English ideal. "Englishness," according to the editors of a recent volume on the subject, "has had to be made and re-made in and through history, within available practices and relationships, and existing symbols and ideas."[2] The aggressive capitalists could cite early- or mid-Victorian precedents for their conduct, while those who sought upward mobility argued that they simply wanted to resemble the most ancient and venerable of models. The rationale of that segment of the middle class which set out to recast the nature of "Englishness" in a pre-industrial mold, however, had wider social implications.

336

The late-Victorian equation of "Englishness" with the rustic, untrammeled countryside is a demonstration of Eric Hobsbawm's concept of "invented traditions." According to Hobsbawm, a fictional, but reassuring sense of continuity with the past is typically manufactured when a rapid transformation of society weakens or destroys social patterns. At these times, he argues, dominant groups often enlist history to legitimate their actions by implying cohesion with the past.[3] While one can easily demonstrate that the rural identification was used to offset the grimy, crowded, and oppressed image of England by politicians, writers, and even authors of dictionaries, it was not exclusively the ideological tool of those in power. Socialists, too, embraced the rural vision, as an instrumental part of their critique of the insidious modern metropolis, conveniently ignoring how narrowly inscribed the existence of the peasantry was before the Industrial Revolution.[4] With this unusually broad-based support, the reconstructed notion of "Englishness" was a formidable obstacle to proponents of progressive modernism and internationalism.

Since visual representation played a key role in elucidating what it now meant to be English, it was imperative that mimesis remain at the heart of artistic practice: it served to remind art's public of the wholesome attractions of the nation's countryside and native character. By the same token, Whistler's forward-looking urban views were rejected in favor of narrative representations of idealized truths. Images from the past were recycled to project a reassuring picture of a tranquil, rural, enduring England that was too stable to be buffeted by the winds of change.

Artists of all persuasions met the demand for rustic landscapes, domestic cottage interiors, and historic costume pieces. Stalwarts of the avant-garde joined with popular members of the St. John's Wood Clique in mining English history. Ford Madox Brown developed an interest in Cromwell, while Burne-Jones turned to soporific legends from the Arthurian past. Even the most important new school of the late nineteenth century, the Arts and Crafts movement, was an historically regressive attempt to stay the onslaught of industrial urbanization.[5] Its artists and architects offered their public a safe haven from the troubled present by producing forms that nostalgically evoked the close-knit communities of bygone days.

So pervasive was the late-Victorian construction of "hearts of oak" nationalism, that the middle class defied its own dictum forbidding the collecting of deceased artists. Dealers rediscovered "the Old Masters of the English School,"[6] who included artists such as watercolorist Paul Sandby,

337

landscapists Copley Fielding and Thomas Creswick, and folksy genre painter George Morland. Addressing this trend, Morland's biographer explained that the artist ably demonstrated "what English country life was like in the days of George III before the modern age had destroyed the picturesqueness of our peasantry and a good deal of the old joyousness and rural prosperity."[7] To collectors, early English art signified a way to stabilize their social category. While they had less control over the increasingly diverse cultural system, this was one area that offered a sense of empowerment, either through instant identification with the past or by its élitist associations.

Exploited by seasoned dealers such as Agnew's, as well as by newcomer Joseph Duveen, the taste for eighteenth-century art attracted a wide range of collectors who aspired to be perceived as gentlemen. Timber merchant Humphrey Roberts and brewer Charles Tennant, and an increasing stream of dollar-rich Americans, notably California's Henry Huntington, began to compete for the privilege of owning Britain's deceased masters.[8] Reporting on this trend, the salesroom correspondent for the *Art Journal* noted, in 1896:

> During the last decade the auction worship of Reynolds, Romney, Gainsborough, and their compeers, has increased with remarkable fervour, and the comparative absence of "Old Master" collections from the sale rooms has had the natural effect of encouraging this worthy and patriotic cult. Not that the desire to acquire Early British examples is confined solely to British collectors. There was a time when American picture-buyers satisfied themselves with securing the magnificent masterpieces of the French School to the exclusion of other works. Now, however, they also acknowledge the attraction of a fine British canvas, and the result is evident in the increased competition at auction.
>
> (p. 282)

Although the nationalist appeal of the British school had little influence with transatlantic buyers, its distinguished provenance did. With only a small indigenous artistic community of their own before the nineteenth century, Americans were particularly receptive to the equation between pastness and greatness.[9] Fascination with the patina of age drew more and more Americans into London's salerooms as the century wound to a close. Hoping that the escalation in prices stimulated by his countrymen had waned by 1898, Maryland cotton magnate Samuel Bancroft was

disappointed to be informed by his London agent that "The sale of old English pictures at extravagant prices still continues."[10] The stature of the British school was further enhanced by the series of retrospective Winter exhibitions staged at the Royal Academy and, for a brief time, at the Grosvenor Gallery. Accompanied by descriptive catalogues, these displays guaranteed the early British school a permanent place in the history of art.

Supported by the twin pillars of retrospective Englishness and a sympathetic Parliament, the art market remained remarkably stable in the midst of the late-Victorian economic depression. The demand for impeccably English pictures was conveniently met after the passage of the Settled Land Act in 1882, which allowed heirs of entailed properties to sell off some of their assets, providing they used the proceeds to improve their estates.[11]

Despite the familiar alliances that were successfully forged between dealers, critics, and collectors, the late Victorian patriotic celebration of the past lacked the exhilaration of the early Victorians' discovery of anecdotal painting or the mid-Victorians' thrill of recognition in subject pictures which extolled their virtues. "Olde" English art did not invite the immediate response of the contemporary image. Remote both in time and message, it avoided the difficulties of daily life through a process of denial.

The swing of the pendulum back toward the gentrified agrarian ideal, combined with the miscarriage of the middle class's management of the economy, has led some contemporary scholars to conclude that there was a decline in the late-Victorian entrepreneurial ideal. Those who support this thesis note the conversion of assets earned in industry into landed estates and an accompanying emulation of the aristocratic lifestyle.[12] Opponents of this theory, however, cite the appearance of newer, more dynamic entrepreneurs, as well as the dynastic insularity of provincial middle-class magnates who resisted gentrified practices.[13] While I concur with those historians who argue that the middle and upper classes were moving closer together, as the nobility and gentry accepted appointments on boards of directors of companies and industrialists sent their sons to be educated at exclusive public schools, I cannot ignore the strong core of affluent middle-class art collectors who valued new business ventures more than the gentlemanly occupations of land and politics and who refused to be assimilated into the upper registers of society. My research into the careers of late-Victorian art collectors indicates that while a small group preferred elegance to industry, the majority consisted of hard-driving men who struggled to keep England's economy on an even keel. For this reason I

will use these final pages to consider the implications of the efforts of some of the high achievers who altered the face of late-Victorian culture and who sparked controversies which are still debated today.[14] To adopt the terminology of D. C. Coleman, men such as William Lever, Thomas Barratt, and Thomas Holloway were "players" rather than "gentlemen."[15] They sprang neither from the gentry nor from the apocryphal ranks of the self-made, but from that intermediate region which had produced most art collectors since the beginning of the century. Uninfluenced by genteel traditions, they managed to amass and enjoy large fortunes without becoming fatally attracted to the ritual of life on landed estates or to an enervating yearning for the past. Instead they looked forward to the innovations of the twentieth century.

My purpose here is not to describe in detail the contents of the private collections formed by these entrepreneurs; rather, I want to consider the lasting effects of their intervention into the cultural sphere. Lever's and Barratt's discovery that the fine arts could help to sell their commercial products anticipated contemporary advertising and mass-marketing practices. Yet, this commodification of culture was not a simple matter: Lever's insistence that the reproductive process enhanced rather than diminished art remains unresolved to this day in the running battle between high and popular culture. While he may not have been concerned about art's aura, other late Victorians, such as the advocates of the "Art for the People" movement, as well as Henry Tate and the many provincial benefactors who endowed civic art galleries in the last decades of the century, continued to demonstrate a belief in the transcendental power of paint on canvas. Nor can we exclude Lever from this group, since he, too, established a public gallery near Liverpool, despite his seeming indifference to original works of art. The diverse deployments of culture in the late-Victorian years indicate that the dialectical tension between self-interest and social concern which I identified in early-Victorian Birmingham and Manchester was still unsettled. Although profit, power, and fame were the goals of many collectors and artists, they were offset by the public-spirited generosity of countless others who tried to live up to the high ideals the middle class had defined for itself.

Despite these differences, the late Victorians were united in their belief that English art had attained a level of visual perfection which made it a superior transmitter of cultural messages. Mimesis was central to the construction of readable images from the past, to the replication of art for the

masses, and to the web of wholeness which countered the dissolution feared by opponents of aesthetic modernism. I will contrast this steadfast loyalty to art's representational value with the transgressive views of the small but vocal group of Francophiles who denied that art's goal was the perfection of perceptual equivalences or the smooth transition from mimesis to narration.[16] The ramifications of the actions of both groups reverberated well into the twentieth century as acceptable standards for the fine arts were acrimoniously debated. Even today, postmodernists continue to assail the premises on which the Victorian progressive enterprise depended.

The careers of Lever, Barratt, and Holloway are a case in point: each prospered by improving on the formula for success. Rather than despairing over crowded urban conditions, they viewed England's expanding population as a captive audience for their products. By first imitating, then perfecting, American advertising techniques, these entrepreneurs reaped the rewards of the mass market, setting in place strategies that are still practiced.

Lever, son of a grocer, became one of the richest men in England by following the middle-class credos of self-help and hard work. Deciding to diversify his family's business interests, he began to manufacture soap in the 1880s. After carefully studying American promotional practices, Lever noted that the most successful products were those with heavily advertised brand names.[17] Determined to make Sunlight soap a household word, he embarked on an extensive marketing campaign that capitalized on pre-existing cultural forms.

Although he would never admit it, Lever first became interested in collecting art as a resource for his soap advertisements in the 1880s.[18] The title of one of his early purchases, G. D. Leslie's *This is the Way we Wash our Clothes*, explains its appropriateness for his purposes. William Frith's *New Frock* (plate 64), however, required further explication: Lever added the slogan, "So Clean," when he reproduced Frith's young girl in a shimmering white dress, causing the artist to protest; however, since Frith had included the copyright in his selling price, he had no legal recourse (p. 66). Was it more demeaning for Frith to have his artistry replicated on soap wrappers than in the thousands of engravings he authorized of *Derby Day*, *The Railway Station*, or *The Race for Wealth*? According to Benjamin's argument concerning the nature of mechanical reproduction, the auras of Frith's original paintings were equally impugned by any form of reproduction. Lever, however, maintained that he was not demeaning art or his customers by

Plate 64. William Powell Frith,
The New Frock, 1889,
oil on canvas

transforming originals into advertising reproductions. He insisted that he
was performing a service to society by satisfying a need for good quality
illustrations in working-class homes. He explained:

> The view I take, however, is this, that works of art are in great demand
> for Cottage homes, and one sees some pictures being hawked about
> from door to door that are anything but works of art. I have a desire to
> reproduce none but the best works by the best men, and although they
> may be reproduced by the tens of thousands to be given in exchange for
> Soap Wrappers, I cannot help but think they must have a good effect in
> raising the artistic taste of the Cottager. (p. 73)

342

The terms of Lever's defense continue to resonate in current debates about the advantages and disadvantages of commodity culture to the working class. John Berger carries Benjamin's thesis a step further when he proposes that, while the quality of high art may be depreciated through replication, it nevertheless maintains a residue of its élitist associations. He contends that although reproductions of works of art enter the mainstream of life and become "ephemeral, ubiquitous, insubstantial, available, value-less, free," they still exert a measure of social control.[19] Thus, according to Berger, even in mass-produced form, images of high art are a reminder of the cultural divide that separates rich from poor and, as such, place an onus on their owners to begin the long climb upward toward aesthetic bliss.

Disciples of the recent school of British Cultural Studies, however, find that the working class's relationship to commodities is not so passive. John Fiske, for instance, claims that "commodities are the resources of the woman (or man) who is exercising some control over her look, her social relations, and her relation to the social order."[20] Contrary to Berger's theory of dominance, Fiske concludes that the possession of objects that are beyond the level of necessity can impart a sense of empowerment to their owners which, in turn, leads to a feeling of control over daily life. American scholars of popular culture are also reassessing the vulnerability of subordinate groups. Expanding on Antonio Gramsci's notion of hegemony, these theorists maintain that when we endorse the messages of advertising executives, entertainers, or celebrities, we "help define the boundaries of common-sense 'reality,'" as opposed to the official version.[21] That is to say that informed or consensual consumption can also contribute to the construction of the wider cultural sphere.

According to this argument, Lever's clients should not be viewed as the victims of commodification, but as willing participants who actively sought to enhance their living conditions. This interpretation is buttressed by recent research in late-Victorian working-class habits which shows that display and the importance of keeping up appearances was a driving force in daily life.[22] Lever was apparently not overstating his case when he professed that "works of art are in great demand for Cottage homes."

A similar line of reasoning was followed by Lever's major competitor, Thomas Barratt of Pears' Soap, who had pioneered the appropriation of art for advertising in England a decade earlier. In the 1870s, Barratt commissioned *Cleanliness is Next to Godliness* from artist Herbert Stacy Marks, a scene of two monks shaving and washing (Morris, p. 14). Based on the

popularity of that print, Barratt went on to commission his most celebrated venture in this vein, John Everett Millais's *Bubbles*, in 1885. Unlike Frith, Millais did not object to the mass production of his image. On the contrary, the artist's son credited Barratt with raising the existing quality of illustrated advertisements by meticulously coloring the reproduction.[23] Moreover, the year before his death and the subsequent purchase of his company by Lever Brothers, Barratt created a museum for the people in the streets of London by hanging one hundred original oil paintings on hoardings as advertisements for Pears' Soap.[24] Winning the respect of the art community was a significant stepping stone toward the goal of Victorian advertisers which Thomas Richards recently described as placing "themselves at the exact juncture of commerce and culture."[25] This strategy would not have succeeded without cooperation across the field of cultural production.

The commodification of fine art was enthusiastically endorsed by the press. M. H. Spielmann, editor of the *Magazine of Art*, praising such populist efforts, wrote, in 1891: "patronage has gone from the Church and taken refuge with the middle-class collector and the advertising tradesman. The transition is fairly complete: from the Cathedral to the Stock Exchange; from Godliness to cleanliness; from the altar and cabinet to candles, screws, and soap" (p. 336). Julie Codell confirms that Spielmann consistently and repeatedly encouraged these new forms of consumer patronage[26] and thus participated in shaping the commodity culture which we have inherited and continue to foster. On this point, newspapers were as outspoken as the art press. The *Manchester Daily Guardian* bluntly editorialized in 1911:

> Don't believe any nonsense about the evils of commercialism in art. There can be no art without commercialism. The art of Flanders and Holland and Italy decayed with their commerce. English painting has steadily developed synchronously with our commerce. Only, just as you have to buy the right cotton and coal and wheat and flour, you must buy the right kind of pictures that will retain their commercial value because their aesthetic value is eternal.[27]

Believing that art's essence remained unsullied by commodification, critics conveniently separated high culture from its "impure" manifestations, leaving the field clear for such entrepreneurs as Lever and Barratt who, wittingly or unwittingly, enhanced the lot of the working class. Adam Smith had recognized over a century earlier that business practices often have paradoxical side effects when he observed that "pursuing his own interests [the merchant] frequently promotes that of society more

effectually than when he really intends to promote it."[28] The truth of this statement is borne out in the personal lives of the two men: despite their advocacy of the public benefits of art, both demonstrated a more self-indulgent attitude toward it in private.

Barratt was censored in the 1880s for using nude children as models in his advertisements.[29] And although Bell Moor, his house in Hampstead, was decorously hung with landscapes by past masters of the English School, a photograph of his saloon (plate 65) reveals that Barratt also owned one of the most celebrated nude images of the Victorian period, John Gibson's full-sized sculpture, *Tinted Venus*, which he prominently displayed in a shrinelike marble alcove. While it might seem natural for someone who was professionally involved in personal hygiene to be interested in realistically rendered nudes, such as Gibson's or Lawrence Alma-Tadema's *The Tepidarium*, which he also owned, the sensual overrides the anatomical in these choices as it also did in Barratt's personal living arrangements.[30]

While none of Barratt's excesses can be laid at Lever's doorstep, his taste seemed driven more by expediency than by aesthetic sensibility. While Lever chose figural subjects with uncluttered compositions to reproduce as advertisements, he bought landscapes and the poetic compositions of Aesthetic movement artists for his private collection, and fell briefly under the spell of the "Olde" English masters, only to change stride once again when he decided to place his collection on permanent view in the memorial gallery he planned in honor of his wife at Port Sunlight. He then turned to large-scale Victorian narrative paintings, explaining that a community gallery required "'exhibition pictures' with a distinctly public message and appeal."[31] What surfaces is a utilitarian relationship with art.

That he was not in awe of the original work of art is demonstrated by his reaction to the portrait he commissioned from Augustus John in 1917 (plate 66). Objecting to its protruding eyes, bent nose, fleshy lips, and bloated face, Lever cut up the canvas and removed the entire head.[32] The violence of this act led art students to march in protest in London. The ensuing controversy rested on the issue of whether an artist maintained a proprietary interest in his creation, even after relinquishing its copyright. Just as in the case of Frith's objection to the mass reproduction of his *New Frock*, Lever's acquisitive business practices led him to justify his exclusive ownership rights. His continual expropriation of original works for advertising divested art in general of any internal mystique in his eyes, thereby reducing it to the status of an easily replaceable commodity.

Plate 65. Saloon, Bell Moor, Hampstead, residence of Thomas Barratt, 1893, photograph

Thomas Holloway resisted the temptation of utilizing art in his advertising campaigns, perhaps because he was in his eighties when he started his art collection. Yet the fact that he employed an agent to make his purchases for him indicates that it was the cultural cachet accorded to art *qua* art that had more meaning for him than individual paintings. This sort of appropriation of symbolic objects makes its owner, in Bourdieu's opinion, "the exclusive possessor of the object and of the authentic taste for that object."[33] Holloway, in other words, was swayed by the discourse of middle-class cultural consumption, just as his customers were persuaded by his ubiquitous advertisements to become consumers of his pills and ointments.

A "player" in the high-stakes league of Lever and Barratt, Holloway progressed from grocer to commercial agent to international purveyor of patent medicines. He rose above the pack by reinvesting a larger portion of his profits in the persuasive medium of advertising. At the time of his death, his media budget amounted to £50,000 annually.[34] Although Holloway made a fortune by preying on his public's gullibility, he nonetheless cannot be typecast as a paradigmatic grasping capitalist.

Like Lever, Holloway believed it his duty to return some of his largesse to society. Also, feeling indebted to his wife for her lifelong support,

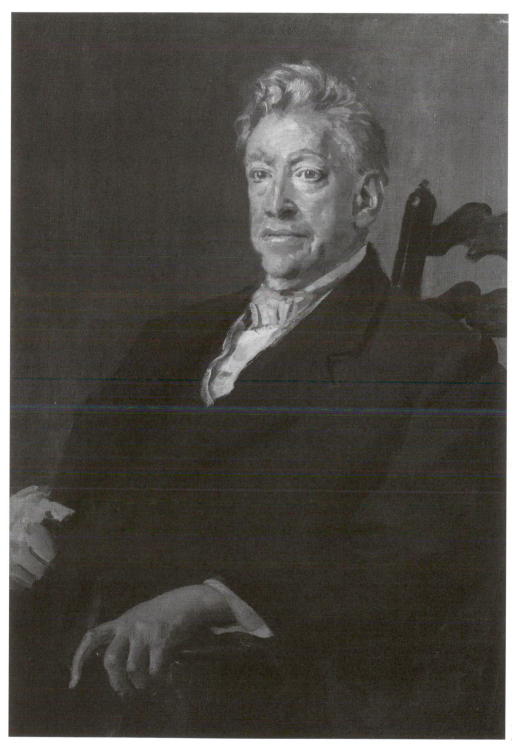

Plate 66. Augustus John, *W. H. Lever, the First Lord Leverhulme*, 1917, oil on canvas

he wanted to construct a monument to her. He not only built an art gallery, but a women's college as well. Holloway, however, cannot claim sole credit for either idea. It was Jane Driver Holloway who, before her death, persuaded her husband to build a college for women, now known as Royal Holloway College, a division of the University of London. She is said to have sympathized with women, "because they are the greatest sufferers."[35] The college was intended for women of the middle and upper middle class, who also happened to comprise the most captive audience for Holloway's Pills and Ointments. Perhaps it was Jane Holloway's guilt at being party to the exploitation of this consumer group, or her regret at not having a profession of her own, that led her to entreat her husband to support postsecondary education. It is curious that she was not more concerned with educating the young working-class women who staffed their factory, filling endless rows of boxes with pills day after day. Nevertheless, given the few opportunities available to women of either class, the college was a major step forward for the incipient women's movement.

Even though among art collectors in these years Baroness Angela Burdett-Coutts is touted as a feminist for defying convention by waiting until age sixty-seven to marry and then insisting that her younger husband assume her surname, she did not support women's liberation.[36] Her ideas about female independence, like her art collection, were molded by more conservative mid-Victorian values.

The same values penetrate the paintings that hang in Royal Holloway College. They were not selected by Jane or Thomas Holloway, however, but by his brother-in-law George Martin, who had been inspired by the collection at Vassar College in New York.[37] Because Holloway's paintings were bought during a short period of intensive bidding at Christie's, it would be wrong to ascribe too much significance to their value as representations. Size and availability were determining factors as much as suitability to a women's college. Jeremy Maas cannot be far off the mark when he concludes that "It was as though [Holloway] had lowered a net into the sea of High Victorian art and the collection was his catch from what was available for purchase at the time."[38] The majority consisted of early- to mid-Victorian Royal Academy exhibition pieces that had passed through a succession of middle-class collections. The names Elkhanan Bicknell, James Eden, Samuel Mendel, and Albert Grant frequent the provenance of the collection.

The main criticism leveled against Holloway by the art press was that he did not buy directly from artists.[39] In this regard, he was no different

from Lever, who assiduously avoided transactions with artists, even those with whom he was well acquainted.[40] These actions led the art world to become increasingly alarmed over the deterioration of the artist–patron bond that had begun to fray in the early-Victorian period. Yet no one traced its tattered remains to the escalating commodification of art by print publishers, advertisers, copyists, dealers, auction houses, and even by artists themselves. Although commerce enriched all of the agents in the cultural field and brought art to the people, its elaborate system of networks enlarged the divide between producers and consumers. John Singer Sargent, for instance, disdainfully remarked, before he journeyed to Sheffield to paint *The Misses Vickers*, "I am to paint several portraits in the country and three ugly young women at Sheffield, dingy hole."[41] With indifference penetrating even the artist's studio, was it any surprise that purchasers no longer looked there for intimate explication?

The conflicting play of priorities in late-Victorian England points to the unsettled role of culture. Distressed by the diminishing power of art's aura, philanthropically motivated groups of citizens attempted to recoup the preeminent position art had enjoyed in its mid-Victorian heyday, when it provided solace and inspiration to an ever-expanding public. Social disturbances and a weak economy managed to jar mid-Victorian complacency, just as self-interest had been sublimated for the sake of the common good in Manchester in the 1850s and in Birmingham in the 1860s as a result of social unrest. Cultural mavens again demonstrated their willingness to act in the interest of the public, believing that art exhibitions still held the potential to breach the chasms between the classes by providing a common culture for people who shared little else. The earnestness of these volunteers resulted in a rash of private loans to art exhibitions in Bethnal Green, Whitechapel, and in dozens of privately endowed gifts to civic galleries in the provinces.

Efforts were made to recapture the working class's enthusiasm for the events surrounding the Manchester Art Treasures exhibition of 1857 and the opening of the South Kensington Museum two years later. New strategies were necessary to revive the rational recreation movement which had lost its momentum during the 1860s and 1870s due to competition from commercial recreations such as music halls. The impetus sprang from an unlikely alliance between socialists and conservatives. Both groups, concerned with the popularity of beer drinking and increased unemployment resulting from the economic slump, resolved to "remoralize" workers by

349

introducing them to the civilizing influence of culture.[42] "Every appropria-
tion of culture, whether by insiders or outsiders," according to anthropolo-
gist James Clifford, "implies a specific temporal position and form of
historical narration."[43] The historical narration of the endorsers of the "Art
for the People" movement centered on the old rubric of self-help, but it
could not have been directed toward more disparate temporal objectives:
socialists wanted to win more independence for workers, while moneyed
mandarins hoped to indoctrinate them in middle-class values.

The subject of these ambitions is captured in *The Night School*,
painted by Edgar Bundy in 1892 (plate 67). The group of men seated in a
classroom after a long day's labor represents the anonymous workers whom
society wished to improve. Easily identifiable by their stocky musculature
and coarse features, all but one is intent on his schoolroom task. It is this fig-
ure in the center who captures our interest, because, unlike the others, he is
lost in his own thoughts: he has abandoned his set of compasses and dis-
tractedly drums his fingers on the desktop. However, any suggestion that
his behavior is defiant is neutralized by the diagonal which links him to the
kindly faced instructor who is bathed in the warm glow of a candle in the
center background. Considering that this picture was exhibited at the
Royal Academy and was bought directly from the artist by Hull industrial-
ist T. R. Ferens, it is more likely that the central character's impatience is a
measure of his desire to succeed as quickly as possible.

Active, robust, and energized, this figure of manhood countered
the effete model adopted by devotees of the Aesthetic movement. A more
masculine male ideal was the mainstream's response to the lethargic and
disillusioned poets, painters, and patrons who "represented a complex
hinge between the fulfillment of a sublime ideal and the haunting embodi-
ment of a reprehensible social failure."[44] In contrast, the strength and man-
liness of the English worker stood for progressive modernism at its finest,
unlike the languid men who appear in Burne-Jones's *Chant d'Amour*, for
instance, who were now accused of being "emasculated by false modern
emotionalism."[45] "True" modernism, by contrast, was masculine, unam-
bivalent, and unemotional. As Kate Flint has pointed out, "effeminacy" was
a term which was frequently employed to condemn Rossetti's painting and
poetry, in contrast to Poynter's images, which were praised as "manly."[46]
The message to Aesthetic patrons and painters was clear: the creation and
consumption of art may be a private activity, but its implications were
public.

Plate 67. Edgar Bundy, *The Night School*, 1892, oil on canvas

Late-Victorian collectors shifted their gaze from the personal to the social when they made loans to exhibitions or outright bequests to museums or galleries. In the process of socializing art, they charged it with an inspirational responsibility. Critic Leslie Stephen insisted that the public was very much affected by art and literature: "The poems which they learn by heart, novels with which they amuse their leisure, the pictures which hang upon their dwelling-rooms, affect their whole theory of life or conduct, or they do nothing."[47] With this philosophy in mind, a series of motivational art exhibitions was launched in London's East End, organized by advocates of the "Art for the People" movement, who shared the belief of the founders of the Manchester City Art Gallery that moral reform could be stimulated by ritualized contact with original works of art, which, by their very nature, possessed a transcendent power.

Yet these efforts at first foundered due to misguided curatorship and an unsympathetic popular press. Not troubling to research its constituency, the Bethnal Green Museum's inaugural exhibition in 1872 consisted primarily of French painting and sculpture borrowed from Francophile Sir

Richard Wallace.[48] While the *Art Journal* was supportive of the museum's mission, it suggested that a more appropriate exhibition for this audience would have been portraits of famous Englishmen, "who have made England what she is. These subjects never fail to interest the public mind, and, in interesting, to elevate it" (p. 217). Consistent with its ideological endorsement of the English School, the subtext of these remarks was a reminder that an appeal to working-class patriotism was a proven means of quelling dissent. Also in accord with the platform it had first adopted in the 1830s regarding art's educative abilities, the *Art Journal* chastised the popular press for demeaning East Londoners as "the savage inhabitants" of "some newly-discovered wilderness." Leaping to their defense, the magazine eloquently editorialized: "London went in its shirtsleeves; but it behaved itself far better than we have often seen it to do when clothed in purple and fine linen." It was this respectful tone that was transmitted in subsequent endeavors at Bethnal Green. Taking the time to note what interested their working-class audience, the museum's organizers branched out beyond fine art to include anthropological objects, furniture, and even boots and shoes. These efforts proved so popular that by 1891 Bethnal Green could boast of 400,000 annual visitors.[49]

Despite these discoveries in working-class taste, the Reverend Samuel Barnett limited the exhibitions he organized in neighboring Whitechapel, in the years between 1881 and 1898, to fine art. Dubious about the fate of reproductions once they entered cottages or lodgings, especially those earned in exchange for soap wrappers, Barnett exhibited only original oil paintings. Transferring his evangelical zeal to art, Barnett professed that paintings were as valid a form of worship as church.[50] Sharing the transcendental belief that images could be effectively used to lift the eyes of the illiterate heavenward, he kept his gallery open twelve hours a day, seven days a week. Of course, he considered only certain forms of representation appropriate. Rejecting social realism for its depressing reminder of the harsh realities of life, Barnett focused on another form of mimetic expression – spiritually elevating academic painting (pp. 58–59). While he did not require the subject matter to be explicitly religious, he insisted it be inspirational. Although Barnett attracted loans from most of the leading artists of the day, Frances Borzello, in her study of Whitechapel, concludes that, "His belief in pictures as sugar-coated sermons was encouraged by his total lack of aesthetic appreciation" (p. 62). This, in part, may be due to Barnett's realization that, in order to succeed, the civic humanist

discourse must be rewritten yet again to minimize self-interest and to maximize social harmony.

The role of representation in the "Art for the People" movement is problematic because of the conflicting religious and political agendas of its organizers. Bethnal Green's curators were the exception in adjusting their standards to appeal to working-class taste. And while the Reverend Barnett made no secret about his faith in paintings, when the movement spread throughout the British Isles, its goals were often obscured by local and individual concerns.

The virtually hundreds of public exhibitions and galleries that were launched in the provinces in the late-Victorian years beg for a separate study.[51] While public donations were minimal during the period that England was strengthening its economic base and building up its Empire, philanthropy accelerated in the face of late nineteenth-century social disarray. The activities of socialists Thomas Horsfall and Charles Rowley in the slums of Manchester have been well documented.[52] Much less is known about the spectrum of diverse interests that prompted benefactors from Aberdeen to Swansea to donate thousands of pounds in art's name. One expects, for instance, in catalogues such as that of the Smith Gift to the town of Brighouse, to encounter descriptions of pictures that "point a moral" or "reflect on the misfortunes of life," in the manner of Thomas Faed's *The Mitherless Bairn* or P. H. Calderon's *Orphan Children*.[53] After all, storytelling art was still deemed the most effective way to communicate to an uneducated audience such master narratives of modern society as self-help and self-denial. But one cannot so simply classify the extraordinary bequests of paintings, antiquities, silver, glass, and coins left by South African sugar and diamond merchant Alfred Aaron De Pass to Bristol, Falmouth, Truro, Plymouth, Oxford, and Cambridge.[54] Nor can one so readily attribute the generosity of brothers George and Samuel Bentlif, boot and shoemakers, who bequeathed over £10,000 and 200 pictures, in addition to paying for the construction of a wing of the art gallery at Maidstone, to a desire to promote social cohesion.[55] Was it a spirit of communitarianism that motivated such men to forgo private shrines to art for public art galleries? The disparity in benefactors' backgrounds, wealth, and interests, combined with the varied content of their gifts, defies any single interpretation for the infectious spirit of art philanthropy that penetrated Great Britain during the last years of Victoria's reign and continued until the outbreak of World War I.

Whatever the personal motivations of their donors, these philanthropic gifts and bequests are representative of the altruistic strain that

defined the highest evolution of the middle-class character. Unselfish individuals endowed communities in the furthest reaches of the British Isles with a cultural identity, enriched people of all classes and, because the objects they donated were on permanent exhibition, they made it possible for working-class visitors to return time after time and thus gradually become at ease in cultural centers.

Nonetheless the working-class viewer had to be singularly persistent in order to benefit from art galleries. While the *Magazine of Art* recognized a growing taste for art among Glasgow's middle class in 1894, it sadly reported that, as far as the working class was concerned, "'the many' remain unaffected: their deepest joy is still in brass bands and fireworks. Perhaps it is the same in all large cities. 'The Masses' elevated and purified by a burning love of art exist only in 'the devout imaginings' of the speakers at young men's debating societies" (p. 154).

As these remarks suggest, the extent to which underprivileged viewers had been educated in the visual protocols of viewing art had not significantly progressed since the Art Treasures exhibition. Unschooled in academic codes, the working class's initial response to painted imagery was bound to be anecdotal. As one journalist noted after observing the crowds at Bethnal Green, "These people look at pictures to get more life out of them, and who shall blame them?" To illustrate his point, he quoted snatches of overheard conversation: "'Poor thing, how tired she is! – Look, look, mother! There's a horrid snake eating a woman!'"[56] Recalling Gombrich's argument about non-Westerners who did not recognize drawings of objects foreshortened in space because they had not learned the conventions of Renaissance perspective, these comments illustrate the pitfalls inherent in the "Art for the People" movement.[57] Without the company of some form of art education – a knowledgeable guide, or the benefit of gallery talks or lectures – the working class could not be expected to penetrate the arcane conventions and symbols of high art.

The branch of the working class that benefited most from this sudden proliferation of exhibitions was already predisposed to art. Laborers in the textile industry were daily exposed to designs which made them more aware of two-dimensional patterning. Thus in reviewing the impact of art exhibitions in Bradford, the *Magazine of Art*, in 1891, could assert that the beneficial influence of art "is being manifested in a direction where it has long been sorely needed – namely, in the improved quality of artistic work displayed in the textile productions of the locality" (p. 344). This claim

reveals that the maxim "art must serve industry," which had been the subject of much public discussion at the time of the founding of the South Kensington Museum and City of Birmingham Art Gallery, became integrated with the social concerns of the "Art for the People" movement. As earnest as the Reverend Barnett was in his attempts to draw attention to the unsullied spiritual aspects of art, his preaching was appropriated by those intent on commercializing culture, both in industry and in the art world.

The dealer–critic nexus, as we saw in the instance of the Grosvenor Gallery, continued to market the "worship of art" as a trendy slogan with only distant echoes of its initial intent. Despite Barnett's efforts to promote art as a repository of religious values, it was slowly and systematically stripped of its orthodoxy by fashionable denizens of London and the provinces who, nevertheless, refused to relinquish its claims to transcendence. So many incantations had been uttered in praise of art over the course of the century, by everyone from reformers to sybarites, that a new non-sectarian discourse finally emerged which simplified all previous disquisitions. Devoid of sermonizing, it reduced the various cantillations sung in art's name to a single worshipful refrain. Without the theoretical substance or guidance of a common cause, the reverential attitude toward art was all too easily commodified.

Artists realized new opportunities from the conflation between art and religion when they imitated the Grosvenor Gallery's *vernissages* by opening their studios to the public on "Show Sunday" a month or two prior to the opening of the Royal Academy. Paula Gillett, in her study of late-Victorian art audiences, notes that the observance of this annual Sunday ritual "reflected very clearly two separate but related tendencies in English life in the latter half of the nineteenth century: the secularization of society and the sanctification of art."[58] To some, the practice undoubtedly filled the gap left in their lives by agnosticism or atheism, but to others it was simply an opportunity to rub shoulders with the élite or to preempt sales at the Royal Academy.

Another expression of art's reputed transcendence was the architectural splendor of the late-Victorian private art gallery. Soaring spaces worthy of cathedrals were designed to display conventional collections. Conservative businessmen such as shipbuilder Thomas Ismay and armaments manufacturer Sir William Armstrong added basilica-shaped galleries to their homes in the 1880s where they displayed art that was closer to the academic end of the spectrum than to the aesthetic.[59] These structures are

remarkable monuments to the yearning, cupidity, and fears of Victorian plu-
tocrats. It is as if they hoped that proof of their cultural epiphany would
quell their mounting anxieties about the future. Evolving from the shrines to
art crafted by Aesthetic patrons, the opulence and hyperbolic scale of these
private galleries parodied the intimacy that characterized the sanctuaries of
Leyland, Rae, and Leathart. Like the Grosvenor Gallery, these structures sac-
rificed intimacy for effect and parroted the symbols of Aestheticism.

By the same token, artists' studios came to imitate the form but not
the substance of the Aesthetic movement. Architect Richard Norman Shaw,
who designed the private galleries of Ismay and Armstrong, noted that
artists were becoming some of his best clients. He crafted clusters of lavish
studio–homes for Royal Academicians in Kensington and Hampstead
which boosted the scale of the Aesthetic artist's retreat.[60] Similarly George
Aitchison, who had transformed Eustacia Smith's London house into a
bagatelle of Aestheticism, placed his talents at the disposal of the President
of the Royal Academy, Sir Frederic Leighton, for whom he created an exotic
Arabland in Holland Park. Its only near rival in foreign ambience was Alma-
Tadema's multicultural evocation of Ancient Rome, Renaissance Florence,
and Japan in Regent's Park.

An engraving of Alma-Tadema's studio, produced for the *Magazine
of Art* in 1882 (plate 68), reveals a liberal extravagance in the accouterments
of taste intended to inspire potential clients to purchase the artist's pictures
and display them in a similar manner. The color scheme of Pompeian reds
and yellows was heightened by the primitive sheen of the animal skins
casually thrown around the room. To the right of the door, at the left, is a
sculptured self-portrait head of the artist crowned with a victor's wreath
which is paired by an actual Roman head over the fireplace. This narcissistic
note would resonate too loudly in the low-keyed ambience of the Aesthetic
studio where the mystique of the artist was discreetly murmured, not boldly
stated in a voice which no longer pretended to disguise the studio's role as a
temple of Mammon. The tone of the dialogue between art and money was
raised to a louder pitch by late-Victorian artists such as Alma-Tadema in
order to attract the attention of collectors who did not accord art such magi-
cal powers.

Alma-Tadema succeeded in catering to the wonts of international
tycoons like Sir John Aird, the contractor who oversaw the construction of
the Aswan Dam and who was knighted in 1901 in recognition of his contri-
butions to the British Empire. Discovering that he and Alma-Tadema

Plate 68. Studio of Lawrence Alma-Tadema, Townshend House, Regent's Park, London

shared a fascination with imperialist iconography, the international builder invited the artist to accompany him to Egypt. Understanding that Aird responded to challenges that were larger than life, Alma-Tadema appealed to him with the opulent *Roses of the Heliogabalus* in 1888, which cinematically depicts a moment in the life of a Roman emperor who enveloped his courtiers in a cascade of fresh rose petals at the climax of a festival.[61] To add to the allure of his painting, the artist let it be known that he had imported dozens of costly roses from the French Riviera in order to achieve the desired effect. The work of Alma-Tadema found buyers whose reasons for owning art had mutated from the internal need of the Aesthetic patron to the external propensity for ostentatious display of the late-Victorian consumer capitalist. While the conscientious moral individualism of the early and mid-Victorians dictated that their expenditures be discreet, the late Victorians embarked on a phase of conspicuous consumption that reverberated well

into the 1960s in art-collecting circles in Hollywood, where Allen Funt, television host of the comedy series *Candid Camera*, proudly displayed *Roses of the Heliogabalus* amongst his collection of thirty-five paintings by Alma-Tadema. In explaining his attraction to these pictures, Funt confided that "every canvas seems to show an artist trying hard to give the viewer his money's worth."[62] Even from his distance in time and place, Funt recognized the equation between time and labor that defined the value structure of Victorian art.

The alliance between art and money, as we have seen, was articulated much earlier in London, but it reached an even closer degree of harmony in the late-Victorian art market. Nothing in the previous decades matched the ingredients that went into this cultural brew: one fresh new millionaire, one well-seasoned dealer–critic, and one slightly ripe journal. Together, they provided enough raw material to fortify Thorstein Veblen's claim that culture can be a wasteful excess when the needs of the self are elevated above those of the body public.[63]

The man responsible for stirring this mix was George McCulloch, a Scot who earned a fortune in the silver mines at Broken Hill and in the gold fields of Western Australia. While rags-to-riches stories were nothing new in the narrative of British capitalism, McCulloch's tale sent pens flowing once again, as it conjured up images of the wild outback, reckless prospectors, and fortunes won and lost in all-night card games. Each telling embellished images of the untold wealth of the legendary British Empire and added luster to the government's emigration policy. What was not mentioned in these colorful accounts was McCulloch's university education or the fact that he was assisted on his arrival in Australia by an uncle who happened to be both Premier of Victoria and a well-off sheep station owner.[64] Nor is it likely, as was popularly claimed, that his £70 investment in the Broken Hill mine grew to £16 million within a few years.[65] One cannot dispute, however, that when McCulloch retired to London in 1893 he surrounded himself with the trappings of the very rich.

He began by refurbishing a large house at 184 Queen's Gate. Recognizing the prominent position given to art in the homes of other rich men, McCulloch determined to assemble a collection of paintings and to display it in a suitably august setting. Designed by architect Theophilus Allen, no expense was spared in making the private art gallery at Queen's Gate a rival to the stateliness of the finest art museums in Europe and America.[66] Deciding that a top light was more effective than side lights,

Allen designed a 26-foot-high pitched glass roof and, to avoid chilliness, he ingeniously installed hot-water pipes beneath the glazed brick floor. Great pains were also taken to protect the pictures in the billiard room, dining room, and drawing room. The walls of each room were lined with brick instead of boarding, while further fireproofing was provided by iron doors. Not since Albert Grant's massive renovations in Kensington had London witnessed private construction on this scale.

A contemporary photograph of George and Mary McCulloch seated in their gallery (plate 69), gives some indication of its grandeur. Flanking Leighton's 65-inch tondo, *The Garden of the Hesperides*, the prosperous couple basks in the reflected glitter of their gold-leaved picture frames and gilded antiques. If evidence of wealth was all that was required for social success, McCulloch would have been guaranteed a place in society. Conspicuous consumption alone, however, was still not sufficient to gain entry to the upper-class circles where fact continued to have more importance than image. McCulloch, nevertheless, cultivated the appearance of a gentleman as his velvet smoking jacket verifies. He had no interest in imitating other "players" such as Lever or Holloway, who denied themselves the leisure to enjoy their fortunes by refusing to relinquish control of their companies or who felt a moral obligation to share some of their wealth with the public. McCulloch had left the business of making money behind him in Australia and now determined to acquire a place in society by investing in two of the most obvious symbols of cultural capital: a public-school education for his son and an enormous art collection.

Alexander McCulloch was entered in Winchester College, where he successfully mingled with his social superiors in the classroom and in sports.[67] The public school, as John Scott and others maintain, played a key role in breaking down barriers between classes.[68] McCulloch, however, engineered other social contacts, such as when he invited international socialite John Singer Sargent to holiday with him and his son in Norway. Payment was discreetly effected by means of a lucrative commission to paint Alexander's portrait. Instead of expediting the young man's ascent up the social ladder, the painting must have caused him to slip a rung or two after critic Roger Fry grouped it with "those desolating *impressions de voyage*, those desperately commonplace originalities of aristocratic vulgarity."[69]

McCulloch also hoped to expedite his social acceptance by forming a dazzling art collection. To select paintings impressive enough to do justice to the gallery at Queen's Gate, he sought the advice of a dynamo in

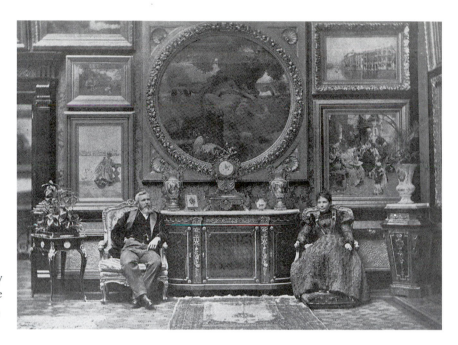

Plate 69. George and Mary McCulloch in their Picture Gallery, 184 Queen's Gate, London

the cultural field, David Croal Thomson, who was not only editor of the prestigious *Art Journal*, but was also in charge of the Goupil Gallery in New Bond Street, although after forming his connection with McCulloch, he was soon invited to become director of Agnew's. For four years, between 1898, when he first went to work for Agnew's, and 1902, when he resigned his editorship at the *Art Journal*, Thomson deftly juggled his responsibilities to the readership of Britain's most widely circulated art periodical, the country's leading dealer, and a private collector willing to spend in excess of £200,000 on art. There was no reason for Thomson to be troubled by having to serve three masters. The dealer–critic alliance was by now an accepted feature of English cultural life. Even the eleven articles published in the *Art Journal* under his editorship, extolling the virtues of the McCulloch collection, aroused no adverse comment.[70] M. H. Spielmann, editor of the rival *Magazine of Art*, was also a strong supporter of dealers and made a point of defending the right of periodicals to give free advertising to galleries.[71] Captured in a photograph taken in McCulloch's gallery sometime before 1909 (plate 70), Thomson proudly stands before George Watts's *Fata Morgana* and George Clausen's *Ploughing*, two of the over 300 recent British and European works of art he was instrumental in bringing to Queen's Gate in a rush of spending.

The timing could not have been more auspicious for the London art market. In a slump since the early 1880s, it was only partially revived by the demand for eighteenth-century British masters, the arrival of American bidders in the salerooms, and the brief flurry surrounding the formation of the Holloway collection. Aging critic F. G. Stephens commiserated with financially troubled patron James Leathart, reminding him that there were larger forces to contend with, forces such as "Mr. Gladstone's pranks, Socialism, Argentines, Barings, etc."[72] Considering the enormity of these threats to the English economy, the few active local buyers provided badly needed assurance that a home market for art still existed. This instability goes a long way in explaining why Thomson's divided interests were condoned.

It was not until after McCulloch's death that Thomson invited the ire of the art establishment. His mistake was to challenge the hierarchy of the cultural field. As long as he respected the codes of the art world, his conflict of interest went unquestioned, but once he dared to criticize official protocols, he placed the balance of the cultural field in jeopardy. Thomson erred in thinking he could make the Royal Academy conform to the commercial standards of the dealer–critic couplet. By pulling strings, he arranged to have McCulloch's collection posthumously exhibited at the Winter Exhibition of 1909, despite the Academy's policy of showing only the works of deceased artists at this time of year. Although he was no longer editor of the Art Journal, Thomson orchestrated its publication of a special memorial catalogue of the McCulloch collection in which he puffed up its importance in order to justify its appearance on the walls of the Royal Academy.[73] In the passage which sparked the most controversy, Thomson referred to the Royal Academy as "the most influential of all the societies which act as intermediaries between the producers and consumers of art works" (p. 6). His choice of economic expressions to describe artists and collectors, however, drew unwelcome attention to the commercial aspects of exhibiting a collection that was destined for the saleroom, causing the Royal Academy to be accused of inflating the value of the McCulloch collection by publicly endorsing it prior to its sale.[74]

No one benefited from the debacle. Even before the exhibition opened, Thomson left Agnew's under strained conditions for the French Gallery, where he abandoned his efforts at promoting English art.[75] The Art Journal managed to limp along for a few more years before it finally ended its seventy-three year reign over English taste in 1912, after failing to cater

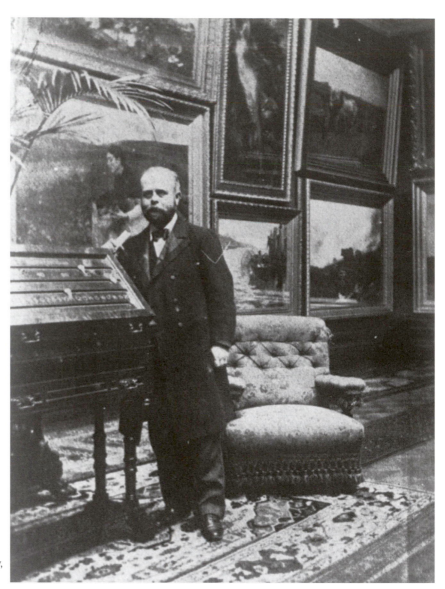

Plate 70. David Croal Thomson
in the McCulloch Picture Gallery,
184 Queen's Gate, London

to the growing international interests of the art public that was met by
newer periodicals such as the *Burlington Magazine* and *Connoisseur*. Finally,
the sale of the McCulloch collection was a disappointment when it occurred
in 1913. After all 326 lots were tallied, Mary McCulloch recouped only
slightly more than half her husband's original investment, despite the fact
that Lever alone bought almost £20,000 worth of pictures.[76] The less than
optimum prices can be ascribed to the worsening international situation on

the eve of World War I, an unsteady art market, and disenchantment with the academic art that characterized the collection.

Even the Royal Academy did not fully recover from the tempest of 1909. Although its standard practice of turning its back on criticism had worked in the past, it soon became apparent that, in this case, it was not going to go away. The *Burlington Magazine*, founded in 1903 as an alternative to the pro-English *Art Journal*, was one of the Academy's most unrelenting critics. A forum for scholarly admirers of continental art, it editorialized that McCulloch's flaw was his dependence on popular, official exhibitions, such as the Royal Academy, which it compared to "a well managed and successful sixpenny magazine," concluding that "the McCulloch of the future," by contrast, would

> recognize that the large exhibition must as necessarily turn to the ephemeral sunshine of popular favour, as the picked exhibition must always depend upon the appreciation of a small critical minority; that the one is supported by thousands upon thousands of shilling entrance fees, the other by the patronage of a few far-seeing collectors.[77]

It is well known that Roger Fry, a founder of the *Burlington*,[78] put this philosophy into practice by attempting to educate "the McCulloch of the future" through his "picked" exhibitions of avant-garde French art in London in 1910 and 1912. Fry's intention was to make collectors *au courant* with innovations which had taken place in France over the past four decades, but he failed to entice significantly more patrons away from the Royal Academy than had earlier efforts on the part of the Durand-Ruel, Goupil, or the Grafton Galleries.[79]

There were three schools of thought to contend with regarding French art: the first indulged in an extreme form of Francophobia and resented any cultural expression emanating from across the Channel; the second was represented by a much smaller group of collectors and critics who endorsed the French avant-garde;[80] while a third objected only to the innovations of Impressionism and Post-Impressionism, but still found much to admire in Barbizon and academic painting. Thomson, for instance, relied on the knowledge he had gained while working for Goupil's to persuade McCulloch to make purchases at the Salon, Champ de Mars, and Salon d'Automne. This pattern had become so widespread by the 1890s that F. G. Stephens felt it necessary to chart its history. He explained:

> Readers may be surprised to learn that the practice, now so rife, of
> buying Continental pictures even for British collections must needs
> be dated from 1854. In that year Mr. Gambart opened the pretty little
> French gallery in Pall Mall and filled it with jewellery of cabinet paint-
> ings of high character by men of foreign renown, not one in ten of
> whom had previously been represented in this island, where Meissonier,
> Gérôme, and Bouguereau, Diaz, Dupré, and Daubigny, Rosa Bonheur,
> Knaus, and Frère, Jules Breton, Rousseau, Corot, and Troyon were prac-
> tically unknown, and even Decamps, the great Rembrandt of France,
> Delaroche and Delacroix, the very poles of modern art, and Ingres, who
> was a sort of frozen Raphael, were hardly talked about and their works
> were seldom seen.[81]

Stephens went on to list the French artists whose work had been included in
the Manchester Art Treasures exhibition and the International Exhibition
of 1862, concluding that the trend had recently gained "amazing force."
Thus dozens of private collections of French art were formed in Britain dur-
ing the mid- and late-Victorian years, most notably those of James Staats-
Forbes and Sir John Day, while numerous others, such as that of Aesthetic
patron C. A. Ionides, liberally mixed French with English canvases.[82] One
reason that the Barbizon painters did not excite controversy, even among
propagandists of the English School, was because some critics suggested
that they owed their naturalist vision to the British landscapists.[83] There
was nothing about either their subject or their technique to offend
Victorian sensibilities, unlike the art of their more radical Impressionist and
Post-Impressionist followers.

That public resistance to the French avant-garde had not lessened
in the intervening fifteen years since the Whistler–Ruskin trial was appar-
ent in 1893, when Degas's *L'Absinthe* (plate 71) was exhibited at the Grafton
Gallery. Attacked because of its unidealized depiction of a woman with an
alcoholic drink in front of her in a cafe seated next to a disheveled-looking
man, the painting evoked long-standing prejudices about the moral laxity
of the French. The ensuing controversy between "Philistine" and "New Art
Critics" was pithily summarized by one of the participants, progressive
Scottish art writer D. S. MacColl, who wrote: "There was a patriotic view of
the question ('French poison'); there was a teetotal view of it ('temperance
tract')."[84] Accustomed to sanitized interpretations of daily life, conservative
viewers defensively denied the suitability of drink or loneliness as subjects
for painting. While the English were willing to assign such social ills to the

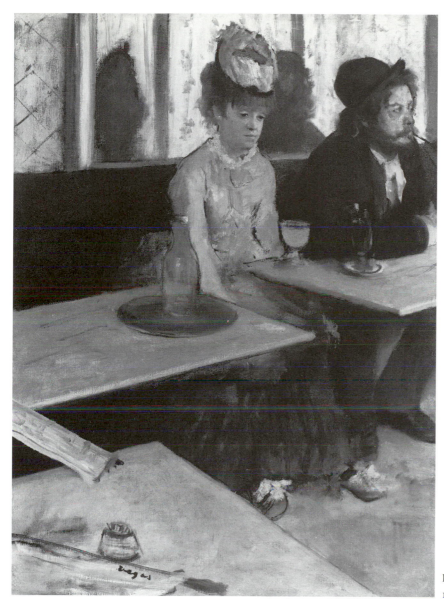

Plate 71. Edgar Degas, *L'Absinthe*, 1875–76, oil on canvas

French, they were reluctant to acknowledge their existence at home, especially in the high-art form of painting which, they still believed, should inspire good behavior. From a critical standpoint, then, the debate hinged on the moral basis of representation.

If art no longer drew attention to the human spirit, if history was no longer called on to document England's intellectual and political

365

advances, if images could not be counted on to validate middle-class progress, what was left to believe in? Since the beginning of the century, too much had been invested in art's power to elevate, motivate, and legitimate to let it founder on the shoals of discord. That alternative was almost too frightening to contemplate: mimesis had to be preserved at all costs to keep anarchy and anomie at bay. English modernism, in other words, depended on preserving the perception that the moral fiber of daily life was as strong as ever.

Arthur Kay, the Glasgow warehouseman who was the owner of *L'Absinthe*, insisted that the negative publicity surrounding his picture was due to a simple mistake: its title should have been catalogued as *Au Café* instead of *L'Absinthe*. That error, according to Kay, "roused the roar of all good total abstainers, momentarily interested in art, against the picture," leading them to consider it "vulgar, boozy, sottish, loathsome, revolting, ugly, besotted, degraded, repulsive, etc., etc."[85] Kay somewhat incredulously maintained that the milky white liquid in the glass in front of the woman contained black coffee instead of absinthe. He then argued for a more respectable reading of the picture, insisting that, "The man is ruminant, the woman dormant." By persuading himself that there was nothing debauched about his picture, Kay constructed a representation with which he could live. His friends, however, were not so easily convinced and, tired of defending the painting to them, Kay eventually sold it, demonstrating that he belonged to a generation to which the subject was still of paramount concern.[86] Even New Art critic George Moore's initial response to *L'Absinthe* was to weave an explanatory tale around its central characters, an interpretation which he later retracted with some embarrassment as the "ridiculous contention that a work of art may influence a man's moral conduct."[87] But that realization was arrived at in hindsight, after Francophiles such as Moore began to perceive form apart from subject.

Due to the persistence of critics such as Fry and Moore and with the backing of atelier-trained instructors who were already in place at the Slade School of Art and in the New English Art Club, the primacy of content in English art was painlessly toppled. Samuel Barlow and Charles Galloway of Manchester added works by Pissarro to their collections of Barbizon and English art and Captain Henry Hill, from whose estate Kay had bought *L'Absinthe*, purchased a total of seven pictures by Degas.[88] That is not to suggest that collectors abandoned their infatuation with clearly articulated, smooth-surfaced canvases overnight. Kay made his preference for definition a matter of public record when he announced: "Do not think

because I admire Degas that my sympathies lie with those impressionists who strive to sing in colour before they can articulate in drawing . . . I have no patience with bad technique nor with those who paint with chemical ignorance in fugitive colours on cheap, ill-prepared, and non-durable surfaces."[89] Thus English artists who studied in France discovered on their return that it was expedient to modify their color and brushwork in order to please patrons.

Henry La Thangue, for instance, developed an expressive "square brushstroke" and high-keyed palette after working *en plein air* in Brittany for almost four years.[90] Yet when he was commissioned to paint a portrait of Bradford wool spinner Abraham Mitchell and his family in 1887 (plate 72), the artist limited his palette to earth tones and blended his strokes to produce a systematically cohesive effect. The only indication that he was aware of other possibilities occurs in the scumbled surface of the magnifying glass that Mitchell holds. Even though La Thangue compromised his technique, he maintained his commitment to the acute observation of nature in his rendering of the art collector. Also known as *The Connoisseur*, his portrait of Mitchell interjects an introspective strain into English art that is akin to Degas's *L'Absinthe* and his earlier portrait of the *Beleilli Family*. Lost in thought and pictorially isolated from his family, Mitchell, who had made a fortune supplying mohair for the luxury trade, appears to share the lonely psychological existence of Degas's subjects, despite his worldly achievements. La Thangue, then, patiently managed to introduce reforms into late-Victorian painting while still adhering to the demands of the mimetic formula and the smooth surface.

Paradoxically the theoretical justification for admitting French innovations into English art was provided by the evolutionary principle on which the Victorians based their ideal of progressive society–the same evolutionary principle that was to inform the arguments of modernist art critics who declared French art superior to English because of its adaptability to the changing circumstances of modern life. The English avant-garde, in its Pre-Raphaelite and Aesthetic movement manifestations, as we have seen, made adjustments to the academic formula by negotiating between the Victorian propensity for highly finished surfaces and representational imagery, on the one hand, and indigenous nationalist values, on the other. A regard for tradition, the Protestant work ethic, and the desires of middle-class patrons were all factored into the English avant-garde's definition of modernism, which lent it an historic and nationalist specificity that was

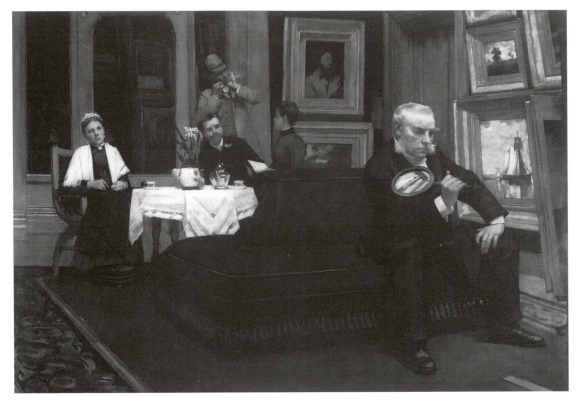

Plate 72. Henry La Thangue,
*The Connoisseur: A Portrait of
Abraham Mitchell*, 1887, oil
on canvas

distinct from that of any other country. The potential for change, however, rested on a strong sense of identity with the past as a storehouse of values that could be called on as a corrective to modern ills. That faith allowed the holistic surface of painting to remain intact well after the English realized that the forces they had put into motion were too complex to be rescued by traditional paradigms. Reluctant to accept that the vision they had struggled to materialize was imperfect, the late Victorians only gradually admitted the uneven texture of modern life into their art when doubt and uncertainty made it impossible for them to continue to defend the panoptic dream.

Progressive art critics developed a Darwinian discourse to encourage the English School to adapt to the altered conditions of modernism. When the evolutionary principle was applied to art criticism, it allowed genre painting to be comprehended from an historical perspective as a necessary, but preliminary, phase in the development of English art. R. A. M. Stevenson, for instance, classified the years between 1817 and 1867 as "a poor period of English art," because of the misguided efforts of painters

368

such as Landseer, Leslie, Maclise, and Mulready.[91] Just as Ruskin expected the Pre-Raphaelites eventually to soar to the poetic heights of Turner once they had mastered the rendering of minutiae, so did Stevenson believe that the remedy for late-Victorian art lay in greater breadth expressed through "general tone" and "executive style."[92]

While Stevenson faulted the technique of the English School, others were more troubled by the restricted world view which had produced it. Walter Armstrong, commissioned by the *Art Journal* before its demise to write about the state of English art, found Millais's *North-West Passage* (1874) culpable for allowing anecdote to override art. "The subject," he concluded, "is embarrassing because it controls the distribution of the masses, and, moreover, does not explain itself without a glance at the catalogue."[93] The didactic impulse, in other words, should not have been permitted to interfere with the aesthetic organization of forms. This charge was frequently, if less eloquently, repeated by such writers as the saleroom correspondent for the *Art Journal*, who witnessed the bidding for early-Victorian artist Thomas Webster's *Roast Pig* in 1910. Disregarding the reasons for original owner Joseph Gillott's attachment to the picture, he bemusedly dismissed it as "a typical instance of the mid-Victorian worship of anecdote as distinct from art" (p. 312). Historic distance lent late-Victorian evaluators the detachment necessary to resist the patriotic pull of content and to agitate for stylistic reform.

The equation between optical duplication and societal progress is a conviction that had persisted throughout nineteenth-century English art. The pains taken by artists to prove that painting could be as accurate as science was an expression of the modernist desire to harness the natural world, whether it be by improving the mechanisms of a cotton gin or the skills of visual transcription. But the friction between technological and aesthetic modernism that had chaffed Pre-Raphaelite and Aesthetic movement artists continued to grate. The crowding and density which had been so important in helping the middle class come to grips with its identity in the earlier years of the Victorian period were no longer expressive to a group that had now arrived. Characterized by Stevenson as "the old piled up style," the boldly defined canvases admired by his predecessors were judged unresponsive to the requirements of the late nineteenth century.[94] Educated to be suitably awed by the immensity of the British Empire and well traveled himself, Stevenson rejected the anecdotal view of the world "as a collection of separate objects" (p. 57). The quantification and examina-

tion of the phenomenology of daily life was now considered hackneyed. Even a conservative critic like Claude Phillips, who went on to become Keeper of the Wallace Collection, recognized that the academic style now appealed mainly to first-time collectors who did not want to be intellectually challenged.[95]

Having formed these conclusions about the hegemony of narrative over artistry, there was nothing to stop the critical press from applying the same standards to Henry Tate's ambitious plans to erect a monument to the English School. Sugar magnate Tate seemed like the perfect candidate for the task. Born the same year as Queen Victoria, he absorbed both the characteristic virtues and distinctive vices of his era. Standard Victorian stereotypes are routinely employed in describing his life, career, and philanthropy; yet, he was a Northerner, but not a Philistine; a self-starter, but not self-made; a good samaritan, but not averse to publicity.[96] A player of the stature of Lever and Holloway, Tate made a bid to insure his immortality, in 1890, when he offered to construct a gallery of British art and to donate the gems of his private collection to the nation.[97] While his overture was greeted with enthusiasm, the art world did not respond with the degree of unconditional optimism with which it had welcomed the Vernon and Sheepshanks Gifts nearly half a century earlier. Not only were the prospects of the English School less roseate, but the public had become more skeptical about the motives of munificent donors. Thus M. H. Spielmann tempered his admiration of the project when he referred to it as "the splendid shrine which Mr. Tate has erected to the glory of English art and to the honour of his own name."[98]

Tate's collection is noteworthy for its stolidly middle-class emphasis on realistically rendered narratives by artists such as Landseer, Millais, and Fildes. Although Tate relied heavily on the advice of William Agnew, he assumed sole responsibility for some of these choices himself, such as when he commissioned Luke Fildes to paint an English subject for him. Finally completed in 1891, *The Doctor* (plate 73), to many, summarizes the overwrought pathos of much late-Victorian representation. Although Fildes was one of a small group of social realists who tried to bring painting into closer alignment with daily life, in *The Doctor* he skirts contemporary issues such as urban poverty and focuses instead on the universal fear of the death of a child.[99] The humble cottage interior, sick girl, and distraught parents work together to suggest that day-to-day problems pale beside life-threatening anxiety. This elemental angst is skillfully communicated through narrative

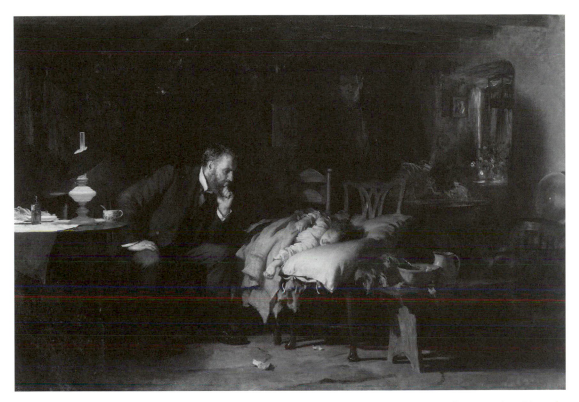

Plate 73. Luke Fildes, *The Doctor*, 1891, oil on canvas

details such as the precariously tilted lamp shade and the vulnerability of the little girl's outstretched hand. Fildes strove to be as scientifically and psychologically precise as possible: he constructed a life-size mock-up of the scene in his studio and drew on his own painful memories of the death of his first child.[100] Yet Tate, as the commissioner of the work, exercised his right to intervene in its production. After taking his suggestions into account, Fildes sent Tate a preliminary sketch with an accompanying note in which he assured his patron that "there is no vagueness whatever about the subject – *that* you can see clearly enough and *that* I understand, is what you first desire to be satisfied about."[101] Tate's literal priorities reveal that he was no different from those early and mid-Victorians who looked to art to recover reality.

This conventional attitude is also evident in the way Tate displayed his collection in his home. A photograph of the billiard room at Park Hill, Streatham (plate 74) shows that Tate favored the multilayered method of hanging pictures which the Aesthetic movement had attempted to ban-

ish. An analogue to "the old piled up style" of painting criticized by R. A. M. Stevenson, Tate's method of display demonstrated that he viewed art from a cumulative and acquisitive perspective as a collection of facts to be sorted and digested visually and intellectually rather than as an outlet for his emotions or as an object of contemplation.

Instead of ensuring a new direction for the future of the English School, the Tate collection disclosed that while artistic skills in tandem with narrative had evolved to an unprecedented level of accomplishment, mimetic representation had reached an impasse. The linear model of progress adopted by Victorian painters resulted in a theory of mimesis that shrank the distance between art and reality. If art's project was self-recognition, it had fulfilled its mandate. As Linda Nochlin argues, realistic details in painting are "there to give credibility to the 'realness' of the work as a whole, to authenticate the total visual field as a simple, artless reflection."[102]

In subscribing to the axiom that art should mirror life, Tate was perpetuating the foundational premises of the English School. To insist, however, that these principles were still as pertinent in the last decade of the nineteenth century as they were in the first, was a contradiction of the Western notion of progress. This became increasingly evident after the turn of the century. Reviewing the annual exhibition at the Royal Academy in 1906, the *Athenaeum*'s critic lamented that "the naturalistic outlook is less applicable than of old."[103] Life had undergone too many changes to be represented by the same time-worn visual formulas.

In the five-part series the *Art Journal* devoted to the Tate collection in 1893, critic Walter Armstrong, in his opening sentence, asserted: "English individualism finds no more striking illustration than in our dealings with Art as a commodity" (p. 65). Armstrong's brief, however, was not belatedly to condemn the cult of success or the machinations of the art market. More in sorrow than in anger, he blamed the lack of public patronage in England for the commodification of art for industrial and commercial purposes by well-meaning individuals. Explaining that without these agents, London would have no public galleries, Armstrong implied that, at the end of the day, the public benefited from the marriage between culture and commerce.

The middle class ably demonstrated that it could be counted on to make art available to the public. Even those Victorians concerned only with using art to satisfy their personal passions contributed to the democratization of culture at large by financing a market for readable representations which were accessible to all. Middle-class money was central to the expan-

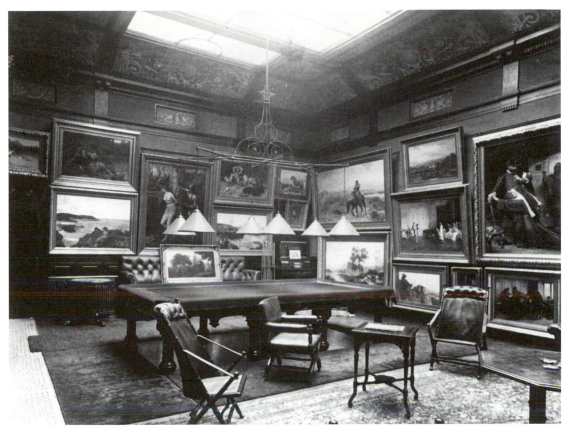

Plate 74. Billiard Room, Park Hill, Streatham, residence of Henry Tate, photograph

sion of the cultural field, to the dealers, printsellers and auctioneers who kept art in circulation, to the critics and art historians who explicated its aesthetic and social meaning, and to the galleries and exhibition societies which awarded it a public seal of approval. Wanting to distinguish themselves from the aristocracy and gentry, the Victorian commercial patriciate utilized the principles it knew best – the *laissez-faire* theories of its business practices – to create a cultural system that inevitably profited some more than others, but which nevertheless made its product more readily available than ever before.

Notes

1 Harold Perkin, *Origins of Modern English Society* (London: 1969; rpt. 1985), p. 453. See also R. H. Tawney, *The Acquisitive Society* (New York: 1920), and E. H. Hobsbawm, *Industry and Empire* (Harmondsworth: 1985).

2 Robert Colls and Philip Dodd (eds.), "Preface," in *Englishness: Politics and Culture, 1880–1920* (London: 1986), n. p. See also the essay in the same volume by Alun Howkins, "The Discovery of Rural England," pp. 62–88.

3 Eric Hobsbawm, "Inventing Traditions," in *The Invention of Tradition*, ed. Eric Hobsbawm and T. Ranger (Cambridge: 1983), pp. 1–14.

4 See Howkins, "Rural England," pp. 68–71, and Chris Waters, *British Socialists and the Politics of Popular Culture* (Manchester: 1990).

5 See Simon Watney's review of S. K. Tillyard, *The Impact of Modernism: The Visual Arts in Edwardian England* (London: 1988), in *Burlington* (1990), 45–46.

6 *Magazine of Art* (1893), 232. For the influence of this trend on contemporary painters, see Laurel Bradley, "From Eden to Empire: John Everett Millais's Cherry Ripe," *Victorian Studies* 34 (Winter 1991), 180–203.

7 J. T. Herbert Baily, *George Morland* (London: 1906), pp. 5–6, cited in Edward Morris, "Paintings and Sculpture," in *Lord Leverhulme: A Great Edwardian Collector and Builder* (London: Royal Academy, 1980), p. 17.

8 For Roberts and Tennant, see appendix. Huntington's collection is preserved in the gallery he founded in 1919, the Henry E. Huntington Library and Art Gallery, in San Marino, California.

9 See Edward Shils, *Tradition* (Chicago: 1981), pp. 13–21 and 75. For a discussion of how American artists invested social values in landscape painting, see Kenneth John Myers, "On the Cultural Construction of Landscape Experience: Contact to 1830," in *American Iconology*, ed. David C. Miller (New Haven: 1993), pp. 58–79.

10 Charles Fairfax Murray to Samuel Bancroft, 16 January 1896, *The Correspondence between Samuel Bancroft, Jr. and Charles Fairfax Murray*, ed. Rowland Elzea (Wilmington: Delaware Art Museum, 1980), p. 106.

11 See Morris, "Paintings and Sculpture", p. 18; Reitlinger, p. 176.

12 See Martin Wiener, *English Culture and the Decline of the Industrial Spirit, 1850–1980* (Cambridge: 1981); Corelli Barnett, *The Audit of War* (London: 1986); and William Rubinstein, "Cultural Explanations for Britain's Economic Decline: How True?," in *British Culture and Economic Decline*, ed. Bruce Collins and Keith Robbins (London: 1990), pp. 59–90.

13 See Keith Robbins, "British Culture versus British Industry," in *British Culture and Economic Decline*, ed. Bruce Collins and Keith Robbins (London: 1990), pp. 1–23; Peter Payne, "Entrepreneurship and British Economic Decline," *ibid.*, 25–58; John Scott, *The Upper Classes: Property and Privilege in Britain* (London: 1982); and Lawrence Stone and Jeanne F. Stone, *An Open Elite? England 1540–1880* (Oxford: 1984).

14 This group consists of Sir John Aird, Thomas Barratt, William Lever, Thomas

Holloway, Abraham Mitchell, George McCulloch, and Sir Henry Tate.

15 D. C. Coleman, "Gentlemen and Players," *Economic History Review* 26 (1973), 92–116.

16 On the question of altered perception, see Arthur Danto, *The Philosophical Disenfranchisement of Art* (New York: 1986), p. 99.

17 W. J. Reader, "Impressions of Leverhulme," in *Lord Leverhulme: A Great Edwardian Collector and Builder* (London: Royal Academy, 1980), pp. 9–10.

18 Morris, "Paintings and Sculpture," p. 14.

19 John Berger, *Ways of Seeing* (London: 1972), pp. 32–33.

20 John Fiske, *Reading the Popular* (Boston: 1989), p. 35. See also Anthony Easthope, *Literary into Cultural Studies* (London: 1991), pp. 77–79, and Patricia Anderson, *The Printed Image and the Transformation of Popular Culture, 1790–1860* (Oxford: 1991), pp. 5–6.

21 T. J. Jackson Lears, "The Concept of Cultural Hegemony: Problems and Possibilities," *American Historical Review* 90 (June 1985), 572, and Antonio Gramsci, *Selections from the Prison Notebooks*, ed. and transl. Quintin Hoare and G. N. Smith (London: 1971).

22 Gareth Stedman Jones, "Working-Class Culture and Working-Class Politics in London, 1870–1900: Notes on the Remaking of a Working Class," in *Popular Culture: Past and Present*, ed. Bernard Waites, T. Bennett, and G. Martin (London: 1982), pp. 101–2.

23 See John Guille Millais, *The Life and Letters of Sir John Everett Millais*, 2 vols. (London: 1899), II, 189.

24 See *DBB*, I, 190.

25 Thomas Richards, *The Commodity Culture of Victorian England* (Stanford: 1990), p. 1.

26 Julie F. Codell, "Marion Harry Spielmann and the Role of the Press in the Professionalization of Artists," *Victorian Periodicals Review* 22 (Spring 1989), 7–15.

27 "New Manchester Exhibition Opened," Manchester Daily Guardian, 8 December 1911, cited in Michael Saler, "Medieval Modernism: The Legitimation and Social Function of Modern Art in England, 1910–1945," unpubl. Ph.D. diss., Stanford University, 1992, p. 38.

28 Adam Smith, *An Inquiry into the Nature and Causes of the Wealth of Nations*, 3 vols. (London: 1752; rpt. 1776; Chicago: 1976), I, 477–78.

29 Morris, "Paintings and Sculpture," p. 39.

30 Although Barratt owed his partnership in Pears' to his marriage to Francis Pears's eldest daughter Mary, he assumed control of her money and replaced her in their home with a mistress after her father's death. Even worse, he disinherited her and left his fortune to his two illegitimate sons. See *DBB*, I, 190.

31 Morris, "Paintings and Sculpture," p. 30.

32 *Ibid.*, no. 20, p. 58. The two sections were reattached in 1954.

33 Pierre Bourdieu, *Distinction: A Social Critique of the Judgement of Taste*, transl. Richard Nice (Cambridge, Mass.: 1984), p. 280.

34 See *DBB*, III, 323.

35 Caroline Bingham, "'Doing Something for Women': Matthew Vassar and Thomas Holloway," *History Today* 36 (June 1986), 49.

36 F. K. Prochaska, *Women and Philanthropy in Nineteenth-Century England* (Oxford: 1980), p. 229.

37 See Bingham, "Vassar and Holloway," p. 49. Vernon Heath substantiates George Martin's role, see *Recollections* (London: 1892), p. 307. Jeannie Chapel states that while it is assumed by some that Thomas Holloway chose the paintings that he wanted Martin to bid on in advance from Christie's catalogues, there is no evidence for this claim. See *Victorian Taste: The Complete Catalogue of Paintings at the Royal Holloway College* (London: 1982), p. 12.

38 Jeremy Maas, "Foreword," in Chapel, *Victorian Taste*, p. 7.

39 *Art Journal* (1884), cited in Chapel, *Victorian Taste*, p. 14.

40 Morris, "Paintings and Sculpture," p. 34.

41 Sargent to Violet Page, 1884, in James Hamilton, *The Misses Vickers* (Sheffield: Mappin Art Gallery, 1984), p. 53.

42 Waters, *British Socialists*, p. 3, and David Owen, *English Philanthropy, 1600–1960* (Cambridge, Mass.: 1964), p. 212.

43 James Clifford, *The Predicament of Culture: Twentieth-Century Ethnography, Literature, and Art* (Cambridge, Mass: 1988), p. 232.

44 Christopher Lane, "The Drama of the Impostor: Dandyism and its Double," *Cultural Critique* 28 (Fall 1994), 38.

45 *Magazine of Art* (July 1878), 81.

46 Kate Flint, "Moral Judgement and the Language of English Art Criticism, 1870–1910," *Oxford Art Journal* 6 (1983), 64.

47 Leslie Stephen, "Art and Morality," *Cornhill* 32 (July 1875), 92, cited in Flint, "Moral Judgement," 59.

48 See C. C. Black, *Paintings, Decorative Furniture and other Works of Art lent by Sir Richard Wallace to the Bethnal Green Museum, 24 June 1872 – April 1875*. For the Wallace collection, see John Ingamells, *The 3rd Marquis of Hertford as a Collector* (London: 1983).

49 Walter Shaw-Sparrow, "The Dixon Bequest," *Magazine of Art*, 15 (1891), 159. See also *Art for the People: Culture in the Slums of Late Victorian Britain* (London: Dulwich Picture Gallery, 1994).

50 Barnett, cited in Frances Borzello, *Civilising Caliban: The Misuse of Art, 1875–1980* (London: 1987), p. 34.

51 I wrote to approximately 140 public galleries in the United Kingdom requesting information about their collections and benefactors. The replies I received indicate that this is a fruitful area of study, but one which requires on-site research, since most do not have printed catalogues.

52 Michael Harrison, "Art and Philanthropy: T. C. Horsfall and the Manchester Art Museum," in *City, Class and Culture: Studies of Social Policy and Cultural Production in Victorian Manchester*, ed. Alan J. Kidd and K. W. Roberts (Manchester: 1985), and Charles Rowley, *Fifty Years of Work without Wages* (London: 1912).

53 "Historical Introduction to the Smith Art Gallery" (Brighouse, Halifax: n.d.), p. 1.

54 *A Short Biography of Alfred Aaron de Pass*, ed. B. D. Price (Falmouth: Royal Cornwall Polytechnic Society, 1982).

55 Maidstone Museums and Art Gallery, "The Bentlif Brothers: From Footwear to Fine Art" (typescript: n.d.).

56 "The Pictures at the People's Palace,"

1888–89, clipping in Queen Mary's College Archive, cited in Borzello, *Civilising Caliban*, p. 101.

57 E. H. Gombrich, *Art and Illusion* (Princeton: 1972), pp. 267–70.

58 Paula Gillett, *Worlds of Art: Painters in Victorian Society* (New Brunswick, N.J.: 1990), p. 196.

59 Macleod (1987), pp. 343–45.

60 Andrew Saint, *Richard Norman Shaw* (New Haven: 1976), pp. 153–62. See also the series on artists' studios published in the *Art Journal* in 1880–81 and Giles Walkley, *Artists' Houses in London, 1764–1914* (Aldershot: 1994).

61 The painting is 54⅛ × 83⅜ inches. See Vern Swanson, *The Biography and Catalogue Raisonné of the Paintings of Sir Lawrence Alma-Tadema* (London: 1990), no. 321. For Aird, see Robert K. Middlemas, *The Master Builder* (London: 1963).

62 Allen Funt, cited in Christopher Forbes, *Victorians in Togas: Paintings by Sir Lawrence Alma-Tadema from the Collection of Allen Funt* (New York: Metropolitan Museum of Art, 1973), p. 5.

63 See Theodor Adorno, "Veblen's Attack on Culture," *Literary Taste, Culture and Mass Communication*, 14 (1980), 11.

64 See *Australian Dictionary of Biography*, 13 vols. (Melbourne: 1966–91), V, 139–40; Geoffrey Blainey, *The Rise of Broken Hill* (Sydney: 1968); and Alan McCulloch, *Encyclopedia of Australian Art*, 2 vols. (1984), II, 730.

65 The apocryphal accounts appear in the *DNB* and *The Royal Academy Winter Exhibition* (London: Art Journal, 1909), p. 2.

66 See "The Collection of George McCulloch, Esq., The Picture Galleries," *Art Journal* 58 (Feb. 1896), 37–40, and Macleod (1987), pp. 344–45 and Pl. 17.

67 Alexander McCulloch achieved a measure of fame as a rower by winning an Oxford Blue. See Morris, "Paintings and Sculpture," no. 37, pp. 76–77.

68 Scott, *Upper Classes*, p. 91.

69 Roger Fry, "J. S. Sargent as Seen at the Royal Academy Exhibition of his Works, 1926, and in the National Gallery," in his *Transformations* (New York: 1956), p. 174.

70 See "McCulloch," *Art Journal* (Jan. 1895–Dec. 1897). On Thomson, see Simon Houfe, "David Croal Thomson, Whistler's 'Aide-de-Camp'," *Apollo* 119 (Feb. 1984), 112–19.

71 Codell, "Spielmann," 8.

72 Stephens to Leathart, 21 June 1893, Leathart Papers, University of British Columbia. For other complaints about the impact of the economy on the art market, see T. Sidney Cooper, *My Life*, 2 vols. (London: 1890), I, 186 and 293–94, and *Magazine of Art* (1881), 265–66.

73 While Thomson is named as a contributor to the catalogue, the two essays which preface the exhibition entries are unsigned. It is safe to assume that they were written by him, coinciding as they did with his abrupt departure from Agnew's and the influence he maintained at the journal. See Houfe, "Thomson," p. 118, and *The Royal Academy Winter Exhibition* (1909).

74 "The McCulloch Collection – I," *Burlington Magazine* 14 (Feb. 1909), 263.

75 Houfe, "Thomson," 118.

76 Reitlinger, pp. 168–70. For Lever's

acquisitions, see Morris, "Paintings and Sculpture," p. 31 and *passim*.

77 "The McCulloch Collection – II," *Burlington Magazine* 14 (March 1909), 330.

78 Frances Spalding, *Roger Fry: Art and Life* (London: 1980), pp. 78–80.

79 On the trials and tribulations of French avant-garde art in England, see Douglas Cooper, *The Courtauld Collection* (London: 1954), and *Impressionists in England: The Critical Reception*, ed. Kate Flint (London: 1984).

80 The late-Victorian collectors of French art who appear in my appendix are Samuel Barlow, Sir John Day, Charles Galloway, Captain Henry Hill, and James Staats Forbes. I have also included Arthur Kay of Edinburgh amongst these English collectors because of the controversy that ensued in London when he allowed Degas's *L'Absinthe* to be exhibited there. The question of Scottish support of French avant-garde art is beyond the scope of this book and is a topic which I plan to pursue separately.

81 Stephens, "Mr. Yerkes' Collection at Chicago," *Magazine of Art* (1895), 96.

82 See appendix.

83 See, for instance, Walter Armstrong, "The Henry Tate Collection – IV," *Art Journal* (July 1893), 193.

84 D. S. MacColl, cited in Ronald Pickvance, "'L'Absinthe' in England," *Burlington* 77 (May 1963), 397. On this controversy, see also Kate Flint, "The 'Philistine' and the New Art Critic: J. A. Spender and D. S. MacColl's Debate of 1893," *Victorian Periodicals Review*, 21 (Spring 1988), 3–8.

85 Arthur Kay, *Treasure Trove in Art*

(Edinburgh: 1939), pp. 27–28. Part of his remarks derive from his letter to the editor of the *Westminster Gazette*, 29 March 1893, which he reprints.

86 Kay, *Treasure Trove*, p. 29. Kay went on to buy *La Répétition*, a less controversial ballet scene by Degas, as well as Manet's more presentable pastel, *Au Café*, from the dealer Vollard (*ibid.*, p. 77).

87 George Moore, *The Speaker* (1 April 1893), cited in Flint, "'Philistine,'" p. 5.

88 See appendix.

89 Kay, *Treasure Trove*, p. 29.

90 For La Thangue's technique and the discussion which follows, see Bradford Art Galleries and Museums, *The Connoisseur: Art Patrons and Collectors in Victorian Bradford* (Bradford: 1989).

91 R. A. M. Stevenson, "Mr. Keiller's Collection in Dundee," *Art Journal* (Feb. 1894), 58. For Keiller, see *Dictionary of Scottish Business Biography, 1860–1960*, ed. Anthony Slaven and Sydney Checkland, 2 vols. (Glasgow: 1986–90), II, 37–39.

92 Stevenson, "Sir John Day's Pictures," *Art Journal* (Sept. 1893), 261.

93 Walter Armstrong, "Notes on British Painting in 1893," *Art Journal* (Jan. 1894), 3. Millais's painting had recently passed from Henry Bolckow's collection to that of Henry Tate.

94 Stevenson, "Keiller," 58.

95 Claude Phillips, "Some Subject Pictures from the Collection of George McCulloch," *Art Journal* (Dec. 1896), 355.

96 See R. H. Blackburn, *Sir Henry Tate: His Contribution to Art and Learning* (London: *c.* 1900) and Tom Jones, *Henry*

Tate 1819– 1899: A Biographical Sketch (London: 1960).

97 J. B. Manson, *The Tate Gallery* (London: 1929); National Gallery, Millbank, *Catalogue British School* (London: 1924); and Press Clippings, Tate Gallery Archive.

98 "The National British Gallery," *Magazine of Art* (Sept. 1897), 280.

99 For Fildes and other social realists, see Julian Treuherz, *Hard Times: Social Realism in Victorian Art* (Manchester: 1987).

100 See Arts Council of Great Britain, *Great Victorian Pictures: Their Paths to Fame* (London: 1978), no. 14, p. 36.

101 Luke Fildes to Henry Tate, 22 June 1890, Tate Gallery Archives.

102 Linda Nochlin, "The Imaginary Orient," in her *The Politics of Vision* (New York: 1989), p. 38.

103 The Royal Academy," *Athenaeum* 79 (19 May 1906), 615.

Appendix: major Victorian collectors

(see Bibliography for full references of abbreviated citations)

AIRD, Sir John (1833–1911)

14 Hyde Park Terrace; 22 Queen Anne's Gate, London; and Wilton Park, Beaconsfield, Buckinghamshire.

Occupation

Contractor, Lucas & Aird, 37 Great George Street, London and John Aird & Sons, 59 Belvedere Road, Lambeth.

Biography

Born in Blackfriars, Surrey, the son of John Aird, John junior joined the firm founded by his father which was famous for erecting the Great Exhibition building and later moving it to Sydenham. Aird left school at the age of eighteen after being privately educated at Greenwich and Southgate. He traveled extensively in connection with his father's business, working on the Berlin Waterworks, the Calcutta Waterworks with Thomas Brassey and the Millwall Docks for Sir John Kelk. After his father's death, Aird was responsible for the construction of the Royal Albert, Southampton, Tilbury, and Hull Docks, and the extension of the District Railways. Aird's most spectacular project was the damming of the Nile at Aswan in 1898. He was created a baronet in 1901. He was mayor of Marylebone and a member of the Council of the Art Union of London. Aird's estate was valued at £1,101,489.

Collection

Aird began collecting in 1874. His extensive holdings included works by Alma-Tadema (with whom he traveled to Egypt), Rossetti, Calderon,

Leighton, Orchardson, Walker, Waterhouse, Fildes, Stone, Marks, and Dicksee's *Chivalry* (Forbes Magazine Collection, New York). He also owned paintings by Dutch artists. He is said to have spent £90,000 on his collection.

Taste

Late Victorian, Aesthetic movement, and Dutch.

Purchasing pattern

Aird bought many canvases directly from artists who called him "St. John Aird of the Large Heart." He commissioned a painting of the Aswan Dam, from A. C. Gow.

Sales and bequests

Christie's, 8 July 1876; 2–4 April 1892; and 1 May 1931 (Malcolm Aird).

References

DNB, DBB, I, 17–20; *WWMP*; *Art Journal* (May 1891), 135–140, *London Directory* (1880); *Kelly's Buckinghamshire Directory* (1907); *Strand* 30 (1905), 433–35; James Bates, *Background of Paddington* (London: 1902); *The Times*, 7 and 12 Jan., 23 March 1911; *Cassier's* 20 (Aug. 1901) 266, 343–344, A. T. C. Pratt, *People of the Period*, 2 vols. (London: 1897), I, 18; G. Potter, *The Monthly Record of Eminent Men*, 4 vols. (1890–91); *Burke's Peerage* (London: 1910); *Who Was Who 1897–1916*; L. Weinthal, *The Anglo-African Who's Who* (London: 1910); *History of Beaconsfield* (Beaconsfield and District Historical Society: 1975), pp. 26–27; H. Blackburn, *Catalogue of the Collection of John Aird* (London: 1884);

Roberts, II, 176–81; Swanson, nos. 126, 321, 410, 416, 417, 427 and 428; Ormond, *Leighton*, p. 168; Surtees, *Rossetti Catalogue Raisonné*, no. 54; *Builder* (13 Jan. 1911); Robert K. Middlemas, *The Master Builder* (London: 1963)

Archival sources: Census Return for 1881; Last Will and Testament, 5 Feb. 1910, Somerset House.

ALEXANDER, William Cleverly (1840–1916)

Aubrey House, Camden Hill, Kensington.

Occupation

Banker, Lombard Street, London.

Biography

Great-grandson of Quaker ship-builder William Cleverly Alexander of Rochester, Alexander came from a well-established family. He married Rachel Agnes Lucas and they purchased Aubrey House in 1873, which had been built by Lady Mary Coke in 1767. Alexander was a friend of Roger Fry.

Collection

Whistler advised Alexander on the decoration of his house. Alexander apparently suggested the peacock theme to Whistler, although he declined the opportunity to incorporate it into his decor (Pennell and Pennell, *Whistler*, I, 204). Alexander, however, did purchase six works from Whistler, including a portrait of his daughter Cicely. He also owned works by Boyce and Fantin-Latour, in

addition to a selection of canvases by the Old Masters and painters of the early eighteenth-century British school, including those of his great-uncle, marine painter Robert Cleverly Alexander (d. 1810). Alexander was among the earliest Victorian collectors of Japanese and Chinese art.

Taste

Aesthetic movement, early British, and Old Master paintings.

Purchasing pattern

Alexander made purchases at the Old Water-Colour Society and the Dudley Gallery, in addition to giving direct commissions to artists.

Sales and bequests

Alexander bequeathed the portraits Whistler painted of his daughters May and Cicely to the National Gallery, but maintained a life interest in them for each sitter. His daughters Frances and Jean Alexander donated his collection of Oriental lacquerwork to the Victoria and Albert Museum and gave forty-two of the Old Masters to the National Gallery and various provincial galleries in 1965.

References

Country Life (2 and 9 May 1957), 872–75 and 922–25; *Evening Standard*, 5 July 1965; *The Times*, 6 July 1965; *Boyce Diaries*, ed. Surtees, p. 51; Graves, *Century of Loan Exhibitions*, II, 1660; Ellis Waterhouse, *Gainsborough* (London: 1966), no. 812; R. Colby, "Whistler and Miss Cissie," *Quarterly Review* 298 (July 1960), 309–20, and "Whistler's Controversial

Masterpiece," *Country Life* 132 (2 Aug. 1962), 260–61; Elisabeth L. Cary, *Whistler* (New York: 1907), pp. 187–88; Pennell and Pennell, *Whistler* I, 172–75, 204, 216 and II, 34; Denys Sutton, *Nocturne: the Art of J. M. Whistler* (London: 1963), 81–87; Young, *et al.*, *Whistler*, nos. 103, 127, and 129–30; Deanna Bendix, *Diabolical Designs: Paintings, Interiors, and Exhibitions of James McNeill Whistler* (Washington DC: 1995), pp. 110–160. Taylor, *Whistler*, pp. 85–87; Curry, *Whistler*, p. 270.

Archival sources: Letters from Whistler to Alexander, British Museum Print Room, and letters from Alexander to Whistler, Glasgow University Library.

ALLCROFT, John Derby (1822–92)

Stokesay Court, Ludlow, Shropshire, and 103 Lancaster Gate, London.

Occupation

Glove and leather manufacturer, J. & W. Dent and Co., Palace Yard, Worcester and Wood Street, London.

Biography

Allcroft was born in Worcester, the only son of Jeremiah Macklin Allcroft and Hannah Derby of Birmingham. As a teenager, he entered the leather manufactory operated by the Dent brothers in which his father was a partner. After purchasing the Dents' share following their retirement, the young Allcroft became sole owner. He concentrated on wresting control of the market from the cheaper French kid gloves by

centralizing his operations and demanding higher standards from his employees, whom he rewarded generously. Allcroft developed an international focus, cultivating markets throughout Europe and in the United States. He retired from business in 1873, although he continued to participate in company affairs. Allcroft devoted considerable energy to the restoration of thirteenth-century Stokesay Castle and the construction of the hundred-room Stokesay Court designed by Thomas Harris on the same 8,500-acre estate. Imitating the lifestyle of a country gentleman to the extent that he served as JP and High Sheriff of Shropshire and Conservative MP for Worcester, Allcroft nevertheless maintained his middle-class identity by remaining active in his business, preferring a modern mansion to a historic house, and opposing High Church ritualism. A devout Evangelical Anglican, Allcroft gave money to the Foreign Bible Society and the YMCA, and endowed five churches. He married Mary Annette Martin in 1854 and, after her death, Anne Jewell Blundell of Timsbury Manor, Hampshire, in 1864, with whom he had six children. Allcroft's estate was proved at almost £500,000.

Collection

Allcroft was attracted to mainstream English painters such as Vicat Cole, Thomas Creswick, B. W. Leader, Frederick Goodall, G. D. Leslie, and Carl Haag. His patronage, however,

also extended to their contemporary foreign counterparts: Koekkoek, Verheyen, and Bouguereau. Allcroft's favorite picture was Thomas Sidney Cooper's *Monarch of the Meadows*, a bucolic scene featuring a bull, a cow, and a calf in a field. His son Herbert added exotic *objets d'art* to the family collection which he purchased on his travels in India, Japan, China, and America. Both parts of the Allcroft collection were stored in the attics and cellars of Stokesay Court when the house was requisitioned during World War II, where they remained until they were sold by Sotheby's in 1994.

Taste

Allcroft preferred academic landscape and genre subjects, although his international business interests are also reflected by the inclusion of foreign artists and Orientalist subjects in his collection. He viewed his collection thematically, hanging religious scenes by Dicksee and Bouguereau in the library, which was apparently used for family prayers.

Purchasing pattern

Allcroft frequented the annual exhibitions at the Royal Academy and the Royal Society of British Artists.

Sales and bequests

By descent. Lady Jewell Magnus-Allcroft sales (Herbert's daughter Jewell Allcroft married Sir Philip Montefiore Magnus in 1943): London, Christie's, 9 Dec. 1992 (jewelry); 19 May 1993 (German and Austrian art); 10 June 1993 (French furniture

and European carpets); New York, Sotheby's, 24 May 1994 (American Indian art); Stokesay Court, Shropshire, Sotheby's, 28 September–1 October 1994 (paintings, *objets d'art*, and furniture).

References

DBB; *WWMP*; Girouard, *Victorian Country House*, p. 421; *Country Life* (1901), 1 and (18 and 25 Aug. 1994), 32–37 and 36–39; Cooper, *My Life*; Reyner Banham, *The Architecture of the Well-Tempered Environment* (London: 1969), p. 66; *Sotheby's Preview* (Oct. 1994), 3–5.

Archival sources: St. Peter's Parish Register, Worcester Record Office; Correspondence with T. S. Cooper, photographs, architectural plans, and 1897 inventory, Magnus-Allcroft Family Papers, Stokesay Court.

ALLNUTT, John (1773–1863)
6 Cedars Road, Clapham Common, London.

Occupation

Wine merchant, 50 Mark Lane, Westminster (his wine vaults remained in Mark Lane until destroyed by bombs in World War II). Master of Grocers Company in 1852. Amateur art dealer: owned the Pall Mall Gallery until 1838.

Biography

Allnutt's grandfather purchased a country estate of 500 acres near Penshurst, Kent, *c.* 1770, which was inherited by Joseph's older brother Richard Allnutt. He married twice,

first to Elizabeth Garthwaite, whose portrait by Lawrence was engraved as the *Morning Walk*; and second to Eleanora Brandram, a member of the gentry. Allnutt lived in Clapham for sixty years in a large house with grounds extending to the Brixton windmills. An amateur student of natural history and archaeology, he traveled in Germany and France. On 23 December 1842, Allnutt hosted his friend Dr. Gideon Algernon Mantell's lecture on the Temple of Serapis, the footprints of birds in the new red sandstone of Connecticut, and on the fossil Infusoria. Mantell's diary also records evenings spent with Allnutt studying animacules under a microscope (*Clapham Antiquarian Society Newsletter*, February 1969). Following Allnutt's death in 1863, his house and land were sold to a builder who subdivided the property. His granddaughter married the railway contractor Thomas Brassey (later 1st Earl Brassey).

Collection

Active from 1815, Allnutt owned Old Masters and oils by Cooper, Ward, Smirke, Lee, Wilson, Callcott, and Constable. Lawrence painted portraits of Allnutt, his two wives, and his daughter. He also owned watercolors and drawings by Turner (some dubious), Barret, Cox, Harding, Prout, etc. In addition, Allnutt collected Roman vases, incrustations, fossil turtles, and microscopes. Waagen notes that a "Mr. Allnut" was one of the purchasers of

the Electoral Gallery at Cassel (1838, I, 54); however, I have been unable to tie this reference to Joseph Allnutt. If Allnutt did indeed purchase this collection of Old Masters, one wonders if that is what prompted him to become proprietor of the Pall Mall Gallery. Despite his experience in the commercial art world, Allnutt's 1863 sale realized only one-quarter of the Bicknell collection, sold the same year.

Taste

Early Victorian and Old Masters. Allnutt was one of the few early-Victorian collectors to appreciate Constable. The *Art Journal* considered his watercolors superior to his oils (1863, 160), perhaps because he unwittingly purchased forgeries. Allnutt added a large picture gallery to his house in 1833, designed by J. B. Papworth (the subject of a watercolor by David Cox in 1845). When not open to the public on selected days, it was used by the family as a morning room. For this purpose, Papworth added a central light-well inspired by that in Benjamin West's painting room. Papworth also avoided using tie beams so that shadows would not be cast on the pictures.

Purchasing pattern

Commissioned pictures from Constable, Cox, Lawrence, Turner, and Müller. Allnutt also bought at sale rooms, the British Institution, and the Old Water-Colour Society. He used the architect J. B. Papworth and the painter George Fennell Robson as agents.

Sales and bequests

Christie's, 18–20 June 1863 (211 pictures and 292 drawings) and 23 and 25 June 1866 (263 pictures and 106 drawings).

References

Art Journal (Aug. 1863), 160–61; *Farington Diary*, ed. Grieg, VI, 95–96; Papworth and Papworth, *Picture Galleries*, pp. 72–74; Whitley, *Art in England 1821–1837*, p. 180; *Diary of B. R. Haydon*, ed. Pope, II, 441; *Clapham Antiquarian Society Newsletter* 28 (Jan. 1950), 126 (July 1958), 252 (Feb. 1969), and 253 (March 1969); Eric Smith, *Clapham* (London: 1976); Solly, *Cox*, pp. 19–20; Butlin and Joll, *Turner*, I, 35, 51, 111–12, 144, 147, 311, and 316; *John Sell Cotman*, ed. Miklos Rajnai (London: 1982), p. 22; Cormack, *Constable*, pp. 84 and 91; Brown, *Callcott*, pp. 75–76; *Ruskin Family Letters*, ed. Bird, II, 599–600 and 606; Lockett, *Prout*, pp. 50, 66, and 74; "Constable Correspondence," VI, pp. 375–76, 398–400, 428, 10, pp. 82–85, and 11, pp. 163–64 and 204; "A Catalogue of the Paintings, Drawings, and Pastels of Sir Thomas Lawrence," ed. K. Garlick, *Walpole Society* 39 (1962–64), 17; K. Garlick, *Sir Thomas Lawrence* (London: 1954), pp. 5 and 24.

Archival sources: Norwood Cemetery Memorial Entries.

ARDEN, Joseph (1799–1879)

1 Upper Bedford Place, Russell Square, by 1840; Cavendish Square, by 1857; and Rickmansworth Park, Hertfordshire (the property was sold to the Royal Masonic School for Girls in 1926 and the house demolished to build the present school).

Occupation

Barrister, Gray's Inn, where he was made a member of the governing body in 1878, and principal of Clifford's Inn. Practiced on the Home Circuit.

Biography

Son of Joseph Arden of Skinner Place, Islington, he inherited Rickmansworth Park from his mother, Temperance Arden, who had lived there since 1831. Arden served as acting magistrate for Hertfordshire from 1867. Active in London cultural life, he was a member of the Garrick Club, where he knew William Thackeray, John Leech, Charles Dickens, and Wilkie Collins. It was Thackeray who introduced Arden to John Everett Millais and encouraged him to buy *The Rescue* (Millais, *Millais*, I, 258). Arden was the proposer and Thackeray one of the seconders when Millais was elected to the Garrick Club in 1855 (Warner, "Millais," p. 93).

Collection

Pre-Raphaelite and early to mid-Victorian. In addition to his works by Millais, Arden owned pictures by a wide variety of painters such as J. F. Lewis, W. S. Burton, Clarkson Stanfield, and F. D. Hardy, which he displayed in his homes in Cavendish Square and at Rickmansworth Park. The *Art Journal* noted that he possessed

many pictures which had made a favorable impression in the exhibitions but quickly disappeared from public view (1857, p. 309). Among Arden's best-known canvases were Burton's *Wounded Cavalier* (later owned by Albert Wood, q.v., Guildhall Art Gallery), Millais's *Order of Release* (Tate Gallery), and *The Rescue* (National Gallery of Victoria, Melbourne). The latter two were conceived as pendants. Also a patron of David Roberts, Arden was the executor of his will. Despite the distinguished nature of his collection, the *Art Journal* charged that Arden did not display it to its advantage (1857, p. 311); moreover, Millais's son noted that when *The Rescue* appeared in Arden's sale at Christie's in 1879 it was covered with spots "due to its having been kept in an uncongenial temperature" (*Millais*, I, 259).

Taste
Early-Victorian and Pre-Raphaelite oils and watercolors.

Purchasing pattern
Commissions from artists such as Millais, Roberts, and J. F. Lewis.

Sales and bequests
Christie's, 26 April 1879 .

References
Art Journal (Oct. 1857), 309–311, and (Dec. 1857), 385; *Hertfordshire Almanac*, 1867–79; *West Hertfordshire and Watford Observor*, 8 Feb. 1879; J. E. Cussans, *History of Hertfordshire,* 5 vols. (London: 1870–81), V, 145; *The Times*, 28 April 1879; Joseph Foster, *Hand List of Men-at-the-Bar* (London: 1885), p. 11; Millais, *Millais*, I, 180, 185, 245, 258–59 and 356–57; Temple, *Guildhall Memories*, Redford, I, 292–93; William James, *The Order of Release* (London: 1948), 174; Warner, "Millais," 75, 92 and 95; James Ballantine, *The Life of David Roberts RA* (Edinburgh: 1866), p. 250; Sim, *David Roberts*, 285; *The Letters and Private Papers of W. M. Thackeray*, ed. G. N. Ray (Cambridge, Mass.: 1946), IV, 392; Reitlinger, pp. 145–46; Maas, *Gambart*, p. 126; Chapel, *Victorian Taste*, p. 131.

Archival sources: Letter from Millais to Arden, Pierpont Morgan Library, New York; Libraries of Gray's Inn, the Law Society, and Inner Temple.

ARMSTRONG, Sir William (1810–1900)
Jesmond Dene, Newcastle; Craigside, Rothbury, and Bamborough Castle, Northumberland.

Occupation
Engineer, inventor, and armaments manufacturer, Elswick Ordnance Co. and Sir W. G. Armstrong Whitworth and Co.

Biography
Grandson of a yeoman farmer of Wreay, near Carlisle, Cumberland and son of a prosperous Newcastle corn merchant who was active in civic and cultural affairs, Armstrong was educated in private schools and qualified as a solicitor. He was a partner in the Newcastle firm of Donkin and Stable. Interested in engineering, he experimented in hydraulics, eventually producing many labor-saving inventions which utilized water power. Armstrong established a plant at Elswick, near Newcastle, to manufacture his inventions. At the outbreak of the Crimean War in 1854, he was commissioned by the War Office to design submarine mines. He also began to produce artillery, forming, in 1859, the Elswick Ordnance Co. In 1868 Armstrong added shipbuilding to his engineering and armaments activities at Elswick, and in 1882 merged his firm with Mitchell and Swann. He was awarded honorary degrees by Cambridge (1862) and Oxford (1870) and was made a member of the peerage as Baron Armstrong in 1887.

Collection
Armstrong's collection represented an historical survey of the English School, ranging from early Victorians, such as Wilkie, to Aesthetic movement artists, such as Albert Moore and Dante Gabriel Rossetti.

Taste
Mid- to late-Victorian landscape and subject pictures.

Purchasing pattern
Armstrong acquired his art from a variety of sources, combining direct commissions with visits to international exhibitions and purchases from other collectors with bidding at Christie's.

Sales and bequests
Christie's 20 and 24 June 1910 and by descent.

References

Athenaeum (13 Sept. 1873), 342; *Magazine of Art* (1891), 158-65 and 193-99; *DNB*; *DBB*, I, 68-74; *Newcastle Journal*, 28 Dec. 1900; Temple, *Guildhall Memories*, pp. 104-5; National Trust, *Cragside; Country Life* (18 Dec. 1969), 1640-43; David Dougan, *The Great Gun-Maker* (Newcastle: 1971); Peter McKenzie, *Sir W. G. Armstrong* (Newcastle: 1983); Young, *Early Victorian England,* II, 419; Benwell Community Project, *The Making of a Ruling Class* (Newcastle: 1978), pp. 24-25; Horsley, *Recollections*, p. 257; Girouard, *Victorian Country House*, pp. 303-17; Saint, *Shaw*, pp. 67-75; Macleod (1986), p. 603; (1987), p. 350; (1989a), p. 188 and *passim*; (1989b), p. 125 and *passim*; Oliver Garnett "'Sold Christie's. Bought Agnew's: the art collection of Lord Armstrong at Cragside," *Apollo* 137 (April 1993), 253-8.

Archival sources: Armstrong Family Papers; National Trust (inventory of purchases to *c.* 1876); and Royal Institution (correspondence with John Tyndall and photographs of Cragside).

ASHBEE, Henry Spencer (1834-1900)

46 Bedford Place, London, and Hawkhurst, Kent

Occupation

Silk merchant, Charles Lavy & Co.

Biography

Only child of Robert Ashbee, manager of Carter and Harvey of Hounslow, gunpowder makers, and father of architect C. R. Ashbee. Ashbee was educated at schools in Esher and Kensington, followed by an apprenticeship in warehousing with Groucock, Copestakes, Moor and Co., for whom he traveled extensively. He left to found his own firm of merchants in partnership with Charles Lavy. They opened a branch in Paris in 1867. Ashbee was made a Fellow of the Society of Arts in 1877 and was the author of numerous articles, particularly on bibliographic subjects. He owned the most extensive library of the works of Cervantes outside Spain. Ashbee also specialized in erotica, which he catalogued under the title, *The Index of Forbidden Books*.

Collection

Ashbee possessed a wide selection of nineteenth-century English landscapes and narrative scenes by artists such as Chambers, Dawson, Egley, and Linnell.

Taste

Mid- to late-Victorian collector whose tastes embraced the entire Victorian school.

Purchasing pattern

Commissions to artists.

Sales and bequests

Ashbee bequeathed his collection of paintings to the South Kensington Museum and his library of over 15,000 volumes to the British Museum in 1900.

References

DNB; *London Court Directory* (1874); *The Times*, 1 Aug. 1900; *Athenaeum* (4 Aug. 1900); Parkinson, *Catalogue of Oil Paintings*, p. xx; Lambourne and Hamilton, *British Watercolours*, pp. xii-xiii.

ASHTON, Samuel (1804-61)

Hyde, near Manchester.

Occupation

Cotton master, fustian manufacturer, spinner and dyer, Ashtons of Hyde.

Biography

Grandson of Benjamin Ashton, a cotton trader and farmer, and son of Thomas Ashton, a farmer-cum-merchant manufacturer, Samuel entered the textile industry along with his three brothers. As Unitarians who believed in the stewardship responsibilities of wealth, the Ashton family attempted to improve the conditions of their workers in their mills and in the community. Thomas senior built housing for his employees, and after Samuel's death his brother Thomas junior kept the mills running during the cotton famine. Thomas junior was also actively involved in local causes as a supporter of Owens College, the Mechanics' Institute, and as a member of the Manchester Art Treasures committee.

Collection

Ashton's collection was hand-picked for him by Agnew's between the years 1848 and 1856. To the standard early-Victorian formula of landscape, figurative, and genre subjects, the Manchester dealer recommended less conventional canvases by Richard Dadd and J. R. Herbert, as well as by contemporary French artists such as Ary Scheffer. Thirty years later, Thomas Agnew's son William marveled at the quality of the watercolors in the Ashton collection. In a letter to one of Samuel's descendants he wrote: "I quite agree in your opinion that you could not get another lot of watercolours so good or beautiful. I am very glad to give you some valuations, and must ask you to believe that if anything I underestimate, and do not exaggerate. If I put my savings thirty years ago in good Watercolours, instead of buying 'Cambrians' and 'Sheffields,' I should be a rich man at this moment! Below see my valuation, which I should be prepared to vindicate in the most material way possible, viz by buying" (Agnew, p. 18). When Thomas junior inherited his brother's collection in 1861, he continued to add to it. Among his purchases were canvases by Turner, William Holman Hunt, and Sir Frederic Leighton.

Taste

Contemporary early-Victorian and academic French oils and watercolors, as well as imaginative works by artists selected by Agnew's.

Purchasing pattern

Depended primarily on Agnew's, with whom he transacted £10,670 in purchases.

Sales and bequests

Bequest of Ary Scheffer to Royal Manchester Institution; remainder of collection bequeathed to his brother Thomas. By descent to Lord Ashton of Hyde.

References

Waagen (1857), pp. 415–17; Agnew, pp. 15–18; Howe, *Cotton Masters*, p. 300; Thomas Middleton, *The History of Hyde and its Neighbourhood* (Hyde: 1932), p. 447; Darcy, pp. 145–46; Morris, "Naylor," p. 76; Butlin and Joll, *Turner*, 147; Patricia Allderidge, *The Late Richard Dadd* (London: Tate Gallery 1974); Elizabeth Conran, "Art Collections," in *Victorian Manchester*, ed. Archer, pp. 65, 72–73 and 210; Faberman, "Egg," p. 173.

For Thomas Ashton junior, see *Royal Manchester Loan Collection of Pictures and Drawings* (Manchester: 1875); *Manchester Guardian*, 22 Jan. 1898; Solly, *Müller*, pp. 167, 281, and 293; Butlin and Joll, *Turner*, I, 76; Heleniak, *Mulready*, p. 198; and Bennett, *Hunt*, p. 26.

BARLOW, Samuel (1825–93)
Stakehill, Middleton, near Manchester.

Occupation
Bleacher, Stakehill, Middleton, Lancashire.

Biography
Possibly the son of John Barlow, a Manchester collector whose holdings were sold at Capes in Manchester on 21 January 1857. Barlow was a founding member of the Manchester Arts Club and a member of the Literary Club. He was a student of the Lancashire dialect and an avid horticulturalist.

Collection

Barlow's home featured a large gathering of English and European artists, including Goodall, Grimshaw, Hans Thomas, Anderson Hague, Joseph Knight, Diaz, Pissarro (four), Fantin-Latour (five), Daubigny, and Corot's *St. Sebastian* (Walters Art Gallery, Baltimore).

Taste

French Impressionist, Barbizon, and regional. Barlow mixed landscapes by Manchester School painters with those of French, Dutch, and German flower and genre painters.

Purchasing pattern

Barlow may have been a client of Durand-Ruel in London in the early 1870s. He purchased his Fantin-Latours from Manchester dealer W. E. Hamer and is also known to have frequented Agnew's and the French Gallery in London. Barlow tried to sell Pissarro's *Village Street* at Christie's in 1882, but bought it in for 21 guineas.

Sales and bequests

Capes, Dunn, & Pilcher, Manchester, March 1894; private sales; and by descent. Barlow's descendants sold Pissarro's *Village Street* to the Manchester City Art Gallery in 1970.

References

Momus, 31 July 1879; *Transactions of the Manchester Literary Club* 19 (1893), 459–62; *Middleton Guardian*, 24 March 1894; Watts, *Watts*, I, 262; Cecil Gould, "An Early Buyer of French Impressionists in England," *Burlington* 108 (March 1966), 141–2; Elizabeth Conran, "Art Collections," in *Victorian Manchester*, ed. Archer, pp. 76–77.

Archival sources: Barlow Family press clippings.

BARNES, John Wheeldon (1825–93)

The Bank, Durham, and 6 Bentinck Street, London.

Occupation

Manager, Backhouse's Bank, 6 Market Place, Durham.

Biography

Son of Robert Barnes of Durham and brother of the Rev. George Barnes, Barnes was educated at Durham Grammar School and entered the employ of the Backhouse bank when he was approximately nineteen. An amateur artist, Barnes occasionally contributed cartoons to *Punch* and became good friends with its editor, Mark Lemon. Active in local affairs, he was made Justice of the Peace and a governor of the Durham County Hospital. In addition, Barnes was a director of the Durham Gas Company.

Collection

Barnes's collection was especially rich in watercolors by George Price Boyce.

He also owned examples by A. W. Hunt, W. H. Hunt and A. Goodwin, as well as woodcuts by Bewick.

Taste

Mid-Victorian English watercolors.

Purchasing pattern

Direct purchases from George Boyce. Barnes bought at least two watercolors by W. H. Hunt from John Ruskin (Witt, *W. Henry Hunt*, p. 201). He also patronized the Old Water-Colour Society's exhibitions.

Sales and bequests

Christie's, 6–7 April 1894, and Newcastle, 10–11 May 1894.

References

Athenaeum (6 Nov. 1875), 614–16; *Durham Directory* (1894), 72–74; *Boyce Diaries*, ed. Surtees, pp. 57, 60, and 62; Witt, *W. Henry Hunt*, nos. 182 and 620; Macleod (1986), p. 604 and (1989b), p. 125.

BARRATT, Thomas James (1841–1914)

"Bell-Moor," Upper Heath, Hampstead, London (now replaced by flats on East Heath Road).

Occupation

Chairman, Pears' Soap, and pioneer of modern advertising.

Biography

Born in London, the son of Thomas Barratt, a pianoforte maker, and Emma Price. Barratt left school at the age of fifteen and worked at various clerical jobs before he was hired as a bookkeeper by A. and F. Pears in 1864. The following year he married Francis Pears's eldest daughter, Mary, and was subsequently made a partner in the firm. The enormous success of the firm can be attributed to Barratt's belief in mass advertising and the introduction of novel promotional methods. Barratt was also an avid amateur historian, publishing a three-volume history of Hampstead, *The Annals of Hampstead*, in 1912. He was vice-president of the Hampstead Antiquarian and Historical Society, a member of the Hampstead Art Society, and a founder of Golders Hill Park. His other consuming hobby was microscopy and he was a fellow of the Royal Microscopical Society. Barratt's estate was valued at £405,564, which he left to his two illegitimate sons after disinheriting his wife.

Collection

Barratt specialized in views of Hampstead, but also collected engravings by Morland, seventeenth-century Dutch landscapes, and eighteeth-century British portraits. He was inordinately proud of Landseer's *Monarch of the Glen* (John Dewar and Sons Ltd) and David Cox's *Vale of Clwyd*. Barratt also owned a large collection of Nelson silver and memorabilia.

Taste

Late-Victorian collector with a preference for seventeeth-century Dutch and early-British art.

Purchasing pattern

Barratt was a client of Agnew's, but he

also made commissions directly
to artists.

Sales and bequests

Christie's, 11–12 May 1916 and
Sotheby's 23 and 31 July 1917. Barratt
bequeathed his Nelson plate to
Greenwich Hospital.

References

Magazine of Art 21 (Jan. 1898), 132–38,
(Feb. 1898), 189–96, (March 1898),
261–68, (Apr. 1898), 289–94; *DBB*, I,
189–91; *The Times*, 27 April 1914;
T. Barratt, *The Annals of Hampstead*, 3 vols.
(London: 1912); *Pall Mall Gazette* (14 June
1884) and (19 May 1888); Carter, *Let Me
Tell You*, pp. 233–36; Marillier, *Christie's*,
p. 161; Reitlinger, 106; Temple, *Guildhall
Memories*, pp. 80–81; C. H. Ward Jackson,
"The Great Persuader," *Blackwood's* 317
(March 1975) 206–19; T. R. Nevett,
Advertising in Britain (London: 1982);
Charles H. Wilson, *History of Uniliver*
(London: 1954); Borough of Camden,
Hampstead One Thousand (London: 1956),
pp. 75–76 and 120.

Archival sources: Camden Library,
Swiss Cottage, Local History
Collection, Bell Moor Collection;
A. and F. Pears, Ltd., manuscripts
and press cuttings book.

BASHALL, William (fl. 1840–71)
Farrington Lodge, Farrington, Lancashire.

Occupation

Cotton spinner, founder and partner,
Bashall and Boardman, Farington,
near Preston.

Biography

Son of William Bashall, who con-
structed a mill in the 1830s which
employed 993 workers by 1851.
William junior built terraces of work-
ers' houses surrounding the mill, as
well as a school and a library. He was
the uncle of William Cottrill (q.v.).

Collection

The *Art Journal* reported that Bashall's
collection was displayed in the lower
rooms of his mansion, which was
"well lighted; insomuch that many
of the pictures look more fresh than
when exhibited" (1857, p. 206). In
addition, he collected architectural
studies and works by Maclise, Linnell,
Frith, Egg, Goodall, E. M. Ward,
Thomas Faed, and a series of animal
subjects by Ansdell and Landseer.
He was a lender to Manchester Art
Treasures exhibition.

Taste

Early-Victorian historical, anecdotal,
landscape, and architectural subjects.

Purchasing pattern

Commissioned or bought directly
from artists and from Royal Academy
private views.

Sales and bequests

Agnew's purchased eighty-five
paintings from his estate on 2 May
1871; Christie's, 22 May 1876
(porcelain, silver, *objets d'art*).

References

Art Journal (July 1857), 206–8 and
(June 1871), 170; Nikolaus Pevsner,
The Buildings of England: North

Lancashire (Harmondsworth: 1969),
p. 119; Christopher Townson, *History
of Farington* (Preston: 1893),
p. 30; Howe, *Cotton Masters*, pp. 13,
21, 23, 77 and 300; Darcy, p. 145;
Robertson, *Eastlake*, p. 267; James
Ballantine, *The Life of David Roberts*,
(Edinburgh: 1866), p. 175; Faberman,
"Egg," p. 175.

BEAUSIRE, Joseph (1833–1907)
*Claughton, Birkenhead, and later, Netherfield,
Noctorum, Birkenhead, Liverpool.*

Occupation

Merchant, Joseph Beausire & Co., and
chairman of the West India and Pacific
Steamship Co.

Biography

Son of Robert Beausire of Liverpool.
Educated at Liverpool College,
Beausire apprenticed with A. Durantz
& Co. in the West Indian, Spanish
Main, and Mexican trade. In 1858 he
launched his own firm, specializing in
the South American trade. In addition
to his shipping interests, Beausire was
a director of the Royal Insurance Co.,
the North and South Wales Bank, the
British and Foreign Marine Insurance
Co., and the Anglo-Chilian Nitrate
Railway Co.. He was a member of
the Philharmonic Society.

Collection

F. G. Stephens, in his account in *The
Athenaeum*, only mentions works by
William Davis of Liverpool; however,
the catalogue for the 1970 Beausire
bequest indicates that he also owned a
work by Copley Fielding.

Taste
Liverpool School.

Purchasing pattern
Agnew's.

Sales and bequests
Christie's, 13 April 1934, and by descent. C. F. J. Beausire bequest to Walker Art Gallery, 1970.

References
Athenaeum (18 Sept. 1886), 378; Orchard, *Liverpool's Legion of Honour,* p. 158; *Liverpool Courier,* 10 Jan. 1907; *Daily Post and Mercury,* 12 Jan. 1907; Walker Art Gallery, *English Watercolours in the Collection of C. F. J. Beausire* (Liverpool: 1970); Macleod (1986), p. 604.

BELL, Sir Isaac Lowthian (1816–1904)
Washington Hall, Durham, and Rounton Grange, Northallerton, Yorkshire.

Occupation
Metallurgical chemist and ironmaster, Clarence Iron and Alkali Works, Middlesbrough, Cleveland.

Biography
Son of Thomas Bell and Catherine Lowthian. Bell's mother's family had for many generations been tenants of the Dean and Chapter of Carlisle. Her brother John established schools in the Lebanon. Bell's father's family were landowners in the West Indies but returned to Lancashire after the abolition of slavery. Thomas Bell settled in Newcastle in 1803 and worked for Losh & Co., alkali manufacturers.

He was later made a partner in the iron-working firm of Losh, Wilson, & Bell. He transferred his interest in chemistry and physics to his son Isaac (commonly known as Lowthian), who studied at Bruce's Academy in Newcastle and at Edinburgh University and the Sorbonne. In 1835, at the age of nineteen, Lowthian Bell entered his father's office. Seven years later he married Margaret Pattinson, daughter of Hugh Lee Pattinson. In 1844, he formed Bell Brothers, an ironworks on the river Tyne, and in 1850, and in partnership with his father-in-law, Lowthian started a chemical works at Washington, near Gateshead (*DNB*). A larger ironworks at Port Clarence on the Tyne followed in 1854, and by 1875 this plant produced one-third of Britain's pig iron (*DBB*). Despite his far-flung interests, Bell devoted much time to public service. He was mayor of Newcastle for two terms and deputy lieutenant and high sheriff of the County Durham, in addition to holding office as a MP Bell was raised to the baronetcy in 1885. His daughter Mary married Lyulph Stanley, brother of Rosalind, Countess of Carlisle. According to a recent biographer, Mary Stanley had a long affair with George Howard, the Earl of Carlisle (Surtees, 1988, p. 147).

Collection
Bell owned works by Boyce, Cox, Millais, A. W. Hunt, Hodgson, H. Moore, A. Goodwin, Prinsep, and Calder. He commissioned a portrait of his three daughters from George Frederic Watts titled *Framing the Most Beautiful.* The interior of Rounton Grange, the house Bell had designed by Philip Webb, was designed by William Morris.

Taste
Mid-Victorian landscapes and subject pictures, in addition to Aesthetic movement designs.

Purchasing pattern
Direct purchases and commissions from artists.

Sales and bequests
By descent and untraced Boroughbridge sale, c. 1954.

References
Athenaeum (18 Oct. 1873), 500–2; *DNB; DBB,* I, 256–60; *Newcastle Evening Chronicle* and *North East Daily Gazette* 20 Dec. 1904; *Journal of the Iron and Steel Institute* 2 (1904), 426–34; *Darlington and Stockton Times,* 9 Dec. 1933; *Boyce Diaries,* ed. Surtees, pp. 40 and 53; Surtees, *Artist and Autocrat,* p. 147 and *passim,* Crane, *Reminiscences,* p. 150; *Country Life* (26 June 1915), 906–12 and (25 Dec. 1920), 846–52; Girouard, *Victorian Country House,* pp. 418–23; Curry and Kirk, *Webb,* pp. 21–26; Macleod (1986), 601 and 604; Macleod (1989a), 188 and *passim;* Macleod (1989b), 125 and *passim.*

Archival sources: Letters from William Bell Scott and Arthur Hughes to James Leathart, Leathart Papers, University of British Columbia.

BELL, Jacob (1810–59)
15 Langham Place, Haringey, London; West

Hill, Wandsworth, Surrey; later, 3 Carlisle Villas, Hastings.

Occupation

Pharmaceutical chemist, John Bell & Co., 225 Oxford Street (later John Bell & Croyden); founder of Pharmaceutical Society in 1841 and of *Pharmaceutical Journal* in 1842.

Biography

Grandson of John Bell, a hosier of Fish Street Hill and a collector of plants, shells, and antiquities; son of John Bell, a Quaker minister and a chemist who founded the family firm. Bell was educated by the Quakers at Darlington and later studied art at Sass's Academy until he was expelled for insubordination. He then apprenticed in pharmacy in his father's business. Bell devoted his career to separating the practice of pharmacy from medicine and reputedly spent a fortune in founding and advancing the Pharmaceutical Society. Bell's introduction to the first issue of the *Pharmaceutical Journal* was reprinted by Theophilus Redwood in his *Historical Sketch of the Progress of Pharmacy of Great Britain* (1880). An intimate friend of Edwin Landseer whom he met at Sass's, Bell acted as his business manager, advising him on investments, and negotiating with publishers and engravers on his behalf. Bell also acted as an intermediary with other patrons for Landseer, corresponding with Wells (q.v.), Sheepshanks (q.v.), Vernon (q.v.), and Bicknell (q.v.). He did the same for Henry Briggs, who had taught him drawing at Sass's. He also investigated the question of copyright as it affected artists. Bell was active in the Artists' Conversazione and City of London Artists' and Amateurs' Conversazione. He gave elaborate parties at Langham Place, where he mixed artists with dispensing chemists. Bell was disowned by the Society of Friends in 1855 because of absenteeism. He became depressed toward the end of his life, and wrote to Frith in 1859 "I wish to be written off as a bad debt and forgotten" (Victoria and Albert Museum Library). After Bell's death from laryngeal phthisis, his estate was proved at under £30,000.

Collection

Bell patronized Edwin Landseer, Charles Landseer, Collins, Briggs, Lee, Frank Stone, E. M. Ward, and Frith, among others. In an undated inventory of his collection Bell valued his 156 pictures, eight pieces of sculpture, and miscellaneous prints at £13,815. He made loans to the British Institution and to the Manchester Art Treasures exhibition (where four of his pictures were damaged).

Taste

Early-Victorian anecdotal subjects and animal scenes.

Purchasing pattern

Mainly direct commissions from his artist friends, e.g. Landseer, Briggs, and Frith.

Sales and bequests

1859 Bequest to National Gallery of sixteen pictures. Foster's sale, 3 May 1860 and Christie's (Mrs. Spencer Bell), 25 May 1893.

References

DNB; Boase; *WWMP*; *Drug Price Current* (1851), 361; Leslie G. Matthews, "Statesman of Pharmacy, Jacob Bell 1810–1859," *Chemist and Druggist* (6 June, 1959), 609–16; G. E. Treuse, "Jacob Bell (1810–1859)," *Pharmaceutical Practice*, I (Dec. 1979), 26–28; Juanita Burnaby, "The Family History of Jacob Bell," *Pharmaceutical Journal*, 230 (21 May 1983), 582–84; *ILN*, 18 (12 April, 1851), 299 and 21 (20 Aug. 1859), 4 and 24; *Annual Register* (London: 1859); Jacob Bell, *Marylebone Literary and Scientific Institution Descriptive Catalogue of Pictures Exhibited March 28 to April 16, 1859*; Jacob Bell and Theophilus Redwood, *Historical Sketch of the Progress of Pharmacy of Great Britain* (London: 1880); Taylor, *Leslie*, I, lviii–lix and II, 212 and 321; Redgrave, *Memoir*, p. 50; Frith, *Autobiography*, I, pp. 41–43; Maas, *Gambart*, pp. 76, 94, 99–102, and 181; Gage, *Turner Correspondence*, pp. 239–40, 269 and 305; Warner, "Millais," p. 104; Robertson, *Eastlake*, pp. 233, 307–309, and 444–45; Ormond, *Landseer*, pp. 9–12ff.

Archival sources: Society of Friends, London; Victoria and Albert Museum Library (letters to Frith and Landseer); Royal Institution, London (correspondence and inventories, including 103 letters from Landseer);

Pharmaceutical Society of Great Britain (correspondence with various artists); Manchester City Archives (Royal Manchester Institution letter books, 1851–53); Somerset House (Last Will and Testament and Probate Papers).

BIBBY, John (1814–92)
Croxteth Drive, Sefton Park, Liverpool, and Fachene, St. Asaph, Wales.

Occupation
Shipowner and copper manufacturer, J. Bibby Sons & Co., Liverpool.

Biography
Bibby was the son of John Bibby of Liverpool, who established the family shipping firm and merchant enterprise in 1807. John and his brother James assumed control of the company after their father's death in 1840 and oversaw the transition from sail to steamships. In 1873 the brothers sold their interest to their junior partner Frederick Leyland (q.v.). For the next sixteen years, the Bibby family concentrated on their copper interests at St. Helens; however, in 1889, they reentered shipping by forming a new company, Bibby Bros. This enterprise created the foundation for the present company. Bibby was also a director of the North and South Wales Bank. He should not be confused with shipowner John Bibby (1819–83) of Hart Hill, Allerton, whose art collection was sold in Liverpool by Branch, Leete, Co. on 16 April 1883 (Liverpool Records Office).

Collection
Bibby owned nine Rossettis, including *La Pia*. He also possessed Hughes's *Ophelia*, watercolors by Madox Brown, and oils by Windus and Wallis. In addition, Bibby owned works by a number of earlier British artists, including Turner, Landseer, Cox, and De Wint.

Taste
Aesthetic movement and early-nineteenth-century British.

Purchasing pattern
Bibby made purchases in Rossetti's studio and at the Dudley Gallery. He also frequented the auctions of other Aesthetic movement collections, notably those of Leyland, Valpy, and the dealer Charles Augustus Howell.

Sales and bequests
Christie's, 3 June 1899.

References
Athenaeum (27 Sept. 1884), 408–9; *Art Journal* (Sept. 1899), 284; *Liverpool Courier* (6 Jan. 1892); Orchard, *Liverpool's Legion of Honor*, p. 174; J. Plight, *History of the Bibby Line* (Liverpool: 1949); G. Chandler, *Liverpool Shipping* (Liverpool: 1960), pp. 83–88 and 221–25; Stephen Hobson, "A Liverpool Family Firm," *Seascape* 5 (Sept. 1987), 10–11; Fredeman, *Bibliocritical Study*, no. 19.17, p. 80; *The Correspondence between Samuel Bancroft, Jr. and Charles Fairfax Murray*, ed. Rowland Elzea (Wilmington: Delaware Art Musuem, 1980), pp. 162 and 167; L. Roberts and M. V. Evans, "'Sweets to the Sweet': Arthur Hughes's Versions of *Ophelia*," *Journal of Pre-Raphaelite and Aesthetic Studies* (Fall 1988), 28–29 and 35; *Rossetti Letters*, ed. Doughty and Wahl, II, 622–23; Surtees, *Rossetti Catalogue Raisonné*, nos. 168R.4, 173A, 174, 198, 201R.1, 207, 255B, 260D, 339.

BICKNELL, Elhanan (1788–1861)
Carlton House, Herne Hill, Camberwell, Surrey.

Occupation
Sperm whale oil merchant and shipowner, Langton & Bicknell, Newington Butts.

Biography
Son of a serge manufacturer who was a friend of John Wesley and who gave up his business to run a school in Enfield named after Elhanan Winchester, after whom he also named his son. Elhanan Bicknell was brought up as a Unitarian and as a liberal. After trying careers in teaching and farming, he joined his uncle in the business of refining and selling spermaceti. Supporting repeal of the navigation laws despite his interest in whaling, Bicknell was an economic adviser to the governments of Disraeli and Gladstone. He married four times; his third wife was the sister of Hablot Knight Browne ("Phiz"). His son Henry married the daughter of the artist David Roberts. Bicknell frequently entertained artists, as well as his neighbors, the Ruskins.

Collection

Bicknell spent over £25,000 on oils by Gainsborough, Turner, Roberts, Callcott, Landseer, Webster, Etty, Eastlake, and Stanfield; watercolors by Fielding, Prout, and De Wint. He also collected sculpture. Active as a collector between the years 1838 and 1854, Bicknell often financed engravings for artists in addition to buying their oils and watercolors.

Taste

Early-Victorian landscapes and seascapes. The *Athenaeum* in 1861 ranked him with Vernon, Wells, and Sheepshanks as one of the four major collectors of modern art; he also owned works by Van Dyck, Gainsborough, and Stothard.

Purchasing pattern

Direct commissions and purchases from artists. Bicknell selectively bought at auctions, notably at the George Knott sale in 1845. He entered into print publishing and other speculative ventures with the dealer William Hogarth.

Sales and bequests

Christie's, 25 April 1863 (oils and sculpture) and 29 April–1 May (watercolors); 7–8 May (prints).

References

Waagen (1854) I, 36 and II, 349–54; *Art Journal* (Jan. 1857), 8–10; (Feb. 1862), 45–46; and (June 1863), 121–22; *Athenaeum* (7 Dec. 1861), 769 and (16 May 1863), 651; *DNB*; Boase; *Christian Reformer* (Jan. 1862); *Globe*, 23 April, 1863; *Spectator,* 25 April 1863; *The Times*, 27 April 1863; *Star*, 28 April 1863; *London Review* (2 May 1863); A. S. Bicknell, *Five Pedigrees* (London: 1912); Edgar Browne, *Phiz and Dickens* (London: 1913); Hall, *Retrospect*, pp. 197–98; Ruskin, *Works*, III, xxviii, 244, 251, 568, and 668; *Diaries of John Ruskin*, ed. Evans and Whitehouse, I, 251, 262, 269, and 270; Harold Shapiro, *Ruskin in Italy* (Oxford: 1972), p. 248; Taylor, *Leslie*, II, 127, 280, 323, and 325; Redford, I, 166–67; Roberts, I, 198–207; Marillier, *Christie's*, 341; Reitlinger, pp. 86–87, 92–93, and 101–2; Agnew, p. 25; Robertson, *Eastlake*, pp. 206–7; Gage, *Turner Correspondence*, p. 240 and *passim*; Chapel, *Victorian Taste*, pp. 131–32; Sim, *David Roberts*, pp. xvii, 209–10, 247, 263–65, 285, 314–15; Peter Bicknell, "Turner's *The Whale Ship*: A Missing Link?," *Turner Studies* 5 (1986), 20–23; Peter Bicknell and Helen Guiterman, "The Turner Collector: Elhanan Bicknell," *Turner Studies* 7 (1987), 34–44.

Archival sources: Percy Bicknell annotated copy of 1863 sale catalogue (collection of Peter Bicknell with copies in Getty Art Center, Fitzwilliam Museum, and Paul Mellon Centre, London); National Library of Scotland (David Roberts correspondence); Fitzwilliam Museum (Landseer and Maclise correspondence), Victoria and Albert Museum (Pye correspondence), and Yale Center for British Art, New Haven (David Roberts correspondence).

BICKNELL, Henry Sanford (1818–80)

Cavendish House, Clapham Common, London (1864–80).

Occupation

Sperm whale oil merchant, Langton and Bicknell.

Biography

Eldest son of Elhanan Bicknell (q.v.) and his second wife Mary Jones. Married Christine Roberts, daughter of the painter David Roberts. They lived in style in a mansion built for Henry Cavendish, nephew of the Duke of Devonshire.

Collection

Henry bought fifteen lots at his father's sale, including three Turner oils. In addition, he and his wife inherited 154 oils and watercolors from David Roberts. To their patrimony, they added a large selection of works by Goodall, Maclise, Stanfield, Phillip, and Elmore. On visiting his collection in 1872, the *Art Journal* complimented Bicknell for following "in the footsteps of his father, by enriching his home with such valuable treasures of Art."

Taste

Early- to mid-Victorian genre and landscape in oils and watercolors.

Purchasing pattern

Inheritance, sale rooms, and direct purchases from living artists.

Sales and bequests

Christie's, 9 April 1881.

References

Art Journal (March 1872), 90–92;
Sim, *David Roberts*, 210.

Archival sources: Bicknell family
papers.

BIRCH, Charles
(fl. 1825–c.1865–72)

*Burnt Tree, near Dudley, by 1825; Metchley
Abbey, Harborne, by 1842; Westfield
House, Woodfield, by 1853; Lutley Lodge,
Birmingham, c. 1858–65.*

Occupation

Coal mine owner and ironmaster.

Biography

Origins unknown. Although the
name Birch figures in the property
rolls of Staffordshire from the seven-
teenth century, there is no evidence
that Charles belonged to one of the
moneyed branches of the family. He
should not be confused with Charles
Birch, the London picture restorer,
whose sale was held at Christie's on
14 June 1828 (Getty Provenance
Index). Charles Birch of Birmingham
made his living as an entrepreneur and
amateur picture dealer. He claimed he
was forced to sell his collection
because his coal mine had caught
fire; however, he anonymously
bought back many items at inflated
prices, presumably in order to raise
the level of bidding, since he later
resubmitted them for auction. Birch
was secretary of the Birmingham
Art Union in 1842, a lender to the
Exposition Universelle in Paris in

1855, and chairman of the committee
of friends who commissioned a por-
trait of David Cox in 1855. A frequent
companion of Birch on sketching
trips, Cox subsequently bequeathed
a drawing to him in his will. Another
example of Birch's regard for artists is
the elaborate dinner he gave in honor
of Rosa Bonheur's visit to
Birmingham.

Collection

Spent £30,000 on the art works he
displayed in his private picture gallery
at Metchley Abbey. They included
Wilkie's *The First Earring*, Maclise's
Alfred in the Danish Camp and *Baron's
Hall*, and Frith's *Dolly Varden*. He
also owned oils by Collins, Etty,
Constable, Turner, Müller, Landseer,
Stanfield, Poole, and Linnell.

Taste

Early-Victorian British and French
oils and watercolors with a predilec-
tion for landscape and idyllic subjects.

Purchasing pattern

Birch explored every possible commer-
cial outlet: trades with other collectors
(notably Joseph Gillott (q.v.)), auctions,
dealers, Royal Academy private views,
and artists' studios.

Sales and bequests

Christie's, 7 July 1853; Foster's, 15
Feb. 1855; Christie's, 1 June 1855
(porcelain, metalwork and furniture);
Foster's, 27–28 Feb. 1856; Foster's,
23–24 Feb. 1857; Foster's, 27 Feb.
1857; (Anon.), Foster's 26 Feb. 1858;
Foster's, 23 March 1859 (English

portraits, furniture, and plate); and
Foster's, 14 June 1865.

References

Art Journal (Feb. 1855), 65; (March 1856),
96; (April 1856), 115; and (April 1857),
129–30; Waagen IV, 403; *Birmingham
Journal* (30 Sept. 1838) and (7 Sept. 1839);
Birmingham Directories, 1845–56; Tom
Presterne, *Harborne, "Once Upon a Time"*
(Birmingham: 1913), pp. 104–5; Solly,
Cox, pp. 47, 82, 91, 100–105, 112–15,
118, 122–24, 130–32, 137, 155, 195–96,
226, and 235; Hall, *Cox*, p. 60; Solly,
Müller, pp. 124, 147, 152, 154, 170, and
230; Story, *Linnell*, II, 14; Redford, I, 187;
Ormond, *Maclise*, p. 97; Butlin and Joll,
Turner, I, 15, 72, 203, 207, 217–19, and
259; Farr, *Etty*, p. 169, no. 177; Adams,
Danby, p. 198, no. 200; Maas, *Gambart*,
p. 80; Ormond, "Victorian Birmingham,"
p. 240; Coan, "Birmingham Patrons";
Chapel, "Gillott," pp. 45–46; Michael
Greenslade, *A History of the County of
Stafford* (Oxford: 1967), pp. 92, 135–37,
174 and 239; John Benson, *British
Coalminers in the Nineteeth Century*
(Dublin: 1980), 20.

Archival sources: Census Report of 1851;
and Provenance Index and Archives
(Gillott Papers), Getty Center, Santa
Monica.

BOLCKOW, Henry (1806–1878)

*Cleveland Street (until 1856); Marton Hall,
Middlesbrough, and 33 Prince's Gate, London.*

Occupation

Ironmaster, Bolckow & Vaughan,
Middlesbrough.

Biography

Son of Heinrich Bölckow of Varehow, Mecklenburg, and Caroline Dussher, owners of a country estate. Bolckow was privately educated and was apprenticed, at approximately age fifteen, to a merchant in Rostock. After a fellow employee left for Newcastle-upon-Tyne, Bolckow joined him in 1827, working for the firm his friend had started, C. Allhusen, grain and shipping merchants. Although he was made a partner, twelve years later Bolckow decided to join John Vaughan in an ironmaking enterprise in Middlesbrough, where they built a forge, foundry, and a rolling mill. Between 1869 and 1875, they claimed profits of £1,659,000 (*DBB*). Bolckow served as Middlesbrough's first mayor and MP. Generous to the community in which he had earned his fortune, he donated £40,000 toward a hospital, day school, and public park. His estate was sworn at under £800,000.

Collection

Bolckow's collection consisted, according to the *Athenaeum*, of pictures "nearly all of the present day, and by living artists" (1873, p. 664). Among the moderns, he owned works by Goodall, Linnell, Maclise, and John Faed. He paid Millais a record £4,930 for *The North-West Passage* in 1874. Bolckow also possessed a number of French canvases by artists such as Frère, H. Browne, Schreyer, Meissonier, and Gallait. Landseer's *Braemar* was his favorite early-Victorian work.

Taste

Early- to mid-Victorian English and French oils.

Purchasing patterns

Bolckow was a client of Agnew's and possibly of Gambart. He also made purchases in artists' studios.

Sales and bequests

Christie's, 5 May 1888; 2 May 1891; and 18 June 1892.

References

Athenaeum (22 Nov. 1873), 664–66; *Art Journal* (Nov. 1888), 342; (Oct. 1891), 309–10; and (Sept. 1892), 286; *DNB*; *DBB*; Thomas Fenwick, *Practical Magazine* I, (1873), 81–90; *Middlesbrough and its Jubilee*, ed. H. G. Reid (Middlesbrough: 1881), pp. 114–15, 128–29; Roberts, II, 129–31 and 157–61; Redford, I, 452; Marillier, *Christie's*, pp. 64–65; Carter, *Let Me Tell You*, 41–45; Reitlinger, pp. 152–53 and 162–63; Ron Gott, *Henry Bolckow, Founder of Teeside* (Northallerton: 1968); William Lillie, *The History of Middlesbrough* (Middlesbrough: 1968); Girouard, *Victorian Country House*, pp. 11 and 412; Macleod (1986), pp. 602–4.

BRODERIP, William John (1789–1859)

2 Raymond Buildings, Gray's Inn.

Occupation

Lawyer and naturalist.

Biography

Son of William Broderip, a Bristol surgeon, Broderip was educated at the Rev. Samuel Seyer's school in Bristol and Oriel College, Oxford. He was called to the bar at Lincoln's Inn in 1817 and was appointed magistrate of the Thames police court five years later. Broderip's deafness caused him to resign from the bench in 1856. He was a fellow of the Linnean, Geograpical, and Royal Societies and a founder of the Zoological Society. In connection with his zoological interests, Broderip published several papers on malacology. He was also a contributor to the *New Monthly Magazine*, *Fraser's Magazine*, and the *Penny Cyclopaedia*. He wrote several books, including *Zoological Recreations* (1847) and *Leaves from the Note-book of a Naturalist* (1852). Broderip was a cousin of Charles Maude of Bath, who also owned a single canvas by Holman Hunt, *Strayed Sheep*. Maude later bought Hunt's *The Hireling Shepherd* at Broderip's sale in 1859, which was sold again two years later in Maude's sale at Christie's on 15 June 1861.

Collection

Broderip's fine-art purchases reflected his catholic interests. In addition to owning seventeenth-century Dutch and Flemish paintings, he possessed works by Hogarth, Turner, Danby, Etty, and Horsley, as well as by William Holman Hunt. Daniel Maclise expressed his delight with Broderip's purchase of Hunt's *The Hireling Shepherd* (Manchester City Art Galleries) in a congratulatory note in which he

called the picture "the work most interesting in the exhibition of the year '52" (Munby, "Letters of British Artists," 100). Broderip also owned an extensive collection of shells.

Taste
Early-Victorian, Pre-Raphaelite, and seventeenth-century oils. His one Pre-Raphaelite canvas was compatible with his other natural subjects.

Purchasing pattern
Unknown. Broderip bought *The Hireling Shepherd* in installments, paying half down, and making quarterly paments of £60 until the 300 guinea balance was paid in full.

Sales and bequests
Christie's, 18 June 1853; 11 June 1859; 21 April 1860; and 5 April 1862 (F. Broderip). Broderip's conchological collection was purchased by the British Museum.

References
DNB; *London Directory* (1852); *ILN*, 9 (1846), 317; *Law Magazine and Law Review* 8 (1860), 174–78; M. Berger, *W. J. Broderip, ancien magistrat, naturaliste, littérateur* (Paris: 1856); Hunt, *Pre-Raphaelitism*, I, 321, 327 and 336–38; Bennett, *Hunt*, no. 22, p. 30; A. N. L. Munby, "Letters of British Artists of the Eighteenth and Nineteenth Centuries," *Connoisseur* 122 (Dec. 1948), 99–100; Butlin and Joll, *Turner*, I, 240–41.

Archival sources: Letter from Broderip to Holman Hunt, 27 July 1852, John Rylands University Library of Manchester.

BRUNEL, Isambard Kingdom (1806–59)
18 Duke Street, Westminster, and Watcombe, near Torquay, Devonshire.

Occupation
Civil engineer. Constructed Paddington Station, Great Western Railway, Clifton Suspension Bridge, and the Thames Tunnel, among other projects, and also designed steamships.

Biography
Brunel was the only son of Sir Mark Isambard Brunel, also a civil engineer. He married Mary Horsley, the daughter of a fashionable musician, in 1836. Brunel was a brother-in-law of the painter J. C. Horsley, with whom he traveled to the Continent in 1842 and 1848. He accepted as an apprentice the son of the painter C. R. Leslie, Bradford Leslie (later Sir Bradford). Brunel's biographer, L. T. C. Rolt, claims he was "more than a great engineer; he was an artist and a visionary, a great man with a strangely magnetic personality which uniquely distinguished him even in that age of powerful individualism in which he moved" (*Brunel*, p. 14).

Collection
Brunel planned a Shakespeare Gallery featuring paintings by modern artists; however, only eight canvases were finished by Landseer, Egg, Callcott, Leslie, Lee, Cope, and Stanfield. The paintings were hung in the dining room of Brunel's Elizabethan-style house. John Horsley recalled the effect created by the gallery: "This room, hung with pictures, with its richly carved fireplace, doorways, and ceiling, its silken hangings and Venetian mirrors, lighted up on one of the many festive gatherings frequent in that hospitable house, formed a scene which none will forget who had the privilege of taking part in it" (Brunel, *Life of Brunel*, p. 507). Brunel also owned Rosa Bonheur's *Landscape with Six Breton Oxen*.

Taste
Early-Victorian scenes from literature. Brunel's engineering background and his own ability as a draughtsman gave him a sound eye for proportion. Horsley states that Brunel felt "a repugnance to works, however excellent in themselves, where violent action was represented. He preferred pictures where the subject partook more of the suggestive than the positive, and where a considerable scope was left in which the imagination of the spectator might disport itself" (Brunel, *Life of Brunel*, p. 508).

Purchasing pattern
Commissions to artists with occasional purchases made abroad, such as his Bonheur.

Sales
Christie's, 21 April 1860

References
DNB; Boase; Brunel, *Life of Brunel,*
pp. 505–11; Lionel Thomas Caswell
Rolt, *I.K. Brunel* (London: 1957, rpt.
Harmondsworth: 1985); K. T. Rowland,
The Great Britain (Newton Abbot: 1971);
Art Journal (June 1860), 181; Taylor,
Leslie, II, 297–99; Horsley, *Recollections*,
pp. 169–90; Ormond, *Landseer*, pp. 189;
Tyne and Wear County Council
Museums, *Stanfield*, p. 162; Buxton
Museum and Art Gallery, *Shakespeare's
Heroines in the Nineteenth Century*
(Derby: 1980), 14; Wainwright,
Romantic Interior, p. 45; Altick, *Paintings
from Books*, p. 75.

Archival sources: Sketchbooks and
diaries in University of Bristol Library;
journals and notes in Huntington
Library, San Marino, California; letters
in Bodleian Library, Oxford; journal
to 1840 owned by great-grandson, Sir
Humphrey Noble; letters of 1830–43
to Society for Diffusion of Useful
Knowledge in Library of University
College, London; letter books (1835–
43) in London Public Record Office.

BULLOCK, Edwin (fl. 1830–70)
*Harborne House, Harborne, and Hawthorn
House, Handsworth, near Birmingham.*

Occupation
Ironmaster.

Biography
Origins unknown. The *Daily News*
claimed that Bullock was "well-known
as one of the most liberal amateurs in
the Midland Counties" (20 May 1870).
He was a friend of Birmingham collec-
tors Charles Birch, Joseph Gillott, and
William Roberts (q.v.). Bullock was
one of Cox's earliest patrons for works
in oil, which he began to purchase in
1831, such as *The Four Seasons*, which he
commissioned from the artist in 1849
for his summer home, Hawthorne House.
He frequently entertained artists such
as Cox, Etty, Turner, and Rosa Bonheur.

Collection
Originally a collector of Old Masters,
Bullock became interested in modern
art in the 1820s. At the time of the sale
of his collection at Christie's in 1870,
the *Daily News* reported that Bullock
had for the last forty years been a con-
stant purchaser of modern pictures
from the various exhibitions and by
many commissions given directly to
artists. He owned over 100 works by
David Cox, seven by Constable, and
other examples by Leslie, Etty, Frost
(eleven), Turner, Maclise, Landseer,
and Dutch seventeenth-century artists.
Waagen singled out his paintings by
Eastlake and Collins for praise.

Taste
Early-Victorian and contemporary
French and Belgian art, in addition to
the Old Masters. Bullock was unusual
among Birmingham collectors in his
interest in genre painting; however, he
also purchased the landscape and poet-
ic subjects favored by his neighbors.

Purchasing pattern
Bullock bought from exhibitions, in
addition to giving many commissions
directly to artists.

Sales and bequests
Christie's, 21–23 May 1870 (492 lots
realized £42,700); 28 March 1884;
and 9 May 1887.

References
Waagen (1857), 402–3; *Art Journal*
(July 1870) 220–21; *Daily News*,
20 May 1870; Redford, I, 180, and
182–83; Roberts, I, 208–11; Solly, *Cox*,
pp. 100, 138, 147, 155, 190, 204–207,
287–88, and 330–31; Taylor, *Leslie*, I,
lxiv and II, 135, 266, 286, 304, 310,
and 322–25; Agnew, p. 26; Gage,
Turner Correspondence, pp. 192–93
and 242; Butlin and Joll, *Turner*, I,
252; Ormond, *Maclise*, p. 97, no. 102;
Reitlinger, p. 100; Maas, *Gambart*,
p. 81; Coan, "Birmingham Patrons,"
pp. 116–19 and 167.

Archival sources: Letter from Bullock
to Joseph Gillott, 23 Aug. 1847, Getty
Archive, Santa Monica.

BURNAND, Arthur C.
(c. 1802–c. 1892)
*Albion Road, Stoke Newington, and
14 Hyde Park Gate, London.*

Occupation
Insurance underwriter, associated
with Lloyd's of London, 14–15 Royal
Exchange, London.

Biography
Arthur Burnand was the grandson of
Paul Burnand, a Swiss insurance and
bill broker who emigrated to London,
and the son of Louis Burnand, whose
occupation he followed at Lloyd's.
He was the brother of Theophilus

Burnand (q.v.) and uncle of F. C. Burnand, who became editor of *Punch* in 1880. A bachelor, Burnand lived with his family in Stoke Newington until his mother's death, when he and his sister Antoinette moved to a house at the corner of Kensington Gardens and Hyde Park, near the studios of Richard Redgrave and Charles Cope. He shared his family's enthusiasm for elaborate amateur theatricals performed on a toy stage with sets painted by Clarkson Stanfield and David Roberts (Burnand, *Reminiscences*, I, 33 and 40). A tenor, Burnand frequently sang at his family's Sunday evening concerts. Also an amateur writer, he founded an informal literary society. Burnand liked to entertain artists and musicians in his home. Goodall recalled a memorable evening when Schumann's widow played "Nachtstück" (*Reminiscinces*, p. 158).

Collection

Burnand began buying and commissioning works from living artists in the late 1850s. The *Art Journal* noted in regard to his collection that "the whole of the pictures, with perhaps two exceptions, have been painted for Mr. Burnand" (1870, p. 366). He owned canvases by such artists as Frith, G. B. O'Neill, Pettie, Ward, Redgrave, Horsley, Cooper, Goodall, Cope, Phillip, and Stanfield.

Taste

Early- to mid-Victorian sentimental genre and landscape.

Purchasing pattern

Direct commissions and purchases from artists.

Sales and bequests

Christie's, 26 March 1872 and 26 March 1892.

References

London Directory (1852–73); *Art Journal* (Dec. 1870), 366–68 and (Sept. 1892), 284; Roberts, II, 175–76; Frith, *Autobiography*, I, 272; II, 2–3; and III, 413–16; Cope, *Reminiscences*, pp. 223 and 236; Goodall, *Reminiscences*, pp. 158 and 176; Marion H. Spielmann, *The History of "Punch"* (London: 1895), pp. 362–68; Burnand, *Reminiscences*, I, 17, 27–34, 40–43, 51–53, 111 and II, 206; Greg, *Cranbrook Colony*, no. 50; Forbes, *RA Revisited*, no. 36, p. 88; *Survey of London* 38 (1975), 34–35; and James Ballantine, *The Life of David Roberts RA* (Edinburgh:1866), p. 253.

BURNAND, Theophilus (1805–c. 1888)

Bolton Street, Piccadilly; 5 Charles Street, Lowndes Square; and 8 Seville Street, London.

Occupation

Insurance underwriter, Marine Insurance Co., 20 Old Broad Street, London.

Biography

Grandson of Paul Burnand, an insurance and bill broker who emigrated to England from Switzerland and son of Louis Burnand, a Lloyd's underwriter. Theophilus was born in Finsbury, Middlesex and spent several years abroad, where he mastered French, Italian, and some German (Burnand, *Reminiscences*, I, 207). He was the brother of Arthur Burnand (q.v.) and the favorite uncle of F. C. Burnand, editor of *Punch*. A bachelor, Burnand is known to have had three servants in 1861, despite the fact that when the *Art Journal* visited him in 1869 it described his residence in Charles Street as "one of the smallest houses in the habitable part of London" (p. 312). Like his brother, Burnand was an aficionado of the opera and hosted musical soirées. The painter Frederick Goodall recalled meeting the violoncello player Piatti and Frau Schumann at one of Burnand's musical evenings (*Reminiscences*, p. 158). Burnand also gave an annual dinner for artists such as Stanfield, Phillip, Roberts, Horsley, and Goodall (*ibid.*). Described by his nephew as "kindness itself," Burnand paid for his relative and J. C. Horsley to holiday in Amsterdam in 1870 (Burnand, *Reminiscences*, II, 249).

Collection

Burnand began collecting in the mid-1840s. Rather than concentrate on one artist, he preferred to have two or three examples of a variety of painters, such as those named above belonging to the early-Victorian school, who continued to work in their earlier manner in the mid-Victorian period. Among the younger artists he patronized were G. B. O'Neill and John Phillip.

Taste

Early- to mid-Victorian oils.

Purchasing pattern

The *Art Journal* held up Burnand as an example of "the liberality of the collector, who has really 'patronized' British Art, by obtaining his treasures directly – without the aid of middle-men – from the artists who produced them," adding that he provided "an example which other collectors would do well to follow" (1869, p. 313).

Sales and bequests

Christie's, 25 Feb. 1888.

References

Art Journal (Oct. 1869), 312–13; *London Directory* (1861); Frith, *Autobiography*, I, 272; Goodall, *Reminiscences*, pp. 158 and 176; James Ballantine, *Life of David Roberts RA* (Edinburgh: 1866), pp. 252–53; Burnand, *Reminiscences*, I, 53, 110–17, 176–77, 200, 202, 207–14, 393 and II, 249.

Archival sources: Census Returns for 1861, 1871, and 1881.

BURNETT, Jacob (1825–96)

Collingwood House, 10 Prior's Terrace, Tynemouth.

Occupation

Manufacturing chemist, T.B. & Sons, Bill Quay, Tynemouth.

Biography

Burnett's social origins are unknown. Since he is frequently referred to in the correspondence of James Leathart (q.v.), he may have been related to the chemists of that name who first employed Leathart as a young boy (Leathart Family Papers). Burnett's firm, by 1871, employed 550 people. He was locally respected for his service as Justice of the Peace. Active in several of the North East's arts organizations, Burnett introduced critic F. G. Stephens to a number of art collectors. His son, John Walter Burnett of the Woodlands, Gosforth, became managing director of the Burnett Steamship Co.

Collection

Burnett owned watercolors by Simeon Solomon, Millais, Girtin, Stothard, Müller, Turner, Prout, Fielding, De Wint, Cox, Linnell, W. Hunt, and A. W. Hunt. Among his oil paintings were Hughes's *Knight of the Sun* and Millais's *Apple Blossoms*. He also owned canvases by Gallait, Cattermole, Frith, and Alma-Tadema.

Taste

Aesthetic movement and English watercolor School.

Purchasing pattern

Burnett made several purchases from Ernest Gambart, either directly or during the visits to Newcastle of Gambart's agent Hobart Moore (Maas, *Gambart*, p. 140). He commissioned *Pot Pourri* from Millais but was unable to pay for it.

Sales and bequests

Christie's, 25 March 1876.

References

Athenaeum (Sept. 20, 1873), 373–74; *Newcastle Daily Journal*, 16 March 1876; *Shields Daily News*, 29 Aug. 1883 and 20 July 1896; *Newcastle Daily Chronicle*, 20 July 1896; William Hayward, *James Hall of Tynemouth,* 2 vols. (London: 1896), II, 138; Redford, I, 217 and 246; Millais, *Millais*, I, 306; Maas, *Gambart*, 140; Swanson, *Alma-Tadema*, no. 74; Macleod, (1986), pp. 599 and 604; Macleod (1989a), p. 197 and *passim*; Macleod (1989b), p. 126.

Archival sources: Mentioned in letters from Bell Scott, Madox Brown, and Leighton to James Leathart, Leathart Papers, University of British Columbia; Leathart Family Papers; 1871 Census Report; and MSS will, Northumberland Record Office.

CARTWRIGHT, Samuel (1789–1864)

32 Old Burlington Street, London, and Nizell's House, Tunbridge.

Occupation

Dentist.

Biography

Born in Northampton, Cartwright began his career as an ivory turner in apprenticeship with Charles Dumergue in Piccadilly. He attended anatomical and surgical lectures in his free time and established himself as a dentist in 1811. He is said to have earned over £10,000 per year (*DNB*). Cartwright was active in achieving recognition for his profession. He was made a fellow of the Linnean, Royal, and Geological Societies. Cartwright retired to Tunbridge in 1857.

Collection

By 1839 Cartwright had amassed a considerable collection of English paintings, including works by artists such as Turner, Landseer, and Horsley.

Taste

Early-Victorian landscape and genre scenes.

Purchasing pattern

Cartwright gave direct commissions to artists. He also disposed of part of his collection in private sales to John Naylor (q.v.) of Liverpool (Morris, "Naylor," p. 77).

Sales and bequests

Christie's, 25 February 1865.

References

Art Union (1839), 122; *DNB*; Horsley, *Recollections*, pp. 72–74; Finberg, *Turner*, p. 416; and Morris, "Naylor," p. 77.

CHAPMAN, John (1810–77)

Hill-End, Near Mottram, Longdendale, Cheshire; and Carlecote's, Dunford Bridge, Yorkshire.

Occupation

Chairman of Manchester, Sheffield, and Lincolnshire Railway.

Biography

Son of John Chapman of Ashton, Lancashire, a reed maker and a trustee of Cross Street Chapel, Manchester. Educated at St. Mary's Hall, Oxford (MA 1838). Chapman was high sheriff of Cheshire in 1855 and MP for Great Grimsby between 1862–65 and from 1874 until his death. He was one of three middle-class collectors Waagen visited in the Manchester area. Chapman does not seem to have been involved in any of Manchester's cultural organizations.

Collection

According to Waagen, Chapman paid Lord Mulgrave's sisters £2,000 for Wilkie's *Rent Day* (1857, p. 417). He also owned oils by Landseer, Mulready, Webster, and Redgrave, in addition to possessing Turner's *Fish-Market on the Sands* and *Rape of Proserpine*. Waagen found his Linnell and two Landseers praiseworthy. Lender to Manchester Art Treasures exhibition.

Taste

Early Victorian and Old Masters. The *Art Journal* described Chapman's collection as containing "the highest class of modern cabinet art" (1858, p. 39). Significantly, he mingled his Landseers with seventeenth-century Dutch canvases by Van de Velde, Steen, and Teniers in his dining room.

Purchasing pattern

Unknown. Does not figure in artists' memoirs.

Sales and bequests

By descent; private sales and Christie's (Edward Chapman), 21 Nov. 1914.

References

Art Journal (Feb. 1858) 39–40; Waagen (1857), 417–20; *Manchester Guardian*, 20 July 1877; Boase; *WWMP*; *Paintings Lent by George John Chapman Esq. and the Executors of the late Edward Chapman Esq.* (Manchester: 1908); Darcy, p. 146; Butlin and Joll, *Turner*, I, 188 and 232–33; Elizabeth Conran, "Art Collections," in *Victorian Manchester*, ed. Archer, p. 65; Heleniak, *Mulready*, p. 204; Sir Thomas Baker, *Memorials of a Dissenting Chapel* (Manchester: 1884), 127; *Railways in the Victorian Economy*, ed. M. C. Reed (New York: 1968), 173.

COLTART, William (c. 1823–1903) and Eleanor Tong Coltart (c. 1829–1917)

Breeze Hill, Prescot, and Woodleigh, 50 Park Road, Claughton, Birkenhead, Cheshire.

Occupation

Iron merchant, Henry Wood & Co., Liverpool.

Biography

Neither Eleanor nor William's social origins are known. Temple suggests that Eleanor may have been an artist's model or perhaps related to one of the Pre-Raphaelites (*Guildhall Memories*, p. 211). William was one of eleven children of William Coltart (1793–1865), who appears prosperously dressed in a three-piece suit in a photograph in the possession of the Coltart family. According to Temple, William junior was employed abroad. He also reports that William first met Eleanor while they were in their teens, and that she married Jonathan Tong while Coltart was working out of the country. Nothing is known about Tong's background either, although

he may have been related to Liverpool artist Robert Tonge who was represented in his collection by seven works. Coltart apparently waited twenty-five years before he finally married Eleanor following Tong's death of typhoid fever in Milan in 1881. Like his business partner Albert Wood (q.v.), Coltart was an amateur artist and a collector of advanced art.

Collection
During her two marriages, Eleanor Tong Coltart collected works by artists such as Rossetti, Armstrong, Burne-Jones, Marks, Madox Brown, Simeon Solomon, and Prinsep.

Taste
Aesthetic movement, Pre-Raphaelite, and standard Victorian.

Purchasing pattern
Eleanor Coltart's 1917 sale catalogue indicates that she purchased works directly from Prinsep and Armstrong. While she was married to Jonathan Tong, they made purchases at the Old Water-Colour Society and the Dudley Gallery, as well as from the dealers Agnew and Gambart. Her second husband is also known to have been a client of Agnew's.

Sales and bequests
Eleanor Coltart donated Madox Brown's *Coat of Many Colours* to the Walker Art Gallery in 1904 and bequeathed Thomas Armstrong's *The Hayfield* to the Victoria and Albert Museum in 1917.

Sales: Brown & Brown, Liverpool, 30 Oct. 1917 – 5 Nov. 1917; by descent; and private sales.

References
Athenaeum (26 Sept 1885), 407–8 and (10 Oct. 1885), 476; *Art Journal* (1896), 97–101; *International Studio* 35 (1908), cxxv–cxxx; Lamont, *Thomas Armstrong*, 10–11, 17, 33, 37, 46, 49, and 119; Temple, *Guildhall Memories*, pp. 211–12; Agnew, 19; Laing Art Gallery, *Albert Moore*, nos. 16 and 22; Bennett, *Brown*, no. 40; Bennett, *Pre-Raphaelite Circle*, no. 1633; Rossetti, *Rossetti as Designer and Writer*, p. 61, *Rossetti Papers*, pp. 47–48; Surtees, *Rossetti Catalogue Raisonné*, nos. 48R.1, 124R.1 and 205R.1; *Rossetti Letters*, ed. Doughty & Wahl, II, 499–500; Lambourne, *Victorian Genre*, pl. 56; Arts Council, *Burne-Jones* (London: 1975), nos. 43 and 49; Reynolds, *Simeon Solomon*, p. 8; Macleod (1986), pp. 599 and 604.

Archival sources: Letter from W. Graham to Burne-Jones, 30 May 1868, Fitzwilliam Museum Library; letter from S. Solomon to James Leathart, Leathart Papers, University of British Columbia; and Coltart Family photos and records.

COMBE, Thomas (1797–1872) and Martha Bennett Combe
Clarendon Press Quadrangle, Oxford.

Occupation
Superintendant of Clarendon Press.

Biography
The son of a Leicester bookseller,

Combe was educated at Repton. He was employed at Parker's bookshop in Oxford before establishing himself as a printer in Leicester and London. Combe joined the Clarendon Press in 1838, where he was instrumental in ensuring its monopoly in printing copies of the Bible. A High Churchman, Combe was married by Cardinal Newman to Martha Edwards Howell Bennett Combe, who shared her husband's religious and artistic sentiments and was an interested party in his negotiations with artists, with whom she often corresponded. Combe financed the erection of a chapel in the Infirmary at Oxford and a church and schools dedicated to St. Barnabas.

Collection
Combe commissioned a portrait of himself from Millais in 1850 and *The Return of the Dove to the Ark* in 1852. He also owned Holman Hunt's celebrated *The Light of the World* and *Christian Missionary Escaping from Druids*, as well as Rossetti's *Dante Drawing an Angel*. In addition, Combe commissioned busts of himself and John Newman from Thomas Woolner. He also owned works by Bonington, Cox, and A. W. Hunt.

Taste
Pre-Raphaelite religious subjects and portraiture and early-Victorian landscapes.

Purchasing pattern
Commissioned directly from artists.

Practiced a paternal form of patronage which extended beyond his acquisitions.

Sales and bequests

J. R. Mallam and Son's, Oxford, 23 Feb. 1894. Mrs. Combe 1894 bequest to Taylorean, Oxford (now in Ashmolean Museum) and gift of Hunt's *The Light of the World* to Keble College, along with funds to construct a chapel to house it.

References

DNB; Millais, *Millais*, I, 87–105 and *passim*; Warner, "Millais," pp. 50, 57–62, 70–71; Hunt, *Pre-Raphaelitism*, I, 217, and II, 143 and *passim*; W. M. Rossetti, *Family Letters*, I, 86 and 89; *Rossetti Letters*, ed. Doughty and Wahl, I, 99; *Letters of Dante Gabriel Rossetti to William Allingham*, ed. G. B. Hill (London: 1897), pp. 41, 125, and 131–32; Woolner, *Thomas Woolner*, p. 184; Grieve, "Pre-Raphaelite Brotherhood," pp. 294–95; Maas, *Gambart*, pp. 59–60, 67–68, 75–76, 105, 115, 119, 132 and 237; Surtees, *Rossetti Catalogue Raisonné*, nos. 54, 58, 114, and 151; John Whitely, "The Combe Bequest," *Apollo* 117 (1983), 302–7; *A Pre-Raphaelite Friendship: The Correspondence of William Holman Hunt and John Lucas Tupper*, ed. James H. Coombs, *et al.* (London: 1986), pp. 47, 62–63, 112, 126, 159, 191, and 242; Colin Hughes, "Thomas Combe: Printer and Patron of the Arts," unpublished paper delivered at Association of Art Historians' Annual Meeting, Birmingham, 8 April 1994.

Archival sources: Correspondence with Hunt and Millais and "Inventory and Valuation of the Pictures and other Works of Art Bequeathed to the University of Oxford by the late Mrs. Combe," Ashmolean, Oxford; letters from Hunt, John Rylands University Library of Manchester; and letters from Rossetti, Troxell Collection, Princeton and Det Kongelige Bibliothek, Copenhagen.

CONNAL, William, Jr. (1819–98)

19 Park Circus, Glasgow; Solsgirth, near Dollar, Perthshire, and 23 Berkeley Square, London.

Occupation

Commodity broker and warehouseman, Connal and Co., 104 W. George Street, Glasgow, and 27 Grange Road West, Middlesbrough.

Biography

Born in Stirling, the son of M. S. Glass and Patrick Connal, a banker. In 1845 Connal entered the commodity house of his uncle William, who had made a fortune in the profitable Virginia tobacco trade. The firm specialized in tea and sugar importing at the time Connal was serving his apprenticeship. After his uncle's death in 1856, William concentrated on warehousing pig iron, quickly dominating the Glasgow market and expanding into Middlesbrough where he was an active member of the Middlesbrough Exchange (1877–98). He married Emilia Jessie Cambell, with whom he had nine children. Connal's estate was

valued at £209,564, although he had transferred substantial shares in his company to his children prior to his death.

Collection

Connal concentrated on the works of Albert Moore and Burne-Jones. He owned Burne-Jones's *Sea Nymph*, *Wood Nymph*, *Danae or the Tower of Brass*, and *Love and the Pilgrim*. Connal also owned canvases by Poynter, Sandys, Stanhope, Watts, Rossetti's *Mnemosyne*, and a nocturne by Whistler, in addition to three drawings and an oil by Khnopff, a Monticelli, and a few Old Master paintings.

Taste

Aesthetic movement, contemporary French and Belgian art, and Old Masters.

Purchasing pattern

Connal bought directly from Moore and Burne-Jones. He was an occasional client of Agnew's. Connal seems to have purchased his Khnopffs at the Grafton Gallery and his Monticelli through dealers Alex Reid or Daniel Cottier.

Sales and bequests

Bequest to Corporation of Glasgow of Burne-Jones, *Danae or the Tower of Brass*.

Sale

Christie's, 14 March 1908.

References

Glasgow Post Office Directory (1882–83); *Middlesbrough Directory* (1879 and

1887); *Dictionary of Scottish Business Biography,* ed. Slaven and Checkland, II, 357–58; *North British Daily Mail,* 15 July 1898; *Magazine of Art,* 18 (1894), 335–41; *Art Journal* (Nov. 1908), 267; *Diary of Sir Michael Connal,* ed. John C. Gibson (Glasgow: 1895); J. O. Mitchell, *"The Auld House" of William Connal & Co.* (Glasgow: 1894); C.A. Oakley, *Connal and Co. Ltd., 1722–1946* (Glasgow: 1946); Bennett, *Brown,* no. 22; Surtees, *Rossetti Catalogue Raisonné,* nos. 132, 234, and 261; Arts Council, *Burne-Jones* (London: 1975), nos. 124 and 177; Laing Art Gallery, *Albert Moore,* nos. 5, 70, and 74; Young *et al., Whistler,* no. 146; Glasgow Art Gallery and Museum, *British Paintings* (Glasgow: 1971), no. 15.

Archival sources: Register of Sasines for Counties of Perth and Kinross.

COOKE, Henry (fl. 1840–77)
Burlington Street; Overstone Terrace; Chetham Hall; and Heald Grove, Rusholme, Manchester.

Occupation
Stock and sharebroker, 4 St. Ann's Churchyard, Manchester.

Biography
Origins unknown. Delivered four lectures at Royal Manchester Institution in 1859, where he was appointed honorable secretary on 14 July 1860.

Collection
Exclusively watercolors. Among the artists represented were Danby, Cattermole, Goodall, Turner (five), Roberts, Herbert, Cox, Müller, Maclise, Hunt, C. Fielding, Haghe, and Landseer. Waagen was reluctant to comment on the quality of Cooke's collection because of his own lack of expertise in watercolors. He wrote: "This gentleman has a choice collection of water-colour drawings by the first masters in this line. As he was not present, and no catalogue in existence, I have given the names merely to the best of my judgment. Mistakes may thus have occurred for which I beg the indulgence of the reader, since I do not profess to have the same knowledge of this class of art as of the old masters, or of the oil-painters of the English school" (Waagen, IV, 413–14). Cooke declined to lend to the Manchester Art Treasures exhibition.

Taste
Early Victorian watercolors. The *Art Journal* commented on Cooke's "refinement and elegance of taste" (1857, p. 42).

Purchasing pattern
Unknown. Possibly depended on dealers, since his name does not appear in artists' memoirs.

Sales and bequests
Christie's, 16 February 1877.

References
Art Journal (Feb. 1857), 42–43; Waagen (1857), pp. 413–15; *Slater's Directory of Lancashire* (Manchester: 1872); and Darcy, pp. 144–45.

Archival sources: Manchester Central Library, Royal Manchester Institution Letter Book (M6/1/49/6), 14 Sept. 1859, arranging the dates for the lectures he was to give, p. 338; the dates were subsequently changed, p. 343; appointed secretary, p. 361; and Cooke's report to the Institution, p. 387.

CORONIO, Aglaia (1834–1906)
1 Lindsey Row and 1A Holland Park West, London.

Occupation
Amateur embroiderer and bookbinder.

Biography
Daughter of merchant and stockbroker Alexander Ionides (q.v.) and sister of Constantine Ionides (q.v.). In 1855 Aglaia married Theodore John Coronio (c. 1828–1903), a merchant who was also interested in art collecting. She was known as one of the "Three Graces," along with Maria Spartali and Maria Zambaco (Mary Cassavetti) who modeled for Burne-Jones's painting, *The Mill.* Her nephew described her as "intensely aesthetic, and jealous of her dignity" (Ionides, *Ion,* p. 24). William Morris regularly corresponded with her and instructed her in bookbinding. Aglaia Coronio committed suicide following the death of her only daughter.

Collection
Aglaia Coronio bought three works from Rossetti and *Grey and Silver: Battersea Reach* from Whistler. She also owned five paintings by Fantin-Latour, whom she entertained at her country house.

Taste

Aesthetic movement and French Realist art.

Purchasing pattern

Aglaia Coronio made direct purchases from artists. She sold her Whistler to Mrs. Potter Palmer in 1892 with the artist's assistance.

Sales and bequests

London, Hampton's, 21 Nov. 1906 (over 500 lots).

References

London Court Directory (1874); Lamont, *Armstrong*, pp. 194–96; Luke Ionides, "Memories," *Transatlantic Review* I (1924), 37–52; Ionides, *Ion*, I, 24 and II, 17–20; J. Atkinson, "The Ionides Family," *Antique Collector* (June 1987), 92; Ormond, *Du Maurier*, pp. 99–102; Daphne Du Maurier, ed., *Du Maurier Letters* (London: 1951), pp. 30–31; Burne-Jones, *Burne Jones*, II, 196; Pennell and Pennell, *Whistler*, I, 79; Druik and Hoog, *Fantin-Latour*, pp. 32, 116, 125–126 and 130; Seltzer, "Legros," pp. 173–75 and 195; Watts, *Watts*, I, 135; Henderson, *Morris*, pp. 112, 134–37, and 160; Norman Kelvin, ed., *The Collected Letters of William Morris* (Princeton: 1984), I, 116 and *passim*; *Rossetti Letters*, ed. Doughty and Wahl, IV, 1555, 1558–59, 1802, 1804–12; Crane, *Reminiscences*, p. 319; Thomas Robert Way, *The Art of James McNeill Whistler* (London: 1912), 97–98; Young, *et al.*, *Whistler*, nos. 46, 48, and 179.

Archival sources: Letters from Whistler, Library of Congress and Glasgow University Library.

COSENS, Frederick William (1819–89)

27 Queen's Gate, later 7 Melbury Road, Kensington, London and The Shelleys, Lewes, Sussex

Occupation

Wine merchant, Silva & Cosens, 4 Hart Street, Mark Lane and 16 Water Lane (one of the largest importers of sherry in London).

Biography

Son of John Cosens, a substantial yeoman at Hunston, near Chichester. Cosens moved to London with his family in 1832 following his father's death. He was sent to school in Scotland soon afterwards. In 1836 Cosens began his career in the sherry trade as invoice clerk at Pinto, Perez, & Co., where he was promoted to county traveler only two years later. In 1845 he married Rosa Collins of Morrow, near Guilford, Surrey, and three years later began importing sherry under his own brand from Jerez. Cosens also became a partner in the Oporto house of Silva. He was a member of the Society of Antiquaries, the Spanish Royal Academy of History, the Academy of Belles Arts, and the Garrick and Arts' Clubs. Cosens was made a Knight Commander of the Spanish Order of Charles III. He was an active member of the Conservative party and wrote frequent columns for the *Sussex Express,* which were reprinted and published under the titles of *Letters by an Indignant Conservative* (1883) and *Letters by an Englishman* (1884 and second series in 1885). Cosens also contributed frequently to the *Athenaeum* and *Notes and Queries* under his initials F. W. C. In addition, Cosens translated *The Moorish Marriage* (1867), *Castelvines y Monteses* by Vega Carpio (1869) and *Los Bandos de Verona* by Rojas Zorrilla (1874). He left a personal estate valued at £203,668.

Collection

Cosens began collecting contemporary art about the year 1860. His selections ranged from Roberts, Stanfield, and Maclise to Holman Hunt, Millais, and Marcus Stone. He owned the original sketch for Frith's *Railway Station* and a replica of the finished work painted by Marcus Stone. Cosens also asked Stone to add figures to a painting he owned by Augustus Egg. Many of Cosens's pictures were bought the year of their exhibition; however, he purchased Hunt's *Rienzi* over twenty years after it was painted, *c.* 1872.

Taste

Mid-Victorian collector. Cosens's interest in Spain is reflected in the number of canvases he owned by John Phillip and the copies he possessed of Velazquez's portrait of Prince Balthazar by Maclise and Phillip. He also had a genre scene by B. Ferrandez, a member of the Spanish school. In addition, he collected works by early- to mid-Victorian British artists.

Purchasing pattern

Unknown.

Sales and bequests

Christie's, 17 May 1890 (oils and watercolors, fetched £13,867) and Sotheby's, 11 November 1890 (books, engravings, and drawings). Frank Cosens sale Christie's, 5 May 1916.

References

Art Journal (Sept. 1872), 224–26; Boase; *London Directory* (1852–73); *National Wills Index* (1890); *Sussex Express*, 14 December 1889; *ILN* (15 Feb. 1890), 220; John Foster Kirk, *A Supplement to Allibone's Critical Dictionary of English Literature* (Philadelphia: 1891); Roberts, *Christie's*, II, 149–50; Hunt, *Pre-Raphaelitism*, I, 183; Ormond, *Maclise*, no. 63, p. 59; Ormond, *Leighton*, no. 100, p. 155; Faberman, "Egg," pp. 475–76; Maas, *Gambart*, p. 136; Chapel, *Victorian Taste*, pp. 88 and 141–42.

Archival sources: Sussex Archaeological Society (mainly press clippings and letters dealing with Cosens's political activities); British Library, letters to W. C. Hazlitt, 1866–85 (Add MSS 38899–905); Edinburgh University Library, forty-three letters to Jo Halliwell-Phillips.

COTTRILL, William (1821–91)

Farrington Lodge, near Preston; Terrace House, the Cliff, Broughton; Singleton House, Higher Broughton, Manchester; and 33 Addison Road North, Notting Hill, London.

Occupation

Cotton spinner, Cottrill & Co., Pendleton, Lancashire.

Biography

Born at Burnage, near Manchester, to a family who was originally named "de Cottrell." His mother was a relative of the Smiths, a prominent family at Lever Hall, near Bolton, where Cottrill lived for a time after his father's death. Educated at a private school in Bolton, Cottrill was apprenticed in the cotton-spinning firm of his uncle, William Bashall (q.v.) at Farrington, near Preston. In 1845 he married Fanny Scott, daughter of a Preston civil servant. Cottrill started his own business in Pendleton in 1852. Wishing to expand four years later, he made an offer on property owned by J. P. Fitzgerald; however, so great was the owner's abhorrence of slavery that the knowledge that Cottrill intended to spin slave-grown American cotton made him extremely reluctant to sell (*Salford Observor*). Cottrill managed to overcome Fitzgerald's concerns and by 1857 had 600 looms in operation. Ten years later he added both a spinning mill furnished with 30,000 spindles and a bleach and dye works. Specializing in the manufacture of fancy shirts, Cottrill exported his goods to Holland, Germany, Australia, and New Zealand. His three sons succeeded him in the family business. Cottrill served as a Salford alderman, but declined the opportunity to become mayor.

Collection

Introduced to the practice of collecting by his uncle William Bashall,

Cottrill owned over 200 works of art by 1870 which he displayed in an "extremely well-lighted gallery" (*Art Journal*, p. 68). The artists represented included Leighton, Ward, Clay, Sant, Ansdell, Linnell, Willis, Creswick, Cole, Archer, Long, Portaels, Isambert, and Turner. Among the mid-Victorian artists in his collection were McTaggart, Dicksee, G. B. O'Neill, M. Stone, Orchardson, and Pickersgill. Cottrill lent Hardy's *Busy Bodies* to the Royal Manchester Institution in 1866. He was offered, but declined to buy, Degas's *Cotton Market* (Metropolitan, *Degas*, p. 186).

Taste

Mid-Victorian British, French, Belgian, and German oils, in addition to early Victorian watercolors.

Purchasing pattern

Cottrill is known to have made purchases at the Royal Academy and at the Old Water-Colour Society exhibitions. He also bought at artists' studio sales and from Agnew's. He may have been an occasional client of Flatow's.

Sales and bequests

Christie's, 25 April 1873 (eighty-six watercolors and 161 oils brought over £23,000).

References

Art Journal (March 1870), 68–71 and (June 1873), 189–190; *Salford Reporter*, 17 Jan. 1891; Ormond, *Leighton*, p. 156; Allwood, *Hicks*, p. 32; Metropolitan Museum, *Degas* (New York: 1988), no. 115, p. 186; Garrard, *Leadership and*

Power in Victorian Industrial Towns, p. 215.

Archival sources: Census Returns for 1861 and 1871.

CRAVEN, Frederick (1818–94)
4 Radford Street, Broughton; Hope Lodge, Higher Broughton, Manchester, and later at Thornbridge, Bakewell, Derbyshire.

Occupation
Calico printer, Bayley & Craven, Spring Vale Printing Co., 54 Moseley Street, Manchester, and Pendleton.

Biography
Craven was the son of Ann Laycock of Bretton and John Craven of Leeds, a merchant. Frederick was a trustee of the Cross Street Chapel and a Commissioner of the Peace for Derbyshire. He married Frances Brooke of Halifax, Yorkshire. They had two children, one of whom died tragically in a carriage accident. Craven made loans to the Manchester Art Treasures exhibition in 1857, Leeds in 1868, the Manchester Jubilee in 1887, and to the Guildhall exhibition in 1894.

Collection
Craven concentrated primarily on watercolors by Aesthetic movement artists such as Rossetti, Simeon Solomon, and Burne-Jones. He also owned Madox Brown's *The Dream of Sardanapalus* (watercolor, Delaware Art Museum). In addition, Craven was a devotee of the early English watercolor school and possessed representative examples by Cox, Cattermole, De Wint, Holland, W. Henry Hunt, Prout, and Turner. He possessed only a few oils, notably Burne-Jones's *Pygmalion* cycle (Private Collection, Paris).

Taste
Aesthetic movement and early-English watercolors. Craven divested himself of early purchases with dubious attributions in 1876. His subsequent choices were often dictated by size.

Purchasing pattern
Craven commissioned and bought works directly from artists. He was also a client of Agnew's.

Sales and bequests
Christie's, 14 January 1876 and 18 May 1895.

References
Art Journal (Jan. 1870), 16–17; (Feb. 1870), 41; (May 1871), 140; and (Sept. 1898), 308; *Manchester Guardian*, 13 April 1894; Baker, *Dissenting Chapel*, p. 172; Rowley, *Fifty Years of Work*, pp. 98–101; Roberts, II, 251–52; Fredeman, *Bibliocritical Study*, no. 19.11, p. 79; Hueffer, *Brown*, pp. 207–208, 252–53, 262–66, 269, 280, and 343; Arts Council, *Burne-Jones* (London: 1975), nos. 102–103 and 137; Solly, *Cox*, pp. 251–55; *Frederic Shields*, ed. Mills, pp. 95–100, 130–31, 136, and 151–52; Rossetti, *Rossetti as Designer and Writer*, pp. 50–51, 56–57, 62, and 75; *Rossetti Papers*, pp. 71, 90, 140–41, 197, 391, and 457–58; *Rossetti Letters*, ed. Doughty and Wahl, II, 524 and *passim*; Surtees, *Rossetti Catalogue Raisonné*, nos. 57R.1, 62R.1, 151R.1, 162R.1, 168R.2, 179, 202, 222, and 238; Reynolds, *Simeon Solomon*, p. 8; *The Correspondance between Samuel Bancroft, Jr. and Charles Fairfax Murray*, ed. Rowland Elzea (Wilmington: Delaware Art Museum, 1980), p. 84; Agnew, 18.

Archival sources: Letters to Rossetti, Angeli-Dennis Papers, University of British Columbia; Brown Family Papers; and Census Returns for 1861 and 1871.

CRAWHALL, Thomas Emerson (1820–92)
Condercum, Benwell, Newcastle.

Occupation
Rope manufacturer, Joseph Crawhall & Sons.

Biography
Son of Joseph Crawhall of Newcastle and Stagshaw Close House, Northumberland, who founded the family firm in 1812. The Crawhalls were an old Newcastle family (*Archaeologia Aeliana*). Nothing is known of Thomas's life before he joined his father's business. He was the brother of Joseph Crawhall, an amateur author and friend of Charles Keene. Thomas was regarded as a skilled amateur artist (Gateshead Central Library Press Clippings). William Bell Scott, however, did not have a high opinion of him as an art collector, telling James Leathart (q.v.) in an undated letter: "He is such a

queer subject, besides that he does very little in buying pictures except at small sums, that I fear it would be of no use now making Hunt refer to him" (Leathart Papers). Crawhall was on the executive committee of the Newcastle Arts Association.

Collection

Crawhall specialized in watercolor drawings by early Victorian artists such as Turner, Cox, W. H. Hunt, A. W. Hunt, and C. Fielding. Although Simeon Solomon knew him, there is no evidence that he purchased that artist's work (Leathart Papers).

Taste

Early-Victorian watercolors.

Purchasing pattern

Unknown.

Sales and bequests

Christie's, 11 and 14 March 1893.

References

Athenaeum (6 Nov. 1875), 614–15; *Newcastle Daily Chronicle*, 4 Jan. 1892; *Archaeologia Aeliana* 10 (1913), 171; Macleod (1986), p. 604; Macleod (1989b), pp. 126–27.

Archival sources: Gateshead Central Library (press clippings) and letters to James Leathart from W. Bell Scott and Simeon Solomon, Leathart Papers, University of British Columbia.

DAY, Sir John Charles Frederic Sigismund (1826–1908)

Collingham Gardens, London, and Falkland Lodge, Newbury.

Occupation

Judge.

Biography

Son of Capt. John Day of the 49th Foot, of Englishbatch, Day was born near Bath and educated at Freiburg and Downside. He entered the Middle Temple in 1845 and was called to the bar four years later. He produced the first annotated edition of the Common Law Procedure Act of 1852 (1872) and was made a judge in 1892. He was a member of the Parnell commission. Day married twice, first to Henrietta Brown in 1846, and after her death to Edith Westby. He was caricatured in *Vanity Fair* by Spy in 1888 and in *Punch,* where he was depicted asleep on the bench with the title *The Close of Day.*

Collection

Day's main interests were French Barbizon and contemporary Dutch painters. R. A. M. Stevenson described him as an ardent admirer of the Barbizon School and credited him for buying his pictures early (*Art Journal* [1893], 262). Day owned works by Millet and Corot as well as by English painters such as Constable and Albert Moore, whose *An Embroidery* is now in the McCormick collection (Casteras, *McCormick Collection,* p. 62). He exchanged Whistler's *Valparaiso* for Jacque's *Shepherdess* (*Art Journal* [1909], 310). Day is said to have spent £43,850 on his collection.

Purchasing pattern

Day bought at Christie's and presumably through dealers.

Taste

Barbizon, contemporary Dutch, and nineteenth-century English.

Sales and bequests

Christie's, 13–14 May 1909, (289 lots brought £94,946), and 17 May 1909 (prints, brought £8,595); by descent.

References

Art Journal (Sept. 1893), 261–65; (Nov. 1893), 309–13; (May 1909), 207–8 and (Nov. 1909), 309–12; *DNB*; Marillier, *Christie's,* p. 121; *The Times* (June 14, 1908); *Men of the Time: A Dictionary of Contemporaries* (1844; revised London: 1859); *Hansard's Parliamentary Debates,* 3rd ser., 329 (1831–91), 806; Burnand, *Reminiscences,* II, 219; Carter, *Let Me Tell You,* pp. 183–86; William Willis, *Sir John Day* (London: 1909); Susan P. Casteras, *The Edmond J. and Suzanne McCormick Collection* (New Haven: Yale Center for British Art, 1984).

DIXON, Joshua (1810–85)

Whitehaven, London, and Winslade House, Winslade, near Exeter.

Occupation

Cotton merchant, New Orleans and Liverpool; and deputy chairman, London, Chatham and Dover Railway.

Biography

Born in East London, the son of

Abraham Dixon of Whitehaven, Dixon attended Leeds Grammar School for only one year before he was forced to find work because of his parents' financial situation. He and a brother went to New York, where they found employment in the cotton trade. They settled in New Orleans. His brother George headed the foreign merchant firm, Rabone Brothers, in Birmingham (1883–98). After extending his business to Liverpool, Dixon returned to England, living in Cheshire until he purchased Winslade Park around 1860. He was a Justice of the Peace and an active philanthropist.

Collection

Dixon owned oils and engravings by artists such as Barret, Creswick, De Wint, Etty, F. D. Hardy, and Frith, including the sketch for *Derby Day*. He also collected Japanese vases and panels, as well as European sculpture.

Taste

Mid-Victorian benefactor who was concerned with "the uplifting nature of art" (Sabin, *Catalogue*, pp. 6–7).

Purchasing pattern

Dixon sometimes employed the dealer Richard Colls.

Sales and bequests

Bequest of oils, watercolors, Orientalia, and sculpture to Bethnel Green Museum in 1885 (transferred to the Victoria and Albert Museum).

References

Magazine of Art, 15 (1892), 158–64,

243–48, 408–12; Boase; *Huish's The Year's Art* (London: 1887), 230; *ILN* (24 Apr. 1886), 440; Bethnal Green Museum, *Catalogue of a Collection of Oil Paintings, Water-Colour Drawings and Engravings, Enamel Paintings, Sculpture, Bronzes, etc. Bequeathed by the late Joshua Dixon, Esq.* (London: 1890); Arthur K. Sabin, *Catalogue of the Dixon Water-Colours Bequest* (London: 1923); Parkinson, *Catalogue of Oil Paintings*, p. xx.

DOBREE, Samuel (1759–1827)

Marsh Street (now Walthamstow High Street), Walthamstow.

Occupation

City merchant and banker, Samuel Dobree and Sons, 65 Old Broad Street and 6 Tokenhouse Yard (later absorbed by Barclay's); also an amateur writer.

Biography

Son of Peter Dobree of Guernsey (the family name was originally D'Aubray and was later changed to Dobrée. Samuel further anglicized it during the Napoleonic Wars by dropping the accent). He compiled a *Book of Death* in 1819 describing dying scenes of famous men and women.

Collection

Wilkie, *Letter of Introduction*; Turner, *Fishermen upon a Lee-shore* and *Sheerness, Coast Scene with Fishermen, A Shipwreck*; Goya's *Caprichos* (Dobree made an English version of the commentary on them), and several Morlands.

Taste

Early-Victorian mixture of genre and landscape.

Purchasing pattern

Commissioned Morland and Wilkie and bought directly from Turner. T. F. Dibdin met Dobree *c.* 1820 and observed: "He loved art in all its varieties, and had been a sort of Maecenas in former days, to Chantrey, to Turner and to Wilkie; having some five sea-pieces of the second (when his style was grand from the breadth of his shadows and the sobriety of his colouring), and of the latter, the original picture of *Hiring the Servant* (*Reminiscences*, II, 686).

Sales and bequests

By descent, and Christie's, 17 June 1842, 31 May 1873, and Foster's 1–2 July 1889.

References

Pigot's *London Directory* (1826–27); *Gentleman's Magazine* (February 1827), 187; Thomas Frognall Dibdin, *Reminiscenes of a Literary Life*, 2 vols. (London: 1836), II, 686–89; Cunningham, *Wilkie*, I, 433, 437 and II, 7–8, 10–13, 63–64; Gage, *Turner Correspondence*, pp. 23–24 and 248–49; Hilda Finberg, "Turner to Mr. Dobree," *Burlington Magazine* 95 (1953), 98–99; Butlin and Joll, *Turner*, I, 15, 39–41, 58, and 109.

Archival sources: Guildhall Library (current account ledger of Samuel Dobree and Sons); Walthamstow

Personal Names Index and Marriage and Birth Registers of St. Mary.

DUNLOP, Walter (fl. 1857–85)
Harden Grange, Bingley, Bradford, Yorkshire.

Occupation
Merchant, partner of Bradford branch of Heugh, Balfour & Co.

Biography
Social origins unknown. Dunlop was the Bradford representative of merchant John Heugh (q.v.). He and banker Alfred Harris, along with interior designer John Aldam Heaton, sponsored Ruskin's two Bradford lectures in 1859 and 1864. Dunlop made loans to the Manchester Art Treasures exhibition in 1857 and to the Bradford Mechanics' Institute in 1873.

Collection
Dunlop owned Rossetti's *Ophelia*, *Love's Greeting*, *Morning Music*, *Annunciation*, and *Bower Meadow*; however, he fell out with the artist after he cancelled his commission for *Ship of Love*. Dunlop also owned oils by Holman Hunt and Millais, as well as watercolors by Bonington, Prout, Roberts, Millais, Hunt, and Turner. He commissioned thirteen stained-glass windows illustrating Tristram and Yseult from Morris & Co. in 1862 which included designs by Madox Brown, Rossetti, Burne-Jones, Hughes, Prinsep, and Morris. Dunlop also recommended Morris & Co. for the design of stained glass windows in Bradford Parish Church and St. John's Church, Bingley.

Taste
Aesthetic movement, Arts and Crafts, and English watercolor school in accordance with the teachings of Ruskin.

Purchasing pattern
Dunlop was a client of John Aldam Heaton and Pilgeram & Lefevre. He made private purchases from his partner John Heugh and from John Miller (q.v.), in addition to granting commissions to artists.

Sales and bequests
Christie's, 8 March 1904.

References
Art Treasures and Industrial Exhibition (Bradford Mechanics' Institute, Bradford: 1873); Edward Healey, *Picturesque Views of Castles and Country Houses in Yorkshire* (Bradford: 1885); Marillier, *Christie's*, p. 105; Hardman, *Ruskin and Bradford*, pp. 48–49, 158–59, 202, 209, 215, and 232–33; Bradford Art Galleries and Museums, *The Connoisseur: Art Patrons and Collectors in Victorian Bradford* (Bradford: 1989), pp. 1–2; Saint, *Shaw*, p. 54; Rossetti, *Rossetti as Designer and Writer*, pp. 10, 46–47, and 84; *Rossetti Papers*, pp. 144–47 and 150–53; *Rossetti Letters*, ed. Doughty and Wahl, II, 511–12, 516–17, 563–64, 566–67, 569, 572–73, 578, and III, 1067; *Owl and Rossettis*, ed. Cline, nos. 146, 300, 304–6, 353, and 359; Surtees, *Rossetti Catalogue Raisonné*, nos. 94R.1, 126, 131, 169, 170R.1, and 229; Bennett, *Hunt*, no. 28; Fredeman, *Bibliocritical Study*, no. 19.19, p. 80.

DYCE, Rev. Alexander (1798–1869)
9 Gray's Inn Square (until 1859), and 33 Oxford Terrace, Paddington, London.

Occupation
Clergyman and amateur author.

Biography
Born in George Street, Edinburgh, the eldest son of a general in the East India Company's service. Dyce's mother was the sister of Sir Neil Campbell, British Commissioner with Napoleon at Elba and afterwards governor of Sierra Leone. He was a cousin of artist and South Kensington art administrator William Dyce. Dyce was educated at Edinburgh High School and at Exeter College, Oxford, where he took holy orders in 1819. He moved to London in 1825, where he became an intimate friend of John Forster (q.v.), who prepared the biographical sketch which accompanies the Dyce bequest (South Kensington Museum, 1875). Dyce's literary interests were directed toward poetry and the classics. He edited and annotated several editions of early English dramatic poetry, beginning with the work of George Peele in 1828, followed by editions of Shakespeare, Webster, Greene, Shirley, Bentley, Skelton, and Marlowe. Dyce's *magnum opus* was his eleven-volume work on Beaumont and Fletcher.

Collection

In assessing Dyce's bequest of books and pictures to the South Kensington Museum, Richard Redgrave stated: "the strength of Mr. Dyce's valuable bequest does not lie in the paintings, which are of a very miscellaneous character" (*Dyce and Forster Collections*, p. 31). His Turners were spurious and many other objects in the collection were misattributed. Dyce, however, donated authentic works by Etty, Girtin, Morland, and Wilkie. His watercolor bequest is considered one of the finest portions of the Victoria and Albert Museum's collection (Lambourne and Hamilton, *British Watercolours*). Dyce also gathered a collection of over sixty miniatures by earlier English, Dutch, Flemish, and Italian painters, including a self-portrait ascribed to Sofinisba Anguissola.

Taste

Early- to mid-Victorian benefactor with a preference for portraits of famous actors, literary genre scenes, and landscapes.

Purchasing pattern

Dyce commissioned artists directly and frequented Agnew's and Christie's.

Sales and bequests

Bequest to South Kensington Museum in 1869 of 14,000 books and 150 oils and watercolors, in addition to a large number of prints.

References

The Reminiscences of Alexander Dyce, ed. Richard J. Schrader (Columbus: 1972);

South Kensington Museum, *Handbook of the Dyce and Forster Collections* (London: 1877); South Kensington Museum, *The Dyce Collection* (London: 1875); "Dyce and Forster Collections," *Art Journal* (May 1888), 129–33; Lambourne and Hamilton, *British Watercolours* p. xi; Parkinson, *Catalogue of Oil Paintings*, passim; Pointon, *Dyce*, pp. 4–5 and 170.

EDEN, James (1797–1874)

Astley Bank, Sharples, near Bolton, c. 1841; Fairlawn House, Lytham, near Preston 1846–74 (now a Masonic home for the elderly); Showley Hall, Clayton-le-Dale, Lancashire, 1869–74.

Occupation

Bleacher, Eden & Thwaites; Water Meetings Bleachworks, Astley Bridge, Sharples; and 1 Upper Booth Street, Salford.

Biography

Origins unknown. Eden was born at Blackburn and filled situations at Preston before becoming a partner with James Hulme in Sharples Bleachworks in Little Bolton. That partnership was dissolved and reformed as Eden & Thwaites in 1829. A bachelor, Eden retired *c.* 1854. When he died twenty years later he left a bequest of almost £50,000 for the erection and endowment of the Eden Orphanage in Little Bolton. A Justice of the Peace, Eden knew other local dignitaries, such as Richard Newsham. Lender to Manchester Art Treasures exhibition.

Collection

Eden's most important canvases were Millais's *Autumn Leaves* (1856), which he disliked and subsequently traded with John Miller (q.v.) for three pictures; Horsley's *The Pet of the Common* (1853), to which Eden allowed a coach builder to apply carriage varnish (Horsley, *Recollections*, p. 229); and Ansdell's large (20 × 14 feet) *The Fight for the Standard*. Eden bought a total of eleven pictures from Richard Ansdell, who became a neighbor in Lytham in 1861, where a road, a railway, and an entire district were named after him (Chapel, *Victorian Taste*, p. 69). In addition, Eden owned landscapes by Linnel (nine), as well as genre paintings by F. D. Hardy (five) and Webster (five). He was also well known as a collector of vintage wines.

Taste

Early- to mid-Victorian, especially Cranbrook Colony artists. Favored child genre and landscape subjects.

Purchasing pattern

Commissioned Horsley, Hardy, Millais, Webster, Hook, Poole, H. O'Neil, J. Phillip, Frost, and Ansdell. Eden was also a client of Agnew's.

Sales and bequests

Christie's, 30 May 1874.

References

Bolton Chronicle, 8 Jan. 1829 and 2 May 1874; *Bolton Journal*, 2 May 1874; *Bolton Guardian*, 2 May 1874; Slater, *Bolton Directories*, 1829–74; Gillbank, *Preston Directory*, 1857; *Art Journal* (July

1874), 221; James H. Longworth, *The Cotton Mills of Bolton 1780–1985, A Historical Directory* (Bolton: 1987); Millais, *Millais*, I, 297; Horsley, *Recollections*, 228–29; Greg, *Cranbrook Colony*; Chapel, *Victorian Taste*, pp. 69 and 106–107; Warner, "Millais," pp. 97–98; Malcolm Warner, "John Everett Millais's 'Autumn Leaves': 'A Picture full of Beauty and without Subject,'" *Pre-Raphaelite Papers*, ed. Parris p. 126.

Archival sources: Mrs. J. J. Thwaites's notes on the Thwaites Family, Dept. of Education and Arts, Bolton; letter from Eden to John Linnell, Linnell Family Papers; Census Report of 1841.

ELLIS, Frederick Startridge (1830–1901)
London and Sidmouth, Devonshire.

Occupation
Bookseller and publisher, 29 New Bond Street, London.

Biography
Grandson of a yeoman farmer from Staffordshire, who moved to London *c.* 1800, and son of Joseph Ellis, proprietor of the Star and Garter at Richmond. The details of Ellis's early education are sketchy, although he is known to have mastered Latin, French, and German. Ellis traveled abroad and on his return apprenticed with a bookseller in Chancery Lane. In 1857 he opened his own shop in Covent Garden, moving to larger quarters in New Bond Street in 1872, where he specialized in antiquarian books. His clients included Ruskin and Tennyson. As a publisher, he produced books for Swinburne, Rossetti, and Morris. He shared the lease of Kelmscott Manor with Morris, who named him his executor. In his last years Ellis was actively involved in editing and compiling publications.

Collection
Ellis owned a small selection of drawings and photographs by Burne-Jones and Rossetti.

Purchasing pattern
Ellis obtained works directly from artists.

Taste
Aesthetic movement.

Sales and bequests
Christie's, 13 Dec. 1918.

References
Letters of D. G. Rossetti to his Publisher F. S. Ellis, ed. Oswald Doughty (Norwood, Penn.: 1978); *Rossetti Letters*, ed. Doughty and Wahl, III, 923 and IV, 1514–15, 1643–44; *Owl and Rossettis*, ed. Cline, nos. 19, 54, 63, 65, 86, 88, 89, 90, 160, 162, 163, 168, 173, 296, and 300; Williamson, *Murray Marks*, pp. 79–81 and 100–1; Burne-Jones, *Memorials*, II, 40–41 and 278; Arts Council, *Burne-Jones* (London: 1975), no. 113; Surtees, *Rossetti Catalogue Raisonné*, nos. 162R.3, 205B, and 213B.

ELLIS, William Stone (1806–76)
Streatham Common, Streatham, London

Occupation
Stockbroker, Ellis, Tucker & Co., 11 Birchin Lane, City of London, and later Barnett, Ellis & Co., 18 French Lane.

Biography
Origins unknown. A bachelor and an amateur artist, Ellis was the executor of David Cox's will. They frequently went on sketching trips together.

Collection
Ellis owned over 300 watercolors by Cox. All were in perfect condition because they were kept in porfolios. He also owned watercolors by Cattermole, Tayler, and Turner. Ellis met Cox approximately five years after first seeing his sepias at Palser's in the Strand *c.* 1825. About these, Ellis wrote in 1860, "They were very broad and beautiful; I would sooner meet with these than with the Turner sepias in Marlborough House" (Solly, *Cox*, p. 66). Ellis also bought some Cox drawings from a dealer named Clay in Ludgate Hill. He took lessons in watercolors from George Fennel Robson in 1829, who, according to Solly, recommended he take further lessons from "Old Farmer Cox."

Taste
Early-Victorian watercolors.

Purchasing pattern
Commissions from Cox and purchases from the dealers Palser and Clay.

Sales and bequests

Christie's 9–10 March 1877 (350 lots, mainly sketches by David Cox, fetched £17,911).

References

Robson's *London Directory* (1834); *Stock Exchange Members and Firms* (1836); *Post Office Directory* (1873); Redford, I, 267; *Art Journal* (Oct. 1877), 312; *The Times*, 12 March 1877; Solly, *Cox*, pp. 66–67, 81, 133–36 and 144–47.

Archival sources: 1871 Census Return and Norwood Cemetery Memorial Entries (Lambeth Archives Department).

ELLIS, Wynn (1790–1875)

30 Cadogan Place, London; Ponsborne Park, Hertfordshire; and Tankerton Tower, near Canterbury.

Occupation

Silk merchant, John Howell & Co.

Biography

Son of Thomas Ellis and Elizabeth Ordway of Barkway, Hertfordshire. According to the *DNB*, Ellis received a good education. By 1812 he was employed in London as a haberdasher, hosier, and mercer. He transferred his energies from retail to wholesale outlet in the 1830s and eventually created the largest silk business in London. He retired from business in 1871. Ellis was Liberal MP for Leicester, 1831–35, and a Justice of the Peace for both Hertfordshire and Kent. A noted philanthropist, he left several bequests to charitable, religious, and fine-art

institutions, including £50,000 to the trustees of the Simeon Fund. His estate was proved at under £600,000.

Collection

At the time Dr. Waagen reviewed his collection in 1854, Ellis owned only four contemporary works; however, his 1876 sale included 135 pictures of the English School alongside his many eighteenth-century works and Old Masters. Many items in Ellis's sale were considered copies or imitations of artists such as Collins (*Art Journal*, 1876). A record price was set for Gainsborough's *Georgina, Duchess of Devonshire,* for which Agnew's paid £10,000. This picture caused a sensation when it was stolen three weeks later. It was not recovered until 1901, when it was located in Chicago and sold to J. Pierpont Morgan. Although Redford doubted its authenticity (I, 220), it is accepted as genuine by Waterhouse (*Gainsborough*, no. 195). Ellis commissioned John Barry to design a mausoleum for his wife in 1872 (*DNB*).

Taste

Early-Victorian, eighteenth-century British, and Old Masters.

Purchasing pattern

Artists' sales and from dealers (Henry Graves).

Sales and bequests

Ellis bequeathed 402 Old Master canvases to the National Gallery, of which the trustees selected only forty-four. The remainder of Ellis's collec-

tion was sold at Christie's, 6 May 1876 (135 early English pictures); 27 May (156 Dutch and Flemish); 17 June (154 French, Spanish, and Italian); 15 July (twenty watercolors and 115 works listed as in the "style of" various artists), earning a total of £56,485.

References

Waagen (1838), II, 403; Waagen (1854), II, 293–98; *DNB*; *WWMP*; *Warehousemen and Draper's Trade Journal* (27 Nov. 1875), 618; *ILN* (8 Jan. 1876), 35–38; *The Times*, 25 Nov. 1875; *London Court Directory* (1873); Roberts, I, 244–49; Redford I, 218–31; *Athenaeum* (4 Dec. 1875), 756–57; *Art Journal* (Nov. 1876), 335; Robertson, *Eastlake*, 82 and 90; Farr, *Etty*, p. 63; Cunningham, *Wilkie*, III, 525; Herrmann, *English as Collectors*, p. 346; Ellis Waterhouse, *Gainsborough* (London: 1966), nos. 195, 936, and 984; Butlin and Joll, *Turner*, nos. 36, 40, 116–17, 133, and 141.

FAIRBAIRN, Sir Thomas (1823–91)

Irwell Bank, Higher Broughton, Manchester, by 1850; Burton Park, Surrey, 1862–67; 23 Queen's Gate, London, 1862–67; Brambridge House, Bishopstoke, 1867–91; and 42 Wilton Place, London, 1878–89.

Occupation

Partner in William Fairbairn & Co., millwrights, iron and brass founders, steam engine manufacturers, and boiler makers. Owner of Fairbairn Engineering Co., which specialized in patented riveting machines and iron

steam boats at Millwall in Manchester and in London.

Biography

Eldest son of Sir William Fairbairn, one of the founders of structural engineering theory, he worked with Robert Stephenson on construction of the Conway and Britannia bridges and was rewarded with a baronetcy in 1869. A Unitarian, William was a member of the Royal Manchester Institution from 1825 and president between 1869 and 1871. Thomas joined the family firm in 1840 and, following his father's example, became involved in cultural organizations. He was a commissioner of the Great Exhibition of 1851, chairman of the executive committee of the Manchester Art Treasures exhibition in 1857, and manager of the Fine Arts Department at the International Exhibition in London in 1862. He was also a non-artist member of the Hogarth Club. Thomas closed Fairbairn Engineering Co. in 1869 because of the depression affecting iron trade, which also caused him to slow down in his collecting. He refused a knighthood for his work on the Art Treasures, succeeding to his father's title in 1874.

Collection

One of Holman Hunt's main patrons, Fairbairn purchased *The Awakening Conscience*, *Valentine Rescuing Sylvia*, and *The Scapegoat*. He also commissioned Hunt to paint his portrait in 1873, and a group family portrait in 1864. Fairbairn advised Hunt in negotions with Agnew's for the sale of *The Shadow of Death*, and with the Fine Art Society for the exhibition of *Triumph of the Innocents*. He owned works by Uwins, Brett (which he tried to sell in 1877), Lear, Egg, Witherington, and Pickersgill, as well as examples of mid-nineteenth-century French salon painting.

Taste

Pre-Raphaelite, early Victorian, and contemporary French. Fairbairn's collection combined academic painting with Pre-Raphaelite modern moral subjects and portraits. He displayed a preference for realistic genre and allegorical treatments of religious themes. Many of his choices were influenced by the painter Augustus Egg.

Purchasing pattern

Bought at the Royal Manchester Institution and Royal Academy exhibitions and gave direct commissions to artists, such as Holman Hunt, Woolner, and Brett.

Sales and bequests

Christie's, 2 March 1885, 7 May 1887, and 25 January 1946; Phillips's, 3 May 1892; and by descent.

References

The Life of Sir William Fairbairn, Bart., ed. William Pole (London: 1877); L. T. C. Rolt, *Victorian Engineering* (London: 1970), pp. 63, 75 and 133–34; Smiles, *Industrial Biography*, pp. 323–33; *Exhibition of the Art Treasures of the United Kingdom, held at Manchester in 1857. Report of the Executive Committee* (Manchester: 1859); *Report of the Commissioners for the Exhibition of 1862* (London: 1863); John Hollingshead, *A Concise History of the International Exhibition of 1862: Its Rise and Progress* (London: 1862); Ian Nairn and Nikolaus Pevsner, *The Buildings of England: Sussex* (Harmondsworth: 1965), 37; Hunt, *Pre-Raphaelitism*, II, 159 and 162; Judith Bronkhurst, "Fruits of a Connoisseur's Friendship: Sir Thomas Fairbairn and William Holman Hunt," *Burlington* 125 (Oct. 1983), 586–97; Woolner, *Thomas Woolner*, pp. 135–38; Conran, "Art Collections," in *Victorian Manchester*, ed. J. Archer, p. 72.

Archival sources: Fairbairn Family Bible; Manchester Central Library Archives; Hunt Correspondence, John Rylands University Library of Manchester; Agnew's Stockbooks; F. G. Stephens Correspondence, Bodleian Library, Oxford.

FLOWER, Cyril, Lord Battersea (1843–1907)

Surrey House, 7 Hyde Park Place, London; The Pleasaunce, Overstrand, Cromer, Norfolk; Aston Clinton, Tring, Buckinghamshire; and Buckingham House, Brecon, South Wales.

Occupation

Barrister.

Biography

Known as the handsomest man in London, Flower was the eldest son of

Mary and Philip William Flower of Furzedown, Streatham, and the grandson of a merchant who prospered in the City of London. His father emigrated to Australia in the 1830s, where he established the merchant house of Flower, Salting & Co. in Sydney. He exported wool, tallow, and gold to England and purchased Colliers Quay and other wharves in London, as well as extensive commercial property in Surrey, Westminster, and Battersea (Metcalf, *Knowles,* p. 179). Cyril was educated at Harrow and Trinity College, Cambridge, and was called to the bar in 1870 after reading with Sir John Day (q.v.). Although he enjoyed practicing law, Flower was expected to manage his father's property following his death. In 1877, he married Constance, eldest daughter of Sir Anthony Rothschild and cousin of Blanche Fitzroy, who founded the Grosvenor Gallery with her husband Sir Coutts Lindsay. Flower served as a Member of Parliament from 1880 to 1892, when he was created Lord Battersea by Gladstone. He was a keen amateur photographer. His cousin Wickham Flower was also an art collector.

Collection

Flower owned paintings and drawings by Rossetti, Burne-Jones, Whistler, and Sandys and sculpture by Storey and Gilbert. He sat for his portrait to Watts, Sandys, and Gilbert. Flower also purchased Old Master canvases. He may have modeled for the figure of Christ in Holman Hunt's *The Finding of the Saviour in the Temple* (Callow, *Autobiography,* p. 118).

Taste

Aesthetic movement and Old Master painters.

Purchasing pattern

Flower gave Sandys weekly advances against commissions. He also was a client of the Grosvenor Gallery and Christie's.

Sales and bequests

Bequests: Tate Gallery, Burne-Jones, *Golden Stairs,* 1907 and Burne-Jones, *Annunciation,* Norwich Museum.

Sales: Private sales of his Whistlers to Charles Freer and J. J. Cowan in 1899 and 1904 through Agnew's and Marchand; Christie's, 17 and 27 July 1891; 30 April 1909; 6 May 1927; 15 March and 31 May 1935.

References

WWMP; Westminster Gazette, 28 Nov. 1907; Battersea, *Reminiscences;* Metcalf, *James Knowles,* pp. 178–81 and 229; William Callow, *An Autobiography,* ed. Herbert Minton Cundall (London: 1908), 118; Brighton Museum and Art Gallery, *Frederick Sandys* (1974), nos. 111–12, 120–23, 142, and 148; Douglas E. Schoenherr, "Frederick Sandys's *Amor Mundi,*" Apollo 127 (May 1988), 318; Reynolds, *Simeon Solomon,* p. 15; Crane, *Reminiscences,* p. 212; *Owl and Rossettis,* ed. Cline, p. 131; Dorment, *Gilbert,* p. 91; Arts Council, *Burne-Jones* (London: 1975), p. 138; Fitzgerald, *Burne-Jones,* pp. 183–85; Pennell and Pennell, *Whistler,* I, 189 and 259; Young *et al., Whistler,* nos. 60, 105, and 269; Curry, *Whistler,* pp. 25–26; Andrea Rose, *Pre-Raphaelite Portraits* (Oxford: 1981), p. 122; Graves, *Century of Loan Exhibitions, passim;* Dimond and Taylor, *Crown and Camera,* p. 178.

FORBES, James Staats
(1823–1904)

Garden Corner, Chelsea Embankment, London.

Occupation

Chairman, London, Chatham, & Dover Railway and Financier.

Biography

Born in Aberdeen, the son of Ann Walker and Capt. James Staats Forbes, James was educated as an engineer at Woolwich. He then entered the office of Isambard Kingdom Brunel (q.v.) in 1840. After working for the Great Western Railway and the Nederlandsche Rhijnspoorweg Mattschappij, Forbes was made general manager of the London, Chatham, & Dover Railway in 1861, which he rescued from bankruptcy. Promoted to chairman in 1873, Forbes's reputation as a "railway surgeon" to troubled companies induced him to lend his expertise to a number of railway enterprises. In addition, he invested in foreign hotels and railways and in mortgage and insurance companies. Forbes was also a promoter of pioneer ventures in electricity and the telephone, becoming president of the National Telephone Co. in

1892. Culturally, he supported the Actors' Benevolent Fund and the theater. He was the uncle of Stanhope Alexander Forbes, RA and friend of George Du Maurier and Sir Francis Burnand. He treated these two friends to a tour of the Barbizon region which included a visit to Millet's widow. Forbes's estate was valued at £272,545.

Collection

Forbes was most interested in Barbizon and nineteenth-century Dutch painting. In addition, he owned several works by Whistler, including *The Widow* and *Girl with a Red Feather*. He stored his paintings at Paddington Station. Following his death, his collection was exhibited at the Grafton Gallery in 1905.

Taste

Barbizon and nineteenth-century Dutch.

Purchasing pattern

Forbes was a client of Durand Ruel.

Sales and bequests

Munich, Fleischmann, 28 March 1905, 20–21 March 1906; London, Puttick, Simpson, 6 July 1906 (sculpture); Christie's, 23 May 1874; 22–24 April 1882; 2 June 1916; 14 June 1918; and 8 Dec. 1919; Barbizon House, July 1919; and private sales by Forbes's executors.

References

Athenaeum (27 May 1905), 664; *DNB*; *DBB*; *Aberdeen Free Press*, 6 April 1904; Julia Cartwright, "The Drawings of J.-F. Millet in the Collection of Mr. James Staats Forbes," *Burlington* 5 (1905), 47–52, 117–59, 192–203, and 361–67; E. G. Halton, "The Staats Forbes Collection," *International Studio* 26 (1905), 30–47, 107–18, and 218–32; Grafton Gallery, *Exhibition of a Selection of Paintings and Drawings from the Collection of the late James Staats Forbes* (London: 1905); Leicester Art Gallery, *One Hundred Drawings by Millet* (Leicester: 1906) and *Corot and the Barbizon School* (Leicester: 1906); Brighton Art Gallery, *Catalogue of an Exhibition of Pictures from the Collection of the late J. Staats Forbes* (Brighton: 1908); Ronald Pickvance, "Henry Hill: An Untypical Victorian Collector," *Apollo* 77 (Dec. 1962), 790; Burnand, *Reminiscences*, II, 250–57; Ormond, *Du Maurier*, pp. 364–66; Graves, *Century of Loan Exhibitions*, II, 1656–57; Marillier, *Christie's*, pp. 162 and 182; Venturi, *Archives de l'Impressionisme*, II, 196; Pennell and Pennell, *Whistler*, II, 93; Cooper, *Courtauld*, p. 22; Curry, *Whistler*, (1984), p. 89; Young *et al.*, *Whistler*, nos. 66, 312, 330, 459, 503, 523–24.

FORSTER, John (1812–76)

58 Lincoln's Inn Fields; 46 Montague Square (1856–62); and Palace Gate House, Kensington, London.

Occupation

Barrister, Inner Temple and critic, historian, and biographer.

Biography

Born in Newcastle, grandson of John Forster of Corsenside, a farmer, and eldest son of Robert Forster, a cattle dealer. Forster was educated at Newcastle Grammar School and at University College, London. He entered the Inner Temple in 1818 and qualified as a barrister in 1843, despite the fact that he had occupied himself during the previous nine years as a journalist and drama critic for the *True Sun*. He went on to serve as editor of various publications, including the *Foreign Quarterly Review* in 1842 and *The Examiner* from 1847–55. Forster married Eliza Ann Crosbie, the wealthy widow of publisher Henry Colburn, in 1856. He was executor of the estate of the Rev. Alexander Dyce (q.v.). Forster authored a series of biographies of literary figures, notably Goldsmith and Dickens. Forster was also an amateur actor.

Collection

Forster owned almost 150 oils and sketches representing a vast spectrum of the history of art from the Old Masters to eighteenth-century British, French, and Italian. He also collected the works of his immediate contemporaries, particularly portraits of writers and playwrights, such as the series of twenty portraits produced by his friend Daniel Maclise and Watts's well-known portrait of Carlyle. In addition, Forster owned dozens of engraved portraits of famous people.

Taste

Early- to mid-Victorian benefactor with a preference for portraits of

famous individuals and literary genre subjects.

Purchasing pattern

Forster bought at Christie's and gave direct commissions to artists.

Sales and bequests

Bequest to South Kensington Museum in 1876 of forty-eight oil paintings, several hundred drawings, sketches, and engravings, and more than 18,000 books.

References

Henry Morley, "Biographical Sketch of John Forster," *Handbook of the Dyce and Forster Collections,* South Kensington Museum (London: 1877); *A Catalogue of the Paintings, Manuscripts, Autograph Letters, Pamphlets, etc. Bequeathed by John Forster,* South Kensington Museum (London: 1893); "Dyce and Forster Collections," *Magazine of Art* (1888), 129–33; Victoria and Albert Museum, *The Library of John Forster* (London: 1972), *British Watercolours* (London: 1980) and Parkinson, *Catalogue of Oil Paintings,* p. xix; Richard Renton, *John Forster and His Friendships* (London: 1912); Davies, *Forster*; Ormond, *Maclise,* p. 76;

Archival sources:

Letters, deeds, and papers, Victoria and Albert Museum Library.

FOX, George (1817–94)

New York City; Fulshaw Hall, Harefield, Wilmslow, Manchester (now owned by Refuge Assurance Co.); and Elmhurst Hall, Litchfield, Staffordshire (1875–94).

Occupation

Cotton merchant, Alexander Stewart & Co., Manchester.

Biography

Son of yeoman parents who lived at Stone Hall, in the village of Stonemouth Kent. Fox was the fourth son of a family of thirteen children. He left home and traveled to New York, where he met department store magnate and art collector Alexander Stewart in 1842. Fox entered Stewart's employ and was sent to Manchester by him in 1847 to establish a branch of his New York import-export business. Other branches were soon formed in Nottingham, Belfast, Glasgow, Lyons, Paris, and Berlin. Fox pursued the gentlemanly hobbies of farming, raising pedigree Shorthorns, and cultivating orchids. In 1875, when he married his American second wife, they moved from Cheshire to Staffordshire, where he was appointed magistrate, deputy-lieutenant, and high sheriff. A philanthropist, Fox contributed £2,000 in 1876 for the building of a church school in Fulshaw, Cheshire in memory of his first wife.

Collection

When the *Art Journal* visited Fox at Harefield in 1872 he possessed 200 pictures. Place of honor in his private picture gallery was given to Noel Paton's *Christ Bearing His Cross.* Fox also displayed smaller works by artists such as Wilkie, James Ward, G. B. O'Neill, and Meissonnier on specially constructed screens. A marvel for its

day, the gallery featured a glass roof and was lit by gas jets for evening viewing. The *Art Journal,* in 1872, reported that Fox had subjected his collection to some "weeding," explaining that "he has had (like all other successful collectors) to buy knowledge" (p. 117). At that time, Fox stated that he intended to add more works by T. Faed, Stone, Pott, Dobson, Cole, Boughton, and Orchardson. He further pruned his collection in 1877 (see sale below). Several of Fox's pictures were exhibited at the Royal Manchester Institution in 1870 and 1871.

Taste

Mid-Victorian English and continental.

Purchasing pattern

Commissions to artists and direct purchases from their studios. Fox also bought from the Royal Manchester Institution, Royal Academy, Society of British Artists, Paris Salon, Brussels Royal Academy, and international exhibitions at Munich and Vienna. The *Art Journal* noted that his purchases were made "without the intervention of the dealer" (p. 117).

Sales and bequests

Christie's, 11–12 May 1877 (180 lots) and 2 May 1895.

References

Art Journal (April 1872), 117–20; *Morris's Directory of Cheshire and Stalybridge* (1874), 876; *Slater's Directory of Cheshire and North Wales* (1869); George Ormerod, *The History*

of the County Palatine and City of Chester, 3 vols. (London: 1882), II, 603; *Lichfield Mercury*, 8 June 1894; W. H. Sutton & Sons, *Harefield House* (Manchester: 1939); ICI, *Harefield House* (c. 1986), 24–33; Chapel, *Victorian Taste*, pp. 100 and 106; Gregg, *Cranbrook Colony*, nos. 39 and 41.

Archival sources: Census Report of 1871; RMI Letter Book (1870–71), pp. 105 and 112, Manchester City Library Archives.

FRY, Clarence Edmund (d. c. 1891)
The Little Elms, Watford, Hertfordshire.

Occupation
Photographer, Elliot & Fry, 55 Baker Street, London.

Biography
Origins unknown. Fry's parents were Quakers. Bevis Hillier states that "almost nothing is known" about Fry and his partner Joseph John Elliott (*Victorian Studio Photographs*, p. 29). They were, however, preeminent portrait photographers who numbered the Royal Family, Thomas Carlyle, William Gladstone, and Buffalo Bill Cody among their clients. H. Baden Pritchard, who visited their studio in 1880, reported that the somewhat higher than average fee of 1 guinea per sitting charged by Elliot & Fry permitted them to enhance their walls with contemporary paintings which, he claimed, were insured for a staggering sum of money (*ibid.*). By 1904 the firm was known as C. E. Fry & Son.

Collection
Among his Rossettis, Fry owned *Astarte Syriaca*. He also purchased Herkomer's *The Last Muster*, in addition to six paintings by Fantin-Latour and several by Sandys. He displayed part of his collection in his studio.

Taste
Aesthetic movement, contemporary French and mid- to late-Victorian paintings.

Purchasing pattern
Fry employed Charles Augustus Howell as an intermediary in his dealings with Rossetti and Sandys, but he gave direct commissions to Fantin-Latour and was on intimate terms with Herkomer. He was said to have speculated on the art market (Druick and Hoog, *Fantin-Latour*, p. 118).

Sales and bequests
Private sales by Fry's widow to Manchester City Art Gallery in 1891; Christie's, 18 April 1891.

References
Henry Baden Pritchard, *The Photographic Studios of Europe* (1882; rpt. New York: 1973); Bevis Hillier, *Victorian Studio Photographs from the Collections of Studio Bassano and Elliot and Fry, London* (London: 1975), pp. 29–30; Maas, *Victorian Art World in Photographs*, p. 116; Dimond and Taylor, *Crown and Camera,* pp. 158, 180–81, and 216; Rossetti, *Family Letters*, I, 350 and II, 363; *Rossetti Papers*, p. 227; *Owl and Rossettis*, ed. Cline, p. 16, nos. 399, 425, 432, 436–38, 441, 443, 447, 449–52,

454, and 460–61; Surtees, *Rossetti Catalogue Raisonné*, nos. 81R16, 81R1j, 216, 237, 249, 249A, and 249C; Angeli, *Pre-Raphaelite Twilight*, pp. 110–13; *Rossetti Letters*, ed. Doughty and Wahl, IV, 1411 and 1430–31; Druick and Hoog, *Fantin-Latour*, p. 118; Baldry, *Herkomer*, pp. 26–28.

Archival sources: Letters from Rossetti, Berg Collection, New York Public Library and University of Texas, Austin; letters from Fry to Rossetti, Bodleian Library, Oxford.

GALLOWAY, Charles John (d. 1904)
Thorneyholme, Knutsford, Cheshire.

Occupation
Boiler and engine manufacturer, W. & J. Galloway & Sons and Knott Mill Ironworks, Manchester.

Biography
Son of John Galloway, a millwright and ironfounder who established W. & J. Galloway in 1835 in partnership with his brother William. After Charles and his cousin John Galloway entered the business in 1856 as full partners, they prospered by exporting steam engines to Russia and India. The dominant personality in the firm, C. J. Galloway became its chairman and managing director. Galloway made his fortune by supplying steam engines throughout Europe.

Collection
Galloway was an early supporter of Degas and Pissarro in England. He

owned Pissarro's *Crystal Palace* and bought Degas's *The Ballet* directly from the artist. In addition, he possessed works by Barbizon painters, academic British narrative painters, landscapes by early-nineteenth-century artists, and more contemporary efforts by the Manchester School. The largest number of works by a single artist in his collection were the thirty-seven paintings by Mancunian painter E. J. Gregory (1850–1919), who specialized in genteel scenes of rural life. Galloway commissioned *The Roll Call* from Lady Butler in 1873 but ceded it to Queen Victoria the following year in exchange for the artist's *Quatre-Bras*. He also collected examples of the work of Burne-Jones, Watts, Fantin-Latour, George Clausen, La Thangue, and Lhermitte, many of which were on display at the International Exhibition in Glasgow in 1901.

Taste
Aesthetic movement, contemporary French, and traditional narrative and genre subjects.

Purchasing pattern
Galloway made direct commissions and purchases from artists. He was also a client of Alex Reid and the Dudley Gallery.

Sales and bequests
Christie's, 28 May 1881 and 26–27 June 1905.

References
"John Galloway," *DBB*, II, 465–58; C. J. Galloway, *Catalogue of Paintings and Drawings at Thorneyholme, Cheshire,*

Collected by Charles J. Galloway (Manchester: 1892); Elizabeth Conran, "Art Collections," in *Victorian Manchester*, ed. Archer, 76; Usherwood and Spencer-Smith, *Lady Butler*, pp. 57–58 and 61; Temple, *Guildhall Memories*, 169–71; Cooper, *Courtauld*, p. 65; and Lefevre Gallery, *Alex Reid*, p. 9.

GASKELL, Holbrook (1813–1909)
Woolton Wood, Gateacre, Liverpool.

Occupation
Chemical trade, United Alkali; colliery owner, White Moss Colliery Co.; and newspaper owner, *Liverpool Daily and Weekly Post and Echo.*

Biography
Son of cousins Roger and Ann Gaskell, who were members of a Lancashire family that could trace its heritage in the county to the sixteenth century. Roger Gaskell was a sailcloth merchant, a business in which his family had been engaged since the eighteenth century. Holbrook was educated at a Unitarian private school near Sheffield until he was apprenticed at the age of fourteen with Yates & Cox, Liverpool iron merchants and nailmakers. He left to enter into partnership in Manchester with James Nasmyth, who subsequently invented the steam hammer. Although Nasmyth & Gaskell became one of Britain's major engineering firms, the partnership was dissolved in 1855 due to Gaskell's ill heath. When he recovered a few months later, Gaskell

formed a partnership with Henry Deacon, an alkali manufacturer. Their firm was one of the most successful in the region and was eventually amalgamated into United Alkali, with Holbrook Gaskell serving as vice-president. Gaskell was a generous donor to local causes: he gave £5,000 toward a chair of botany at Liverpool University and made contributions to the Children's Convalescent Home. He married Frances Ann Bellhouse of Manchester. Gaskell's estate was proved at £499,769.

Collection
Gaskell's collection was notable for the high prices earned at his sale in 1909. Constable's *Arundel Mill and Castle* brought 8,400 guineas and Turner's *Burning of Houses of Parliament* earned 12,500 guineas. In addition, he owned Millais's *The Rescue* and Alma–Tadema's *Rose of all the Roses*.

Taste
Mid- to late-Victorian and early nineteenth-century landscape and figure subjects.

Purchasing pattern
Agnew's.

Sales
Christie's, 24–25 June 1909 (249 lots brought £55,636); and by descent.

References
Athenaeum (4 Oct. 1884), 437–39; *Art Journal* (Nov. 1909), 309–10; *DBB*, II, 499–500; *Liverpool Courier*, 9 March 1909; *Daily Post and Mercury*, 15 March 1909; Marillier, *Christie's*, pp. 123 and

168; Smiles, *Industrial Biography*, pp. 284ff.; *James Nasmyth, Engineer: An Autobiography,* ed. Samuel Smiles (London: 1883); David William F. Hardie, *A History of the Chemical Industry in Widnes* (London: 1950), pp. 32 and *passim*; Albert Edward Musson and Eric Robinson, *Science and Technology in the Industrial Revolution* (Manchester: 1969); Macleod (1986), p. 604; Wolverhampton Art Gallery, *Gaskell Collection* (Wolverhampton: 1951).

Archival sources: Eccles Central Library, Nasymth Collection (correspondence) and Gaskell obituaries.

GIBBONS, John (1777–1851)
Bristol until mid-1820s; 9 Westbourne Road, Edgbaston, near Birmingham by 1843; and 17 Hanover Terrace, Regent's Park, London, 1845–51.

Occupation
Ironmaster.

Biography
A member of a prosperous Bristol family of sugar merchants that traced its roots back to the seventeenth century, Gibbons was educated in the Classics (Adams, *Danby*, p. 109). Although in delicate health, he continued to manage his iron foundry until 1845, when he retired and left Birmingham for London, selling his house to Joseph Gillott (q.v.). An amateur artist, Gibbons participated in an informal sketching club in Bristol.

Collection
Began collecting while living in Bristol, where he was Francis Danby's chief patron. While continuing to support Danby over a thirty-year period, Gibbons extended his patronage to Leslie, Stanfield, Linnell, Webster, Mulready, and Frith. Frith considered him "a most kind and generous patron" and classified Gibbons "amongst a few picture-collectors of the old school, whose love for art and genuine enjoyment in its possession were the sole guides in the accumulation of their treasures" (*Autobiography*, III, 196). Gibbons's fondness for artists was manifested in the number of portraits of them he owned. His collection grew to over 200 works of art.

Taste
Early-Victorian oils and watercolors. Shared aristocratic preferences for figurative and landscape subjects. Gibbons did not mind if living artists were inspired by the Old Masters, telling Frith, "where there is beauty, finish, and taste, I care little about 'originality'" (*Autobiography*, III, 202). Gibbons, however, drew the line at allegory. Although he succumbed to the fashion for genre painting, he preferred subjects taken from inspirational sources such as Goldsmith's *Vicar of Wakefield* over Shakespeare's comedies. He wrote: "There is nothing in the 'Merry Wives' to touch the heart or the affections, nothing from which one could weave a story or a dream – a hearty laugh or two, and all is over" (*ibid.*, 208). He purchased one Pre-Raphaelite work, William Holman Hunt's *Rienzi Vowing to Obtain Justice for the Death of his Young Brother* (1848–49); however, the artist considered this an act of generosity, since Gibbons kept the painting in a closet (Hunt, *Pre-Raphaelitism*, I, 183).

Purchasing pattern
Mainly direct commissions to artists.

Sales and bequests
Christie's, 11 June 1831; 27 June 1863; 17 March 1883; 5 May 1883; 26 May 1894; 29 Nov. 1912; and by descent.

References
Roberts II, 49–50 and 230; Taylor, *Leslie*, II, 214, 251, 286, 292, 298, 301, 321, and 323–24; Storey, *Linnell*, II, 15–17; Frith, *Autobiography*, III, 196ff. Adams, *Danby*, 13, 46, 49, 50, 60, 70, 89–90, 96, 101–2, 107–12; and 128; Heleniak, "John Gibbons and William Mulready," pp. 136–41; Hunt, *Pre-Raphaelitism*, I, 183; Heleniak, *Mulready*, p. 165; Morris, "Naylor," p. 73; Francis Greenacre, *The Bristol School of Artists* (Bristol: 1973), pp. 27ff.

Archival sources: Gibbons Family Papers.

GILLOTT, Joseph (1799–1872)
Newall Street, Birmingham; 9 Westbourne Road, Edgbaston; The Grove, Stanmore, near Harrow; and 62 Avenue Road, London (purchased from Ernest Gambart in 1868, but doubtful that Gillott lived there).

Occupation
Manufacturer of steel pens.

Biography
Born in Sheffield, the son of a work-

man in the cutlery trade, Gillott began his career forging and grinding knife blades. He moved to Birmingham in 1821, where he worked in the light steel toy trade, manufacturing steel buckles, chains, and other ornaments. Sometime around 1830 he was alerted to the marketing potential of steel pens and adapted a press to make them, after much experimentation. At first he kept his method a secret, fashioning his pens with his own hands and selling them to stationers. As the demand grew, he established a manufacturing plant in Graham Street, Newhall Hill, in 1859, where he produced steel pens in enough quantity to earn a fortune. Gillott employed 450 persons, for whom he established a benevolent society. For relaxation, he regularly attended the theater, afterwards adjourning to the Hen and Chickens Hotel to smoke his "churchwarden" and talk with friends (*Practical Magazine*). Gillott married Miss Mitchell, daughter of a steel pen maker. His will was sworn at under £250,000.

Collection

An early collector of Etty, Müller, Linnell, Maclise, Mulready, Roberts, and Prout, whose paintings he displayed, alongside his many Turners, in a series of toplit picture galleries in his homes in Edgbaston and Stanmore. The *Practical Magazine* noted in 1873: "The Edgbaston house, to use a familiar phrase, was an exhibition in itself. Not only was every inch of wall space occupied in the three

galleries built specially for the purpose, but the living rooms of the family, and even the bed-chambers, were adorned with pictures and drawings of surpassing interest; while large numbers of other drawings of priceless beauty were stored away in folios. The great strength of Mr. Gillott's collection lay in Turners and Ettys – the last-named artist being a special friend of the collector …he had no love for the Pre-Raphaelites; none of their works were to be found in his collection" (p. 323).

Taste

Early-Victorian oils and watercolors. Gillott began by collecting Old Masters and turned to modern British art in the 1830s. He preferred the landscape and idyllic subjects collected by Birmingham amateurs to genre painting or Pre-Raphaelite art. He insisted on high finish and light, bright colors, while abhorring varnish.

Purchasing pattern

Gillott was in constant contact with a battery of dealers and private collectors, with whom he bought, sold, and traded hundreds of works of art during his lifetime. He frequently gave commissions to artists, although he did not always keep the pictures he ordered for himself.

Sales and bequests

Christie's, 19 April–3 May 1872. The *Practical Magazine* bemoaned: "The sale of his collection – a lamentable dispersion of art treasures – is too

recent to be forgotten by our readers. The enormous produce of the sale, £170,000, affords proof that art not only yields the highest pleasures, but 'pays' in a commercial sense – for Mr. Gillott's pictures brought in all cases a large profit upon their purchased price" (p. 323). Additional posthumous sales: Cheshire & Gibson's, Westbourne Road, Edgbaston, 4–11 June 1872, and The Grove, Stanmore, 29–31 July 1872; Christie's, 30 April 1904; and Thomas & Bettridge's, 8–12 April 1892 (Alfred Betts).

References

Waagen (1857), pp. 403–4; *DNB*; Boase; *Practical Magazine*, I (1873), 322–25; *Timmins's Birmingham and Midland Hardware District* (Birmingham: 1866), pp. 634–37; *Mayhew's Shops and Companies of London* (London: 1865), pp. 98–100; *Birmingham Daily Post*, 6 and 15 Jan. 1872; Edwards, *Recollections*, pp. 89–100; *Annual Register* (1872), 38; Henry Bore, *The Story of the Invention of Steel Pens* (New York: 1892); Gill, *History of Birmingham* (London: 1952), I, 300–302; *Art Journal* (1846) 328–29; (Feb. 1872) 47–48; (June 1872) 165–66; (July 1872), 187–88; and (Nov. 1908) 267; Collins, *Collins*, II, 48, 206, 286 and *passim*; Story, *Linnell*, II, 18–21; Cooper, *My Life*, I, 294–95 and II, 3–4; Ellis Waterhouse, *Gainsborough* (London: 1966), pp. 113–14, 117, and 121; Solly, *Cox*, pp. 151–52, 165, 204, and 331; Taylor, *Leslie*, I, xxi, xxxiv, xliv, lxii; II, 179, 193, 225, 262, 320–22, and 325; Roberts, I, 213–22; Baron Webber,

James Orrick, 2 vols. (London: 1903), II, 70–71; Solly, *Müller*, p. 95; Redford, I, 185–89; Farr, *Etty*, pp. 90–101; Thornbury, *Turner*, I, 388–89; Finberg, *Turner*, pp. 409 and 427–28; Butlin and Joll, *Turner*, I, 8, 29, 47, 49, 98, 187, 192, 217–19, 257–59, 266, and 277; Agnew, p. 26; Adams, *Danby*, pp. 112–15, 128, and 131; Wolverhampton, *William Henry Hunt*, no. 39; Loftie, *Art in the House*, pp. 14–15; Greg, *Cranbrook Colony*, passim; Evan Firestone, "John Linnell and the Picture Merchants," *Connoisseur Yearbook* 182 (Feb. 1973), 125 and "John Linnell: The Eve of the Deluge," *Cleveland Museum of Art Bulletin* 62 (1975), 137–38; Maas, *Gambart*, passim; Reitlinger, pp. 86, 89, 92, 100 and 102–4; Morris, "Naylor," p. 76; Bernard Denvir, "Pens and Patronage, Some Unpublished Letters to Joseph Gillott," *Connoisseur Yearbook* (1958), 71–77; Chapel, "Turner Collector," 43–50.

Archival sources: Getty Archives, Santa Monica (letterbooks, ledgers, and correspondence); E. D. Johnson, "Joseph Gillott," 1955, unpubl. MSS in possession of Gillott family; "Schedule of Properties belonging to the Estate of the late Joseph Gillott comprised in the General Residuary Devise," and "Inventory and Valuation of the ...Estate of the Late Alfred Betts Esq.," Executed by Thomas and Bettridge, February 1892, MSS in possession of John Betts (Alfred Betts was Gillott's son-in-law).

GILLUM, Colonel William James (1827–1910)

The Moated House, White Hart Lane, Tottenham, until 1868; Church Hill House, New Barnet (also called Oakleigh Park); Church Barnet, until c. 1897; and 1 Pembridge Place, North Kensington, London.

Occupation

Army officer, philanthropist, and amateur artist.

Biography

Gillum's family had owned commercial property in Shoreditch for over a hundred years. He was presumably related to Dr. Ralph Gillum of Bath (Pevsner, "Gillum," p. 78). Gillum entered the army and served in the Crimean War, where he lost a leg. After the war, Gillum indulged his passion for art: he took painting lessons from Ford Madox Brown, whom he induced to teach at his Boy's Home on Euston Road. He also studied furniture design and was a founding member of the Hogarth Club. Independently wealthy, Gillum was a generous philanthropist. He served on the management committee of the Euston Road Industrial Home for Destitute Boys from 1860, and in the same year founded the Church Farm Boys' Home in East Barnet. He integrated his interests in art and philanthropy by having the children in his homes produce furniture designed by Philip Webb.

Collection

Gillum patronized Aesthetic and Arts and Crafts movement artists. He was introduced to Rossetti by Robert Browning in 1860 and put the artist on a quarterly retainer as an advance against a series of drawings he commissioned (Rossetti, *Ruskin: Rossetti: Preraphaelitism*, p. 248). Gillum was also a major purchaser at the artist's estate sale in 1883. From Madox Brown he bought a reduced duplicate of *The Last of England*, as well as *The Hayfield* and *Walton-on-the-Naze*. He also commissioned furniture from Lethaby & Webb and a stained-glass window from Morris, Marshall, Falkner, & Co. In addition, Webb designed a terrace of shops in Shoredich in 1863 on Gillum family property.

Taste

Aesthetic and Arts and Crafts movement artists and architects. Gillum preferred artists who were concerned with social reform.

Purchasing pattern

Gillum gave direct commissions to artists and frequented Christie's.

Sales and bequests

Mrs. Gillum bequeathed eleven Rossetti drawings to the British Museum in 1910 (*The Times*, 14–15 Dec. 1910); and by descent.

References

Nikolaus Pevsner, "Colonel Gillum and the Pre-Raphaelites," *Burlington* (March 1953), 78–81; Rossetti, *Family Letters*, I, 205, 247 and II, 155 and 157, *Rossetti as Designer and Writer*, p. 38; *Ruskin: Rossetti: Preraphaelitism*,

pp. 248–49; *Rossetti Allingham Letters*, ed. G. B. Hill (London: 1897), pp. 60, 276; *Rossetti Letters*, ed. Doughty and Wahl, I, 375, II, 499, 803, 805; Hueffer, *Brown*, pp. 169 and 196; *The Builder* 21 (1863), 620; *Barnet Press and Finchley Borough News*, 2 May 1936; *The Times* 14–15 Dec. 1910; *Brown Diaries*, ed. Surtees, p. 212; Surtees, *Rossetti Catalogue Raisonné*, nos. 64B, 76B, 81R.2C, 94A, 108, 127, 154, 243, 260C, 495, 496 and 544; Naylor, *Arts and Crafts Movement*, p. 99; Watkinson, *Pre-Raphaelite Art and Design*, p. 169; Lethaby, *Philip Webb*, pp. 36–37; Gillian Gear and Diana Goodwin, *East Barnet Village* (London: 1980), 10.

GRAHAM, William (1816–85)

Langley Hall, near Manchester; 54 Lowndes Square and 44 Grosvenor Place, London; and Urrad and Stobhall, Perthshire.

Occupation

Merchant, William Graham & Co., 10 Royal Exchange Square, Glasgow and Liverpool, with offices in Lisbon and Oporto.

Biography

Eldest son of Catherine Swanston and William Graham of Burntshields, Renfrewshire, who was principal partner in the family merchant enterprise specializing in cotton and wine which he established along with his three brothers at the beginning of the century. William's uncle John imparted his enthusiasm for art collecting to him. Graham was educated at a private school and at Glasgow University. He then entered his father's company, subsequently representing its interests in India and on the Continent. In Manchester he frequently transacted business with Samuel Mendel (q.v.). Elected Member of Parliament for Glasgow in 1865, Graham retired from public office in 1874 because of ill health following the death of a favorite son. In 1884 he was appointed a trustee of the National Gallery by Gladstone. Like his fellow Scot, John Miller (q.v.), Graham enjoyed entertaining artists at his Highland holiday residences.

Collection

Graham owned over 500 works of art by such artists as Burne-Jones, Rossetti, Millais, Walker, and Legros. He was also a passionate collector of Old Master canvases.

Taste

Graham preferred works of Aesthetic movement artists, Italian Primitives, and sixteenth-century Venetians.

Purchasing pattern

Graham liked to commission works dircetly from artists; however, he sometimes negotiated with Agnew's, Howell, and Gambart.

Sales and bequests

Gifts: Graham donated Charles Lucy's *Cromwell with his Family at Hampton Court* (1863) to Glasgow in 1870.

Sales: Christie's, 26 March 1884; 2–3, 8–10 and 22 April 1886 ; 23 Oct. 1887; and by descent.

Bequests: Graham's daughter Lady Jekyll bequeathed Rossetti's *Girlhood of Mary Virgin* to the Tate Gallery in 1937.

References

Boase; *WWMP*; *The Bailie* (15 Jan. 1873), 1–2; *Glasgow Herald*, 16 July 1885; *ILN* 48 (10 Feb. 1886), 144; *Spectator* 59 (10 April 1866), 484–85; *Lord Provosts of Glasgow 1833–1902*; Horner, *Time Remembered*; Redford, I, 429–434 and 446–447; Roberts, II, 86–90; Marillier, *Christie's*, pp. 62 and 76; Ruskin, *Works*, ed. Cook & Wedderburn, XXXIV, xxxi and 147ff.; Burne-Jones, *Memorials*, I, 295 and *passim*; Fitzgerald, *Burne-Jones*, pp. 130 and 210; Arts Council, *Burne-Jones* (London: 1975), nos. 119, 120, 134, 135, 195, and 208; *Burne-Jones Talking*, ed. Mary Lago (Columbia: 1981), pp. 16 and 155; W. A. L. Seaman and S. C. Newman, "A Burne-Jones Discovery," *Burlington* 107 (Dec. 1965), 632–33; Francis Russell, "Advice for a Young Traveller from Burne-Jones: Letters to Agnes Graham, 1876," *Apollo* 108 (Dec. 1978), 424–27; Garnett, "William Graham"; Rossetti, *Rossetti as Designer and Writer*, p. 64 and *passim*, *Rossetti Papers*, pp. 304, 327, and 350; *Family Letters*, I, 243, 317, 400–1 and II, 250, 253, 274, and 355; *Owl and Rossettis*, ed. Cline, p. 5 and *passim*; Surtees, *Rossetti Catalogue Raisonné*, no. 40 and *passim*; *Rossetti Letters*, ed. Doughty and Wahl, I, 346 and *passim*; Watts, *Watts*, II, 10–11; Pennell and Pennell, *Whistler*, I, 212, 234, and 269;

Love Locked Out: The Memoires of Anna Lea Merritt, ed. G. Gorokhoff (Boston: c. 1981), pp. 80, 95, and 118; *Frederic Shields*, ed. Mills, pp. 132–33; Crane, *Reminiscences*, pp. 161–62; Dorment, *Gilbert*, p. 86; Carter, *Let Me Tell You*, pp. 282–84; Colvin, *Memories*, p. 55; Herrmann, *English as Collectors*, pp. 427, 433; Agnew, pp. 26, 33–34; Glasgow Art Gallery, *British Paintings* (Glasgow: 1971), p. 45; Bennett, *Pre-Raphaelite Circle*, pp. 142 and 171; Seltzer, "Legros," p. 230, n. 52.

Archival sources: Letters to Burne-Jones, Fitzwilliam Museum Library; letter to Legros, Papiers Clement-Janin, Doucet, Paris; and Graham Family Papers; Oliver Garnett, "William Graham: Pre-Raphael Collector and Pre-Raphaelite Patron," typescript of lecture delivered at Mellon Centre, London, 21 March 1989.

GRANT, Baron Albert (born Abraham Gottheimer) (1830–99)

6 Bedford Villas, Dingwall Road, Croydon (1856–c. 1859); Maida Vale (c. 1859–61); Roseau House, 86 Addison Road, Kensington (by 1865); Italy (1868–70); Queen's Gate Terrace (until 1879); Cooper's Hill, Englefield Green, Egham (110 rooms, sold 1871); Horstead Hall, near Norwich (1872); purchased Old Kensington Bedlam, a private lunatic asylum near Kensington Palace, along with Colby House (1872). Grant tore both buildings down and built an Italianate palace on the site called Kensington House, which was alleged to have cost him nearly £350,000 (it was sold in lots in 1882 and covered by Kensington Court); and Aldwick Place, Bognor, Sussex, where he died in 1899.

Occupation

Financier, Albert Gottheimer & Co., Fenchurch Street (by 1856); manager of the Mercantile Discount Co. (1859–61); Albert Grant and Co. (1863); Crédit Foncier & Mobilier of England (1864–68); Grant Brothers & Co., 24 Lombard Street (1871–78); General Banking Co. (1878–79).

Biography

Born in Dublin, the son of Bernard Gottheimer, an impoverished German peddlar, who succeeded in becoming an importer of foreign fancy goods in London, Abraham was educated in London and Paris, first working as a clerk, then as a wine dealer. He married Emily Isabella Robinson in 1856 after having begun his career as a merchant in the City of London. Gottheimer then became a banker and discount agent in 1858, forming the Mercantile Discount Co. a year later, which failed during the leather crisis of 1860–61 (*DBB*). He changed his name to Grant in 1863 and became a major company promoter in 1864, when he established the Crédit Foncier, from which he resigned in 1868 following a shareholder's inquiry into his activities. After spending two years in Italy, Grant returned to London, where he founded the firm of Grant Brothers & Co. in 1871. Acting as private bankers, Grant and his brother Maurice floated shares for Belgian public works, the Imperial Bank of China, the Lisbon Steam Tramways Co., the Emma Silver Mine in Utah, and the Mineral Hill Silver Mine in Nevada with capital estimated at £1 million in shares and profits estimated at £800,000 a year. Despite his earnings, Grant only paid his investors a shilling for each £20 share, although he received £100,000 in promotion money and raised a total of about £24 million. His machinations resulted in his investors losing about £20 million. Sued by investors, Grant's fortune rapidly dwindled. He filed a bankruptcy petition in 1885, listing his liabilites at £217,000 and his assets at £74,000. His debts were finally settled in 1894, when a division of a farthing in the pound was declared. Surprisingly, Grant recovered financially, but was bankrupt again in 1897. Before his bankruptcy, Grant bought *The Echo*, a London evening paper, for £20,000 in 1874, selling it a year later. Grant was MP for Kidderminster from 1865 to 1868 and deputy lieutenant of Tower Hamlet in 1868. He was made president of the society for the improvement of the city of Milan, for which he was created an hereditory baron of the Kingdom of Italy and Commander of the Order of St. Maurice and Lazare in 1868. Grant was also created Commander of the Order of Christ by the King of Portugal.

Collection

Said to have spent £150,000 on his

collection (*The Times*, 24 April 1877). Grant intended to display paintings by artists such as Landseer, Frith, Millais, Calderon, Phillip, and Leighton in Kensington House in a specially constructed, top-lit gallery (106 × 25 feet), which was designed with two watercolor galleries at either end, divided from the main gallery by velvet curtains.

Taste

Mid-Victorian collector. Began by buying the works of minor artists, but after 1870, Grant concentrated on Royal Academy favorites and well-known outsiders, such as Holman Hunt.

Purchasing pattern

Agnew's, Christie's, and direct commissions to Woolner and Graham.

Sales and bequests

Grant contributed a garden and statue of Shakespeare in Leicester Square in 1874 costing £28,000. In 1874 he bought Landseer's portrait of Sir Walter Scott at Christie's and presented it to the National Portrait Gallery, for which he was given a vote of thanks in the House of Commons.

Sales: Christie's, 14 Nov. 1863 (143 lots); 20 June 1868 (185 lots); 27–28 April 1877 (205 lots of pictures; £106,262); 22 & 25 May and 7 July 1877 (engravings, woodcuts, etchings); 14 May 1878 (sculpture and porcelain); 7 June 1879; 6 & 22 July 1880 (plate); 28 July 1880 (coins); 25 July 1885 (pictures).

References

DNB; Boase; *DBB*, II, 623–29; *WWMP*; *A List of Companies Established under the Auspices of Mr. Albert Grant* (London: 1872); *Builder* (8 July 1876), 653–54; *The Times*, 24 April 1877; Tom Taylor, *Leicester Square, its Associations and its Worthies* (London: 1874), pp. 478–84; John Hollinghead, *The Story of Leicester Square* (London: 1892), pp. 11 and 55–60; *Art Journal* (Jan. 1864), 18 and (Nov. 1877), 341–43; Redford, I, 253–257; Roberts, I, 270–76; Kempt's *Pencil and Palette* (London: 1881), 162–66; *Men and Women of the Time: A Dictionary of Contemporaries*, (London: 1891), p. 388; *Vanity Fair* (21 Feb. 1874); *ILN* (4 July 1874), 4 and (9 Sept. 1899), 47; Loftie, *Kensington*, pp. 120–25; *Survey of London 42* (1986), 62–67; Metcalf, *James Knowles*, pp. 246–51; Wilfred Thomas Cousins King, *History of the London Discount Market* (London: 1936), pp. 223–25; O'Hagan, *Leaves from My Life*, I, 29–38 and 79; Ormond, *Leighton*, nos. 131–32; Maas, *Gambart*, p. 240; Reitlinger, pp. 99, 105, 127, and 163; Chapel, *Victorian Taste*, nos. 13, 19, 25, 65, and 71; Greg, *Cranbrook Colony*, no. 18; Arts Council, *Great Victorian Pictures*, nos. 53 and 59; Bennett, *Pre-Raphaelite Circle*, nos. 58, 80, 148; *Owl and Rossettis*, ed. Cline, nos. 299, 382, 435–37; 440, 443–52, 454–55, 457; *Rossetti Letters*, ed. Doughty and Wahl, IV, 1386, 1389, 1398, 1642, 1653.

HALDIMAN, Mrs. George (fl. 1820–61)

Belgrave Square, London.

Occupation

Married to a London financier.

Biography

Daughter of John Prinsep, a London alderman. According to artist Thomas Uwins, Mrs. Haldiman competed with Baroness Rothschild in commissioning artists to paint watercolors for her famous album. He reports that he relinquished a watercolor intended for Mrs. Haldiman to Baroness Rothschild: "At this moment Madame Rothschild was making up an album, and she almost forced me to sell it to her. In Mrs. Haldiman's book it would have been the weakest of the set, but in the Baroness Rothschild's it shines out amongst the bald and meagre attempts of the French, Italian, and German artists ... I regret exceedingly that unconsciously I should have given to [Mrs. Haldiman's] rival what was intended for her; but after all it is good to encourage rivalry in those who have money to spend. The artists are the gainers" (*Uwins*, II, 49 and 57).

Collection

Watercolor collection formed for her by Durham-born watercolorist George Fennel Robson, who was also the teacher of W. Stone Ellis (q.v.). His patroness asked Robson to acquire a broad representation of modern watercolors and he accordingly bought 100 drawings (averaging 7 ×

10 inches), which were divided into three albums. In 1827, twenty-seven of them were placed on a screen and exhibited at the Old Water-Colour Society. These included works by Callcott, Cattermole, Daniell, W. H. Hunt, Turner, and Uwins. Mrs. Haldiman also had a similar set of albums filled with watercolors by French artists in 1833, including Isabey, Decamps, Watelet, Granet and Devéria.

Taste
Early-Victorian watercolors mounted in albums and on screens.

Purchasing pattern
Used the artist George Fennel Robson as an agent.

Sales and bequests
Christie's, 2 June 1861; and by descent with additional works sold at Christie's, 18 March 1980.

References
Uwins, *Uwins*, I, 184, II, 48–49, 57, and 101; Redford, I, 352; and Clarke, *Tempting Prospect*, pp. 137–39.

HALL, James (1826–1904)
Prior's Terrace, Tynemouth; Dilston Hall, Corbridge; and Bywell Castle, Northumberland.

Occupation
Shipowner, Palmer, Hall & Co.

Biography
Son of Bentham Hall, a Newcastle carver and gilder, and Eleanor Cooke of Hexham. Hall left school at the age of eleven to apprentice with Thomas Wooster, a wharfinger. He joined the shipowners Palmer, Beckwith & Co. in 1841. He married Isabella Sopwith in 1863, daughter of Thomas Sopwith, a noted engineer and inventor. Not lacking in diffidence, Hall commissioned William Hayward to write his biography in 1896. He was a member of the Newcastle Arts Association, a patron of the Bewick Club, and author of "Our Neglected Children," an article which S. C. Hall published in *Social Notes* in 1878.

Collection
Hall bought Holman Hunt's *Isabella and the Pot of Basil* (Laing Art Gallery, Newcastle) in April 1870 for £1,550. He also owned Millais's *The Widow's Mite* (The Priory Church, Christchurch, Dorset), Alma-Tadema's *The First Whispers of Love*, E. M. Ward's *The Prison of the Conciergerie, 1793*, and works by Newcastle painter H. H. Emmerson. During his travels on the Continent, he bought Italian sculpture and Spanish paintings.

Taste
Mid-Victorian academic and Pre-Raphaelite canvases, as well as contemporary foreign painting.

Purchasing pattern
Hall was a client of Gambart.

Sales and bequests
By descent and family bequest to Laing Art Gallery.

References
Athenaeum (20 Sept. 1873), 374–75; *Newcastle Evening Chronicle*, 28 Dec. 1904; William Hayward, *James Hall of Tynemouth: A Beneficent Life of a Busy Man of Business*, 2 vols. (London: 1896); Maas, *Gambart*, pp. 216 and 219; Macleod (1986), p. 605; Macleod (1989b), p. 127.

Archival sources: Letter from W. Bell Scott to James Leathart, Leathart Papers, University of British Columbia.

HEATON, Ellen (1816–94)
7 Briggate; 31 Park Square until 1859; and 6 Woodhouse Square, Leeds.

Occupation
Traveler and philanthropist.

Biography
Granddaughter of a clothier and daughter of John Heaton, a bookseller and printer who was apprenticed to John Binns in the 1780s, and who accrued enough capital to retire in 1827. Sister of Dr. John Deakin Heaton (1817–80), a physician educated at Caius College, Cambridge, University College, London, and in Paris, who was made senior physician at Leeds General Infirmary in 1843. President of the Leeds Philosophical and Literary Society, Dr. Heaton was an active participant in local cultural affairs. He was one of the sponsors of *The Glowworm*, an ephemeral literary journal which may have inspired the Pre-Raphaelite publication, *The Germ*

(Warner, "Millais," p. 38). Ellen Heaton was educated by the Misses Plint in Wellington Street, Leeds, and at the Misses Waltham's finishing school in Mirfield. After inheriting a substantial income on the death of her father in 1852, she traveled extensively. Her interest in patronage parallels that of her mentor John Ruskin: she actively collected art until 1864 when she turned to social causes, such as Ruskin's Winnington Hall School and the cultural enrichment of Leeds's working class. Heaton was related to two other Victorian collectors through the marriage of her niece to the son of R. S. Newall (q.v.) and through her brother's wife, who was the sister of John Aldam Heaton, an interior designer.

Collection

After purchasing a few works by local artists in the early 1850s, Heaton turned to Ruskin for advice about Turner in 1855 which he willingly provided. He also encouraged her to sponsor the Pre-Raphaelites Rossetti, Hughes, and Inchbold, but advised against Ford Madox Brown. Significantly, Ruskin failed to mention Millais to her. Generally eager to comply with his wishes, Heaton, however, balked at Ruskin's recommendation of Burne-Jones. She commissioned Thomas Richmond to paint her portrait in 1847.

Taste

Pre-Raphaelites and Turner. Preferred Rossetti and a select group of Pre-Raphaelite followers who worked in the early manner of the style. Heaton concentrated on watercolors.

Purchasing pattern

Bought her Turners from dealers and her Pre-Raphaelite works directly from the artists.

Sales and bequests

By descent to Beresford Rimington Heaton, who bequeathed the collection to the Tate Gallery in 1940.

References

Boase (John Deakin Heaton); *Memoir of John Deakin Heaton, MD of Leeds*, ed. Thomas Wemyss Reid (London: 1883); "Extracts from the Journals of John Deakin Heaton, MD, of Claremont, Leeds," ed. Brian and Dorothy Payne, *Publications of the Thoresby Society* 53 (1971), 93–153; *Sublime and Instructive*, ed. V. Surtees, p. 141 and *passim*; Rossetti, *Family Letters*, I, 189 and II, 169 and 351; *Rossetti as Designer and Writer*, 26–27, 42, and 61, *Rossetti Papers*, pp. 295–96; *Ruskin: Rossetti: reraphaelitism*, pp. 35, 59, 61, 106, 118, 124–125, 141, and 192; Hardman, *Ruskin and Bradford*, pp. 47, 56, 148, 191–97, 199, 201, 205, 236–37, and 319; Warner, "Millais," pp. 37–38; B. Lewis, "Plint," *Pre-Raphaelite Review* 3 (May 1980), 87–88; Surtees, *Rossetti Catalogue Raisonné*, nos. 50, 74, 75, 78, 81R.1, 93, 94R.1; 104, 110R.1, 151, 159, 163R.1, 165, 168 and 182; *Rossetti Allingham Letters*, ed. Hill, p. 181; Maas, *Gambart*, p. 173; Rosalie Mander, "The Tryst Unravelled," *Apollo* 79 (March 1964),

221–23; R. J. Morris, "Middle-Class Culture, 1700–1914," in *A History of Modern Leeds*, ed. Fraser, pp. 205–206.

Archival sources: 53 letters from Rossetti, Beinecke, Yale; Journal of John Deakin Heaton, Yorkshire Archeological Society; and letter to Isidore Spielmann, 1904, Victoria and Albert Museum Library.

HENDERSON, John (1797–1878)

3 Montague Street, Russell Square, London.

Occupation

Archaeologist and amateur artist.

Biography

Grandson of George Keate, FRS and son of John Henderson, an amateur artist and early patron of Turner and Girtin, who was Dr. Munro's neighbor on Adelphi Terrace. He was educated at Balliol College, Oxford (BA 1817 and MA 1820). Henderson read for the bar, but did not practice law. He devoted his time to painting in the style of the young Turner, studying archaeology, and collecting works of art. Henderson was a fellow of the Society of Antiquaries.

Collection

Owned canvases and watercolors by David Cox, Birkit Foster, James Holland, William Henry Hunt, and Samuel Prout, among other artists. Henderson also collected Netherlandish oils and majolica.

Taste

Mid-Victorian, early-nineteenth-century, and Old Master pictures, as well as *objets d'art* and antiquities.

Purchasing pattern
Inheritance and some direct commissions. Henderson's relationship with dealers is untraced.

Sales and bequests
Bequest in 1878 to British Museum (watercolors by Canaletto, Turner, Girtin, Cozens, Cox, and Müller, in addition to Russian silver and enamels, porcelain, pottery, metalwork, and his grandfather's correspondence with Voltaire). Bequest to National Gallery (twenty-two watercolors by Cattermole and twenty-six by De Wint [now in Tate Gallery] and a selection of eight oils to be made from his Old Masters). Bequest to Oxford (Greek and Roman vases and Egyptian antiquities).

Sales: Christie's, 16–18 Feb. 1882 (113 pictures and 275 watercolors).

References
Waagen (1857), pp. 202–13; *DNB*; Solly, *Müller*, pp. 257–64; Redford, I, 314; R. Davies, "George Cattermole," *Old Water-Colour Society Club*, 9 (1932).

Archival sources: National Gallery Report of 1879 and Board Minutes of the Trustees' Committee Meeting, 4 Feb. 1879.

HERMON, Edward (1822–81)
Winckley Square, Preston; Wyfold Court, Henley-on-Thames, Oxfordshire; 1 Wilton Place and 13 Berkeley Square, London.

Occupation
Cotton textile manufacturer and East India merchant, Horrockses, Miller & Co., Preston.

Biography
Born in London, the son of Richard Hermon of Kilburn, Middlesex, and Sandygate, Kent, who was reputedly a "South Country gentleman of modest rank" who had prospered in the London building trades (*Fortunes Made in Business*). According to Edward's obituary in the *Preston Guardian*, he "received a good education, and when a young man was engaged in the London warehouse of Messrs. Horrockses, Miller, and Co." When Thomas Miller (q.v.) died in 1865, he left control of the firm to Hermon since his own sons were uninterested in the business (*DBB*). As head of the largest mid-Victorian cotton enterprise, Hermon instantly attained an enviable status in the commercial world. He embraced a gentrified lifestyle by purchasing a Scottish shooting lodge and Wyfold Court, a 900-acre Oxford estate. As a result, his company foundered: "Little capital was reinvested, machinery was antiquated, the managers incompetent, the partners disgruntled" (*DBB*). Hermon married Emily Letitia Udner, daughter of George Udner, a member of the Supreme Council of India. He was a member of the Church of England. Hermon's philanthropy included gifts for essays on the prevention of explosions and accidents in coal mines. His estate was sworn at £588,000, making it one of the largest fortunes earned in nineteenth-century textiles.

Collection
Hermon owned works by such early Victorian artists as David Cox and Thomas Faed and such mid-Victorians as E. W. Cooke, John Pettie, William Frith, and Edwin Long, from whom he commissioned *The Babylonian Marriage Market* for 3,000 guineas. He also commissioned W. E. F. Britten, William Chappel and H. Stacy Marks to execute decorative paintings for Wyfold Court.

Taste
Mid-Victorian supporter of Royal Academicians.

Purchasing pattern
Agnew's, who bid for Hermon at the Mendel sale.

Sales and bequests
Christie's, 13 May 1882 (eighty-four lots realized £34,380, many of which were bought by Thomas Holloway [q.v.]).

References
Boase; *DBB*, III, 178–81; *WWMP*; *Preston Guardian*, 7 May 1881; *Manchester Guardian*, 15 May 1882; *Fortunes Made in Business*, ed. James Hogg (London: 1891), p. 178; Gale Pedrick, *The Story of Horrockes* (London: 1950); Edward Hermon, *Catalogue of Modern Pictures* (London: 1882); *Art Journal* (Oct. 1882), 317 and (Nov. 1882), 349; Chapel, *Victorian Taste*, pp. 76ff.; Treuherz, *Hard Times*, p. 12; Carter, *Let Me Tell You*, pp. 37–39;

Roberts, I, 327; Agnew, p. 28; Smith, *Decorative Painting*, no. 28; Peter Howell, "Wyfold Court, Oxfordshire," in *The Country Seat: Studies in the History of the British Country House* ed. Howard Colvin and J. Harris (London: 1970), 244.

HEUGH, John (fl. 1845–78)

13 Upper Brook Street, Chorlton-on-Medlock; Firwood, Alderley Edge, Manchester; Holmewood, Tunbridge Wells, Kent; and Gaunt House, Dorsetshire.

Occupation

Merchant, Heugh, Balfour & Co., 110 King Street, Manchester.

Biography

Origins unknown. Possibly descended from the Presbyterian divine Hugh Heugh (*DNB*), Heugh was a partner of Bradford merchant Walter Dunlop (q.v.). He was a member of the 1860 committee to found an art gallery for Manchester. In the same year he loaned several Pre-Raphaelite canvases to an exhibition in the Bradford Old Exchange.

Collection

Heugh's enormous collection included canvases by Turner, Bonington, Dyce, Frederick Walker, and Tissot. He bought seventy-five works by David Roberts from Agnew's in 1859. His Pre-Raphaelite works included a replica of Millais's *Sir Isumbras at the Ford* and the original version of *The Vale of Rest*. He also owned Holman Hunt's *The Scapegoat*

and *Festival of St. Swithin* as well as a replica of *The Shadow of Death* and Madox Brown's *Last of England* and *Pretty Baa Lambs*. Heugh bought Rossetti's *Ecce Ancilla Domini* sometime after McCracken's sale. He also bought *The Two Mothers* from the T. H. McConnell sale, but he canceled commissions for Rossetti's *Mary Magdalene* and *Aspasia Teaching Socrates to Dance*.

Taste

Early-Victorian and contemporary oils and watercolors, as well as Pre-Raphaelite and French canvases.

Purchasing pattern

Agnew's, from whom Heugh bought and sold Turners; Christie's; and direct commissions to artists.

Sales and bequests

Christie's, 28 April 1860; 31 May 1873; 24–26 April 1874; 24 April 1877; 17 March 1877; 10 May 1878; and 26 Feb. 1879.

References

Art Journal (June 1860), 181 and (June 1874), 175–76; *Manchester Directory* (1845–74); *London Court Directory* (1873); *Kent Directory* (1874); Taylor, *Leslie*, II, 232, 284, 321, and 323; Thornbury, *Turner*, pp. 398–99; Roberts, I, 278–79 and II, 158 and *passim*; Marillier, *Christie's*, pp. 11, 164, and 206; Agnew, p. 18; Maas, *Gambart*, p. 185; Pointon, *Dyce*, p. 87; Butlin and Joll, *Turner*, pp. 4, 35, 72, 146, 196, 201, 212, 310 and 317; Rossetti, *Rossetti Papers*, pp. ix, 144, 147–149 and 152,

Rossetti as Designer and Writer, pp. 47–48; Surtees, *Rossetti Catalogue Raisonné*, I, nos. 109 R.2 and 176; Millais, *Millais*, I, 437 and II, 41; *Rossetti Letters*, ed. Doughty and Wahl, II, 512, 517, 568, 570–74; *Owl and Rossettis*, ed. Cline, nos. 257, 300, 304–306, 353, 356–57, 359; Bennett, *Pre-Raphaelite Circle*, nos. 38, 73, 136, and 168; Hardman, *Ruskin and Bradford*, p. 214.

Archival sources: Letters to Rossetti, Angeli-Dennis Papers, University of British Columbia; Agnew Stockbooks.

HILL, Captain Henry (1812–82)

53 Marine Parade, Brighton

Occupation

Quartermaster of the 1st Sussex Rifle Volunteers.

Biography

Social origins unknown. Hill is thought to have been born in Uttoxeter. He was the brother of Edward Hill, who married artist Frank Holl's sister. After serving in the army, Hill settled in Brighton, where he became a member of the town council. He assisted in the establishment of the Free Library and the Brighton School of Science and Art, founding the annual Winter exhibition of modern art at the Brighton Pavilion. Hill donated a window to his parish church.

Collection

Hill began to purchase art in the

1860s, favoring works by members of the older generation of English artists, such as Cox, Crome, and Morland. In the early 1870s, he turned to canvases by living artists, including Mason, Walker, Holl, Philip Morris, Orchardson, and McTaggart. His collection was notable for his early appreciation of the Barbizon painters Corot and Millet, and for his prescient support of Degas who was represented by seven works in Hill's home.

Taste
Avant-garde appreciation of French art in addition to the English School.

Purchasing pattern
Durand-Ruel and Charles Deschamps, London. Hill bought directly from many English artists, including Frank Holl and Phil Morris.

Sales and bequests
Christie's, 5 June 1882; 25 May 1889; 25 May 1889; and 19 Feb. 1892.

References
Magazine of Art (1882), 1–7, 80–84 and 116–121; *Art Journal* (Oct. 1889), 303; Boase; *Brighton Gazette*, 6 April 1882; *Brighton Herald*, 8 April 1882; Roberts, II, 139–40; Reitlinger, I, 173; Ronald Pickvance, "Henry Hill: An Untypical Victorian Collector," *Apollo* 77 (Dec. 1962), 789–91 and (May 1963), 396; Ronald Pickvance, "Degas's Dancers: 1872:1876," *Burlington* 105 (June 1963), 256–66; Metropolitan Museum, *Degas* (New York: 1988), nos. 106, 124, 128, 129, 172; Clifford Musgrave, *Life in Brighton* (London: 1970), pp. 334–35;

Treuherz, *Hard Times*, p. 11; Cooper, *Courtauld*, pp. 60–61; *Impressionists in England*, ed. Flint, p. 9.

HILL, Sir John Gray (1839–1914)
Mere Hall, Oxton-by-Noctorum, Birkenhead, and Jerusalem.

Occupation
Solicitor, Hill, Dickinson, & Co., 10 Water Street, Liverpool.

Biography
Born in Tottenham, London, son of Ellen Tilt Maurice and educator Arthur Hill; nephew of Sir Rowland Hill, the postal reformer; and brother of bibliophile George Birkbeck Hill, who knew Morris and Burne-Jones at Oxford. Hill was educated at his father's school, Bruce Castle at Tottenham, before he articled in the law firm of Gregory, Skirrow, & Co. He then moved to Liverpool, where he entered into parnership with A. T. Squarey. Hill specialized in shipping and commercial law and was knighted in 1904. He was Frederick Leyland's (q.v.) solicitor and executor. Hill married Caroline Hardy, a noted amateur artist, who painted murals for the Law Society, London. They spent Winters at their home in Jerusalem, where they collected relics and studied the local geography. Hill described some of his experiences in *Among the Bedouin*.

Collection
Despite Hill's brother's friendships with artists, it was apparently Leyland

who introduced Hill to Rossetti and Arthur Hughes. He made several purchases at William Graham's sale in 1886. In addition, Hill owned works by Gainsborough, Reynolds, Wilkie, and painters of the Dutch and German Schools.

Taste
Aesthetic movement, earlier English School, and continental.

Purchasing pattern
Hill bid at Christie's and made direct purchases from artists.

Sales and bequests
Christie's, 11 Feb. 1911.

References
Athenaeum (25 Sept. 1886), 408–9; *Liverpool Courier*, 20 June 1914; *Birkenhead News*, 20 June 1914; O'Hagan, *Leaves from My Life*, I, 387–90; Surtees, *Rossetti Catalogue Raisonné*, no. 535.

Archival sources: Leonard Roberts research into the career of Arthur Hughes, Vancouver, B.C.

HOLLOWAY, Thomas (1800–83)
London and Tittenhurst Lodge, Sunninghill, Berkshire.

Occupation
Patent medicine manufacturer, Holloway's Pills and Ointment, 533 Oxford Street, London.

Biography
Holloway was the son of a retired militia warrant officer who became a baker and later landlord of a pub in

Penzance. He was educated at Camborne and Penzance until the age of sixteen, when he left school following his father's death and started a grocery business. He moved to London in 1828, where he was employed as a merchant and a commercial agent. Discovering the profitability of medicinal ointments from an Italian client, Holloway announced a competing ointment for sale in 1837, followed by Holloway's Pills three years later, which he promoted by advertising heavily. Overexpenditure in newspapers led to a brief stay in Whitecross Debtors' Prison. He quickly bounced back, and at the time of his death was spending about £50,000 annually on advertising. He also operated a bank during the 1870s that reputedly earned almost £100,000 a year in profits. In 1840 he married Jane Driver, who helped him in his business. They had no children. A philanthropist, Holloway built a sanatorium for the mentally afflicted which catered to the lower middle class and he erected Royal Holloway College, a school for women, in memory of his wife, at Mount Lee, Egham Hill, Surrey in 1879. His will was proved at £596,335. Holloway's was taken over by Eno's Fruit Salts in 1930.

Collection

Holloway conceived of his collection as a public gift for Royal Holloway College and, thus, did not begin to buy art until he was eighty-one years old. His first purchase was Landseer's *Man Proposes and God Disposes,* for which he paid £6,000. He went on to pay record prices for large-scale canvases by Edwin Long, Luke Fildes, William Frith, and Frank Holl. Holloway's private collection at Tittenhurst contained approximately sixty-five Old Master paintings, which he bought as part of the contents of a previous house.

Taste

Late-Victorian exhibition pieces. Holloway disliked the Pre-Raphaelite and Aesthetic movement painters, preferring more edifying and traditional subject painters.

Purchasing pattern

Holloway spent over £83,000 on pictures in two years. He bought primarily at auction, where he enlisted his brother-in-law George Martin to make selections and to bid for him.

Sales and bequests

Holloway gave seventy-seven paintings to Royal Holloway College. His Old Masters were sold in 1912.

References

Magazine of Art (1891), 234–41 and 269–75; *Art Journal* (1897), 129–33, 202–6, 306–10, and 334–40; *DNB*; *DBB*, III, 323–25; Boase; Thomas Holloway, *A Sketch of the Commencement and Progress of Holloway's Pills and Ointment by the Proprietor* (London: 1863); C. W. Carey, *Royal Holloway College, Egham. Catalogue of Pictures* (London: 1888); Chapel, *Victorian Taste, passim; ILN* (5 Jan. 1884), 24; (20 June 1885), 621–22; (3 July 1886), 19–21; (10 July 1886), 28–29; *The Times* (28, 29, 31 Dec. 1883); *Graphic* (5 Jan. 1884), 5 and (10 July 1886), 29–30, 44–45; *Pall Mall Gazette* (28–29 Dec. 1883), 1–2, 5, 9–11, 16, 19; Thomas Holloway, *Some Small Memories as to the Origin of Holloway Collection* (London: 1886); Redford, I, 321 and 358–59; Owen, *English Philanthropy*, pp. 395–401; Agnew's, *Thomas Holloway: The Benevolent Millionaire* (London: 1981); Caroline Bingham, "'Doing Something for Women': Matthew Vassar and Thomas Holloway," *History Today* 36 (June 1986), 46–51; *The History of Royal Holloway College 1886–1986* (London: 1987); Derryan Paul, *Royal Holloway College Archives, A Guide* (London: 1973).

Archival sources: Holloway Family Papers; Royal Holloway College Archives.

HOLT, George (1824–96)

Edge Lane, Liverpool; Bradstones, West Derby; and Sudley, Aigburth, Liverpool (1884–96).

Occupation

Shipowner, Lamport & Holt; director of Union Bank; and director of the Liverpool, London, & Globe Insurance Co.

Biography

Grandson of Oliver Holt, a wool manufacturer in Town Mill, Rochdale, and son of George Holt (1790–1861), a

Liverpool cotton broker and banker, who served as a borough magistrate and member of the Liverpool Corporation. Brother of Alfred Holt, founder of the Blue Funnel Line and Robert Holt, first Lord Mayor of Liverpool. After apprenticing with T. & J. Brocklebank Co., Holt junior formed a partnership with William Lamport. They established a regular steamship service between Liverpool and Brazil, serviced by nearly fifty vessels. A member of the Unitarian Church and a noted philanthropist, Holt endowed chairs of physiology and pathology at Liverpool University and funded the George Holt physics laboratory. With his brothers he donated Wavertree Park to the city in 1895. Holt was a member of the Dock Board and a magistrate.

Collection

Holt inherited works by Creswick, Callcott, Ward, and Phillip from his father and began collecting on his own in the late 1860s. He bought works by early-nineteenth-century painters, including Wilkie, Mulready, and Turner, and from leading mid-Victorian Royal Academicians, such as Leighton and Millais, in addition to such continental artists as A. Bonheur and A. Scheffer. In the mid-1880s, Holt added works by Reynolds, Raeburn, and Gainsborough to his collection. He established personal relationships with Calderon and Strudwick.

Taste

Holt preferred subject pictures by academic painters. In addition to modern British painters, he was interested in the continental schools, as well as watercolors and miniatures.

Purchasing pattern

Holt supplemented the collection he inherited in consultation with Agnew's, beginning in 1868. Holt also favored the Liverpool dealers W. G. Herbert, T. Hardman, and James Polak and London dealers such as Stephen Gooden, Thomas Joy, and Cremmeti of the Hanover Gallery (*Emma Holt Bequest*, pp. 3–4). In addition, he bought at the annual exhibitions and frequented artists' studios.

Sales and bequests

Presented works by Millais and Fontana to the Walker Art Gallery. Holt's daughter Emma bequeathed Sudley and its contents to the Corporation of Liverpool, 1944.

References

Athenaeum (16 Sept. 1882), 376–77; Boase; *Liverpool Courier* and *Daily Post*, 4 April 1896; Liverpool City Council, *The Emma Holt Bequest, Sudley* (Liverpool: 1971); Francis E. Hyde, *Blue Funnel: A History of Alfred Holt and Company of Liverpool* (Liverpool: 1957); Chandler, *Liverpool Shipping*, p. 150 and *passim*; Hughes, *Liverpool Banks*, p. 208; Macleod, (1986), p. 605; Steven Kolsteren, "The Pre-Raphaelite Art of John Melhuish Strudwick," *Journal of Pre-Raphaelite and Aesthetic Studies* I (Fall 1988), 2–4.

Archival sources: Diary (1845–61), Liverpool Record Office; Holt Papers, Walker Art Gallery.

HUTH, Charles Frederick (1806–95)

25 Upper Harley St., and later 9 Kensington Palace Gardens, London, and 77 Mount Ephraim, Oakhurst, Tunbridge Wells.

Occupation

Merchant and banker, Frederick Huth & Co., 10 Moorgate St. and Tokenhouse Yard, Bank, London.

Biography

Eldest son of Frederick Huth, a German who emigrated to England from Spain in 1809 and established the family merchant house. Brother of Louis Huth (1821–1905), whose collection fetched over £50,000 at Christie's on 20 May 1905. While the brothers shared similar tastes, Louis eventually became an occasional patron of Aesthetic movement artists Watts and Whistler. A third brother, Henry, was a noted bibliophile. Charles was a director of the Bank of England from 1866 until his death.

Collection

Huth owned Constable's *Stratford Mill*, Wilkie's *The Errand Boy*, Webster's *Cherry Seller,* and oils by Linnell, Frith, and Collins. He is said to have possessed examples of every distinguished member of the water-color school. The *Art Journal* in 1857 stated that his watercolor collection "may be considered unique, as containing rare examples; and, in addition to these may be mentioned a variety of 'first thoughts' by very many of the most distinguished painters, constituting altogether a curious,

interesting, and valuable collection" (p. 91). Huth's watercolors were well preserved at the time of his 1895 sale because, according to Roberts, they were kept in portfolios (II, 262). The Cliffords, however, suggest that some of his Cromes were purchased as copies by other hands and that he and his brother Louis passed them off as originals (*Crome*, pp. 278–79). While Frith considered Charles a liberal and intelligent patron (*Autobiography*, I, 196), Firestone classifies Louis as a dealer (*Linnell*, p. 129).

Taste
Early-Victorian modern oils and watercolors, including many sketches.

Purchasing pattern
Bought directly from David Roberts and commissioned Frith's *Scene from Don Quixote*. Huth bought his Constable in 1848 from the widow of Mr. Tinney, to whom it was given by Archdeacon Fisher (*Art Journal* [1857], 90). Also made purchases at Christie's.

Sales and bequests
Christie's, 11 February 1890; 6–9 July 1895 (425 oils and watercolors) and 10–11 July 1895 (339 miniatures, etc.). By descent: family sale Christie's, 19 March 1904.

References
Art Journal (March 1857) 90–91; (Sept. 1904), 330; and (Oct. 1905), 304–7; Boase; *London Directory* (1861–80); *The Times*, 13 March 1895; Roberts, II, 262–64; Clifford and Clifford, *John Crome*, pp. 277–79; Tate Gallery,

Constable, no. 177; Frith, *Autobiography*, I, 196–97; Farr, *Etty*, p. 148; Young, *et al.*, *Whistler*, nos. 61, 93, 105, and 125; Chapman, *Watts*, p. 147; Firestone, "John Linnell and the Picture Merchants," p. 129.

IONIDES, Alexander (1810–90)
Cheetham Hill, Manchester; 9 Finsbury Circus, Tulse Hill; 1 Holland Park, London (after 1864); and Windycroft, near Hastings, Kent.

Occupation
Merchant and stockbroker, Ionides & Co., Manchester and 125 Gresham House, Old Broad Street, London; managing director of Banque de Constantinople; and Greek Consul General, London from 1854–1866.

Biography
Son of Constantine Ipliktzis (1775–1852), a Greek textile merchant who emigrated to England in 1815. Alexander settled in Manchester in 1827, changing his name to Ionides and founding a company bearing his new name in 1832. He married Euterpe Sgonta, who shared his interest in staging theatrical and musical entertainments at their Monday "at homes" on Tulse Hill, where they were neighbors of Elhanan Bicknell (q.v.). Their children, Constantine Alexander (q.v.), Aleco, Luke, and Aglaia Coronio (q.v.), were also art collectors. Although Ionides is said to have lost £120,000 in a bank failure in 1864, the loss did not curtail his activ-

ities as a patron. He endowed a library, hospital, and orphanage in Athens. Their son Aleco presided over his parents' house in Holland Park after they retired to Hastings in 1875, where he commissioned Thomas Jeckyll to add a billiard room in the Japanese style and employed Morris & Co. to redecorate several rooms. Ionides senior left his fortune to his wife and daughters rather than to his sons, believing that "dead men's money" was a curse, especially to male descendants (Ionides, *Ion*, pp. 46–50).

Collection
Ionides was a friend and patron of Watts, Armstrong, Poynter, Rossetti, and Whistler, whose brother William married Ionides's niece Helen. His house at 1 Holland Park was remodeled by Philip Webb and decorated by William Morris and Walter Crane. He also owned works by Rosa Bonheur and collected amphori and vases, as well as Tanagra and Bocotian figures.

Taste
Aesthetic movement.

Purchasing pattern
Direct commissions to artists.

Sales and bequests
Christie's, 13–15 March 1902 (Oriental china and Greek antiquities); by descent.

References
Art Journal (May 1893), 139–44; Cooper, *Opulent Eye*, pl. 37; *Architectural Review* 2 (1897), 206; Luke Ionides, *Memories* (London: 1923);

Ionides, *Ion*; Elizabeth Pennell, *Whistler the Friend* (Philadelphia: 1930); Crane, *Reminiscences*, pp. 218–19; *Morris Letters* ed. Henderson; *The Young du Maurier,* ed. du Maurier, pp. 30–31; Ormond, *Du Maurier*, pp. 98–100 and 106; Smith, *Decorative Painting*, no. 31; Julia Atkins, "The Ionides Family," *Antique Collector* (June 1987), 86–92; Marillier, *Christie's*, pp. 94–95; Druick and Hoog, *Fantin-Latour*, pp. 159–62 and 202; Brighton Art Gallery, *Sandys*, no. 66; Lamont, *Armstrong*, p. 195; Burne-Jones*, Burne-Jones*, I, 303; Williamson, *Murray Marks*, pp. 98–99; *Rossetti Letters*, ed. Doughty and Wahl, II, 502; Watts, *Watts*, I, 32–35, 76–77; Blunt, *Watts*, pp. 12, 45–48; Pennell and Pennell, *Whistler*, I, 124, 153–54, and 211.

IONIDES, Constantine Alexander (1833–1900)

8 Holland Villas Road, London; Oakwood, Crayford; and 23 Second Avenue, Hove, Brighton (after 1881).

Occupation

Merchant, Manchester; Stockbroker, Ionides & Barker, 37 Threadneedle Street (1866–74); Ionides & Co., 2 Copthall Buildings, London (1877–80).

Biography

Grandson of Constantine Ipliktzis and eldest son of Euterpe Sgonta and Alexander Ionides (q.v.), Constantine Alexander was born in Manchester, where he entered his father's company in 1850. He was sent to Bucharest in 1855, where he spent five years in the wheat trade and where he also married Agathonike Fenerli, with whom he had eight children. After returning to London, Ionides joined Clapham Brothers, a firm of stockbrokers. He left to start his own company in partnership with Henry Barker and retired in 1882 after amassing a substantial fortune. He was also a director of the Tunisian Railway Co. Ionides counted astronomy among his hobbies.

Collection

Ionides began buying art on a large scale between the years 1878 and 1884. The *Magazine of Art* described his collection as "A crowd collected from various nations and various centuries" (p. 37). His was the largest holding of Barbizon paintings in London, with the exception of the Wallace collection at Hertford House. Ionides also collected jade, lacquer, cloisonné, Chinese porcelain, silver, bronzes, and gemstones. He was a friend of several artists, including Alphonse Legros and George Watts.

Taste

Aesthetic movement and modern French and Belgian oil painting. Ionides also collected seventeenth-century canvases.

Purchasing pattern

Ionides was advised by Legros, who encouraged him to buy the works of Millet, Lhermitte, and Degas through the agency of Durand-Ruel's London gallery. He also made purchases at Christie's. Ionides gave direct commissions to Fantin-Latour and Watts, among other artists.

Sales and bequests

Bequest: Ionides gave his collection to the Victoria and Albert Museum in 1901 on the condition that it be kept together and not concealed from the public.

Sales: Ionides sold six paintings before he died, including Millais's *Isabella*, Corot's *The Storm*, and several pastels by Millet (Christie's, 5 May 1883).

References

Magazine of Art 7 (1884), 36–44, 120–27, 208–14; *Art Journal* (1893), 139–44 and (Sept. 1904), 285–88; *Burlington* 5 (1904); *DNB*; Boase; *The Times*, 23 July 1900; *ILN* (15 Sept. 1900), 394; Victoria and Albert Museum, *Catalogue of the Constantine Alexander Ionides Collection* (London: 1925); Claus Michael Kauffmann, *Catalogue of Foreign Paintings*, 2 vols. (London: Victorian and Albert Museum: 1973); Luke Ionides, "Memories," *Transatlantic Review* 1 (Jan. 1924), 37–52; Ionides, *Ion*; William Stillman, *Autobiography, passim*; Ronald Pickvance, "Henry Hill: An Untypical Victorian Collector," *Apollo* 77 (Dec. 1962), 789; Clifford Musgrave, *Life in Brighton* (London: 1970), p. 334; Lamont, *Armstrong*, pp. 194–96; Surtees, *Rossetti Catalogue Raisonné*, no. 259; *Rossetti Letters*, ed. Doughty and Wahl, IV, 1774–75, 1786; Crane, *Reminiscences*, pp. 218–21; Fitzgerald, *Burne-Jones*, pp. 112, 132, 142, 185; Venturi, *Archives de*

l'Impressionisme, II, 196; Druick and Hoog, *Fantin-Latour*, pp. 117–18; Seltzer, "Legros," pp. 176–78; Cooper, *Courtauld*, p. 60.

Archival sources: Victoria and Albert Museum Library.

ISMAY, Thomas Henry (1837–99)
Beech Lawn House, Waterloo (1865–84), and Dawpool, Birkenhead, Liverpool (1884–99).

Occupation
Shipowner, White Star Line, 10 Water Street, Liverpool.

Biography
Great-grandson of Joseph Middleton, a shipbuilder of Maryport, Cumberland, grandson of Henry Ismay, a sea captain, and son of Margaret Sealby and Joseph Ismay (1804–50), a timber merchant, shipbuilder, and shipbroker. Thomas was sent to Croft House School, near Carlisle, in 1849, where he took advantage of its progressive emphasis on science (*DBB*). He was apprenticed to Imrie & Tomlinson, shipowners and shipbrokers, between 1853 and 1858, when he left to found his own company with Philip Nelson. They engaged in the West Indian, Mexican, and West Coast trade. The partnership was dissolved in 1862, when Ismay formed his own company. By 1866, he owned twelve vessels. Joining forces with William Imrie in 1868, Ismay launched the White Star Line of iron steamers in the Australian trade, branching out to the American trade two years later. The *Oceanic II*, built in 1899 in consultation with architect Norman Shaw, was the largest and most luxurious ship in the world, only to be surpassed by the White Star Line's *Titanic* in 1914. Ismay's company pioneered a new degree of comfort by moving passengers' state rooms to midship and by introducing the practice of offering bedding and eating utensils to third-class passengers, a feature which was imitated by the rival Cunard and Inman lines. At the time of Ismay's retirement in 1892, the fleet of the White Star Line consisted of eighteen steamers. Ismay was also a director of the London and North Western Railway. He was sheriff of Cheshire in 1892 and was made a freeman of the city of Belfast in 1899, after having declined a baronetcy a year earlier. Ismay's career is marked by his generosity: he took 200 deaf and dumb children on a cruise and donated £20,000 toward a pension fund for needy Liverpool sailors. Ismay's estate, which was sworn at £1,284,749, included bequests to his domestic and business emloyees.

Collection
Ismay's collection of modern British pictures included Millais's *The Fringe of the Moor* and *Dew Drenched Furze*, Wilkie's *Cotter's Saturday Night*, and Phillip's *La Bomba*, as well as a selection of eighteenth-century and early-Victorian canvases.

Taste
Mid-Victorian English and continental academic painters, as well as representatives of the earlier British school.

Purchasing pattern
Ismay bought his art from a variety of sources, including the dealers Agnew's and Stephen Gooden, Christie's, the Royal Academy, and artists' studios.

Sales and bequests
Presented Briton Rivière's *Daniel in the Lion's Den* to the Walker Art Gallery, Liverpool, 1900.

Sale: Christie's, 4 April 1908 (eighty-four lots brought £12,175).

References
Athenaeum, (3 Sept. 1887), 315–16; *DNB*; Boase; *DBB*; *Daily Post* and *Liverpool Mercury*, 27 Nov. 1899; *The Times*, 24 Nov. 1899; *Vanity Fair*, 15 Nov. 1894, *ILN*, 2 Dec. 1899; Orchard, *Liverpool's Legion of Honour*, pp. 411–15; "Dawpool," *Country Life* 29 (1911), 234–41; Wilton J. Oldham, *The Ismay Line* (Liverpool: 1961); Roy Claude Anderson, *White Star* (Prescot: 1964); Saint, *Shaw*, pp. 260–64; Arts Council, *Great Victorian Pictures*, no. 48; Macleod (1986), p. 605; Macleod (1987), pp. 343–44.

Archival sources: Merseyside County Archives, Ismay Family Papers and Diaries.

JARDINE, David (1827–1911)
Highlea, Beaconsfield Rd., Woolton, Liverpool.

Occupation
Timber broker, Farnworth & Jardine, 2 Dale Street, Liverpool. Chairman of Cunard Co. Director of the Royal

Insurance Co., Pacific Loan and Discount Co., and Standard Marine Insurance Co.

Biography

Born in New Brunswick, Canada, a fact which suggests that Jardine's family was involved in the Canadian timber industry along with that of Robert Rankin (q.v.), his brother-in-law. Jardine settled in Liverpool and worked for six years in the office of Frost & Farnworth before he was made a partner. He joined the board of directors of the Cunard Steamship Co. on its formation in 1880 and was later made chairman. Jardine's estate was proved at £825,852. He left bequests to the Liverpool Seamen's Orphanage, Blue Coat Hospital, and David Lewis Northern Hospital, among other charities.

Collection

Jardine favored Turner, Bonington, and eighteenth-century British painters.

Taste

Mid-Victorian collector with a penchant for eighteenth-century and early-Victorian art.

Purchasing pattern

Agnew's.

Sales and bequests

Christie's, 16 March 1917.

References

Athenaeum (31 Sept. 1887), 899–900; *Journal of Commerce*, 9 Oct. 1911; *Liverpool Courier*, 11 Oct. 1911; Orchard, *Liverpool's Legion of Honour*,

p. 418; Marillier, *Christie's*, pp. 164 and 186; Macleod (1986), p. 605.

Archival sources: Agnew's Stockbooks; 1881 Census Return.

JONES, John (1799–1882)

95 Piccadilly, London.

Occupation

Tailor and military clothier, 6 Waterloo Place and, by 1827, 6–8 Regent Street, London.

Biography

Born in Middlesex, Jones's social origin is unknown. He was established as a tailor and army clothier by 1825 and opened a branch in Dublin in 1840. Jones retired in 1850 but maintained an active interest in his firm, particularly when business increased due to the Crimean War in 1854. He traveled extensively, making frequent visits to France. Although Jones's bachelor's quarters were lavishly decorated, he apparently preferred to sleep on a military camp bed. Nor did he demonstrate any interest in improving his social position. Jones's estate was proved at £359,000.

Collection

Began collecting works of art when he retired. He is said to have spent over £250,000 on furniture, porcelain, miniatures, and pictures. He owned paintings by English artists such as Turner, Collins, Stanfield, Mulready, Etty, Landseer, and Frith. Jones also collected Rococo canvases

by Lancret, Boucher, and Pater. His one concession to Pre-Raphaelite art was decorative: he commissioned painted roundels by Rossetti for one of his bookcases.

Taste

Mid-Victorian collector, specializing in early-Victorian artists rather than his contemporaries, and eighteenth-century French paintings and decorative arts.

Purchasing pattern

Jones bought extensively on his visits to Paris. In London he is known to have used the dealer Wallis and to have bid at auction.

Sales and bequests

Bequeathed almost one hundred oil paintings and twenty watercolors to the South Kensington Museum in 1882, half of which are English. Jones also gave his collection of decorative arts and furniture to the Museum, whose director, Sir Philip Cunliffe-Owen, was instrumental in acquiring the collection.

References

DNB; *Huish's The Year's Art* (London: 1882), 176; A. W. Hogg, *Handbook of the Jones Collection* (London: 1883); Basil Someset Long, *Catalogue of the Jones Collection* (London: 1923); Claus Michael Kauffmann, *Catalogue of Foreign Paintings* (London: 1973); *Victoria and Albert Museum Guide* (1986), 28–31, 53, and 73; Parkinson, *Catalogue of Oil Paintings*, pp. xix–xx; *Apollo* (Oct. 1962), 208–14 and 228; (Feb. 1963), 29–37; (1965), 434–43; and (March 1972),

156–211; Heleniak, *Mulready*, pp. 202–3; Ormond, *Landseer*, p. 76; Davis, *Victorian Patrons*, pp. 63–68.

Archival sources: Victoria and Albert Museum Library.

JOYCE, William Alfred (1812–65)

112 Tulse Hill, London (his property backed onto Holy Trinity Church; it was destroyed and replaced by flats).

Occupation

Master lighterman, waterman, and custom house agent, 13 Water Lane, City of London, and Old Kent Road, Surrey.

Biography

Joyce's modest occupation sets him apart from the mainstream of early Victorian collectors. It is not known whether he inherited wealth or had another source of income; however, he lived comfortably in a very large house on Lower Tulse Hill and educated two of his sons at Dartmouth House, a private school (1861 Census Report). Three of his sons followed their father's calling. The occupations for his remaining four sons are given in the 1871 Census as farmer, brewer, hat manufacturer, and coffee merchant.

Collection

Owned modern oils and watercolors by Frith, Creswick, Redgrave, Egg, O'Neill, Faed, Webster, Landseer, Goodall, Stanfield, and Le Jeune. The *Art Journal* described Joyce's holdings as "examples of the feeling and manner of a numerous catalogue of our most eminent painters" (1858, p. 13).

Taste

Early-Victorian small-sized canvases.

Purchasing pattern

Depended upon the advice of W. E. Bates, the landscape and marine painter (*Art Journal* [1858], p. 13).

Sales

Christie's, 22 July 1876 (ninety-nine lots).

References

Post Office Directory (1855); *Art Journal* (Jan. 1858), 13–14; Celia Davis, "Skilled Boatmen of the Thames: The Company of Watermen and Lightermen," *Country Life* (14 Nov. 1974), 1488–99.

Archival sources: Census Reports for 1851, 1861, and 1871; West Norwood Cemetery Memorial Inscriptions.

KAY, Arthur (c. 1860–1939)

Auld Reekie, Glasgow and Sussex.

Occupation

Warehouseman, Arthur & Co., Queen Street, Glasgow.

Biography

Son of John Robert Kay of Yorkshire who moved to Glasgow, Kay studied at Glasgow University and then traveled to art galleries in Paris, Vienna, Hanover, Leipzig, and Berlin. While abroad, he took music lessons from Liszt. On his return, Kay gave up the idea of becoming a lawyer and entered his father's business. He continued to travel widely, venturing as far as Africa and Australia. Kay was active in civic and national societies, such as the Glasgow Ratepayers' Federation, the Lord Roberts National Service League, the Society of Antiquaries, and the Scottish Modern Arts Association. He married the watercolorist Kate Cameron (1874–1965). Kay wrote *Treasure Trove in Art*, an anecdotal account of his experience as a collector. He was a business partner of T. G. Arthur, who was also an art collector.

Collection

Kay's interests were diverse: he collected paintings by the Hague School (especially Matthys Maris), seventeenth-century Dutch masters, Tiepolo, Goya, and eighteenth-century British painters such as Raeburn and Reynolds. In 1892 Kay bought Manet's pastel, *Au Café* from Vollard and Degas's *La Répétition* and *L'Absinthe* from Alex Reid. He sold both Degases soon afterwards, but still had the Manet at the time of the Glasgow exhibition in 1901.

Taste

Contemporary French, Hague School, eighteenth-century British, and Old Masters.

Purchasing pattern

Kay frequented the dealers Vollard, Alex Reid, Colnaghi, and possibly Craibe Angus and van Wisselingh.

Sales and bequests

Paris, Martin et Camentron, April 1893.

References

Richard Marks, *Burrell: A Portrait of a Collector* (Glasgow: 1988), pp. 62–66; *The Bailie* (20 March 1901) 1–2; *Who's Who in Glasgow* (Glasgow: 1909); Scottish Arts Council, *A Man of Influence: Alex Reid* (Edinburgh: 1967), pp. 10 and 12; Metropolitan Museum, *Degas*, nos. 172 and 239; *Impressionists in England*, ed. Flint, p. 9; Ronald Pickvance, "'L'Absinthe' in England," *Apollo* 77 (May 1963), 395–96; Cooper, *Courtauld*, p. 61; Kay, *Treasure Trove*.

KNOTT, George (d. 1844)
Bohun Lodge, East Barnet, London.

Occupation

Wholesale grocer, Lime Street and Upper Thames Street, City of London.

Biography

Origins unknown. Married his kinswoman Ann Aldridge, the wealthy widow of a timber merchant, in 1834, and moved into her house, Bohun Lodge. Both died in 1844, leaving a young family. George Knott junior (1835–94) was educated at University College, London. He was the author of more than thirty papers on astronomical subjects.

Collection

Knott owned Collins's *Sunday Morning, Disciples at Emmaus*, and *The Peace-maker*, Mulready's *The Widow*, Leslie's *Uncle Toby and the Widow Wadman*, Redgrave's *Going into Service*, and Etty's *Musidora*, among other works. His collection was "intended to

be illustrative of the work of the most distinguished contemporary English painters" (Cass, *East Barnett*, p. 134). Two family portraits painted by the Chalon brothers in 1843 are in the Victoria and Albert Museum.

Taste

Early-Victorian landscapes, poetic subjects, and genre. Ferriday claims Knott asked that Maclise's *The Play Scene in Hamlet* be explained to him because he was unfamiliar with Shakespeare's play, but once he learned about the plot he refused to buy the painting ("Victorian Art Market," p. 1457).

Purchasing pattern

Commissioned Collins and Stanfield and bought his Etty at the Royal Academy in 1843.

Sales and bequests

Christie's, 26 April 1845 (seventy-one oils and watercolors). Elhanan Bicknell (q.v.) bought several works at this sale, including *An English Landscape* by Landseer and Callcott for which he paid 1,000 guineas.

References

Boase; F. C. Cass, *East Barnet* (London: 1885–1892; rpt. 1983), p. 134; *The Times*, 8 May 1883; Collins, *Collins*, II, 66, 187, 189, 348–50; Heleniak, *Mulready*, pp. 169–70, 203, 261n.; Ferriday, "Victorian Art Market," p. 1457; Farr, *Etty*, p. 100; Tyne and Wear, *Stanfield*, p. 132.

Archival sources: Greater London Record Office (marriage settlement

and will) and Family Records, Barsinghausen, Germany.

KURTZ, Andrew George (1825–90)
Grove House; Dovedale Towers, Wavertree, Liverpool; and Clan y mor, Penmaenmawr, Wales (by 1885).

Occupation

Chemical manufacturer, Sutton Alkali Works.

Biography

Grandson of Erard Kurtz and son of Andrew Kurtz (1781–1846) of Reutlingen, Germany, who moved to Paris, where he worked for twenty years as a chemist, earning the Legion of Honor in 1824. After becoming an American citizen "in order to exploit a gunpowder invention in that country," Andrew senior emigrated to England (Hardie, *Chemical Trade*, p. 23). He settled in Manchester in 1820, relocating to Liverpool in 1830, where he manufactured bichromate of potash. Kurtz senior turned to the manufacture of alkali in 1842 at St. Helens. Andrew George first studied for the law, but after the death of his father entered the family business, completing his training in Paris. A philanthropist, Kurtz provided St. Helens with its first public baths and funded the Cottage Hospital. He was also an accomplished amateur musician.

Collection

Works by Millais, Leighton, Turner, Prout, Cox, and other British artists

were displayed in a gallery in his home, which was open to the public. Kurtz also collected works by Delaroche and Bougival and was a notable autograph collector.

Taste
Mid-Victorian collector of contemporary British and foreign, as well as early-British, oils.

Purchasing pattern
Agnew's.

Sales and bequests
Kurtz presented Dicksee's *Ideal Portrait of Lady Macbeth* and Leighton's *Elijah* to the Walker Art Gallery in 1878–79. He bequeathed his collection of autograph letters to the British Museum.

Sales: Christie's, 9 and 11 May 1891.

References
Athenaeum (12 Sept. 1885), 341–42 and (5 Oct. 1890), 455; *Art Journal* (Oct. 1890), 310; Boase; J. Fenwick Allen, *Some Founders of the Chemical Industry* (London: 1906); *Liverpool Daily Post*, 15 April 1890; D. W. F. Hardie, *A History of the Chemical Trade in Widnes* (London: 1950), pp. 23–24, 124, 218–19, and 231; J. R. Harris, *A Mersey Subtown of the Industrial Revolution: St. Helens* (London: 1954), pp. 233, 320, 382, and 464; Marillier, *Christie's*, p. 65; Roberts, II, 161–63; A. N. L. Mundy, *Cult of the Autography Letter in England* (London: 1962), 71; Walker Art Gallery, *Merseyside Painters*, p. 163; Bennett, *Pre-Raphaelite Circle*, pp. 150 and 153; Edward Morris and

Christopher Fifield, "A. G. Kurtz: A Patron of Classical Art and Music in Victorian Liverpool," *Journal of the History of Collections* 7 (1995), 103–14. Ormond, *Leighton*, nos. 180 and 248; Forbes, *RA Revisited*, no. 21, p. 58; Macleod (1986), pp. 602 and 605.

Archival sources: Letter to F. G. Stephens, 27 Aug. 1885, Stephens Papers, Bodleian Library; Correspondence, Liverpool Record Office, Liverpool City Libraries; Agnew's Stockbooks.

KURTZ, Charles (d. 1878)
Springwell House, Orwell, Liverpool, and Coed y celyn, Llanrwst, Wales.

Occupation
Manufacturing chemist, Charles Kurtz & Sons, 33–39 Carruthers Street, Liverpool.

Biography
Origins unknown. Possibly related to A. G. Kurtz (q.v.), who was also involved in the chemical industry. Kurtz was married to Lucy Charlotte Kurtz. Their son Andrew George Kurtz worked in the family business. Kurtz's estate was proved at under £90,000.

Collection
Kurtz owned oils by Gallait, Rosa Bonheur, Frère, Landseer, Stanfield, and Phillip, in addition to a selection of watercolors by British artists. Several of Kurtz's foreign works had been exhibited at the French Gallery and at the Doré Gallery.

Taste
Mid-Victorian oils and watercolors and contemporary French.

Purchasing pattern
Agnew's and possibly Gambart.

Sales and bequests
Christie's, 12 March 1880 and 12 February 1881.

References
Art Journal (Nov. 1870), 335–36 and (April 1881), 128; *Liverpool Directory* (1879); *The Times*, 15 March 1880; Redford, I, 308–9.

Archival sources: Agnew's Stockbooks; Calender of Probate (1878), Liverpool Record Office.

LANGTON, Charles (1813–1900)
Bark Hill Road, Aigburth, near Liverpool.

Occupation
Insurance merchant, T. & W. Earle Co. Director of the Bank of Liverpool, the British Shipowners' Co., the Liverpool Exchange Buildings Co., the Scottish Equitable Life Assurance Co., and the Runcorn Soap and Alkali Co.

Biography
Son of Joseph Langton, the first manager of the Bank of Liverpool. The family was connected with Liverpool since the beginning of the nineteenth century. Charles was educated at public school and at university. He then entered the firm of Frederic Huth & Co. before forming his own marine insurance brokerage in partnership with T. D. Headlam. Langton married

Jessie Gilmour of Londonderry in 1854. He was active in the founding of the Training School and Home for Nurses and the Royal Infirmary. He was Justice of the Peace for Lancashire and deputy lieutenant of the County Palatine.

Collection

Langton owned Millais's watercolor sketches for *The Huguenot, First and Second Sermon, Proscribed Royalist,* and *The Order of Release.* In addition to works by Turner, Cox, A. W. Hunt, and Prout, he possessed a number of drawings by J. F. Lewis, which he sold at Christie's in 1862.

Taste

Mid-Victorian collector of early- to mid-nineteenth-century oils and watercolors by Royal Academicians and Pre-Raphaelites.

Purchasing pattern

Agnew's.

Sales and bequests

Christie's, 17 May 1862 and 20 April 1901.

References

Art Journal (July 1862), 158; *Athenaeum,* (Sept. 25, 1886), 409; *Magazine of Art* (Nov. 1901), 44; *Liverpool Courier* and *Liverpool Mercury,* 19 Nov. 1900; Orchard, *Liverpool's Legion of Honour,* pp. 433–44; Macleod (1986), p. 605.

LEATHART, James (1820–95)

12 Framlington Place, Newcastle, and, after 1869, Braken Dene, Low Fell, Gateshead.

Occupation

Lead manufacturer, Locke, Blackett, & Co., St. Anthony's on the Tyne, Newcastle.

Biography

Born in Alston, Cumberland, Leathart was the son of a struggling mining engineer and prospector. He attended grammar school at Allston before he was apprenticed to Locke, Blackett, & Co. at the age of fourteen after working briefly for a chemical firm owned by the Burnett family. Motivated to study chemistry and metallurgy in his own time, Leathart was promoted to positions of greater responsibility as his knowledge of lead manufacturing improved. In 1846 he was placed in charge of his company's new plant at St. Anthony's. He was made a partner in 1846 and promoted to joint managing partner five years later (*DBB*). It was at this time that Leathart became interested in art collecting. Serving as Secretary of the Newcastle School of Art, he began to purchase the works of local artists. He was gradually won over, however, by the enthusiasm for the Pre-Raphaelites shown by William Bell Scott, head of the School of Art. Leathart married Maria Hedley, daughter of a prosperous soap manufacturer and mayor of Newcastle. They lived in Gateshead, next to the Newalls (q.v.). Although Locke, Blackett, & Co. was probably the largest lead-manufacturing firm on Tyneside, the company ran into financial difficulties in the late 1870s as a result of overcapacity and foreign competition. Facing increasing financial difficulties in the 1890s, Leathart sold part of his art collection. At the time of his death, he left his wife and ten surviving children an estate valued at £14,924.

Collection

Leathart began by collecting English watercolors, many of which he later sold or traded with Agnew's after he had come to prefer the work of Pre-Raphaelite and Aesthetic movement artists. F. G. Stephens considered his collection representative of the poetic values that characterized the avant-garde art of the 1870s. Many of these paintings are in public collections today, including Madox Brown's *Romeo and Juliet* (Delaware Art Museum), *The Body of Harold Brought before William the Conqueror* (Manchester City Art Galleries), and *Work* (Birmingham Museum and Art Gallery), Albert Moore's *A Musician* (Yale Center for British Art, Paul Mellon Fund), and Rossetti's *The Salutation of Beatrice* (National Gallery of Canada, Ottawa).

Taste

Pre-Raphaelite and Aesthetic movement.

Purchasing pattern

Leathart commissioned a large portion of his collection directly from

artists, although he occasionally dealt with Agnew's and made purchases at Christie's.

Sales and bequests
Exchange with Agnew's, 1869–70; Goupil Gallery sale, June–July 1896; Christie's, 19 June 1897; and by descent.

References
Athenaeum (13 Sept. 1873), 342–44; *DBB*; *Newcastle Daily Chronicle*, 12 August 1895; David John Rowe, *Lead Manufacturing in Britain* (London: 1983); Walter White, *Northumberland and the Border* (London: 1859); W. M. Rossetti, "A Pre-Raphaelite Collection," *Art Journal* (May 1896), 129–34; Rossetti, *Family Letters*, I, 188, 205, 239, 247–48 and II, 153 and 166, *Rossetti as Designer and Writer*, pp. 36, 39–40, 57, and 80; *Rossetti Letters*, ed. Doughty and Wahl, II, 621 *passim*; Hueffer, *Brown*, pp. 162–63, 172, 183, 197, and 232; Scott, *Autobiographical Notes*, II, 48; Laing Art Gallery, *Paintings from the Leathart Collection* (Newcastle: 1968); Reynolds, *Simeon Solomon*, p. 7; *The Correspondance between Samuel Bancroft, Jr. and Charles Fairfax Murray*, ed. Rowland Elzea (Wilmington: Delaware Art Musuem, 1980), pp. 81, 99, 101, 105, 110, and 112; Macleod (1986), pp. 601, 605, and fig. 37; Macleod (1989a), pp. 188–208; Macleod (1989b), pp. 9–37 and 128.

Archival sources: Leathart Family Papers; Angeli-Dennis Papers and Leathart Papers, University of British Columbia; Agnew's Stockbooks.

LEVER, William Hesketh, Viscount Leverhulme of the Western Isles (1851–1925)
Park Street, Bolton; Thornton Manor, Thornton Hough; Hillside, Bolton; Hyde Park Court, 20 Norfolk Street, and The Hill, Hampstead, London.

Occupation
Soap manufacturer, Lever Brothers, Ltd., Bolton, Lancashire.

Biography
Lever was the son of a Bolton grocer who branched out into wholesaling in 1864. He was educated at the Church Institute, Bolton, until he entered the family business at age sixteen. Made a partner five years later, Lever carefully studied American business techniques, with the result that he began to emphasize advertising and sales promotion. Highly successful, Lever expanded the family empire to the Solomon Islands and Belgian Congo, where he bought plantations to insure the company's source of palm oil. He also entered into the merchant and shipping businesses in West Africa. By 1912, Lever assessed his personal assets at £3 million, while by 1924 the capital of Lever Brothers was valued at nearly £57 million. His philanthropies included Liverpool University and the construction of Port Sunlight for his workers. Lever was created a baronet in 1911, a baron in 1917, and a viscount in 1922. Following his death, Lever Brothers merged with the Margarine Union to become Unilever.

Collection
Lever began by collecting paintings as a source for his soap advertisements in the 1880s. By the following decade, he indulged his personal interest in the classical subjects of Leighton, Moore, Alma-Tadema, and Waterhouse, as well as eighteenth-century British masters. After Lever finalized his plans for a public art gallery, he changed course once again, concentrating on gallery-sized canvases with more easily discernible narratives. Lever also collected sculpture, porcelain, furniture, and *objets d'art*.

Taste
Late-Victorian narrative and classical painting, in addition to eighteenth-century portraits and landscapes.

Purchasing pattern
Lever rarely commissioned works directly from artists, preferring to have a series of dealers supervise negotiations for him. His first purchase was made through the Liverpool dealer Kidson's. Amateur artist James Orrick was responsible for most of Lever's eighteenth-century purchases, while Arthur Tooth intervened on his behalf at the Royal Academy and F. W. Fox did his bidding at auction. Lever also frequented Agnew's and David Croal Thomson's Barbizon House.

Sales and bequests
Lever arranged to have the bulk of his collection housed in a memorial gallery to his wife, the Lady Lever Gallery in Port Sunlight, near Liverpool, which opened in 1922. The remainder

of his collection and the contents of his various houses were sold in a series of sales: Knight, Frank & Rutley, 9–17 Nov. 1925, 3–18 June 1926, 24–25 June 1926, and 8–30 July 1926; Phillips Son & Neal, 11 Nov. 1925; Anderson Galleries, New York, 9 Feb.–11 May 1926; Christie's, 26 Nov.–2 Dec. 1926; and Bain & Morrison, 20–21 April 1926.

References
DNB; *The Times*, 8 May 1925; William Percy Jolly, *Lord Leverhulme* (London: 1976); Andrew M. Knox, *Coming Clean* (London: 1976); Viscount Leverhulme, *Viscount Leverhulme, by his Son* (London: 1927); Charles Wilson, *The History of Unilever I* (London: 1954); Royal Academy, *Lord Leverhulme: A Great Edwardian Collector and Builder* (London: 1980); and Edward Morris *et al.*, "Art and Business in Edwardian England: The Making of the Lady Lever Art Gallery," *Journal of the History of Collections* 4 (1990), 169ff.

LEYLAND, Frederick Richards (1831–92)
Speke Hall, Speke, and Woolton Hall, Woolton, Liverpool; 23 Queen's Gate and, after 1876, 49 Prince's Gate, London; and The Convent, Kingsgate, near Broadstairs, Kent (1891–92).

Occupation
Shipowner, Frederick Leyland & Co., 27 James Street, Liverpool.

Biography
Son of John Leyland of Liverpool, a bookkeeper, who died in 1839. According to Liverpool historian W.

H. Wakefield, Leyland's mother sold pies on the street after she was deserted by his father. Leyland was educated at the Liverpool Institute in Mount Street and was apprenticed to the shipowning firm of Bibby & Sons, where his father had worked. He was promoted to manager while still in his thirties. In 1873, Leyland made an aggressive move to gain control of the company and expanded its interests in the lucrative steamship trade between Liverpool, Boston, Portugal, and other Mediterranean ports. Leyland's innovative designs for cargo vessels revolutionized British shipping. He was also chairman of the National Telephone Co. and director of the Edison and Swan Electric Light Co. Leyland spoke Italian and French fluently and was an accomplished amateur musician. His estate was proved at £1 million.

Collection
Leyland constantly refined his holdings through trades and sales. His final gathering of art works consisted of canvases by Rossetti, Burne-Jones, Whistler, Albert Moore, and the Italian schools.

Taste
Aesthetic movement, Italian Primitive, and Venetian painters.

Purchasing pattern
Leyland gave many direct commissions to artists and also employed the services of Charles Augustus Howell and Murray Marks.

Sales and bequests
Private sales through dealers in 1870, 1872, and 1874. Christie's, 9 March 1872, 13 June 1874, 26–28 May 1892, 19–20 July 1892, and 24 Feb. 1893; Sotheby's, 12–13 Feb. 1880; Osborne & Mercier, 13 June 1892. By descent; private family sales; Orbach Galleries, June 1904, and Christie's, 24 Nov. 1916.

References
Athenaeum (30 Sept. 1882), 438–40 and (21 Oct. 1882), 534–35; Boase; F. R. Leyland, letter to the editor, *The Times*, 23 May 1878; *Liverpool Courier*, 6 Jan. 1892; *Liverpool Daily Post*, 6 Jan. 1892; *Daily News*, 30 May 1894; Child, "Pre-Raphaelite Mansion," 81–99; Val Prinsep, "Rossetti and his Friend," *Art Journal* (May 1892), 129–34 and "A Collector's Correspondence," *Art Journal*, (May 1892), 249–52; Lionel Robinson, "The Leyland Collection," *Art Journal* (May 1892), 134–38; Roberts, II, 187ff.; Marillier, *Christie's*; Rossetti, *Family Letters, passim, Rossetti as Designer and Writer*, p. 41 and *passim, Ruskin: Rossetti: Preraphaelitism*, p. 92 and *passim*; *The Rossetti–Leyland Letters*, ed. Francis L. Fennell (Athens, Ohio: 1978); *The Diary of William Rossetti, 1870–1873*, ed. Odette Bornand, 20 and *passim*; Surtees, *Rossetti Catalogue Raisonné*, I, nos. 109N, 124, 173R2, 198, 222, 233, 239, 244R1, 254, 260; *Rossetti Letters*, ed. Doughty and Wahl, II, 736 and *passim*; Arts Council, *Burne-Jones* (London: 1975), nos. 109–12, 117, and 129; Burne-Jones, *Burne-Jones*, I,

295 and II, 9–11; Crane, *Reminiscences*, pp. 199–200; Saint, *Shaw*, pp. 153, 423, and 433; George Walter Thornbury, *Old and New London*, 6 vols. (London: 1879–85), I, 135; Luke Ionides, "Memories," *Transatlantic Review* 1 (Jan. 1924), 47–48; Duval, "Leyland", 110–16; Peter Ferriday, "The Peacock Room," *Architectural Review* 125 (June 1959), 407–14; Curry, *Whistler*, pp. 53–69; Chandler, *Liverpool Shipping*, pp. 87–88, 126–27; Duncan Haws, *Merchant Fleet in Profile* (Brighton: 1979); Clement Jones, *Pioneer Shipowners* (Liverpool: 1934); Pennell and Pennell, *Whistler*, I, 125 and *passim*, II, 127; Macleod (1986), pp. 599, 601, 605; Macleod (1987), pp. 341–42 and pl. 15.

Archival sources: Wakefield MSS, Liverpool City Libraries; Jeremy Cooper, "Frederick Leyland and 49 Princes Gate," unpubl. MSS.; letters from Whistler to Leyland, Pennell Collection, Library of Congress; Whistler-Leyland Correspondence, University of Glasgow.

MANN, J. H. (fl. 1827–70)
Old Chapel House, Kentish Town, London.

Occupation
Color manufacturer, Lincoln's Inn Field.

Biography
Origins unknown. Possibly related to Joshua Hargrave Sams Mann, London painter of domestic subjects. J. H. Mann was chairman of the Artists' General Benevolent Institute and one of the founders of the North London School of Drawing and Modelling, which the *Art Journal* described as the first of the "Suburban Artizan Schools" (1857, p. 283). He was also a patron of the Society of Engravers.

Collection
Owned works by J. H. S. Mann, Roberts, Elmore, Stothard, Wilkie, Millais, Frith, Creswick, Lance, Reynolds, and Etty.

Taste
Early-Victorian poetic subjects and genre. The *Art Journal* characterized Mann's collection as consisting of "early works of men who have now risen to eminence, and the pictures of others who are yet infirm in public estimation" (*ibid.*).

Purchasing pattern
Probably bought from the artists to whom he sold canvases and paint or came in contact with through his connections with artists' groups.

Sales and bequests
Christie's, 16 December 1871. The *Art Journal* noted that Mann's collection had "never been weeded with any view to commercial advancement" (*ibid.*).

References
Post Office Directory (1838); *Art Journal* (Sept. 1846), 258 and (Sept. 1857), 283–84; Pye, *Patronage*, pp. 5, 332–39, 348–50, 358–59; Warner, "Millais," p. 35; "Constable Correspondence," XVIII, 264–65 and 323.

MARSHALL, William (1796–1872)
85 Eaton Square and Patterdale Hall, Ambleside, Cumberland.

Occupation
Barrister; admitted to the Bar but never practiced.

Biography
Grandson of a draper and son of John Marshall (1765–1845), a flax spinner in Leeds and Shrewsbury (Marshall & Co.) who was a friend of Wordsworth's, a founder of the Leeds Parliamentary Reform Association, and a patron of Leeds artists (Dunbar and Richter). Brother of John Marshall (1840–1894) of Headingly Hall, Leeds, 41 Upper Grosvenor Street, London, and Derwent Island, Cumberland, who became a partner in his father's firm and married into an old gentry family. William was privately educated before entering the Inns of Court, where he was called to the Bar. As a student, he was given an allowance of £700 a year by his father, from whom he eventually received a total of £150,000 in gifts and bequests. He was elected Liberal MP for Yorkshire in 1826 and went on to serve in various constituencies until 1868. He was also a member of the 1853 Select Committee on the National Gallery.

Collection
Waagen describes William's display at Eaton Square as "small in number," but representing "a very correct taste in art" (1857, p. 183). He owned works by

F. R. Lee, Callcott, Turner, Collins, Wilkie, and Eastlake, in addition to Claude Lorraine and Murillo; he lent some to the Manchester Art Treasures exhibition. There is a good deal of confusion in the literature, even amongst the Victorians, about the art collecting of the various members of the Marshall clan since they were all active, to some extent, in the art market. Wilkie, for instance, states that a Mr. Marshall of Upper Grosvenor Street (residence of John Marshall Junior) asked him to paint *Napoleon and Pope Pius IV* (Cunningham, *Wilkie,* III, 77), while Waagen describes this address as being at the Eaton Square residence of William Marshall (1857, p. 184). Moreover, Collins visited the houses of all three Marshalls in the Lake District, and sold paintings to each, including a replica of *The Cherry Seller.* William Marshall purchased Rossetti's *"Hist!" Said Kate the Queen, The Queen's Page,* and *Fra Pace* in the 1850s. They later appeared in the 1881 sale of John Marshall. As Gage notes, their identities are complicated by the fact that a John Marshall of Coniston and a James Marshall were also buyers of Turner and Collins (*Turner Correspondence,* p. 269).

Taste
Early Victorian, Pre-Raphaelite, and Old Masters.

Purchasing pattern
Commissioned Collins and Wilkie and bought directly from Rossetti.

Sales and bequests
Foster's, 6 Dec. 1911. Descendants' donation of Rossetti's *"Hist!" Said Kate the Queen* to Eton College. John Marshall sales, Christie's, 28 May and 9 June 1881 and 26 May 1888.

References
WWMP; Rev. Richard Vickerman Taylor, *Biographia Leodiensis* (London: 1865), pp. 364–66 and 411–14; William Gordon Rimmer, *Marshall's of Leeds, Flax Spinners 1788–1886* (Cambridge: 1960); Waagen (1857), pp. 183–85; Cunningham, *Wilkie,* III, 77–78, 221; Collins, *Collins,* I, 170, 199, 235 and II, 11, 13–14, 103–4, and 162; Whitley, *Art in England,* p. 109; Fawcett, *Provincial Art,* pp. 65, 88, 89; Robertson, *Eastlake,* pp. 269, 290; Butlin and Joll, *Turner,* I, 227; Gage, *Turner Correspondence,* pp. 268–69; Rossetti, *Family Letters,* I, 143; Surtees, *Rossetti Catalogue Raisonné,* nos. 49, 87 and 88; *Rossetti Letters,* ed. Doughty and Wahl, I, 184 and 301–2; Tyrrel, "Class Consciousness," pp. 102–25.

MATTHEWS, Charles Peter (1819–91)
Gidea Hall, Romford, Essex; 23 Hertford Street, Mayfair, London; and, by 1867, The Bower House, Havering-atte-Bower, Essex (now Ford Motor Co. Marketing Institute).

Occupation
Brewer, Managing partner, Ind, Coope & Co., Romford, Essex.

Biography
Origins unknown. Matthews was born in Middlesex and lived in Baldock, Hertfordshire, before moving to Essex in 1845, where he joined the brewers E. Ind, V. Ind, and G. Coope as a partner in their firm. By the time of Matthews's death in 1891, the business had expanded to "gigantic proportions" (*Essex Times*). The details of Matthews's education are unknown; however, his correspondence with Dante Gabriel Rossetti reveals a familiarity with the classics. He served as a Justice of the Peace for over twenty years. In addition, he was commissioneer of sewers and a churchwarden. Politically, Matthews was a staunch Conservative. He was married twice, first to the daughter of Mr. Kemp of Norwich, with whom he had five children, and, after her death in 1861, to the daughter of his partner E. Ind. They lived in historic Bower House, where English monarchs had stayed from the time of Charles I. Rebuilt in 1729, the house was decorated with murals by James Thornhill. It commanded a magnificent view: "on a clear day the ridge of Blackheath and Shooter's Hill, made famous by Dickens, can be seen" (Partridge, p.c.). Matthews is commemorated by the east window in Havering Church. He was an original member of the Burlington Fine Arts Club in 1867.

Collection
Matthews owned six Leightons, including *Iostephane* and *The Music Lesson,* four Millaises – *The Sisters, The Ransom, Early Days* and *The Flood* –

thirteen J. C. Hooks, seven J. F. Lewises, Holman Hunt's *Finding of the Saviour in the Temple, Afterglow*, and *Street Scene in Cairo: The Lantern Maker's Courtship*, Gérôme's *Gladiators*, two G. D. Leslies, and works by Phillip, Holland, Müller, Linnell, Cooke, Etty, Calderon, Mulready, Poole, Pickersgill, Creswick, Orchardson, Henriette Brown, and Simeon Solomon.

Taste
Mid-Victorian classical and Orientalist subjects, in addition to landscape.

Purchasing pattern
Although the *Magazine of Art* complimented Matthews for not using dealers, he bought Mulready's *Toyseller* and a landscape by Creswick from Agnew's and Hunt's *Saviour* from Gambart. He also made direct purchases from Hunt and Frith and unsuccessfully tried to commission a major work from Rossetti.

Sales and bequests
Christie's, 6 June 1891 (125 lots brought £58,000, which, according to *The Times*, was much less than Matthews paid for his pictures).

References
Magazine of Art (1881), 265–70 and 333–37; *Art Journal* (Oct. 1891), 311–12; Boase; *The Times*, 8 June 1891; *Essex Times*, 25 Feb. 1891; Hallé, *Painter's Life*, pp. 157–58; Ormond, *Leighton*, nos. 163–65 and 167; Chapel, *Victorian Taste*, no. 14; Heleniak, *Mulready*, no.

172; Frith, *Autobiography*, I, 368; Bennett, *Millais*, no. 61; Bennett, *Hunt*, nos. 28, 29, and 31; Rossetti, *Rossetti Papers*, pp. 268–69, 280–81, 292–96, 308, and 350, *Rossetti as Designer and Writer*, pp. 58 and 61–62; Reynolds, *Simeon Solomon*, p. 10; Roberts, II, 163–68; Maas, *Gambart*, pp. 204, 219, and 229; Forbes, *RA Revisited*, no. 14; Arts Council, *Great Victorian Pictures*, no. 45; John Vaizey, *The Brewing Industry, 1886–1951* (London: 1960), p. 36; Harold Smith, *History of Havering-Atte-Bower* (London: 1925), pp. 127–33; Ford Marketing Institute, *About Bower House* (n.d.); *Victoria History of the County of Essex*, 9 vols. (Oxford: 1959), VII, 10; Christopher Hussey, "The Bower House, Havering, Essex," *Country Life* (17 and 24 March 1944), 464–67 and 508–11.

Archival sources: Letters to Rossetti, Angeli-Dennis Papers, University of British Columbia; Essex Record Office (title deeds); Census Return of 1881; letter to the author from D. A. Partridge, Havering Central Library, 9 March 1989.

MAW, John Hornby (1800–85)
55 Aldermanbury, London, and Roydon, Essex; West Hill House, Hastings between 1838 and 1848.

Occupation
Surgical instrument manufacturer, Maw and Co., 11 Aldergate Street, London (now S. Maw, Son, and Thompson). Producer of decorative tiles.

Biography
Born on the Isle of Axholme, the son of George Maw who later moved to London, where he became a manufacturer of druggists' sundries and a pill maker. Maw was educated at Apsley in Bedfordshire and at the Merchant Taylor's school. He was then apprenticed to his father and to a chemist and apothecary in Croydon before studying the making of surgical instruments under Abernethy at St. Bartholomew's Hospital. In 1826 Maw was taken into partnership with his father and in the same year married Mary Anne Johnson, the daughter of a gold and silver refiner in Maiden Lane. Maw's granddaughter notes: "He made money rapidly and bought a small estate near Roydon, Essex, on which to spend the summer months, and there was visited by De Wint from whom he took some sketching lessons. Mr. and Mrs. David Cox and their young son were also beloved and intimate friends and many a sketch and larger picture by both artists did my grandfather purchase" (Burnby, "Pharmecutical Connections," p. 9). Turner attended the fifth birthday party of Maw's daughter Anne Mary in 1835. By 1837 Maw had earned enough money to retire to Hastings and spend his leisure time taking sketching trips to Wales and Yorkshire with David Cox, entertaining W. H. Hunt and his family, and exhibiting his own watercolors at the Royal Academy between 1840 and 1848. He was also the author of a treatise on

landscape painting in watercolors, a correspondent of the *Art Union*, member of the Artists' Conversazione from about 1825, and a founder-member of City of the London Artists' and Amateurs' Conversazione in 1831, where he met Jacob Bell (q.v.). In 1850 Maw purchased Chamberlains of Worcester, a firm that manufactured encaustic tiles, which he moved to Broseley, close to the Ironbridge Gorge in Shropshire (now part of the Ironbridge Gorge Museum). He won awards for his tiles at the International Exhibition of 1862. Maw returned to London and retired for a second time.

Collection
Owned four of Turner's *England and Wales* drawings by 1833 and about fifty watercolors by John Sell Cotman. Maw also possessed a large collection of watercolors by Bonington, Cox, De Wint, J. F. Lewis, Prout, W. H. Hunt, and Girtin.

Taste
Early-Victorian watercolors.

Purchasing pattern
Commissions and direct purchases from artists.

Sales and bequests
Christie's, 24 May 1842.

References
William Collingwood, "Reminiscences: William Hunt," *Magazine of Art* (1898), 503–5; Marianne North, *Recollections of a Happy Life*, 2 vols. (London: 1892), I, 28; Donald McDonald, *The Johnsons of*

Maiden Lane (London: 1964); J. G. L. Burnby, " Pharmaceutical Connections: The Maw Family," *Pharmaceutical Historian* 15 (June 1985), 9–11; Michael Pidgley, "Cotman and his Patrons," in *John Sell Cotman, 1782–1842*, ed. Miklos Rajnai (London: 1982), 22; Gage, *Turner Correspondence*, pp. 150, 154, 168, 174, 237, 269; Wolverhampton, *William Henry Hunt*, p. 22; Sydney D. Kitson, *Life of John Sell Cotman* (London: 1937); *Ruskin Family Letters*, ed. Bird, II, 723; Marcia Pointon, *The Bonington Circle* (Brighton: 1985), 119; Clarke, *Tempting Prospect*, p. 133.

Archival sources: British Museum Add. MS 45883, ff. 7v–8, 28v–9, 33v; letter from W. H. Hunt, 8 March 1839, Hastings Museum and Art Gallery; Family Papers.

McCONNEL, Henry (1801–71)
Polygon, Ardwick, Manchester, and Cressbrook Hall, Cressbrook, Derbyshire.

Occupation
Cotton spinner, McConnel & Kennedy, Union Street, Ardwick, and also at Cressbrook, where he specialized in fine yarn for the luxury market.

Biography
Grandson of a Scottish farmer and son of James McConnel, who founded McConnel & Co. in 1791. Henry married the daughter of John Kennedy, his father's business partner. In 1833 the firm employed 1,553 people. Production declined during the years

1837–43, but returned to prosperity in 1851, when McConnel & Kennedy joined in the purchase of the patent for Heilmann's new combing machine. McConnel retired in 1860, but remained active in community affairs as a governor of the Royal Manchester Institution, although continuing to live at Cressbrook Hall in Derbyshire.

Collection
Active from the 1830s. Began his collection with works by Collins, Constable, Turner, and Uwins before he added pictures by Millais and Wallis. McConnel sold part of his first collection to John Naylor (q.v.) of Liverpool. He formed a second collection chiefly under Agnew's guidance. His last additions were John Phillip's *Murillo* and Rosa Bonheur's *Horse Fair*. Lender to Manchester Art Treasures exhibition.

Taste
Early-Victorian oils and watercolors and Pre-Raphaelite art. Initially adventurous, McConnel's taste became more conventional in the 1860s as he sought out artists who had been famous in the 1830s (Treuherz, "Turner Collector," p. 41).

Purchasing pattern
Commissioned directly from Callcott, Turner, Wilkie, Etty, Landseer, Eastlake, and Collins, but increasingly came to depend on Agnew's.

Sales and bequests
Presented a painting by Salvator Rosa

to the Royal Manchester Institution in 1832. McConnel sold five pictures privately to John Naylor in 1849. At the time of his posthumous sale at Christie's on 27 March 1886, *The Times* noted that it was "the most interesting of its kind that has occurred since the famous dispersions of Mr. Gillott's collection in 1872, Mr. Mendel's sale in 1875, and Mr. Grant's in 1877, the last-named having derived its chief pictures from the Mendel sale" (Redford, I, 427).

References

Art Union (Feb. 1839), 5; *Athenaeum* (14 Dec. 1861), 808; *Art Journal* (Sept. 1870), 286–88; (Oct. 1872), 265; and (Oct. 1886), 306; *Manchester Directories*, 1855–63; de Tocqueville, *Journeys*, p. 108; Francis White, *History, Gazetteer and Directory of the County of Derby* (Sheffield: 1857), p. 642; *The Times*, 29 Jan. 1887, 29 March 1886, and 1 April 1886; Redford I, 427–30; Heath, *Recollections*, pp. 258–59; John Wankyln McConnel, *McConnel and Co. Ltd. A Century of Fine Cotton Spinning* (Manchester: 1906); Clive H. Lee, *A Cotton Enterprise 1795–1840: A History of M'Connel & Kennedy, Fine Cotton Spinners* (Manchester: 1972); Howe, *Cotton Masters*, pp. 77, 97, 296 and 300; Thackray, "Natural Knowledge," pp. 698 and 704; Darcy, p. 163; Treuherz, "Turner Collector," 37–42; Gage, *Turner Correspondence*, pp. 154–56, 159, and 267; Butlin and Joll, *Turner*, I, 205–206, 210–11, 238, 240, and 246; Elizabeth Conran, "Art

Collections," in *Victorian Manchester*, ed. Archer, p. 73; Collins, *Collins*, pp. 333–34; Robertson, *Eastlake*, pp. 266–67; Ormond, *Landseer*, p. 168; Pointon, *Mulready*, p. 70; Heleniak, *Mulready*, pp. 170, 189, 199, 206, 218, and 236; Ormond, *Landseer*, p. 168.

Archival sources: Mulready Correspondence, Victoria & Albert Museum Library; Derbyshire Record Office (notes of Mrs. Vanda Wright).

McCONNEL, Thomas Houldsworth (fl. 1845–74)

Polygon, Ardwick; Moorfield, Higher Broughton; Crumpsall Lodge, Cheetham Hill; Hale Carr, Hale; 2 Dolphin Place, Ardwick; Broughton Park, Cheetham Hill; and Dane Bank, Congleton, near Manchester.

Occupation

Insurance agent, McConnel & Hadfield, 26 Pall Mall, Manchester.

Biography

A relative of Henry McConnel (q.v.) of Manchester. The 1845 Census reporter found him living at the Polygon, Ardwick, the home of Henry's father, James McConnel, who married the sister of Thomas Houldsworth in 1799. Thomas was chairman of the Hale Vestry Committee. He built Hale Carr in the 1850s, which was one of the earliest examples of houses built by Manchester businessmen who wished to live outside of the city (now converted into flats). McConnel was a friend of Manchester artist Frederick Shields, who introduced him to Rossetti.

Collection

McConnel owned watercolors by Rossetti, Shields, Madox Brown, Turner, Cox, Faed, Cooper, A. Bonheur, Phillip, H. Browne, Linnell, and W. Henry Hunt.

Taste

Aesthetic movement and early-Victorian watercolors.

Purchasing pattern

McConnel made direct purchases from Rossetti and Madox Brown.

Sales and bequests

Christie's, 25 June 1864 (145 lots), and Capes & Dunn, Manchester, 31 July 1872.

References

Manchester Directory (1845–74); *Art Journal* (Sept. 1864), 267; Rossetti, *Rossetti as Designer and Writer*, pp. 62–63, 77, *Rossetti Papers*, p. 345; *Rossetti Letters*, ed. Doughty and Wahl, II, 640–41, 644, 929 and III, 1274–75; Surtees, *Rossetti Catalogue Raisonné*, I, nos. 133–139 and 200; *Frederick Shields*, ed. Mills, pp. 113 and 126–27.

Archival sources: Angeli-Dennis Papers and Leathart Papers, University of British Columbia.

McCRACKEN, Francis (fl. 1840–64)

Hillbrook House, Holywood, Belfast, by 1843; 98 Donegal Street by 1846; and Richmond House, Antrim Road, Belfast, by 1863.

Occupation

Cotton spinner, York Lane, Belfast.

Biography

Origins uncertain, possibly the son of Francis McCracken, a Belfast merchant who died in 1837. McCracken's background and occupation were confused by the Pre-Raphaelites themselves. These errors have been continued by such scholars as Ruskin's biographers Cooke and Wedderburn, who incorrectly associated the cotton spinner with James and Richard McCracken, who were packers and shippers for the Royal Academy (IV, 38–39). Not a wealthy man, Francis McCracken often paid for his pictures in installments, offering works by other artists as down payment. He regularly attended exhibitions in Dublin, Liverpool, and London. He sought Ruskin's opinion before buying one of his Rossettis.

Collection

McCracken commissioned Turner's *Morning, Returning from the Ball, St. Mastino* and *Going to the Ball* but rejected both canvases. They were subsequently bought by Windus (q.v.). McCracken owned Ford Madox Brown's *Pretty Baa Lambs* and his oil sketch and finished picture, *Wycliffe*. He later sold both to the dealer D. T. White, who, in turn, sold them to Windus. In addition, McCracken bought and sold Millais's *Othello*, Hughes's *Ophelia*, and Hunt's *Valentine Rescuing Sylvia from Proteus*. He also owned works by Cooper, Creswick, and Danby, among other early-Victorian artists.

Taste

Pre-Raphaelites, Turner, and early-Victorian landscape, genre, and poetic subjects.

Purchasing pattern

McCracken gave direct commissions to artists; made trades and exchanges with artists, dealers, and other collectors, and frequented the salerooms. He was known to employ agents to bid his items up at auction (*Rossetti Letters*, ed. Doughty and Wahl, I, 203).

Sales and bequests

Christie's, (anon.) 17 June 1854 and (anon.) 31 March 1855.

References

Belfast Directories, 1843–63; Millais, *Millais*, I, 151; Warner, "Millais," p. 73; Hunt, *Pre-Raphaelitism*, I, 282 and 309; Hueffer, *Brown*, pp. 68, 84–86, 93, and 101; *Brown Diary*, ed. Surtees, pp. 74, 80 and 82; Rossetti, *Family Letters*, I, 121–22 and 160–61, *Rossetti as Designer and Writer*, pp. 14–15, 17–21, 23, and 36, *Ruskin: Rossetti: Pre-Raphaelitism*, pp. 4, 9, 19, 138, and 191–92; *Rossetti Letters*, ed. Doughty & Wahl, I, 126–27, 133–34, 148, 151, 155, 158, 164–65, 167, 185, 196–98, 202–3, 206, 219, and 253; *Rossetti Allingham Letters*, ed. G. B. Hill (London: 1897), 4, 20, 23–26, 30, 48, 84, 125–26, 131, and 150; Surtees, *Rossetti Catalogue Raisonné*, nos. 44, 58, 64 and 110; Gage, *Turner Correspondence*, pp. 267–68; Butlin and Joll, *Turner*, pp. 263 and 266–67; Woolner, *Thomas Woolner*, pp. 52, 59, and 71; Bennett, "Check List of Pre-Raphaelite Pictures," p. 486; Leonard Roberts and Mary Virginia Evans, "'Sweets to the Sweet': Arthur Hughes's Versions of *Ophelia*," *Journal of Pre-Raphaelite and Aesthetic Studies* I (Fall 1988), 29.

Archival sources: Guildhall Library, London; Public Record Office of Northern Ireland, Belfast.

McCULLOCH, George (1848–1907)

Glasgow; Broken Hill, Victoria, Australia; and 184 Queen's Gate, London.

Occupation

Investor in Australian silver and gold mines at Broken Hill and in the gold fields of Western Australia.

Biography

Although the Victorians touted McCulloch as one of their most successful self-made men, he was well educated and well traveled before he made his fortune in Australia. Born in Glasgow, the son of a contractor, McCulloch attended Andersonian University. He then traveled to Mexico and South America, ostensibly to study farming methods. Deciding to emigrate to Australia in 1870, he was sponsored by his uncle James McCulloch who was Premier of Victoria and a successful sheep station owner. He appointed George manager of his Mount Gipps station, near Broken Hill, giving him a one-eighth share of the profits. Fortuitously for McCulloch, he was in Broken Hill when miner Charles Rasp discovered a rich lode of silver. Advising Rasp to

form a syndicate, McCulloch enlisted the advice of government surveyor William Jamieson in developing the mine. After forming Broken Hill Property Company, McCulloch went to London for financing. Enormously successful, McCulloch retired to England in 1893, where he lavished money on the construction of his home and art collection. He married Mary Agnes Mayger, the widowed daughter of miner William Smith. His estate was valued at £436,000. Mary McCulloch went on to marry artist J. Coutts Mitchie.

Collection
McCulloch spent over £200,000 on some 300 paintings by contemporary English and French artists, including Millais's *Lingering Autumn* (Lady Lever Art Gallery, Port Sunlight) and works by Leighton, Forbes, Watts, Dicksee, Alma-Tadema, Fildes, Albert Moore, Henry Moore, Waterhouse, Whistler, Gérôme, and Bastien-Lepage.

Taste
Late-Victorian collector of contemporary English and French large-scale paintings. McCulloch preferred landscapes and classical subjects.

Purchasing pattern
Relied on the advice of the dealer-critic David Croal Thomson.

Sales and bequests
London, Christie's, 23–30 May 1913 (fetched £136,859).

References
Art Journal (Jan. 1895), 11–12; (Jan 1896), 1–5; (Feb. 1896); 37–40; (March 1896); 65–68; (Dec. 1896), 355–58; (Jan. 1897), 1–4; (Feb. 1897) 57–58; (March 1897), 69–72; (July 1897), 217–19; (Nov. 1897), 325–28; (Dec. 1897), 373–76; *Art Journal* (1909); *Burlington* 14 (Oct. 1908), 329–31 and (March 1909), 263–65; *Australian Dictionary of Biography*, 13 vols. (Melbourne: 1966–91), V, 139–40; Geoffrey Blainey, *The Rise of Broken Hill* (Melbourne: 1968); Bobbie Hardy, *West of the Darling* (Jacaranda: 1969); *The Times*, 5–30 Jan. 1909; *Saturday Review*, 27 Feb. 1909; Royal Academy, *Winter Exhibition* (London: 1909); *Connoisseur* 36 (1913), 191–92; Carter, *Let Me Tell You*, p. 80; Agnew, p. 44; *Boyce Diaries*, ed. Surtees, pp. 56 and 113; Harrison and Waters, *Burne-Jones*, pp. 166–68; Hardie, *John Pettie*, p. 18; Royal Academy, *Lord Leverhulme: A Great Edwardian Collector and Builder* (London: 1980), pp. 30–31; Arts Council, *Great Victorian Pictures*, nos. 1, 13, 23, and p. 95; Houfe, "David Croal Thomson," pp. 112–19.

MEIGH, Charles (d. *c.* 1861)
Grove House, Shelton, Staffordshire.

Occupation
Pottery manufacturer, Old Hall Works, Hanley; reformed as a limited liability company in 1861 and renamed the Old Hall Earthenware Co., Ltd. which it remained until 1886, when it became the Old Hall Porcelain Co., Ltd.

Biography
Grandson of a successful Staffordshire pottery manufacturer, and son of Job Meigh, who invented a glaze for common pottery that was free of the deleterious qualities of the usual lead glaze. Charles took over the business in 1835 and oversaw the display of his company's Crouchware and White Stoneware Saltglaze at the Great Exhibition in 1851. His son, Charles junior, who continued in the family business, was an amateur artist and a pupil of Müller. Meigh was chief baliff of Hanley.

Collection
Meigh is said to have hung "an enormous and valuable picture" in his showroom (Scarratt, *Old Times*, p. 181), presumably Joseph Wright of Derby's *Maid of Corinth,* which was originally painted for Josiah Wedgwood. Ward considered it "so suitable to its present situation, that we, looking at it with the fondness of local association, and not with the eyes of connoisseurs, cannot but consider it as one of the most valuable of the collection" (*History*, p. 385). Meigh also owned works by Maclise, Uwins, Hilton, Herbert, Wilson, Reynolds, Gainsborough, Morland, West, Stothard, Creswick, Lee, Constable, Turner, Cooper, Roberts, Collins, Etty, and Mulready which he displayed in a private gallery attached to his home. The *Art Union* described his choices as "one of the largest and best private collections of pictures in this country" (p. 367).

Purchasing pattern

Meigh frequented dealers such as
Hogarth, Colls, and Griffith, in addi-
tion to bidding at Christie's.

Taste

Early-Victorian and eighteenth-
century English School.

Sales and bequests

Christie's, 21–22 June 1850.

References

Art Union (Dec. 1845), 366–67; *A
Critical and Descriptive Catalogue of the
Collection of Pictures at Grove House,
Shelton* (privately printed, Hanley:
1843); Simeon Shaw, *History of the
Staffordshire Potteries* (1829; rpt.
Newton Abbot: 1970), pp. 44–45;
Rupert Simms, *Bibliotheca Staffordiensis*
(Lichfield: 1894); *Staffordshire
Directory* (1851); William Scarratt, *Old
Times in the Potteries* (1906; rpt. East
Ardsley: 1969), pp. 180–81; John
Ward, *History of the Borough of Stoke
upon Trent* (1843; rpt. London: 1969),
pp. 384–86; Geoffrey Godden, "A
Unique Pair of Exhibition Vases,"
Connoisseur (April 1963), 217;
Llewellyn Jewitt, *Ceramic Art of Great
Britain* (1878; revised London: 1972),
pp. 55–61; Morris, "Naylor," pp.
76–77; Reitlinger, p. 87; Solly, *Müller*,
p. 144; Hall, *Retrospect*, pp. 198–99;
Finberg, *Turner*, pp. 409 and 421;
Heleniak, *Mulready*, pp. 189 and 201;
Collins, *Collins*, II, 351.

MENDEL, Samuel (1814–84)

*The Priory, Greenheys; Manley Hall,
Chorlton; Whalley Range, Manchester; and
Nightengale Lane, Clapham Common,
Surrey.*

Occupation

Cotton and shipping merchant,
Chepstow Street, off Portland Street,
Manchester.

Biography

Son of Emmanuel Mendel, a success-
ful Liverpool ropemaker and draper
who was also active in the cotton trade
(Williams, *Manchester Jewry*, pp. 35 and
93). Emmanuel moved to Manchester
in 1817, when Samuel was three years
old. A non-practicing Jew, Emmanuel
sent Samuel to a school on Brasennose
Street in about 1833 and later into the
employ of Manchester warehouseman
Bernhard Liebert. While working
there, Mendel traveled on business to
Germany and South America, but left
the firm when he was refused a part-
nership. Mendel then rented a ware-
house from Robert Gardner and went
on to become one of the leading mer-
chants and shippers in Manchester,
where he was known as the "merchant
prince" (obituaries). The *Manchester
Guardian* noted that Mendel "did per-
haps the greatest business in grey
goods of any one firm in the trade.
India and China were his chief mar-
kets, but he sent goods all the world
over" (18 Sept. 1884). The competi-
tion resulting from the opening of the
Suez Canal undermined his business
and Mendel suffered reverses which
led him to retire in 1875 and to liqui-
date his art collection (Manchester
City Library press clippings).

Collection

"One that fairly rivals the Gillott col-
lection, sold three years back, in the
number and excellence of the pic-
tures" (Redford I, 199). When
described by the *Art Journal* in 1870,
Mendel's collection consisted of 252
oils, 142 drawings (twenty by Millais),
and nearly all of Turner's engravings.
It was considered to represent a "his-
torical survey of English painting";
however, the collection omitted
works by Hogarth, Wilson, and
Morland. The *Art Journal* claimed that
Turner, Mulready, and Wilkie were
not represented by their best works in
his collection (p. 153). Among the
moderns, Mendel owned Leighton's
Noble Lady of Venice (Leighton House
Museum), Wallis's *Chatterton* (Tate
Gallery), Rossetti's *The Blue Bower*
(Barber Institute of Fine Arts,
University of Birmingham), and
Millais's *Jephtah's Daughter* (National
Gallery of Wales), for which he paid
£4,200 in 1867. He also owned
canvases by such contemporary conti-
nental painters as Gérôme, Delaroche,
Frère, and Koekkoek. The collection
was hung in connecting rooms with
sliding doors which, when opened,
formed a continuous gallery. Mendel
displayed a separate collection of
sculpture in a conservatory.

Taste

Mid-Victorian collector of English
art, ranging from early to contempo-
rary works of art, including sculpture,
paintings, and watercolors arranged

in portfolios, in addition to Old Master engravings. Redford claimed that Mendel's possessions ranked high in importance, even compared to public collections. Agnew notes that Mendel had "a great weakness for Bonington and the more highly finished Turner" (p. 21).

Purchasing pattern

Agnew's, with whom Mendel often exchanged pictures. Redford commented on Mendel's reliance on dealers, noting that he avoided direct commissions and the sale rooms.

Sales and bequests

Christie's, for twenty-one days, beginning 15 March 1875. The sale of pictures on 23 April netted £98,000; however, 100 of the most important works were privately sold to Agnew beforehand for an estimated £50,000 (Agnew, p. 21).

References

Art Journal (April 1870), 106; (May 1870), 153–56; (July 1870), 209–11; and (April 1875), 342; Boase; *Manchester Guardian*, 18 Sept. 1884; W. E. A. Axon, *The Annals of Manchester* (Manchester: 1886), p. 407; *Manchester City News*, 15 Nov. 1913; *The Times*, 18 Feb. 1875; Frith, *Autobiography*, I, 270; Redford, I, 199–201; Roberts, I, 228–32; Heleniak, *Mulready*, p. 211; Agnew, pp. 20–21; Maas, *Gambart*, pp. 104 and 185–88; Reitlinger, pp. 101–3 and 152; Elizabeth Conran, "Art Collections," in *Victorian Manchester*, ed. Archer, pp. 73–75; Carter, *Let Me Tell You*, p. 68; Ormond, *Leighton*, no. 115, p. 156; Chapel,

Victorian Taste, nos. 13, 19, and 71; Rossetti, *Rossetti as Designer and Writer*, p. 53; Surtees, *Rossetti Catalogue Raisonné*, no. 178, p. 102; Bill Williams, *The Making of Manchester Jewry* (Manchester: 1985), pp. 35, 93, 98, and 157.

Archival sources: Manchester City Libraries biographical press clippings; Agnew's Stockbooks; Angeli-Dennis Papers, University of British Columbia (mentioned in letters of William Graham (q.v.) to Rossetti).

MILLER, John (1798-1876)

9 Everton Brow; 1 Gloucester Place, Low Hill, by 1858; Breeze Hill, Liverpool; and Ardencraig House, Isle of Bute, from 1840.

Occupation

Tobacco, cotton, and timber merchant, shipowner, and arbiter, Miller, Houghton & Co., Liverpool.

Biography

Origins unknown. Miller was born in Scotland, the younger brother of George Miller of Frankfield and Gartcraig. He is often confused with Thomas Miller of Preston (q.v.), who was also a patron of Millais. He was a partner in Miller, Houghton, & Co. which was one among many modest firms engaged in the North American trade in cotton, timber, and tobacco (Porter, *Victorian Shipping*, p. 28). According to the *Buteman*, Miller gave up his business to become an arbiter in commercial disputes. He was elected president of the Council of the Liverpool Academy in the 1850s, which was known as "'the Miller' and

his Men" (Elias, *Lea*, p. 15). Prior to the founding of the Liverpool Academy, Miller hosted a weekly "reunion" of artists and collectors in his home. William Michael Rossetti called him "one of the most cordial, large-hearted, and lovable men I ever knew" (*Designer and Writer*, p. 15). Two of Miller's daughters were amateur artists; Gussy Miller married Peter Paul Marshall, one of the founders of Morris, Marshall, Faulkener, & Co., while Margaret married Donald Currie, who formed his own shipping company and was later knighted. Art collecting also played a role in the lives of Currie and his sisters, who married Liverpool patrons Robert Rankin (q.v.) and David Jardine (q.v.). The sale of a portion of Miller's collection in 1858 may have been prompted by his decision to become an arbiter; however, he continued to make purchases from Agnew's in the 1860s. Although Miller left an estate of less than £5,000 (Porter, *Victorian Shipping*, p. 29), his son Peter continued to add to the family art collection.

Collection

Miller began collecting the works of Turner, Etty, Cox, Linnell, and Constable in the 1840s. He became interested in the Pre-Raphaelites in the early 1850s, when he bought Millais's *The Blind Girl* (Birmingham City Art Gallery) and *Autumn Leaves* (Manchester City Art Gallery), Madox Brown's *An English Fireside* (Walker Art Gallery, Liverpool), and Holman

Hunt's *The Eve of St. Agnes* (Walker). He lent pictures to the Hogarth Club exhibition in Russell Place in 1858. Miller also owned pictures by the Liverpool artists Davis, Tonge, and Windus. Miller encouraged Davis to abandon figure painting for landscape and was Windus's first supporter. His collection outgrew his home and overflowed into his office where pictures "were stacked, face against the wall, several deep" (Elias, *Lea*, p. 15). Miller frequently entertained artists and introduced them to other collectors, such as when he brought Rossetti to the attention of F. R. Leyland (q.v.) in 1865.

Taste
Pre-Raphaelite and Liverpool school artists, in addition to Royal Academicians.

Purchasing pattern
Commissions and direct purchases from artists. Miller was an occasional client of Agnew's in the 1850s and 1860s. He also traded with other collectors, notably James Eden and Joseph Gillott (q.v.).

Sales and bequests
Christie's, 21 June 1851 and 20-22 May 1858; Liverpool, Branche & Leete, 6 May 1881.

References
The Buteman, 28 Oct. 1876; *Wilson's Guide to Rothesay and the Island of Bute* (Rothesay: 1848), pp. 85-86; J. B. Lawson, *Rothesay and its People Fifty Years Ago* (Glasgow: 1923); Elias, *John Lea*, 15-16; *Riches into Art*, ed. Starkey, pp. 54–66; Andrew Porter, *Victorian Shipping, Business and Imperial Policy: Donald Currie, the Castle Line and Southern Africa* (Woodbridge: 1986), pp. 28-29, 153; Hunt, *Pre-Raphaelitism*, I, 282 and II, 95; Rossetti, *Some Reminiscences*, 2 vols. (London: 1906), I, 9, 226; Rossetti, *Family Letters*, I, 217, *Rossetti as Designer and Writer*, pp. 15, 39, 46, 48, 59, *Pre-Raphaelite Diaries and Letters*, pp. 32-33, 44, and 46, *Rossetti Papers*, pp. 232-34, *Ruskin: Rossetti: Preraphaelitism*, pp. 185-86 and 243; *Rossetti Letters*, ed. Doughty and Wahl, I, 317 and *passim*; *Rossetti Allingham Letters*, ed. G. B. Hill (London: 1897), pp. 129, 150-52, 187, and 254; Surtees, *Rossetti Catalogue Raisonné*, nos. 89, 120, 131, and 229; Hueffer, *Brown*, pp. 136-37, 143-44; 166, 171, 178, and 180; *Brown Diary*, ed. Surtees, pp. 188-90, 195, 204, and 207; Ford Madox Ford (Francis Hueffer), *Ancient Lights and Certain Reflections* (London: 1911), pp. 24-25; Bennett, "Liverpool Prize," pp. 748-53, "Check List of Pre-Raphaelite Pictures," p. 489; Darcy, pp. 147-49; Agnew, p. 19; Maas, *Gambart*, p. 66; Butlin and Joll, *Turner*, I, 32, 85-86, 124, 195-96, 233, 239, 257, 261-62, and 312; Graves, *Century of Loan Exhibitions*, nos. 508, 700-1, 1325, 1330-32, and 1695; Warner, "Millais," p. 72.

Archival sources: Letters from Frith and Rossetti, Fitzwilliam Museum Library; 5 letters from Gillott (1858), Gillott Papers, Getty Archives, Santa Monica; letters from Rossetti, Troxell Papers, Princeton; Leathart Papers, University of British Columbia; Agnew's Stockbooks.

MILLER, Thomas (1811–65)
Singleton Park, Great Singleton, Lancashire (now a home for physically handicapped children operated by Lancashire County Council).

Occupation
Cotton manufacturer, Horrocks, Miller & Co., Preston.

Biography
Son of Thomas Miller (1767–1840) of Bolton, who moved to Preston in 1802 to manage a portion of Horrocks & Co. Miller senior was made a partner in Horrocks, Miller, & Co in 1809. "The name of Horrocks became, as it has remained ever since, a household word wherever good cotton fabrics were used. Horrocks' long-cloths secured a reputation that ultimately extended to every part of the habitable globe" (*Fortunes*, ed. Hogg, p. 170). Miller was mayor of Preston for three terms, and when he died, in 1840, left a considerable fortune. His son Thomas junior, known as Alderman Miller, became principal partner in the firm in 1846 and sole proprietor in 1860. He was chief of the Liberal, Dissenting millowners, but remained aloof from parliamentary politics (Howe, *Cotton Masters*, p. 118). He provided a public park for Preston, built the parish church of St. Anne, endowed a scholar-

ship at Preston Grammar School (1865), and was a lender to Manchester Art Treasures exhibition. At his death Miller left a fortune of almost half a million pounds (*Fortunes*, ed. Hogg, p. 178).

Collection

Miller displayed his extensive art collection in a specially constructed gallery adjoining Singleton Park. His purchases included Constable's *View on the Stour*, Turner's *Venice*, *Quilleboeuf*, and *Bonneville*, as well as oils by Millais (four), Maclise, Leslie, Mulready, Frith, Etty, Webster, Ward, Dyce, Linnell, Landseer, Poole, and Hook. He also owned a large collection of watercolors. A current descendant, Richard Dumbreck, recalls that when he made his first visit to Singleton Hall in 1926, he was struck by Millais's *The Huguenot*. He also recollects that "one of the Millers must have had a strong sadistic streak as the house was full of blood-bespattered taxidermy, ranging from an elephant's head on the stairs with a tiger hanging from it, to stoats doing nasty things to rabbits" (letter to the author, 13 Oct. 1986).

Taste

Pre-Raphaelite and early-Victorian oils and watercolors.

Purchasing pattern

Direct commissions and purchases from artists as well as from Agnew's.

Sales & Bequests

Miller left his oil paintings to his son

Thomas Horrocks Miller (1846–1916) and his watercolors to his other son William Pitt Miller (d. 1893). Also a client of Agnew's, Thomas Horrocks Miller added works by Landseer, Leslie, Linnell, Constable, Turner, and the Pre-Raphaelites before he lent his collection to the Royal Academy Winter Exhibition of 1889. Both portions of the collection passed to Thomas Pitt Miller after Thomas Horrocks Miller's widow died in 1941. Thomas Pitt Miller's death in 1945 precipitated his sale at Christie's on 26 April 1946.

References

Art Journal (Feb. 1857), 41–42; *Fortunes Made in Business*, ed. James Hogg (London: 1891), pp. 161–78; Howe, *Cotton Masters*, pp. 10, 21, 25, 27, 116, 118, 278, 292, and 299–300; Royal Academy, *Catalogue of the Exhibition of Works by the Old Masters, and by Deceased Masters of the British School* (London: 1889); Frith, *Autobiography*, I, 155–56, 261–62, and 264; Darcy, p. 144; Agnew, p. 18; Cope, *Reminiscenses*, pp. 225–26; Uwins, *Uwins*, I, 137–39; Taylor, *Leslie*, II, 196, 214, 262, 269, 281, 311, and 323; David Ballantine, *Life of David Roberts* (Edinburgh: 1866), p. 184; Temple, *Guildhall Memories*, p. 97; Walter Armstrong, *Turner* (London: 1902), pp. 219 and 232; Butlin and Joll, *Turner*, I, 15, 35, 195, 203, and 240; Millais, *Millais*, I, 149; Warner, "Millais," pp. 100 and 103; Heleniak, *Mulready*, p. 200; Pointon, *Mulready*, p. 71; Faberman, "Egg," pp. 176 and 229–30.

Archival sources
Private family press clipping album; recollections of Richard Dumbreck; letter to Miller from Frith, Fitzwilliam Museum Library (MS3-1966).

MITCHELL, Abraham (1824–96)
Bowling Park, Rooley Lane, Bradford, and Tourmakeady, Ireland.

Occupation

Worsted spinner.

Biography

Son of Thomas Mitchell, who died in 1852. Abraham and his brother Joseph inherited the family business, which specialized in producing mohair for the luxury trade. They built twin mansions designed by John Tertius Fairbank on the outskirts of Bradford. The brothers were unrelated to John Mitchell (q.v.) of Bradford. Abraham's son Thomas was a founding member of the Arcadian Art Club.

Collection

Mitchell's collection was largely formed in the 1860s and 1870s and consisted primarily of cabinet-sized oil paintings by artists such as Thomas Faed, Goodall, and La Thangue which he displayed in a private gallery attached to his home.

Taste

Mid- to late-Victorian preference for contemporary English and French canvases.

Purchasing pattern

Mitchell was a client of Agnew's

Manchester branch, but he also commissioned artists directly.

Sales and bequests
By descent and bequests to Bradford Art Gallery.

References
Bradford Art Galleries and Museums, *The Connoisseur: Art Patrons and Collectors in Victorian Bradford* (Bradford: 1989).

MITCHELL, Charles (1820–95)
Low Walker and, after 1869, Jesmond Towers, Jesmond, Newcastle.

Occupation
Shipbuilder, Sir W. Armstrong, Mitchell, & Co., Low Walker and Elswick.

Biography
Born in Aberdeen, the son of Margaret Gillas and George Mitchell, a merchant, Charles was privately educated at Ledingham's Academy and Marischal College prior to his apprenticeship in ironfounding and engineering with William Simpson & Co. He concentrated on shipbuilding after leaving Scotland for Tyneside in 1842, where he worked for local entrepreneurs for ten years before establishing his own shipyard at Low Walker. An expert in the building of iron vessels, Mitchell was invited to St. Petersburg in 1862 to supervise the conversion of its dockyard from wooden to iron construction. Mitchell merged his shipbuilding enterprise with the Elswick yard of Sir William Armstrong (q.v.) in

1882, forming a mammoth operation that employed 15,000 workers. At the time of Mitchell's death in 1895 the company was valued at £3 million. Mitchell's philanthropy extended to the establishment of a Mechanics' Institute at Walker; the construction of St. George's Church, Jesmond; and bequests to Marischal College. He was also the financial benefactor of the Newcastle Arts Association. Mitchell's patronage was continued by his son Charles William (1855–1903), a professionally trained painter who channeled his artistic interests into the public sphere after he inherited his father's financial empire.

Collection
An insurance inventory taken of Mitchell's collection in 1883 lists over 400 works of art. He displayed the choicest items in a private picture gallery designed by Thomas Ralph Spence for Jesmond Towers. Mitchell's purchases ranged from artists of the early English School, including Girtin, Morland, Danby, Westall, and Etty, to Aesthetic movement practitioners such as Albert Moore and Walter Crane. The tastes his son acquired in Paris can be detected in the selection of pictures by Greuze, Bouguereau, Comte, and Fantin-Latour. Mitchell also possessed works by Newcastle painters and a collection of contemporary sculpture.

Taste
Aesthetic movement and figurative subjects by English and French contemporary painters.

Purchasing pattern
Artists' studios and presumably from exhibitions and salerooms.

Sales and bequests
Newcastle, Atkinson & Garland, 20 Sept. 1910, and Anderson & Garland, 20–21 Sept. 1926.

References
Newcastle Daily Chronicle, 23 Aug. 1895; Donald F. McGuire, *Charles Mitchell, 1820–1895, Victorian Shipbuilder* (Newcastle: 1988); Sydney Middlebrook, *Newcastle Upon Tyne* (Newcastle: 1950), p. 243; Temple, *Guildhall Memories*, pp. 208–209; Benedict Read, *Victorian Sculpture* (New Haven and London: 1982), pp. 243–44; Macleod (1989a), pp. 201–7 and pl. 38c; Macleod (1989b), pp. 29 and 128–29.

Archival sources: Mitchell Family press clippings; estate records and inventories, Northumberland County Record Office; Leathart Papers, University of British Columbia.

MITCHELL, John (1808–84)
Parkfield House, Bradford (now a convent and boarding school); Manchester, after 1869; died at Lytham St. Anne's, Lancashire.

Occupation
Merchant, manager of Bradford branch of A. & S. Henry, international shipping and trading firm until 1869

when he was appointed manager of the company's head office in Manchester.

Biography

Social origins unknown. Mitchell was influenced by Ruskin's *Political Economy of Art* and invited him to speak in Bradford in 1859 and 1864. He was an election agent and also worked behind the scenes on Cobden's commercial treaty with the French in 1860. Mitchell also knew Louis Kossuth, the Hungarian liberator. He was a member of the National Association for the Promotion of Social Science and a patron of the Bradford Choral Society. Although Mitchell purchased two works by Rossetti, he can hardly be considered a patron, since his object was to find art that was "effective as a room decoration" (Hardman, *Ruskin*, p. 504).

Collection

Mitchell began buying from Rossetti in 1864. Despite his admiration for Ruskin, he owned the critic's least favorite Rossetti, *Venus Verticordia*. Rossetti considered Mitchell "the decentest of the lot" in Bradford (*Letters*, II, 516).

Taste

Aesthetic movement.

Purchasing pattern

Mitchell employed John Aldam Heaton as his agent.

Sales and bequests

Christie's, 1 March and 22 July 1875; 13 July 1898 (silver).

References

Athenaeum (21 Oct. 1865), 11; Hardman, *Ruskin and Bradford*, pp. 34, 225–37; *Manchester Guardian*, 21 Aug. 1884; *Parkfield House Sale Catalogue* (Manningham: 1899); *Rossetti Letters*, ed. Doughty and Wahl, II, 504, 516, 518–19, 555–56, 570, 606, 786, 896–97, III, 928; Surtees, *Rossetti Catalogue Raisonné*, I, nos. 167 and 173; *Frederic Shields*, ed. Mills, pp. 139–40, 146; Hueffer, *Brown*, p. 57; *The Winnington Letters*, ed. Van Akin Bird (London: 1969), pp. 100–1.

MORRIS, John Grant (1810–97)

Allerton Priory, Woolton, Liverpool and 36 Grosvenor Place, London. Also resided in Norfolk and Cannes.

Occupation

Coal mine proprietor.

Biography

Son of T. Morris of Liverpool. Reportedly a self-made man, Morris rose through the ranks of the coal trade, first becoming a manager, and then an owner. He built a large mansion in the Gothic style designed by Alfred Waterhouse (1867–70). Morris served as an alderman and mayor of Liverpool in 1866. He married Miss Baines, a member of an old and well-known Liverpool family (*Liverpool Mercury*). Two of their sons became barristers. His will was proved at £295,904.

Collection

A mixed gathering of modern English and foreign artists, including W. Henry Hunt (five), Palmer, Turner, Fielding, Millais, Linnell, Frère, Gérôme, Breton, Frith, and Redgrave. Morris lent P. H. Calderon's *Her Most High and Puissant Grace* to the International Exposition in Paris in 1867.

Taste

Early to mid-Victorian: English, French, and Pre-Raphaelite.

Purchasing pattern

Possibly Agnew's.

Sales and bequests

Christie's 21–22 April 1898 (china) and 23–25 April 1898 (paintings and watercolors).

References

Athenaeum (13 Sept. 1884), 340–41; *Liverpool Courier*, 24 June 1897; *Liverpool Mercury*, 19 August 1897; Orchard, *Liverpool's Legion of Honour*, p. 510; Marillier, *Christie's*, p. 74; Pevsner, *South Lancashire*, p. 210; Girouard, *Victorian Country House*, p. 442; Witt, *W. Henry Hunt*, p. 257; Macleod (1986), p. 606.

MORRISON, James (1789–1857)

Finsbury Square and later at 95 Upper Harley Street, London; bought Balham Hill, near Clapham in 1820s and Fonthill Pavilion as well as Basildon Park, Pangbourne, Berkshire, in the 1830s. Basildon was remodeled by J. B. Papworth and remained in the family until it was sold to Lord Iliff in 1954, who gave it to the National Trust.

Occupation

Merchant (silk mercer and draper), Morrison, Dillon, & Co. (later Fore St. Co.) and merchant banker, Morrison, Sons, & Co.

Biography

Son of Joseph Morrison, an innkeeper, near Salisbury. Morrison married the daughter of Joseph Todd, a Cheapside silk mercer and draper, and was made a partner in this firm, later known as Morrison, Dillon, & Co. He was one of the first English traders to depend for his success on the lowest remunerative scale of profit. His motto, "small profits and quick returns" (*DNB*), resulted in an immense fortune. Morrison bought land in Berkshire, Buckinghamshire, Kent, Wiltshire, Yorkshire, and Islay, Argyllshire, and he invested in Robert Owen's experiment at New Lanark. He was a member of the Bentham Circle of radicals and a Freethinking Christian. Morrison was Liberal MP for St. Ives and Ipswich 1830–37 and for Inverness 1840–47. He was also one of the prime movers behind the Government School of Design in 1837. His estate at his death was valued between £1.5 million in Britain and almost £1 million in America.

Collection

Began collecting *c.* 1823. Morrison owned Wilkie's *Confessional*, Turner's *View of Stourhead*, *Pope's Villa at Twickenham*, and *Thomson's Aeolian Harp*. He also purchased Constable's *The Lock*, as well as works by Hilton,

Eastlake, Collins, Webster, Hogarth, Stanfield, Ward, Poussin, Leonardo, and Teniers. Eastlake tried to interest him in having Lawrence's collection preserved for the National Gallery, without success. He holds the distinction of being the only English collector Constable sold to by 1828 other than Archdeacon Fisher (Whitley, *Art in England*, p. 143). He also entertained Turner at Basildon. Morrison displayed his English paintings in the magnificent Octagon Room at Basildon Park (see Waagen, IV, 301–4). This room was sold to the Waldorf-Astoria Hotel in New York in the 1930s. In 1831 Morrison turned his attention to the collecting of Old Masters (see Brigstocke, *Buchanan*).

Taste

Early-Victorian landscape and subject pictures and Old Masters.

Purchasing pattern

Asked advice of Chantrey, Pickersgill, Papworth, and Eastlake. It was Pickersgill who persuaded him to buy his Constable at the Royal Academy in 1824. For his Old Masters he consulted Buchanan.

Sales and bequests

Private sales and by descent. Major beneficiary is the Walter Morrison Picture Settlement, Sudeley Castle, Winchcombe, Cheltenham.

References

Waagen (1854), II, 260–63; Waagen (1857), pp. 300–12; *DNB*; *DBB*; *Pigot's London Directory* (1838); Wyatt A.

Papworth, *J. B. Papworth, Architect to the King of Wurtenburg, Life and Works* (London: 1879); Collins, *Collins*, I, 249, 264, 266 and II, 346; "Constable Correspondence," XVIII, 205; Cormack, *Constable*, p. 157; Whitley, *Art in England*, pp. 61, 143, 265; Butlin and Joll, *Turner*, I, 55 and 64; Edward Boykin, *Victoria, Albert and Mrs. Stevenson* (New York: 1957); Brigstocke, *William Buchanan*, pp. 31, 33–35; Robertson, *Eastlake*, pp. 52, 263, 377; Marcia Pointon, *The Bonington Circle* (Brighton: 1985), p. 265; Graves, *Century of Loan Exhibitions*; *County Life* (5 May 1977), 1158–61; (12 May 1977), 1227–30; (19 May 1977), 1298–99; Gatty, *James Morrison*.

Archival sources: Morrison Papers, Lord Margadale Collection, Fonthill House; and Guildhall Library.

NAYLOR, John (1813–89)

Liscard Manor in 1846, and in 1851, Leighton Hall, Welshpool.

Occupation

Partner in banking firm, Leyland & Bullins, Liverpool.

Biography

The son of middle-class parents, Naylor inherited £600,000 from his great-uncle Thomas Leyland, who, after winning a state lottery, increased his fortune in the slave trade, property, and banking. Naylor was educated at Eton, where he studied drawing. After his marriage in 1846, he bought Liscard Manor and five years later

spent £285,000 on the property and neo-Gothic construction of Leighton Hall. His brother Richard of Hooton Hall, Chester, was also an art collector (see description of his sale in *Art Journal* [1875], 344).

Collection

Naylor spent £57,000 on contemporary paintings and sculpture between 1848 and 1860. According to Edward Morris, Naylor "preferred the older generation of artists born at the end of the 18th Century; he avoided the avant-garde Pre-Raphaelites and Constable; James Ward and Henry Howard are curious omissions; Haydon was too notorious for a banker; Leslie presumably 'did' for E. M. Ward, Frith for Egg and Martin for Danby; Crome, Stark and Constable were perhaps too 'natural' but Müller is an odd omission" ("Naylor," pp. 78–79). In addition, Naylor owned works by Turner, Gainsborough, and Reynolds, as well as paintings by Delaroche, Scheffer, and Horace Vernet which he bought in Paris in 1850 and 1852.

Taste

Mid-Victorian collector of earlier and modern English school and conservative French art.

Purchasing pattern

Naylor rarely bought directly from artists, preferring to purchase pictures which had already been approved by other collectors. He was a bidder at the Samuel Cartwright (q.v.) sale in 1865 and made private transactions with Gillott (q.v.) and Henry McConnel (q.v.). He was also a client of Agnew's and the Liverpool dealer R. H. Grundy.

Sales and bequests

Christie's, 2 Aug. 1875, and by descent; Christie's 19 Jan. 1923; Liverpool, Harrods, 17–19 March 1931; Lloyd, 21–22 Sept. 1950.

References

Waagen (1854), III, 241–42; T. H. Naylor, *The Family of Naylor from 1589* (Liverpool: 1967); *Catalogue of Pictures Exhibited at a Soirée given by John Buck Lloyd, Mayor of Liverpool, at the Town Hall, September 23rd, 1854*; Morris, "Naylor," p. 72–101; *Riches into Art*, ed. Starkey, pp. 49–54; Darcy, pp. 146–47; Hawthorne, *English Notebooks*, p. 127; Arthur Todd, *The Life of Richard Ansdell* (London: 1919), p. 17; Taylor, *Leslie*, II, 72 and *passim*; Collins, *Collins*, II, 348–49; Cooper, *My Life*, I, 267–69; Farr, *Etty*, p. 149; Frith, *Autobiography*, I, 122ff.; Cunningham, *Wilkie*, III, 239; Redford, I, 427; Agnew, p. 19.

Archival sources: Inventory of Collection, Naylor Family Papers.

NEWALL, Robert Stirling (1812–89)
Ferndene, Gateshead.

Occupation

Engineer, astronomer, inventor, and manufacturer of wire rope for submarine telegraph cable.

Biography

Born in Dundee, son of Robert Newall, a merchant, Newall first worked in a mercantile office and then relocated to London, where he was employed by Robert McCalmont on a series of experiments in the rapid generation of steam. McCalmont sent Newall to America for two years, and when he returned, in 1840, he took out a patent for wire ropes, establishing his own firm at Gateshead-on-Tyne to manufacture them in partnership with Liddell and Gordon. These ropes provided the basis for the submarine telegraph cable, the first of which was laid between Dover and Calais in 1851. Further improvements and inventions followed, and Newall was frequently present at the laying of various cables around the world. His company manufactured half of the first Atlantic cable. In addition, Newall developed a telescope in 1871. He married, in 1849, Mary, the daughter of chemical manufacturer Hugh Lee Pattinson. Their daughter Phoebe married the art collector Norman Cookson, while their son Frederick married the niece of Ellen Heaton (q.v.). A second son, William, was a sculptor and art collector (see *Art Journal* [Aug. 1903], 224–29). Newall's Gateshead neighbor was James Leathart (q.v.).

Collection

Newall began collecting in the early 1860s. He owned works by A. W. Hunt, Turner, Cox, Holliday, Leighton,

Landseer, Mason, the Faeds, Goodall, and Watts. His grandson Christopher Newall suggests that he may have owned a study that combined the figures in Albert Moore's *Battledore* and *Shuttlecock* (Christie's sale catalogue, 13–14 Dec. 1979, no. 211).

Taste
Mid-Victorian nature subjects and figural compositions. Newall's scientific interests attracted him to precise renderings of light and color.

Purchasing pattern
Purchases from artists and Agnew's.

Sales and bequests
Newall's collection was divided among his five children. Portions were sold at Christie's, 27–28 June 1922 (William Newall) and 13–14 Dec. 1979 (N. D. Newall). Robert Newall 1979 bequests to Ashmolean Museum of Leighton's *Acme and Septimus* and to National Gallery.

References
Athenaeum (27 Sept. 1873), 407–8 and (27 April 1889); *DNB*; Boase; *DBB*; *Newcastle Daily Leader*, 23 April 1889; Holiday, *Reminiscences*, pp. 169–73; Maas, *Victorian Art World in Photographs*, pp. 187–88; Ormond, *Leighton*, no. 181; Macleod (1986), p. 606; Macleod (1989a), p. 196 and pl. 40a; Macleod (1989b), p. 129.

Archival sources: A. W. Hunt Papers, Cornell University; Newall Family Records.

NEWSHAM, Richard (1798–1883)
Winckley Square, Preston.

Occupation
Barrister (practiced until 1842) and partner in the Old Preston Bank.

Biography
Son of Richard Newsham, a banker and a cotton trader who was a partner in Horrocks, Miller & Co. Richard junior inherited his estate, valued at £50,000, in 1843, which enabled him to retire. An Anglican, Newsham junior was an active philanthropist, donating over £25,000 to schools, churches, and cotton famine relief funds. He also served as a county Justice of the Peace. He was a lender to the Manchester Art Treasures exhibition. Newsham was the only early Victorian in the Manchester area to bequeath his art collection to the public.

Collection
Newsham followed the example of his friend Thomas Miller in purchasing the works of living artists. He owned paintings by Danby, Linnell, Egg, Lewis, Phillip, Müller, Collins, Creswick, Roberts, W. Henry Hunt (twenty), Cox (ten), and Frith. He stopped collecting after his walls were covered with over 100 pictures. His last addition was J. F. Lewis's *The Beys Garden* in 1865. In 1883, in preparation for his bequest to the corporation of Preston, Newsham drafted an itemized catalogue in which he noted what he had paid for each work, and rendered a current valuation of its worth (MS Harris Library and Museum). An amateur artist, Newsham designed his own memorial in stained glass for St. James's, Preston.

Taste
Early-Victorian academic and popular oils and watercolors. Newsham favored the intimate format of the anecdotal keepsake.

Purchasing pattern
In addition to seeking Miller's advice, Newsham patronized Agnew's (Agnew, p. 18) and the Manchester dealer R. H. Grundy. Beginning in the year 1820, he was also a frequent visitor at Royal Academy exhibitions, where he either bought or commissioned pictures directly from E. M. Ward, Linnell, Roberts, Phillip, Egg, Hook, O'Neill, Cope, and Leslie. He was known to attend sales at Christie's, notably the Vernon sale in 1849, where he acquired a Landseer, and the Mendel sale in 1875, where he bid on a Linnell (*Newsham Bequest*, nos. 29 and 56).

Sales and bequests
Bequest to Harris Library and Museum, Preston.

References
Art Journal (Nov. 1858), 322–23; *Magazine of Art* (Oct. 1900), 49–56; *Manchester Examiner and Times*, 15 Jan. 1884; *Fortunes Made in Business*, ed. James Hogg (London: 1891), p. 169; Agnew, 18; Frith, *Autobiography*, I, 150 and 250; *Catalogue of the Pictures and Drawings of the Newsham Bequest to the Corporation of Preston*, ed. James

Hibbert (Preston: 1884); Cope, *Reminiscences*, pp. 190 and 225; Taylor, *Leslie*, II, 296, 304, and 323–24; David Ballantine, *Life of David Roberts* (Edinburgh: 1866), p. 164; Witt, *W. Henry Hunt*, p. 56; Faberman, "Egg," p. 173; Frederick J. Cummings and Alan Staley, *Romantic Art in Britain* (Philadelphia: 1968), p. 284; Stephen V. Sartin, "Richard Newsham's Collection," *Antique Collector* (July 1985), 42–49.

Archival sources: Newsham's holographic catalogue, Harris Library and Museum, Preston; letter from Frith to John Miller, Fitzwilliam Museum; Royal Manchester Institution Letter Book (M6/1/49/5), pp. 263, 271, 275, 370, and 371 (loans to the Art Treasures exhibition).

PATTINSON, William Watson (1813–94)

New House, Felling, Gateshead and London (after 1888).

Occupation

Chemical manufacturer, H. L. Pattinson & Co., Felling, Newcastle.

Biography

Grandnephew of Thomas Pattinson of Alston, Cumberland, a retail trader, and nephew of Hugh Lee Pattinson (1796–1858), who invented the processes for the desilverization of lead which produced the German verb *pattinsoniren* and the French *pattinsonage* (*DNB*). William Watson entered the family business, where he remained until the firm was closed in 1888. In

keeping with their Quaker principles, the Pattinsons expressed their concern for the social conditions of their workers by building a school at Felling, as well as a newsroom and a library (*Newcastle Daily Chronicle*). His cousins married art collectors Isaac Lowthian Bell (q.v.) and Robert Stirling Newall (q.v.), while his cousin Hugh Lee Pattinson junior (1830–98) was also an art collector.

Collection

Pattinson purchased works by William Bell Scott, John Varley, Birket Foster, Charles Napier Hemy, Arthur Hughes, and Simeon Solomon.

Taste

Mid-Victorian collector of landscape and Pre-Raphaelite subjects.

Purchasing pattern

Possibly bought Turner's *Lyme Regis* from Gambart (*Athenaeum*). Pattinson commissioned a "Chinese picture" from Simeon Solomon (Leathart Papers) and a family portrait from Arthur Hughes titled *A Birthday Picnic* (Forbes Magazine Collection, New York).

Sales and bequests

Newcastle-upon-Tyne, Davison & Son, 15 and 21 April 1885; 21 and 22 Dec. 1886.

References

Athenaeum (16 Oct. 1875), 515–16; *DNB* (Hugh Lee Pattinson); Boase; *Newcastle Daily Chronicle*, 24 Oct. 1898; Henry Lonsdale, *The Worthies of Cumberland*, 5 vols. (London: 1867–73), IV, 319; Leslie Cowan

Arthur Hughes (Cardiff: 1971), nos. 17 and 18; Macleod (1989b), p. 129.

Archival sources: Letter from Simeon Solomon to James Leathart (n.d.), Leathart Papers, University of British Columbia.

PENDER, Sir John (1815–96)

18 Arlington Street, Green Park, London; Crumpsall Green, Manchester; Footscray Place, near Sidcup, Kent; and Middleton Hall, Linlithgow.

Occupation

Cotton merchant and pioneer of submarine telegraphy, Eastern & Associated Telegraph Co., Old Broad Street, London.

Biography

Son of Marion Mason and James Pender of Dumbarton, who belonged to "the Scotch [sic] Lowland and middle class" (*DBB*). Pender was educated at the Vale of Leven parish school and Glasgow High School. He worked as a merchant in textile fabrics in Glasgow and Manchester. In Manchester he was commended for keeping on his workers during the cotton famine and for organizing charitable relief (*DBB*). Pender became interested in submarine telegraphy and was one of the founders of the first Atlantic Cable Company in 1856. He and his associates made four attempts to lay a transatlantic cable, finally succeeding in 1866. Using this expertise, Pender extended his efforts to India and China until, by 1873, his Eastern & Associated Telegraph Co. owned a

third of all cable mileage then in existence (*DBB*). Pender later became chair of the Metropolitan Electric Supply Co. in London. He was a MP, county Justice, and deputy lieutenant. Pender also served as a member of the Free Art Gallery and Museum committee in Manchester in 1860. He was knighted in 1888 and made a baronet in 1892. Pender's estate was proved at £337,180.

Collection

Art collecting was Pender's main interest outside his work. His holdings increased to such an extent between 1872 and 1892 that the *Art Journal* reviewed his collection twice. Pender's private *Catalogue* listed works by Landseer, Stanfield, Roberts, Callcott, Ward, Phillip, Collins, Webster, Goodall, Copley, Elmore, Etty, Wilkie, Thomas Faed, Linnell, Müller, Gérôme, Frère, and W. Henry Hunt. Millais's *Leisure Hours* is a portrait of Pender's daughters. He also owned Millais's *Enemy Sowing Tares* and *Proscribed Royalist*, Leighton's *Phoebus*, and several Turners.

Taste

Mid-Victorian collector of early- to mid-nineteenth-century genre and landscapes by English and continental artists.

Purchasing pattern

Agnew's, Christie's, and direct purchases and commissions from artists such as Stanfield, Maclise, Roberts, Landseer, and Halswelle.

Sales and bequests

Christie's, 27 Jan. 1873; 29–31 May 1897; 10 May 1919 (Sir John Denison-Pender).

References

Art Journal (Jan. 1872), 8–10; (March 1873), 80; and (June 1892), 161–68; *DNB*; Boase; *DBB*; *Vanity Fair*, 28 Oct. 1871; *WWMP*; *The British Australasian* (26 July 1894), 953–70; *Manchester Guardian*, 8 July 1896; *Pictures, Drawings, and Sculpture Forming the Collection of Sir John Pender* (London: 1894); Marillier, *Christie's*, p. 72; Cooper, *My Life*, II, 5–6 and 214–17; Goodall, *Reminiscences*, p. 157; David Ballantine, *Life of David Roberts* (Edinburgh: 1866), p. 224; Millais, *Millais*, I, 379; Ward, *Memories of Ninety Years*, pp. 148 and 279; Agnew, p. 19; Reitlinger, p. 104; John Cornforth, "A Countess's London Castle," *Country Life Annual* (1970), 138–39; Ormond, *Leighton*, no. 321, p. 168; Robertson, *Eastlake*, p. 445; Greg, *Cranbrook Colony*, no. 70; Butlin and Joll, *Turner*, nos. 114, 357, 391, and 393; *James Tissot*, ed. K. Matyjaszkiewicz, (London: Barbicon Art Gallery, 1985), no. 40; Charles Bright, *Submarine Telegraphs: Their History, Construction and Working* (1898: rpt. New York: 1974); and Hugh Barty-King, *Girdle Round the Earth: The Story of Cable and Wireless* (London: 1979).

Archival sources: Letter from David Roberts, 1862, Fitzwilliam Museum Library; Royal Manchester Institution Letterbook (1862 loans), Manchester City Library.

PLINT, Thomas Edward (1823–61)
Leeds.

Occupation
Stock and share broker.

Biography
Son of Thomas Plint, a woolen cloth manufacturer and radical reformer. Like his father, Thomas junior was a devout Nonconformist and a political activist. He was one of the founders of the Leeds Parliamentary Reform Association, which agitated for household suffrage and Corn Law repeal. Plint was a prosperous stockbroker until 1860, when he was forced to suspend payment in his business; however, he continued to commission pictures even after that date.

Collection
Spent £25,000 on Turners and Pre-Raphaelite art, including Millais's *Christ in the House of His Parents, Black Brunswicker,* and *Proscribed Royalist*, Ford Madox Brown's *Work*, Hunt's *Finding of the Saviour in the Temple*, William Morris's *Queen Guinevere*, and Burne-Jones's *Blessed Damozel* and *Wise and Foolish Virgins*. Plint also owned works by John Martin, Samuel Palmer, A. W. Hunt, David Cox, Copley Fielding, and Clarkson Stanfield.

Taste
Pre-Raphaelites, Turner, and early to mid-Victorians. Plint insisted that the paintings he ordered include women, but not with ugly faces (Hueffer, *Brown*, pp. 165–66).

Purchasing pattern

Commissioned artists, whom he paid in installments or in advance; however, Plint told Brown that he preferred working with dealers, who were more businesslike. A client of Agnew and Gambart.

Sales and bequests

Foster's, 17 May 1860; Christie's, 7–8 March 1861 and 17 June 1865.

References

Athenaeum (20 July 1861), 89 and (15 March 1862), 367–68; *Art Journal* (Aug. 1861) 255 and (April 1862), 105–6; Boase; *Building News* (14 March 1862); Taylor, *Biographia Leodiensis*, pp. 497–98; (F. G. Stephens), *Leeds Mercury*, 4, 5, and 10 March 1862; *Leeds Intelligencer*, 3 August 1861; *The Times*, 5 March 1862; *Magazine of Art* (1904), 283; Hueffer, *Brown*, pp. 111–12, 141, 146, 153–57, 162–66, 173–76, and 203; *Brown Diary*, ed. Surtees, pp. 192–94, 198–200, and 204; Bennett, "Checklist of Pre-Raphaelite Pictures," pp. 489–90; Rossetti, *Family Letters*, I, 205–6, 213–14 and II, 145–46, *Rossetti as Designer and Writer*, pp. 30, 36, and 38, *Rossetti Papers*, p. 139, *Ruskin: Rossetti: Preraphaelitism*, pp. 181–82; 193–94; 223, 249, 275, 285, and 287–88; *Rossetti Letters*, ed. Doughty and Wahl, I, 310, 325, 333, 348, 350, 355 and *passim*; *Rossetti Allingham Letters*, ed. G. B. Hill (London: 1897), pp. 60, 190, and 198; Surtees, *Rossetti Catalogue Raisonné*, nos. 60, 95, 97, pp. 106, 109, 112, 119R1, 144, and 161; Redford, I,

164–65; Roberts, I, 196–98; Maas, *Gambart*, pp. 106, 126, 139–40, 142–43, 145, 147, 149–50, 166, and 169; Lewis, "Plint," pp. 77–101; Millais, *Millais*, I, 363 and 365; Warner, "Millais," pp. 19, 124, and 130–32; Burne-Jones, *Burne-Jones*, I, 152–54 and 175; Heleniak, *Mulready*, p. 168; Boime, "Work," pp. 116–25; Cherry, "Hogarth Club," p. 238; Tyrrell, "Class Consciousness," pp. 108–9; Robert John Morris, "The Middle Class and British Towns and Cities of the Industrial Revolution, 1780–1870," in *The Pursuit of Urban History*, ed. Fraser and Sutcliffe, pp. 292–93.

Archival sources: Letter to Mulready, Victoria and Albert Museum Library; Leathart-Brown correspondence, Leathart Papers, University of British Columbia; Brown Family Papers; letter from Ruskin to Plint, John Rylands University Library of Manchester; Agnew's Stockbooks; West Yorkshire Record Office, Wakefield.

POCOCK, Lewis (1801–82)

70 Gower Street, London.

Occupation

Director of Argus Life Assurance Co. and inventor.

Biography

Third and youngest son of Thomas Pocock, he was educated in England and in Tours, France. In 1852 Pocock patented a plan for electric lighting. He was a founder member and hon-

orary secretary of the Art Union of London, secretary of the Old Water-Colour Society, treasurer of the Graphic Society, and an active member of the Society for the Prevention of Cruelty to Animals. He was survived by his wife and twelve children.

Collection

Pocock owned a large assortment of early-Victorian watercolors and oils by artists such as Bonington, Cox, W. Henry Hunt, Cattermole, and F. D. Hardy, in addition to four Pre-Raphaelite works: Madox Brown's *Childhood – A Sketch*, William Holman Hunt's oil sketches for *Claudio and Isabella* and *Valentine Rescuing Sylvia from Proteus*, and Millais's oil, *The Proscribed Royalist*, in which Pocock collaborated with the artist in developing the subject (Warner, "Millais," p. 74). In addition, Pocock possessed a large collection of Johnsoniana.

Taste

Pre-Raphaelite and early-Victorian oils and watercolors.

Purchasing pattern

Commissioned Millais. Holman Hunt claimed that Pocock was an amateur dealer (*Pre-Raphaelitism*, I, 317–18), an accusation that perhaps related to Pocock subletting the Old Water-Colour Society's rooms for exhibitions of oil sketches and drawings in 1850 and 1852. The Pre-Raphaelites participated in the second event and it was there that Ruskin first saw Rossetti's work.

Sales and bequests

Foster's, 18 March 1857.

References

DNB; *The Times*, 21 Oct. 1882; *Builder*, 28 Oct. 1882; *Graphic*, 22 Dec. 1882; *Brown Diary*, ed. Surtees, pp. 120, 124 and 197; Millais, *Millais*, I, 163–64 and 172; Warner, "Millais," p. 74; Hunt, *Pre-Raphaelitism*, I, 316–18; Bennett, *Hunt*, pp. 27 and 29; Maas, *Gambart*, pp. 53, 58–59, and 65; and King, *Industrialization of Taste*, pp. 36–38, 55, 88, 129, 153, 160, and 206.

PRICE, David (*c.* 1809–91)

10 York Terrace, Regent's Park (until c. 1869), and 4 Queen Anne Street, London.

Occupation

Wool merchant, Price, Coker, & Co, Gresham Street, London.

Biography

Father's occupation unknown. Price was born in Cardiganshire, Wales, the son of William and Sarah Price. He apprenticed in the drapery trade before moving to London, where he was employed by Cook, Son, & Co. in St. Paul's Churchyard. He left to found his own business as London agent for wool manufacturers, eventually acting solely for himself. Price was a bachelor who was well known for his Mondays "at home," where he entertained lawyers, artists and literary figures (*Art Journal*, 1891). Price's estate was proved at £148,500. He left bequests totaling £40,000 to various charities, including thirteen hospitals and the Artists' General Benevolent Fund (£1,000).

Collection

Price began collecting in the mid-1850s and owned 150 oils by living artists when the *Art Journal* first visited him in 1872. By the time of the *Journal*'s second review in 1891, he possessed 300 pictures. Although when he bought his home on Queen Anne Street it contained a gallery constructed by Anastatius Hope of Amsterdam (d. 1831), Price built a second gallery which connected the original gallery with his house. Despite this space, Price preferred works of small or moderate dimensions, which he displayed according to size in two long rows (*Art Journal* [1891], 323). By 1891, he possessed fourteen Pooles, ten Linnells, nine Hooks, nine Creswicks, eight Friths, seven Frères, six Nasmyths, and Millais's *Apple Blossoms* and *Sound of Many Waters*, which Price commissioned in 1877, in addition to works by Alma-Tadema, Phillip, Rosa Bonheur, Meissonier, and Long. Price also collected proof print books and figurines in china, marble, and bronze. He is reputed to have spent £90,000 on his collection (Roberts, II, 180).

Taste

Early- to mid-Victorian English and French small-scale canvases.

Purchasing pattern

Direct purchases and commissions from artists. Price considered dealers rascals (Frith, *Autobiography*, I, 226).

Sales and bequests

Christie's, 2 April 1892.

References

Art Journal (Nov. 1872), 281–83; (Nov. 1891), 321–28; and (Sept. 1892), 2; *London Directory* (1861–80); *International Genealogical Index for Wales* (1984), 94; Frederick George Stephens, *Catalogue of the David Price Collection* (London: 1885); Roberts, II, 176–81; Frith, *Autobiography*, I, 225–26 and 318; Michael Lewis, *John Frederick Lewis* (Leigh-on-Sea: 1978), no. 606; Butlin and Joll, *Turner*, no. 374; and Ann Saunders, *Regent's Park* (Newton Abbot: 1969), p. 92.

Archival sources: Last Will and Testament, 3 Nov. 1891, Somerset House; Census Returns for 1861, 1871, and 1881.

QUAILE, Edward (d. *c.* 1900)

Lynmore, Claughton, Birkenhead, Liverpool.

Occupation

Unknown.

Biography

Possibly the author of *Bidston Hill Preserved* (1894) and several other locally published books on regional history. Lent pictures to the Manchester Art Treasures exhibition and in 1876 to the Wrexham exhibition.

Collection

Quaile's sale in 1907 consisted of over 400 works by artists such as Birket Foster, Hicks, O'Neill, Solomon, Noel Paton, Leader, and Marks.

Taste

Mid-Victorian English oils, watercolors, and miniatures, as well as Old Masters.

Purchasing pattern

Sale rooms.

Sales and bequests

Branche & Leete, Liverpool, 18–19 April 1888.

References

Athenaeum (18 Sept. 1886), 377; *Birkenhead Directory* (1900); Macleod (1986), p. 606.

QUILTER, William (1808–88)

Knight's Hill, Lower Norwood (until 1871); 28 Norfolk Street, Park Lane, London; and Silverwood Farm.

Occupation

Accountant, Quilter & Ball, London.

Biography

Son of Suffolk farmer Samuel Sacker Quilter and Sarah Chapman. Quilter left Suffolk for London in 1825, where he was articled to Peter Harris Abbott, the leading public accountant of his day. After forming his own firm in partnership with John Ball, Quilter specialized in bankruptcies. The collapse of the railroad mania in 1847 provided him with numerous clients and an expertise in railway shares. By 1849 Quilter claimed that his practice in this field was the largest in England (*DBB*). Quilter's fortune, however, was largely earned through his personal investments in railways. Although, by today's standards, some doubt would be cast on

Quilter's objectivity as an auditor for companies in which he had an interest, his contemporaries did not consider his involvement unethical (*DBB*). Quilter became the founding president of the Institute of Accountants in 1870. When the Institute failed to achieve a royal charter, its members questioned his leadership and Quilter resigned in 1877 (*DBB*). He married Elizabeth Cuthbert in 1834. Among their five children were Sir William Cuthbert Quilter, who was also an art collector, Harry Quilter (1851–1907), an art critic of note, and Elizabeth, whose husband Charles Eley was party to the inflated bidding which occurred at the sale of Quilter's collection at Christie's in 1875. Quilter's estate was proved at £580,934, the largest of its size for any Victorian accountant.

Collection

Quilter owned several hundred watercolors by artists such as Cox, Turner, Fielding, W. Henry Hunt, De Wint, Roberts, Stanfield, Müller, Poole, Lewis, and Bonington. The *Art Journal* noted that Quilter's house at Lower Norwood was "specifically designed" for the display of watercolors (1871, p. 110). His dining room was exclusively hung with the drawings of David Cox, while other works were contained in portfolios and drawers.

Taste

Mid-Victorian collector of English watercolors. Quilter preferred landscapes by late- eighteenth-century and early- Victorian artists.

Purchasing pattern

Agnew's and direct purchases from artists such as Poole, Fripp, Haag, and Burton.

Sales and bequests

Christie's, 8 April 1875 (517 lots) and 18 May 1889; and by descent.

References

Art Journal (April 1871), 110–12; (Nov. 1875), 341–42; (Oct. 1889), 301; Boase; *DBB*; *The Times*, 14 and 16 Nov. 1888; *The Accountant* 14 (24 Nov. 1888), 769; *Catalogue of the Unrivalled Collection of Watercolour Drawings formed by William Quilter* (London: 1875); Redford, I, 204–7; Roberts, I, 232–36; Howitt, *Chartered Accountants*; Jones, *Accountancy*, (1985), pp. 53 and 67; Solly, *Cox*, pp. 255–61; Clarke, *Tempting Prospect*, pp. 146–47; Reitlinger, p. 100; Rosamond Alwood, *George Edgar Hicks* (London: 1982), p. 60; and Michael Lewis, *John Frederick Lewis* (Leigh-on-Sea: 1978), nos. 607 and 609.

RAE, George (1817–1902)

Redcourt, 57 Devonshire Road, Claughton, Birkenhead, Cheshire.

Occupation

Chairman, North and South Wales Bank.

Biography

Born in Aberdeen, the son of George Rae, a messenger at arms, Rae was educated at the Classical and Commercial Academy. First articled in a lawyer's office, Rae left before com-

pleting his course of studies to accept a post as branch accountant with the North of Scotland Bank. He was appointed inspector of branches for the North and South Wales Bank, Liverpool, at the age of twenty-two. Six years later he was made general manager. By the time of his retirement as chairman in 1898, Rae had the satisfaction of having headed one of the largest banks in the United Kingdom. He also achieved acclaim for his guide to practical banking, *The Country Banker: His Clients, Cares and Work* (1885), which was printed in seven editions. Rae was a Fellow of the Royal Society of Arts. He first married Elspeth Kynoch of Keith and, after her death, Julia Williams in 1854. His son Edward married Margaret, daughter of James Leathart (q.v.), in 1895. Rae left bequests to his wife, daughter, and two daughters-in-law, as well as to charity. The net value of his estate was £192,000.

Collection
Rae owned over 200 pictures by Aesthetic movement painters such as Rossetti, Madox Brown, Burne-Jones, and Albert Moore, as well as by members of the Liverpool school.

Taste
Aesthetic movement and Liverpudlian landscape tradition.

Purchasing pattern
Rae primarily made direct commissions to artists.

Sales and bequests
Private sale of Madox Brown's *Coat of Many Colours* in 1875 and executors' sale to Tate Gallery in 1916 and to Lord Leverhulme in 1917. The remainder of Rae's collection was bequeathed to his descendants, who have subsequently parted with several items in sales to the Walker Art Gallery (1964) and at Sotheby's Belgravia (9 June 1981).

References
Athenaeum (2 Oct. 1875), 443–45 and (9 Oct. 1875), 480–82; *DBB*; George Rae, *The Country Banker: His Clients, Cares and Work* (London: 1885) and *Holiday Rambles by Land and Sea*, 2 vols. (London: 1891); *Daily Post* and *Liverpool Mercury*, 5 Aug. 1902; Orchard, *Liverpool's Legion of Honour*, pp. 573–76; Wilfred F. Crick and J. E. Wadsworth, *A Hundred Years of Joint Stock Banking* (London: 1936); Edwin Green, *Debtors to their Profession: A History of the Institute of Bankers* (London: 1979); Alexander Keith, *The North of Scotland Bank Ltd.* (Aberdeen: 1936); (George Rae), *Catalogue of Mr. George Rae's Pictures* (Birkenhead: c. 1872); Dugald Sutherland MacColl, "Monthly Chronicle," *Burlington* 29 (May 1916), 80–81; Hueffer, *Brown*, p. 180 and *passim*; Rossetti, *Rossetti as Designer and Writer*, pp. 41–44, 77–78, and 93; *Diary of W. M. Rossetti*, ed. Bornand, pp. 263–66; *Rossetti Letters*, ed. Doughty & Wahl, II, 535, III, 1236, 1252, IV, 1500, 1510–11, 1514–17, 1519, 1522–24, and 1567; Surtees, *Rossetti Catalogue Raisonné*, I, 75, 86R1, 90, 91, 91R1, 97, 99, 101, 113, 116A, 124, 164, 173R1, 186, 182, 191, 193, 228A, 287; Temple, *Guildhall Memories*, pp. 105–6; Bennett, "Checklist of Pre-Raphaelite Pictures," p. 490; Bennett, *Pre-Raphaelite Circle*, p. 172; Macleod (1986), pp. 599, 602, 606; Macleod (1987), pp. 338–40.

Archival sources: Letters to F. G. Stephens, Stephens Papers, Bodleian Library, Oxford; letters to Rossetti, Angeli-Dennis Papers, University of British Columbia; letters from Rossetti, Lady Lever Gallery, Port Sunlight, Cheshire; Midland Bank Archives, London.

RANKIN, Robert (1830–98)
6 Fulwood Park, near Liverpool.

Occupation
Merchant and shipowner, Rankin, Gilmour & Co., South John Street, Liverpool.

Biography
Son of Robert Rankin, a Scottish shipbuilder and timber merchant who emigrated to Canada to pursue the Gilmour family's business interests. Rankin was born in the province of New Brunswick, but moved to England to be educated at the Collegiate Institution, Liverpool. In 1847 Rankin joined the merchant and shipowning firm of his uncle Robert Rankin. He was made a partner in 1861. In 1862 he married the sister of Sir Donald Currie and Mrs. David

Jardine (q.v.), who died shortly after the birth of their daughter Elizabeth. Rankin was chairman of the Docks and Quays Committee and a director of the Midland Railway and of the Pacific Steam Navigation Company.

Collection

Rankin preferred the paintings of the older English school: Girtin, Hogarth, Wilson, and Bonington. He owned a few early modern works by artists such as Wilkie and Mulready. His mid-Victorian canvases were by Phillip, Thomas Faed, Creswick, Frith, Poynter, and Frère.

Taste

Mid-Victorian collector of eighteenth- and nineteenth-century British figure and landscape subjects.

Purchasing pattern

Agnew's.

Sales and bequests

Rankin bequeathed two paintings, one of which was by Richard Wilson, to his brother-in-law David Jardine. Christie's, 14 May 1898 at which Agnew's paid a record price for Morland's *Post Boy's Return* (1,250 guineas).

References

Athenaeum (2 Oct. 1886), 440–41; *Liverpool Courier*, 21 Jan. 1898; *Liverpool Daily Post*, March 1898; Orchard, *Liverpool's Legion of Honor*, p. 577; *Art Journal* (Sept. 1898), 309; Macleod (1986), p. 606.

RATHBONE, Philip (1828–95)

The Cottage, Greenbank, near Liverpool.

Occupation

Insurance underwriter, Rathbone, Martin & Co.

Biography

Grandson of William Rathbone of Liverpool (1757–1809), a merchant in the American trade, and son of William Rathbone, insurance broker and mayor of Liverpool (1837), who orchestrated relief funds during the Irish famine of 1846–47. Rathbone was educated at private schools followed by a period of travel in Switzerland, China, and America. After spending two years in the office of W. S. Lindsay & Co. in London, he returned to Liverpool to join his family's underwriting firm. He was active in reforming the standards of his profession and subsequently became chairman of the Underwriters' Association. Involved in community affairs, Rathbone was chairman of the Commercial Law Committee and president of the Chamber of Commerce. He was also an active public patron of the arts, serving as deputy chairman of the Library and Museum committee and as founding president of the Liverpool Arts Club. Rathbone was instrumental in establishing the Roscoe Chair of Art at Liverpool University. An amateur poet, he was father of artist Harold Rathbone and architect Edmund Rathbone.

Collection

Rathbone owned a mixed selection of canvases by Pre-Raphaelites Hughes and Millais, Aesthetic movement painters Moore, Rossetti, and Sandys, and French artists, such as Legros. He also owned a number of Old Master paintings.

Taste

Aesthetic movement, Pre-Raphaelite, contemporary French, and Old Masters.

Purchasing pattern

Rathbone frequented artists' studios and the saleroom at Christie's.

Sales and bequests

Bequest of seven Old Masters and paintings by Moore and Legros to Walker Art Gallery, Liverpool, 1895. Christie's sale, 24 Feb. 1906.

References

Athenaeum (18 Sept. 1886), 377–78; Boase; *Liverpool Courier*, 23 Nov. 1895; Orchard, *Liverpool's Legion of Honor*, pp. 577–79; Philip Rathbone, *The Political Value of Art to the Municipal Life of a Nation* (Liverpool: 1875); *Realism, Idealism and the Grotesque; The Mission of the Undraped Figure in Art* (Liverpool: 1878); and *The Place of Art in the Future Industrial Progress of the Nation* (1884); Eleanor F. Rathbone, *William Rathbone, A Memoir* (London: 1905); Morris, "Philip Henry Rathbone," pp. 59–80; Bennett, *Pre-Raphaelite Circle*, p. 106; *Rossetti Letters*, ed. Doughty and Wahl, IV, 1860 and *passim*.

Archival sources: Rathbone Family Papers, Liverpool University.

RICKARDS, Charles Hilditch (1812–86)

"The Beeches," Seymour Grove, Old Trafford, Manchester.

Occupation

Wholesale papermaker.

Biography

Son of Charles Rickards of Upton-on-Severn, Worcestershire, who settled in Manchester at the turn of the century and worked as a cotton spinner, and Frances Broome of Sandbach, daughter of landowners who had lived in the district for more than 300 years. Rickards was born in Salford and attended Manchester Grammar school at a time when "the main instruments of education were the Latin grammar and the cane" (*Manchester Guardian*, 9 July 1886). Once his business was established, Rickards devoted time to city and county affairs. He was a magistrate and member of the Manchester Board of Guardians. It was during his tenure as Chairman of the Guardians (1855–68) that he organized an extensive relief program during the cotton famine. Rickards established a scholarship fund at the Manchester Grammar School for the encouragement of classical learning.

Collection

Rickards's collection was distinguished by its almost exclusive concentration on the works of George Frederic Watts. When the *Art Journal*

visited his home in 1871, it counted twenty-six pictures by Watts, to whom Rickards was introduced in 1865 by critic Tom Taylor. According to Conran, Rickards sold his collection of early- nineteenth-century art in 1871 in order to finance his purchases by Watts ("Art Collections," p. 75). Rickards claimed that he bought everything Watts would let him have. Revealing a proprietory interest, Watts supervised the hanging of his pictures at "The Beeches," advising Rickards to paper over his walls in a more appropriate color. By the 1880s, Rickards owned over sixty works by Watts. He urged Watts to have an exhibition in Manchester, the success of which led to the artist's Grosvenor Gallery exhibition in 1881 (Chapman, *Laurel and Thorn*, pp. 96–98). On Watts's recommendation, Rickards purchased a canvas from Alphonse Legros.

Taste

Aesthetic movement.

Purchasing pattern

Direct purchases and commissions from artists.

Sales and bequests

1871 (untraced) and Christie's, 2 April 1887. Rickards's executors donated his portrait by Watts (1866) to the Manchester City Art Gallery.

References

Art Journal (November 1871), 256–57 and (Oct. 1887), 337–38; Boase; *Manchester Courier*, 30 Dec. 1876; *Manchester Guardian*, 9 July 1886;

Howe, *Cotton Masters*, p. 300; Macmillan, *George Frederic Watts*, p. 34; Watts, *Watts*, I, 222–28, 243–47, 261–62, 275–79, 302–5; II, 3–5; Chapman, *The Laurel and the Thorn*, pp. 96–98; Blunt, *Watts*, p. 58 and *passim*; Whitechapel Art Gallery, *George Frederic Watts* (London: 1974); Elizabeth Conran, "Art Collections," in *Victorian Manchester*, ed. Archer, p. 75;

Archival sources: Watts–Rickards correspondence, Beinecke Library, Yale University.

ROBERTS, Daniel (1798–c. 1880)

265 Old Kent Road, London.

Occupation

Master tanner, Learmouth & Roberts, Pages Walk, Bermondsey, London.

Biography

Social origins unknown. Born in Battersea, Surrey, Roberts was trained as a dyer. By 1841 he was in partnership in Bermondsey with Learmouth, whose family had operated a tannery for some fifty years. They employed almost 300 workmen who operated steampowered splitting machines, lathes, and finishing wheels for light skins and strong hides. According to the *Victoria History of Surrey*, the finishing wheels allowed one worker to do as much as five men. As a result, Learmouth & Roberts tanned almost 350,000 calf, sheep, deer, and goat skins each year to meet the middle-class demand for shoes, saddles, gloves, and handbags. Part of

Roberts's success was attributed to his secret recipe for dyes, particularly for the fugitive tints of archil (*Victoria History*, p. 338). Even so, Roberts continued to live near his work in a three-story home on the unfashionable Old Kent Road.

Collection

The *Art Journal* in 1872 described a gathering of art works in Roberts's home primarily by living or recently deceased artists such as Collins, Leslie, Goodall, Frith, Cooper, and Millais. Roberts's 1881 sales consisted of eighty oils and fifty-six watercolors.

Taste

Mid-Victorian collector. Roberts owned works by early- to mid-Victorian English, French, and Belgian artists, in addition to the Old Masters. The *Art Journal* noted that "Mr. Roberts's tastes do not limit him in his choice to any particular line or department, but extend to all productions in which reside the essential element of beauty" (1871, p. 53).

Purchasing pattern

Known to have commissioned a work by E. Duncan.

Sales and bequests

Christie's, 26 March 1881 and 23 March 1889.

References

Art Journal (Feb. 1872), 53–54 and (May 1881), 160; *London Directory* (1871); G. W. Phillips, *The History and Antiquities of the Parish of Bermondsey*

(London: 1841); George Dodd, *Days at the Factories, or the Manufacturing History of Bermondsey Described* (London: 1843); Edward T. Clarke, *Bermondsey* (London: 1901); *Victoria History of the County of Surrey*, ed. H. E. Malden, 4 vols. (Oxford: 1967), II, 337–38; London Borough of Southwark, *The Story of Bermondsey* (London: 1984).

Archival sources: Census Reports for 1851 and 1871; Rate Book (1867); Tax Valuation Plan (1839–43), London Borough of Southwark Records Office.

ROBERTS, Humphrey (1819–1907)

15 The Esplanade, Waterloo, Liverpool, and 8 Queen's Gate Place, London.

Occupation

Timber merchant, Humphrey Roberts & Co., 4–6 Camden Street East, Liverpool.

Biography

F. G. Stephens described Roberts as chief of one of the oldest historic families of Britain (*Art Journal* [1908], 267) which makes his omission from biographical sources puzzling. Stephens also claimed that Roberts was an industrial leader and man of science and one who had made astute investments in land adjoining the Mersey docks. Roberts's obituary in the *Journal of Commerce* only notes his occupation as a timber merchant and his chairmanship of the London board of the State Fire Insurance Co. (31 Dec.

1907). Roberts, however, was well known in the art-collecting world as one of the "Birkenhead Bees," others of the "hive" being Joseph Beausire (q.v.) and T. H. Ismay (q.v.). Roberts's estate was valued at £106,000.

Collection

According to Stephens, Roberts inherited paintings by Titian, Van Dyck, and Reynolds. To this gathering he added eighteenth-century British pictures and contemporary works such as Millais's *The Gambler's Wife* (1869) and Albert Moore's *Topaz*, in addition to canvases by Hook, Henry Moore, Goodwin, Roberts, Gregory, Walker, A. W. Hunt, and Orchardson. Roberts was also interested in the Barbizon School, buying seven pictures by Corot and others by Diaz, Dupré, Troyon, Jacque, Millet, Daubigny, Israels, and Breton. English watercolors also formed a part of his collection.

Taste

Eighteenth-century British, Barbizon, and late Victorian. Stephens noted that "Mr. Roberts's tastes incline to Art which excels in colour, fidelity to nature, is finished, realistic and refined, easily recognisable by its Englishness and, above all, inspired by sentiment, pathetic, and expressive" (*Art Journal* [1888], 121).

Purchasing pattern

Agnew's.

Sales

London, Christie's, 5 April and 12 June 1873; 21 May 1908 (309 lots brought £65,673).

References

Art Journal (April 1888), 121–24; (June 1888), 167–70; (Nov. 1888), 321–24; (Sept. 1908), 250; (Nov. 1908), 267–69; *Magazine of Art* 19 (1896), 41–47, 81–87, 121–28, 170–76; *Journal of Commerce* 31 Dec. 1907; Butlin and Joll, *Turner*, no. 38; Ellis Waterhouse, *Gainsborough* (London: 1966), no. 859.

ROGERS, Samuel (1763–1855)

22 St. James's Place, Westminster, London.

Occupation

Banker and poet.

Biography

Son of a London banker (his grandfather was a glass manufacturer at Stourbridge, Worcestershire), Rogers was brought up as a dissenter. He was educated at private schools in Hackney and Stoke Newington and wanted to become a Presbyterian minister but his father persuaded him to enter the bank. Rogers began publishing poetry, which he turned to full-time after his father died in 1793 and he inherited an income of £5,000 a year. He visited Paris in 1802 during the Peace of Amiens to look at art (he had already been introduced to many artists in London by his brother-in-law Sutton Sharpe and was involved with others in plans to bring over the Orleans Gallery). In 1803 Rogers built

a house in St. James's Street overlooking Green Park, which was modest in size but elaborately decorated by Flaxman and Stothard. He was a patron of Cary (the Dante translator), and knew Byron, Wordsworth, and Shelley. Rogers was offered the laureateship on Wordsworth's death, but declined.

Collection

Mainly Old Masters and older English painters (Gainsborough, Reynolds and Fuseli), but Rogers also owned works by Leslie, Haydon, Turner, Wilkie, and Bonington. He helped artists with their finances, introduced them to other collectors, and reconciled their quarrels (*Rogers*, ed. Hale, p. 32). In some ways, Rogers modeled himself after aristocratic patterns: for instance, his modern English collection was not hung in the drawing room (which was reserved for Old Masters), but in the library, dining room, and bedroom (see Waagen, 1854). His house was open to the public in fine weather after 2:00 p.m. by written application.

Taste

Early-Victorian landscapes and literary subjects and Old Masters. The *Art Union* described Rogers as having "classic taste" and his home as a "Temple of Taste" (1847, p. 85), while Anna Jameson credited him for daring to mix schools and periods (*Private Galleries*, pp. 384–85).

Purchasing Pattern

Commissioned artists and bought at sales.

Sales and Bequests

Christie's, 18 December 1855, 28 April 1856, and the following seventeen days (fetched £42,367, with the pictures alone bringing in £30,180). Nearly every picture realized two to three times what he paid (Roberts, I, 180).

References

Waagen (1854), II, 131–46; *Art Union* (March 1847), 83–85; *Art Journal* (June 1856), 188–89; *Athenaeum* (Dec. 29, 1855); *DNB*; Jameson, *Private Galleries*, pp. 381–412; Anna Bray, *Life of Thomas Stothard* (London: 1851), p. 235; Taylor, *Leslie*, I, 73 and *passim*; "Constable Correspondence," VIII, 134–35 and XVIII, 167–68; Roberts, I, 180–87; Samuel Rogers, *Recollections* (London: 1859); Peter W. Clayden, *The Early Life of Samuel Rogers* (London: 1887) and *Rogers and his Contemporaries*, 2 vols. (London: 1889); *The Italian Journal of Samuel Rogers*, ed. John R. Hale (London: 1956).

Archival source: M. H. Bloxham, *Sale Catalogue* and *Catalogue of Purchases of Samuel Rogers Collection*, British Museum.

ROGERS, Sarah (1772–1855)

5 Hanover Terrace, Regent's Park, London.

Occupation

Amateur artist.

Biography

Daughter of a London banker and

eldest sister of Henry and Samuel Rogers (q.v.). Sarah traveled with Samuel in Switzerland, Italy, Germany and Holland in 1814 and in Switzerland again in 1821. She also supervised the publication of the 1822 edition of *Italy*. Sarah lived with her brother Henry until his death in 1832 then moved to Hanover Terrace. Her house was described in 1838 as "a sort of imitation – and not a bad one either – of her brother's in St. James's" (Clayden, *Rogers*, II, 165). Turner visited her there on several occasions.

Collection

Autographs, curiosities, and objects of *virtu*, like her brother Samuel's collection. After visiting her home, Anna Jameson reported: "Miss Rogers, the sister of the poet, possesses a small, but very elegant collection of pictures …Though none of these pictures are large or very important, some among them are exceedingly curious and valuable, and by painters whose works are rarely found in English collections" (*Galleries*, p. 412).

Taste

Early-Victorian landscape and subject pictures and Old Masters.

Purchasing pattern

Inherited collection from her brother Henry and continued to buy on her own.

Sales and bequests

Untraced.

References

Waagen (1854), II, 266–71; Jameson, *Private Galleries*, pp. 412–13; Anna Bray, *Life of Thomas Stothard* (London: 1851), p. 236; Collins, *Collins*, II, 102; Taylor, *Leslie*, I, 117, 136, 240 and II, 309; Gage, *Turner Correspondence*, pp. 153, 208, 211, 235, 270, 278–80; Butlin and Joll, *Turner*, I, 312; Mary Lloyd, *Sunny Memories* (London: 1880); Peter W. Clayden, *Rogers and his Contemporaries*, 2 vols. (London: 1889), II, 165.

ROSE, James Anderson (1819–90)

65 Trinity Square, Southwark and, by 1876, Wandsworth Common, Surrey.

Occupation

Solicitor, Rose & Thomas, 11 Salisbury Street, Strand, and, after 1882, 1 Lancaster Place, London.

Biography

Rose was descended from one of the oldest families in Great Britain, Rose of Kilravock of Nairnshire. He was the eldest son of Arthur Miller Rose, an oil merchant who settled in Southwark and who died in 1864, and was a nephew of Sir William Rose. Rose was educated at Westminster School and University College, London. He began his legal training by articling to Joseph Bibb in 1838 and was made a partner in 1844. Rose later entered into partnership with the solicitor and art dealer Ralph Thomas, which lasted until 1875. He was undersheriff of the City of London in 1862, master of the court of the Cordwainer's Co. in 1889, and chairman of the Strand Conservative Association. Rose was solicitor to the popular novelist Ouida and the artist Frederick Sandys, and drafted the deed of partnership for Morris, Marshall, Falkener & Co. (Merrill, *Pot of Paint*, p. 59). He also represented Whistler in his celebrated suit for libel against Ruskin. He lost thousands of pounds in 1866, when the Bill to establish the Hampstead, Highgate, and Charing Cross Railway was defeated. Rose was a member of the Arundel Club.

Collection

Rose owned works by Madox Brown, Burne-Jones, and his clients Rossetti, Sandys, and Whistler. He also collected paintings by eighteenth-century artists, such as Romney, and by the Old Masters. Rose possessed an extensive collection of engravings, which he meticulously catalogued (see below).

Taste

Aesthetic movement, eighteenth-century British, and Old Master artists.

Purchasing pattern

Rose gave direct commissions to artists and sometimes used Charles Augustus Howell as his intermediary.

Sales and bequests

Christie's, 23 March 1867, 16 May 1868, and 5 May 1891; Sotheby's, 27 June – 7 July 1876.

References

Athenaeum (27 Sept. 1890), 424; Boase; *Trades and Court Directory* (1876); *Academy* 38 (1890), 324; *Law Journal* (4 Oct. 1890), 586; James Rose, *On the*

Necessity for Additional Common Law Judges (London: 1867) and *Collection of Engraved Portraits Exhibited by John A. Rose*, 2 vols. (London: 1895); Liverpool Art Club, *Collection Illustrative of Etchings lent by John A. Rose* (Liverpool: 1874); *Boyce Diaries*, ed. Surtees, pp. 33, 35, 38, 40, 43–44; Hueffer, *Brown*, p. 182; Dorment, *Gilbert*, p. 40; Rossetti, *Family Letters* I, 211, 239, 247, 256 and II, 170–71, *Rossetti Papers*, pp. 14, 225, and 227; *Diary of William Michael Rosesetti*, ed. Bornand, pp. 182–83, 213–14, and 251; Surtees, *Rossetti Catalogue Raisonné*, nos. 95, 118R.s, 122, 160A, 162, 185, and 186; *Rossetti Letters*, ed. Doughty and Wahl, 395 and *passim*; Fredeman, *Bibliocriitical Study*, nos. 3.2 and 19.7; Pennell and Pennell, *Whistler*, I, 156, 225, 231, 245; Taylor, *Whistler*, pp. 61, 77, 85; Merrill, *Pot of Paint*, pp. 23–24 and *passim*; Brighton Art Gallery, *Frederick Sandys* (Brighton: 1974), nos. 45–46, 136, 208ff.

Archival sources: Letters from Rossetti, Berg Collection, New York Public Library; Correspondence with Whistler, Pennell–Whistler Collection, Library of Congress, Washington, D.C.

RUSKIN, John (1819–1900)

28 Herne Hill; Denmark Hill, London; and Brantwood, Coniston Water.

Occupation

Art critic, amateur artist, author, and social reformer.

Biography

Son of J. J. Ruskin (q.v.), Ruskin was educated at Oxford and trained as an amateur artist. He first became interested in Turner in 1833 after his father gave him Rogers's *Italy*. Ruskin met Turner on 22 June 1840 at dinner with the dealer Thomas Griffith and dined with him again on 20 October 1843 at Windus's (q.v.) when Turner thanked him for writing *Modern Painters* (*Turner Correspondance*, ed. Gage, pp. 282–83). He was named executor of Turner's will but declined. Ruskin first wrote about the Pre-Raphaelites in 1851 after hearing their praises sung by the artist William Dyce and the poet Coventry Patmore. He adopted Millais as his protégé until the artist married Effie Ruskin in 1855, who had won an annulment from her husband. Ruskin placed Elizabeth Siddall on an annual stipend in exchange for drawings and watercolors and closely monitored the artistic output of Rossetti, whom he recommended to the circle of women who eagerly sought his advice. Less compliant, Ford Madox Brown did not receive the critic's endorsement. Ruskin practiced an aristocratic form of paternal patronage in his private dealings with artists, despite the egalitarian pronouncements he made in public. Although he complained about the art market's high prices, he consorted with dealers. Ruskin inherited £157,000 plus property on his father's death in 1864 and earned, on the average, £4,000 a year in royalties from his books (*DNB*).

Collection

Drawings, oils, manuscripts, engravings, books, and mineral specimens.

Taste

Turner, the Pre-Raphaelites, and a select group of early-Victorian painters, including Samuel Prout, Copley Fielding, William Henry Hunt, and G. F. Watts. Ruskin also admired certain Old Masters, particularly the sixteenth-century Venetians.

Purchasing pattern

Commissions from artists whom he closely monitored. He bought his Turners from dealers and in the salerooms.

Sales and bequests

Christie's, 15 April 1869, 8 June 1872, 20 May 1882, and 3 June and 22 July 1882. In 1861 Ruskin gave forty-eight Turner drawings to Oxford University and twenty-five to Cambridge. He donated a further twenty-eight Turner drawings to Oxford in 1871 (Ruskin School Collection), as well as £5,000 to endow a mastership of drawing. Bequest to St. George's Museum, Sheffield.

References

DNB; Boase; John Ruskin, *Praeterita* (London: 1885–89) in Ruskin, *Works*, ed. Cook and Wedderburn, xxxv; letters of John Ruskin, *ibid.*, xxxvi–xxxvii; Edward Thomas Cook, *Life of John Ruskin* (London: 1911); Derrick Leon, *Ruskin, the Great Victorian* (London: 1949); Joan Evans, *John Ruskin* (London: 1954);

Rosenberg, *Darkening Glass*; Hilton, *John Ruskin*; Gage, *Turner Correspondence*, p. 282 and *passim*; Herrmann, *Ruskin and Turner*; Lutyens, *Millais and the Ruskins*; Millais, *Millais*, *passim*; Warner, "Millais," pp. 76–82; Hunt, *Pre-Raphaelitism*, *passim*; Burne-Jones, *Burne-Jones*, *passim*; *Brown Diary*, ed. Surtees, pp. 90, 98, 105, 133, 144, 154, 156–57, 170, 173, 195, and 197; Rossetti, *Ruskin: Rossetti: Preraphaelitism*; Surtees, *Rossetti Catalogue Raisonné*, nos. 74, 75, 78, 78A, 89, 125, and 239B.

Archival sources:
Ruskin Galleries, Bembridge.

RUSKIN, John James (1785–1864)
54 Hunter Street, Brunswick Square (1818–23); 28 Herne Hill (1823–42); Denmark Hill, London (1842–64).

Occupation
Wine merchant, Ruskin, Telford, & Domecq, 7 Billiter Street, London.

Biography
Son of an Edinburgh grocer, Ruskin attended Royal High School and studied art under Alexander Nasmyth. He moved to London in 1807, where he worked as a clerk in a mercantile house before becoming a founding partner in a firm of wine merchants in 1814. Ruskin owned some £1,200-worth of pictures by 1840 and frequently entertained artists such as George Richmond, Samuel Prout, and Turner. Ruskin left his son £157,000 plus property at Herne Hill and Denmark Hill, and his pictures.

Collection
Ruskin began to collect in 1832–33 with the purchase of a Scottish scene and a sea piece by Copley Fielding. He purchased his first Turner watercolor for his son John in January 1839 and two others, *Gosport* and *Winchelsea*, within the next year. John Ruskin junior (q.v.), at age seventeen, encouraged his father to buy art, telling him "a room without pictures is like a face without eyes" (*Family Letters*, I, 328). The young Ruskin described his home in 1845 as containing works by Turner and W. H. Hunt in the breakfast room, while the dining and drawing rooms "had decoration enough in our Northcote portraits, Turner's *Slave Ship*, and, in later years, his *Rialto*, with our John Lewis, two Copley Fieldings, and every now and then a new Turner drawing" (*Praeterita*, in *Works*, xxxv, 380). In April 1860 Ruskin offered (unsuccessfully) to head a subscription list with £500 towards the purchase of Turner's *Venice, from the Porch of Madonna della Salute* (1835) for presentation to the Louvre "as Turner is so little known and so little esteemed on the Continent" (Maas, *Gambart*, p. 114).

Taste
Early-Victorian oils and watercolors.

Purchasing pattern
Ruskin bought from artists and from Turner's agent, Thomas Griffith, often trading-in one work as partial payment for another. He also frequented the Old Water-Colour Society and the British Institution.

Sales and bequests
By descent; and Christie's, 15 April 1869 (John Ruskin).

References
DNB (listing for John Ruskin); John Ruskin, *Praeteria,* in *Works*, ed. Cook & Wedderburn, xxxv; Gage, *Turner Correspondence*, p. 282 and *passim*; Butlin and Joll, I, 213, 219, and 236; *Ruskin Family Letters*, ed. Bird; Maas, *Gambart*, p. 114; Clarke, *Tempting Prospect*, p. 146.

Archival sources: Ruskin Galleries, Bembridge (account book and inventories).

RUSTON, Joseph (1835–97)
Monk's Manor, Lincoln, and 5 St. George's Place, Hyde Park, London.

Occupation
Manufacturer of agricultural machinery, Ruston, Proctor, & Co., Streat Ironworks, Lincoln.

Biography
Born in Chatteris, Cambridgeshire, the eldest son of Margaret Seward and Robert Ruston of the Isle of Ely, a farmer, Ruston was educated at Wesley College, Sheffield, and began his commercial life as an engineer. He moved to Lincoln c. 1852 and with "a moderately large capital" started the firm of Ruston, Proctor, and Co., agricultural implement makers and engineers, which eventually employed 2,000 people with agencies all over the world. He was mayor of Lincoln in 1870, MP for Lincoln 1880–86, and

sheriff of Lincolnshire in 1891. The *Lincolnshire Advertisement Extract* described Ruston as having "a deep interest in movements the objects of which have been the social and moral elevation of the people." As a member of the Independent Church, he was active in the temperance movement and the YMCA, as well as the Mechanics' Institute and the Newland Science Classes. Ruston was president of the Lincoln School of Art for over twenty years. His philanthropies included the building of a children's ward in the hospital and the restoration of Queen Eleanor's memorial in the cathedral. He married Jane Brown of Sheffield in 1859. Ruston frequently displayed his products at international exhibitions. He was granted the cross of the Legion of Honor and the Order of the Osmanieh. His estate was proved at under £950,000. Enlightened for his time, Ruston left each of his five daughters a legacy of £60,000 with the stipulation that they not give more than half to their spouses.

Collection
Ruston began to acquire pictures in the early 1870s. He eventually formed an extensive collection of eighteenth-century British portraitists, such as Reynolds, Gainsborough, Romney, and Hoppner, and early nineteenth-century landscapists, including Müller, Turner, and Linnell. The central portion of his collection consisted of canvases by Aesthetic movement painters, such as Rossetti's *Dante's*

Dream, Watts's *Hope, Love and Life*, and *Love and Death,* and Burne-Jones's *Chant d'Amour* and *Mirror of Venus.* Ruston also owned works by a series of French artists, including Scheffer, Delaroche, Meissonier, Francia, and Fantin-Latour, as well as a small selection by Old Masters.

Taste
Aesthetic movement painters dominated Ruston's collection, although he was also interested in Old Masters, the early British school, and contemporary French art.

Purchasing pattern
Ruston began his collecting career by giving commissions to George Hicks. He went on to bid at the sales of well-known collections of Aesthetic art, notably those of Graham (q.v.) and Leyland (q.v.). He was a client of Agnew's.

Sales and bequests
Christie's, 21 & 23 May 1898; 21 June 1912; and 4 July 1913.

References
Boase; *WWMP*; *Magazine of Art* 18 (1894), 37–44 and 97–101; *Art Journal* (Sept. 1898), 307; *Lincoln Advertisement Extracts* (1880); *The Congregationalist* (Oct. 1884); *The Times*, 2 June 1897; Fredeman, *Bibliocritical Study*, no. 19.15; Marillier, *Christie's*, pp. 76, 146, and 187; Reitlinger, p. 96; Bennett, *Pre-Raphaelite Circle*, p. 96; Rosamond Allwood, *George Elgar Hicks* (London: 1982), pp. 57–58; Surtees, *Rossetti Catalogue Raisonné*, I, 81R2, 228, 232.

Archival sources:
Ruston Estate Papers, Lincolnshire Archives Office and press clippings, Lincoln Central Reference Library.

SCHLOTEL, George (1806–84)
Essex Lodge, Brixton Rise, London.

Occupation
Stockbroker.

Biography
Born in Camberwell, London. Social origins unknown. Schlotel's sons Frederick and Albert were also stockbrokers.

Collection
Schlotel, according to the *Art Journal*, owned a large proportion of watercolors by English artists, such as Turner, J. G. Lewis, Prout, Frith, Maclise, Webster, W. Henry Hunt (seven), and Millais. He also possessed several very elaborate watercolor studies by foreign painters, including Bonheur, Gérôme, Gallait, Dyckman, Meissonnier, and Henriette Browne. His collection of cabinet-sized oils spanned both the British and the foreign schools, including artists such as John Phillip.

Taste
Mid-Victorian collector. Purchased early- to mid-Victorian British watercolors and oils, in addition to French, Belgian, and German art.

Purchasing pattern
Unknown.

Sales and bequests
Christie's, 25 and 27 April 1885.

References

Art Journal (Nov. 1869), 341–43; *London Directory* (1874); *Green's South London Blue Book* (1869 and 1876); Greg, *Cranbrook Colony*, no. 71; Witt, *W. Henry Hunt*, p. 257.

Archival sources: 1871 Census Return; Norwood Cemetery Inscriptions, Minet Library, Lambeth.

SHARP, William (1795–1881)

Endwood Court, Handsworth, near Birmingham.

Occupation

Lead and glass merchant, Stock & Sharp, Needless Alley, Birmingham.

Biography

Origins unknown. Originally from Manchester, Sharp settled in Birmingham sometime before 1850, where he quickly became involved in local philanthropies, including the Grammar School, Handsworth Bridge Trust, the Deaf and Dumb Asylum, the Bluecoat School, and the General Hospital. Sharp also supported the Society of Arts and the School of Design, in addition to serving as a trustee of the Public Picture Gallery Fund. He was made JP for Warwickshire in 1856 and Staffordshire in 1857.

Collection

An early patron of Cox and Müller, he was one of four Birmingham collectors introduced to Dr. Waagen by John Horsley. In addition to his Coxes and Müllers, Sharp owned a number of works by Collins, Fielding, Linnell, Cooper, Maclise, and Poole.

Taste

Early-Victorian landscape and historical subjects.

Purchasing pattern

Commissioned artists and sometimes used agents as intermediaries.

Sales and bequests

Donated G. E. Hering's *Sunset* to Birmingham City Art Gallery. The remainder of his collection was auctioned at Christie's on 9 July 1881 (eighty lots). Although Sharp parted with Cox's *Vale of the Clywd* for £2,000 after the artist's death (Hall, *Cox*, p. 73), he refused an offer of £10,000 for his seven Müllers (Roberts, I, 326).

References

Waagen (1857), p. 404; *The Times*, 12 July 1881; Roberts, I, 326; Redford I, 313; Hall, *Cox*, p. 73; Chapel, *Victorian Taste*, pp. 77, 83, 119, and 125; Ormond, "Victorian Birmingham," p. 246; Coan, "Birmingham Patrons," p. 132.

Archival sources: J. T. Bunce volume of obituary notices, p. 44, Birmingham Central Library.

SHEEPSHANKS, John (1787–1863)

Leeds and then 172 New Bond Street by 1827. Also rented Weymss Cottage, Pond Road, Blackheath (which he rechristened Fairlawn) in 1833. In 1842 he relocated to 24 Rutland Gate, Brompton, London.

Maintained an additional residence at 11 London Road, Brighton.

Occupation

Merchant, York & Sheepshanks, Leeds, until his retirement *c.* 1826.

Biography

Grandson of Richard Sheepshanks, a well-to-do yeoman of Linton-in-Craven who apprenticed four of his sons to Leeds merchants in the 1760s, one of whom was Joseph, the father of the collector. Joseph Sheepshanks became a wealthy cloth manufacturer and merchant and founder of the family firm to which his son succeeded. After his retirement from business, John made several trips to the Continent but lived relatively modestly. Outside of art his major interest was gardening; he discovered a new species of geranium called *Sheepshanksiana grandiflora.* He was made a fellow of the Royal Horticulture Society and a member of the Athenaeum Club. A bachelor, Sheepshanks liked to entertain painters and engravers at informal Wednesday "at homes." He was the brother of the astronomer, Rev. Richard Sheepshanks, who was a fellow of Trinity College, Cambridge.

Collection

Sheepshanks began as a collector of books and Flemish and Dutch prints. Before moving to London he made purchases at the Northern Society in Leeds. In London, among the artists he actively patronized were Landseer, Mulready, Leslie, Callcott, and Cooke.

Sheepshanks was also a patron of the Society of Engravers and supported their cause for recognition by the Royal Academy.

Taste

Early-Victorian cabinet pictures of anecdotal, sentimental, and instructive subjects, as well as scenes from literature.

Purchasing Pattern

Direct commissions from Mulready, Leslie, Edward Cooke, etc. and purchases at sale rooms and in studios.

Sales and bequests

1836 sale of etchings to British Museum. Gift to South Kensington Museum of 233 oils, 298 watercolors, etchings, and drawings in 1857 (valued at the time at £60,000). Sotheby's sale, 5–7 March 1888 and by descent.

References

Art Journal (Jan. 1857), 33; (March 1857), 122 and 129; (April 1857), 129; (August 1857), 239–40; (Dec. 1863), 241 (obit.); *Athenaeum* (1857), 796; Johann David Passavant, *Tour of a German Artist in England*, 2 vols. (London: 1836), I, 242–43; Waagen (1854), I, 30 and 36–37; II, 258 and 299–307; *DNB*; Taylor, *Biographia Leodiensis*, pp. 514–15; *The Times*, 8 Dec. 1856; *Leeds Intelligencer*, 13 Dec. 1856; *Inventory . . . Gift of John Sheepshanks with an Introduction by Richard Redgrave* (London: 1857); Richard Redgrave, *The Sheepshanks Gallery* (London: 1870); Cope,

Reminiscences, pp. 120–22; Taylor, *Leslie* II, 230ff.; Horsley, *Recollections*, pp. 49–55; Uwins, *Uwins*, pp. 43, 193, and 200; Cole, *Fifty Years*, I, 325 and 329; Goodall, *Reminiscences*, pp. 120–22 and 173–74; Frith, *Autobiography*, I, 203–5; Redgrave, *Memoir*, pp. 164–67, 171, 179, 214, and 290; Davis, *Victorian Patrons*, pp. 74–79; Herrmann, *English as Collectors*, pp. 236 and 327; Steegman, *Consort of Taste*, pp. 52 and 58; Whitley, *Art in England*, pp. 188–89 and 339; "Constable Correspondence," IV, 117–23, VIII, 134, 139, 142–45, X, 117–20, XI, 163–64, 186–87, 204, XVIII, 132–34, 244; Gage, *Turner Correspondence*, pp. 175–76 and 284; Adams, *Danby*, pp. 17–18, 138, 148, and 162; Heleniak, *Mulready*, pp. 166–68 and 173–74; Robertson, *Eastlake*, pp. 42, 48, 208, 256, 262, 356, and 377; Reynolds, *Constable Catalogue*, pp. 1–2; Ormond, *Landseer*, pp. 55ff.; Morris, "Naylor," pp. 75–77; Brown, *Callcott*, pp. 87 and 89; Altick, *Paintings from Books*, pp. 68 and 92–93; Fawcett, *Provincial Art*, p. 89; Wilson, *Gentlemen Merchants*, pp. 25–27, 212 and 247–48; Heaton, *Yorkshire Woollen and Worsted Industries*, p. 280; Neil Rhind, *Blackheath Village and Environs* (London: 1976), pp. 125–26.

Archival sources: Brotherton Library, University of Leeds (6 letters to William Gott, 1816–1855 [Gott 16435]); Victoria and Albert Museum Library (correspondence with Mulready, Pye, and Landseer; William

Collins's "List of Pictures and Patrons;" William Mulready's "Account Book;" "John Sheepshanks's Deed of Gift" [1857]); Local History Library, Greenwich (Blackheath ratebooks); Somerset House (Probate copy of Will); Family Papers.

SMITH, Thomas Eustace (1831–1903) and Mary "Eustacia" Dalrymple Smith

Gosforth House, Newcastle (sold to Gosforth Racing Co. in 1880; the interior was destroyed by a fire started by Suffragettes in 1914, but was restored in 1921); 52 Prince's Gate, London, until 1887; Algiers; and Coxlease, Lyndhurst.

Occupation

Shipowner and shipbuilder; Smiths' Dock Co.

Biography

Smith was descended from an old Northumberland family which had owned the Togston Hall estate, near Warkworth, for over 300 years. Thomas Smith (b. 1783) was a ropemaker who took over William Row's shipbuilding business in 1810 with his brother William. They also owned East Indianers and a fleet of colliers that ran between the Tyne and the Thames and operated a sailmaking loft and warehouse on the East India Docks in London. Thomas Eustace Smith carried on the business with two partners, James Southern, who managed the London department, and George Luckley, who was in charge of Tyneside (Welford, *Men of Mark*). He spent some years in Germany and Italy and was

educated privately. Smith served as Liberal MP for Tynemouth for eighteen years and was a local magistrate. He was a patron of the Tynemouth Fine Art Club. In 1855 he married Mary Dalrymple of North Berwick, the eldest daughter and co-heir of Capt. Clarence Dalrymple. They had nine children. In 1865 the Smiths spent many months in Palestine. They returned to the East after the eruption of the scandal involving their married daughter Virginia Crawford and Sir Charles Dilke. When they finally returned to England, the Smiths settled in Lyndhurst.

Collection

Mary Dalrymple Smith, better known as Eustacia, played a prominent role in the selection of art for their London home at 52 Prince's Gate. She made purchases in artists' studios and commissioned Walter Crane and Frederic Leighton to paint friezes for the interior. Leighton also painted her portrait. The Smiths' collection of paintings included Armstrong's *Woman with Calla Lilies* (Laing Art Gallery, Newcastle), Watts's *The Wife of Pygmalion* (The Faringdon Trust, Buscot Park, Oxfordshire), Albert Moore's *A Garden* (Tate Gallery), and works by Rossetti, Mason, and Legros.

Taste

Aesthetic movement art and design.

Purchasing pattern

Although the Smiths worked directly with artists, they occasionally consulted dealers.

Sales and bequests

Prince's Gate and a large portion of its contents were sold to Lord Faringdon in 1887. Some objects still remain with the family.

References

Athenaeum (20 Sept. 1873), 372–73 and (16 Oct. 1875), 515; *WWMP*; *Builder* (6 May 1875), 425; *Shields Daily News*, 29 Aug. 1883; *Newcastle Evening Chronicle*, 16 Dec. 1903; Richard Welford, *Men of Mark 'Twixt Tyne and Tweed*, 3 vols. (London: 1895), III, 406–10; Stephen Gwynn and Gertrude M. Tuckwell, *The Life of Rt. Hon. Sir Charles W. Dilke*, 2 vols. (London: 1917), II, 172–73; Betty Askwith, *Lady Dilke* (London: 1969); Jenkins, *Sir Charles Dilke*; Crane, *Reminiscences*, p. 166; Lamont, *Armstrong*, pp. 15–16; Millais, *Millais*, I, 384; Hawthorne, *Shapes that Pass*, pp. 134–39; Ormond, *Leighton*, p. 72; Blunt, *Watts*, p. 111; *Rossetti Letters*, ed. Doughty and Wahl, II, 882; Surtees, *Rossetti Catalogue Raisonné*, I, 224A; Laing Art Gallery, *Albert Moore*, p. 131; *Boyce Diaries*, ed. Surtees, pp. 62 and 117; Smith, *Decorative Painting*, p. 6; Timothy Wilcox, "The Aesthetic Expunged: The Career and Collection of T. Eustace Smith, MP," *Journal of the History of Collections* 5 (1993), 43–57; Macleod (1986), p. 606; Macleod (1989b), pp. 27–28, 129–30.

Archival sources: Dilke-Roskill Archive, Churchill College, Cambridge; Westminster City Libraries (ratebooks); Author's correspondence with Richard Enthoven.

SOANE, Sir John (1753–1837)

13 Lincoln's Inn Fields, London, and Pitzhanger, Ealing.

Occupation

Architect.

Biography

Son of a small country builder from Goring-on-Thames, Soane became Professor of Architecture at the Royal Academy. Active in the Artists' General Benevolent Institute, he began planning his museum *c.* 1808 and formalized it after his son and heir criticized his architecture in an article in *The Champion* in 1815. Anna Jameson questioned Soane's motives when she wrote: "It were too curious to inquire what alloy of vanity, of selfish feeling, of an impetuous temper long irritated, mingled with the public spirit which dictated this magnificent bequest" (*Public Galleries*, p. 548).

Collection

Hogarth, Turner, Piranesi, Thornhill, Fuseli, Flaxman, Canaletto. Soane opened it to students after 1812.

Taste

Early-Victorian, older English school, and foreign.

Purchasing pattern

Soane bought directly from Turner and other artists.

Sales and bequests

Endowed his home and collection as a museum in 1833.

References

Waagen (1854), II, 179–82; III, 310–21;

DNB; Anna Jameson, *Public Galleries*, II, 545–79; "Constable Correspondence," VIII, 78; Dorothy Stroud, *Sir John Soane, Architect* (London: 1984).

Archival sources: Soane Museum (correspondence and office papers); Victoria and Albert Museum Library (letter to M. C. Wyatt).

STEVENSON, Alexander Shannan (1826–1900)

The Old House, 45–46 Front Street, Tynemouth; Auchineilan; Auchnacloich, Argyllshire; and Oatlands Mere, near Weybridge, Surrey.

Occupation

Chemical broker, Stevenson, Vermehren, & Scott; shipbroker and agent for Royal Life and Fire Co. and Liverpool Royal Insurance Co.; partner in Jarrow Chemical Co.; and owner of *Shields Gazette*.

Biography

Stevenson was born in Glasgow, the son of cotton broker James Stevenson, who moved to South Shields in 1844, where he became a senior partner in the Jarrow Chemical Company, manufacturers of alkali. Alexander was educated at Glasgow University before becoming a chemical broker on Newcastle Quay with Hermann Vermehren and William Henry Scott. They acted as agent for Jarrow Chemical Co. and as shipbrokers for two insurance companies. After his father's death, Stevenson was made a partner and director of Jarrow

Chemical Co. and one of the original directors of United Alkali Co. He was a magistrate for Northumberland and Argyll. Stevenson married Alice Knothe Kewney, the widowed daughter of a North Shields solicitor. She was a linguist and an amateur artist who exhibited locally. Their daughter married F. H. Leyland Stevenson, maternal grandson of Liverpool collector Frederick Leyland (q.v.). Stevenson was president of the Tynemouth Arts Association, vice-president of the Newcastle Society of Antiquaries, and a member of the executive committee of the Newcastle Arts Association. A member of Archaeologia Aeliana, he wrote articles for their journal. Stevenson's estate was proved at £51,000.

Collection

Stevenson's art collection was displayed in ambient surroundings in accordance with the dictates of the Aesthetic movement. Each room of his Tynemouth residence was furnished to represent a different nationality (Stirling, *Victorian Sidelights*). His summer home in Scotland was embellished with Morris designs and Japanese *objets d'art*. Among the pictures Stevenson owned were Rossetti's *Lady Lilith* (private collection), *Loving Cup* (Sotheby's sale, 21 Nov. 1989), *Sibylla Palmifera*, and *King René's Honeymoon* (Williamson Art Gallery and Museum), Albert Moore's *Lilies* (Sterling and Francine Clark Art Institute, Williamstown, Mass.), and a

portrait by Orchardson. He also owned works by Simeon Solomon and Colin Hunter.

Taste

Aesthetic movement art and design.

Purchasing pattern

Untraced.

Sales and bequests

By descent; family sales.

References

Athenaeum (27 Sept. 1873), 406–7; *Shields Daily News*, 29 March 1900; *Newcastle Leader* and *Shields Daily Gazette*, 30 March 1900; *Archaeologia Aeliana* 10 (1913), 280–81; Anna Maria Stirling, *Victorian Sidelights* (London: 1954), pp. 238–39; Greville Macdonald, *George Macdonald and his Wife* (London: 1924), pp. 389–96; Donald Macmillan, *The Life of Professor Hastie* (London: 1926); Jan Reynolds, *Birket Foster* (London: 1984), p. 175; Rossetti, *Rossetti as Designer and Writer*, p. 78; Bennett, *Pre-Raphaelite Circle*, p. 171; Surtees, *Rossetti Catalogue Raisonné*, I, 193B, 201R3, 205R2; Macleod (1986), p. 606; Macleod (1989a), p. 204, pl. 40b; Macleod (1989b), pp. 26–27, 130.

Archival sources: Family documents and notes provided by Hew Shannan Stevenson; 1881 Census Report.

STUART, Peter (1814–88)

Waterloo and Elm House, Crosby Road, Seaforth, near Liverpool.

Occupation

West African merchant, Douglas, Stuart, & Co.

Biography

Born in Liverpool, although Stuart's family had lived in Italy for a number of years, where, on subsequent visits, he became acquainted with Mazzina, Garibaldi, Orsini, and Kossuth, whose cause he financially supported (*Liverpool Daily Post*). Stuart was known to have aided a number of political refugees in their escape to America.

Collection

Stuart owned a selection of paintings by Scheffer, Doré, Müller, Maclise, Phillip, Wilkie, Holl, Creswick, Etty, J. F. Lewis, and W. Davis. He was a follower of the homeopath Samuel Hahnemann and the phrenologist Spurzheim, whose teachings inspired Stuart to form a collection of casts of heads of eminent personages. He also owned memorabilia documenting Garibaldi's struggle for independence. Stuart was president of the African Association, a member of the Liverpool Exchange, and a city magistrate.

Taste

Mid-Victorian collector. Having lived abroad, Stuart's taste was more cosmopolitan than that of the typical Northern collector. He owned works that reflected his interests in both art and science.

Purchasing pattern

Stuart is known to have commissioned a portrait from Edward Long.

Sales and bequests

Untraced.

References

Athenaeum (3 Sept. 1887), 316–17; *Liverpool Daily Post*, 26 Sept. 1888; Macleod (1986), p. 607.

TATE, Sir Henry (1819–99)

Woolton, Liverpool, and Park Hill, Streatham Common.

Occupation

Sugar refiner, Love Lane, Liverpool, and Sugar Quay, Lower Thames Street, London.

Biography

The eldest son of Agnes Booth and grocer William Tate of Chorley, Lancashire, Tate began as his father's assistant. He then entered the firm of sugar refiner John Wright in Liverpool. In 1872 an invention was brought to him for cutting up sugar loaves into small pieces for domestic use which he patented and thus laid the foundations of his fortune. In 1880 he migrated to London, where he eventually made "Tate's cube sugar," known all over the world. Consistent with his motto, "Think and Thank," Tate donated £42,000 to University College of Liverpool and to various Liverpool hospitals. He married twice, first to Jane Wignall and secondly to Amy Hislop, who was thirty-one years his junior. After announcing that he intended to give his art collection to the nation, Tate was made a trustee of the National Gallery in 1897 and a baronet a year later.

Collection

Contemporary English, including Millais's *Ophelia*, *North-West Passage*, and *Vale of Rest* and Fildes's *The Doctor*. Tate built a spacious gallery to house his pictures at Park Hill, which he opened to the public on Sunday afternoons. He gave an annual dinner for leading artists just before the opening of the Royal Academy.

Taste

Late-Victorian subject pictures.

Purchasing pattern

Tate depended on Agnew's for advice, but also occasionally approached artists with commissions on his own.

Sales and bequests

In 1890 Tate began to formulate the idea of giving his collection to the nation. His offer met with the same sort of political maneuvering that Vernon (q.v.) had faced fifty years earlier. Tate rejected the Chancellor of the Exchequer's proposal that his collection be housed in the South Kensington Museum, requesting that it be displayed in an extension to the National Gallery instead. Negotiations were at an impasse until Sir William Harcourt donated the former site of Millbank Prison and Tate agreed to provide the funds to construct and maintain the building in which the collection is presently housed. The trustees of the National Gallery accepted sixty-five pictures from Tate's collection. Sixty-four works were later added from the Chantrey bequest, eighteen were

given by artist George Frederic Watts, and ninety-eight were transferred from the National Gallery.

References

Art Journal (March 1893), 65–71; (April 1893), 121–26; (May 1893), 130–35; (July 1893), 193–98; (Oct. 1893), 297–301; (Jan. 1894), 1–4; (Feb. 1894), 31–34; (June 1894), 177–80; (July 1894), 194–96; (Dec. 1894), 370–74; *Magazine of Art* (1893), 145–49, 192–96, 244–48, 263–67 and (1897), 276–80; *DNB*; Boase; *The Times*, 9 Dec. 1899; *ILN*, 9 Dec. 1899; *Saturday Review* (Dec. 9, 1899); *Tate Gallery Illustrated Catalogue* (London: 1897); *The Collection of Pictures of Henry Tate, Park Hill, Streatham Common* (London: 1894); National Gallery, Millbank, *Catalogue*; Manson, *The Tate*; John Rothenstein, *The Tate Gallery* (London: 1958); Blackburn, *Sir Henry Tate*; Tom Jones, *Henry Tate, 1819–1899: A Biographical Sketch* (London: 1960); John Alexander Watson, *A Hundred Years of Sugar Refining* (Liverpool: 1973) and *The End of a Liverpool Landmark: The Last Years of Love Lane Refinery* (Liverpool: 1985); Geoffrey Fairrie, *The Sugar Refining Families of Great Britain* (London: 1951); Anthony Hugill, *Sugar and All That: A History of Tate & Lyle* (London: 1978).

Archival sources: Correspondence with Luke Fildes, Victoria and Albert Museum Library; correspondence with Sir William Harcourt relating to the Tate Gallery, Bodleian Library, Oxford; correspondence, press clippings, and photographs, Tate Gallery Archives.

TAYLOR, Thomas (1810–92)

Wallgate, Wigan; The Limes, Standish, Lancashire; Aston Rowant, a landed estate in Oxfordshire near Thame and Prince's Risborough which was gutted by fire in 1957 (1860–c. 1880); and Port Street, Southport, Lancashire.

Occupation

Cotton spinner and manufacturer, Thomas Taylor & Brothers, Victoria Mills, Wallgate, Wigan. The mills were partially destroyed by fires in 1934 and 1938 and are now the location of tufted carpet spinning.

Biography

Son of James Taylor of Wigan, owner of a tannery in Billinge. Taylor first worked in his father's business before establishing a cotton mill, around 1835, with his brothers James and Richard, who had been trained as a surgeon. At the time of Taylor's death, the mills were said to be amongst the largest in Britain, employing 3,000 hands. A shrewd businessman, Taylor bought all the cotton stocks he could afford while on a trip to America shortly before the outbreak of the Civil War. This maneuver allowed him to control the cotton market on his return and provided him with his fortune. Taylor Brothers subsequently expanded to Egypt, China, and Japan. Taylor was a Lancashire Justice of the Peace from 1848, mayor of Wigan (1854–55), and High Sheriff of Oxfordshire (1863), where he built a school. Taylor also gave £12,000 for a free public library in Rodney Street, Wigan, in 1878.

Collection

Taylor's vast collection was displayed in a private gallery (70 × 26 feet) at Aston Rowant, where it was open to the public on Wednesdays. Among his most celebrated pictures were Fildes's *The Widower* and *Applicants for Admission into a Casual Ward* (for which he paid 2,500 guineas in 1874). Taylor also collected paintings by artists from the older generation, such as David Roberts, Vicat Cole, and John Linnell. Among the mid-Victorians, Taylor owned works by Long, Hodgson, Dillon, Rivière, Waller, and Marcus Stone. His foreign canvases were works by Bonheur, Piloty, Frère, Münthe, and Verboeckhoven.

Taste

Mid- to late-Victorian collector of nineteenth-century English and foreign oils.

Purchasing pattern

Direct purchases from Rivière, Hodgson, Burgess, Fildes, and other artists. Redford claimed that Taylor was "not handicapped by the usual profit of the middleman between artist and amateur" (p. 353); however, he was an occasional customer of Christie's.

Sales and bequests

Christie's, 28 April 1883 and 18 February 1893.

References

Magazine of Art (1882), 309–14; *Art Journal* (Oct. 1883), 322; Boase; *Wigan Observer*, 16 March 1892, 7 April 1934, and 20 Jan. 1967; *Wigan Examiner*, 16 and 19 March, 1892; *The Times*, 30 April 1883; *The Comet*, 20 Feb. 1892; Redford, I, 353–54; Roberts, II, 47–49; Marillier, *Christie's*, p. 59; Reitlinger, I, 157, L.V. Fildes, *Luke Fildes, RA* (London: 1968); Howe, *Cotton Masters*, pp. 253, 260, 300; Chapel, *Victorian Taste*, pp. 70–71, 84–86, 95, 98, 100, 105, 126, and 131; Treuherz, *Hard Times*, p. 11; *Victoria History of the County of Oxford*, ed. L. F. Salzman, 12 vols. (London: 1964), VIII, 18; Greg, *Cranbrook Colony*, no. 39.

Archival sources: Wigan Record Office, *Copy of Address to Thomas Taylor, Esquire, on the Occasion of the Presentation by him of the Free Library to the Corporation of Wigan*, 16 Oct. 1877.

TEBBS, Henry Virtue (d. 1899)

West Hill, Highgate, and St. John's Gardens, Ladbroke Grove, London.

Occupation

Proctor and notary, 15 Knightrider Street, London.

Biography

Social origins unknown. Tebbs married Emily Seddon, sister of architect J. P. Seddon. He aided Rossetti in obtaining permission to exhume his manuscript from Elizabeth Siddall's grave in 1869. Tebbs was a member of the Burlington Fine Arts Club, where he knew Whistler. He shared Rossetti's interest in séances. Tebbs wrote the introduction to the catalogue for the retrospective exhibition of Rossetti's works at the Burlington Fine Arts Club in 1883.

Collection

Tebbs collected etchings, sketches, and oils by his artist friends, who included Rossetti, Boyce, Whistler, Millais, Seddon, Bell Scott, and Madox Brown. He also owned a copy of Turner's *Liber Studiorum*. Tebbs shared the Aesthetic movement's interest in *objets d'art* such as Japanese netsukes, lacquer, and bronzes and Chinese porcelain and cloisonné.

Taste

Aesthetic movement and Pre-Raphaelite engravings, drawings, and oils.

Purchasing pattern

Tebbs was a well-known visitor to artists' studios. He also bought at exhibitions such as the Old Water-Colour Society.

Sales and bequests

Christie's, 8–10 March 1900.

References

London Trades and Court Directory (1876); Rossetti, *Family Letters*, I, 274 and II, 220; Fredeman, *Bibliocritical Study*, nos. 14.3 and 19.18; Surtees, *Rossetti Catalogue Raisonné*, nos. 52, 60, 96, 132A, 148R.1, 176, 180A, 249B, and 255A; *Rossetti Letters*, ed. Doughty and Wahl, IV, 1851 and *passim*; *Boyce Diaries*, ed. Surtees, pp. 51, 54, 56; *Brown Diary*, ed. Surtees, pp. 118, 209; Bennett, *Pre-Raphaelite Circle*, p. 27; *Pictures, Drawings, Designs and Studies by the Late Dante Gabriel Rossetti* (London: Burlington Fine Arts Club, 1883).

Archival sources: Letters to Rossetti, University of Toronto.

TENNANT, Sir Charles (1823–1906)

195 West George Street, Glasgow; The Glen, Peeblesshire, Scotland; and 35 Grosvenor Square, London.

Occupation

Industrialist, Charles Tennant & Sons, St. Rollox and 217 W. George Street, Glasgow.

Biography

A third-generation industrialist, Tennant was born in Glasgow, where he was educated at Ayr Academy. After studying commerce in Liverpool, at age twenty-seven he entered the chemical manufacturing firm founded by his grandfather. Anxious to take advantage of the investment opportunities offered by Britain's expanding economy, Tennant constructed a second manufactory at Hebburn-on-Tyne and formed the Tharsis Sulphur and Copper Co. which controlled pyrite mines in southern Spain. He also spearheaded the purchase of gold mines in India and the formation of the Cassel Gold Extraction Co. His later efforts were directed toward steel and explosives. Tennant married Emma Winsloe in 1849 and, following her death, Marguerite Miles in 1898. He fathered sixteen children. Tennant was

a trustee of both the National Gallery and the National Portrait Gallery. He was also a member of the Burlington Fine Arts Club. His estate was proved at £3,151,974.

Collection

Tennant supported the late-Victorian revival of interest in the eighteenth-century English school. He owned paintings such as Reynolds's *Viscountess Crosbie* and Hoppner's *The Sisters*, both of which were exhibited at Burlington House in 1906. He also collected nineteenth-century English art by painters including Constable, Cox, Bough, and Millais.

Taste

Eighteenth-century English and proven nineteenth-century English artists, such as Millais.

Purchasing pattern

Agnew's and Christie's.

Sales and bequests

Tennant bequeathed to the National Gallery Millais's portrait, *Gladstone* (1879), which he had bought from the Duke of Westminster at the time of the Home Rule split. He also gave Millais's last picture, *A Forerunner*, to the Glasgow Gallery, along with Sam Bough's *Dunkirk Harbour*. By descent.

References

DNB; *Glasgow Directory* (1886–87); *Dictionary of Scottish Business Biography*; Margot Asquith, *An Autobiography* (London: 1922); Nancy Crathore, *Tennant's Stalk* (London: 1973); Sydney F. Checkland, *The Mines of Tharsis*

(London: 1967); *Art Journal* (Aug. 1906), 255 and (Sept. 1906), 288; *Connoisseur* 176 (1971), 3–15; and Peter Payne, *Colvilles and the Scottish Steel Industry* (Oxford: 1979).

TREVELYAN, Lady Pauline (1816–66)

Wallington Hall, Northumberland (now property of the National Trust) and Nettlecombe Court, Somerset.

Occupation

Amateur artist.

Biography

Daughter of an impoverished Suffolk parson, Pauline Jermyn married Sir Walter Trevelyan in 1835, who was descended from the Blacketts who had made their fortune in the seventeenth century in Newcastle coal and lead mining. While her husband occupied himself with botany, geology, agriculture, antiquities, and the temperance movement, she pursued her interests in the visual arts and in writing. Lady Trevelyan wrote reviews for the *Scotsman* and the *Edinburgh Review*. She admired Ruskin and sought his advice in artistic matters, beginning in 1848. Somewhat eccentric, she was reported on one occasion to serve her guests a lunch of artichokes and cauliflower (Hare, *My Life*, II, 277).

Collection

After roofing over the central courtyard at Wallington, Lady Trevelyan commissioned artists to join her in decorating it. William Bell Scott pro-

duced a mural cycle illustrating the history of Northumberland (1856–60), while Woolner and Munro submitted sculpture. In addition, she bought works by Rossetti, Turner, Cox, and Leighton.

Taste

Pre-Raphaelites and Turner.

Purchasing pattern

Commissioned artists for the Wallington project.

Sales and bequests

Sir Walter Trevelyan, in his will, stipulated that the British Museum and National Gallery be allowed to make selections from his collection. The National Gallery selected nothing, while the British Museum chose porcelains and coins. The Pre-Raphaelite portion of the collection remains at Wallington Hall.

References

Trevelyan, *Pre-Raphaelite Circle*; *Reflections of a Friendship*, ed. Surtees; August J. C. Hare, *The Story of My Life*, 2 vols. (London: 1896), II, 260, 277, and 347–50; *Autobiographical Notes of William Bell Scott*, ed. Minto, II, 53–54 and *passim*; Woolner, *Thomas Woolner*, pp. 118–19, 125–27, 137–38, 142, 154–56, 159, 194, 199, 240, and 262; Robin Ironside, "Pre-Raphaelite Paintings at Wallington: Note on William Bell Scott and Ruskin," *Architectural Review* 92 (Dec. 1942), 147–49; Raleigh Trevelyan, "William Bell Scott and Wallington," *Apollo* (Feb. 1977), 117–20; National Trust, *Wallington*, (London: 1979); Smith,

Decorative Painting, pp. 67–68
Rossetti, *Family Letters*, II, 149, *Ruskin: Rossetti: Pre-Raphaelitism*, pp. 159–60, 214–15, and 285–86; Surtees, *Rossetti Catalogue Raisonné*, nos. 110 and 110 R.1; Maas, *Gambart*, pp. 127 and 140.

Archival sources: Correspondence of Pauline Trevelyan with William Bell Scott, Dante Gabriel Rossetti, William Michael Rossetti, Thomas Woolner, George Watts, and Algernon Swinburne, University of Newcastle, Newcastle-upon-Tyne.

TRIST, John Hamilton (1811–91)
1 Upper Rock Gardens, 22 Vernon Terrace, and 11 Compton Terrace, Brighton.

Occupation
Wine merchant, Brighton.

Biography
Descended from yeoman farmers who had worked the land in Devon since 1519, Trist's father became a wine merchant *c.* 1800. Pursuing the same occupation, John's interests extended to the arts. An amateur artist, he was introduced to the Pre-Raphaelites by Arthur Hughes after he bought the artist's *Ophelia* at Christie's in 1854. He also made the acquaintance of other collectors of Pre-Raphaelite and Aesthetic movement art, such as Rae, Leyland, Graham, Turner, and Leathart (q.v.). Trist's brother George also collected Pre-Raphaelite art.

Collection
Trist's manuscript catalogue of his collection lists 139 items, including seven Rossettis, seventeen works by Arthur Hughes, and Albert Moore's *Pomegranates*, in addition to examples by Madox Brown, Legros, Mason, Burne-Jones, Anthony, Leighton, Alma-Tadema, Boyce, Goodwin, W. Henry Hunt, Prout, Stanfield, Varley, Anthony, and Carrick.

Taste
Avant-garde mingled with standard efforts.

Purchasing Pattern
Trist chiefly purchased directly from artists. He also bought at Christie's and dealt privately with other collectors such as Leathart, to whom he sold Albert Moore's *Elijah's Sacrifice,* and Capt. Henry Hill (q.v.), from whom he bought several works by Phil Morris.

Sales and bequests
Christie's, 19 April 1892 and 23 April 1937.

References
Magazine of Art 6 (1883), 62–70; Clifford Musgrave, *Life in Brighton* (London: 1970), p. 334; *Rossetti Letters,* ed. Doughty and Wahl, pp. 505, 516, and 519–20; Rossetti, *Rossetti as Designer and Writer*, p. 44, *Rossetti Papers*, pp. 62–63, *Family Letters*, I, 247; Surtees, *Rossetti Catalogue Raisonné*, nos. 155, 166, 175, 190, 205A, 222, and 328 R.1; Arts Council, *Burne-Jones* (London: 1975), no. 93; Robin Gibson, "Arthur Hughes: Arthurian and Related Subjects of the Early 1860s," *Burlington* 112 (July 1970), 455–56; National Museum of Wales, *Arthur Hughes* (Cardiff: 1971);

Leonard Roberts and Mary Virginia Evans, "'Sweets to the Sweet': Arthur Hughes's Versions of *Ophelia*," *Journal of Pre-Raphaelite and Aesthetic Studies* 1 (1988), 32; Bennett, *Pre-Raphaelite Circle*, pp. 59 and 61.

Archival sources: "Catalogue of Pictures and Drawings at 22 Vernon Terrace and 11 Compton Terrace," (MSS: 1876–86), Tate Gallery Archives; correspondence with James Leathart, Leathart Papers, University of British Columbia; letters from Arthur Hughes, Trist Family Papers. I am grateful to Leonard Roberts of Vancouver, B.C. who is preparing a catalogue raisonné of the works of Arthur Hughes for sharing his research with me.

TURNER, Henry James (c. 1832–c. 1909)
16 Hamilton Terrace, St. John's Wood, and Stockleigh House, Northgate, London (by 1880).

Occupation
Merchant.

Biography
Origins unknown. Born in Bloomsbury, London.

Collection
Turner's collection was divided between English artists such as Roberts, Ward, Frith, Phillip, Millais, Faed, Frost, Simeon Solomon, Linnell, and Prout and foreign painters such as Gérôme (six), Isabey, and Rosa Bonheur.

Taste
Mid-Victorian collector of nineteenth-century English and contemporary foreign oils.

Purchasing pattern
Possibly bought his Alma-Tadema from Gambart and his Gérômes from Arthur Tooth.

Sales and bequests
Christie's, 4 April 1903 (166 lots brought £29,126) and 24 April 1925.

References
Art Journal (Jan. 1871), 18–19; *London Directory* (1852–80); *Marylebone Directory* (1863 and 1880); Hardie, *John Pettie*, p. 222.

TURNER, William Alfred (1839–86)
The Laurels, Pendleton (1870–78), and Barlow Fold, Poynton, Cheshire.

Occupation
Cotton spinner, Kingston Mills, Poynton.

Biography
Born in Pendleton, Turner was the son of Wright Turner, a chief magistrate and owner of the Kingston Mills. He was possibly the grandson of calico printer William Turner of Blackburn, who served as High Sheriff of Cheshire in 1826 and whose mill was converted to spinning and weaving after his death in 1842 (Howe, *Cotton Masters*, p. 15). Turner entered the family business and was one of the first to introduce electric lighting into cotton

mills. He subsequently became a director of the Edison Electric Lighting Co. and also served as a Justice of the Peace. Turner was a governor of the Royal Institution, where he sponsored the measure by which the building in Mosley Street was taken over as an Art Gallery by the Manchester Corporation. He was chairman of the Art Subcommittee which controlled the annual Autumn exhibitions and the permanent collection. His wife, the daughter of Philip Gillibrand, was an accomplished embroideress.

Collection
Turner presumably inherited a small collection of Old Master paintings which he supplemented with canvases by Rossetti, Madox Brown, Stanhope, and Prinsep. Under the advice of his neighbor William Agnew, Turner purchased the works of a number of early-nineteenth-century landscapists, including David Cox and Richard Bonington, and examples by Royal Academicians Birket Foster and Philip Calderon. He also collected manuscripts, including the poems of Ruskin. Turner made loans to the Royal Jubilee Exhibition in 1887.

Taste
Aesthetic movement, Victorian figurative, and early nineteenth-century landscapists.

Purchasing pattern
Although Turner was a client of Agnew's, he also bought directly from artists.

Sales and bequests
Turner donated Prinsep's *At the Golden Gate* to the Manchester City Art Gallery in 1882.

Sale: Christie's, 21, 27–28 April 1888.

References
Art Journal (Nov. 1888), 341; *Manchester Guardian*, 18 June 1886; Roberts II, 129; Alfred Darbyshire, *An Architect's Experiences* (Manchester: 1897); Howe, *Cotton Masters*, pp. 15 and 260–61; Fredeman, *Bibliocritical Study*, p. 78, no. 19.5; Agnew, p. 18; *Frederic Shields*, ed. Mills, pp. 219, 223, and 233; Rossetti, *Rossetti as Designer and Writer*, pp. 76, 102–3, 106–7, 109, 168, and 266, *Family Letters*, I, 325 and II, 348; *Rossetti Letters*, ed. Doughty and Wahl, III, 1510, 1519–20, 1541–43, 1560, 1570–72, 1594, IV, 1801, 1933; *Rossetti and Jane Morris Correspondence*, ed. John Bryson (Oxford: 1976), p. 45; Surtees, *Rossetti Catalogue Raisonné*, nos. 160R.1, 196, 226, 233, 240A, 252, and 261B; *The Correspondance between Samuel Bancroft, Jr. and Charles Fairfax Murray*, ed. Rowland Elzea (Wilmington: Delaware Art Museum, 1980), pp. 1, 13, 92–99, 102, 202–203, and 230.

Archival sources: Letters to Samuel Bancroft, Delaware Art Museum; letters from Rossetti, Morgan Library, New York; letters to Rossetti, Angeli-Dennis Papers, University of British Columbia; Royal Manchester Institution Letter Books, Manchester City Library.

VALPY, Leonard (1825–84)

5 Upper Montague Street, London, and Bath (after 1878).

Occupation

Solicitor, Valpy & Chaplin, 19 Lincoln's Inn Fields, London.

Biography

The grandson of Richard Valpy (1752–1859), headmaster of Reading School and author of widely used textbooks on Greek and Latin grammar and classical mythology (*DNB*). Rossetti referred to Leonard Valpy as "the grandson of that intoxicated latchkey or insane corkscrew which figured in the bitter pages of our school books" (Smetham Letters, V&A). Valpy qualified as a solicitor in Hilary term 1859 and by 1867 he was in partnership with the solicitor Ledsom, where he remained until 1876, when he became Chaplin's partner. Valpy was solicitor to John Ruskin (q.v.), although he did not assist in defending him in the libel charges brought by Whistler in 1878. He married in 1868. Valpy's prosperity suffered in 1873 because of an unsuccessful investment in a slate mine (*Owl and Rossetti*, ed. Cline, no. 290). He retired from the law five years later and settled in Bath, where he wrote numerous religious tracts.

Collection

Valpy's sales indicate that, at one point, he shared the mainstream Victorian taste for watercolor views by artists such as Cox, Fielding, and De Wint. In 1863, however, he began to commission works from artists and played an active part in the conception of Samuel Palmer's Milton series. He began to patronize Rossetti in 1867 and also bought four studies from Burne-Jones. In addition, Valpy owned watercolors by George Price Boyce, Birket Foster, and Frederick Walker.

Taste

Aesthetic movement and nineteenth-century English landscape watercolors and romantic subjects.

Purchasing pattern

Valpy gave direct commissions to artists, made purchases at the Old Water-Colour Society, and bought through intermediaries, such as Charles Howell.

Sales and bequests

Christie's, 26 May 1883 and 26 May 1888.

References

Athenaeum (6 Oct. 1877), 440–41; *London Directory* (1861–78); *Law List* (1867); *Paintings and Etchings by Samuel Palmer with an Account of the Milton Series of Drawings by L.R. Valpy*, Fine Arts Society (London: 1881); Rossetti, *Family Letters*, I, 247 and *passim*, *Rossetti as Designer and Writer*, pp. 64, 78, 85–88, 104–7, 118–19, 172–73, and 266, *Rossetti Papers*, pp. 267–68; Surtees, *Rossetti Catalogue Raisonné*, no. 81R.1 and *passim*; *Owl and Rossettis*, ed. Cline, no. 44 and *passim*; Alfred Herbert Palmer, *Life and Letters of Samuel Palmer* (London: 1892), pp. 148ff.; Raymond Lister, *Samuel Palmer: A Biography* (London: 1974), p. 62 and *passim*; *Letters of Samuel Palmer*, ed. Raymond Lister, 2 vols. (Oxford: 1974), II, 684 and *passim*; *Boyce Diaries*, ed. Surtees, pp. 40–41, 48, 52, and 101; Fredeman, *Bibliocritical Study*, no. 19.5.

Archival sources: Letters from Rossetti, University of British Columbia and Boston Public Library; letter from Ruskin to John Giles, 30 Jan. 1858, Ivimy MS; letter from Rossetti to James Smetham (n.d.), Victoria and Albert Museum Library, Box II, 86NN, no. 33.

VAUGHAN, Henry (1809–99)

28 Cumberland Terrace, Regent's Park, London.

Occupation

Antiquarian.

Biography

Son of Elizabeth Andrews and George Vaughan, a Southwark hat manufacturer. Vaughan was privately educated. He came into his inheritance at age nineteen and dedicated his life to traveling and collecting art. Sidney Colvin described him as "a man of the most quiet and retiring, devoutly beneficent and charitable disposition" (*Memories*, p. 206). Vaughan was one of the founders of the Burlington Fine Arts Club and a member of the Athenaeum Club. He was elected FSA in 1879.

Collection

Vaughan collected both the ancients and moderns. He had a special predilection for the works of Stothard, Flaxman, Constable, and

Turner, especially the latter's water-colors and *Liber Studiorum*.

Taste
Mid-Victorian collector of earlier English watercolors, etchings, and oils.

Purchasing pattern
Christie's and the dealers Cooke, Cooper, and White. Vaughan purchased several Turners from the Windus (q.v.) collection.

Sales and bequests
Before his death Vaughan gave Constable's *Hay Wain* to the National Gallery and a group of drawings by Michelangelo and Raphael to the British Museum. Vaughan bequeathed the remainder of his large collection to several institutions. He left Turner's original drawings for the *Liber Studiorum*, along with Constable's oil sketches, and studies by Reynolds and Leslie to the National Gallery. To the British Museum he gave his Old Master drawings, Flaxman studies, and watercolors by Stothard and other English artists. The Victoria and Albert Museum received Constable's oil studies for the *Hay Wain* and *Leaping Horse* and Vaughan's collections of stained glass and carved panels, as well as his Turner drawings. The rest of Vaughan's Turner drawings and watercolors went to the National Gallery of Ireland and the National Gallery of Scotland.

References
DNB; *The Times*, 27 Nov. 1899; *Athenaeum* (2 Dec. 1899), 767; Colvin,

Memories, p. 206; Andrew Wilton, *Turner in the British Museum* (London: 1975), p. 8; National Gallery of Scotland, *The Vaughan Bequest of Turner Watercolours* (Edinburgh: 1980).

VERNON, Robert (1774–1849)
Mount Street, Berkeley Square; 2 Halkin Street, Grosvenor Place, by 1820; Tichfield, Hampshire; Marble Hill Cottage, Twickenham, c. 1835; 50 Pall Mall by 1839; and Ardington House, Wantage, Berkshire, by 1838.

Occupation
Hackneyman and stable owner, Halkin Street, Mayfair, and investor in London property.

Biography
Son of Mary and William Vernon, Robert Vernon claimed to be of humble origins, although his father owned a successful carriage rental business in London, as well as two stableyards. Robert also inherited substantial furnishings from a house in Doncaster in 1812. He turned his inheritance into a fortune by expanding the family business and by investing in real estate. While the *DNB* claims Vernon earned part of his fortune as an army contractor during the wars with Napoleon, Hamlyn (*Vernon's Gift*) maintains that there is no evidence to support this claim. There is no question, however, about his business acumen, which enabled him to purchase a mansion on Pall Mall and a large country house in Berkshire, where he lived the life of a

squire, hunting and riding to hounds until prevented by attacks of gout. Although Vernon was made a fellow of Society of Antiquaries, he was not granted the knighthood or baronetcy he anticipated for donating his extensive art collection to the nation.

Collection
Vernon inherited a collection of Old Master paintings from his father, all by minor artists with the exception of a Metsu which has since been reattributed to Vermeer. By the 1820s he had begun to add modern British artists, on whose works he was reputed to have spent £150,000. Vernon weeded and refined his collection after he conceived the idea of donating a survey of British art to the National Gallery. Although he allowed the Trustees to select what they wished from his collection, they essentially confirmed his choices.

Taste
Conservative and diverse, in accordance with Vernon's ambition of endowing a school of modern art. He collected representative examples of British art from Gainsborough and West to Wilkie and Turner. Despite his reputation as a collector of contemporary art, he never sold his Old Masters or stopped lending them to exhibitions.

Purchasing pattern
Vernon commissioned or bought directly from living artists, while occasionally using such go-betweens as his nephew and George Jones,

Keeper of the Royal Academy, who was also a painter and a fellow Wellington buff. In addition, Vernon frequented the sale rooms and the Royal Academy private view.

Sales and bequests

Christie's, 6 May 1842; 22 April 1847; 5 July 1849; 21 April and 3 May 1877. Vernon's Gift of 157 pictures in 1847 is now in the Tate and National Galleries. The residue of his modern collection was sold by his heirs in 1849; the historical portraits were sent to the sale room in 1877.

References

Art Union (March 1839), 19 and numerous additional references through 1854; Waagen (1854), I, 359ff.; *DNB*; *Gentleman's Magazine* 186 (July 1849), 98–99; *ILN* 13 (4 Nov. 1848), 284, and 14 (2 June 1849), 381–82; *The Times*, 30 Oct. and 8 Nov. 1849; Vernon Heath, Letter to *The Times*, 23 April 1878, and *Recollections*; *Punch* 14 (1848), 253, and 15 (1849), 138, 208, and 221; *National Gallery Catalogue of the Vernon Gallery* (London: 1848); *The Vernon Gallery of British Art*, ed. Samuel Carter Hall, 4 vols. (London: 1849–54); Collins, *Collins*, I, 343 and II, 47, 67, and 319–22; "Constable Correspondence," IV, 289, VIII, 123–24, 131–32, X, 117 and 120–23, XI, 28–29, 48, 179, and XVIII, 138–40; Charles Robert Leslie, *Life and Letters of John Constable* (London: 1896; rpt. 1951), pp. 239–40 and 245–56; Horsley, *Recollections*, p. 58; Anna Bray, *Life of Thomas*

Stothard (London: 1851), pp. 236 and 243–44; Cunningham, *Wilkie*, III, 90–93, 109, and 115; Hall, *Retrospect*, I, 357 and II, 502–503; Redford, I, 260; Whitley, *Art in England*, pp. 142 and 281; Steegman, *Consort of Taste*, pp. 52 and 58; Herrmann, *English as Collectors*, pp. 236–37; Haskell, *Rediscoveries*, p. 52; Robertson, *Eastlake*, pp. 296–97; Cooper, *My Life*, II, 293; Heleniak, *Mulready*, pp. 138 and 166–70; Gage, *Turner Correspondence*, pp. 5, 292–93, and 341; Hamlyn, *Robert Vernon's Gift*.

Archival sources: Jenkyns Papers II, Balliol College, Oxford; National Gallery; Peel Papers, British Library; Victoria and Albert Museum Library (William Mulready's Account Book and William Collins's List of Pictures and Patrons); Doncaster Record Office; London Public Record Office (Probate Copy of Will).

WELLS, William (1768–1847)
Canister House, Chislehurst; 47 Harley Street, London; and Redleaf, Penshurst, Kent.

Occupation

Partner in shipbuilding firm at Blackwall Docks on Thames; investor in Meux Brewery.

Biography

Although Wells is often described as a typical *nouveau-riche* collector, he was descended from an old Kentish family connected with shipbuilding from the seventeenth century. He played an active role in the family business, supervising the building of East

Indiamen and battleships for the government, including three that were used in the Battle of Trafalgar. Wells was honored by having Wells Street, Poplar, named after him (renamed Mackrow Street in 1939). He sold his shipbuilding interests in 1810 and retired with his wife, Mary Hughes, to Redleaf (for which he had paid £50,000) in a part of the country where his family were established members of the landed gentry. There he entertained royalty, sportsmen, and artists, especially Landseer and F. R. Lee. Wells was a director of the British Institution and a Trustee of National Gallery. He was also a serious and inventive gardener (one of his under-gardeners was Joseph Wells, the father of H. G. Wells, but no relation to himself – see *Country Life* [1976], 1923–24). The 1841 Census lists twenty-three employees on his estate. Wells was an active member of the Anglican Church and a liberal benefactor to the poor. He left his estate to his grandnephew William Wells (1818–89), MP for Beverly and Peterborough, who was a noted agricultural reformer and who depleted most of his fortune by draining Whittlesea Mere just before the great agricultural depression, which resulted in the sale of the Wells collection, in 1890, following his death.

Collection

Landseer, Callcott, Cooke, Collins, Creswick, Etty, Gainsborough, Goodall, Grant, F. R. Lee, Müller,

Webster, Wilkie, and other British artists. Wells owned two albums by Landseer – portrait sketches of artists and famous people done at Redleaf (lots 146–47 in the 1890 sale). He also possessed an extensive collection of Dutch, Flemish, and Italian paintings. Wells promised sixteen paintings to the National Gallery, but bequeathed only Guido's *The Glorification* (bought at Sir Thomas Lawrence's sale for 1,200 guineas.). He sold his Van Dyck, *Three Heads of Charles I*, to George IV for 1,000 guineas (the amount he had paid). Wells told Farington that he had drawn a will expressing his wish to have his collection preserved as an heirloom for at least a generation or two (*Farington Diary*, VII, 39).

Taste
Early-Victorian landscape, animals, some genre, and Old Masters (mainly Dutch and Flemish). Wells's modern paintings harmonized with his old ones, much in the manner of many aristocratic collections.

Purchasing pattern
Wells bought his Old Masters through the dealers Mortimer and Buchanan. He also commissioned and bought works directly from living artists.

Sales & bequests
By descent. Family sales: Christie's 12–13 May 1848 (Old Masters), 20 May 1852, 21–22 Jan. 1857, 27 April 1860, 9 June 1877, 10–14 May 1890 (thirty Landseers brought £42,000).

References
Art Journal (1847), 335 (obituary); (1848), 197; (1852), 216; (1860), 181; (1890), 307; Waagen (1854), II, 404; Christopher Greenwood, *Epitome of the History of Kent* (Bath: 1838); John Burke, *A Genealogical and Heraldic History of the Commoners of Great Britain and Ireland* (London: 1964); Carl Gustav Carus, *The King of Saxony's Journey through England and Scotland in the Year 1844* (London: 1846), pp. 43–44; *Annual Register* (11 August 1847); *Gentleman's Magazine* 29 (1848), 87; Johann David Passavant, *Tour of a German Artist in England*, 2 vols. (London: 1836), I, 227; Whitley, *Art in England*, pp. 229–30; Frith, *Autobiography*, I, 319–21; Horsley, *Recollections*, pp. 55–58; Roberts, I, 61, 105, 156–58, II, 144–49; *Farington Diary*, ed. Grieg, VI, 11, 14, 29, 51, 97–98 and VII, 38–39, 41–42, 45–46, 218, and 250; Collins, *Collins*, I, 193, 232, 237, 238, 250–51, 264–65, 268, 275–76, 315, II, 235, 250, 345–47; Goodall, *Reminiscences*, pp. 117–26, 172–74; "Constable Correspondence," VIII, 23, 94, 97, 111, 123, 134 and XI, 19–20, 22, 184–85; Butlin and Joll, *Turner*, I, 58 and 188–89; Saint, *Shaw*, pp. 25, 150; Solomon Hart, *Reminiscences of Solomon Hart, RA* (London: 1882), p. 88; Taylor, *Leslie*, II, 225, 321; Redgrave, *Memoir*, p. 50; Edward T. Cook, *Life of John Ruskin*, 2 vols. (London: 1911), I, 325; Ormond, *Landseer*, p. 9; Ferriday, "Victorian Art Market," p. 1457; Elisabeth Bond, "Mr. Wells and Joseph Wells," *Country Life* 160 (Dec. 1976), 1923–24; John Loudon, *The Villa Gardener* (London: 1850), pp. 299ff.; J. Robinson, *Journal of Horticulture and Cottage Gardener* (London: 1861), p. 4; Henry Green and Robert Wigram, *Chronicles of Blackwall Yard* (London: 1881), pp. 37–40 and 45–48; Banbury, *Shipbuilders*, pp. 139–41; Evan Cotton, *East Indiamen: The East India Company's Maritime Service* (London: 1949), pp. 21–24; Peter Mathias, *The Brewing Industry in England, 1700–1830* (Cambridge: 1959), pp. 302–3.

Archival sources
Victoria and Albert Museum Library (letters to Landseer); 1841 Census Report; Family Records.

WILLIAMS, Thomas (*c.*1800–78)
13 Elm Tree Road, St. John's Wood, London.

Occupation
Certified Conveyancer, Northumberland House, Charing Cross Road.

Biography
Origins unknown. Born in Portugal, Williams's profession as a legal conveyancer of properties was apparently a lucrative one. As a certified conveyancer, he could enjoy membership in the Inns of Court, even if he had no intention of being called to the Bar. Because of the success of men like Williams, attorneys complained that conveyancers were free of discipline and did not have to pay as many taxes (Kirk, *Portrait*, p. 134). Williams's large home on Elm Tree Road was situated on a double plot of land in a wealthy

neighborhood (Westminster Archives). His only son, Thomas Goddard Williams, continued in the legal profession as a barrister at Gray's Inn.

Collection

The *Art Journal* singled out Williams for his middle-class patronage, noting that he owned approximately eighty works of art in 1869 by artists such as E. M. Ward, Frith, Goodall, Maclise, Phillip, Roberts, Etty, Lewis, and Morland. A number of his oils were replicas.

Taste

Mid-Victorian collector of conservative early- to mid-century oils and watercolors.

Purchasing pattern

Commissioned a replica of Maclise's *Play Scene from Hamlet* (original in Robert Vernon collection).

Sales and bequests

Christie's, 17 April 1880.

References

Art Journal (Sept. 1869), 279–80; *London Directory* (1866 and 1875); Foster, *Men-at-the-Bar*; Harry Kirk, *Portrait of a Profession* (London: 1976); Ormond, *Maclise*, no. 77.

Archival sources:

Census Return of 1871 and City of Westminster Archives press cuttings.

WINDUS, Benjamin Godfrey (1790–1867)

56 Tottenham Green, London.

Occupation

Coachbuilder with premises at 73 Bishopsgate Without, London, and proprietor of medicine warehouses at 61 Bishopsgate Within and 21 Spital Square, where he manufactured Windus's Pills. Although Windus's occupation was listed on his death certificate as "retired coach builder," he identified himself in the 1851 Census Return as a "landed proprietor," no doubt due to the extensive rental property he owned in Tottenham.

Biography

Born in London, the son of Edward William Windus, from whom he inherited his property on Tottenham Green which he subsequently enlarged to 31 acres by buying the house and grounds next door (now located between Philip Lane and Clyde Road). Married Mary Row in 1814 and had one daughter, also called Mary, who married Peter de Putron (1830–1915), Curate at Holy Trinity. Windus was involved, as his father had been, in the furnishing of Trinity Chapel, which was built in 1830 on Tottenham Green adjoining their propery. He was a trustee of Tottenham Free School and Clerk to the Parochial Charities until his retirement in 1864. He was related to Thomas Windus and his son Arthur, who were coachbuilders at the same address in Bishopsgate Within. Arthur Windus was also a collector, specializing in gem engravings, which he displayed in a museum connected to his home, the Gothic Hall, Stamford Hill, near Edmonton (see Boase and

Christie's sale, 27–28 February and 1 March 1855).

Collection

Windus began by collecting watercolors and drawings by Harding, Westall, Cattermole, Roberts, etc. He owned over 650 drawings by Wilkie, but sold 159 of them in 1842. Beginning in 1820, Windus became a major patron of Turner (he owned 200 watercolors and drawings by 1839). He also acquired Girtin's *White House*, and works by Bonington, Maclise, Egg, etc. In addition, Windus possessed a large collection of Stothard's productions for the *Novelist's Magazine* and his drawings for the edition of *Robinson Crusoe* published in 1790. In an 1839 article on Windus's collection, the *Art Union* noted: "Such gentlemen as Mr. Vernon and Mr. Windus, and many others to whom we shall have occasion to refer, expend in procuring intellectual gratification monies which are too frequently lavished upon far less worthy objects" (p. 49). Windus also owned several Pre-Raphaelite works, including Millais's *Isabella*, *Mariana*, *Huguenot*, and *Ophelia*, Holman Hunt's *Scapegoat*, and Madox Brown's *Last of England*. He allowed the public to view his collection once a week.

Taste

Early-Victorian and Pre-Raphaelite oils and watercolors.

Purchasing pattern

Bought from artists, salerooms, the Royal Academy, and dealers, especial-

ly D. T. White, whom Windus considered to have "exquisite taste" (F. M. Brown, *Diary*, ed. Surtees, p. 125). Millais accused Windus of dealing in his works and refused to sell to him after 1855 (Warner, "Millais," p. 101). He may also have been active in selling off Turners (Gage, *Turner Correspondance*, p. 299).

Sales and bequests
Christie's 1–2 June 1842, 20 June 1853, 26 March 1859, and 19 July 1862. By descent. Family sales: Christie's 14–15 February 1868 and 16 March 1912 (Mrs. de Putron).

References
Art Union (April 1839), 49; (July 1859), 154–55; and (Sept. 1862), 193; Waagen (1854), II, 339; *Pigot's London Directory* (1827, 1834, and 1839); Boase; *Gentleman's Magazine* (Feb. 1852), 200; William Robinson, *The History and Antiquities of Tottenham*, 2 vols. (London: 1840), I, 83–90; Harriet Couchman, *Reminiscences of Tottenham* (London: 1909), pp. 13–14, 42–43; Fred Fish, *The History of the Ancient Parish, of Tottenham*, 2 vols. (London: 1923), II, 321–22; "Extracts from Thomas Tudor's Diary," *National Library of Wales Journal*, 21 (Summer 1980), 243–45; Anna Bray, *The Life of Thomas Stothard* (London: 1851), p. 235; *Ruskin Family Letters*, ed. Bird, II, 606, 608, 723, 734–35, and 739; Finberg, *Turner*, pp. 280, 352–53, 403, 413, and 439; Butlin and Joll, *Turner*, I, xv, 187, 202–3, 243–44, 259, and 265; Con McCarthy, "Tottenham's Turners,"

Ambience 2 (Spring 1971), 5–7; Selby Whittingham, "Tottenham's Turners," *Turner Society News* (July/Oct. 1983), 6, and "The Turner Collector: Benjamin Godfrey Windus 1790–1867," *Turner Studies* 7 (1987), 29–35; Gage, *Turner Correspondence*, p. 299; Rossetti, *Rossetti Papers*, pp. 298–300; *Brown Diary*, ed. Surtees, pp. 123–25, 131, 157, 168, 178, and 197; Millais, *Millais,* I, 161; Lutyens, *Millais and the Ruskins*, p. 162; Warner, "Millais," pp. 101–2; Reitlinger, pp. 87, 101, and 146; Maas, *Victorian Art World in Photographs*, pp. 166–67; L. Stainton, *British Landscape Watercolours, 1600–1860* (Cambridge: 1985), 72.

Archival sources: 1851 Census Return, London Public Record Office; Borough of Haringey Archives (Tottenham Parish Records, Tithe Apportionment of 1844, Ratebooks 1820 and 1837, Windus's death certificate); Somerset House (Probate copy of Will); Royal Pharmaceutical Society (specimen of Windus's Pills).

WOOD, Albert Salisbury (1838–1911)
Liverpool and, after 1871, Benarth Hall and Bodlondeb, Conway, Wales.

Occupation
Chain and anchor manufacturer; Henry Wood & Co., Liverpool.

Biography
Wood was born at Holt Hill, Birkenhead, the son of Henry Wood, who established a Liverpool branch of the family firm which had been founded in 1780 at Stourbridge in Worcestershire. The company's prosperity was established as a result of an incident in Santiago Bay when, during a storm, only the British ships fitted with anchors made by Wood remained secure. Thereafter, the firm's products were favored by the Royal Navy and commercial ships throughout the world. After Albert junior joined the family business he offered a partnership to William Coltart (q.v.). He retired to Wales in 1871 after receiving an inheritance from an aunt. Six years later he built Bondlondeb, where he entertained luminaries such as Lloyd George and Edward Elgar. Wood was High Sheriff, Deputy Lieutenant, and Justice of the Peace of Caernarvonshire. He was elected mayor of Conway eleven times. Wood was an amateur artist and an avid yachtsman with a fleet of thirty-five sailboats.

Collection
Wood owned Aesthetic movement paintings by artists such as Simeon Solomon, Leighton, Burne-Jones, and Rossetti. He also possessed several notable Pre-Raphaelite canvases, including Millais's *The Blind Girl*, Burton's *Wounded Cavalier*, and Windus's *The Outlaw*. In addition, he owned works by both older and younger British artists, from Landseer and Cox to La Thangue and Graham. Subscribing to the taste for Orientalia, Wood had an extensive collection of blue-and-white-porcelain.

Taste
Aesthetic movement, Pre-Raphaelite,

and earlier and later British school, in addition to a few Old Master canvases.

Purchasing pattern

Wood gave direct commissions to Madox Brown and was a frequent client of Christie's, buying at the Arden, Graham, Bashall, and Turner sales (q.v.). He used Agnew as an intermediary on some of these occasions.

Sales and bequests

In 1911 Wood was persuaded to sell Burton's *Wounded Cavalier* to the Guildhall (Temple, *Guildhall Memories*); Christie's, 13 June 1874; Bonlondeb, Wales, Sotheby's and Driver, Jones & Co., 20 Oct. 1936; private family sales and by descent.

References

Athenaeum (24 Oct. 1885), 342–43 and (11 Sept. 1886), 342–44; *North Wales Pioneer*, 7 April 1932; Temple, *Guildhall Memories*, pp. 314–15; Jane Johnson, *Dictionary of British Artists* (Woodbridge: 1976), p. 556; Macleod (1986), p. 607.

Archival sources: Aberconway Council Report (1983); Leathart Papers, University of British Columbia; F. G. Stephens Papers, Bodleian Library, Oxford; Family Records.

YOUNG, George (1798–1880s)

London and Ryde, Isle of Wight, where he moved c. 1847 and bought Appleby Tower.

Occupation

Merchant.

Biography

Origins unknown. Born in Scotland in 1798, Young described himself on the 1871 Census Report as a merchant and landowner. In 1855 he married Emma Curtis, the widow of Captain Garrett, and was still alive at the time of her death in 1880. Young has been confused with the surgeon George Young, who retired to Brighton in the 1820s, where Constable met him ("Constable Correspondence," VI, p. 369 and Julian Young, *Memoir of Charles Mayne Young* [1871], pp. 7–9). However, the George Young whose collection was visited by Waagen told the artist Thomas Tudor in 1847 (at the time he purchased Turner's *Fifth Plague of Egypt* from the dealer Thomas Griffith) that he was about to move the picture to a house he had recently bought on the Isle of Wight (Butlin and Joll, *Turner*, I, 11–12). He is perhaps the collector described by Horsley: "In Turner's day there was a Scotch [sic] gentleman named Young residing in London, who delighted in British art and artists, especially in assembling the latter at his hospitable board and hearing them discuss questions connected with their calling" (*Recollections*, p. 240).

Collection

Waagen holds Young up as an example of the "development of the taste for works of art during the last ten years among a class in whom it was before then, generally speaking, unknown" (1854, II, 257). Collins, from whom Young commissioned the picture *Ventnor* in 1845, notes that the Scottish collector was an early friend of Wilkie's, who was represented in his collection by the sketch for *Distraining for Rent*, and by a bacchanalian subject. Young also owned Collins's *Skittle-Players* and works by Callcott, Stanfield, Webster, Creswick, and Constable in addition to examples of the seventeenth-century Dutch school.

Taste

Early-Victorian landscape and genre as well as seventeenth-century Dutch.

Purchasing pattern

Artists' studios, dealers (Griffith) and commissions (Collins).

Sales and bequests

Christie's, 19 May 1866.

References

Waagen (1854), II, 257–58; Cunningham, *Wilkie*, III, 382–83; Collins, *Collins*, II, 9–10 and 269; Horsley, *Recollections*, p. 240; Butlin and Joll, *Turner*, I, 10–12.

Archival sources: 1871 Census Report, Isle of Wight Record Office; information provided by Mr. Roy Brinton of Ryde.

Bibliography

Archival Sources

Agnew's Stockbooks. Microfiche. Courtauld Institute, London, and Getty Provenance Index, Santa Monica, Calif.

Angeli-Dennis Papers. Special Collections. University of British Columbia Library, Vancouver, B.C.

Armstrong Family Papers.

Barlow Family Press Clippings.

Berg Collection. New York Public Library and University of Texas, Austin.

Bicknell Family Papers.

Birmingham Central Library. J. T. Bunce's Obituary Notices.

Bolton Department of Education and Arts. Lancashire.

British Biographical Archive. Microfiche. Guildhall Library, Aldermanbury, London.

British Museum Print Room.

British Steel Corporation, Northern Regional Records Centre, Middlesbrough.

Brunel, Isambard. Sketchbook and Diaries. University of Bristol Library.

Brunel, Isambard. Journals and Notes. Huntington Library, San Marino, Calif.

Camden Library Local History Collection. Swiss Cottage, London.

Census Returns. Greater London Public Record Office.

Coltart Family Papers.

Combe Papers. Ashmolean Museum, Oxford.

Cosens, Frederick. Correspondence. British Library and Edinburgh University Library.

Cunard Archives. London.

Fitzwilliam Museum Library. Cambridge.

Forster, John. Letters, Deeds, and Papers. Victoria and Albert Museum Library.

Gaskell, Holbrook. Correspondence. Nasymth Collection, Eccles Central Library.

Gateshead Central Library.

Gibbons Family Papers.

Gillott Papers. Provenance Index and Archive. Getty Center, Santa Monica, Calif.

Graham, William. Correspondence. Fitzwilliam Museum Library, Cambridge, and Angeli-Dennis Papers, University of British Columbia.

Dilke-Roskill Archive. Churchill College, Cambridge.

Gray's Inn. London.

Havering Central Library. Essex.

Heaton, Ellen. Correspondence. Beinecke Library, Yale University.

Holt, George. Diary and Correspondence. Liverpool Record Office and Walker Art Gallery.

Hunt, A. W. Correspondence. Cornell University Library.

Hunt, William Holman. Correspondence. John Rylands University Library, Manchester.

Inner Temple. London.

Ismay, Thomas. Family Papers and Diaries. Merseyside County Archives.

Lambeth Archives Department.

Landseer, Edwin. Correspondence. Fitzwilliam Museum Library, Cambridge.

Law Society. London.

Leathart Papers. Special Collections, University of British Columbia Library, Vancouver, B.C., and Private Family Papers.

Leyland, Frederick Richards. Correspondence. Pennell Collection. Library of Congress and University of Glasgow.

Linnell Family Papers.

Liverpool City Libraries.

Lloyd's Register of Shipping Technical Library. London.

London Public Record Office.

Maclise, Daniel. Correspondence. Fitzwilliam Museum Library, Cambridge.

Manchester City Libraries Archives.

Mersey Docks and Harbour Board Archives. Liverpool.

Midland Bank Archives. London.

Miller, John. Correspondence. Fitzwilliam Museum Library, Cambridge.

Miller, Thomas. Miller Family Press Clippings.

Mitchell, Charles. Mitchell Family Press Clippings.

Morrison James. Papers. Lord Margadale Collection, Fonthill House and Guildhall Library.

Mulready, William. Correspondence. Victoria and Albert Museum Library.

National Gallery Minutes of the Trustees. London.

National Registry of Archives. Quality Court, London.

National Trust. 42 Queen Anne's Gate, London.

National Trust for Scotland. 5 Charlotte Square, Edinburgh.

Naylor Family Papers.

Newall Family Records.

Newsham, Richard. Holographic Catalogue. Harris Library and Museum, Preston.

Northumberland Record Office.

Norwood Cemetery Memorial Inscriptions. Minet Library, Lambeth.

Pears, A. & F. Ltd. London.

Pharmaceutical Society of Great Britain. London.

Public Record Office of Northern Ireland. Belfast.

Rae, George. Correspondence. Lady Lever Art Gallery, Port Sunlight, Cheshire.

Rathbone Family Papers. Liverpool University.

Register of Sasines for Counties of Perth and Kinross.

Registry of Wills. St. Catherine's House (formerly Somerset House).

Roberts, David. Correspondence. National Library of Scotland, Edinburgh, and
 Yale Center for British Art, New Haven.

Royal College of Physicians Library. London.

Royal Commission of the Historical Monuments of England.

Royal Holloway College Archives.

Royal Institution. Albemarle Street, London.

Royal Manchester Insitution Letter Book. Manchester City Libraries.

Royal Pharmaceutical Society. London.

Ruskin, John James. Account Book and Inventories. Ruskin Galleries, Bembridge.

Ruston, Joseph. Estate Papers, Lincolnshire Archives Office, and Press Clippings,
 Lincoln Central Reference Library.

Society for Diffusion of Useful Knowledge. University College Library, London.

Sheepshanks Correspondence. Brotherton Library, University of Leeds, Victoria
 and Albert Museum Library, and Private Collections.

Soane, John. Correspondence and Office Papers. Soane Museum, London.

Society of Friends. London.

Southwark Records Office.

Stephens, Frederick George. Correspondence. Bodleian Library, Oxford.

Stevenson Family Papers.

Sussex Archaeological Society.

Tate Gallery Archives.

Tottenham Parish Records.

Trevelyan, Lady Pauline. Correspondence. University of Newcastle.

Trist Family Papers.

Troxell Collection. Princeton University.

Turner, W. A. Correspondence. Delaware Art Museum, Morgan Library, New York,
 and Angeli-Dennis Papers, University of British Columbia.

Vernon, Robert. Correspondence and Inventories. Jenkyns Papers II. Balliol
 College, Oxford.

Vicker's Defence Systems. Newcastle.

Victoria and Albert Museum Library. London.

Victoria Library. City of Westminster.

Walthamstow Personal Names Index.

Wellcome Institute. London.

Wells Family Records.

West Yorkshire Record Office. Wakefield.

Whistler, James Abbott McNeill. Correspondence. Library of Congress and
 Glasgow University Library.
Wigan Record Office.
Yorkshire Archeological Society.

Select bibliography of published sources

Ackerman, James. "On Judging Art without Absolutes," *Critical Inquiry* 5 (Spring
 1979), 441–69.
Adams, Eric. *Francis Danby: Varieties of Poetic Landscape* (New Haven: 1973).
Agnew, Geoffrey. *Agnew's, 1817–1967* (London: 1967).
Allingham, Helen, and E. B. Williams, eds. *Letters to William Allingham* (London:
 1911).
Allwood, Rosamond. *George Elgar Hicks: Painter of Victorian Life* (Inner London
 Education Authority: 1982).
Alpers, Svetlana. "Art History and its Exclusions: The Example of Dutch Art," in
 Feminism and Art History: Questioning the Litany, ed. Norma Broude and M.
 Garrard (New York: 1982), pp. 183–99.
Altholz, Joseph, ed. *The Mind and Art of Victorian England* (Minneapolis: 1976).
Altick, Richard. *Paintings from Books: Art and Literature in Britain, 1760–1900*
 (Columbus, Ohio: 1985).
Anderson, Patricia. *The Printed Image and the Transformation of Popular Culture,
 1790–1860* (Oxford: 1991).
Angeli, Helen Rossetti. *Pre-Raphaelite Twilight: The Story of Charles Augustus Howell*
 (London: 1954).
Appadurai, Arjun, ed. *The Social Life of Things: Commodities in Cultural Perspective*
 (Cambridge: 1986).
Appelman, Philip, W. A. Madden, and M. Wolff, eds. *1859: Entering an Age of Crisis*
 (Bloomington: 1959).
Archer, John H. G., ed. *Art and Architecture in Victorian Manchester* (Manchester:
 1985).
Armstrong, Walter. "Notes on British Painting in 1893," *Art Journal* (Jan. 1894), 1–3.
Art for the People: Culture in the Slums of Late Victorian Britain. (London: Dulwich
 Picture Gallery, 1994).
The Art Journal: A Short History (London: 1906).
Arts Council of Great Britain. *Great Victorian Pictures: Their Paths to Fame* (London:
 1978).
Burne-Jones (London: 1975).
Bagehot, Walter. Introduction to the Second Edition. *The English Constitution*
 (London: 1872; rpt. 1964).
Bailey, Peter. *Leisure and Class in Victorian England* (London: 1978).
Baily, James T. Herbert. *George Morland* (London: 1906).
Baker, Sir Thomas. *Memorials of a Dissenting Chapel* (Manchester: 1884).

493

Bakhtin, Mikhail. *The Dialogic Imagination*, transl. Michael Holquist and
 C. Emerson (Austin, Tex.: 1981).

 Rabelais and his World, transl. Hélène Iswolsky (Bloomington, Ind.: 1984).

Baldry, Alfred Lys. *Hubert von Herkomer, RA: A Study and a Biography* (London: 1901).

Banbury, Philip. *Shipbuilders of the Thames and Medway* (London: 1971).

Barrell, John. *The Political Theory of Painting from Reynolds to Hazlitt* (New Haven:
 1986).

Barthes, Roland. *S/Z*, transl. Richard Miller (London: 1975).

Battersea, Constance de Rothschild Flower. *Reminiscences* (London: 1923).

Baudrillard, Jean. *For a Critique of the Political Economy of the Sign*, transl. Charles
 Levin (Telos: 1981).

 "The Precession of Simulacra" in *Art after Modernism: Rethinking Representation*
 ed. Brian Wallis (New York: 1984), pp. 253–81.

Bayard, Jane H. "From Drawing to Painting: The Exhibition Watercolor," unpubl.
 Ph.D. diss. Yale University, 1982.

Beardsley, Monroe. *Aesthetics: Problems in the Philosophy of Criticism* (New York: 1958;
 rpt. 1981).

Bedarida, François. *A Social History of England, 1851–1975*, transl. A. S. Forster
 (London: 1979).

Behagg, Clive. "Myths of Cohesion: Capital and Compromise in the
 Historiography of Nineteenth-Century Birmingham," *Social History* 11
 (Oct. 1986), 375–84.

Bell, Florence. *At the Works: A Study of a Manufacturing Town* (London: 1907; rpt.
 1985).

(Bell, Jacob). *Descriptive Catalogue of Pictures, etc. Exhibited at Marylebone Literary and
 Scientific Institution* (London: 1859).

Bell, Quentin. *The Schools of Design* (London: 1964).

Benjamin, Walter. *Illuminations*, ed. Hannah Arendt, transl. Harry Zohn (New York:
 1969).

 Reflections: Essays, Aphorisms, Autobiographical Writings, transl. Edmund Jephcott
 (New York: 1978).

Bennett, Mary. *Artists of the Pre-Raphaelite Circle: The First Generation* (London: 1988).

 "A Check List of Pre-Raphaelite Pictures Exhibited at Liverpool, 1846–67,
 and Some of their Northern Collectors," *Burlington* 105 (Nov. 1963),
 486–95.

 Ford Madox Brown (Liverpool: Walker Art Gallery, 1964).

 PRB, Millais, PRA (Liverpool: Walker Art Gallery, 1967).

 "The Pre-Raphaelites and the Liverpool Prize," *Apollo* 76 (Dec. 1962), 748–53.

 "Sudley," in *The Emma Holt Bequest, Sudley* (Liverpool: 1971).

 William Holman Hunt (Liverpool: Walker Art Gallery, 1969).

Berger, John. *Ways of Seeing* (London: 1972).

Best, Geoffrey. *Mid-Victorian Britain, 1851–1875* (London: 1971).

Betterton, Rosemary, ed. *Looking On: Images of Femininity in the Visual Arts and Media* (New York: 1987).

Bingham, Caroline. "'Doing Something for Women': Matthew Vassar and Thomas Holloway," *History Today* 36 (June 1986), 46–51.

Bird, Van Akin, ed. *The Ruskin Family Letters*, 2 vols. (Ithaca: 1973).

Blackburn, R. H. *Sir Henry Tate: His Contribution to Art and Learning* (London: c. 1900).

Blunt, Wilfrid. *"England's Michaelangelo": A Biography of George Frederic Watts* (London: 1975).

Boime, Albert. "America's Purchasing Power and the Evolution of European Art in the Late Nineteenth Century," in *Saloni, gallerie, musei e loro influenza sullo sviluppo dell'arte dei secoli XIX e XX*, ed. Francis Haskell (Bologna: 1979), pp. 123–40.

"Entrepreneurial Patronage in Nineteenth-Century France," in *Enterprise and Entrepreneurs in Nineteenth- and Twentieth-Century France*, ed. Edward C. Carter, Robert Forster, and Joseph N. Moody (Baltimore: 1976), pp. 137–207.

"Ford Madox Brown, Thomas Carlyle, and Karl Marx: Meaning and Mystification of Work in the Nineteenth Century," *Arts Magazine* 56 (Sept. 1981), 116–25.

"Sargent in Paris and London: A Portrait of the Artist as Dorian Gray," in *John Singer Sargent*, ed. Patricia Hills (New York: Whitney Museum of American Art, 1986), pp. 75–109.

"Sources for Sir John Everett Millais's 'Christ in the House of His Parents,'" *Gazette des Beaux-Arts* 86 (1975), 71–84.

Bonython, Elizabeth. *King Cole* (London: 1982).

Borzello, Frances. *Civilising Caliban: The Misuse of Art, 1875–1980* (London: 1987).

Bourdieu, Pierre. *Distinction: A Social Critique of the Judgement of Taste*, transl. Richard Nice (Cambridge, Mass.: 1984).

The Field of Cultural Production (New York: 1993).

Bourne, J. M. *Patronage and Society in Nineteenth-Century England.* (London: 1986).

Bradford Art Galleries and Museums. *The Connoisseur: Art Patrons and Collectors in Victorian Bradford* (Bradford: 1989).

Bradley, Laurel. "From Eden to Empire: John Everett Millais's *Cherry Ripe*," *Victorian Studies* 34 (Winter 1991), 180–203.

Branca, Patricia. *Silent Sisterhood: Middle Class Women in the Victorian Home* (London: 1975).

Briggs, Asa. *A Social History of England* (1983; rpt. Harmondsworth: 1985).

Victorian Cities (London: 1963).

Brighton Museum and Art Gallery. *Frederick Sandys, 1829–1904* (Brighton: 1974).

Brigstocke, Hugh. *William Buchanan and the Nineteenth-Century Art Trade* (London: 1982).

Bronkhurst, Judith. "Fruits of a Connoisseur's Friendship: Sir Thomas Fairbairn and William Holman Hunt," *Burlington* 125 (Oct. 1983), 586–97.

Bronner, Simon J., ed. *Consuming Visions: Accumulation and Display of Goods in America, 1880–1920* (New York: 1989).

Brown, David Blayney. *Augustus Wall Callcott* (London: Tate Gallery, 1981).

Brown, Julia Prewitt. *A Reader's Guide to the Nineteenth- Century English Novel* (New York: 1985).

Brunel, Isambard. *The Life of Isambard Kingdom Brunel, Civil Engineer* (London: 1870).

Bullen, Barrie. "The Palace of Art: Sir Coutts Lindsay and the Grosvenor Gallery," *Apollo* 102 (Nov. 1975), 353–57.

Bürger, Peter. *Theory of the Avant-Garde*, transl. Michael Shaw (Minneapolis: 1984).

Burn, William Laurence. *The Age of Equipoise: A Study of the Mid-Victorian Generation* (London: 1964).

Burnand, Sir Francis. *Records and Reminiscences Personal and General*, 2 vols. (London: 1904).

Burne-Jones, Georgiana. *Memorials of Edward Burne-Jones*, 2 vols. (London: 1904).

Butlin, Martin, and Evelyn Joll. *The Paintings of J. M. W. Turner*, 2 vols. (New Haven: 1984).

Calinescu, Matei. *Five Faces of Modernity: Modernism, Avant- Garde, Decadence, Kitsch, Postmodernism* (Durham, N.C.: 1987).

Cannadine, David. *Lords and Landlords: The Aristocracy and the Towns, 1774–1967* (Leicester: 1980).

Carey, William. *Some Memoirs of the Patronage and Progress of the Fine Arts . . . with Anecdotes of Lord de Tabley* (London: 1826).

Carlisle Art Gallery. *George Howard and his Circle* (Carlisle: 1968).

Carlyle, Thomas. *Works*, 30 vols. (London: 1897; rpt. New York: 1969).

Carr, J. Comyns. *Some Eminent Victorians* (London: 1908).

Carter, Albert Charles Robinson. *Let Me Tell You* (London: 1940).

Carus-Wilson, Eleanora Mary, ed. *Essays in Economic History*, 3 vols. (New York: 1954–66).

Cary, Elisabeth Luther. *The Works of James McNeill Whistler* (1907; rpt. New York: 1971).

Castille, Hippolyte. *Les Frères Péreire* (Paris: 1861).

Catalogue of the Art Treasures of the UK Collected at Manchester in 1857 (Manchester: 1857).

Chandler, George. *Liverpool Shipping* (London: 1960).

Chapel, Jeannie. "The Turner Collector: Joseph Gillott, 1799–1872," *Turner Studies* 6 (Winter 1986), 43–50.

Victorian Taste: The Complete Catalogue of Paintings at the Royal Holloway College (London: 1982).

Chapman, Ronald. *The Laurel and the Thorn: A Study of G. F. Watts* (London: 1945).

Checkland, Sydney G. *The Rise of Industrial Society in England, 1815–1885* (Oxford: 1964).

Cherry, Deborah. "The Hogarth Club: 1858–1861," *Burlington* 122 (April 1980), 237–44.

Painting Women: Victorian Women Artists (London: 1993).

Cherry, Deborah, and Griselda Pollock. "Patriarchal Power and the Pre-Raphaelites," *Art History* 7 (Dec. 1984), 480–94.

Child, Theodore. "A Pre-Raphaelite Mansion," *Harper's* 82 (Dec. 1890), 81–99.

Church, Roy A. *The Great Victorian Boom, 1851–1873* (London: 1975).

Clark, Timothy J. *The Painting of Modern Life: Paris in the Art of Manet and his Followers* (London: 1985).

Clarke, Michael. *The Tempting Prospect: A Social History of English Watercolours* (London: 1981).

Cleveland, S. D. *The Royal Manchester Institution* (Manchester: 1931).

Clifford, Derek, and Timothy Clifford. *John Crome* (London: 1968).

Clifford, James. *The Predicament of Culture: Twentieth-Century Ethnography, Literature, and Art* (Cambridge, Mass.: 1988).

Coan, Catherine. "Birmingham Patrons, Collectors, and Dealers, 1830–1880," unpubl. MA thesis. University of Birmingham, 1980.

Codell, Julie F. "Marion Harry Spielmann and the Role of the Press in the Professionalization of Artists," *Victorian Periodicals Review* 22 (Spring 1989), 7–15.

Cole, Sir Henry. *Fifty Years of Public Work*, 2 vols. (London: 1884).

Coleman, Donald Cuthbert. "Gentleman and Players," *Economic History Review* 26 (1973), 92–116.

Collins, Bruce, and Keith Robbins, eds. *British Culture and Economic Decline* (London: 1990).

Collins, Wilkie. *A Rogue's Life* (first pub. in *Household Words* [1856]; rpt. London: 1879).

Memoirs of the Life of William Collins RA, 2 vols. (London: 1848).

Colls, Robert, and Philip Dodd, eds. *Englishness: Politics and Culture, 1880–1920* (London: 1986).

Colvin, Sir Sidney. *Memories and Notes of Persons and Places, 1852–1912* (New York: 1921).

Constable, John. "John Constable's Correspondence," ed. R. B. Beckett (vol. 18 ed. Leslie Parris and Ian Flemming-Williams) *Suffolk Records Society*, vols. 4, 6, 8, 10, 11, 12, and 18 (1962–75).

Cooper, Douglas. *The Courtauld Collection* (London: 1954).

Cooper, Nicholas. *The Opulent Eye: Late Victorian and Edwardian Taste in Interior Design* (New York: 1977).

Cooper, Thomas Sidney. *My Life*, 2 vols (London: 1890).

Cope, Charles Henry. *Reminiscences of Charles West Cope* (London: 1891).

Cormack, Malcolm. *Constable* (Oxford: 1986).

Cowell Frank R. *The Athenaeum Club and Social Life in London 1824–1974* (London: 1975).

Crane, Walter. *An Artist's Reminiscences* (London: 1907).

Crary, Jonathan. *Techniques of the Observer: On Vision and Modernity in the Nineteenth Century* (Cambridge, Mass.: 1990).

"Unbinding Vision," *October* 68 (Spring 1994), 21–44.

Crouzet, François. *The First Industrialists: The Problem of Origins* (Cambridge: 1985).

Cunningham, Allan. *The Life of Sir David Wilkie*, 3 vols. (London: 1843).

Curry, David Park. *James McNeill Whistler at the Freer Gallery of Art* (New York: 1984).

Curry, Rosemary J., and Sheila Kirk. *Philip Webb in the North* (Middlesbrough: 1984).

Danto, Arthur. *The Philosophical Disenfranchisement of Art* (New York: 1986).

Darcy, C. P. "The Encouragement of the Fine Arts in Lancashire, 1760–1860," *Historical and Literary Remains of the Chetham Society* 24 (1976).

Davidoff, Leonore. *The Best Circles: Society Etiquette and the Season* (London: 1973).

Davidoff, Leonore, and Catherine Hall. *Family Fortunes: Men and Women of the English Middle Class, 1780–1850* (Chicago: 1987).

Davies, James. *John Forster: A Literary Life* (London: 1983).

Davis, Frank. *Victorian Patrons of the Arts* (London: 1963).

Deane, Phyllis, and W. A. Cole. *British Economic Growth 1688–1959* (Cambridge: 1962).

Debord, Guy. *The Society of the Spectacle* (Detroit: 1977).

Dent, Robert Kirkup. *Old and New Birmingham, a History of the Town and its People*, 2 vols. (Birmingham: 1880).

De Tocqueville, Alexis. *Journeys to England and Ireland*, ed. J. P. Mayer (New Haven: 1958).

Deuchar, Stephen. *Painting, Politics and Porter: Samuel Whitbread II (1764–1815) and British Art* (London: Whitbread and Museum of London, 1984).

Dictionary of Business Biography, ed. David J. Jeremy, 5 vols. (London: 1984–86).

Dictionary of Scottish Business Biography, ed. Anthony Slaven and Sydney Checkland, 2 vols. (Glasgow: 1986–90).

DiMaggio, Paul. "Cultural Entrepreneurship in Nineteenth-Century Boston. Part I: The Creation of an Organizational Base for High Culture in America. Part II: The Classification and Framing of American Art," *Media, Culture and Society* 4 (1982), 33–50 and 303–22.

Dimond, Frances, and Roger Taylor. *Crown and Camera: The Royal Family and Photography, 1842–1910* (Harmondsworth and New York: 1987).

Disraeli, Benjamin (Lord Beaverbrook). *Coningsby* (1844; rpt. London: 1959).

Dorment, Richard. *Alfred Gilbert.* (New Haven and London: 1985).

Douglas, Mary, and Baron Isherwood. *The World of Goods* (New York: 1979).

Druick, Douglas, and Michel Hoog. *Fantin-Latour* (Ottawa: National Gallery of Canada, 1983).

Du Maurier, Daphne, ed. *The Young George du Maurier: A Selection of his Letters, 1860–67* (London: 1951).

Duval, M. Susan. "F. R. Leyland: A Maecenas from Liverpool," *Apollo* 124 (Aug. 1986), 110–16.

Dyson, Anthony. *Pictures to Print: The Nineteenth-Century Engraving Trade* (London: 1984).

Eagleton, Terry. *The Ideology of the Aesthetic* (Oxford: 1990).

Easthope, Anthony. *Literary into Cultural Studies* (London: 1991).

Edwards, Edward. *Personal Recollections of Birmingham and Birmingham Men* (Birmingham: 1877).

Elias, Frank. *John Lea, Citizen and Art Lover* (Liverpool: 1928).

Elkins, James. "From Original to Copy and Back Again," *British Journal of Aesthetics* 33 (April 1993), 113–20.

Elsner, John, and Roger Cardinal. *The Cultures of Collecting* (Cambridge, Mass.: 1994).

Emerson, Ralph Waldo. *English Traits* (1856; rpt. Cambridge, Mass.: 1956).

Errington, Leslie. *Tribute to Wilkie* (Edinburgh: National Galleries of Scotland, 1986).

Ettlinger, Leopold D. "Ford Madox Brown and the Ethics of Work," in *Kunst als Bedeutungsträger: Gedenkschrift für Günter Bandmann* (Berlin: 1978), pp. 459–77.

Faberman, Hilarie. "Augustus Leopold Egg, RA (1816–1863)," unpubl. Ph.D. diss., 4 vols., Yale University, 1983.

Farr, Dennis. *William Etty* (London: 1956).

Fawcett, Trevor. *The Rise of English Provincial Art: Artists, Patrons, and Institutions outside London, 1800–1830* (Oxford: 1974).

Ferriday, Peter. "The Victorian Art Market – I," *Country Life* (9 June 1966), 1457.

Finberg, Alexander Joseph. *The Life of J. M. W. Turner, RA* (Oxford: 1938; 2nd edn., 1961).

Firestone, Evan R. "John Linnell and the Picture Merchants," *Connoisseur* 182 (Feb. 1973), 124–31.

Fiske, John. *Reading the Popular* (Boston: 1989).

Fitzgerald, Penelope. *Edward Burne-Jones* (London: 1975).

Flint, Kate. "Moral Judgement and the Language of English Art Criticism, 1870–1910," *Oxford Art Journal* 6 (1983), 59–66.

"The 'Philistine' and the New Art Critic: J. A. Spender and D. S. MacColl's Debate of 1893," *Victorian Periodicals Review* 21 (Spring 1988), 3–8.

ed. *Impressionists in England: The Critical Reception* (London: 1984).

Forbes, Christopher. *The Royal Academy (1837–1901) Revisited: Victorian Paintings from the Forbes Magazine Collection* (New York: 1975).

Victorians in Togas: Paintings by Sir Lawrence Alma-Tadema from the Collection of Allen Funt (New York: Metropolitan Museum of Art, 1973).

Fortunes Made in Business, ed. James Hogg, 3 vols. (London: 1884).

Foster, Joseph. *Men-at-the-Bar* (London: 1885).

Foucault, Michel. *The Archaeology of Knowledge*, transl. A. M. Sheridan Smith (New York: 1972).

 The Order of Things: An Archaeology of the Human Sciences (1966; rpt. New York: 1973).

Fraser, Derek, ed. *A History of Modern Leeds* (Manchester: 1980).

 ed. *Municipal Reform and the Industrial City* (Leicester: 1982).

Fraser, Derek, and Anthony Sutcliff, eds. *The Pursuit of Urban History* (London: 1983).

Fredeman, William E. "The Letters of Pictor Ignotus: William Bell Scott's Correspondence with Alice Boyd, 1859–1884." *Bulletin of the John Rylands University Library* (Autumn 1975), 66–111 and 306–52.

 Pre-Raphaelitism: A Bibliocritical Study (Cambridge, Mass.: 1965).

Frith, William P. *My Autobiography and Reminiscences*, 3 vols. (London: 1887–88).

Fry, Roger. *Transformations* (New York: 1956).

 "Rossetti's Water Colours of 1857," *Burlington Magazine* 29 (June 1916), 100–9.

Frykman, Jonas, and Orvar Löfgren. *Culture Builders: A Historical Anthropology of Middle-Class Life* (Rutgers: 1987).

Fullerton, Peter. "Patronage and Pedagogy: The British Institution in the Early Nineteenth Century," *Art History* 5 (March 1982), 59–72.

Gage, John, ed. *Collected Correspondence of J. M. W. Turner* (Oxford: 1980).

Gagnier, Regenia. *Idylls of the Marketplace: Oscar Wilde and the Victorian Public* (Stanford: 1986).

Garnett, Oliver. "William Graham and the Patrons of Burne-Jones," in *Burne-Jones: Dal Preraffaelismo al Simbolismo*, ed. M. Benedetti and G. Piantoni (Rome: Galleria Nazionale d'Arte Moderna, 1986).

Garrard, John. *Leadership and Power in Victorian Industrial Towns, 1830–80* (Manchester: 1983).

Gash, Norman. *Mr. Secretary Peel: The Life of Sir Robert Peel to 1830* (Cambridge, Mass.: 1961).

Gatty, Richard. *Portrait of a Merchant Prince: James Morrison, 1789–1857* (Northallerton, Yorkshire: 1977).

Gay, Peter. *The Bourgeois Experience: Victoria to Freud*, 4 vols. (Oxford: 1984–95).

Gibbs, Henry S. *Autobiography of a Manchester Cotton Manufacturer.* (London: 1877).

Gill, Conrad. *History of Birmingham*, 3 vols. (London: 1952–74).

Gillett, Paula. *Worlds of Art: Painters in Victorian Society.* (New Brunswick, N.J.: 1990)

Gilmour, Robin. *The Idea of a Gentleman in the Victorian Novel* (London: 1981).

Girouard, Mark. *The Victorian Country House* (New Haven: 1979).

Gombrich, Ernst H. *Art and Illusion* (Princeton: 1972).

 Ideals and Idols: Essays on Values in History and in Art (Oxford: 1979).

 Meditations on a Hobby Horse (Oxford: 1963).

Goodall, Frederick. *Reminiscences* (London: 1902).

Gooding-Williams, Robert. "Nietzsche's Pursuit of Modernism," *New German Critique* 41 (Spring-Summer 1987), 95–108.

Gramsci, Antonio. *Selections from the Prison Notebooks*, ed. and transl. Quintin Hoare and G. N. Smith (London: 1971).

Graves, Algernon. *Art Sales*, 3 vols. (London: 1918).

A Century of Loan Exhibitions, 1813–1912, 3 vols. (London: 1913–15; rpt. Bath: 1970).

Greaves, Margaret. *Regency Patron: Sir George Beaumont* (London: 1966).

Greenberg, Clement. "Avant-Garde and Kitsch." *Partisan Review* 6 (Fall 1939); rpt. in *Art and Culture: Critical Essays.* (Boston: 1961), pp. 3–21.

Greenfeld, Liah. *Nationalism: Five Roads to Modernity* (Cambridge, Mass.: 1992).

Greg, Andrew. *The Cranbrook Colony* (Newcastle-upon-Tyne: Laing Art Gallery, 1977).

Grieg, James, ed. *The Farington Diary*, 8 vols. (London: 1923–28; rpt. 1952).

Grieve, Alistair. *The Art of Dante Gabriel Rossetti. 1: Found. 2: The Pre-Raphaelite Modern-Life Subject* (Norwich: 1976).

"The Pre-Raphaelite Brotherhood and the Anglican High Church," *Burlington* 111 (May 1969), 294–95.

Hall, Douglas. "The Tabley House Papers," *The Walpole Society* 38 (1960–62), 59–122.

Hall, Samuel Carter. *Retrospect of a Long Life from 1815 to 1883* (New York: 1883).

Hall, William. *A Biography of David Cox* (London: 1881).

Hallé, Charles E. *Notes from a Painter's Life, Including the Founding of Two Galleries* (London: 1909).

Hamerton, Philip Gilbert. *Thoughts about Art* (London: 1871).

Hamilton, James. *The Misses Vickers* (Sheffield: Mappin Art Gallery, 1984).

Hamlyn, Robin. *Robert Vernon's Gift* (London: Tate Gallery, 1993).

Hardie, Martin. *John Pettie, RA, HRSA.* (London: 1908).

Hardman, Malcolm. *Ruskin and Bradford* (Manchester: 1986).

Hardy, Barbara. *The Exposure of Luxury: Radical Themes in Thackeray* (London: 1972).

Harrison, J. F. C. *The Early Victorians, 1832–1851* (London: 1971).

Harrison, Martin, and Bill Waters. *Burne-Jones* (London: 1973).

Haskell, Francis. *Rediscoveries in Art* (Ithaca: 1976).

Hawthorne, Julian. *Shapes that Pass: Memories of Old Days* (Boston: 1928).

Hawthorne, Nathaniel. *The English Notebooks*, ed. Randall Stewart (New York: 1962).

Haydon, Frederic Wordsworth. *Benjamin Robert Haydon: Correspondence and Table-Talk*, 2 vols. (London: 1876).

Heath, Vernon. *Recollections* (London: 1892).

Heaton, Herbert. *The Yorkshire Woollen and Worsted Industries* (Oxford: 1965)

Heleniak, Kathryn Moore. "John Gibbons and William Mulready: The

Relationship between a Patron and a Painter," *Burlington* 124 (March 1982), 136–41.

 William Mulready (New Haven: 1980).

Hemingway, Andrew. "The 'Sociology' of Taste in the Scottish Enlightenment," *Oxford Art Journal* 12 (1989), 3–35.

Henderson, Philip. *William Morris: His Life, Work and Friends* (New York: 1967).

Henderson, W. O. *The Lancashire Cotton Famine, 1861–65* (Manchester: 1934; rpt. 1969).

Hendy, Philip. *The National Gallery London* (London: 1960; revised 1971).

Herbert, Robert. "Impressionism, Originality, and Laissez- Faire," *Radical History Review* 38 (1987), 7–15.

 ed. *The Art Criticism of John Ruskin* (New York: 1964).

Herrmann, Frank. *The English as Collectors: A Documentary Chrestomathy* (London: 1972).

 Sotheby's: Portrait of an Auction House (London: 1980).

Herrmann, Luke. *Ruskin and Turner* (New York: 1969).

Hichberger, Joany. "Captain Jones of the Royal Academy," *Turner Studies* 3 (1983), 14–20.

Higonnet, Anne. "Secluded Vision: Images of Feminine Experience in Nineteenth-Century Europe," *Radical History Review* 38 (1987), 16–36.

Hilton, Timothy. *John Ruskin: The Early Years, 1819–1859* (New Haven and London: 1985).

 The Pre-Raphaelites (London: 1970).

Hobsbawm, Eric. *Industry and Empire* (Harmondsworth: 1985).

Hobsbawm, Eric, and T. Ranger, eds. *The Invention of Tradition* (Cambridge: 1983).

Holiday, Henry. *Reminiscences of My Life* (London: 1914).

Horner, Frances Graham. *Time Remembered* (London: 1933).

Horsley, John Callcott. *Recollections of a Royal Academician by John Callcott Horsley, RA*, ed. Mrs. Edmund Helps. (London: 1903).

Houfe, Simon. "David Croal Thomson, Whistler's 'Aide-de-Camp,'" *Apollo* 119 (Feb. 1984), 112–19.

Houghton, Walter E. *The Victorian Frame of Mind, 1830–1870* (New Haven: 1957).

Howe, Anthony. *The Cotton Masters, 1830–1860* (Oxford: 1984).

Howitt, Sir Harold. *The History of the Institute of Chartered Accountants in England and Wales, 1880–1965, and of its Founder Accountancy Bodies, 1870–1880* (London: 1966).

Hueffer, Ford M. *Ford Madox Brown: A Record of his Life and Work* (London: 1896).

Hughes, John. *Liverpool Banks and Bankers, 1760–1837* (Liverpool: 1906).

Hunt, William Holman. *Pre-Raphaelitism and the Pre-Raphaelite Brotherhood*, 2 vols. (London: 1905–6).

Hyndman, Henry Mayers. *Commercial Crises of the Nineteenth Century* (London: 1892; rpt. New York: 1967).

Ingamells, John. *The Third Marquis of Hertford as a Collector* (London: 1983).

Inglis, Alison. "Sir Edward Poynter and the Earl of Wharncliffe's Billiard Room,"
 Apollo 126 (Oct. 1987), 249–55.

Ionides, Alexander C. *Ion: A Grandfather's Tale*, 2 vols. (Dublin: 1927).

Isichei, Elizabeth. *Victorian Quakers* (London: 1970).

Jackson-Stops, Gervase, ed. *The Treasure Houses of Britain: Five Hundred Years of
 Private Patronage and Art Collecting* (New Haven and London: 1985).

Jameson, Anna. *Companion to the Most Celebrated Private Galleries of Art in London*
 (London: 1844).

 A Handbook to the Public Galleries of Art in and near London, 2 vols. (London:
 1842).

 Private Picture Galleries (London: 1844).

Jay, Martin. *Downcast Eyes: The Denigration of Vision in Twentieth-Century French
 Thought* (Berkeley: 1993).

Jenkins, Roy. *Sir Charles Dilke: A Victorian Tragedy* (London: 1965).

Jensen, Robert. *Marketing Modernism in Fin-de-Siècle Europe* (Princeton: 1994).

Johnson, Edward Dudley Hume. *Paintings of the British Social Scene* (New York: 1986).

Jones, Edgar. *Accountancy and the British Economy, 1840–1980* (London: 1981).

Jones, Gareth Stedman. *Outcast London: A Study in the Relationship between Classes in
 Victorian Society* (1971; rpt. New York: 1984).

 "Working-Class Culture and Working-Class Politics in London, 1870–1900:
 Notes on the Remaking of a Working Class," in *Popular Culture: Past and
 Present*, ed. Bernard Waites, T. Bennett, and G. Martin (London: 1982),
 pp. 92–121.

Jones, George. *Sir Francis Chantrey, RA: Recollections of his Life, Practices and Opinions*
 (London: 1849).

Kay, Arthur. *Treasure Trove in Art* (Edinburgh: 1939).

Kay-Shuttleworth, James. *The Physical and Moral Condition of the Working Classes
 Employed in the Cotton Manufacture in Manchester* (Manchester: 1932).

Kent, Christopher. "'Short of Tin' in a Golden Age: Assisting the Unsuccessful
 Artist in Victorian England," *Victorian Studies* 32 (Summer 1989),
 487–506.

Kestner, Joseph. *Mythology and Misogyny* (Madison: 1989).

Kidd, Alan J., and K. W. Roberts, eds. *City, Class and Culture: Studies of Social Policy and
 Cultural Production in Victorian Manchester* (Manchester: 1985).

King, Lyndel Saunders. *The Industrialization of Taste: Victorian England and the Art
 Union of London* (Ann Arbor, Mich.: 1985).

King, Wilfred Thomas Cousins. *History of the London Discount Market* (London:
 1936).

LaCapra, Dominick, and Steven L. Kaplan, eds. *Modern European Intellectual History,
 Reappraisals and New Perspectives* (Ithaca: 1982).

Lago, Mary M., ed. *Burne-Jones Talking, his Conversations, 1895–98* (London: 1982).

Laing Art Gallery. *Albert Moore and his Contemporaries* (Newcastle-upon-Tyne: 1972).
 Paintings from the Leathart Collection (Newcastle-upon-Tyne: 1968).

Lambourne, Lionel. *An Introduction to "Victorian" Genre Painting* (London: 1982).

Lambourne, Lionel, and Jean Hamilton. *British Watercolours in the Victoria and Albert Museum* (London: 1980).

Lamont, L. M., ed. *Thomas Armstrong, CB: A Memoir* (London: 1912).

Landow, George. *William Holman Hunt and Typological Symbolism* (New Haven: 1979).

Lane, Christopher. "The Drama of the Imposter: Dandyism and its Double," *Cultural Critique* 28 (Fall 1994), 29–52.

Langford, John Alfred. *A Century of Birmingham Life* (Birmingham: 1868).

Lears, T. J. Jackson. "The Concept of Cultural Hegemony: Problems and Possibilities," *American Historical Review* 90 (June 1985), 567–93.

Lefevre Gallery. *Alex Reid and Lefevre, 1926–1976* (London: 1976).

Lethaby, William Richard. *Philip Webb and his Work* (London: 1935).

Lethève, Jacques. "La Connaissance des peintres Préraphaélites anglais en France (1855–1900)," *Gazette des Beaux-Arts* 53 (1959), 315–28.

Lewis, Brian. "Thomas E. Plint – a Patron of Pre-Raphaelite Painters," *The Pre-Raphaelite Review* 3 (May 1980), 77–101.

Lillie, William. *The History of Middlesbrough* (Middlesbrough: 1968).

Lippincott, Louise. *Selling Art in Georgian London: The Rise of Arthur Pond* (New Haven: 1983).

Lister, Richard. *Victorian Narrative Painting* (London: 1966).

(Lister, T. H.) Review of Allan Cunningham, *Lives of the Most Eminent British Painters, Sculptors, and Architects, Edinburgh Review* 59 (April 1834), 53–64.

Lockett, Richard. *Samuel Prout, 1783–1852* (London: Victoria and Albert Museum, 1985).

Loftie, Rev. William J. *Kensington Picturesque and Historical* (London: 1888).
 A Plea for Art in the House (London: 1876; rpt. New York: 1978).

Lugt, Frits. *Répertoire des catalogues de ventes*, 4 vols. (The Hague: 1938–87).

Lunn, Eugene. *Marxism and Modernism* (Berkeley: 1982).

Lutyens, Mary. *Millais and the Ruskins* (London: 1967).

Lyotard, Jean-François. *The Postmodern Condition: A Report on Knowledge*, transl. Geoff Bennington and Brian Massumi (Minneapolis: 1984).

Maas, Jeremy. *Gambart: Prince of the Victorian Art World* (London: 1975).
 Holman Hunt and the Light of the World (London and Berkeley: 1984).
 "S. C. Hall and the *Art Journal*," *Connoisseur* 191 (March 1976), 206–9.
 The Victorian Art World in Photographs (New York: 1984).

Macaulay, Thomas Babington. *The History of England from the Accession of James II*, 5 vols. (1849; rpt. New York [n.d., *c.* 1879])

MacColl, Dugald Sutherland. *The Administration of the Chantrey Bequest* (London: 1904).

Macleod, Dianne Sachko. "Armstrong the Collector," in *Cragside* (London: National Trust, 1992), pp. 35–42.

"Art Collecting and Victorian Middle-Class Taste," *Art History* 10 (Sept. 1987), 328–50.

"Avant-Garde Patronage in the North East," in *Pre-Raphaelite Painters and Patrons in the North East* (Newcastle: Laing Art Gallery, 1989), pp. 9–37 and 125–31.

"The Dialectics of Modernism and English Art," *British Journal of Aesthetics* 35 (Jan. 1995), 1–14.

"Mid-Victorian Patronage of the Arts: F. G. Stephens's 'The Private Collections of England,'" *Burlington* 128 (Aug. 1986), 597–607.

"Private and Public Patronage in Victorian Newcastle," *Journal of the Warburg and Courtauld Institutes* 52 (1989), 188–208.

Macmillan, Hugh. *The Life-Work of George Frederick Watts* (London: 1903).

Mainardi, Patricia. *Art and Politics of the Second Empire: The Universal Expositions of 1855 and 1867* (New Haven: 1987).

Manson, James Bolivar. *The Tate Gallery* (London: 1929).

Margaux, Adrian. "The Art of Edward John Poynter," *Windsor Magazine* (1905), 67–82.

Marillier, Henry Currie. *"Christie's" 1766 to 1925* (London: 1926).

Marsh, Jan. *Pre-Raphaelite Sisterhood* (London: 1985).

Marshall, Alfred. "The Present Position of Economics" (1885), in *Memorials of Alfred Marshall*, ed. A. C. Pigou. (London: 1925; rpt. New York: 1956), pp. 152–74.

Marx, Karl. *Capital: A Critique of Political Economy* (1867–94), 3 vols., transl. David Fernbach (New York: 1981).

Karl Marx: Selected Writings, ed. David McLellan. (Oxford: 1977).

Marx, Karl, and Frederick Engels. *Karl Marx and Frederick Engels, Collected Works*, 41 vols. (New York: 1975–85).

McCarthy, Kathleen D. *Women's Culture: American Philanthropy and Art, 1830–1930* (Chicago: 1991).

McKerrow, Mary. *The Faeds* (Edinburgh: 1982).

Melada, Ivan. *The Captain of Industry in English Fiction, 1821–1871*. (Albuquerque: 1970).

Merrill, Linda. *A Pot of Paint: Aesthetics on Trial in Whistler v. Ruskin* (Washington, D.C.: 1992).

Metcalf, Priscilla. *James Knowles: Victorian Editor and Architect* (Oxford: 1980).

Metropolitan Museum of Art. *Degas* (New York: 1988).

Middlemas, Robert K. *The Master Builder* (London: 1963).

Mill, John Stuart. *On Liberty* (London: 1859; rpt. Boston: 1864).

Millais, John Guille. *The Life and Letters of Sir John Everett Millais*, 2 vols. (London: 1899).

Miller, David. C., ed. *American Iconology* (New Haven: 1993).

Mills, Ernestine, ed. *Life and Letters of Frederic Shields* (London: 1912).

Minihan, Janet. *The Nationalization of Culture* (London: 1977).

Modernism and Modernity: The Vancouver Conference Papers, ed. Benjamin H. D. Buchloh, S. Guibaut, and D. Solkin (Halifax, Nova Scotia: 1983).

Morris, Edward. "John Naylor and Other Collectors of Modern Paintings in Nineteenth-Century Britain," *Annual Report and Bulletin*, Walker Art Gallery, Liverpool, 5 (1974–75), 72–101.

"Paintings and Sculpture," in *Lord Leverhulme: A Great Edwardian Collector and Builder* (London: Royal Academy, 1980), pp. 9–82.

"Philip Henry Rathbone and the Purchase of Contemporary Foreign Paintings for the Walker Art Gallery, Liverpool, 1871–1914," *Annual Report and Bulletin*, Walker Art Gallery, Liverpool, 6 (1975–76), 58–80.

Morris, Robert John. *Class and Class Consciousness in the Industrial Revolution 1780–1850* (London: 1979).

ed. *Class, Power and Social Structure in British Nineteenth-Century Towns* (Leicester: 1986).

Morris, William. *The Collected Letters of William Morris*, 2 vols., ed. Norman Kelvin (Princeton: 1984–87).

The Letters of William Morris to his Family and Friends, ed. Philip Henderson (London and New York: 1950).

Muensterberger, Werner. *Collecting: An Unruly Passion* (Princeton: 1994).

Mukerji, Chandra. *From Graven Images: Patterns of Modern Materialism* (New York: 1983).

Mukerji, Chandra, and Michael Schudson, eds. *Rethinking Popular Culture: Contemporary Perspectives in Cultural Studies* (Berkeley: 1991).

Mulhall, Michael. *Balance-Sheet of the World for Ten Years, 1870–1880* (London: 1881).

Mulvey, Laura. "Visual Pleasure and Narrative Cinema," in *Feminism and Film Theory*, ed. Constance Penley (New York: 1988), pp. 57–68.

Musson, Albert Edward, and Eric Robinson. *Science and Technology in the Industrial Revolution* (Manchester: 1969).

Myers, Frederick. "Rossetti and the Religion of Beauty," *Cornhill Magazine* 47 (1883), 213–24.

National Gallery, London. *"Noble and Patriotic": The Beaumont Gift 1828* (London: 1988).

National Gallery, Millbank. *Catalogue of the British School* (London: 1924).

Naylor, Gillian. *The Arts and Crafts Movement: A Study of its Sources, Ideals and Influence on Design Theory* (London: 1971).

Nead, Lynda. *Myths of Sexuality: Representations of Women in Victorian Britain* (Oxford: 1988).

Nicoll, John. *The Pre-Raphaelites* (London: 1970).

A New Biographical Dictionary of Contemporary Public Characters (London: 1825).

Nochlin, Linda. "The Imaginary Orient," in her *The Politics of Vision* (New York: 1989), pp. 35–57.

Nunn, Pamela Gerrish. *Victorian Women Artists* (London: 1987).

O'Hagan, H. Osborne. *Leaves from My Life*, 2 vols. (London: 1929).

Olsen, Donald. *The Growth of Victorian London* (Harmondsworth: 1976).

Orchard, B. Gurness. *Liverpool's Legion of Honour* (Birkenhead: 1893).

Ormond, Leonée. *George Du Maurier* (London: 1969).

Ormond, Richard. *Daniel Maclise, 1806–1870* (London: Arts Council, 1972).
 Sir Edwin Landseer (Philadelphia and London: 1981).
 "Victorian Paintings and Patronage in Birmingham," *Apollo* 87 (April 1968), 240–51.

Ormond, Richard, and Leonée Ormond. *Lord Leighton* (London: 1975).

Owen, David. *English Philanthropy, 1600–1960* (Cambridge, Mass.: 1964).

Palgrave, Francis. *Essays on Art* (New York: 1867).
 Handbook to the International Exhibition (London: 1862).

Papworth, John W., and Wyatt Papworth. *Museums, Libraries, and Picture Galleries, Public and Private* (London: 1853).

Parker, Stanley. *The Future of Work and Leisure* (London: 1971).

Parkinson, Ronald. *Catalogue of British Oil Paintings, 1820–1860* (London: Victoria and Albert Museum, 1990).

Parris, Leslie, ed. *Pre-Raphaelite Papers* (London: 1984).

Parry, Jonathan, and Maurice Bloch, eds. *Money and the Morality of Exchange* (Cambridge: 1989).

Pears, Iain. *The Discovery of Painting: The Growth of Interest in the Arts in England, 1680–1768* (New Haven and London: 1988).

Pêcheux, Michel. *Language, Semantics and Ideology: Stating the Obvious*, transl. Harbans Nagpal (London: 1982).

Pennell, Elizabeth Robins, and J. Pennell. *The Life of James McNeill Whistler*, 2 vols. (London: 1908).

Perkin, Harold. *Origins of Modern English Society* (London: 1969; rpt. 1985).

Pevsner, Nikolaus. *The Buildings of England: South Lancashire* (Harmondsworth: 1969).

Phillipps, Kenneth C. *Language and Class in Victorian England* (Oxford: 1984).

Physick, John Frederick. *The Victoria and Albert Museum, the History of its Building* (Oxford: 1982).

Pidgley, Michael. "Cotman and his Patrons," in *John Sell Cotman*, ed. Miklos Rajnai (London: 1982), pp. 20–22.

Pietz, William. "Fetishism and Materialism: The Limits of Theory in Marx," in *Fetishism as Cultural Discourse*, ed. Emily Apter and W. Pietz (Ithaca: 1993), pp. 119–51.

Poggiolo, Renato. *The Theory of the Avant-Garde*, transl. Gerald Fitzgerald (Cambridge, Mass.: 1968).

Pointon, Marcia. "'Voisins et Alliés': The French Critics' View of the English Contribution to the Beaux-Arts Section of the Exposition Universelle in 1855," in *Saloni, gallerie, musei e loro influenza sullo sviluppo dell'arte dei secoli XIX e XX*, ed. Francis Haskell (Bologna: 1979), pp. 115–22.

"W. E. Gladstone as an Art Patron and Collector," *Victorian Studies* 19 (Sept. 1975), 73–98.

William Dyce: A Critical Biography (Oxford: 1979).

William Mulready 1786–1863 (London: Victoria and Albert Museum, 1986).

ed. *Pre-Raphaelites Re-Viewed* (Manchester: 1989).

Pollock, Griselda. *Vision and Difference: Femininity, Feminism and the Histories of Art* (London and New York: 1988).

Pope, Willard Bissell, ed. *The Diary of Benjamin Robert Haydon*, 5 vols. (Cambridge, Mass.: 1960–63).

Poynter, Edward. *Ten Lectures on Art* (London: 1880).

Pratt, A. T. C., ed. *People of the Period*, 2 vols. (London: 1897).

Presents from the Past: Gifts to Greater Manchester Galleries from Local Art Collectors (Manchester: 1978).

Prochaska, F. K. *Women and Philanthropy in Nineteenth-Century England* (Oxford: 1980).

Pye, John. *Patronage of British Art, an Historical Sketch* (London: 1845).

Rathbone, Philip H. *Realism, Idealism and the Grotesque in Art: Their Limits and Functions* (Liverpool: 1877).

Redford, George. *Art Sales: A History of Sales of Pictures and Other Works of Art*, 2 vols. (London: 1888).

Redgrave, F. M. *Richard Redgrave: A Memoir Compiled from his Diary* (London: 1891).

Redgrave, Richard, and Samuel Redgrave. *A Century of British Painters* (London: 1866; rpt. 1947).

Reed, M. C., ed. *Railways in the Victorian Economy* (New York: 1968).

Reitlinger, Gerald. *The Economics of Taste* (New York: 1961).

Reynolds, Graham. *Catalogue of the Constable Collection* (London: 1973).

Painters of the Victorian Scene (London: 1953).

Victorian Painting (London: 1966).

Reynolds, Simon. *The Vision of Simeon Solomon* (Stroud, Glos.: 1984).

Richards, Thomas. *The Commodity Culture of Victorian England* (Stanford: 1990).

Roberts, David. *Paternalism in Early Victorian England* (New Brunswick, N.J.: 1979).

Roberts, Helene. "Exhibition and Review: The Periodical Press and the Victorian Art Exhibition System," in *The Victorian Periodical Press*, ed. Joanne Shattock and Michael Wolff (Leicester: 1982), pp. 79–107.

"'The Sentiment of Reality': Thackeray's Art Criticism," *Studies in the Novel* 13 (Spring–Summer 1981), 21–39.

Roberts, William. *Memorials of Christie's: A Record of Art Sales from 1766 to 1896*, 2 vols. (London: 1897).

Robertson, David. *Sir Charles Eastlake and the Victorian Art World* (Princeton: 1978).

Rodée, Howard D. "France and England: Some Mid-Victorian Views of One Another's Painting," *Gazette des Beaux-Arts* 91 (Jan. 1978), 39–48.

Rolt, Lionel Thomas Caswell. *Victorian Engineering* (London: 1970).

Rosenberg, John D. *The Darkening Glass: A Portrait of Ruskin's Genius* (New York: 1986).

Rossetti, Dante Gabriel. *Dante Gabriel Rossetti and Jane Morris: Their Correspondence*, ed. John Bryson and J. C. Troxell (London: 1976).

 Gabriel Charles Dante Rossetti: The Works, ed. William Michael Rossetti (London: 1911).

 Letters of Dante Gabriel Rossetti, ed. Oswald Doughty and J. R. Wahl, 4 vols. (Oxford: 1965–67).

 Letters of Dante Gabriel Rossetti to William Allingham, 1854–1870, ed. George Birkbeck Hill (London: 1897).

 The Owl and the Rossettis, ed. C. L. Cline (University Park, Penn.: 1978).

 The Rossetti–Leyland Letters, ed. Francis Fennell Jr. (Athens, Ohio: 1978).

Rossetti, William Michael. *Dante Gabriel Rossetti as Designer and Writer* (London: 1889).

 Dante Gabriel Rossetti: His Family Letters, with a Memoir, 2 vols. (London: 1895).

 Diary of William Michael Rossetti, 1870–1873, ed. Odette Bornand (Oxford: 1977).

 Praeraphaelite Diaries and Letters (London: 1900).

 Rossetti Papers, 1862–1870 (London: 1903).

 Ruskin: Rossetti: Preraphaelitism (London: 1899).

Rowley, Charles. *Fifty Years of Work without Wages* (London: 1912).

Rubinstein, W. D. "Wealth, Elites and the Class Structure of Modern Britain," *Past and Present* 76 (Aug. 1977), 99–126.

Ruskin, John. *The Complete Works of John Ruskin*, ed. E. T. Cook and Alexander Wedderburn, 39 vols. (London: 1903–12).

 Diaries of John Ruskin, ed. J. Evans and John Whitehouse (Oxford: 1956–59).

 Ruskin in Italy: Letters to his Parents, 1845, ed. Harold Shapiro (Oxford: 1972).

Saint, Andrew. *Richard Norman Shaw* (New Haven: 1976).

Saisselin, Rémy. *The Bourgeois and the Bibelot* (New Brunswick, N.J.: 1984).

Saler, Michael. "Medieval Modernism: The Legitimation and Social Function of Modern Art in England, 1910–1945," unpubl. Ph.D. diss., Stanford University, 1992.

Schofield, Robert E. *The Lunar Society of Birmingham* (Oxford: 1963).

Scott, John. *The Upper Classes: Property and Privilege in Britain* (London: 1982).

Scott, William Bell. *Autobiographical Notes of the Life of William Bell Scott*, 2 vols., ed. W. Minto (New York: 1892).

Sekora, John. *Luxury, the Concept in Western Thought, Eden to Smollett* (Baltimore: 1977).

Seltzer, Alexander. "Alphonse Legros: The Development of an Archaic Visual Vocabulary in Nineteenth-Century Art," unpubl. Ph.D. diss., Graduate School of the State University of New York at Binghamton, 1980.

Sherburne, James Clark. *John Ruskin or the Ambiguities of Abundance: A Study in Social and Economic Criticism* (Cambridge, Mass.: 1972).

Shils, Edward. *Tradition* (Chicago: 1981).

Sim, Katharine. *David Roberts RA, 1796–1864: A Biography* (London and New York: 1984).

Simmel, Georg. *The Philosophy of Money* (1900), transl. Tom Bottomore and David Frisby (London: 1990).

Sitwell, Sacheverell. *Narrative Pictures* (London: 1937).

Smiles, Samuel. *Industrial Biography: Iron Workers and Tool Makers* (London: 1863). *Thrift: A Book of Domestic Counsel* (London: 1875; rpt. 1929).

Smith, Adam. *An Enquiry into the Nature and Causes of the Wealth of Nations*, 3 vols. (London: 1752; rpt. 1776; Chicago: 1976).

Smith, Dennis. *Conflict and Compromise: Class Formation in English Society, 1830–1914* (London and Boston: 1982).

Smith, Helen. *Decorative Painting in the Domestic Interior in England and Wales, c. 1850–1890* (New York: 1984).

Solkin, David. *Painting for Money: The Visual Arts and the Public Sphere in Eighteenth-Century England* (New Haven and London: 1993).

Solly, N. Neal. *Memoir of the Life of David Cox* (London: 1873). *Memoir of the Life of William James Müller* (London: 1875).

Spalding, Frances. *Roger Fry: Art and Life* (London: 1980).

Spencer, Robin. "Whistler's First One-Man Exhibition Reconstructed," in *The Documented Image: Visions in Art History*, ed. Gabriel P. Weisberg, L. S. Dixon, and A. B. Lemke (Syracuse: 1987), pp. 27–49.

Staley, Allen. *The Pre-Raphaelite Landscape* (Oxford: 1973).

Starkey, Pat, ed. *Riches into Art: Liverpool Collectors 1770–1880* (Liverpool: 1993).

Steegman, John. *Consort of Taste 1830–1870* (London: 1950).

Stephens, Frederic George. *Dante Gabriel Rossetti* (London: 1894; rpt. 1908). *William Holman Hunt and his Works: A Memoir of the Artist's Life with Descriptions of his Pictures* (London: 1860).

Stewart, Susan. *On Longing: Narratives of the Miniature, the Gigantic, the Souvenir, the Collection* (1984; rpt. Durham, N.C.: 1993).

Stillman, William James. *The Autobiography of a Journalist* (Boston: 1901)

Stone, Lawrence, and Jeanne F. Stone. *An Open Elite? England 1540–1880* (Oxford: 1984).

Story, Alfred Thomas. *The Life of John Linnell*, 2 vols. (London: 1892).

Strong, Roy. *And When Did You Last See Your Father? The Victorian Painter and British History* (London: 1978).

Surtees, Virginia. *The Artist and the Autocrat: George and Rosalind Howard, Earl and Countess of Carlisle* (London: 1988).

 The Paintings and Drawings of Dante Gabriel Rossetti (1828–1882): A Catalogue Raisonné, 2 vols. (Oxford: 1971)

 ed. *The Diaries of George Price Boyce* (Norwich: 1980).

 ed. *The Diary of Ford Madox Brown.* (New Haven and London: 1981).

 ed. *Reflections of a Friendship: John Ruskin's Letters to Pauline Trevelyan, 1848–1866* (London: 1979).

 ed. *Sublime and Instructive: Letters from John Ruskin to Louisa, Marchioness of Waterford, Anna Blunden and Ellen Heaton* (London: 1972).

Survey of London, 42 vols. (London: 1900–).

Swanson, Vern. *The Biography and Catalogue Raisonné of the Paintings of Sir Lawrence Alma-Tadema* (London: 1990).

Swinburne, Algernon Charles. *Notes on the Royal Academy Exhibition* (London: 1868).

 The Swinburne Letters, ed. Cecil Y. Lang, 6 vols. (New Haven: 1959).

Taine, Hippolyte. *Taine's Notes on England* (1870), transl. Edward Hyams (London: 1957).

Tate Gallery. *Constable: The Art of Nature* (London: 1971).

 The Pre-Raphaelites (London: 1984).

Tawney, Richard Henry. *The Acquisitve Society* (New York: 1920).

Taylor, Hilary. *Whistler* (New York: 1978).

Taylor, Rev. Richard Vickerman. *Biographia Leodiensis* (Leeds: 1865).

Taylor, Tom. *Autobiographical Recollections by the Late Charles Robert Leslie, RA*, 2 vols. (London: 1860).

Temple, Alfred George. *Guildhall Memories* (London: 1918).

Thackeray, William Makepeace. *The Four Georges* (London: 1856).

 The Letters and Private Papers of William Makepeace Thackeray, 4 vols., ed. Gordon N. Ray (Cambridge, Mass.: 1945–46).

 The Newcomes, 2 vols. (London: 1855).

Thackray, Arnold. "Natural Knowledge in Cultural Context: The Manchester Model," *American Historical Review* 79 (June 1974), 672–709.

Thomas, Ralph. *Serjeant Thomas and Sir J. E. Millais* (London and Toronto: 1901)

Thompson, Francis Michael Longsbreth. *English Landed Society in the Nineteenth Century* (London and Toronto: 1963).

 "Britain," in *European Landed Elites in the Nineteenth Century*, ed. David Spring (Baltimore: 1977), pp. 22–44.

 "Painter of Victorian Life," *History Today* 33 (Jan. 1983), 42–44.

 The Rise of Respectable Society: A Social History of Victorian Britain (Cambridge, Mass.: 1988).

Thornbury, Walter. *The Life of J. M. W. Turner, RA* (1862; rpt. London: 1904, 1970).

Tilly, Louise A., and Joan W. Scott. *Women, Work, and Family* (New York: 1978).

Treuherz, Julian. *Hard Times: Social Realism in Victorian Art* (Manchester: 1987).

"The Turner Collector: Henry McConnel, Cotton Spinner," *Turner Studies* 6 (Winter 1986), 37–42.

Trevelyan, Raleigh. *A Pre-Raphaelite Circle* (London: 1978).

Trollope, Anthony. *The Way We Live Now* (1874–75), ed. Robert Tracy (Indianapolis: 1974).

Tupper, John. "The Subject in Art." *The Germ* (March 1850); rpt. Oxford: Ashmolean Library, 1979, pp. 118–25.

Tylecote, Mabel. *The Mechanics' Institutes of Lancashire and Yorkshire before 1851* (Manchester: 1957).

Tyne and Wear County Council Museums. *The Spectacular Career of Clarkson Stanfield, 1793–1867: Seaman, Scene-Painter, Royal Academician* (Newcastle-upon-Tyne: 1979)

Tyrrell, Alexander. "Class Consciousness in Early Victorian Britain: Samuel Smiles, Leeds Politics, and the Self-Help Creed," *Journal of British Studies* 9 (May 1970), 102–25.

Usherwood, Paul, and Jenny Spencer-Smith. *Lady Butler, Battle Artist, 1846–1933* (Gloucester: 1987).

Uwins, Sarah. *A Memoir of Thomas Uwins, RA,* 2 vols. (London: 1858).

Vaughan, William. "The Englishness of British Art," *Oxford Art Journal* 13 (1990), 11–23.

Venturi, Lionello. *Les Archives de l'Impressionisme,* 2 vols. (Paris and New York: 1939).

Victoria and Albert Museum. *Arthur Boyd Houghton* (London: 1975).

Waagen, Gustav. *Galleries and Cabinets of Art in Great Britain.* (London: 1857).

Treasures of Art in Great Britain, 3 vols. (London: 1854).

Works of Art and Artists in England, 3 vols. (London: 1838).

Wainwright, Clive. *The Romantic Interior: The British Collector at Home* (New Haven and London: 1989).

Walker Art Gallery. *Merseyside Painters, People and Places* (Liverpool: 1978).

Walkley, Giles. *Artists' Houses in London, 1764–1914* (Aldershot: 1994).

Walpole, Horace. *Anecdotes of Painting in England,* 4 vols. (London: 1765–71).

Walton, Kendall. *Mimesis as Make-Believe* (Cambridge, Mass.: 1990).

Ward, Mrs. E. M. (Henrietta Mary Ada). *Memories of Ninety Years* (New York: 1924).

Warner, Malcolm John. "The Professional Career of John Everett Millais to 1863, with a Catalogue of Works to the Same Date," unpubl. Ph.D. diss., University of London, Courtauld Institute of Art, 1985.

Waterhouse, Ellis. *Painting in Britain 1530 to 1790* (Harmondsworth: 1953).

Waters, Chris. *British Socialists and the Politics of Popular Culture* (Manchester: 1990).

"Manchester Morality and London Capital: The Battle over the Palace of Varieties," in *Music Hall: The Business of Pleasure,* ed. Peter Bailey (Milton Keynes: 1986), pp. 141–61.

"Socialism and the Politics of Popular Culture in Britain, 1884–1914," unpubl. Ph.D. diss. Harvard University, 1985.

Watkinson, Raymond. *Pre-Raphaelite Art and Design* (Greenwich, Conn.: 1970).

Watts, Mary S. *George Frederic Watts: The Annals of an Artist's Life*, 3 vols. (London: 1912).

West, Shearer. "Tom Taylor, William Powell Frith, and the British School of Art," *Victorian Studies* 33 (Winter 1990), 307–26.

White, Cynthia, and Harrison White. *Canvases and Careers: Institutional Change in the French Painting World* (New York: 1965).

Whitechapel Art Gallery. *G. F. Watts, 1817–1904* (London: 1974).

Whitley, William. *Art in England, 1800–1820* (Cambridge: 1928).
 Art in England, 1821–1837 (Cambridge: 1930).

Whittingham, Selby. "A Most Liberal Patron: Sir John Fleming Leicester, Bart., 1st Baron de Tabley, 1762–1827," *Turner Studies* 6 (1986), 24–36.

Wiener, Martin. *English Culture and the Decline of the Industrial Spirit, 1850–1980* (Cambridge: 1981).

Williams, Raymond. *The Sociology of Culture* (New York: 1981).

Williams, R. Folkestone. "English Pictures and Picture-Dealers," *Belgravia* 2 (May 1867), 288–94.

Williamson, George Charles. *Murray Marks and his Friends* (London: 1919).

Wilson, R. G. *Gentleman Merchants: The Merchant Community in Leeds, 1700–1830* (Manchester: 1971).

Wilton, Andrew. "The 'Monro School' Question: Some Answers," *Turner Studies* 4 (1984), 8–23.

Witt, Sir John. *William Henry Hunt (1790–1864): Life and Work* (London: 1982).

Wolff, Janet. "The Problem of Ideology in the Sociology of Art: A Case Study of Manchester in the Nineteenth Century," *Media, Culture and Society* 4 (1982), 63–75.
 The Social Production of Art (1981; rpt. New York: 1984).

Wolff, Janet, and J. Seed, eds. *The Culture of Capital: Art, Power, and the Nineteenth-Century Middle Class* (Manchester and New York: 1988)

Wolverhampton Art Gallery. *William Henry Hunt 1790–1864* (Wolverhampton: 1981).

Woolner, Amy. *Thomas Woolner, RA, Sculptor and Poet* (New York: 1917)

Young, Andrew McLaren, Margaret F. Macdonald, Robin Spencer, and Hamish Miles. *The Paintings of James McNeill Whistler* (New Haven: 1980).

Young, George Malcolm, ed. *Early Victorian England, 1839–1865*, 2 vols. (London: 1934).

Zelizer, Viviana. *The Social Meaning of Money* (New York: 1994).

Index

Numbers in **bold** refer to the plate numbers of illustrations.